D1361284

*Achille Bocchi and the Emblem Book as Symbolic Form* examines the life and work (the *Symbolicae Quaestiones*) of one of the sixteenth century's greatest intellectuals. Esteemed by his contemporaries, Achille Bocchi was a renowned poet, teacher of rhetoric, local historian, publisher, and founder of a literary academy in Bologna. Part One of this study establishes the life of and intellectual context for Bocchi, who is here presented as a participant in the debates at the academy and university and as an individual whose views were shaped by the syncretic philosophical currents of his time. No evidence supports the widely held view that Bocchi concealed heretical leanings in his writings. Part Two explores poetic theory and the role of the symbol in the development of Bocchi's *symbola* and also examines the rhetorical strategies of paradox and the symbolism of mythology as they shape the content of his work. The iconography of the emblematic units of poem, engraving, and motto in the *Symbolicae Quaestiones* and the related facade design of Bocchi's *palazzo* are revealed to be a programmatic statement of Bocchi's interrelated projects, all of which were informed by the intellectual and cultural themes of his day.

# ACHILLE BOCCHI
# AND THE EMBLEM BOOK
# AS SYMBOLIC FORM

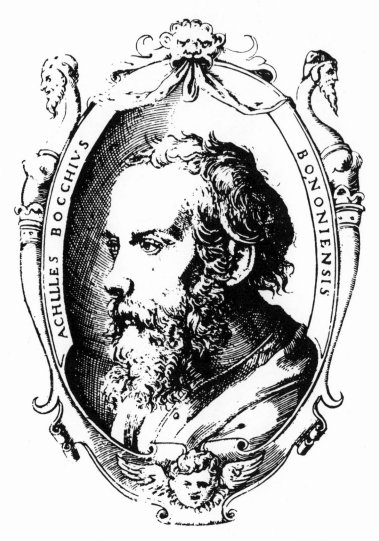

Portrait of Achille Bocchi. *Symbolicarvm Qvaestionvm. . . . Libri Qvinqve.*
Bologna, 1555, Symb. II. By courtesy of the Princeton University
Libraries.

# ACHILLE BOCCHI
# AND THE EMBLEM BOOK
# AS SYMBOLIC FORM

ELIZABETH SEE WATSON

CAMBRIDGE
UNIVERSITY PRESS

Published by the Press Syndicate of the University of Cambridge
The Pitt Building, Trumpington Street, Cambridge CB2 IRP
40 West 20th Street, New York, NY 10011-4211, USA
10 Stamford Road, Oakleigh, Melbourne 3166, Australia

First published 1993

Printed in the United States of America

*Library of Congress Cataloging-in-Publication Data*
Watson, Elizabeth See.
Achille Bocchi and the emblem book as symbolic form / Elizabeth
See Watson.
p.   cm.
Based on the author's thesis (doctoral) – Johns Hopkins University.
Includes bibliographical references and index.
ISBN 0-521-40057-0
1. Bocchi, Achille, 1488–1562. Symbolicarum quaestionum de
universo genere.   2. Bocchi, Achille, 1488–1562 – Criticism and
interpretation.   3. Emblems – Italy – Early works to 1800.
4. Symbolism in art – Italy.   I. Title.
N7740.W38   1993
704.9'46 – dc20                        92-20390
                                              CIP

A catalog record for this book is available from the British Library.

ISBN 0-521-40057-0  hardback

*372607*

# Contents

# *Illustrations*

---

Illustrations follow page 260.

# *Preface*

I have conceived of this book as an introduction to Achille Bocchi and his Symbolic Questions rather than as a definitive study of the emblems by themselves. For this reason, I have stressed Bocchi's debt both to his Bolognese ambiance and to a broad range of intellectual and cultural strands. Bocchi's work may seem atypical for the sixteenth century, but it was not without precedent.

For references within the text and for the symbol numbers I have used the 1572 edition of the *Symbolicae Quaestiones* because it is available in reprint form, because the order and number of its symbols have been standardized, and because in it the errata of the first edition have been corrected. However, I have reproduced illustrations from the original 1555 edition (two copies were used) in order to show the engravings as they looked to Bocchi himself, because most modern reproductions come from retouched plates. I have expanded abbreviations in italics but have not modernized the spelling.

Those to whom I owe my thanks are legion. First and foremost are Nancy Struever and Elizabeth Cropper of The Johns Hopkins University, who were dissertation advisers for this work in its thesis form and who kindly read the revised and expanded version (or parts of it) and offered comments and continuing encouragement. The suggestions and support of other members of the dissertation committee, of Humanities Center faculty, and of Charles Dempsey have been most valuable.

Without the assistance of graduate fellowships from the Humanities Center and from the Charles S. Singleton Center for Italian Studies in Florence, I could never have undertaken any serious research on Bocchi. I especially appreciate the Getty Center for the History of Art and the Humanities for its Post-Doctoral Fellowship, which gave me time to turn my dissertation into a book; with its helpful staff, its facilities and library, and its access to other Los Angeles–area institutions, the Center proved a most congenial base for productive labor.

I also have all the libraries and librarians I consulted to thank. I did the basic research at the Milton S. Eisenhower Library of The Johns Hopkins University, where the Special Collections and the most helpful Interlibrary Loan Departments

contributed to my progress. Also in the United States, I had access to the collections of the Library of Congress, the Folger Library, the University of California at Los Angeles Library, and the University Library of Princeton University, besides the Getty Center Library. In Italy, the library staffs of the University of Bologna and the Archiginnasio of Bologna, the Riccardiana, the Laurenziana, the Kunsthistorisches Institut, the National Library of Florence, and the Vatican Library patiently assisted my research.

In addition, I am most grateful to Thomas Marier for his assistance in revising my translations of, and in some cases himself translating, the Latin passages. He generously shared his time with me to thrash out problems.

Finally, I want to recognize the support of my family and especially of Amanda, who understands the writing process.

# Achille Bocchi:
# A Life
# in Its Context

# The Early Years

On dit qu'Achille, en remaschant son ire,
De tels plaisirs souloit s'entretenir,
Pour addoulcir le triste souvenir
De sa maistresse, aux fredons de sa lyre.
(Joachim Du Bellay, *Les Regrets*)[1]

When the *Symbolicae Quaestiones* appeared in print in 1555, its author was sixty-six or sixty-seven years of age. The book had evolved over many years and recorded the literary, philosophical, and cultural trends of half a century. Its author, Achille Bocchi, either through the accidents of history or through an innate cautiousness, remains a somewhat shadowy and ambivalent figure, the product of a period of turmoil and change that is itself not fully understood. His vision, expressed in the union of verbal and visual symbols, requires a new introduction.

To what extent, however, can a modern biographer get beyond the bare and scattered facts of a sixteenth-century life? How much can the biographer reconstruct the ideas that nourished a sixteenth-century work without in the process freighting them with twentieth-century notions of the Renaissance? In order to determine "the precise location of our ignorance," in the words of Bernard O'Kelly, we need to reconsider both the life and times of the subject.[2] The study of an author's life in its context still offers one way to trace the threads through the labyrinth of a complex work of art. Yet the validity of this pursuit will always be tempered by the problems E. H. Gombrich found inherent in the "old-fashioned biography of the 'Life and Letters' type":

> The average academic lacks the nerve to deal with a man of the past who was not also a specialist. Nor is his reluctance dishonourable; we know how little me know about human beings and how little of the evidence we have would satisfy a psychologist interested in the man's character and motives. The increasing awareness of our ignorance about human motives has led to a crisis of self-confidence.[3]

Nevertheless, the desire to know more about Bocchi and his vision is enough to impel this researcher to risk the charge of superabundance of nerve or even of "vana curiositas." But because not even Bocchi's contemporaries could paint a clear picture of him, there will be no attempt to provide a psychological portrait of Bocchi here.

Achille Bocchi had no contemporary biographer. A manuscript dated 1587 with the title "Informat[ion]e della familg[i]a et propria linea di Fran[cesc]o Bocchj..." (Bologna, Archiginnasio, MS. B. 470, no. 9), which contains materials gathered to prove the family's nobility, provides some details and their dates of Bocchi's career. The earliest printed biography is the brief notice in Giovanni Nicolò Pasquali Alidosi's *Dottori bolognesi di teologia, filosofia, medicina, e d'arti liberali dall'anno 1000 per tutto marzo del 1623.*[4] Another brief seventeenth-century account appears in Pompeo Scipione Dolfi's *Cronologia delle famiglie nobili di Bologna.*[5] By the eighteenth century, a greater interest in Bocchi as a writer, and in the works of writers in general, led to entries in Pellegrino Antonio Orlandi's *Notizie degli scrittori bolognesi*, Francesco Saverio Quadrio's *Della storia e della ragione d'ogni poesia*, Giammaria Mazzuchelli's *Gli scrittori d'Italia*, and Giovanni Fantuzzi's *Notizie degli scrittori bolognesi.*[6] Fantuzzi, the last of this group to write, gives the most detailed account; he includes the texts of some documents available to him and is generally reliable except when attempting to reconcile conflicting earlier accounts.[7] The major biography presently available is that contributed by Antonio Rotondò to the *Dizionario biografico degli Italiani (DBI)*, which, although carefully researched and thorough, reflects Rotondò's preoccupation with Bocchi as a supporter of Catholic reform.[8]

Part I of this study assumes that the making of Achille Bocchi's *Symbolicae Quaestiones* cannot be fully understood without some grasp of the author and his personality, his family and social standing, his teachers and colleagues, and his personal friends and enemies and of the outstanding events and ideas of Bocchi's times. Although all these factors have been taken into account in the ensuing chapters, it has not always been possible to discuss them chronologically. This first chapter takes Bocchi from his birth through the early stages of his public teaching.

### Bocchi's Birth and Education

Achille Bocchi was born into a patrician family in Bologna, Italy, in 1488. The Bocchi family had had associations with the Studio (University) of Bologna since the early fifteenth century when Giovanni Bocchi (or Bucchi) taught natural philosophy and medicine there. After his death, Giovanni's daughter Dorotea (fl. ca. 1417–33) was said to have continued teaching his students both in private and in public lectures.[9] Achille's cousin, Romeo Bocchi, taught law for many years until his death in 1577. Of Bocchi's immediate family not too much is known. One sister, a nun, Suor Giulia in the Convent of Santa Cristina, was a beneficiary of Bocchi's will of 1556.[10] His mother, Constantia Zambeccari Bocchi, also came from a noble family with ties to the Studio. His father, Giulio, served Bologna as a member of the *Anziani* (Senate) in 1497 and probably was a merchant.[11] The Bocchi family were partisans of the ruling Bentivoglio line, which had maneuvered by shifting alliances with Florence and Milan and, between 1474 and 1506, with the invading French forces to maintain the power it had seized from the Papal State.[12]

All that is certain about Bocchi's education is that he had as his principal teacher Giovanni Battista Pio degli Andali, who was born in Bologna around 1475 and died in Rome after 1537. Before reaching grammar school (the age of entrance varied), Bocchi may have learned the rudiments of reading and arithmetic in the vernacular, perhaps from the type of teacher known as a *ludi magistro*.[13] Whether Pio taught young grammar school pupils is not certain. Depending on a family's wealth, grammar school teaching could be carried out by home tutoring, by independent private instruction in a grammarian's home-based school (sometimes these were boarding schools with a wide reputation), or by the public grammar school in the student's neighborhood. In Bocchi's case, his musical training (to be discussed in the section "The Musical Context of Bocchi") also raises the possibility that he attended a choir school at a local church. Any of these types of school could have afforded him a solid humanist foundation during this period.[14]

Bocchi's university education was interrupted by several turbulent years. A severe earthquake that struck Bologna in 1505 was followed by a typhus epidemic and, not many months later, by the papal invasion. The popular Filippo Beroaldo the Elder died just before the invading armies arrived. During Beroaldo's funeral procession, in which the entire Studio took part, the cortège was forced to turn back from its original destination just outside the city when sounds of an approaching army could be heard; the procession retreated to the Carmelite church of San Martino Maggiore, where Beroaldo was buried (and Bocchi would be as well).[15] Following several months of siege by the combined papal and French forces under the command of Lieutenant-general Chaumont (Charles II d'Amboise), governor of Milan, and some unsuccessful negotiations between Giovanni II Bentivoglio and the French, the city surrendered in 1506. The Bentivoglio family was banished, and Pope Julius II made his triumphal entry into the restored Papal State on November 11, 1506. In order to assert his power, the pope set about building a fortress for which Michelangelo was summoned to create a huge bronze statue of Julius.[16] A German student in Bologna, Christoph Scheurl, reported to a friend:

Vidi ego Bononiae pestem, terrae motum, caritatem annonae et haec omnia extrema; reservavit me quoque fortuna, ut bellum quoque viderem, intestinas discordias et triduo trinam reip. Bononiensis mutationem: quae omnia spero mihi aliquando non mediocriter profutura.[17]

(In Bologna I myself saw pestilence, an earthquake, high food prices, and every kind of distressing condition; and fortune spared me so that I might also see war, internal dissension, and three changes in the government of Bologna in as many days. I hope that all of these things will at some time be of no little use to me.)

The impact on the Studio of this violent transition from government by local nobility to administration from Rome was felt immediately. Not only did the Studio close for two months and lose a number of students, but it also lost faculty to other schools: Johannes Baptista Plautius (rhetoric and poetics, on the *Rutuli dei lettori legisti e artisti dello Studio bolognese*, 1504–6), Benedictus de Pistorio (rhetoric and poetics, 1482–1505), Giovanni Grecolino (rhetoric and Greek, 1500–6), and Gaspare Mazzoli

Argilensis (rhetoric and poetics, 1485–1505).[18] In addition to Beroaldo, typhoid had claimed the lives of a promising young poet, Diomede Guidalotti (rhetoric and poetics, 1504–5), and of Giovanni Garzoni, a physician and teacher of philosophy and medicine in Bologna from 1466 to 1505. Garzoni, who had studied rhetoric with Lorenzo Valla in Rome and Greek with Antonio Codro Urceo (d. 1500) in Bologna, was a close friend and sometime critic of his philologian colleagues.[19] Bocchi's own teacher, Pio, fled Bologna to Brescia for perhaps a year but returned to serve as one of only a few teachers of rhetoric during the transition between the lively years at the turn of the century and the more subdued period that followed.[20] There were as well some new faces: Paolo Bombace (*Rotuli*, 1505–13), Bernardino Novello (1506–11), Sebastiano Scarpo (1506–43), and Giulio Bonhomini Valeriano (1507–29).

Bocchi obtained his *laurea* in 1508. Apparently, his family was able to afford the expenses entailed by the degree and therefore must have escaped serious repercussions from the fall of the Bentivoglio, although at least two Bocchi relatives (Cesare and Fabio) went into exile and had their property confiscated.[21] In this same year, Achille's marriage to Taddea Grassi, or at least the formal arrangement for it, was settled by Taddea's relative and Bocchi's cousin, Cardinal Achille Grassi.[22] With Bocchi's appointment to the Studio as an instructor of Greek in 1508, his future seemed assured.

### Bocchi and the Faculty of Rhetoric

The *Symbolicae Quaestiones* stands as testimony to Bocchi's association with the Studio both before and after the watershed year of 1506, yet we do not really know what he taught before 1555 or about his teaching methods. Few commentaries and textual notes remain, either in print or in manuscript, from the first forty-six years of his teaching career, beginning with his lectureship in Greek from 1508 to 1512, in rhetoric and poetics from 1513 to 1524 and from 1527 to 1539, and in *Studia Humanitatis* from 1524 to 1527 and from 1539 to 1562.[23] One lengthy inaugural lecture, *Democritus, Id est Vanitas,* in an undated Vatican manuscript (Fondo Barbariniano Lat. 2030), probably represents a reworking of the "Democritus" requested by Marcantonio Flaminio in a letter of 1515.[24] The Vatican Library also possesses an *Argumenta in orationes invectivas Ciceronis,* some scattered and fragmentary texts relating to Bocchi's teaching, and two copies of a dialogue entitled *Ptolemaevs, Sive De Officio Principis In Obtrectores* (Fondo Barbariniano Lat. 2030 and 2163); again, these are undated and the dialogue falls perhaps around 1540.[25] What survives in print are Bocchi's defenses of his mentor, Giovanni Battista Pio: the 1508 *Apologia in Plautum,* to which Bocchi appended his own translation of Plutarch's *Vita Ciceronis,* and his 1509 *Carmine in laudem Io. Baptistae Pii.* The *Apologia,* probably a mouthpiece for Pio, answered the detractors of Pio's *Commentario in Plautum* with testimonials from Beroaldo the Elder, Bembo, and others.[26] It is to Pio and to Bocchi's other teachers and colleagues, therefore, that we turn to develop the background for Bocchi's early teaching in terms of academic genres, curriculum, philosophic content, linguistic style, and teaching method.

Of the university genres, the commentary was the oldest and traditionally the one closest to university teaching, although surviving commentaries on works of

literature do not appear in Italy until the second half of the thirteenth century. The popularity of the commentary as a mode of access to newly discovered texts and a corrective to poorly preserved and corrupted texts peaked in the late fifteenth century.[27] Pio, with at least eleven published works on authors from Nonus Marcellinus and Lucan to Lucretius and Fulgentius, was the most prolific commentator of the early sixteenth century.[28] However, he could never equal in popularity his own teacher, Filippo Beroaldo the Elder, who earned the sobriquet "commentator bononiensis" for published works on Pliny (1476), Propertius (1487), Suetonius (1493), Cicero's *Tusculanae Disputationes* (1496), Apuleius (1500), and Columella (1504).[29]

The commentary permitted the scholar a measure of freedom in interpreting literal and allegorical meanings, in bringing a wide range of erudition to bear on a text (especially etymology and mythology), and in digressing for the purposes of stylistic effect, humorous diversion (to rouse the *lector vegetus*), moral asides, or autobiographical detail.[30] Nevertheless, the line-by-line and often word-by-word approach to texts adopted by commentators precluded unified treatment of a single work or author or subject. According to Bernard Weinberg,

> It inculcated and promoted the habit of regarding texts as collections of fragments and hence as collections of isolated precepts; contrariwise, it prevented any effort to see over and beyond the single line or paragraph to the total philosophical form of the work.[31]

For an eloquent overview of an author or authors, *praelectiones* (lectures introducing a single course) and *prolusiones* (formal lectures before an entire school to inaugurate a new term) served as media for the teaching humanist.[32] Here we find Beroaldo and Pio taking advantage of the printing press, as for example, with Pio's undated *Praelection in Plautum, Aelium et Apulejum,* and *Praelectio in Lucretium et Suetonium* and Beroaldo's *Oratio Proverbialis,* all of which were first issued as separate publications.[33] Beroaldo and Antonio Codro Urceo produced collective editions of orations and poetry as well.[34] These lectures allow a glimpse at the emerging authority and individuality of the scholar beyond the constraints of the *auctor* of the text; in them we see the rigorous Hellenism and ironic wit of Urceo and the cultural encyclopedism espoused by Beroaldo in orations in praise of music, history, symbols, and many other topics.[35]

Another mode of evading the constraints of the commentary form was the collection of various annotations, which developed an independent academic genre in the late fifteenth century. Angelo Poliziano's *Miscellaneorum centuriam primam* (published in 1489 but completed by 1488), Beroaldo's *Annotationes centum* (1488), Pio's *Adnotamenta* (1488, 1496), and Jacopo Cruce's *Annotationes* all cast back to the unsystematized annotations of the *Noctes Atticae* of Aulus Gellius to justify extended and selective studies of textual *cruces,* proverbs, obscure gods, ancient trees and plants, and Egyptian hieroglyphs.[36] The intense interest in culling from a multiplicity of ancient texts these brief notes and miniature essays on myth and symbol, on proverbs, and on many other topics of interest to humanists carried over into the emblems of Bocchi and Alciato (who studied law in Bologna from around 1511 to 1514 or 1515).[37] Annotations were the academic contribution to those "keys to culture or

convenient agents of cultural transfer" that Rosalie Colie described in her lecture "Small Forms: Multo in Parvo" as miniature genres.[38]

Through these academic genres, some information about which authors were taught at Bologna during Bocchi's university years can be gleaned. The curriculum of the faculty of rhetoric at Bologna had widened dramatically with the advent of printing. If the *Elegies* of Propertius were first published in 1472, then the elder Beroaldo would soon teach them (*Oratio habita in principio enerrationes Propertii continens laudes amores*) and comment on them (Bologna, 1487). If editions of Lucretius appeared around 1473 (Brescia), 1486 (Verona), 1495 (Venice), and 1500 (the Aldine edition of Avantius in Venice), then G. B. Pio would publish before 1501 his *Praelectio in Lucretium et Suetonium* and, in 1511, the first Renaissance commentary on Lucretius.[39] Furthermore, a rhetorician such as Beroaldo soon learned how to boost his own sales by publishing his commentary on the *Golden Ass* of Apuleius (1500) prior to a course for which it was recommended.[40] After 1506 the curriculum probably expanded at a slower rate. Paolo Bombace, for example, taught Plautus and Lucian in 1507 and the *Odes* of Horace and *De bello civili* of Caesar in 1509.[41]

Nevertheless, the new generation of rhetoricians was less prolific and has been less studied. With the exception of the steadfast Pio, Bolognese philologians almost ceased publishing full commentaries and annotations. Several did publish editions of ancient texts or Latin translations from the Greek, as, for example, Filippo Beroaldo the Younger's edition of Tacitus (1515) and Filippo Fasanini's translations of the *Opusculum De non credendis fabulosis narrationibus* of Palaephatus (1515) and the *Hieroglyphica* of Horapollo (1517).[42] The two Fasanini translations have admiring dedicatory poems by Bocchi and Pio respectively. His *Hieroglyphica* was explicitly intended for a course given in the fall of 1516: To the text of Horapollo was appended a *praelection*, the "Declaratio Sacrarum Literarum," which Fasanini delivered "to the common utility of the studious" in the Studio of Bologna on September 1, 1516.[43] Romolo Amaseo (*laurea*, 1512; *Rotuli*, 1512–21, 1524–45), despite a high reputation for scholarship, published only editions of Pausanius and Xenophon, the latter with "interpretation" (1534), and some orations – not much considering the length of his career and warmth of praise accorded to him.[44]

Bocchi's lack of scholarly publishing after 1508 reflects the pattern of his generation. The reasons are multiple. Bologna's shift from princely state to papal state ended the kind of encouragement the Studio had been shown by Giovanni II Bentivoglio rather than producing overt repression. The economic climate changed, leaving fewer presses to publish academic work.[45] Taste changed and literary commentaries were no longer seen in a positive light; more often they were now dismissed as "verbosos commentarios."[46] Suddenly teachers had a mass of materials readily available in print that rendered their own labors less significant and their own notes less urgently needed. The turbulence of the first third of the century also took its toll: Paolo Bombace lost most of his manuscripts and ultimately his life in the Sack of Rome in 1527, and Camillo Paleotti (*Rotuli*, 1503–13), after an abortive attempt to bring back the Bentivoglio, was imprisoned in Rome by Julius II from 1512 to 1513 and never returned to teaching.[47] Bocchi's life, as much as is known of it, was less eventful, so that the scarcity of manuscript teaching materials before the 1556 lectures on Cicero's *Laws* suggests the loss of some of his works.

The drying up of scholarly publication in Bologna, however, does not indicate a withering of interest in broadly based rhetorical studies but rather a temporary slowdown. The recuperation by late fifteenth-century scholars, especially Beroaldo, of the total culture of the ancients remained a goal of sixteenth-century scholars. Compendious tomes began to appear with the term *encyclopedia* in their titles for the first time, and their readers and authors were praised as universal men. Ancient authors prized for their encyclopedic breadth – Varro, Quintilian, Martianus Capella, and Vitruvius – fascinated *litterati* both within and without the faculties of rhetoric.[48] For rhetoricians, what began as a joyous exploration of ancient learning and as confidence in philology as a guide for the study of texts in any and every subject would bear fruit toward the middle of the century in a more systematic encyclopedism. Bocchi's universality of culture took root in the Studio of Bologna, the school where Beroaldo told his students: "Cultura animi est ingenuas disciplinas amplexari. Cultura animi est ipsa eloquentia..." (The culture of the mind consists in embracing liberal studies. The cultivation of the mind is eloquence itself...).[49]

## The Debates on Latin Style

Bolognese rhetorical styles before 1506 encompassed a spectrum of Latinity from "Attic" austerity to "Asian" (or "Apuleian") luxuriance.[50] Because the generation of Beroaldo, Urceo, and Pio was censured for founding a Bolognese school of soft and "sordid" Asianism by the following generation, especially by Francesco Florido Sabino (studying law in Bologna from 1533 to around 1538) and after him by the nineteenth-century classicist, Remigio Sabbadini, its real contribution to teaching and scholarship has been ignored until recent decades.[51] Renaissance and post-Renaissance polemics have left the impression that the stylistic debates had only to do with Ciceronianism and anti-Ciceronianism or with Cicero's early "lapses" into an Asian style versus late Ciceronian Attic restraint. Beroaldo, however, greatly admired and praised the mature Cicero and, at the same time, practiced a florid style that suited his own warm, effusive personality, sonorous voice, and photographic memory.[52] Urceo, drawn to Attic models in Homer and Hesiod, also advocated a balanced "middle" style. He joked that he always carried under his arms the two "asses" of Lucan and Apuleius, the one for *breuitate* (brevity) and the other for *copia* (abundance) and *eloquentia* (eloquence).[53] Rather, Bolognese styles represent the coming together of certain trends: the practice of a *stile a mosaico* advocated by Quintilian and by the leading teachers of the fifteenth century,[54] the study of early and minor or provincial Latin texts, the expansion and enrichment of Latin lexicons,[55] and a parallel Latin and vernacular taste for a mannered literary style.[56]

Both Beroaldo and the more pedantic Pio had their followings, at least for a time. By 1500, Beroaldo, observing the excesses of his former pupil, Pio, was already beginning to restrain and modify his own style, and he included an apology for his loquacity in his *Oratio Proverbialis*. Pio announced a new style in the *Annotamenta* (also published as *Annotationes Posteriores*) of 1505; in reality he found it difficult to move toward a chastened practice.[57] Criticism came early from within the Studio. Battista Spagnuoli Mantuano, the Carmelite poet and teacher, charged the Apuleius commentary of his friend Beroaldo with weakness of style and with immorality.[58]

Garzoni, in his *De eloquutione libellus* (1503), urged his colleagues to adopt a Ciceronian *misura* and objected specifically to Pio's use of "verba nova aut prisca" (new and archaic words). Pio responded by dedicating the 1505 edition of his *Annotamenta* to Garzoni with praise for the latter's Ciceronian fecundity and *anima*, adding a section of emendations in a cleaner style.[59] The jibe at Pio's "verba sesquipedalia ed ampullosa" (one-and-a-half-foot-long and bombastic words) by Filippo Beroaldo the Younger in 1502 was not so gracefully resolved and was only the first of a series of increasingly hostile attacks from that quarter.[60]

After 1506, a moderate Ciceronianism, or Quintilianism, prevailed at the Studio of Bologna. According to Carlo Dionisotti, this triumphant Ciceronian style was built upon the cultural foundations made possible by the stylistic aberrations of Pio, Beroaldo, and Poliziano.[61] Everywhere, experiments in the Asian, Apuleian, and early Latin styles were condemned or in retreat. Declarations of adherence to a Ciceronian prose model were now the rule in Italy and often beyond her borders. Although this new decorum brought the poles of the controversy closer, there remained the basic issue of whether Latin prose was a living, evolving language or whether it was a sacred language that had attained perfection with Cicero.[62] Increasingly, elements of nationalism, politics, and religion complicated the language issue.[63] For this reason, the term "anti-Ciceronian" is inappropriate for sixteenth-century polemicists; even "Ciceronian" and "Ciceronianism," as J.-C. Margolin reminds us, are ambiguous terms and shift with each step in the controversies involving Erasmus.[64]

A number of younger Bolognese scholars moved to Rome during the papacy of Leo X (1513–21), a period in which the pro-Ciceronian forces were at their peak.[65] Of these, most sided with the Ciceronians against Giovanni Battista Pio (in Rome between 1512 and 1514), who was the butt of scathing satires by Roman academicians in 1513. Bocchi himself visited Rome in 1513; whether he sided openly with his friend and mentor Pio is not clear.[66]

These Bolognese in Rome may have "done as the Romans do," but in Bologna, rhetoricians could not afford to antagonize their large numbers of foreign pupils by claiming Ciceronian Latin to be an Italian monopoly. They taught more courses on Cicero, but they also taught Quintilian and appear to have kept out of pro-Ciceronian polemics. Throughout the first third of the century, they still offered a range of styles, from Pio's somewhat chastened archaisms to Romolo Amaseo's ornate Ciceronianism.[67]

Characteristic of Bologna is the friendship between Erasmus and Paolo Bombace, who hosted the young Dutch scholar in his Bologna home for thirteen months in 1506 and 1507, a friendship that continued despite Bombace's later association with the Academia Coryciana and Erasmus' mocking of the Roman Ciceronianism that the group espoused.[68] Erasmus condemned both extremes and treated the elder Beroaldo and even Pio with unusual mildness for the times.[69] This may reflect Erasmus' personal debt to Beroaldo's writings (which has not yet been fully studied) or his own penchant for occasional use of "Asian" elements ("filthy Apuleian tags," charged Dolet), but it is more likely to have grown out of the Erasmian campaigns to salvage the notion of *copia* (abundance) from the "Asian" debacle (*De Copia Verborum*, 1512) and to push for a linguistic decorum that takes into account genre

(*Opus de conscribendi epistolis,* 1522) and historic linguistic change (*Ciceronianus,* 1528).[70]

After the *Ciceronianus* was published, polemics continued; hardly anyone now, however, defended extreme Ciceronianism.[71] The debate was shifting to whether Latin was, in fact, a living language, a view that Romolo Amaseo defended by promulgating Latin as the language of the noble class in his university prolusion *De linguae latinae usu ritenendo,* delivered before Emperor Charles V and Pope Clement VII in Bologna in December 1529, or whether it had died, as Giulio Camillo argued in his *Della imitazione,* written around 1530.[72]

Bocchi maintained a middle style: He was neither praised as a Ciceronian nor blamed as an Apuleian. His first and only published prose work, the *Apologia in Plautum* (1508), was similar enough in style to his mentor's that Ezio Raimondi and others suspect Pio's close involvement in or even authorship of the text.[73] The *Apologia* served the double function of reducing the damage to Pio's career from the virulent attack of Giovan Francesco Boccardo ("Pilade") of Brescia and of gaining for the young Bocchi, whose *Vita Ciceronis, auctore Plutarcho* was appended to the defense, an increase in salary.[74] The *Vita Ciceronis* may have been the only work of Bocchi known to Erasmus, who in the *Ciceronianus* placed him in a list of those whose styles cannot be properly judged because they published only translations from the Greek into Latin rather than original works.[75] In his *Apologia adversus linguae latinae calumniatores,* Francesco Florido Sabino judged Bocchi (along with Romolo Amaseo, Alessandro Manzuoli, and Sebastiano Delio) a minor Latinist, reserving honors in style for nonacademics such as Scipione Bianchini, a Bolognese noble who never published his writings, and Cardinals Sadoleto and Contarini.[76]

When Bocchi was praised for style, it was for his elegance, as in Marcantonio Flaminio's early poem "Ad Achillem Philerotem Bocchium," which begins "Achille pater elegantiorum" (Achilles, father of eloquence), and in Leandro Alberti's "Proemio" to his *Historie di Bologna* (1541) with its reference to Bocchi "col suo elegante stile," or in Ovidio Montalbani's description of Bocchi's history as in an "elegantissimo stilo" (1641) and in the early-eighteenth-century Ghiselli's *Memorie* of Bocchi as a "scrittore elegantissimo."[77] In the *Symbolicae Quaestiones,* Bocchi's dedicatees were more often known for their Ciceronianism – Gaspare Mazzoli Argilensis, Mario Nizolio, Giulio Camillo, Marcantonio Flaminio, and Romolo Amaseo – than for an Asian style, although one symbol was dedicated to Pio. Even in Bocchi's early poetry, Cicero was the one "who flowed with a milky torrent of sweet eloquence."[78]

To Bocchi, the best style meant imitating all the best stylists, not just Cicero. His Quintilianesque approach to the Latin language and Latin style probably paralleled the position taken by a fictional Bocchi as chief interlocutor in the *Annotationi Della Volgar Lingva* (Bologna, 1536) of Giovanni Filoteo Achillini. Achillini's dialogue appears to respond to Claudio Tolomei's as yet unpublished *Il Cesano de la Lingua Toscana,* a defense of the use of the Tuscan language written at least in part before 1529.[79] Although there are no extant vernacular works by Bocchi to permit a study of his Italian prose style, Achillini used Bocchi to defend the Bolognese Italian of his verse epic *Fedele* against an aulic, Bembesque vernacular defended by interlocutor Romolo Amaseo and a pure Tuscan advocated by Fra Leandro Alberti.[80] The host,

wealthy Bolognese Count Cornelio Lambertini, declined to name a winner in the debate, but it is clear from the prominant position given to interlocutor Bocchi and the extensive quotations from Guido Guinicelli, Dante, Petrarch, and ancient poets that roll forth from Bocchi's lips that Achillini promulgates a Tuscan improved by Bolognese elements. This dialogue supports a view of Bocchi as generally flexible in his approach to language, and it gives us a glimpse into a sodality whose members, including the absent philosopher Lodovico Boccadiferro, the taciturn Alessandro Manzuoli, and Achillini himself, had been friends as far back as the beginning of Bocchi's career.[81]

Bocchi's flexibility of language stayed within the bounds of early-sixteenth-century decorum; his elegant style unfolded not personality but a decorous public self. By the time Gianfrancesco Pico, in letters he exchanged with Bembo in 1512 and 1513 (unprinted until 1518), defended eclecticism as a means for each writer to find his own innate personal style, academics had largely discounted personality as an element of Latin prose style.[82] This had not been the case at the Studio of Bologna in the period from about 1470 to 1506, when academics threw themselves into the presentation of the self to the point of creating a cult of personality. Judging by the number of anecdotes that exist about academic "characters," from the tyranny-fighting Cola Montano (at the Studio, 1476–7) and Galeotto Marzio (1463–5, 1473–7), accused of practicing magic and atheism, to the loquacious Beroaldo the Elder, noted for his love of women, dining, and gambling, the eccentric Codro Urceo, whose constant irony and facetiousness left listeners unable to determine what he really thought, and the archaically stilted Pio, Bolognese students loved these perform-ances.[83] Concomitant to such individualism was an expanded and exalted conception of the professional rhetorician's role in culture. Although many academics of this period came from rather modest backgrounds, their high culture brought them into the court of Giovanni II Bentivoglio along with vernacular poets and a few outstanding artists.[84] Rhetoricians now believed themselves creatively inspired: To Beroaldo, the interpreter of a text could not unveil poetic mysteries without himself sharing the divine *afflatus*.[85] The generation of Beroaldo, much influenced by Ficinian Neoplatonism, produced its own crop of inspired, saturnine rhetoricians.

Bocchi's generation was different. There was no longer a court in Bologna, so humanists aspiring to be courtiers had to leave for Rome, where positions for those whose families had not supported the Bentivoglio were available. There are, quite suddenly, no more anecdotes about eccentric teachers and, with the exception of Pio, much less individualism in linguistic style. If a divine *mania* did still enter the classroom, its presence was neither honored nor even noted.

### The Young Bocchi: The Cultural Ambiance outside the Studio

In the realm of letters outside the university, the trend toward self-expression in style remained a little longer in Latin verse and in vernacular prose and poetry. Castiglione's *Libro del Cortegiano* may reflect ideas current well before its 1528 publication date, but it also kept alive the argument for a "linguistic pluralism with the defense of each individual's mode of speech and conduct."[86] A balance between one's own nature and desires and those of the great *auctores* being imitated was

recommended by Bocchi's friend, Bartolomeo Ricci, in his 1541 *De imitatione*.[87] Gradually, the impact of "increasing formalism," of the growing number of non-Tuscan writers in minor orders and in curial "families" as opposed to the secular courts (now diminished in number), and of the resurgence of Aristotelianism, was felt.[88] In poetry, according to Ezio Raimondi, there was a shift from late-fifteenth-century Platonically inspired poetry to a brief period of equilibrium during which Ariosto could harmonize creative imagination with a high order of technical mastery and Bembo could blend Platonic inspiration with formal Ciceronian language. From 1530, however, with Aristotle's *Poetics* gradually replacing Horace's *Ars Poetica* as the leading critical text, the critics' standards for genre, structure, decorum, and unity grew more rigorous, and then in response, the poets sought greater mastery over their work. The poet whose innate personal style was revealed through divine inspiration made way for the "poet-maker" who exercised technical control over his creations.[89]

Bocchi's poetic practice spanned the first half of the sixteenth century when these shifts and changes were taking place. His two manuscript collections of poetry, the *Lvsvvm Libellvs Ad Divvm Leonem .X. Pont.* (hereafter *Libellus*) (Florence, Laur., Plut. 33, Cat. 428, ca. 1515–21) and the elegantly illuminated *Lvsvvm Libri Dvo* (hereafter *Lusuum*), dedicated to Cardinal Legate Giulio de' Medici between 1517 and 1523 (Vat., Lat. 5793), already have an air of retrospection.[90] In the latter are scattered nine poems Bocchi claims to have written between the ages of fourteen and eighteen, that is, from around 1502 to 1506 – the Bentivoglio years. Of these, most are love poems dedicated to "Albia" or "Lydia," and some already use the word *ludere* (as, for example, *Lusuum*, fol. 62r). They draw on a conception of love as *insania*, a term more Lucretian than Platonic, and introduce Bocchi's Latin tag "Phileros." The earliest (*Lusuum*, fols. 60r–61v) is a translation "ex Graeco Lemmate / anno aetat. XIIII." One is dedicated to Giovanni Filoteo Achillini (*Lusuum*, fol. 57v) and another, the longest of the *juvenalia* (71 lines, *Lusuum*, fols. 49v–51v), is entitled "Pro quodam Con- / cionante, In Lav- / dem Carmelita- / nae Religionis / pene Extem- / pore / Anno Aetatis XV." This poem was perhaps written for, or at least stimulated by the presence of, Battista Spagnuoli Mantuano (1447–1516), the Carmelite poet and reformer, who spent parts of his life teaching theology in Bologna at the Convent of San Martino near Bocchi's home. Mantuano encouraged his many literary friends, among them Filippo Beroaldo the Elder and Francesco and Gianfrancesco Pico della Mirandola.[91]

Only five poems from the early collections reappear in the *Symbolicae Quaestiones*: They are Symbols CXXIX and CXXIIII, dedicated to G. B. Pio and Marcantonio Flaminio respectively; part of LIX; and two love poems (V and VII), purged of their dedications to "Lydia." The remaining early poems, besides the *juvenalia*, represent poetic trends typical of the first quarter of the century: love poems; epigrams, often satirical; scattered translations from Greek, Hebrew, and the vernacular; funerary poems, most of them short *viator* dialogues modeled on the Greek Anthology (*Antologia Planudea*); and poems in praise of family, friends, patrons, and admired members of Peter Burke's "creative elite" (Baldassare Castiglione, M. A. Flaminio, Andrea Navagero, Pietro Aaron, Galeazzo Florimonte, and Aldo Manuzio).[92] Bocchi's favorite genre was the ode, always identified by such titles as "Ad Divam

Virginem / Ode tricolos / tetrastrophos" or "Ad Marium / Siderotomum Parmensem / Ode / dicolos / distrophos" (*Lusuum,* fols. 2r, 10v).[93] The term *lusuus* (games, play) for a loosely organized verse sequence appears also in a group of poems entitled "Lusus Ticenenses," written around 1515 or 1516 by a Bocchi pupil, Nicolò d'Arco. It was soon developed by another Bocchi friend and a fellow classmate of Arco, Marcantonio Flaminio, into a pastoral verse sequence, the *Lusus Pastoralis,* written in 1526, although not published until 1548.[94] The neo-Latin *lusus* functioned as the lyric voice of a sodality of poets and had its vernacular equivalent in the *sonetto pastorale* of Claudio Tolomei, Benedetto Varchi, Francesco Molza, and Bernardo Tasso.[95]

Bocchi's contribution to this group of young and mobile poets – colleagues, students, and former students – attracted notice. Because he and his friends experimented extensively with amorous verse, especially in their imitations of Horace and the Greek Anthology, older friends disapproved. This was especially true when Marcantonio Flaminio addressed a seven-line poem to "Achille pater elegantiorum" (Achilles, father of elegance), his "optimum sodalem" (best friend), praising Bocchi's eyes, to which Achille replied with a fourteen-line poem, "Achillis Phil. Bochii Responsum ad Eundem M. Ant. Flam." (*Libellus,* fols. 18v–19r), converting lines from the first poem into praise of the younger man's eyes.[96] Because eyes featured almost exclusively in erotic poetry at this time, a disapproving Leandro Alberti passed the verses and his suspicions concerning them on to Marcantonio's father in Imola, who then wrote to scold his son, more for the impropriety of writing the lascivious "odas oculis" than for anything else. Bocchi, however, lashed out in rage at Alberti for interfering, and Giovanni Antonio Flaminio hastened to mediate between his quarreling friends, urging Leandro in letters from the spring and summer of 1515 to stop preaching "Religionem, et Christi" and to conquer the wrath of Achilles through kindness.[97]

Moreover, responses by friends to one of Bocchi's early love poems, "Ad Glyceren / Ode" (*Libellus,* fol. 11v), which begins "Ergo me Glycere fugis" (Therefore, Glycere, you flee from me), evoke a shadowy poetic persona for Bocchi. This surfaces in a brief unpublished poem, "In Achil. Bocchium," by Nicolo d'Arco, which opens: "Quo fugis o Bocchi vicini litora Rheni" (Why, O Bocchi, are you fleeing the banks of the nearby Reno?).[98] In his "Ad Dianam," Marcantonio Flaminio alludes to Bocchi's youthful humanistic and pagan activities:

> Bocchius, linguae decus utriusque,
>    Doctus errantes agitare cervos,
>    Hanc tibi villa media locatam
>       Dedicat ulmum.
>    (*Carmina illust. poet. ital.,* 4:382)
>
> ("Bocchius, the glory of the two tongues,
>    Skilled in rousing the wandering deer,
>    Dedicates to you this elm in the middle
>       Of his estate.")[99]

Flaminio hints that it is the running tongue and not the hunter Bocchi that is chasing does and lynxes through the woods; he may also be alluding to the erotic

association between *garrulitas* and *lascivia* made in later Northern emblems illustrating flying tongues.[100] Furthermore, the Bocchi / fleeing stag association may suggest why Piero Valeriano, who visited Bocchi in 1527, dedicated to him Book VII of his *Hieroglyphica* (first published in 1556) on the symbolism of the stag. The stag, Valeriano informs us, was a symbol of *fugacitas* and as such was used to characterize the fleet-footed Achilles by ancient authors from Homer on. Among other traits of the stag are its *formido* (fear, dread) and its *lasciviae poenitentia;* it is also *mulierosus* (having a weakness for women).[101] Bocchi's presence in and contributions to coterie poetry suggest a broad network of poetic exchange, the dynamics of which have been lost to future readers in the process of anthologizing.

Early-sixteenth-century poems, besides being passed from friend to friend, were often performed as declamations, as improvisations, or as songs to instrumental accompaniment. Poetic fecundity, musical ability, and precocity in very young poets: These admired commodities meant gifts from patrons, benefices, or even a position at court. To someone who was not born noble, poetry could provide an entrée, as it did for the young Marcantonio Flaminio, who was sent on his own to Rome at fifteen to present his poems to the newly elected Leo X and who then visited the court at Urbino before returning home.[102] Prolific and profluent Latin versifiers bore the jeers of the intelligentsia and mock laureations in Rome – but they ate at Leo X's own table in return for their performances.[103] Vernacular poets with lutes or viols, the *improvvisatori,* circulated mainly among the secular courts where their status was usually higher than in Rome, although one of their number, Antonio Tebaldeo (1463–1537), converted from the Italian Petrarchism that had made his reputation to the Latin epigram when he moved to Rome.[104] Bocchi's *Libellus* shows his awareness of Leo's literary tastes by drawing attention to those poems that were first delivered extemporaneously, and the *Lusuum* (dedicated to Cardinal de'Medici) includes not only the *extempore* poems but the *juvenalia* as well.

In Bologna, the *magistri* of rhetoric and poetics published only Latin poetry, with the exception of Diomede Guidalotti's *Tyrocino delle cose volgare* (Bologna, 1504).[105] Because students risked fines for speaking in their native tongues while attending the Studio, their teachers may have also faced some constraints on using the vernacular. Practitioners of Latin, of course, did admire outstanding writers in Italian. At the death in 1500 of the most famous *improvvisatore* of his time, Serafino Aquilano, even Latin Rome paid tribute at the funeral sponsored by his patron, Duke Cesare Borgia, and, from Bologna, Giovanni Filoteo Achillini solicited memorial verses from poets all over Italy. The resulting *Collettanee grece, latine e vulgari nella morte de l'ardente Serafino Aquilano in uno corpo redatte* (Bologna, 1504) brought together contributions from every Italian city, including works by such authors as Guido and Annibale Rangone, Giuliano de' Medici, Marcantonio Vida, Antonio Tebaldeo, Angelo Colocci, Bernardo (Unico) Accolti, Jean des Pins, Giuda di Salomone "ebreo" of Modena, several artists, and many Bolognese, notably, Filippo Beroaldo the Elder, Alessandro and Giovanni Achillini, Ludovico Boccadiferro, Diomede Guidalotti, and Giovan Andrea Garisendi.[106]

The last-named poet, the notary Garisendi, served as *cancelliere* of the Bolognese Senate from December 1506 until 1525 and recorded for the Studio the names, dates, and questions for each university disputation.[107] Garisendi was the recipient of a

poem accompanying a gift of pens in a case from Achille Bocchi. He also composed a poetic dialogue entitled *Dialogo ovvero Contrasto de Amore. Interlocutori: Antiphylo et Phylero extemporalmente cantanti,* which he dedicated to Lucrezia d'Este in 1509.[108] As previously mentioned, Bocchi had adopted the Latin tag "Phileros" by the time he was eighteen (1506 or 1507) and probably performed the role of "Phylero" in this dialogue of one hundred fifty stanzas in *ottava rima.* The singer of the part of "Antiphylo" cannot be determined at this time; it may have been sung by Garisendi himself in the role of *improvvisatore* or perhaps by Bocchi's friend Tiresio Foscarari, canon of San Petronio and later apostolic protonotary under Leo X. Although better known for religious poetry, Foscarari sang *carmi* of Bembo accompanied by his lyre before Leo X in November 1520.[109]

Another candidate for Antiphylo is Marcantonio Flaminio, not because there is evidence for his having singing ability or disdain for Amor, but because several of Antiphylo's stanzas closely resemble Bocchi's Symbol CXXIIII, which was dedicated to Flaminio and perhaps reflects a shared experience. In Bocchi's stanzas the terms of abuse heaped by Antiphylo on Love are recycled (in different order) as an attack on courtiership.[110] Antiphylo's later description of Pandora reemerges in the depiction of Pandora in the symbol's engraving (Figure 1). Both Garisendi and Bocchi represent a Pandora loosing the ills of humanity from a vase.[111] A brief comparison of their anti-love and anti-courtier vituperation follows:

> Homicida, sacrilego, nephario,
> Infame, adulator, finto e mendace,
> ................................
> Ladro, simulator, perfido e vario
> (Garisendi, in Frati, *Rimatori,* 299)

(Homicide, sacrilege, crime; an ill-famed hypocritical and lying adulator ... a thief, a simulator, both perfidious and of uncertain motives.)

> Lites, simultates, dolos, mendacia,
> ............................
> Fictos amicos, factiosos, inuidos
> Hostes domesticos, malignos, perfidos,
> (Bocchi, Symbol CXXIIII, lines 4, 17–18)[112]

(Quarrels, rivalries, acts of deception, lies, false friends, rabble-rousers, envious domestic enemies, malicious people, perfidious people.)

While warning Flaminio that the dangers of curial office make it a "misery distinguished by public office" (*miseria honorata*), Bocchi reminds him not only of a shared and unhappy curial experience but also of an earlier, more carefree period in Bologna.[113]

Garisendi's closing arguments shift to a brief debate on the relative merits of written poetry (Antiphylo) and inspired song (Phylero). Phylero, citing the glory of Orpheus and his lyre, Amphion, Arion, Lorenzo de' Medici, and Bernardo Accolti (Unico Aretino), claims victory in the final stanzas for the glorious poets seized by "il furor d'Apol."[114] However, it is Antiphylo who sets forth the question:

Unde tra i docti par che non se stima
Materia dicta in versi a l'improvista,
E a me non piace ancor, la cause è questa,
Però ch'al paragon rima non resta.

Come la voce ferm' è il valor perso
Di queste rime d'improviso sparte;
Ma sempre dura un ben pensato verso
Col calamo depincto in pure carte,
La gloria d'un ingegno arguto e terso
Eterna far si pò sol per quest'arte,
Quella è di vetro e questa è un'aurea tromba
Che col suo sono un huom trae da la tomba.

(Frati, *Rimatori,* 324)

(Therefore, among the learned it seems that a subject improvised in verse is not admired, and, furthermore, it does not please me; the reason is this, because by comparison the rhyme does not last.

As the voice ceases, the strength of these improvised and scattered rhymes is lost; but a well thought-out verse inscribed by pen on plain paper can only by this skill make the glory of a keen intelligence eternal. The former is of glass and the latter is a golden trumpet that with its sound draws a man forth from the tomb.)

Garisendi's dialectic of love – bad Cupid versus good, the infernal "giardin di spine e d'aboscelli" (garden of thorns and shrubs, 302) compared to the Cyprian garden of love, the alternation of vituperation and praise for love, and the opposition between written and improvised poetry – might tempt us to see a further clash between a Dantesque Phylero speaking of "l'alta essentia d'Amor ch'ogn'altra excede" (the deep essence of Love that exceeds every other thing, 287) and a Petrarchan Antiphylo's "Nemico a pace e dio fatto di guerra" (an enemy to peace and a god suited to war, 291). These identifications do not fully take place in the text, where there are Dante allusions by Antiphylo (largely to *Inferno*) and Petrarchan references by Phylero. The impact of Dante, however, outweighs that of Petrarch; Garisendi's Phylero as much as Giovanni Filoteo Achillini's interlocutor Bocchi from the *Annotationi della volgar lingua* comes out a "Dantista."[115] Although Bocchi's vernacular role as an improvising poet and a lover of Dante left even fewer traces on his own later work than his "fleeing stag" persona did, it nevertheless signals a richness of poetic activity flourishing in a university environment.[116]

## The Musical Context of Bocchi

Not only did the young Bocchi figure in the context of the vernacular dialogues of Garisendi and Giovanni Filoteo Achillini, but, as his ability to sing "all'improvviso" suggests, there were also associations with both musical practice and musical theory. Bocchi played not a courtly lute or viol but the organ. According to Fantuzzi, "si dilettò di Musica e nel toccar l'organo doveva di tale abiltà, che il nostro Duomo di

S. Pietro l'aveva scelto a suo Organista." Fantuzzi then cited a document of December 1514 licensing Bocchi to retain both the position of organist and his lectureship, which, Fantuzzi believed, was to aid his father in a period of great financial strain.[117] How long Bocchi remained as organist of San Pietro is not known. A lay person could be employed as a church musician, and, in fact, Bologna's largest church, San Petronio, had a lay music director, Giovanni Spataro, from 1512 to 1542.[118] Financial considerations would not have been the only motivation, however, for a young Bocchi trained by his teachers of rhetoric to admire the ideal of a practicing poet-musician.[119]

Bocchi's connection with theory occurs in yet another dialogue, or rather, in a treatise on music theory translated from Italian into Latin by Giovanni Antonio Flaminio and cast into a token dialogue form: the *Libri tres de institutione harmonica* (Bologna, 1516) of Pietro Aaron (or Aron, ca. 1489–1545).[120] This dialogue, with G. A. Flaminio taking only a minor role and Aaron the major one, was conceived at a *cenacolo* in Faenza at which Aaron was a guest along with the adolescent Marcantonio Flaminio, just back from Rome (that is, 1515), Leandro Alberti, and Achille Bocchi (described in the text as "my Phileros, a most outstanding youth, very learned in Greek and Latin, and a friend to both our circles").[121] G. A. Flaminio completed his introduction to the work of Aaron by lauding music in terms close to those of Beroaldo's *In Tusculanas et Horatium*.[122]

After meeting Aaron, Bocchi wrote "Ad Petrum Aaron Florentinum, Ode..." (*Lusuum*, fols. 6r–7r; *Libellus*, fols. 6v–7v), in which he invented a fable about Apollo rescuing Musica from Momus. He concluded it with praise for Aaron's purging the music of their time of its *squallore*.[123] The allusion is to Aaron as a follower of Bartholomé Ramos de Pareja, who had lectured on *musica pratica* publicly in Bologna from after 1472 to sometime before 1491 and who proposed, among other things, a major revision of the tonal proportions of the musical scale to replace the standard Guidonian practice.[124] Aaron corresponded with Ramos' pupil, Giovanni Spataro, music director of San Petronio, and in his four succeeding treatises (all in Italian) managed to combine a practical scheme of notation and terminology with the claims of music as a divine art, which, at its best, is practiced by the inspired genius.[125]

### Bocchi and the Visual Arts

Although nothing in Bocchi's early career records a love of the visual arts, a passion for painting, engraving, antiquities, and architecture flourished among his friends and acquaintances. Praise by Filippo Beroaldo the Elder, Giovanni Filoteo Achillini, Girolamo da Casio, and Angiomichele Salimbene for Bologna's major early-sixteenth-century painter, Francia (Francesco Raibolini) – and Francia's own sonnet lauding Raphael – demonstrates their admiration for the creative gifts of individual artists.[126] Many more Bolognese painters, architects, and engravers who were active in the last decades of the Bentivoglio rule were also lauded by Achillini in his *Viridario* (Bologna, 1513), especially the engraver responsible for Achillini's own portrait, Marcantonio Raimondi, "Che imita de gli antiqui le sante orme / Col disegno e bollin molto e profondo" (who follows in the sacred steps of the ancients with much design

and a profound imprint).[127] Besides numerous works by local artists in churches and private collections, Bocchi would have had the opportunity to see paintings by Parmigianino in the Palazzo Manzuoli and by Raphael (the *Vision of Ezechial*) and by Correggio at the Palazzo Ercolani as well as Michelangelo's statue of Julius II, although that statue and many other art works in Bologna were lost or destroyed in the turmoil of 1506 and subsequent years.[128]

Private collectors in Bologna were particularly proud of the antiquities they amassed. None could compete with the great collectors of Rome; what they could show their friends and visitors were inscriptions, fragments of statues, coins and medals, cameos and other jewelry, and perhaps small bronzes. The largest of these collections, still intact in 1560, was that of Giovanni Filoteo Achillini,

> il quale avea uno bello studio de asaisime cosse antiche, zioè de medaglie de oro, de argente, de mettalo, molte belle; et anchora statue de marmoro: fra le altre avea la testa de Senecha e quela de Tuliola figliola de Cicerone et molte altre teste de imperatori et altre cosse fantasticho antiche....[129]

> (who had an admirable treasure room with more than enough ancient things, such as medals of gold, silver and metal, very beautiful; and also marble statues: among them he had the head of Seneca and that of Tulliola, Cicero's daughter, and many other heads of emperors and other fantastic ancient things.)

According to Andrea Emiliani and Konrad Oberhuber, Bolognese illustrated books of the early sixteenth century are virtually unstudied, and very few explorations of illustrated books as forerunners of the emblem are to be found.[130] In Bologna, printed books lagged behind those of Venice, Florence, and Ferrara in the use of illustrations and during the early sixteenth century remained pictorially simple.[131] Bolognese readers, however, not only had access to illustrated books from other Italian cities but to those from the North as well. The teachers of rhetoric at the Studio had at least one copy of Sebastian Brant's *Ship of Fools;* they may also have seen the 1502 "Strassburg Vergil," edited by Brant, the first printed book to adopt a narrative form of illustration that condensed multiple episodes into one frame (as in painting).[132] Through Italian merchants, Lyonnaise imprints would have been available, and Bocchi had access to the Paris 1510 edition of philosophical treatises written and illustrated by Charles de Bovelles (Bovillus) by the late 1540s.

The illustrated book most important to Bocchi's *Symbolicae Quaestiones* and to others in his circle of friends as well was the *Hypnerotomachia Poliphili* of Francesco Colonna (Venice, 1499).[133] For Bocchi, it provided a personal *impresa* and several emblem sources as well. Filippo Fasanini knew the work by 1516, and references to inlaid silver letters in the *Viridario* of Achillini (who cited Colonna directly in his 1536 *Annotamenta*) and to unusual inlaid mosaic pavements in the *Laude delle Donne Bolognese* (Bologna, 1514) of Claudio Tolomei, then a student of Fasanini and of law in Bologna, also suggest familiarity with the *Hypnerotomachia*.[134] In addition, another law student in Bologna from around 1511 to 1514 – one who may have seen a copy of the *Hypnerotomachia* in Milan and who had already written on Milanese antiquities – was Andrea Alciato, soon to invent the emblem genre.[135] The Colonna work, along with one of its sources, Petrarch's *Trionfi,* inspired the treatment of the frontispieces to each of the six books of Leandro Alberti's *De Viris Illustribvs Ordinis*

*Praedicatorvm* (Bologna, 1517), a book to which Fasanini, G. A. Flaminio, and a number of others contributed and for which Bocchi negotiated with publishers.[136] Each of the six prints portrayed a different Dominican saint on a triumphal *carro*, with symbolic accoutrements rather more simple and chaste than those of Colonna's model. In his dialogue on Dominican poets, Alberti has an interlocutor Fasanini praise Colonna as a writer of "uarium, ac multiplex ingenium" (varied and many-sided talent), comparable to Dante in allegorical power.[137]

## Bocchi and the Acquisition of Social Status

In addition to and perhaps as a result of Bocchi's auspicious beginnings as a teacher and poet, he experienced a rapid gain in social status in his early adulthood. All his activities were consonant with the requirements of nobility; the possible exception was his position of organist, and that was defended by Fantuzzi in 1781 on the grounds that anything to do with the church was noble.[138] Bocchi had the advantage of birth into the lesser nobility when society's concept of nobility was shifting from one grounded on virtue in the fifteenth century to one based on birth alone in the sixteenth century.[139] Spanish domination was in part responsible for a hardening of class lines through legal restrictions, the code of *onore,* and the proliferation of titles of honor.[140] Professionals in the sixteenth century, including university professors, were increasingly expected to be noble, and the Roman Curia grew less open to the lay humanist, thus diminishing avenues of mobility lay and nonnoble scholars had previously enjoyed.[141] There were some exceptions to this decrease in social mobility, most notably, the slow, steady inprovement in the status and education of artists, who occasionally were recognized by the awarding of titles of nobility (Carlo Crivelli in 1490, Gentile Bellini, Mantegna, Michelangelo, Titian, Sebastiano del Piombo, and Sodoma), and of musicians (Gian Maria, a German Jew named "Conte di Varruchi" by Leo X).[142] By 1520 both emperor and pope had begun conferring titles of nobility with such a free hand that in 1555 Giovanni Della Casa lamented:

> e, si come anticamente si solevano avere i titoli determinati e distinti per privilegio del papa o dello 'mperatore . . . cosi oggidì se deono più liberamente usare i detti titoli e le altre significazioni d'onore a titoli somiglianti, perciocchè l'usanza, troppo possente signore, ne ha largamente gli uomini del nostro tempo priviligiati.[143]

> (and just as formerly titles were customarily determined and differentiated by privilege of the pope or emperor, so nowadays the said titles and other trappings of honor resembling titles are more freely granted to be used, because usage, too powerful a ruler, has with them liberally privileged the men of our time.)

A title of honor first appeared beside Bocchi's name in a dedicatory poem, "A Ph. Bocchii Equitis Bonon. Tetrast. extempore," in the *Logica pamph. collecta sub ecellenti artivm et medicina* (Bologna, 1512) of Panfilo Monti (Faculty of Logic and Medicine, 1510–41, 1545–54).[144] This suggests that Bocchi had been awarded the title *eques aurato* by 1512, a title said by some sources to derive from his service to Alberto Pio of Carpi, imperial orator, in Rome in this capacity during the period of 1513 to 1518. Just when Bocchi began serving Alberto Pio as a courtier is uncertain,

because Bocchi was not in Rome early in 1512. He was there for part of 1513 as "primario consigliero del Ill.ᵐᵒ Alberto pio conte di Carpi a Roma," according to the Bocchi family chronicler.[145] One manuscript source places the date of the award of the title of Count Palatine (*comes palatinus*) to Bocchi as June 20, 1520, and early sources call him imperial orator as well.[146] However, it is difficult to understand how Bocchi's brief period of courtiership could have earned him such honor; certainly the title of imperial orator is an error. Bocchi's return to Bologna by October 1513 may have resulted from illness, because at that time he wrote to two Roman friends: "Ego vero infelix, & quartanarius sum..." (I am truly unhappy, and am suffering from a malarial fever).[147] He was given a leave of absence from teaching because of his health in 1514 and again in 1516.[148] Nor does the evidence of an initially successful role at court (or with Pio of Carpi at the papal court) explain the bitterness of the anti-curial poem dedicated to Marcantonio Flaminio (*Lusuum*, fol. 24r–v; later Symbol CXXIIII). This poem (discussed earlier) may have been written for Marcantonio before his first youthful trip to Rome in 1514 or, as is more likely, by 1519 when Marcantonio had returned to Rome for a curial career of his own.[149]

Nevertheless, Bocchi's nobility assured him a civic role in Bologna. He became a member of the *Anziani* in 1522, was serving on a committee concerning the architectural fabric of San Petronio in December 1526, and tutored in his home the very young papal legate Cardinal Ascanio Sforza in 1536, thereafter serving Sforza as an informal advisor.[150] The titles of *cavaliere aureato* and *conte palatina* brought with them certain privileges: power to award university degrees, to create notaries, to bear the arms of knighthood, and to legitimize one's bastards.[151] The latter privilege was taken more seriously than twentieth-century scholars would usually care to admit: Bocchi, who apparently had two natural daughters, wrote a dedicatory epigram for the future cardinal Gabriele Paleotti's defense of illegitimate children, *De nothis spurisque filiis* (Bologna, 1550, 1572).[152] The emperor Charles V granted the right to apply for full nobility with the usual privileges to the entire faculty of the Studio at the time of his coronation in Bologna in 1530, but this would not have helped the illegitimate.[153]

Anxiety about nobility and legitimacy contributed to a serious quarrel between Bocchi and his friend and former pupil Romolo Amaseo (*laurea*, Bologna 1512).[154] Amaseo was born in 1489 to Gregorio Amaseo and a nun, Suor Fiore da Marano, in Udine. Gregorio had his son legitimized in 1506 by privilege of Bishop Achille Grassi (Bocchi's cousin), but Romolo continued to doubt whether the document was valid.[155] He began teaching rhetoric at the Studio of Bologna in 1512 and married the noble Violante Guastavillani the same year. By September 23, 1513, Romolo was bragging to his father that the godfathers of his firstborn, Pompilio, were "tre ricchissimi Uomini di Bologna."[156]

Padua invited the rising young rhetorician, and Amaseo taught there from 1520 until 1524. Despite the attempts of Pietro Bembo to keep him in Padua, he returned to Bologna to take the then vacant seat of G. B. Pio, but he found the salary lower than he had expected (325 lire instead of 400 lire) and went back to Padua.[157] Cardinal Giberti negotiated his triumphal return to Bologna along with a contingent of pupils in 1525, whereupon Pio, Bocchi, and other teachers of rhetoric at Bologna protested to Giberti about their treatment, citing both their lower salaries and the insults

Amaseo reportedly had made about them.[158] Eventually, a close friendship between Bocchi and Amaseo was restored, as attested by a "De reconciliatione facta inter Romulum Amaseum et Achillem Bocchium arbitro sese" in two undated manuscripts in Cremona, and by the series of letters from Bocchi to Amaseo (1546–9) now in Milan.[159] In the meantime (1533), Gregorio Amaseo, having presented a series of documents proving the family's noble origins in medieval Bologna, procured for himself, his son, and his grandchildren Bolognese citizenship and nobility, thus putting to rest Romolo's anxieties.[160]

## Conclusion

By age thirty, Achille Bocchi had achieved a secure teaching position, titles of honor, and a good marriage. His pride in himself and his city's pride in him emerge from the *Rotuli* of the Studio, where he is the only member of the Faculty of Arts regularly titled *eques,* or "knight." His early training in Greek and Latin letters and the stimulation he received from his Bolognese professors toward acquiring an encyclopedic expanse of knowledge and an appreciation of the arts, though, are reflected not so much in his early academic and recreational writing as in the *Symbolicae Quaestiones* of his maturity. At the same time, the preoccupations of the youthful and courtly persona of Bocchi – the singing poet, the fleeing stag, even the humanist sobriquet "Phileros," or lover of Eros – disappear in the later Bocchi to permit a more "weighty" personality to emerge. If, in the suppression of these early elements a sense of Bocchi's doubleness emerges, it is a dissimulation based on a new propriety in academic and social life in an age grown less frivolous and more controlled from both within and without the individual – a prudent self-masking.

 CHAPTER TWO

# The Quiet Years:
## Bocchi's Religion and Philosophy

Il silenzio è compagno ai gran consigli,
e de la sicurtà ministro fido;
però tacete, o sol parlate quanto
basta a dissimular quel che riposto
avrete dentro al cor.
(Federico Della Valle, *Adelonda di Frigia*)[1]

Between the years 1530 and 1542, Bocchi remained on the roster of university teachers and maintained some degree of civic participation, as evidenced by his association with Cardinal Guido Ascanio Sforza, legate to Bologna from 1536 to 1538, and by his role as historian of Bologna (see Chapter 3 for Bocchi's *History*). Beyond these facts, little is known about this stage of Bocchi's life. Nevertheless, these same years saw both the intensification of Bocchi's studies on the mind and the soul and the rise of religion and philosophy as problematic issues in Italy. Because of the questions that have been raised by twentieth-century critics about the possibility that Bocchi was dissimulating heterodox religious ideas, Chapter 2 examines the evidence concerning Bocchi's religious position and his apparent association with religious dissidents. The ramifications of secrecy in sixteenth-century society become clear from an exploration of the spiritual and intellectual context in which Bocchi lived.

To prove a midsixteenth-century individual a heretic on the basis of acquaintance-ships or a Nicodemite – one who hides one's private religious convictions – on the basis of an elusive and esoteric literary work is not only a difficult task, but also a project founded upon an insufficiently refined vocabulary. If the term "Nicodemite" represents too narrow a position and if the term "circle of friends" serves as a catchall for social relationships of many types, then the inquiry becomes locked into questions of religious orthodoxy. An impression of religious ambiguity tends to be reinforced by the general view of Bologna as both center of a conservative papal state and locus of spiritual ferment and dissidence. But the city at midcentury was much more than this view of it. Bologna provided a fertile intellectual ambiance in which

23

Italians mixed with foreigners, lay people with the religious, academics with merchants and artists, and *letterati* with mathematicians, lawyers, and doctors. These groups shared each others' methods and absorbed ideas from other fields into their own. A careful examination of present modes of viewing Bocchi's place within this ambiance is in order. Only then can we resituate this reticent writer and his ambiguous text within the broader intellectual climate of his time.

### Bocchi and the Critics

Bocchi escaped the scrutiny of avid students of libertinism, atheism, and skepticism only to be seized upon by those who argue that there was widespread heresy and spiritual deviance in the sixteenth century. Such an interpretation grew out of the work of historians beginning with Delio Cantimori, was further developed by Antonio Rotondò, Cesare Vasoli, and Carlo Ginzburg, and then found general acceptance by art historians. The cases made by the historians follow in chronological order.

In 1959 Delio Cantimori opened the discussion by introducing the *Symbolicae Quaestiones* as a problematic text that urged the reader both directly and indirectly to refrain from the pursuit of hidden knowledge and that suggested an intimate, personal religiosity. He noted the ambiguity of the *"syncera fides"* with its image of Proteus bound, recommended to Renée of France, duchess of Ferrara, in Symbol LXI. A different type of "propaganda," which Cantimori saw in emblems such as the two variations on the Rape of Ganymede (Symbols LXXVIII and LXXIX), is both mystic-platonic and "quietistic" in nature. Cantimori found it difficult to determine whether Bocchi's work more clearly reflected an indifference toward dogmatic religious positions or an invitation to his readers to remain within the Old Church in a state of resigned Nicodemism, and he concluded that Bocchi's religious state was one typical of a gentleman and a humanist, embodying a humanist propaganda in enigmatic form.[2]

Cantimori argued from Bocchi's text; subsequent critics focused on the man. Antonio Rotondò, in "Per la storia dell'eresia a Bologna nel secolo XVI," placed Bocchi at the center of a circle of friends who admired Erasmus and Sadoleto and were in contact with Marcantonio Flaminio.[3] Bocchi's *sodales* (companions) included Alessandro Manzuoli, Claudio Lambertini, Leandro Alberti, Romolo Amaseo, Ludovico Boccadiferro, and one openly heretical ex-Franciscan known as Camillo Renato (also called Paolo Riccio and Lisio Fileno). The *Symbolicae Quaestiones*, in Rotondò's opinion, reflected the religious and Platonizing views of Jacopo Sadoleto. Rotondò maintained this view of Bocchi as both an admirer and a friend of Sadoleto in further works, and he discussed briefly Bocchi's role as a guarantor of Renato's appearance before the judiciary of Bologna in 1540 as an attempt to help Renato avoid arrest for heresy. According to Rotondò, the symbols are characterized by important strains of oriental symbolism (hieroglyphics and the Cabala) and "motivi mistico-scritturistici."[4] In another study, he called Bocchi's friends "sostanzialmente moderati" in their ideas and practices but a circle, nevertheless, into which a Nicodemite Bocchi seemed to "insinuate" his "erasmiane aspirazioni di rinnovamento attraverso le sue Symbolicae quaestiones" under the

pretext of statements of friendship dedicated to bishops, cardinals, and popes.[5] In addition to Bocchi's documented contact with Renato, Rotondò designated Bocchi as a friend and possibly a teacher of Cipriano Quadrio, who had known Renato in Padua prior to their renewed contact in Bologna.[6]

This question of Bocchi's relationship with Renato has continued to worry critics for the last three decades. Rotondò published the works of Renato, including the *Apologia* written for the inquisitorial tribunal at Ferrara in December 1540, in which Renato claimed to have had the assistance of Bocchi, Alessandro Manzuoli, and Cornelio Lambertini.[7] Hubert Jedin interpreted the influence of Renato as that of a Valdesian spiritualism touching members of the best families of Bologna, although Alessandro Manzuoli, Claudio Lambertini, Achille Bocchi, Leandro Alberti, and Romolo Amaseo were not necessarily Renato's *Anhänger*.[8] To George Huntston Williams, Renato was a forerunner of the Socinian movement and ultimately of Unitarianism. He concluded from the *Apologia*'s references to tutoring Bolognese youths and to friendships with Bolognese aristocrats whose names are dropped:

> Unlike a Franciscan under conventual discipline, Phileno [Renato] appears to have spent a good deal of his time in the homes of Bolognese patricians and nobles like the Lambertini, Danesi, Biancani, Manzoli, Bolognetti, and Bocchi. He appears to have been accepted in their homes as a moral reformer and as a preceptor of their children.[9]

Next, Aldo Stella characterized the religion of Renato in 1540 as still in an indistinct pre-antitrinitarian phase in which radical spiritualism was mixed with an autonomously developed antitrinitarianism. On the whole, Stella followed Rotondò's assessment of Bocchi, describing Bocchi as one who with a genuine humanist spirit "esaltava la possibiltà dell'uomo d'innalzarsi al di là del contingente *luminis aetherni authore spirante benigno*" (extolled the possibility of man to lift himself beyond the contingent as long as the source of eternal light breathes as a kindly one).[10] Bocchi's Platonizing circle, Stella suggested, may have influenced Camillo Renato as much as he influenced Bocchi. Finally, Carlo Ginzburg's important study of Nicodemism cast back to Cantimori's discussion of the Nicodemite tendencies in Bocchi, which Ginzburg called "acutissime."[11] Bocchi's intervention in the Camillo Renato case, he felt, proved the relationship between them to have been more than superficial.

Other historical studies touched on Bocchi briefly, as, for example, Salvatore Caponetto's biography of Aonio Paleario, which referred to Paleario as a friend of several members of Angelo (*sic*) Bocchi's Erasmian circle.[12] Romeo De Maio believed Bocchi to be the "Messer Achille" involved in a discussion of divine prescience with Cardinal Pole reported in a dialogue by Antonio Brucioli.[13] Cesare Vasoli accepted Bocchi as friend to the *spirituali* and of questionable secret religious orientation; Camillo, because he moved in the same ambient, was also a possible Nicodemite and was in France with Jacopo Broccardo and Alessandro Citolini, both of whom were said to be former Bocchi students later known as heretics.[14] In addition, Gennaro Savarese stressed Bocchi's associations with men such as Reginald Pole, Giulio Camillo Delminio, and Marcantonio Flaminio. Savarese deemed the *Symbolicae Quaestiones* an important example of Nicodemism.[15]

Similarly, according to Manfredo Tafuri, the religious dissimulation fostered by Bocchi's circle had an influence on Camillo Renato, Giulio Camillo Delminio, Sebastiano Serlio, and Ulisse Aldrovandi.[16] In all these studies, it must be noted, Bocchi remained a peripheral figure.

In the last decade, art historians have taken the historians' work on Bocchi seriously. A collection published in Bologna in 1982, *Le arti a Bologna e in Emilia dal XVI al XVII secolo,* contains two articles that touch on the problem of the religious views of Bocchi. To Adalgisa Lugli, the hermetic, Neoplatonic, and mythological synthesis of Bocchi served, as Cantimori suggested, as a cover for "una religiosità tentata fuori dall'ortodossia" and as Nicodemite propaganda aimed at a group of initiates.[17] She gave the following reasons: first, "documented ties" with an Anabaptist ambient; second, emblems dedicated to heterodox figures such as Camillo Orsini and Marcantonio Flaminio; and third, elements of Northern influence on the Bonasone illustrations, as, for example, heads copied from the Locher edition of Sebastian Brant's *Stultifera navis* and a motto paraphrased from Dürer's portrait of Melanchthon for Bocchi's portrait in Symbol II (Frontispiece).[18] In the same collection, Vera Fortunati Pietrantonio placed Bocchi and Cardinal Gabriel Paleotti at opposite sides of the "cultural divide" of the Council of Trent.[19] Bocchi (she said in a private discussion) represents not just a humanist world of classical virtues and deities like those Prospero Fontana painted in the Palazzo Bocchi but an Anabaptist religion in Nicodemite form.

Also appearing in 1982 was a work on the early years of the architect Jacopo Barozzi da Vignola with a detailed and carefully researched study of Vignola's Bolognese cultural milieu by Anna Maria Orazi.[20] Like Rotondò, Orazi considered Bocchi an Erasmian despite his contacts with Camillo Renato, whom she called a guest of the Academia Hermathena. Although a lack of documentary evidence prevented Orazi, who attributed the design of the Palazzo Bocchi to Vignola, from concluding that Vignola participated in the Bocchi circle, she did see in Vignola some generalized "Erasmian" tendencies, which she listed as tolerance, indifference to money, humanism, and pacifism, the latter because Vignola was not known to have practiced military architecture.[21]

Stefania Massari, in her introductory essay to the catalogue of the 1983 Giulio Bonasone exhibition sponsored by the Istituto Nazionale per la Grafica-Calcografia in Rome, noted the difficulty in pinpointing Bocchi's individual religious position within a generalized Neoplatonic and mystical approach.[22] To Massari, not only do Bocchi's friendships, as with the inquisitor Leandro Alberti and the heretic Camillo Renato, seem at odds, but the emblems often seem so as well, confirming the validity of the traditional Roman Catholic Church on one hand and hinting at an internalized, highly personal religion of radical spiritualism verging on Anabaptism on the other. Bocchi, therefore, like Renato, considered religion to be a dimension of one's internal life and was indifferent to dogmatic positions. Furthermore, this individualized, very aristocratic, and Neoplatonic religiosity, almost deistic in character, does imply Nicodemism in its ambiguities and intellectual subtleties.[23] To confuse matters further, Massari attributed the intellectual content of the *Symbolicae Quaestiones* to the engraver, Giulio Bonasone, although the questionable friends were linked to Bocchi.[24]

## The Critics Evaluated

Only rarely have critics remained neutral on the question of the religious orientation of the *Symbolicae Quaestiones,* and one of the few who rejected the Nicodemite theory – Claudio Mutini – did so in terms of the contribution of Giulio Bonasone.[25] The critics presented in the last section discussed both personal relationships and overt and covert textual statements. What, then, were the direct consequences of Bocchi's supposed heterodoxy? When the extratextual facts concerning Bocchi's religious orientation are laid out, we find little evidence to support the critics' charges. Bocchi's *Symbolicae Quaestiones,* published first with the approval of Pope Julius III in 1555 and again in 1574 by the Societas Typographiae Bononiensis (whose founders included the brother of Cardinal Gabriele Paleotti), never appeared on the Index of Prohibited Books nor did any other work by Bocchi. Massari suggested that the second edition was made possible by political pull, but, because both Bocchi and the majority of his most important dedicatees were no longer living in 1574, this argument fails to convince.[26]

Nor is there any evidence that Bocchi himself or any close relative of his was ever prosecuted for heresy, although this does not rule out a secret trial, the common treatment for errant nobility before the Council of Trent. In fact, Bocchi's name is conspicuously absent from all accounts of heresy in Bologna except for Renato's testimony. Not even did a satire on Bologna's professors that appeared around 1540 and was attached to the statue of Pasquino in Rome attack Bocchi's religion, although it did lampoon his personality.[27]

Finally, there is the question of whether Achille Bocchi can be presumed heterodox on the basis of his given name. De Maio's and Massari's tentative identification of the Bolognese Achille with the "M. Achille, tanto nominato philosopho" in the minidialogue between Cardinal Pole and Achille, which the Duchess of Urbino, Leonora Feltria di Gonzaga, related within her dialogue (XVI) with Camillo Orsino in Brucioli's *Dialogi . . . de la metaphysicale Philosophia* (the 1538 Venetian edition), lacks substantiation.[28] Bocchi dedicated an emblem to Pole and one to Orsino, but the Achille whose doubts on divine prescience were resolved by the cardinal could have been another person altogether. "Achille" was not a not uncommon given name; in early-sixteenth-century Bologna alone there were, besides Achille Bocchi, Cardinal Achille Grassi and his cousin Bishop Achille Grassi; Achille Marozzo, who conducted a school of martial arts; and Achille della Volta, a familiar of Bishop Gilberti. In addition, the title "Messer," used in the dialogue for Achille, usually implied a lawyer or a doctor, although it could refer to a teacher.[29] As a rule, Bocchi was addressed by the title "eques" or "cavaliere." In the case of Brucioli's dialogue, "Achille" may well represent a nickname rather than a given name, the most likely candidate being the noted philosopher and teacher of Pole, Pietro Pomponazzi, who was referred to by both Girolamo Fracastoro and Agostino Nifo as an "Achilles." Pomponazzi was known to have religious doubts.[30] Furthermore, there is no evidence of contact between Pole and Bocchi beyond the emblem to Pole. Pole does not mention Bocchi in his correspondence despite the "bellissime ragionamenti" that Brucioli claims he had with "Achille."[31] For these reasons, Achille Bocchi can be ruled out as the doubting Achille of Brucioli's dialogue.

## Bocchi and His Associates: The Presumed Heretics

The mere fact that Bocchi taught youths later known as heretics does not prove that he taught them heterodox ideas.[32] In fact, Vasoli, in his study of Giulio Camillo, does not provide a source to prove that Broccardo and Citolini were pupils of Bocchi, let alone close to him, and I have not been able to verify this statement. Bocchi probably knew Broccardo from literary circles; "il Venetien Brocardo" was present at a joust attended by all the academic and literary figures of Bologna in 1525, according to Girolamo Casio.[33] Nor does Bocchi dedicate any symbols to Agostino Abioso, although he was probably a Bocchi pupil and someone to whom an earlier manuscript verse is addressed (Vat. Bibl. Apost. Lat. 5793, fol. 54v). Abioso was labeled a Lutheran in the 1551 *Costituti* of Pietro Manelfi, but Bocchi's name does not appear.[34] Bocchi may have taught Giulio Camillo Delminio, who was in Bologna during much of the period between 1519 and 1532 as a member of the *familia* of Stefano Saulio and as a private teacher of dialectic or rhetoric. Camillo, who was never prosecuted for heresy, contacted reformers in Paris in 1530 on his first trip there and was praised for his theology by Johannes Sturm.[35] Bocchi's Symbol LXXXVIII is dedicated to Camillo; it makes no reference to religion but instead presents a moral fable. In 1525 Bocchi would not have known of heresy in acquaintances; if he heard rumors about these individuals later, he probably would have acted prudently to preserve his reputation and the private academy he was running for young noblemen. Some evidence of caution can be seen in the symbol that Bocchi dedicated to his pupil Jacopo Casonio, who was warned against bad teaching (CXX), and in the awarding of a laurel crown to a young German anti-Lutheran poet, Simon Lemnius, in Bocchi's academy in 1543.[36] Also, the only name dropped from the manuscript copy of the *Symbolicae Quaestiones* was that of Vincentio Bovio, one of a group of Bolognese who were arrested in 1548 and imprisoned in the Castel Sant'Angelo in Rome until November 1549.[37]

Turning to the more difficult question of Bocchi's relationship to Camillo Renato, we quote from the *Apologia* the only known evidence of contact between Bocchi and Renato:

> Interea audio fratres Predicatorum ordinis mihi insidias parare ut me capiant in templo, in concione, in scholis, in platea et per totam urbem. Mox ego accersitos quosdam ex nobilibus civibus, scilicet dominum Alexandrum Manzolum, comitem Cornelium Lambertinum ac equitem Achillem Bochium, ad reverendum inquisitorem et fratres eiusdem ordinis transmisi nunciarentque rogavi quid a me vellent fratres et pollicerentur me libentissime, data tamen fide commeatus, accessurum ac rationem rediturum de omnibus.
>
> *(Opera, 85)*

> (Meanwhile, I heard that the friars of the Order of Preaching were laying traps for me, in the hope that they might catch me in church, in the public meeting place, in the lecture hall, in the open square, and throughout the entire city. Soon, I summoned certain noble citizens, namely Lord Alessandro Manzuoli, Count Cornelio Lambertini, and Sir Achille Bocchi, and sent them over to the Reverend Inquisitor and the friars of the Order, and I asked them to report

what the friars wanted from me and to assure them that I would come most willingly and explain everything provided they would give me a guarantee of safe passage.)

The text nowhere claims that Renato ever visited Bocchi's home or academy, and there is only Renato's word for the association with Bocchi. Renato denied charges made by his accuser, an unknown Neapolitan, that he had subverted Bolognese men and women in their homes or that he was in the home of Cesare and Cornelio Lambertini on the Lenten day he was accused of eating cheese and butter illegally.[38] Bocchi and the wealthy Cornelio Lambertini, from one of the oldest families of Bologna, and Alessandro Manzuoli, born a Sforza Attendoli but adopted by his maternal grandfather as heir, had as their mutual friend Fra Leandro Alberti, described as "saggio Inquisitore" by Giovanni Filoteo Achillini in 1536 and as "brusco inquisitore" by Paolo Giovio in 1540. Alberti would be Bologna's inquisitor from 1550 to 1551.[39] His long-standing friendship with the Dominican Alberti and with another Dominican, Reginaldo Nerlio, recipient of Bocchi's Symbol CXXVIII and inquisitor of Bologna from 1551 to 1554, suggests Bocchi had no aversion to orthodoxy or orthodox patrons. One possible explanation of the Renato question is that the three nobles were approached precisely because of their impeccable respectability. Alternatively, their respectability may have been a facade, which Renato took care to maintain in return for the aid of such useful friends and co-religionists.

There remains a third possible reason for Bocchi's association with Renato, one that posits that the three middle-aged aristocrats were protecting their sons, or at least a son of one of them. Renato, according to Rotondò, had his biggest following among youth and may have agreed to avoid any statements incriminating a young Bocchi, Lambertini, or Manzuoli in return for the assistance of the fathers. This would have prevented difficulties for the families, although in 1540 nobles were usually spared public disgrace and severe penalties if they abjured heresy in a private hearing.[40] A potentially more serious problem could have arisen from a homosexual relationship between one or more of the sons of the three nobles and Renato, homosexual activity being a crime punishable by banishment (and after 1555, by death).[41] That Bocchi had a son with homosexual tendencies is suggested by Symbol LIX in the second part, captioned "Ad Filium": "Culpa tua est: siquidem tua iam corrupta voluntas / Fallitur heu prauis sensibus implicita" (To my son. The fault is yours, if in fact your now corrupted will is led into error, entangled, alas, in base feelings). Coming as they do in an era of relative sexual freedom for men, Bocchi's strong words probably refer to a homosexual situation rather than a heterosexual one. Clearly, homosexuality is a subject of poems that Renato addressed to his young male pupils.[42] Rotondò passed over these "Horatian" poems quickly and with no commentary. G. H. Williams reported (with relief?) rumors of Renato's "ribald" conduct as a bigamist in Bologna according to some intelligence transmitted by Cardinal Contarini to the inquisitors at Ferrara.[43] The fear of scandal of a moral or religious nature or both may have induced the noble protectors of Renato to work for his quiet removal from the scene before the noisy public accusations of heresy, sedition, and ribaldry shifted to include their own families in the glare of publicity.

Renato did not wait for them, however; he left Bologna before his trial and fled to Modena.[44]

Documents discovered by Carlo Ginzburg may also shed some light on Renato's activities in Bologna. In the 1570 trial of a miller called Pighino, the accused heretic testified that he had learned false doctrine while a servant in a house in Bologna, where a *frate* whose name he did not know read to a group meeting. He could and did name the group's members, including Antonio Bonasone. Bonasone held a chair of philosophy in 1540, was probably around thirty years old, and was a relative, possibly the brother, of Bocchi's engraver, Giulio Bonasone.[45] The second time Pighino listed names, he altered the name of Vincenzo Bolognetti to "Bonini," which suggests that he belatedly and naïvely thought to protect his former *padrone*. Thus the "domo equitis Bolognetti" referred to by Camillo Renato in his *Apologia* may have been the home of Vincenzo rather than that of Francesco Bolognetti, a poet-dilettante friend of Bocchi.[46] No Bocchi, no Manzuoli, no Lambertini appear on Pighino's list. The evidence connecting Bocchi personally to Renato, therefore, is not compelling and may point in other directions.

### Bocchi and the Religious Positions of His Patrons and Friends

During an active life Bocchi came to know and be known by many of his contemporaries, as attested to by the dedications to his poems, by his letters (relatively few of these are known to survive), and by allusions to him made by others. Given the lengthy list of names – colleagues, students, neighbors, relatives, scholarly friends, patrons – we associate with him, it is often difficult to determine which of these individuals were especially close to him. Many of the recipients of symbols represent lay and clerical power – François I, Henri II, Charles V, Cosimo de' Medici, Popes Clement VII, Paul III, and Julius III, papal legates, governors of Bologna, and eighteen cardinals. These are clearly patrons to whom Bocchi was bound by reciprocal claims of service and reward. Symbols dedicated to them required praise and support rather than a personal meeting of minds. Such relationships represent "instrumental friendships," as defined by Jeremy Boissevain and Dale Kent.[47]

In terms of religious orientation, however, the dedicatees represent a range of religious positions cutting across social classes. Extreme conservatives like Paul IV (Paolo Carafa) and Girolamo Aleandro are conspicuously absent, but orthodox thinkers such as Paolo Giovio and Claudio Tolomei are included.[48] Although the religious orientation of many persons named remains to be determined, several have been labeled "Erasmian" (Alciato and Giano Vitale), some *spirituali* (Cardinal Pole, Ludovico Beccadelli, Marcantonio Flaminio, Camillo Orsini, Giulio Camillo, and Antonio Bernardi), and only one a heretic (Renée of France, duchess of Ferrara). Although Paolo Simoncelli portrayed Flaminio and Pole as representatives of the radical faction of the *spirituali* (also called "Evangelists"), the respect commanded by these two men among intellectuals like Bocchi makes it clear that they were not deemed heretical and dangerous in academic circles.[49]

Bocchi addressed enough emblems to *spirituali* to suggest that his sympathies lay with them, yet there are no dedications to Cardinal Caspare Contarini, their moderate leader, or to Cardinal Pole's protegé, Cardinal Giovanni Morone, both papal legates

to Bologna in 1542 and from 1544 to 1548, respectively. Nor do published letters and other writings of Pole, Contarini, or Ludovico Beccadelli ever mention Bocchi.[50] Volume 16 of Bocchi's *Historiarum Bononiensium Libri* does contain a dedicatory letter to Morone as papal legate, however.[51]

Among the friends of Bocchi who were sometimes associated with the *spirituali* was Giulio Camillo, who taught privately in Bologna around 1519 to 1522 and was there in 1530 and 1532, by which time his Memory Theater had been constructed in Venice.[52] Another such friend, Antonio Bernardi of Mirandula, studied at Bologna, taught philosophy there between 1533 and 1539, and received Bolognese citizenship along with his inscription into the rolls of the nobility between 1542 and 1544.[53] With Marcantonio Flaminio, whom Bocchi knew from boyhood, the period of closest friendship was the years 1517 to 1520. Available evidence does not indicate any meetings or correspondence after 1526, which was well before Flaminio's years of religious crisis, although Flaminio did visit Bologna in June 1542.[54] That Bocchi's feelings toward Flaminio remained cordial, however, is shown by Bocchi's letters of 1546 and 1547 to Romolo Amaseo in Rome asking Amaseo to pass along his greetings to Flaminio.[55]

In the Bolognese Ludovico Beccadelli, Bocchi had an important link with the *spirituali*. Beccadelli served as secretary to Papal Legate Contarini, continuing the Legate's duties after Contarini's death in 1542 and resuming his secretarial activities for Cardinal Morone in 1544. Bocchi paid tribute to Beccadelli as a generous host, who gathered his friends (including Marcantonio Flaminio) at the villa Pradalbino outside Bologna for summer vacations and autumn university breaks, in "Concilij humani, conuictus, colloquiorum" (Symbol LXXVII).[56]

Beccadelli, never a serious theologian, served the *spirituali* as the propagandist for and chief architect of a campaign mounted in defense of their respectability and orthodoxy.[57] Beccadelli's biographies of a prudent Pole, of a saintly and "unspotted" Contarini, and of Cosimo Gheri, Pietro Bembo, and Marcantonio Flaminio were written after 1555. Along with defenses of Pole's "sana doctrina" by Pietro Carnesecchi and Girolamo Seripando (1561), they sought, according to Simoncelli, the recuperation as much to defend their own careers as to honor the deceased *spirituali*.[58]

Nevertheless, these self-protective moves do not fully explain the lasting bonds of loyalty created by the *spirituali*. When Bocchi's friend Bartolomeo Ricci wrote of his deep grief on the loss of his close ("amicissimus") friend of forty years, Marcantonio Flaminio, he did not question Flaminio's religious state. However, at the death in 1556 of Sebastiano Corrado, a mutual friend with whom Ricci had corresponded, whom he had visited in Bologna, and with whom he had maintained a long friendship, Ricci expressed only tepid praise and said it was too bad that Corrado had turned out to be another "Aonio Paleario" (or Protestant).[59] Corrado, who had held the chair of eloquence at the Studio and also taught privately at Bocchi's academy, was the recipient of Symbol CXXII. He was probably the closest friend of Bocchi's full maturity to be thus associated with heresy by hearsay, but there is nothing to substantiate such a charge, unless the return of Corrado in 1555 to his former home in Reggio implied a prudent retreat from imminent prosecution.[60] Ricci does not implicate Bocchi, leaving us with a type of inconsistency that seems

especially common when *spirituali* are involved. Such loyalties seem to stem not so much from the fellowship of faith or the ties of political party as from an intense form of male bonding within a Renaissance *sodalitas,* in this case the early-sixteenth-century group in Padua that included Ricci, Flaminio, Contarini, and Pole. It is not known whether Bocchi ever visited this sodality in Padua or whether most of his contacts with its members came at intervals when they were in Bologna. Bocchi displays the same loyalties, although he does not criticize Corrado in any way.[61]

The issue of Calvinism emerges for only one of Bocchi's dedicatees: Renée of France's Symbol LXI was the one Cantimori found so ambiguous. But I have found no evidence of any real contact between Bocchi and this member of the French royal house, known for her open support of Calvinism. When in 1554 Renata was held incommunicado in Ferrara and forced to recant, her papers were examined carefully and all incriminating documents collected and itemized by Alessandro Fiaschi, the duke's ambassador to France. The only Bolognese listed in these manuscripts (now in the Archives of Modena) was Innocenzio Ringhieri, who wrote at least five letters to the duchess on the publication of sacred works, on his own vernacular Psalm translations, and about unspecified "heretical" matters. Ringhieri, a noble with French leanings, published some of his own writings and was active in Bologna's academies, perhaps even Bocchi's.[62] Not only was his *Libro de' Salmi di David Re* (Bologna, 1555) published by permission of Vice-Legate Lenzi and the inquisitor,[63] but his correspondence with Renée led to no known prosecution. If Bocchi had sent a copy of his symbol of Proteus bound to Renée before her forced recantation of 1554, it did not disturb her examiners; if he had sent it to her after 1554, it might imply encouragement in Nicodemism – or a rather tactless celebration of her "return" to orthodoxy.[64] Renée's troubles stemmed from both the openness of her views and the conservatism of the time, yet an Italian woman to whom a sonnet on predestination and the elect is attributed, Veronica Gambara, maintained a high reputation and close ties to literary circles in Bologna.[65]

These examples of Bocchian friendships do not provide evidence of heresy. Many people whom Bocchi knew were suspected of heterodoxy at one point or another, and instances of suspected heretical activity, including trials by inquisitors, can be documented for almost every year between 1530 and 1560 in Bologna alone.[66] Few if any of these questionable people appear to have been close friends of Bocchi. No acquaintance brought before an inquisitional tribunal received a dedication from Bocchi, including his pupil Ulisse Aldrovandi, who was arrested in 1549, and Cardinal Morone, papal legate from 1544 to 1547, who was tried a first time and acquitted in 1552 to 1553.[67] The only name of a dedicatee to be dropped between the manuscript and the printed edition of the *Symbolicae Quaestiones* was that of Vincentio Bovio, one of several members of his family imprisoned in the Castel Sant'Angelo in Rome in 1549 on charges of heresy.[68] Camillo Renato, whose potentially damaging link to Bocchi lends itself to several very different readings, also received no emblem. On the whole, the sheer number of dedications to church leaders reflects not only the patronage needs of a writer whose princes are the clergy but also an affirmation of that power structure, with special respect directed toward those concerned with reform of the Roman Church from within. The presence of a few heterodox dedicatees does not necessarily mean that Bocchi's religious persuasion

must be identified with the extremes of the continuum. In these cases an overriding propriety may have been present, such as the royal blood of Reginald Pole and Renée of France or the long, close friendship with Marcantonio Flaminio.[69]

There is presently no way to determine the precise relationship between religion and the individual or between one religious individual and another. We need to define our terms in a more useful way in discussing Renaissance interpersonal relationships. If the term *sodality* were to be applied only to small groups whose members shared close friendships and similar tastes and ideas, then the term *circle* could be used to refer to the many other groups – kinship, parish, professional, academic, and so forth – to which an individual might belong. Membership in a circle would not imply a necessary identification of goals and interests beyond the scope of that particular circle and, hence, would be of limited use in determining the extent of heretical belief. Typically, an individual belongs not to one circle, but to overlapping circles that are not static and whose members change over time. A sodality can form the nucleus of a circle, such as an academy, without being identical with it. Because of its private nature, the sodality has a greater impact on the religious views of its members than a circle does, yet that same privacy and informality makes its membership harder to determine. The relationship between a sodality and an academy probably resembles the structure of Bolognese confraternities, which displayed, according to Christopher F. Black, "an officially recognised difference between a *stretta,* inner group, and the *larga,* wider membership," with the inner elite group ruling the company and serving it with greater commitment.[70]

The sodality to which Bocchi belonged in the first half of his adult life had lost some members by 1540 and most of the rest by 1555. It is not clear who Bocchi's closest friends were at the time of the publication of his *symbola,* although over a century later Carlo Cesare Malvasia reported that the home of Prospero Fontana, a painter, was a gathering place for the outstanding people of this time, including Ulisse Aldrovandi and Achille Bocchi.[71]

### Bocchi's Symbols and the Religious Climate

When we move on to the text of the *Symbolicae Quaestiones,* we face the internal questions of dogmatism and Nicodemism first raised by Cantimori. Here the answers remain inconclusive. There are no affirmations of justification by faith alone (although there are allusions to true faith in Symbol LXI and to faith as the highest good in Symbol CXXX), no "benefit" of Christ, and no direct attacks on corrupt clergy. The Roman curial court, however, is harshly criticized in Symbol CXXIIII dedicated to Marcantonio Flaminio, and there are attacks on atheism and false doctrine in Symbol CXXX, dedicated to the Bolognese senator Andrea Casalio, and on religious error in Symbols LXI and CXX, dedicated to Renée of France and to Jacopo Casonio, a pupil, respectively. The highly intellectual, internal, and aristocratic nature of Bocchi's spirituality suggests some aspects of Evangelism, as characterized by Delio Cantimori and Eva Maria Jung, but without the strong emphasis on the Gospels and Pauline Epistles one would expect to find if the work were influenced by Protestant writings.[72] Philip McNair located this humanist, intellectual, and nonpopular religious "climate" in an Erasmian season of mild Catholic reform that

would appear to be reflected in Bocchi's ethical stance, in his cultivation of Wisdom (*Sapientia* and *Mens*), and in his allusions to Folly and *Pazzia*.[73] Among Bocchi's symbols are Stoic statements of patient suffering, of moderation, of avoidance of wrath, and of the virtue of self-knowledge. Divine knowledge would be profaned by the masses (I, XX) and should not be probed too deeply by anyone (XL, XCVIII). On the other hand, the renewal (XX, XCVIII) and the mystical-Platonic elevation (CXXX, CXXXX) of the soul reward the "Mente syncerissima."[74] Finally, Bocchi himself assures his readers in Symbol I that the doctrine under his poetic and symbolic veils is sound and accurate: "Sed inuolucra esse abdita/Scientiae haud erraticae, / Nec peruagatae" (But they are hidden cloaks of a knowledge that is accurate and not widespread).

Publication of the *Symbolicae Quaestiones* fell between the second (1551–2) and third (1562–3) sessions of the Council of Trent. Some traces, therefore, of the Council's influence might be expected to surface in Bocchi's symbols. Hubert Jedin has found that nearly all the topics dogmatized by the conclusion of the Council had first been examined, discussed, and formulated in the Bologna session of 1547. Because the Council was relatively open and its efforts were summarized for the public from the pulpit of San Petronio,[75] the total absence of references to the sacraments of the Roman Catholic Church in Bocchi's work cannot reflect his ignorance of contemporary religious trends. The Council's concern for propriety in art may have imposed some restraints on the engravings for the symbols in that there is no nudity in representations of religious subjects and the work observes conventional decorum.[76] The engravings are slightly more "Catholic" than their texts, as, for example, the pilgrim in Symbol XXXIX, who displays his beads while observing Christopher (not addressed as "Saint" in the text) with the child "Religio" on his back. Bocchi's inattention to sacraments and liturgy, to Purgatory, and to the Trinity resulted from the moralizing and essentially secular nature of the symbols. He classified in a "Syntagma" (or systematic index) seventy-seven symbols as "Moralia," forty-four as "Philologica," twenty-two as "Theologica," and eight as "Physica." Theology, which is listed first, contains poems of a markedly cerebral quality that might substantiate Cantimori's imputation of "indifference toward dogma."[77] Yet these poems are far from the nondogmatic devotional literature in popular demand, such as the *Beneficio di Cristo*. Bocchi's religious stance as a whole appears eclectic and intellectual but intimate. It was possibly at variance with formulations made by the Council of Trent but shows no signs of being in conflict with the more flexible theology of the earlier sixteenth century. If Bocchi held any false doctrine, he clearly knew enough to avoid self-incrimination.

### Potential Areas of Religious Conflict

In a number of areas the *Symbolicae Quaestiones* does evoke at least the potential for conflict with Counter-Reformation orthodoxy. These issues derive not only from a new doctrinal rigidity developing after 1547 but also from changed notions of propriety and from overreactions to Protestant intellectual efforts. Their presence does not prove heretical intent, but they may have affected the immediate reception

of the *Symbolicae Quaestiones,* and they have influenced the *fortuna* in ways that have touched recent criticism.

The issues in question all stem from the intense Renaissance drive to recuperate the past in a pristine and uncorrupted form. There were two main approaches to antiquity available to Bocchi and his peers, one philological and the other, for want of a better term, rhetorical. The philologists, having developed an increasingly refined method and having applied their competence to the correction of texts in all fields, posed a threat to the Roman Church by their ability to prove the forgery of documents (the Donation of Constantine), to correct the Vulgate itself, and to get new, accurate translations into the hands of a wider body of readers.

For Bocchi, the area of potential philological difficulty arose from his Hebrew studies. The first half of the sixteenth century was a period of intense cultivation of the Hebrew language and Hebrew texts.[78] Universities had been encouraged to set up chairs of Hebrew as far back as the Council of Vienne in 1312 to enable preachers to convert the Jews more easily, and humanistic Hebrew studies had been pioneered by Gianozzo Manetti (1396–1459) in the midfifteenth century.[79] Despite the privileged status of Hebrew as the language in which the Old Testament was written and that "Adam spoke,"[80] the study of texts in Hebrew had provoked controversy by 1500. Some Dominicans attacked Cornelius Agrippa, Pico della Mirandola, and especially Johannes Reuchlin for treating the Jews with too much sympathy. Many of Reuchlin's supporters had had their names printed on the list of "Capnionis defensores acerrimi viri" in the *Illustrium virorum epistolae* (Hagenau, 1519), a roll of names headed by Erasmus and including Egidio of Viterbo and the younger Filippo Beroaldo of Bologna, a teacher of rhetoric at the Studio and later a papal librarian.[81] And at least several men with connections to Bologna's Studio corresponded with Reuchlin: namely, Filippo Beroaldo the Younger and Cardinal Achille Grassi, Bocchi's cousin.[82]

On the whole, the uneasiness regarding the study of Hebrew texts that was shown by Erasmus, Bembo, and some other humanists after 1525 concerned the Cabala with its magical overtones and Hebraizing theological syncretism rather than the Hebrew language itself. Theologians also tended to be disturbed by the implications of philological methods as applied to those studies of the Hebrew Bible that called into question the primacy of the Vulgate.[83] Christian studies of Hebrew lost their openness as religious conflict increased, and the use of anti-Semitic slurs by some scholars of Hebrew against their own rivals came to weaken the position of all of them.[84] By the midsixteenth century, the Hebrew language, Hebrew texts, and the Jewish people faced a hostile and increasingly restrictive climate. The major "Counter-Reformation" actions taken were the following: the banning (and burning) of the Talmud by Julius III in 1553; the virtual disappearance of Hebrew presses from the Papal States by 1556; the condemnation of some Hebraizing works, including the *Ars Cabalistica* by Reuchlin, in the Index of 1559 and of the Cabala itself in 1563; the expulsion of the Jews from all papal territories except Rome and Ancona in 1569; and the prohibition by Clement VIII of the use of the Hebrew language in the Catholic world in 1592 (it had already been banned in the Spanish territories since 1559).[85]

Bologna in the early sixteenth century was more tolerant toward Hebrew studies and Jews than Reuchlin's Cologne had been. For example, the Jewish physician Jacob ben Samuel Mantino (d. 1549) had been invited to teach at the Studio of Bologna in 1529.[86] Because the government of Bologna did not finance the teaching of theology (the convents did), there are no official records of Hebrew courses in the theological faculty of the Studio, although Agostino Giustiniani mentioned that he had taught Hebrew in a Dominican convent in Bologna around 1514.[87] Humanist interest in Hebrew had stimulated the establishment of a chair of Hebrew and Chaldean in 1464 to 1465; it was held by the obscure Vincentius de Bononia (arts faculty) from 1465 to 1490. This interest also resulted in the teaching of Hebrew by Ambrogio Teseo in the early years of the sixteenth century and the Hebrew chair (also arts faculty) held by a Ioannis Flaminius (probably Marcantonio Flaminio's father, Giovanni Antonio Flaminio) from 1520 until his death in 1526.[88] Flaminio had been called to Bologna by his Dominican friend, Leandro Alberti.[89] Apparently no one succeeded Flaminio in the chair of "Litt. hebraicas et Caldaeas" in 1526. Besides Christian teachers of Hebrew, however, there was a relatively affluent Jewish community in Bologna ensuring the presence of educated Jews, Hebrew presses, and, at least for a time, a Talmudic academy founded by the physician and scholar Obadiah Sforno (1475–1550).[90]

The monastic teaching orders of Bologna produced the most important Hebraists associated with the city. The Augustinian convent of Bologna provided the locus for studies of Hebrew by Agostino Steuco of Gubbio between 1518 and 1525 and Peter Martyr Vermigli around 1530 to 1532, who named as his Hebrew teacher a certain Isaac, a Jewish physician.[91] Also, the Dominican Joannes Baptista Theatinus mentioned in his *In opus Andronicum concioncinia hebraicis caldaicisque sententiis referta* (Ancona, 1520) that he had been working on the Book of Esdras during a stay in Bologna.[92] Achille Bocchi began his studies of Hebrew before 1520 under either a member of the theological faculty of the Studio or someone outside, possibly a Jewish tutor; his earliest collections of poetry contain some Hebrew. Others who probably studied their Hebrew in Bologna in the first half of the sixteenth century were Francesco Florido Sabino (in 1538), Ulisse Aldrovandi (1539, or between 1542 to 1547), Ercole Bottrigari (early 1540s), and Jerome Osorio (d. 1580).[93]

Bocchi's use of Hebrew is not extensive. He paraphrased a Hebrew psalm (115), which he included in his *Lusuum* (Vat., Lat. 5793, fol. 33v) and again in the *Symbolicae Quaestiones* as the second part of Symbol CXLVIII, and he added Hebrew inscriptions to three of his symbols in Book V (XC, CXXX, and CXLVIII). On the facade of the Palazzo Bocchi (Figure 9) he inscribed a quotation in Hebrew from Psalm 119/120.2 ("Deliver me, O Lord, from lying lips, from a deceitful tongue"). There appear to have been no retroactive corrections to Bocchi's text when Hebrew was banned, although Hebrew words were deleted from those works that the Index revised.[94] On the other hand, one of the existing engraved versions of the Palazzo Bocchi exhibits a blank space on the left side of the facade where the Hebrew inscription should have appeared but retains the Latin words on the right. This print, dated 1555 but probably issued later, may imply a Hebrew problem for Bocchi; whether the omission was due to fear of an overzealous application of censorship or

to prudence in an appeal for patronage from someone hostile to Judaism (perhaps Pope Paul IV) cannot be determined.[95]

## Bocchi and Syncretism

The second major approach to antiquity, the "rhetorical," sought to resuscitate an ancient Wisdom, now dispersed, corrupted, veiled, or buried. Its adherents proceeded by encyclopedic compilation and syncretism to sift through the *disiecta membra* of the past for those tantalizing fragments that intimated a glorious whole just beyond their grasp. This Wisdom, believed compatible with Christian Truth, was not just theology or philosophy or morality or cosmology but drew on all of these; it was what Paolo Rossi has termed *pansophia*.[96] Its most characteristic forms were the following: *philosophia perennis* (perennial philosophy), which stressed continuity in transmission from the pre-Socratics on; *prisca theologia* (ancient theology), which posited a more discontinuous reception of an original divine revelation; and the occult, which dealt with the forces of the natural world through alchemy, astrology, and magic.[97] For their sources the Renaissance pansophists turned to Neoplatonic, Cabalistic, and Hermetic compilations and to the scattered fragments of proverbs, Pythagorean *symbola*, Orphica, and Egyptian hieroglyphs embedded in Greek and Roman texts. These seekers pushed back the boundaries of wisdom from the time of Moses and Hermes Trismegistus (Ficino) to Noah and Janus (Annio of Viterbo), and back to Adam. They extended the frontiers of wisdom to encompass Egyptian, Persian, Arabic, and Celtic realms as well as Hebrew and Graeco-Roman ones.[98]

The pansophists sought the Logos of a pre-text world using rhetorical and poetic tools: analogy, metaphor, figure, and symbol.[99] Rhetoric, because it was seen to unify all knowledge, and poetics, because ancient poets were believed to be theologians (*magi*), shared a privileged role.[100] The Cabala in particular was studied for a key to the hidden relationships between word and meaning, which led to further work on etymology and onomastics.[101] In addition, each word and thing were then joined to others by invisible bonds of sympathy into a vast concord or were repelled by antipathy into discord. This sympathy, based on likeness and, according to Proclus, on a series of chains moving from unity into multiplicity and back, could only be expressed through metaphor, analogy, and symbol.[102] Neoplatonists like Dionysius the Areopagite were already calling for the use of incongruous symbols to maintain difficult access to mystical revelation and sacred discourse.[103] According to Quintilian, *figura* originated as veiled allusion in oratorical practice.[104] These rhetorical and poetic tools all had visual applications, and, as Claude-Gilbert Dubois has demonstrated, sixteenth-century thinkers found it difficult to speak of the question of language without recourse to iconic analogies.[105]

Syncretism, although not the only current in the Renaissance, represented one of its "most characteristic intellectual movements," according to Charles B. Schmitt.[106] It must be noted, however, that the syncretists aroused considerable uneasiness and suspicion, such as was voiced by Jacob Brucker in his monumental *Historia Critica Philosophiae* (1766).[107] For one thing, syncretism represented antirationalist and mystical reactions to scholastic philosophy, especially in its rigid separation of

philosophical and theological truth (the so-called double truth).[108] To the rationalists the enormous energy expended by the synthesists in heroic efforts to make everything "fit" could only appear misguided and futile, although *docta theologia* tended to be nonsystematic. Thus, Ernst Cassirer in 1942 would "absolve" Pico della Mirandola "from the charge of 'bad syncretism,' " but he rejected any positive use of the term.[109] Despite objections to and attacks on syncretism, a number of studies document important contributions of syncretism to the formation of a Nicholas of Cusa or a Leibnitz, to the programs promulgated by Italy's academies, to the development of linguistics and of universal history, to the rehabilitation of ancient gods as Renaissance symbols, and to fruitful rapprochements between art and poetry (*ut pictura poesis*) and between the arts and mathematics.[110]

In addition to philosophic doubts about the validity of syncretic approaches, there were questions about *pansophia* from the Church in general and especially from the Counter-Reformation Church of Rome. Although a syncretist like Agostino Steuco might denounce Luther or one like Paolo Ricci might proclaim the Cabala a valuable means of converting the Jews, such writers frequently found themselves targets for attack. For example, Erasmus, who was critical of the Hebraizing efforts of Reuchlin and Francesco Giorgio (Zorzi), came under fire himself for his assimilation of classical learning into Christian contexts.[111] Another concern of the nonsyncretists (whom Schmitt would call "exclusionists") was the occult world of magic, which had fascinated Ficino and which the Jesuits would later associate with the Cabala.[112] In theory, syncretists like Steuco could follow Clement of Alexandria as a model for accepting everything that agreed with Christianity as true and everything that did not as erroneous and heretical.[113] In practice, Steuco and others found it difficult to jettison some of the ancient ideas that appealed to them. For this reason, Cesare Vasoli believed that the syncretic fondness for the ancient and esoteric could not fail to produce disturbingly heterodox implications.[114]

Into this syncretic approach to antiquity we can securely place Achille Bocchi. He interwove the strands of Pythagoreanism, Platonism, and Hermeticism and mixed his pagan gods – Egyptian Harpocrates, Greek Hermes, Gallic Hercules, and Roman Janus. As a syncretist, however, his loosely structured work stressed moral rather than theological teaching, thus diffusing the potential for conflict with the institution of the Roman Church. Bocchi classified his symbols but did not systematize them. Yet he was acquainted with such systems, because the major syncretic works of his time, from Pico and Ficino to Giorgio and Steuco, were available in print. Without leaving Bologna, Bocchi could have encountered any or all of the following syncretists: Erasmus in 1506; Agrippa of Nettesheim, around 1507 to 1510 and in 1530; Agostino Steuco, around 1518 to 1525, 1530, and 1548; Giulio Camillo Delminio, writing from Bologna in 1519, 1522, 1526, and 1530; and Piero Valeriano in 1528.[115] In his list of acknowledgments (sigs. A2r–A3v), Bocchi presented only ancient syncretists, among them Varro, Macrobius, Cornelius Labeo, and Martianus Capella, whose *De Nuptiis Philologiae et Mercurii* drew on lost works by Varro and Labeo and whose scholarly syntheses found a sympathetic reader in Bocchi.[116]

Most of the major syncretists just mentioned functioned outside the universities. Within the universities, syncretic and arcane studies tended to be the province of faculties of rhetoric and poetics. This was very much the case with Bologna's first

syncretist of note, Galeotto Marzio, who was trained in philosophy, astronomy, medicine, and letters and who taught rhetoric and poetics at the Studio from 1463 to 1465 and again from 1473 to 1477. Marzio's interest in the ancient Hebrew foundations of learning, in free will and predestination, and in magic and alchemy led to a charge of heresy against him, and he served a prison term in Venice after 1477.[117] By the early sixteenth century, hieroglyphics and Pythagorean *symbola* (obscure maxims attributed to Pythagoras) had been interpreted in lectures and commentaries at the Studio by Filippo Beroaldo the Elder, whose lectures Bocchi probably attended, and by Giovanni Baptista Pio, whom Bocchi considered his major teacher.[118] Beroaldo had known Pico della Mirandola and had developed an interest in Florentine Neoplatonism that he transmitted to his followers. Hieroglyphics also played an important role in the circle of Giovanni Antonio Flaminio, Leandro Alberti, Giovanni Filoteo Achillini, and Bocchi: Their friend, and Bocchi's colleague, Filippo Fasanini (d. 1531), published a Latin version of Horapollo's *Hieroglyphica* without illustrations in 1517. At the end of the translation appeared his "Declaratio Sacrarum Litterarum" in which Fasanini described hieroglyphs as "aenigmaticaque ac symbolicae scalpturae," which Renaissance scholars could apply to their epistles for secrecy and to their decorative schemes for pleasure.[119]

Despite Bocchi's close association with Fasanini and Valeriano, his own hieroglyphs in Symbols I and CXLVII were borrowed directly from Francesco Colonna's 1499 *Hypnerotomachia Poliphili,* which Fasanini and Alberti also admired (Figures 2, 3, and 4).[120] Bocchi's Pythagorean *symbola* were provided with moral interpretations in Symbols XXVI, XXVII, and XXXII, and he also employed Pythagorean geometric symbolism (LXXVI and CXXVI) and the *Monas,* or primal One (LXIIII, CXXXII, and CXXXIIII). Hermetic allusions devolve largely around Mercury-Hermes as silencing agent of outward speech (LXIIII and LXXXV).[121] For the Cabala there is but a limited role, most visible in the seven-branched candlestick of Symbol LXIIII. Bocchi's sources were probably secondary ones, because the Zohar was not published until 1558, but here too there is evidence that the Cabala was being discussed by Bocchi's friends by 1513.[122] Whether Bocchi's projected new collection of symbols (not extant) was to have explored the Cabala in greater depth is not certain; he did refer to this new work as comprising "cabalistic and theological symbols founded on Sacred Scriptures" in a letter dated June 6, 1556, and he listed it in his will of July 14, 1556, as "libros epigramatum cum Symbolis cabalisticis."[123] Given the repressive climate under Paul IV, it is not surprising that no trace of a new collection of symbols remains.[124]

Although many of Bocchi's emblems are obscure and learned, relatively few of them are devoted specifically to the more esoteric forms of syncretism. He even adds the caution to Symbol XCVIII, which is illustrated by a copy of Raphael's *Transfiguration:* ARCANA QVAERENS CVRIOSVS, PERIT (The curious person, in seeking for secret truths, perishes). There is no praise for the Jews, no "Deus Socrates," and no Moses/Janus. The frequent references to *Mens* (Divine Mind) and *Sapientia* (Wisdom), however, attest to Bocchi's belief in a single, ancient wisdom. The heavens sometimes belong to the pagan gods (VIII and LXXXIX) and sometimes to the Christian God (CXXXV). Bocchi's syncretism does at times link Christian and pagan, most notably in Symbols LXXVII and LXXIX, dedicated to Roberto

Magio and Cardinal Pole respectively, in which Ganymede represents the mystically rapt mind. Such humanistic syncretism was one type of "error" inquisitorial correctors deleted from suspect texts.[125] Bocchi's text apparently was not considered suspicious enough to warrant correction on minor points of syncretism and language.

### Philosophy and the Religious Climate

Whereas the range of philological and rhetorical studies at the Studio expanded, the philosophical framework within which they were undertaken did not. Although there were variations from place to place in the sixteenth century, according to Charles B. Schmitt, "the basic framework remained the Aristotelian one which had been forged in the medieval universities," because the century "could in no way produce a comprehensive alternative system to replace the established one." Schmitt continued: "What did happen, however, was that a syncretic approach was developed by a number of philosophers of the Renaissance, and we find non-Aristotelian doctrine being absorbed increasingly into commentaries and textbooks."[126]

In fact, the increasing syncretic content of university philosophy courses that Schmitt discussed is a direct result of the collision between the Averroistic Aristotelianism of the Bologna-Padua school of the beginning of the sixteenth century and the growing theological conservatism. The first and most noted of these philosophers taught in the studios of both Padua and Bologna: Alessandro Achillini, who died in Bologna in 1512, was the brother of Bocchi's friend Giovanni Filoteo Achillini; and Pietro Pomponazzi, who was at Bologna from 1512 until his death in 1525, could number the finest minds and most notable public figures of his time as pupils.[127] Bocchi's closest friends in the Faculty of Philosophy were Ludovico Boccadiferro, who taught a modified Averroism (Brucker classified him as a syncretist) most of the years between 1515 and 1545, and Antonio Bernardi of Mirandola, who followed a similar pattern of "safe" Averroism.[128]

As a rule, the Aristotle of the rhetoricians was by tradition the moral philosopher of the *Nicomachean Ethics* as interpreted by Thomas Aquinas, but scholars, especially those with solid training in philosophy, reflected some of the trends found among the philosophers and showed the greatest range of interests around 1500. Antonio Codro Urceo found in his Aristotle the source of a nominalistic and natural philosophy basic to the study of Greek texts in mathematics and the sciences.[129] G. B. Pio's scholastic Aristotle was the yardstick against which every text had to be measured. This was particularly true of the *De Rerum Natura* commentary in which Pio countered Lucretius' Epicureanism with Aristotle, Plato, and nominalist and patristic sources.[130] Beroaldo the Elder, who espoused a Ficinian Neoplatonism, dismissed his colleagues as *philophastri* but privately communicated to a former teacher that he was moving from the Stoic camp into the Epicurean one.[131] The rhetoricians, especially around 1500, had also contributed to a Pythagorean revival, quieter and less easy to pinpoint than the Platonic rebirth but manifested in their interest in the life, travels, and cult of Pythagoras, in his cosmology (Urceo, and through Urceo, Copernicus), and in his mathematical ratios, a rethinking of which led to new work in mathematics, in music, in perspective, and in architecture.[132]

Academic philosophy, however, also could lead to "correction" by religious authorities. Achillini and Pomponazzi had works on the Index by 1590, and Gerolamo Cardano, who taught philosophy and medicine at Bologna from 1562 to 1570, was ordered by the Holy Office to abjure and to cease his writing and teaching as of February 18, 1571.[133] What led to reactions, both official and nonofficial, was the lively and widely followed debate over the nature and immortality of the soul. There is now no reason to consider Pomponazzi as the founder of a school of skepticism in Italy, according to Charles B. Schmitt and P. O. Kristeller.[134] Those who have labeled Pomponazzi and Cardano libertines (J.-Roger Charbonnel) and atheists (Don Cameron Allen) have relied uncritically on charges made by enemies of the philosophers.[135] In fact, one of those who attacked Pomponazzi's theories of the soul was Gianfrancesco Pico, nephew of Giovanni Pico della Mirandola and the first serious reader of the ancient Skeptic Sextus Empiricus in the Renaissance.[136] Another reader of Sextus who attacked Aristotelianism in general was Mario Nizolio, to whom Bocchi dedicated an emblem, and Bocchi himself names "Sextus philosophus" as an authority in the *Symbolicae Quaestiones* (sig. A4v).[137]

Although some theologians, including Cardinal Cajetan, defended their philosophy teachers, others condemned Averroist theories of the soul. Chief among these was Cardinal Egidio da Viterbo, a pupil of the Averroist Agostino Nifo but one whose own philosophical position was based on Platonic and Cabalistic syncretism. By 1509 the cardinal had accused Pomponazzi of impiety; in 1513 he played a major role at the Fifth Lateran Council, which prohibited the teaching of any philosophy inimical to Roman Catholic doctrine and recommended a program of censorship that was later put into place as the Tridentine Index. These proclamations were issued in the bull "Apostolici regiminis," which was signed by Pope Leo X, Egidio da Viterbo, Cardinal Cajetan (Tommaso del Vio), Gianfrancesco Pico, and others.[138]

The Lateran Council's pronouncements had a major impact on what could be said about the soul by both Aristotelians and Platonists, but it in no way quelled the *anima* debates of the first half of the century. Pomponazzi said he would accept the Council's views as *veritas*, but in a letter he admitted his perplexity in adjusting these doctrines to the Averroistic philosophy he felt he could not abandon: "'Alius ego fui dubius et perplexus de hac difficultate'" (I was another one of those who were uncertain and perplexed about this difficulty).[139]

Bocchi's philosopher friends Lodovico Boccadiferro and Antonio Bernardi demonstrate the accommodations Aristotelians were forced to make after 1513. The former commented on Aristotle at length in a theologically safe manner but did not publish his *Quaestio de immortalitate animae* or his lectures on *De anima* (published posthumously in Venice in 1566) in which he tried, unsuccessfully, to work out problems raised by the previous generation.[140] Bernardi, to whom Bocchi dedicated Symbol LXII, commented extensively on Aristotle and attacked Pomponazzi's treatment of the soul; he asserted the demonstrability of the intellective soul's immortality by both reason and faith.[141] Bocchi's teacher, Giovanni Battista Pio, had already approached the topic of the soul in his Lucretius commentary, which criticized a frequently cited source, Duns Scotus, for an unconvincingly weak proof of the soul, but Pio did rely on the Scot for his theory that the immortality of the soul is susceptible only to probable proofs.[142] In addition, Bocchi would have had

access to a number of other works on the soul, including Gianfrancesco Pico's *De animae immortalitate digressio* (Bologna, 1523), an attack on Averroism, and Giovambattista Fantuzzi's *Quaestio de anima,* published in 1526 in Bologna by Cinzio Achillini, younger brother of Alessandro and Giovanni Filoteo Achillini.[143]

The *Symbolicae Quaestiones* of Bocchi contains many general references to the soul, always avoiding such dangerous topics as the Averroistic inability to prove the existence of the soul by reason or the Platonic world soul or the Pythagorean transmigration of souls. Bocchi does not fail to take a stand in the *anima* debates, however, in his Symbol CXXXX, dedicated to Cesare Cataneo.[144] Above the engraving, which illustrates God infusing the divine breath into a terrestrial globe as though blowing a glass ball or a soap bubble through a pipe, is the motto ΕΝΤΕΛΕΧΙΑ ΨΥΧΗ (ENTELECHIA PSYCHE, or perfection, or actualization, of soul). According to Bocchi, the soul is created by God out of nothing and is not made of matter; it is eternal; its nature is hidden from humanity; and it is perfect and in perpetual motion.

Several specific controversies are alluded to here by Bocchi. First, the argument about the soul created out of nothing is the Christian's counter to the Aristotelian teaching that nothing can be created from nothing. Bocchi, although he must have followed other sources more closely, had read the treatise *De Nichilo* of Charles de Bovelles, because Symbol CXXXX's engraving is an adaptation of Bovelles's illustration at the beginning of *De Nichilo* (Figures 5 and 6).[145] Another context was the philological debate raging in the late fifteenth century over Cicero's use of *endelechia* (continuous motion) instead of the Aristotelian *entelechia* (perfect actualization) in describing the soul in the *Tusculanes Quaestiones* (Disp. II, 15, 35). Filelfo and Greeks of Byzantine extraction had declared this an error on the part of Cicero, whereas Poliziano had defended it (*Centuria prima,* Cap. I) as a deliberate choice made by Cicero in order to fuse the Aristotelian to the Platonic conception of soul as continual motion in the *Phaedo.*[146] In Bocchi's syncretic philosophy, the soul is both perfect ("haec perfectio summa," l. 24) and endowed with everlasting motion ("ipsa motu sempiterno praedita," l. 19). Although Bocchi could not develop proofs for his theory of the soul in twenty-five lines of verse, his personal reconciliation of Aristotle and Plato, of Filelfo and Poliziano, and also of the knowable (divine origin) and not-knowable, fused rational and antirational approaches to philosophy. This Aristotelian/Platonic mix was a form of syncretic philosophy widely practiced in northern Italian academies, especially in Florence and Padua and evidently Bologna as well – a philosophy distinct from that taught in the universities but disseminated to a wide public eager for culture.[147]

## The Question of Dissimulation

Finally, we return to the question of whether Bocchi's symbols can be read in the light of Nicodemism (dissimulation for religious purposes). In discussions of Nicodemism, the terms "simulation" and "dissimulation" were often used interchangeably. "Simulation" tended to mean "hypocrisy," as in a 1554 letter by Giuseppe Pallavicino ("O falsa religione di questi simulati pietosi huomini!" O false religion of those people of simulated piety!) and in a discussion of hypocrisy in the

1544 *Ricordi* of Sabba Castiglione ("la simulata santità è una doppia iniquità"; simulated holiness is a double iniquity).[148] "Dissimulation" usually implied two conflicting sets of views, one superimposed over another rather than over something lacking. Early in the sixteenth century, dissimulation covered a wide range of political and social behavior, often not in a pejorative sense, as in Baldassare Castiglione's comment on how a woman might, if too heavy or too thin, too dark or too pale, "aiutarsi con gli abiti, ma dissimulatamente più che sia possibile" (help herself with her clothing, but as discreetly as possible).[149] It was, furthermore, the Latin rhetorical term for irony, which Cicero defined as "saying one thing and meaning another."[150] Bocchi's early poems contain one occurrence of the term "dissimulation" in his "De Leone X Pont. Opt. Max. Rxᵐᵉ Ac Illvs. Ivlio Medice Car.": "Vix graii... poterant dissimulare patres" (Only with difficulty were the Greek fathers able to dissimulate).[151] Later, he used the term warily in a letter to Romolo Amaseo dated March 4, 1547: "... temetsi ab ipsis multos quoque timeri sit necesse quod tamen ipsi dissimulant" (even if it is necessary that many people be feared by them because they themselves dissimulate).[152]

In the first decades of the century, "dissimulation" often meant prudence, as, for example, in the *Ricordi* of Francesco Guicciardini: "E grandississima prudenza e da molti poco osservata, sapere dissimulare le male satisfazione che hai di altri..." (It is the greatest prudence, and little observed by many people, to know how to dissimulate the lack of approval you have for others).[153] Dissimulation as a prudent option for the modest person was suggested by Giovanni Pontano in his *De Sermone* (Liber VI, 4, 2).[154] Pontano's pupil Antonio de Ferrari, however, condemned all simulation and dissimulation in his "Dell' ipocrisia."[155] Galeazzo Florimonte, a friend from Bocchi's early years (before 1525), followed Aristotle in condemning irony and dissimulation as vicious extremes at the opposite end of the spectrum from boastfulness.[156] By 1554 Sabba Castiglione was employing "dissimulation" only in the context of hypocrisy, but he did use another term much favored by Baldassare Castiglione – "accomodarsi" – claiming that it is not against the *honore* of God or the soul to accommodate oneself to the times ("Ricordo LXXIIII. Cerca l'accommodarse [sic] ai tempi, ai lvoghi, et alle persone").[157] Bocchi, although he avoided the now risky term "dissimulation" in 1555, except for "simultates" (dissimulators) in Symbol CXXIIII and "dissimulem" in CXLIIII, did not adopt a Counter-Reformation language of submission and obedience, as the accommodating Sabba did, but continued in a traditionally humanist style.

With the advent of Northern Reform movements, the term "dissimulation" quickly and increasingly took on theological meaning. Renaissance debate on religious dissimulation was opened in 1512 by the publication of the Pauline commentary of Jacques Lefèvre d'Etaples. Erasmus located further patristic sources defending simulation in his *Novum Instrumentum,* which drew fire from Ulrich von Hutten and Otto Brunfels in 1524. Brunfels, by 1527, had changed his stance to one favoring dissimulation in his *Pandectae,* according to Carlo Ginzburg, who saw an organized movement of dissembling spiritualism.[158] By 1530, Erasmus defended the right of deliberate deception in his *Adversus mendacum admonitio.* The pattern of these defenses of dissimulation, argues Albano Biondi, is linked to the Stoic concept of *adiaphora,* an indifference neither good nor bad in itself.[159] Attacks on simulation

43

and dissimulation came quickly, however, from Luther, who called Erasmus a fleeing Proteus and an Epicurean (1524), and from Calvin, who coined the term "Nicodemite" (1543) to snipe at the well-educated French and Italians (the "notaries") who had accepted the new faith but were too timid to speak out. Calvin's numerous tirades against simulation, beginning in 1543, included the Nicodemites and the more dangerous libertines (Epicureans) and "Lucianic" atheists as well.[160]

The pro-Nicodemite debaters in the North generally adopted the forums of letter and dialogue.[161] In Italy, by the 1530s, the topic of caution in religion as prudent policy turned up in epistles from Jacopo Sadoleto to Aonio Paleario and from Celio Calcagnini to Pellegrino Morato, both urging their recipients to stay away from the perilous waters of dogma.[162] The question of Camillo Renato's unusually candid discussion of heretical ideas in his *Apologia* arose during the Bologna 1541 trial of Fra Giulio Della Rovere (Giulio da Milano), who testified that he had received a letter from Cipriano Quadrio that criticized Renato for *not* being a Nicodemite. Renato wanted to tempt God, Quadrio said, and he had too much faith in himself.[163] Among the *spirituali*, evidence of Nicodemism surfaced in a brief letter from Pole to Contarini dated October 26, 1541, in which Pole stated that he would respond to Contarini's request and to all future ones concerning divine matters as Plato had done, by "il mezo di una lettera viva, che di epistole scritte con inchausto" (by means of a living letter rather than letters written in ink); that is, he would rely on Beccadelli to communicate his messages orally.[164]

In Bologna in 1550, Anselmo Giaccarello printed one of the first direct responses of an Italian to Calvin's anti-Nicodemite polemics, the *Epistola di Giorgio Siculo servo fidele di Jesu Cristo alli cittadini di Riva di Trento contro il mendatio di Francesco Spiera et falsi dottrini de' Protestanti*. This work purported to be a vision of a future regenerated church whose adherents would, until its coming, conform with Roman Catholic practice as Nicodemites in good conscience.[165] A Benedictine friar, Siculo attacked Calvin's doctrine of predestination, but he also rejected most of the sacraments, the Trinity, immortality of the soul, the cult of the Virgin and saints, and the "idols" of Rome.[166] Siculo had brought his visionary teachings to Bologna in 1547, trying unsuccessfully to influence the Council of Trent. While in Bologna, he stayed at the Spanish College of the Studio, where he formed a study group. Siculo was arrested and hanged in Ferrara in May 1551 as an impenitent heretic.[167]

Nicodemism, as religious dissimulation, bore the seeds of its own defeat. When it produced silence instead of leadership, even moderates were critical. Thus, Seripando attacked Cardinal Pole, who left the Council of Trent in June 1546 just before they had begun to discuss justification by faith, as a man to whom taciturnity and silence ("'taciturnitate ac silentio'") were neither appropriate nor necessary.[168] Furthermore, repeated abjurations by the same individuals could lead only to heightened suspicion and frustration on the part of the inquisitors and to stiffer penalties. After 1550, according to Dermot Fenlon: "The result was that equivocation, which had been the hall-mark of the *spirituali* and Nicodemists, became little less reprehensible than formal heresy. Few people died, but more and more people began to come within the purview of enquiry and suspicion."[169] Nicodemism spread through Europe in the sixteenth century to Protestant societies as well as Catholic ones, among dissenting

natives and disillusioned exiles. At the same time, it shifted to become a reaction to both religious and political orthodoxy and repression.[170] We return to the point where "dissimulation" becomes the more appropriate term.

Clearly, Italian "Nicodemism" showed an awareness of Northern Protestant polemics. But was the Northern debate the source of Italian religious simulation, as Carlo Ginzburg believes, or did it fall into an already fermenting peninsular situation? If religious dissimulation was chiefly a response to religious repression just as political dissimulation was a response to political repression, as theorized by Albano Biondi and Carlos M. N. Eire, were there other kinds of dissimulation?[171] Eire's conclusion that Nicodemism represents an international and "amorphous" phenomenon and an "attitude rather than a movement" helps demolish the notion of a single line of development of religious dissimulation, although he subordinated the political aspects to the religious.[172] Biondi, as author of what Eire called a "very broad interpretation of the problem of simulation in the sixteenth century," also demonstrated the lack of unity of Nicodemism, but he did so within the more inclusive frame of a major ethical problem of the Renaissance.[173] This allowed him to tackle as a moral issue the justifications of intellectuals like Erasmus for concealing deep religious truths from the general populace for its own good.[174]

What is the relationship, if any, between dissimulation and syncretism? When confronted by the elitism of Evangelism, Ginzburg tended to see it as a Valdesian phenomenon; he failed to distinguish between an interior spirituality and the syncretists' pursuit of a veiled wisdom, deliberately concealed within poetic language. These represent two different types of search. Bocchi, as already mentioned, dedicated enough emblems to *spirituali* to suggest his interest in their views. His Symbol XXXII (Figure 7), however, with its motto SAT EXTAT IPSA VERITAS VANA ABSIT OSTENTATIO (The truth itself is sufficiently apparent; let us do away with vain ostentation), which lacks a dedicatee and cites Epictetus in an apparently secular context, inspired the following Ginzburg interpretation: "Non c'è dubbio che la 'verità' di cui parla il Bocchi sia la verità in senso religioso, la vera fede" (There is no doubt that the "truth" of which Bocchi speaks is the truth in a religious sense, the true faith).[175] The text implies a learned *veritas* of "docti viri," whose actions do not accord with what they know. The illustration of the symbol, in which shepherds see the great light of an incendiary device, alludes in a bizarre way to the Nativity. Is this Evangelism or is it "docta theologia"?

There is no doubt that the shocks of the sixteenth century produced dissimulating reactions, whether of an increased inner spirituality and search for an inner freedom, postulated by Salvatore Caponetto, or of an increasing spiritual indifference under the cloak of conformity, as Antonio Santosuosso sees it.[176] Peter Zagorin, in fact, calls the Renaissance "the Age of Dissimulation" because of the "widespread resort of intellectuals to dissimulation in response to repression by states and churches."[177] Yet a new interest in doubleness preceded the usually cited crises and grew out of humanism's heightened sensitivity to moral issues. What was once just the sin of hypocrisy had become problematized on all levels of society from the interpersonal to the political, the intellectual, and the spiritual. This is evident in a new consensus on what constituted prudent behavior.

## Dissimulation in the Arts and Letters

In the arts, myths and symbols of silence and dissimulation – Pythagorean neophytes in their two years of silence; the Egyptian god Harpocrates and the Roman goddess Angerona, both with their fingers to their lips; Janus the two-faced; Proteus the changeable – were all circulating by the beginning of the sixteenth century. A chronicler such as Gregorio Amaseo, father of Bocchi's colleague Romolo Amaseo, could comment about a town meeting he had attended in 1526 at which artisans and "traitors" began calling for the liberty of Udine: "Io fece de Harpocrates" (I acted like Harpocrates).[178] Doubleness and semblance were part of a carefully cultivated lifestyle described by Baldassare Castiglione, Giovanni Della Casa, and Francesco Guicciardini, whose *Ricordi* noted how people praised openness, but were more often praised for simulation.[179] Guicciardini here echoed Ariosto in *Orlando Furioso*, canto quarto, where Bradamante is advised to feign in all her dealings with the deceitful Brunello:

(1)  Quantunque il simular sia le più volte
     ripreso, e dia di mala mente indici,
     si trova pur in molte cose e molte
     aver fatti evidenti benefici,
     e danni e biasmi e morti aver già tolte;
     ché non conversiam, sempre con gli amici
     in questa assai più oscura che serena
     vita mortal, tutta d'invidia piena.

(2) . . . . . . . . . . . . . . . . . . . . . . . . . . . . . . . . . . .
     che de' far di Ruggier la bella amica
     con quel Brunel non puro e non sincero,
     ma tutto simulato e tutto finto,
     come la Maga le l'avea dipinto?

(3) Simula anch'ella; e così far conviene
     con esso lui di finzioni padre:

("Deceit is normally held in low esteem, pointing as it does to an evil disposition; there are, nonetheless, countless instances when it has reaped obvious benefits and deflected all manner of harm and ill report and mortal perils. For our conversation is not always with friends in this earthly life, dogged as it is by envy, and compounded of shadow far more than light. / ... [W]hat is fair Bradamant to do with Brunello, who is neither open nor honest but false through and through, just as the enchantress had described him? / She too dissimulated – perforce she had to with Brunello, the begetter of so many fictions.")[180]

Some of those later deemed heretics referred to the necessity of conducting all aspects of life under a mask. Marcello Palingenio Stellato in his *Zodiacus vitae* (1534), for example, advised: "... nam dissimulare tacendo, / Maxima plerumque est prudentia. Vivere nescit, / Ut bene vulgus ait, qui nescit dissimulare" (for to dissimulate by keeping silent is often the greatest form of prudence; one does not

know how to live who does not know how to dissimulate, as common opinion has it).[181] Palingenio here combined the theme of dissimulation as prudence and an adaptation of the proverb "Qui nescit dissimulare nescit regnare" (He who does not know how to dissemble does not know how to rule), which George Puttenham in his *Arte of English Poesie* (1589) attributed to "the great Emperor" (Tiberius).[182] Palingenio's astrological poem also charted the reign of the ambiguous and changeable gods Vertumnis and Proteus.[183] The *Zodiacus vitae,* which was numbered among the heretical works on the Index, had a wide circulation outside Italy. Nevertheless, the idea of a hidden life was apparently popular in Italy as well. Andrè Dudith, who had been in the circle around Reginald Pole in Padua in the 1530s and who may even then have been a Nicodemite, remaining in the Roman fold for decades until he returned to his native Hungary and expressed his Socinian faith, inscribed in the *Album Amicorum* of Abraham Ortelius: " – bene qui latuit, bene vixit ... / Ignotus moritur sibi" (he who lies well hidden, has lived well; [he who is too well known] dies unknown to himself), which alludes to Ovid's *Tristia* (III, iv, 25).[184] Dudith also quoted the familiar "Qui nescit dissimulare nescit regnare." Bocchi placed a Greek motto almost identical to the one in Dudith's autograph under the dedication to Romolo Amaseo in Symbol CXXXIII. Also, the motto over his engraving reads NEC VIXIT MALE QVI NATVS, MORIENSQ[UE] FEFELLIT (he has not lived badly who was born and died obscurely), which paraphrases Dudith's inscription. In the poem Bocchi announced a desire to detach himself – "latebras mihi quaerere, et antra / auia" (to seek for myself hiding places and trackless caves) – from the world of so many trials and risks.[185] There is no direct reference to dissimulation and no need to take this widely felt desire for a low profile in life as Nicodemism.

## Social and Political Dissimulation

Furthermore, the sixteenth century witnessed the development of politically sanctioned forms of doubleness. Social events, such as entries of famous persons into cities, were staged to mask an often bitter and unpalatable reality. For example, when Pope Julius II entered Bologna in 1506 as a conqueror, he threw gold coins to the people, a privilege reserved by Roman law for emperors, in order to gain the favor of the populace and to assert his own status.[186] The many entries into Italian cities by Charles V all stressed *romanitas* and the role of Charles as a new founder to the point that entry routes either bypassed or painted "Roman" features over traditional medieval structures.[187] The coronation of Charles V by Pope Clement VII in Bologna, February 22 to 24, 1530, which was staged as the apotheosis of peace, was in reality an attempt "to secure the legality of the imperial title by reproducing Rome in Bologna, down to wooden replicas of Roman chapels ... erected in S. Petronio," according to Frederick Hartt.[188] Symbols had become stage props and cities the theater of illusion.[189] Describing a Rome still in ruins and tense with the presence of forty-five hundred troops in April 1536, Paolo Giovio wrote: " 'Noi aspettiamo qui in pubblica letitia et privata luctu la sua Cesarea Maestà.' "[190]

Life at court required dissimulation not only by the courtier but by the prince as well. It was an advantage to the prince to be shrouded in secrecy and presented to

the people as heir to an innate, occulted wisdom.[191] To Nancy Struever, Guicciardini best introduces us to the court's ambiance: "The *Ricordi* stress not only the web of dissimulation which invests courtly activity, but insist on the opacity of the court to civic framework, of the palace to the forum: 'often there is a dense cloud or a thick wall between the palace and the market place that the human eye is unable to penetrate' (141)."[192] As in other areas of society, direct references to dissimulation in any positive sense disappear from courtly writing toward the middle of the sixteenth century. Thus, Giovanni della Casa speaks of *discrezione* in his *Galateo;* rarely does he use *prudenza* and never *dissimulazione.*[193]

The cloaking of the prince in myth and esoteric wisdom is echoed to some extent in the preoccupation with facades, especially in the semi-public world of the academy. Given the fascination with Roman architecture and, especially, with the writings of Vitruvius among intellectuals of the early sixteenth century, the move from public facades and ceremony to private symbolic facades required only a short step. There was no question about symbolic meaning if an idealized version of a facade, such as the engravings of the Palazzo Bocchi, begun in 1545, did not correspond very closely to the building as it actually stood.[194] Bocchi was, in fact, praised for creating a symbol of a perfect academy by both Giovanni Battista Pigna and Lilio Gregorio Giraldi.[195] Nor was there a great distance between a facade that represented an ideal function and one that concealed a potential disfunction with the social fabric, according to critics. The Accademia Veneziana (della Fama), which opened in 1557 in the magnificent palazzo of Federico Badoer, was decorated to represent an encyclopedia of universal knowledge, much influenced by Giulio Camillo's Memory Theater.[196] Badoer's academy was suppressed by Venetian authorities in 1561, and he was arrested on charges of subversion, financial mismanagement, and possible heresy.[197] Perhaps it was the Badoer case that suggested to twentieth-century critics that suspicion might be transferred to Bocchi's academy, the Bocchiana (or Hermathena), even though the largely political infractions of the Venetian academy are unrelated to recent questions about religious dissidence in the Bolognese academy. Very little is known of the activities of the Bolognese academy's members, although there is a close relationship between the academy and the Palazzo Bocchi facade and Bocchi's book. As Adalgisa Lugli perceptively observed, the facade is the frontispiece – originally an architectural term – of the *Symbolicae Quaestiones.*[198] This facade,. as will be demonstrated in Chapter 7, opens up the text rather than effacing it or creating a sense of doubleness.

## Conclusion

Bocchi can be placed in the center of the mythological, Pythagorean, Hermetic, syncretic, and playful modes of concealed wisdom current by the early sixteenth century. These are all exemplified by the *Symbolicae Quaestiones.* Bocchi can be located at least on the periphery of social, political, and religious dissimulation as well. He took part in civic life, looked to courts for patronage, and was acquainted with persons and texts that fell under suspicion of heresy. The paradoxes and ambiguities, the doctrinal vagueness, the many allusions in his symbols to silence, the references to veiled speech, and the "doubleness" of an abstemious private life

(XXVII) as opposed to a life of magnificent public roles (CXLV, CXVIII) all point to a Bocchi clearly within a tradition in which dissimulation has become a prudent style of life.

Historians and art historians have interpreted Bocchi's dissimulation as Nicodemism, that is, as a specifically religious phenomenon. I cannot justify using this narrower term for Bocchi. There is no convincing evidence of heresy arising from his associations in Bologna, and there are no clear expressions of sectarian doctrine in the *Symbolicae Quaestiones*. No scholar has worked out a way to distinguish between symptoms of Nicodemism and those of other forms of dissimulation. For the same reasons, it is possible to reject the charge of proselytizing because some degree of dogma would have to be expressed in the text in order to create converts. Again, religious propaganda, even when restricted to a "noncontroversial" form,[199] is very difficult to locate unless one can find symbols of Bocchi used in a specifically theological context by someone close to him to prove the existence of adepts. For Bocchi's theological impact, there is only an undated manuscript by a Franciscan priest, Giovanni Antonio Delfino, which commented at length on the theological nature of true pleasure as exemplified by Silenus Alcibiadis in Bocchi's Symbol X.[200] Bocchi himself made relatively few open statements of deep religiosity, most notably in his Symbol CXXXIII, dedicated to Romolo Amaseo, which contains a brief credo: "Vni igitur, veroque Deo seruire, nec vlli / Praeterea statuo. est etenim verus Deus vnus" (Therefore, I propose to serve the only true God, and no other, because He is the one true God). He insisted in his Symbol I that his doctrine was correct. This is as much as one can expect in a secular context. Indeed, in the confused, fluctuating mix of religious, social, and philosophical ideas at the midpoint of the century in Italy, as Rotondò reminded us, coherent systems of doctrine were rarely manifested.[201]

It is what Bocchi does *not* say about his religion that has made him appear to have an affinity with such mystical and indifferent (in the theological sense) heretics as Giorgio Siculo and Camillo Renato. Bocchi's predicament with both the suspicious minds of his own time and the critics of today lies in the problem of secrecy, which Francis Bacon dissected in his essay "Of Simulation and Dissimulation."[202] Bacon first described the types of dissimulation:

> There be three degrees of this hiding and veiling of a man's self. The first, closeness, reservation, and secrecy; when a man leaveth himself without observation, or without hold to be taken, what he is. The second, dissimulation, in the negative; when a man lets fall signs and arguments, that he is not that he is. And the third, simulation, in the affirmative; when a man industriously and expressly feigns and pretends to be that he is not.[203]

The first of these types, seemly, moral, and discreet, invites confessions; it also rouses curiosity and prying that force the secretive person into dissimulation at times: "They will so beset a man with questions, and draw him on, and pick it out of him, that, without an absurd silence, he must shew an inclination one way; or if he do not, they will gather as much by his silence as by his speech." Simulation, practiced by the weak minded, is almost always culpable because "it depriveth a man of one of the most principal instruments for action, which is trust and belief." Bacon concluded: "The best composition and temperature is to have openness in fame and opinion;

secrecy in habit; dissimulation in seasonable use; and a power to feign, if there be no remedy" (19). Bocchi as a "close" man has invited scrutiny by retreating under his cloak of mystery (which Bacon considered more comely than "nakedness" of mind). Bocchi clearly avoided the use of the term "dissimulation" – now too closely associated with Nicodemism by Roman Catholics – in his maturity, yet his conduct reflected the prudent dissembling widely accepted by the moral philosophy of the early decades of the sixteenth century.

# The Scholar's Utopia:
# Bocchi's Projected Vision

Io son quei che trattando
per ben diritta ed infallibil via
e la riga, e lo squadro,
ed al mondo insegnando
a compor con misura e simmetria
edificio leggiadro,
stabil colonna al nome mio fondai,
Tempio immortale a la mia gloria alzai:
e fabricai più d'ogni marmo forte
di fragil carta l'Obelisco a Morte.
(Giovanni Battista Marino, "Vitruvio")[1]

By his early fifties, Bocchi was searching for a coherent framework within which to order his multiple roles of courtier, poet, historian, civic figure, head of a private school, university professor, and founder of an academy. Collectively, these undertakings imposed a heavy burden on a man who suffered at times from ill health, perhaps from recurrent malaria contacted in 1513 (see Chapter 1). Individually, each role contributed to the symbols that Bocchi created for his *Symbolicae Quaestiones*. In one way, this emblematic project was yet another undertaking competing for Bocchi's time and attention; in another, it was the culmination of Bocchi's drive to fulfill his academic, cultural, and social ambitions through a work that would display its creator as an ideal Renaissance figure. In this chapter, I examine the major roles that Bocchi filled in his mature years and his syncretic vision of a scholar's life.

### Achille Bocchi, Historian

The *Historiarum Bononiensium Libri XVII* was Bocchi's major civic contribution. Through his labors in Bolognese history, he hoped to synthesize the many earlier chronicles and histories of Bologna and produce, in an elegant Livian style, a work that would be a credit and an honor to the city. Bocchi dedicated the first manuscript

volume to Cardinal Legate Giulio de' Medici and to Governor Bernardo Rossi (Bernardus Rubrius) in 1517. The succeeding sixteen volumes appeared at uneven intervals until the last in 1551, carrying Bolognese history from its origins only to the year 1262. They bore dedications to the Senate and people of Bologna and to Leo X (Volume 1), Cardinal Innocentio Cibo (4), Governor Francesco Guicciardini (9 and 10), Cardinal Guido Ascanio Sforza (13), Cardinal Giovanni Morone (16), and others.[2] Bocchi had hoped that the city would relieve him of his public teaching duties so that he could devote more time to the history and because he had been granted a pension of one hundred gold ducats a year by Clement VII to enable him to write. The money, however, was to come out of Bologna's, not Clement's, treasury, and Bocchi was forced to continue his public lectures as well as his private teaching and the history by civic leaders critical of the slowness of his work.[3]

Bocchi carried on a tradition of humanist local history that first appeared for Bologna in Niccolò Perotti's letter to Giovanni Guidotti entitled *De Bononiae origine* (or, *De Civitate Bononiae*) and was developed by Giovanni Garzoni into a "formally impeccable humanist commentary, one that recognized the continuing vitality of Bologna as a community of citizens," according to Eric Cochrane.[4] Like Livy's history of Rome, also the investment of a lifetime, Bocchi aimed at a literary product first; he accepted sources uncritically and used them without always crediting the postantique writers.[5] Unlike Livy, however, he filled some sections with minute and voluminous detail, whereas in others, where sources were limited, he sketched in material not essentially changed from the medieval chronicles.[6] Bocchi's first volume began with the Deluge and presented as fact the myths of the foundation of Etruscan "Felsina." He mentioned almost no antiquities or inscriptions for the classical period, but this volume, appeared, after all, in 1517, well before such auxiliary information was commonly to be found in histories.[7] To Cochrane, Bocchi's history represents a failure "because the author tried to do too much – namely, to include every detail he could find in every chronicle, history, or archival document that had anything to do with Bologna." Cochrane continued: "And it failed because, in the absence of a thesis to sustain or a lesson to illustrate, he lacked the only criteria provided by humanism for emphasis and selection."[8] Despite the confused accumulation of detail, Bocchi's history, according to Gisela Ravera Aira's study of it, demonstrated a growing critical judgment in the later volumes.[9]

Bocchi did provide what many of his fellow Bolognese wanted from a local history: elegance and ancestral records. Thus, in a proem dated 1540, Leandro Alberti described him as a man of singular erudition who "col suo elega*n*te stile, resucitare faccia le cose della Città, si per beneficio de uiuenti, come per loro delettatione, leggendo l'opere fatte dalli suoi auoli" (with his elegant style, makes the events of the City revive, as much for the benefit of the living, reading about the deeds of their ancestors, as for their pleasure).[10] Further, there are the comments of Pietro Aretino in a letter dated May 15, 1538, to Messer Francesco de l'Arme (of a Bolognese family):

> Dovrebbe il mio cavalier Bucchi farne menzione negli *Annali,* che dite che fa di Bologna. Sua Signoria ha tolto imprese da suo dosso, perchè altro che un bolognese non sarebbe atto a scrivere i gesti di questo conte e di quello.[11]

(My Cavalier Bocchi must make mention in his *Annals* of what they say happens in Bologna. His lordship has taken the burden on his back because no one other than a Bolognese would be able to write about the deeds of this count or that one.)

Nor did the descendents carp: Romeo Bocchi, grandson and namesake of Bocchi's cousin, also paid tribute to Bocchi's Livian eloquence and accurate reporting of the "vero dell'historie."[12] Bolognese authorities, however, when presented with the facts of the deeds of their ancestors, rarely allowed their publication. Bocchi's labors, like those of his predecessor Garzoni and his successors Carlo Sigonio and Cherubino Ghirardacci, as well as the latter parts of Leandro Alberti's vernacular history of Bologna, were never published.[13]

Bocchi had arranged with the Senate of Bologna in 1551 that his son Pirro (*Rotuli*, in Greek, 1543–51) would continue the *Historia Bononiensium* in the event that Achille should die before its completion.[14] In 1556, however, Pirro fled Bologna after being accused of complicity in a murder.[15] On hearing of his father's death in 1562, Pirro set to work from his new home in Hungary on a continuation, which he completed in June 1564 and sent to the Senate of Bologna. The Senate then requested that Pirro return to Bologna to continue the project if he wished to receive further remuneration. Pirro refused but kept up a correspondence that lasted until 1568, when the Senate officially cut off his stipend and commissioned Carlo Sigonio (1523–84) to continue the history.[16]

Despite Bocchi's deep involvement with Bologna's past, it was to general history he looked for the symbols. Those *exempla* he adapted from Greek and Roman history were chosen for their universal appeal. Specific incidents from early Bolognese history do not figure in the *Symbolicae Quaestiones,* in part because they would have been unfamiliar to a wider audience and perhaps also because Bocchi had become increasingly skeptical about the myths of founding. Events from contemporary Bologna, however, did become emblematized, more for their messages than their local content. For example, a Turkish tightrope walker who performed in the hall of the Podestà on April 11, 1547, was used to illustrate Aristotle's Golden Mean in Symbol. LVII. Bocchi also exploited the fork invented by a Bolognese cook, Bartolomeo Scappi, for its *hamo/amo* (hook/love) pun in Symbol XCVIII, which recounts the misfortune of a guest at a banquet who accidentally swallows broken tines.[17]

The iconography of a number of symbols alluded to ceremonial entries of powerful legates, prelates, and rulers. Whether Bocchi's role in these entries went beyond the inevitable academic processions to the planning of the iconographic programs is not known, but his representation of Patience (Symbol XLIX) and of "Bononia" (or, Bologna, Symbol CXV) match the description of those personifications as they appeared in the apparatus described by Pompeo Vizani for Julius III's entry into Bolognà on September 24, 1541.[18] Bocchi's Symbols CXLVIII and CXLIX, dedicated to Julius III and Cardinal Innocentio Montano, respectively, use elements of a fresco painted in 1550 by Nicolo dell'Abate on the exterior wall of the Palazzo Carbonesi in Bologna to honor Cardinal Legate Giovanni Maria del Monte's election to the papacy.[19] When Bocchi wished to be critical of modern ceremony,

he sought out appropriate examples from the past to soften the effect, as in Symbol CV in which money thrown to an Athenian audience to bribe it probably alludes to the practice begun by Pope Julius II, who during his 1506 entry into Bologna threw gold coins to the crowd as though he were a Roman emperor.[20]

### Bocchi as Educator

In the private area, Bocchi's chief occupation was his school. His appointment to a lectureship at the Studio qualified him to conduct private classes of university-level students. Not only did the *maestri* of rhetoric and poetics teach students matriculating in letters, but they also, by tradition, organized schools for both day and boarding pupils, schools that provided a full range of subjects on a preparatory level, bringing in assistants to help with less advanced students and with any subjects they did not feel qualified to teach themselves. An important factor in teachers' income was the number of fee-paying private students they had. For this reason, the ninety-some pupils Romolo Amaseo bragged of in 1525, even though many had followed him to Bologna from Padua, probably did represent a drain on the incomes of established teachers such as Pio and Bocchi.[21]

Bocchi termed his school an *academia* (Latin), a name that (like its Italian counterpart, *accademia*) makes it difficult to distinguish between its formal, private educational program as a school for the young and its conjoined function as a literary academy open to the public (to be discussed shortly). This is especially true of the first reference to the Academia Bocchiana in the publication of Paulus Abstemius's (Pál Bornemisza's) *In funere . . . Francisci Vardaei episcopi Transilvaniensis oratio*, published in "Bononiae, ex Academia Bochiana octavo Calendas Aprileis MDXXVI."[22] Giovanni Antonio Flaminio's school was referred to as an academy by Romolo Amaseo in a 1513 letter to Flaminio ("ex Academia tua").[23] The term "academy" seems to have been applied loosely in the first half of the sixteenth century. The references to "academy" and "gymnasium" in a dedicatory letter by Annibale Camillo to Veronica Gambara, dated 1516 but published in 1520, are to the literary gatherings at Gambara's villa at Correggio.[24] On the other hand, Christoph Scheurl referred to the Studio as "academiam Bononiam" in 1515, and the academy listed as one of the sights to be visited in Bologna in Márten Brenner's 1553 "Odoeporicum in perigrinatione Italia" may refer to Bocchi's school or it may refer to the Studio: "Bononia, civitas opulenta. Visenda: Academia . . ." (Bologna, an opulent city. Places worth visiting: the Academy, and so forth).[25]

In fact, academy/schools, with their double functions, existed elsewhere in Italy during this period. For example, Angelo Colocci and Giovanni Lascaris founded a Greek school in Rome by 1515, although the boarding school took place in Colocci's house and his academy met somewhere else.[26] Although Bocchi may have known of the Greek Academy as early as its planning stages and although he taught Greek in Bologna's Studio, his school was never called a "Greek" academy. It may have been closer to the Accademia Cricioli founded by Gian Giorgio Trissino in Vicenza at his suburban Villa Cricioli, which comprised both a literary academy and a school whose program was conducted by Bernardino Partenio for "'giovani letterati e studiosi animati dal diventare perfetti gentilhuomini'" (young men of letters and

students eager to become perfect gentlemen).[27] (Trissino is better remembered for sponsoring in his academy the training in letters and in the text of Vitruvius of a gifted young stonemason – Andrea Palladio.)[28] In Bologna, another academy/school was that of Camillo Paleotti, a "convitto" (residential school) of "cavalieri nobili" of all nations known as the "Accademia [or Collegio] degli Ardenti," or "Accademia del Porto," which hired *maestri* to teach the youths but was organized like a literary academy with a *capo* and a *priore* who rotated monthly.[29]

Several features of sixteenth-century private schools in Bologna stand out. First, there appears to have been a proliferation of schools, both in number and kind, in Bologna between 1530 and 1560: the academy/schools just discussed; the new colleges privately founded for the nobles of specific national origins (the Collegio Ungarico di Zagabia in 1537 and the Collegio Ferrerio for Piedmontese students in 1541);[30] and the school of martial arts founded by Achille Marozzo, a "maestro di scherma," by 1536.[31] Second, the goal of these schools was the training of gentlemen. Along with the books of manners by Baldassare and Sabba Castiglione and Giovanni Della Casa and the classes in martial arts, these schools helped produce the new breed of noble. Bocchi's school, by the 1550s at least, was no exception. Giovanni Battista Pigna, discussing Italian academies, reported: "In quella di Bologna, al Bocchio & al Corrado questi ha vna compagnia di giouanni veramente gentilhuomini . . ." (In that of Bologna, under Bocchi and Corrado, it has a company of youths who are truly gentlemen.)[32] According to Gian Paolo Brizzi, it was only the academy type of school that was transformed into the *seminaria nobilium* of the Counter-Reformation; of these residential colleges, he thinks, the Accademia degli Ardenti of Camillo Paleotti was the first.[33] It is more likely that Paleotti's academy was modeled on Bocchi's school and perhaps on other earlier schools termed "academies."

The curriculum of Bocchi's school is not known, but it probably resembled that studied by young "gentlemen" elsewhere. Camillo and Gabriele Paleotti (born in 1520 and 1522) had their early lessons with the tutor Nicolò Bargilesi and music with the composer Domenico Ferrobosco.[34] The Accademia degli Ardenti, which Camillo Paleotti founded in 1555, hired teachers of grammar, "Umanità," mathematics, singing, "il Suono" (instrumental music), dancing, and drawing.[35] Trissino's "perfect gentlemen" studied a variety of subjects and spent an hour every day on music.[36] The young Ercole Bottrigari (who was awarded the title *cavaliere* at the age of ten by Cardinal Legate Contarini in 1542) studied at home with tutors: F. Lucchino in Latin and Greek, Nicolò Simo (faculty of arithmetic, 1544–7, and astronomy, 1549–63) in mathematics, the architect G. Ranuzzi in perspective and architecture, and G. Spontano in music.[37] Some of the schools taught courses on the martial arts. In a letter on dueling written in 1564 (two years after Bocchi's death), Girolamo Muzio complained:

> In Bologna vi ha una Academia, dove fra le altre si trattano cose di cavalleria; e mi è stato fatto intendere che vi sono alcuni, i quali non istudiano in altro che in morder me, e come hanno parlato contra gli scritti del Muzio, par loro esser gran duellanti, cartellanti e giganti![38]

(In Bologna there is an academy where, among other things, chivalric studies are offered; and it has been conveyed to me that there are a few of them who

are studying only in order to murder me, and as they have attacked the writings of Muzio, it seems that they are great duelers, card players, and giants!)

Confidence in the power of the word had faded by midcentury; to control one's destiny one now needed noble status, social and aesthetic skills, and martial arts.

Bocchi's school provided some professional training. Only later in his life, however, did Bocchi himself teach jurisprudence as well as rhetoric.[39] The major work of this phase is his *Praelectiones In Libros De Legibvs M.T. Ciceronis Habitae Bononiae In Academia Bocchiana,* a series of lectures delivered before his academy in 1556 and extant in an elegant manuscript presentation copy dedicated in 1557 to Bishop Tommaso Contuberio, vice-legate and acting governor.[40] In addition, a manuscript containing miscellaneous lectures, all in the same hand (Bologna, Bibl. Univ., Cod. Lat. 350–10), includes a group signed "A. Bocchij," some of which have added in a different hand at the top, "Achillis Bocchii." The first and fourth (fols. 22r and 31r) are clearly Achille's; they are prelections with references to the *academia* and to Cardinal Alessandro Farnese and with quotations from Homer in Greek, and they are written in a polished Latin style. The other two, "In Prohemio Disputationis" (fol. 25r, dated 1547) and "Post Disputationem" (fol. 29), exhibit a dry legal style very different from their companions. Perhaps they are by Romeo Bocchi or possibly by an Alessandro Bocchi, whose name appears in a list of tribunes and *confalonari* in 1549.[41] A brief, undated letter to the Bolognese Senate requesting confirmation of a privilege to teach law "in casa" is signed "A. Jl. Bocchio." The "Jl." may refer to Achille's father Giulio, but the letter, unlike any other letter from Achille known to me, is in Italian and not identifiable as to style.[42]

### Bocchi and the Bolognese Academies

The 1540s witnessed a remarkable confluence of Bocchi's interests in architecture, iconography, poetry, and printing, all brought together by his organization of an academy. The standard biography by Rotondò dated the formation of the Academia Bocchiana (Academia Bocchiale, or Hermathena) as 1546, the outset of construction of the Palazzo Bocchi as 1546, the initial operation of the academy's printing press as 1555, and the publication of the *Symbolicae Quaestiones* as 1555.[43] These dates, however, do not accurately reflect the development of Bocchi's activities.

As background to an understanding of Bocchi's own academy, both Bocchi's early participation in academies and the development of academies in Bologna and elsewhere in Italy need to be examined. Bocchi was involved in academies from the beginning of his teaching years. As already mentioned, the term *academia* (Latin), or *accademia* (Italian), was used loosely in the early sixteenth century. What began as little more than sodalities meeting on a fairly regular basis, often in the *locus amoenus* of a country villa, gradually developed into full-fledged academies with their own rules, programs, and officers and, eventually, with their own (usually urban) quarters.[44] In Bologna, the process is seen in sodalities of the late fifteenth and early sixteenth centuries, including that of Bartolomeo Bianchini at his country villa Scornetta[45] and that of Bocchi's good friend Giovanni Filoteo Achillini, who founded the Accademia del Viridario in 1511. Achillini's academy met at the

Palazzina della Viola in its park just outside the city walls[46] and had its own *impresa* of a laurel plant and the motto E SPE IN SPEM.[47] It is possible that Achillini envisioned a printing press for his academy like the one that Angelo Colocci had in Rome or that he looked to the model of the Aldine Academy, which was associated with the Aldine Press in Venice; his youngest brother, Cinzio, between 1525 and 1527, published small editions of six works, most of them with fine frontispieces and figured texts.[48]

Certainly Bocchi also was experimenting with printing around the same time, as the funeral oration by Paulus Abstemius (Pál Bornemisza) published "ex Academia Bochiana" in 1526 attests.[49] It seems unlikely that Bocchi printed from a press at his school because another quarter of a century passed before any more Bocchi editions came out. Because Abstemius was a pupil of Bocchi, the "Academia Bocchiana" of this period was probably only a school and not a literary academy, or else the existence of a literary academy with that name was discontinuous.

Shortly before 1530, the poet Veronica Gambara of Correggio founded an academy (or perhaps just a literary circle) in her rented house in Bologna not only for local *letterati* but also for the numerous visitors to the city for the coronation of Charles V by Pope Clement VII (October 1529 to March 1530).[50] Among the Bolognese said to frequent this academy were Achille Bocchi and his friends Giovanni Filoteo Achillini, Filippo Fasanini, Alessandro Manzuoli, and Giovanni Gandolfi (a poet and teacher of rhetoric at the Studio before 1541).[51] After Veronica Gambara's departure from Bologna, either as a continuation of her circle or as a new academy altogether, the Accademia die Sonnacchiosi, with its motto SPERO AVANZAR CON LA VIGILIA IL SONNO (I hope to promote sleep with a night vigil) and *impresa* of a bear, was founded, around 1543 Lodovico Domenici thought.[52] It is more likely that the Sonnacchiosa represents a new academy, because 1543 was also the year in which Veronica Gambara was invited to become a member.[53] If it was a new academy, it was not the next one to emerge in Bologna.

Evidence of an academy in Bologna in the 1530s came from Bocchi himself. In February 1531, Francesco Guicciardini arrived in Bologna to serve as the city's only civilian governor until November 21, 1534.[54] These were difficult years for Bologna, but literary gatherings survived nonetheless. Later, in a 1538 letter to Guicciardini Bocchi reminded the former governor of the time when Guicciardini had read selections from his own history of Italy before the membership of "our academy" ("nostrae huius Academiae").[55] Whether the academy referred to was the Viridario (Achillini lived until 1536), the Sonnacchiosa, the Bocchiana, or some unrecorded group cannot be determined; whichever it was, Bocchi played an active role in it.

Of course, one's associations with academies were not necessarily limited to those in one's own city. Gaetano Giordani reported that Bocchi and his friend Alessandro Manzuoli were both members of the Vitruvian Academy of Rome,[56] although the existence of this academy remains problematic. Usually it is identified with Claudio Tolomei's Accademia della Virtù, which by 1542 had embarked on a serious study of the Vitruvian text, the only surviving Roman treatise on architecture.[57] Maria Rosa Franco Subri theorized that two separate Vitruvian academies existed: one, the Accademia della Virtù (studying Vitruvius from about 1541 on), and the other, an earlier academy of architecture, probably never formally organized.[58] The purpose

of the earlier association was to make accurate records of the buildings of ancient Rome.[59] The Tolomei academy also hoped to obtain drawings and measurements to illustrate specific buildings discussed in Vitruvius (and in general to protect the ruins), but textual study was its primary concern.[60] The two architectural associations shared some members, notably, Tolomei, Alessandro Manzuoli, Bernardino Maffei, and Marcello Cervino (to be Pope Marcellus in 1555), "ed altri," including perhaps Bocchi, who dedicated symbols to all four of them (Symbols LX to Cervino, LXXVII and XCVI to Maffei, XCIIII to Tolomei, and CXXVII to Manzuoli).[61]

But when might Bocchi have taken part in Vitruvian studies in Rome? Manzuoli was there at least briefly in 1534 and was linked to Tolomei's academy prior to 1543 by letters of Tolomei written in 1543 and 1547;[62] no such evidence appears for Bocchi. Whether the architect Jacopo Barozzi da Vignola, whose early biographers have him measuring ruins for the "Accademia d'Architettura" of Cervino, belonged is also uncertain; he and other young architects collecting data for the academy may not have had a membership in it, among the nobles, but belonged instead to their own guild with its similar name, the Congregazione di San Giuseppe al Pantheon, then called "dei Virtuosi."[63]

It is also possible that the "Vitruvian Academy" to which both Bocchi and Manzuoli belonged was not a Roman one. In Venice, Sebastiano Serlio, a disciple of Vitruvius from Bologna, held a school of architecture from at least 1537 until early in 1541.[64] Serlio's Venetian circle of friends included Pietro Aretino, Giulio Camillo Delminio, Francesco Giorgio (Zorzi), and Titian. His architectural pupil, Guillaume Philandrier (Filander), moved to Rome, joined Tolomei's Accademia del Virtù, and published a commentary on Vitruvius in Rome in 1544.[65] Serlio, although from a poor family and trained as a painter of perspective scenes, had made literary friends before leaving his native Bologna. It is likely that Bocchi and Manzuoli were among them; certainly their friend Giulio Camillo Delminio was. Camillo stayed with Serlio when the latter lay gravely ill in Venice in 1528, and to show his gratitude Serlio wrote a will leaving everything he had to Camillo.[66] Besides Camillo, who frequently traveled to follow his patron, Stefano Sauli, Serlio maintained other contacts with Bologna, which can be seen in his praise of persons of good judgment and "le salde dottrine del principe de l'architettura" (sound understanding of the principles of architecture) for "Bologna patria mia il Caualier Bocchio [e] il giudicioso M. Alessandro Manzolo."[67]

Whether the Venetian circle of Serlio formally supported Camillo's project to devise a program for a "memory theater," is not clear. Titian, however, provided designs for paintings for the project, and Serlio probably assisted with the construction of the wooden model. This model was completed by March 28, 1532, when Frison Viglius (Wigle d'Aytta) wrote the first of two letters to Erasmus describing the project and its founder Camillo – who was designated an *architect* and a former teacher.[68] Although Bocchi dedicated Symbol LXXXVIII to Camillo, he did not refer to a memory theater or to an academy of architecture.

Bocchi's Academia Bocchiana flourished in a fertile decade for academies, an efflorescence beginning in 1540 with the founding of the Accademia degli Umidi (Humydi) of Florence, the Accademia degli Infiammati of Padua, the Accademia degli Accesi of Reggio, and the Accademia degli Elevati in Ferrara, and by the next year,

the academies of the Argonauti (Casale di Monferrato) and the Sempiterni (Venice).[69] The Umidi was reorganized as the Accademia Fiorentina with the approval of Cosimo II dei Medici in 1541.[70] In Bologna, Bocchi's academy did not stand alone: the Accademia degli Affumati, founded by Gabriele Paleotti and Marco Thiene, functioned between October 1542 and June 1543, or perhaps longer;[71] and the Sonnacchiosi, as already mentioned, came into existence by 1543. In the next two decades there would be a succession of new academies: the Sizienti (or, dei Sitibondi) for law, founded by Celso Socino in 1551; the Animosi, begun in 1552 for the study of physics, mathematics, and medicine;[72] the Ardenti, founded by Camillo Paleotti in 1555;[73] the Gelati, founded by Melchiorre Zoppio in 1557;[74] the Conviviale of Francesco Bolognetti, founded around 1560; the Oziosi, which began meeting in the Vizani home in 1563; the Desiosi of lawyer Giovanni Battista Montalbani, founded in 1564; the Storditi, which flourished in 1564;[75] and even the Peregrini, which thrived between 1563 and 1575 in a Servite monastery.[76] About half of these academies had their *imprese* and mottoes recorded in an eighteenth-century Bolognese manuscript compiled by Abbot Andrea Verardini Prendiparti.[77] Of the academies formed by 1570, however, only the Gelati was still meeting in 1600.

The first solid evidence of the Academia Bocchiana's existence as a literary academy as distinct from a school appeared in the records of the German Nation of the Bolognese Studio when that student organization gave an honorary free membership to the young anti-Lutheran poet, Simon Lemnius, on the occasion of his acceptance of the laurel crown at Bocchi's academy in 1543.[78] Lemnius expressed his gratitude later in the dedication of his *Odysseae Homeri Libri XXIIII* (Basel, 1549): "'ob ingenium in nobilissimam Bochiorum equitum Bononiensium in Italia familiam ascitus Bononiaeque laureatus'" (accepted, on account of talent into the very noble household of the Bocchi, knights of Bologna, in Italy, and made a laureate at Bologna).[79] By 1543, Bocchi had ample opportunity to learn what other academies were doing through Benedetto Varchi, who had been among the first members of the Florentine Accademia degli Umidi, had fled to Padua in 1540, where he joined the Infiammati, and then had moved to Bologna to study with Ludovico Boccadiferro from 1541 to 1542.[80] Varchi, one suspects, would have joined any available academy in Bologna – and he clearly was on good terms with Bocchi, whom he called "beate Bocchi" in a poem.[81] Another member of the Infiammati, Alessandro Piccolomini, followed Varchi to Bologna in 1542 to study with Boccadiferro;[82] a lecture of Piccolomini's delivered before the Infiammati had already been published, probably at Varchi's behest, by Bartholomeo Bernardi and Marcantonio da Carpi in Bologna in July 1541.[83] The presence of Varchi and Piccolomini would have stimulated the formation of Bocchi's academy, if indeed it did not already exist by 1541.

Although some post-sixteenth-century scholars tended to call Bocchi's academy by the more colorful name derived from its *impresa* of the union of Hermes/Mercury and Athena, that is, "Hermathena," neither the first reference to his academy nor any subsequent ones I have found dating from Bocchi's lifetime refer to the organization as "Academia Hermathena." Letters from Bocchi in the early 1540s have not been located, but those to Romolo Amaseo after the latter's move to Rome (1546–9) refer to the building in progress as "Domus Academica" (Milan. Bibl. Ambros. D145 inf., fols. 6r and 10v, both from 1549) and the academy itself as

"Academica nostra" (fols. 12v and 14r, dated 1546 and 1547), "Farnesina Academia" (fol. 22r, 1548), and "Academia Bononiensia" (fol. 14r, 1547). In the same collection, there is an undated manuscript entitled "De Academia Bononiensia contituenda" (fols. 20v–21r). Although its title suggests an academy constitution, the manuscript is, in fact, a memorandum outlining the points that Bocchi wished Amaseo to make in Rome when appealing for funds for the Bolognese academy, and it largely concerned Bocchi's personal projects. Its readers do not learn anything about the academy's membership, frequency of meeting, or agenda. They do sense a fundamental ambivalence in Bocchi's effort on the one hand to provide *the* academy for Bologna and on the other to run an academy as an extension of his own work and as a showcase for his own writings. This ambivalence is reflected in Bocchi's shifting between the two names of "Academia Bononiensia" and "Academia Bocchiana."

By the mid-1550s, Bocchi usually called his academy the "Academia Bocchiana," as he does in the index to his 1555 *Symbolicae Quaestiones* (sig. D1r) and in the 1557 manuscript *Praelectiones In Libros De Legibvs M. T. Ciceronis,* formally delivered before the "Academia Bocchiana," or "Academia Bochia."[84] In addition, Giambattista Pigna alluded to the "Accademia Bocchiana" in his *I romanzi* in 1554 (100), and Anton Francesco Doni entered it as "Academia Bocchia" in *La Libraria* in 1557.[85] This uncertainty over the name of Bocchi's academy makes it especially difficult to determine whether unnamed Bolognese academies alluded to in sources near Bocchi have, in fact, to do with his academy rather than any other.[86]

For its formal organization, the Academia Bocchiana had, in addition to its sponsor, Bocchi, a rotating government by a *principe,* a typical feature of academies of this period. In 1554 or a little earlier, the *principe* was "il Calcagnino" (not the Ferrarese humanist Caelio Calcagnino but possibly his nephew Tommaso), succeeded by Alberico Longo until his death on July 13, 1555, and by Cesare Odone in 1556.[87] Honored guests were the patrons, including Cardinal Alessandro Farnese (Symbols LXIII, CIII, CIX, CX, CXXV), Stephano Saulio (Symbol CII), and probably Francesco Baiardo (Symbol CLI), or they were visitors to Bologna, as, for example, Michel de L'Hospital, Claude d'Urfé, and Johannes Hangest, who were delegates of François I and Henri II to the Council of Trent in 1547.[88] The membership included the young student-gentlemen as well as "uomini letterati."[89] (For a more complete listing of members, see the Appendix.) Doni admired both the leaders and the members of Bocchi's academy: "Questa ha principiato il dottissimo cavalieri, e fia una eterna e mirabile Academia, perciò che la sarà un ridotto di tutte le sorte virtù e sollevamento e aiuto ai virtuosi, ricetto e utillità" (This academy has initiated the most learned knights and will be an everlasting and marvelous academy, because it will be a gathering of all kinds of qualities both for the comfort and benefit of the talented people and for their refuge and profit).[90]

The purpose of the Academia Bocchiana, historians from the seventeenth century on insist, was to correct and edit texts for publication. A typical description reads as follows: "Accademia Bocchi, detta Ermatena, fu fondata l'anno 1546, de Achille Bocchi nel proprio Palazzo: era composta d'Uomini Letterati, i quali assistevano alla correzione dei libri, chi ivi si davano alle stampe, e molte belle edizioni si vedono stampate *in AEdibus Novae Accademiae Bocchianae*" (The Academy Bocchi, called Hermathena, was founded in 1546 by Achille Bocchi in his own home; it was

composed of literary men, who participated in the correction of books, which were printed there in many beautiful editions "at the press of the New Academy Bocchi").[91] Nevertheless, the only work to come forth labeled "In aedibus novae Academiae Bocchianae" (besides the Bornemisza funeral oration from the earlier press) was Bocchi's own *Symbolicae Quaestiones* in 1555. By 1556, Gavino Sambiguccio's *In Hermathenam Bocchiam interpretatio*, a lecture on Bocchi's Symbol CII, was published by Antonio Manuzio, a son of Aldo Manuzio active in Bologna between 1555 and 1557.[92] Yet engraved emblem illustrations for the *Symbolicae Quaestiones* were being produced as early as 1547 and glued to manuscript copies of emblems singly or in clusters, according to Bocchi's letters to Amaseo. Even the engravings probably were issued by some other press, because Bocchi's press would have been set for type and may have operated only in 1555 and early 1556 for the various printings of the *Symbolicae Quaestiones*.

The sponsorship of lectures appears to have been a major function of Bocchi's Academy. Unlike those of most other Italian academies, members of the Academia Bocchiana, under the leadership of university rhetoricians, delivered their lectures in Latin. This may have reduced its public audience to some extent but would not have seriously affected its size in a large community of teachers, students, clergy, and other professionals.[93] With such a professional membership, it is no accident that the one extant set of lectures delivered before the academy in 1556 and the several prelections by Bocchi existing in manuscript all treat legal texts from a literary point of view and in a style not found in traditional law courses. In one 1547 lecture studied by Rotondò, Bocchi specifically contrasted the intimate disputes of his academy with the "austerity" of his formal public teaching.[94] These legal lectures reflect not only the interests of many members of the academy but also the tremendous impact on the humanistic study of legal texts of Andrea Alciato. Alciato's brief tenure at the Studio of Bologna in 1538 and 1539 to 1542 may have coincided with the founding of the Academia Bocchiana and probably did coincide with the stirring of Bocchi's interest in emblem form as well.[95] To Bocchi, Alciato was the good friend to whom he dedicated Symbol XL, "Ad Andream Alciatvm Amicorvm Opt. / Lvce caret, pvlchri qvi cavssam nescit amoris" (To Andrea Alciato, best of friends. He is devoid of light who does not know why people love beauty).

Other than the publishing of Bocchi's *Symbolicae Quaestiones*, there is nothing to indicate the kind of collective scholarly venture common in midsixteenth-century academies (such as the Accademia della Virtù's methodical study of Vitruvius). Given Bocchi's interests, it is likely that architecture was one subject studied.[96] In its poetic activity, however, the Academia Bocchiana was typical. Members read their own work before the academy. Besides Bocchi, the poets reading probably included Alberico Longo, Giovani Battista Camozzi, and Tiresio Foscarari, whose *De conversio Paulii* Bocchi sent to Romolo Amaseo in 1547.[97] If Michel de L'Hospital had written his "De Fide Christiana" for Bocchi while in Bologna, which seems likely, he would have been invited to read it. Some younger neo-Latin poets who may have contributed were Johannes Sambucus, who later dedicated an emblem to Bocchi, and Sambucus's friend Petrus Lotichius Secundus, who wrote "Ad Bononiam Italiae Civitatem" in praise of Bocchi and of Bologna as a city friendly to the muses.[98] The academy bestowed the laurel crown upon at least two poets, Simon Lemnius

in 1543 and Achille Bocchi himself, as illustrated in Symbol CXLV with a poem by Alberico Longo (Figure 8). This honor would have involved the active cooperation of a representative (governor or legate) of papal power in Bologna.

Like other contemporary academies, the Bocchiana sponsored lectures commenting on individual poems.[99] The only two known written commentaries to survive both adopted emblems of Bocchi as a point of departure: Gavino Sambiguccio (Sambigucius) used Symbol CII in his *Hermathenam Bocchiam interpretatio* to condemn *ozio* – once praised by the early rural and suburban academies – as the ruination of the human body and mind.[100] The theme of *ozio,* or leisure, does not even arise in Symbol CII but was presumably introduced as an exhortation appropriate to an inaugural lecture opening a new season of academic activity. Giovanni Antonio Delfino's unpublished and undated *In Symbolvm Decimvm Achillis Bocchij Commentariolvs* proceeded word by word and phrase by phrase, laboriously expanding the themes evoked in the emblem.[101] Whereas Bocchi may have affected a certain modesty about commenting on his own symbols in public, his eagerness to explain his symbolism is evident in several of his letters to Romolo Amaseo; a 1548 letter to Amaseo, for example, includes a lengthy informal description and interpretation of a hanging lantern within an armillary sphere – the image of divinity of mind – in Symbol CXXXII, dedicated to Amaseo.[102]

Literary and other intellectual debates promoted contact between academies. The Academia Bocchiana, under the leadership of Alberico Longo, sided with Annibale Caro in his attacks on Lodovico Castelvetro from 1553 to 1555. Whether Bocchi himself took part in the affair is uncertain. Castelvetro, in Bologna in 1555 and on trial for contumacy growing out of accusations of heresy by Caro, soon found himself the object of rumors depicting him as the murderer of Alberico Longo – rumors that had probably been started by Caro – and was forced to flee, eventually to Switzerland.[103] Bocchi also played at least a minor role in the quarrel between Lodovico Ferrari and Niccolò Tartaglia over Tartaglia's unauthorized publication of the solution to the quadratic equation. Bocchi headed the list of four Bolognese citizens to receive a copy of Ferrari's *Primo Cartello.*[104] The selection of Bocchi may represent the serious study of some technical project, perhaps on architecture, undertaken by his academy, because other humanists listed as recipients of the *Cartelli* had all produced some work relevant to mathematics, such as a treatise on the sphere by Trifone Gabriele or on ancient weights and measurements by Andrea Alciato.[105]

Recreation was an important function of sixteenth-century academies. When we look for the lighter side of the Academia Bocchiana, however, we can find no evidence of the banquets, holiday and anniversary festivities, disputes on facetious topics, or other playful activity present in most Italian academies. Nor do we know if women attended academy functions.[106] Theatrical activities, such as the comedy performed publicly in 1543 by the Accademia degli Affumati under Gabriele Paleotti, also formed part of the occasional events sponsored by academies, but none are documented for the Academia Bocchiana.[107] Games, which were especially popular as a social activity in general, contributed to academic play. Again, we see individuals active in academies publishing and compiling instructions for games, and, again, we do not know whether the Academia Bocchiana hosted such games or whether Bocchi kept his play separate from his academy. Bocchi's friend Innocenzio

Ringhieri named him and "Il Amaseo" (perhaps Pompilio Amaseo) modern poets in his "Giuoco de Poeti" in 1551, and this may imply Bocchi's participation in Bolognese games.[108] Certainly, the games of the literate Bolognese echoed topics treated seriously in Bocchi's academy or in his *Symbolicae Quaestiones:* architecture (Ringhieri's "Giuoco del Palazio" and "Giuoco delle' opre gloriose"),[109] notable painters, especially Michelangelo (Ringhieri's "Giuoco della pittura"),[110] the labors of Hercules, a recurrent theme in Bocchi's emblems (Ringhieri's "Giuoco delle Vittorie d'Hercule"), *imprese* (Ringhieri's "Giuoco dello Scudo et dell'Impressa del Re, e della Reina Christianissimi di Francia"),[111] and Pythagorean mathematics (Ringhieri's "Giuoco de numeri," Benedetto Varchi's *Il giuoco di Pitagora,* and Ulisse Aldrovandi's *Tavola metodici dei giuochi*).[112]

## Bocchi and Architecture

The success of an academy depended in some measure upon its ability to accommodate a growing membership. Unless the academy had the good fortune to have a wealthy patron and meet in a princely house, it often faced being housed in a succession of rented rooms. Bocchi's literary academy may have shared its quarters with his school from its inception. It is possible that he tried the model of a country villa as *locus amoenus* for the academy, just as Trissino had done near Vicenza and Ficino before him at Careggi.[113] Leandro Alberti reported in 1543 that Bocchi's country property, the "Vado de Bucchi" (or, "Va de Bocchi") along the Savena River near Bologna, was "molto ristorato d'Achille, anche egli cavaliere e di prestante dottrina illustrato" (much restored by Achilles, knight and man of outstanding learning).[114] Such a location would not have facilitated regular weekly meetings and would have been vulnerable to the hostile troop movements troubling the province at frequent intervals in the first half of the sixteenth century. There may also have been a suburban location in the former Bentivoglio Palazzina della Viola, then just outside the city walls and said to have belonged to Giovanni Filoteo Achillini and later to a member of the Bocchi family, who sold it before 1540.[115]

In 1545, Bocchi's dream of a "domus academica" to house family, school, and literary academy seemed close to realization.[116] On July 28 of that year, a notarial document, "Achille Bucchi conventioni con Agostino Bolognotto," was signed to permit construction of the Palazzo Bocchi on an inherited property in Via Goito.[117] An engraving of the idealized elevation of the facade entitled "Orthographia Meridionalis Academiae Domus Bocchianae Bonon." appeared the same year (Figure 9).[118] A second document, however, "Concessio edificandi D. Achille Bocchio equiti," dated May 21, 1546, granted Bocchi's petition to cut from a neighboring wall space for his escarpment (the slanting basement wall) and "in formam decentiorem reedificare" (to rebuild in more suitable form).[119] The puzzling wording of this document signals a change in the appearance of the palazzo; it may mark a shift from the ornate facade of the engraving to the present form of the building, which has less ornamentation and fewer levels than originally specified.[120]

Although the documents for the Palazzo Bocchi do not name Vignola as the architect, some architectural historians accept the 1583 account of Egnazio Danti: "[Vignola] fece la casa del Bocchio, seguitando l'humore del padrone di essa"

(Vignola made the house of Bocchi, following the wishes of its master).[121] Vignola was working in Bologna at the time, and the "Tuscan" (Etruscan) style of the present Palazzo Bocchi resembles that of Vignola's Villa Giulia in Rome. However, the first contract of 1545 named Agostino Bolognotto as "Archittector [here, 'builder'] et lapicida," another man for stonework "alla rustica," and decoration to be furnished by Bocchi as the work progressed, "'seguitando l'humore del padrone di esse.'"[122] According to Giancarlo Roversi, it is not at all common to find the name of the owner of a building on so many of the documents specifying technical aspects of construction (such as the choice of a stone quarry).[123] We can theorize that Bocchi's "humor" governed not just the ornamentation but also the original design for the Palazzo Bocchi, as represented by the 1545 print, and that the second document marks the intervention or advice of a professional architect, perhaps Vignola, to correct a problem, improve the basic plan, or reduce the elaborate facade to a more severe style. Thus, Vignola, or possibly another architect, retained the escarped basement, the rustic portal, and the alternation of rounded and angular cornices over the windows of the third-floor *piano nobile,* all of these "Tuscan" features found in a number of Vignola's succeeding works.[124] Complicating the story is the modified facade engraving dated 1555, which flaunts more, not less, ornament than the previous one (Figure 10).

The prints of the facade, however, resemble much more closely the architectural theory and illustrations of the works of Sebastiano Serlio, the chief advocate of the "Tuscan" and "Rustic" styles in Italy, whose *Quattro libri d'architettura* was first published in 1551.[125] To begin with, Serlio recommended the rustic style for a middle class of dwelling suitable for *literati* and merchants.[126] The large cut stones (*bugne*) of the escarpment symbolize the palazzo's links to the Etruscan founding of Bologna in the remote past and to the Tuscan villas of some of Bocchi's present patrons.[127] Above the *piano nobile,* the 1545 engraving reverted to the Doric style, especially in the central top-floor loggia and the small templelike structure perched above it; these closely resemble details illustrated in Serlio's Doric Venetian palaces (Figure 11).[128] Serlio praised Florentine villas as "miste però di quella rustichezza, et delicatura," a mixture used judiciously by the ancients and suitable for moderns, especially for public buildings.[129] It is this mixture of Doric and Tuscan orders – a union of private and public styles – that must have offended the Bolognese sense of propriety, because the Doric floors were dropped from the final structure (Figure 12).[130]

One further affinity of the print with Serlio's work rests in the predilection for square buildings.[131] Bocchi's ideal palace is a cube topped by a small cubed "tempietto" and contains within its square ground-floor plan a square courtyard.[132] The cube symbolized stability as opposed to the round ball of Fortuna (see Symbols XXIII and CXI); it evoked the eternal city of Rome (Symbol CXXIIII) and, to the students of mystical Pythagoreanism, the element earth.[133] As the seat of virtue ("Quadrata sedes virtutis," Symbol CXXVII), the cubic palace suits the functions of school and academy.[134] As a symbol of perfect symmetry and harmony, the cube was also celebrated by writers well known to Bocchi: For example, the marvelous palace of the muses shaped like a perfect *quadro* in Giovanni Filoteo Achillini's *Viridario* (fols. LIIv–LIIIr) and the *quadratura* of Francesco Colonna's glorified architect both predate the works of Serlio.[135]

Bocchi may have possessed a sketch by Serlio of his ideal facade, which he kept for at least five years while trying to raise money for construction, or he may have designed the entire project himself, copying details from Serlio's printed works and from drawings in Serlio's own collection, with the result given to an accomplished engraver to transform into the print of 1545.[136] A passion for architecture had stimulated several humanists to design their own villas: Mario Maffei (d. 1537), brother of Bocchi's friend Bernardino Maffei, built his own palace in Volterra, and Gian Giorgio Trissino produced the plans for the Villa Criccoli near Vicenza.[137] Other humanists took an active role in building programs for their villas, either specifying many details (as Girolamo Aleandro did) or establishing antique models as prototypes for their new villas (the Colonna family at Palestrina and Marcello Cervino at Monte Amiato in Tuscany).[138] Moreover, for rhetoricians, the frequent comparison of eloquence to architecture was both a stimulus to build and a reflection of interest in architectonic structure from Quintilian (X.4.27) forward.[139]

Serious financial obstacles delayed the construction of the Palazzo Bocchi. In March 1547, Bocchi wrote to Romolo Amaseo of the liberality of "Heri nostri" towards the academy (Milan, Bibl. Ambros., D145 inf., fol. 14r), and a brief vernacular letter to the "Quaranta," or ruling body of Bologna, dated August 1547 (written from Rome) and signed only with an initial that may be an "H" (Ambros., MS. D145 inf., fol. 18r), recommended that the virtue and learning of Cavalier Bocchi earn him an increased emolument. Yet by early 1548, with funds depleted, Bocchi's letters reflect a search for new patrons. Through "Claudius Roseus [Claude d'Urfé?], Joannes Angestus pontefix nouiodunensis [Johannes Hangest], et Michael Hospitalis viri clarissimi, Galliani . . . in Concilio Bononiensi" (Ambros., MS. D145 inf., fol. 44r), Bocchi received promises of aid from François I, whose death shortly thereafter removed that source of patronage. April 1548 saw Bocchi looking again to Rome for aid; he sent to Cardinal Archinto, a former pupil, copies of his 1545 "Descriptionem orthographicam" and his Symbol CII, which depicts the Hermathena *impresa* as it was planned for future execution in marble at the corner of the first floor just above the escarpment (Ambros., D145 inf., fol. 16r).[140] Earlier that year Bocchi had written a letter to Amaseo in which he asked his friend to convey to the pope that his lack of funds made the completion of the building impossible ("ne Farnesinae Domus Academicae monimentum uelit [?] imperfectum per inopiam meam remanere," Ambros., MS. D145 inf., fol. 6r).

Nevertheless, some progress had been made by mid-April 1549 for Bocchi announced that a good part of the structure was completed to the roof ("bona pars Academica' Domus ad fastigium," Ambros., MS. D145 inf., fol. 10v), but not paid for. The family quarters were probably not habitable for another year or so. It is possible, however, that the large ground-level lecture hall was operational by 1549, even though its decoration was not complete; the mythological and allegorical frescoes by Prospero Fontana in the hall are now thought to have been painted in the early 1550s.[141] Bocchi began to sign letters "Bononiae ex Academia A. Bocchi" by 1551, according to the dedication of the seventeenth volume of his *Historiarum Bononiensium*.[142] Whether the Palazzo Bocchi ever attained the form specified by the revised plan of 1546 (which is not extant) during Bocchi's lifetime is not known, but Bocchi did live there for the last decade of his life at least. It is likely that the palazzo

was almost complete as we know it today but that its owner never ceased to speak of adding the fifth floor and *tempietto* illustrated in the engraving; this may explain why the 1555 facade engraving did not reflect the present structure and why Pietro Lamo described the palazzo as unfinished in 1560.[143]

### Bocchi and the Production of the Symbolicae Quaestiones

The completion of the Palazzo Bocchi — at least to the point where family, school, academy, and a printing press could move in — enabled Bocchi to turn to the printing of his *Symbolicarvm Qvaestionvm De Vniverso Genere Qvas Serio Lvdebat Libri Qvinqve* early in 1555. Armed with a letter from Julius III, Bocchi and his heirs held a license valid for fifteen years to print and sell the work, along with the pope's promise of two hundred gold ducats from Apostolic coffers and words of praise for the book "cum suis affigurationibus pulcherrimis in aes incisis, opus sane non iocunditate solum, & utilitate, sed dignitate etiam maxima commendatissimum, unde studiosi omnes bonarum, & honestarum artium uberrimos, & suauissimos fructus percipere ualeant" (with its very beautiful bronze engravings, a work that is to be praised not only for its jocundity and utility but also for its great value, a work from which all students of the fine and honorable arts may gather fruits quite rich and delightful).[144]

The printing process itself was at least in part an amateur effort, with students of the academy providing some of the physical labor. This would account for many of the variations in the printing, especially the badly botched exemplar of the *Symbolicae Quaestiones* in Bologna's Biblioteca Universitaria and the incorrectly duplicated engravings in a number of copies (but different errors in different copies).[145] Dennis Rhodes argues, on the basis of several ornamental initials in the 1555 edition and the nonappearance of other works printed by the academia, that the book was not printed at the Academia Bocchiana but at the press of Anselmo Giaccarelli.[146] Perhaps Bocchi arranged to have text printed professionally but used students to print the engravings in a separate step. Eventually, printings without missing or transposed pages or duplicated engravings came out, although by then Pope Julius III, author of the letter of imprimatur, had died (March 23, 1555). At least a few 1555 copies were also dedicated to Paul IV (elected to the papacy on May 26, 1555); the Newberry Library copy's dedicatory letter has the date "nonis aprilib. MDLVI."[147] Bocchi also tried to ensure that the French would not pirate his book; some copies contain a letter of imprimatur from François I of France "'a notre cher et bien aimé Achilles Boccy Gentilhomme de Boulogne la grasse'" and other copies bear a similar letter from Henri II.[148] The evidence of a series of printings suggests that the *Symbolicae Quaestiones* sold well even though a large number of copies may have been set aside as complimentary copies.

What may have served as the printer's copy is the manuscript *Symbolicae Quaestiones* now in the British Library (MS. Sloane 5185). The scattered revisions (made in a poor and often shaky hand) to text and mottoes in this manuscript were all incorporated into the printed version.[149] The varying hands, the changes in page numbers in some sections and emblem numbers in others, and the overlapping section between folios 53r to 56v all testify that this manuscript was pieced together from

several almost complete, but not identical, manuscripts. Cut down to their frames, tiny engravings were glued into the manuscript.

Further uncertainties arise with the engraving process. Not until Carlo Cesare Malvasia's *Felsina pittrice* of 1678 was the name of Giulio Bonasone introduced as an engraver. Malvasia attributed the cutting of all the copperplates and the contribution of part of the original drawings and copies of works of other artists to him, along with Prospero Fontana, the Bolognese painter who frescoed the walls of the meeting room in the Palazzo Bocchi.[150] More recently, Stefania Massari in the 1983 exhibition catalogue, *Giulio Bonasone*, treated Bonasone as the chief "inventore" of the engravings. Since then, reports that eighty-two Bonasone drawings for the *Symbolicae Quaestiones* were sold by one private collector to another at Christies in London in 1972 have raised new questions.[151] Because the drawings, which have never been published, are superior in quality to the engravings of the symbols (but not to Bonasone's work as a whole), Frederick G. Schab and Diane DeGrazia believe that the drawings are Bonasone's, but that the engravings of the 1555 work were done by someone else, perhaps a shop assistant.[152] Adalgisa Lugli, however, turning back to Milizia's account, has suggested that the drawings were by Prospero Fontana and the engravings by Bonasone.[153] As the comprehensive cataloging of Italian art in English collections progresses, the artistic contribution to the *Symbolicae Quaestiones* may be clarified.[154]

The artist as printmaker need only have been associated with Bocchi's project from perhaps 1548, when Bocchi used the term *effigies* (image, Milan, Ambros., D145 inf., fol. 3r) in connection with Symbol CXXXII. As the *inventore* of the drawings, Bonasone's association with Bocchi could have been closer and over a longer period of time, yet the letters do not help us by naming an artist. That Giulio Bonasone played an important role is certain. Born into a wealthy Bolognese family, his career, based on dated prints, spanned the years from 1536 to 1574. He was an artist judged by Malvasia to be weak in landscape and in hatching (shading) but excellent "per la cognizione di tutte le più bello maniere di tutte le cose buone, anzi migliori de' maestri, per l'universale erudizione, per le tante invenzioni, che seco portano esse le stampe" (in the understanding of all the most beautiful styles of all good things, and thus was better than most of his masters for his universal erudition and for the many ideas that he transmitted to his engravings).[155] He was also weak in perspective drawing, usually a forte of Bolognese studios.[156] Because of Bonasone's particular strengths and weaknesses as an artist, one might suspect that he came to printmaking through the route of the dilettante rather than by an apprenticeship and that he may have joined Bocchi's academy first as an educated youth and only later contributed his talents to the *Symbolicae Quaestiones*.[157]

When did Bocchi conceive of illustrated poems as *symbola*? Friends outside Bologna received samples of the symbols well before their publication. In his 1554 *I Romanzi*, Giovanni Battista Pigna paid tribute to Bocchi's academy and especially to the Palazzo Bocchi: "Quegli vna fabrica va edificando tanto ben compartita, che potrebbe essere da lui posta tra suoi Simboli per l'essempio d'una perfetta Academia" (That man is building a structure so well arranged that it could be placed by him among his symbols as the example of a perfect academy).[158] Pigna appears to have been admiring a copy of the 1545 print of the Palazzo Bocchi, although he may

have visited the academy in Bologna as well. Engraved copies of symbols, perhaps accompanied by a print of the palazzo, were alluded to even earlier by Lilio Gregorio Giraldi (1479–1552) in his *De Poetis svorvm temporvm Dialogvs,* which was written between 1548 and 1551.[159] In the second dialogue, Bocchi's friend Bartolomeo Ricci speaks as interlocutor:

> Quae cum dixissem, sermonem secutus Riccius de poetis, Achilles, inquit, Bocchius eques Bononiensis in hoc genere laudis & caeterarum optimarum artium non mediocrem honorem sibi comparavit, qui in omni hac pene facultate praeclara documenta dedit superioribus annis, & nunc publice in patria honeste profitendo, & eius historias conscribendo, simulque magnificas aedes construens, sibi & Musis symbola conficit, ex variis cum philosophiae sententiis, tum historiis & fabulis, quae vario carminum genere exponit, & elegantissime graphide compingi facit subtilissime in aere adeo, ut his symbolis illa tria conficiat, quae bonus poeta & orator efficere debet, hoc est, ut prosit, ut delectet, & in utramque partem moveat.[160]

(And after I had said this, Ricci took up the discussion of poets and added, "Achille Bocchi, nobleman of Bologna, has gained no little recognition in this genre of praise and of other of the fine arts. In his later years, he has given us outstanding works in nearly every faculty of knowledge. He has taught in public and with distinction in his homeland, has written a history, and is likewise building a magnificent edifice. And now he has composed a book of symbols for himself and for the Muses, drawing from varied sources not only the ideas of philosophy but also historical accounts and myths, which he sets forth in various poetic forms. He has had this book of symbols illustrated so elegantly and precisely with bronze engravings that by these symbols he has reached the three goals for which every good poet and orator ought to strive, namely, that his work may be useful, that it may give delight, and it may move the readers now to happiness, now to sadness.")

Ricci refers both to symbols and to elegant prints; he also alludes to Bocchi's purpose as a poet by naming the Horatian ends of poetry as profiting, delighting, and moving. There may be a specific reference as well to Bocchi's Symbol CXXXVII on the taming of the Chimera of Rhetoric with its motto: ARS RHETOR. TRIPLEX MOVET, IVVAT, DOCET, SED PRAEPOTENS EST VERITAS DIVINITVS. SIC MONSTRA VITIOR. DOMAT PRVDENTIA (The art of rhetoric, having three purposes, moves, pleases, and teaches, but preeminent is the truth that comes from God. Thus Prudence subdues the monsters of the vices).

Nearly every letter Bocchi wrote to Romolo Amaseo in Rome between 1547 and 1551 at least mentions the symbols and some provide texts of poems without accompanying engravings (Milan, Ambros., D145 inf., fols. 3v, 7r, 25r).[161] Several symbols are alluded to only by number, indicating that the process of ordering was underway before June 1547, when Bocchi cited Symbols VII and XXX; Symbol LXXV (now LXXXV) was mentioned in February 1548 (fols. 7r, 8v). Symbol CXXXII, "De mentis effigiis," dedicated to Amaseo himself, received a detailed commentary in 1548 (fols. 15r–v). In April 1548, Bocchi sent a group of symbols, no

longer with their accompanying letter (fol. 16v): "Mitto tibi Symbola quattuor Academica, quorum primum est...HERMATHENAE" (I am sending you four symbols of the academy, of which the first is ... that of Hermathena [CII]). The others, along with a fifth one, were DIALECTICA (LXII), NOCTVA PALLADIS (LXXXIII), ANTEROS (LXXX), and ALEXANDRI MACEDONIS (LXVI). Because Amaseo was already familiar with Bocchi's projects, the letters make no reference to the scope of the work on symbols and define no terms.

To trace Bocchi's symbols back to their moment of conception, the researcher must concentrate on the years from around 1539 to 1544, a period for which little information can be found. Yet this was the most fruitful period of Bocchi's life in terms of literary creativity, academic activity, and architectural planning. Most important to Bocchi at this time was the presence on the law faculty from 1538 to 1541 of Andrea Alciato, whose fame as the author of the *Emblematum liber* had been spreading rapidly since the Steyner (Peutinger) edition of 1531, the Wechel Paris editions of 1534, and the French and German translations of 1546.[162] Bocchi dedicated to Alciato one of the most "emblematic" of his symbols (Figure 13), "AD ANDREAM ALCIATVM AMICORVM OPT. / LVCE CARET, PVLCHRI QVI CAVSSAM / NESCIT AMORIS / Symb. XL" (To Andrea Alciato, the best of friends: He is devoid of light who does not know why people love beauty), based on the proverb "oculi sunt in amore duces" (the eyes are the rulers in love). And, in the first symbol, which defined the term for his readers, Bocchi praised Alciato as the creator of one type of symbol:

> VT ALCIATI Emblemata
> Dicuntur & Σuvθηματα,
> Mysteriorum plena, quae
> Documenta commodissima
> Illa omnium, & pulcherrima
> Vitae, atque morum continent,
> Sanis rectata, caeterum
> Incognita imprudentibus.
>
> (lines 38–45)

(As the *Emblems* of Alciato are called, and conventional signs, being full of divine mysteries and containing those most apt and magnificent examples of all things – of life and character – revelations to men of sound mind but incomprehensible to the ignorant.)

In Alciato's emblems, brevity ruled: A tightly constructed epigram explicated a single conceit or moral dictum, accompanied by a motto and an engraving that depicted a single action or symbolic creature, plant, or antiquity. Bocchi allowed himself much greater freedom of form in his use of the ode as well as the epigram and in the more complex subjects of both poem and engraving. Mottoes proliferate, occurring above the engraving, over the poem, and sometimes within the engraving as well. Bocchi also created a much greater number of dedications to individuals than did Alciato. His aim was to explore the symbol in all its forms. (The varied types of symbols and how they function in the *Symbolicae Quaestiones* will be discussed in detail in Chapter 5.)

Among Alciato's emblems are two with the word *symbolum* in their titles. One, "Concordiae Symbolum," is illustrated in the Steyner edition of 1531 by a crowned crow governing three other crows. The second, "Fidei Symbolum," represents personifications of Chaste Love, Truth, and Honor.[163] These two emblems, along with the lively debate over emblems, *imprese,* and other symbolic modes that probably took place during Alciato's tenure in Bologna, may have determined the form Bocchi's own emblems would take.

### Postscript: Bocchi's Later Years and Fortuna

After the publication of the *Symbolicae Quaestiones*, Bocchi's remaining years were played out under the shadow of family problems and illness. He continued his labors, delivering before his academy the series of lectures on Cicero's *De Legibus* in 1556. Not until November 1557 was he able to complete a manuscript presentation copy of these lectures for Bishop Thomas Contuberio. Because of his poor health and difficult times, he had suspended his work on Cicero and on his history ("cuius caussam partim temporum malignitas, partim incommoda ualetudo").[164] No more volumes of Bolognese history came from Bocchi's pen after 1551. The projected second volume of *symbola* in three books, of which he spoke both in a June 1556 letter to Giovanni Battista Pigna and in his will also never appeared.[165] His collected letters remained unpublished as well. After 1556, Bocchi's scholarly work is mentioned only in passing by Bartolomeo Ricci in a letter to Marco Tullio Bero in Bologna dated May 1559.[166] Bocchi's school operated at least until August 1558, when Giovanni Romangilio, writing to Ulisse Aldrovandi, referred to "li boni qualità del giouani . . . in casa del caualier Bocchio in Bologna" (the good quality of the youths in the house of Cavalier Bocchi in Bologna).[167]

Bocchi wrote his will and had it signed by two witnesses and recorded in the archives of the notary Cristoforo Zellini on July 14, 1556. Although Pirro's troubles with the law were not mentioned in a letter until November of that year, Pirro was cut off in Bocchi's will with a minimal inheritance of twenty-five "libbre di moneta usuale" and a comment about Bocchi's confidence in his son's "auxilio doctrinae, qualitatibus et virtutibus" (in the aid of his education, his qualities and his virtues), which Gisela Ravera Aira considered very ironic.[168] To Bocchi's three daughters in convents – Suor Prudenza at Santa Agnese and Suor Lucidania and Suor Deodata in Santa Cristina – went annual sums of ten "libbre." To his favorite daughter, Constantia (Costanza), then living at home, Bocchi left six thousand "libbre" should she marry or one thousand "libbre" should she enter a convent (which also required a dowry).[169] Bocchi's wife, Taddea Grassi, was to receive the thirty-five hundred "libbre" from her father's dowry, a servant, and her maintenance in her husband's home for her lifetime, or, if she chose to leave the house, twenty-five gold "scudi" a year.[170]

The chief beneficiaries of the will were to be Bocchi's son Lelio, about whom nothing is known, and Matteo Maria de Maresani, Achille's pupil and protégé. Lelio, however, would not come into his inheritance until age thirty-three, although he would receive an allowance for his upkeep and medicine before then; his affairs would always be administered by Taddea Bocchi and Matteo Maria de Maresani. This

arrangement suggests that Lelio was either physically or mentally incapable of caring for himself. Maresani, although he might have been a natural son of Bocchi never legitimized, probably was the scholarly heir of Bocchi as Bocchi had been to Giovanni Battista Pio. The will specified that Maresani be named "'Princeps Caput et Primarius'" of the academy and that he and the other heirs see to the publishing not only of Bocchi's works but also of a few works by Pio that Bocchi had inherited.[171]

Achille Bocchi died on November 6, 1562. Whether Lelio and his mother remained in the Palazzo Bocchi after this date, or whether Maresani maintained the Academia Bocchiana there is not known. By 1587, Francesco Bocchi, the oldest son of Bocchi's cousin Romeo, was living in the Palazzo Bocchi.[172] Constantia Bocchi did marry Gianfrancesco Malvezzi, but probably not until 1560 when a medal was issued in her honor: COSTANTIA BOCCHIA VIRGO ACHILLIS F. MDLX.[173] Apparently the money for her dowry specified in the 1556 will came at least in part from the gifts of Bishops Thomas Contuberio and Paulus Abstemius.[174] Constantia outlived her father by only four years, dying childless in 1566.[175] The works Bocchi spoke of in his will not only were not published but also have disappeared without a trace.

Only in 1574 after the fifteen-year privilege had expired was the second edition of Bocchi's *Symbolicae Quaestiones* published. Bocchi's was the first of nineteen titles issued under the auspices of the Società Tipografica Bolognese, a printing society founded by a group of nobles that included Camillo Paleotti the Younger, Carlo Sigonio, Paris Grassi, Francesco Maria Bolognetti, and Cesare Fasanini.[176] The engravings of the 1574 edition were retouched by Agostino Carracci.

Not much is known about the early distribution of copies of the *Symbolicae Quaestiones;* one copy of the 1555 edition, however, was in the large collection of Bocchi's pupil Johannes Sambucus in Vienna, and another copy (edition not given) found its way by 1599 into a collection of illustrated books belonging to the Tuscan Bartolomeo Giotti de Peruzzi.[177] Bocchi's collection of symbols was treated much as other emblem books were: One copy at least was used as an autograph book (*album amicorum*), and another, listed for sale in 1784 by the Duc de la Vallière, was described as a "superbe exemplaire . . . avec les figures parfaitement coloriées."[178] Both editions exist in some numbers: Between listings in secondary sources and libraries visited, I have accounted for nineteen American and European copies of the 1555 edition and more than twenty copies of the 1574 edition.[179] Probably as many more copies remain scattered in private collections and other libraries. For a privately printed and distributed sixteenth-century book, the *Symbolicae Quaestiones* is not especially rare and is available both in a reprint edited by Stephen Orgel[180] and Volume 2 of the Stefania Massari catalogue *Giulio Bonasone* (the latter with a translation into Italian by Maria Bianchelli Illuminati).[181]

After his death, Bocchi was rarely mentioned as a university scholar. Only John Caius in his *De libris proprius liber* (London, 1570) recorded Bocchi's teaching of Homer and Pliny and the use by Bocchi and his colleagues of the "old" method of pronouncing Greek.[182] Bocchi's younger colleague, Sebastiano Regoli, honored him as a teacher in a 1563 (Bologna) commentary, *In Primvm Aeneidos Virgilii Librvm, Ex Aristotelis De Arte Poetica & Rhetorica praeceptis explicationis.*[183] Nevertheless, the *Symbolicae Quaestiones*, whether classified as a work of philosophy,[184] as a collection

of poetry, or as an emblem book, kept Bocchi's reputation alive.[185] Few emblem books gave contemporaries any credit as sources, so Bocchi's name, although mentioned with respect, never became the household word that Alciato's did. Some of his poems, both from the *Symbolicae Quaestiones* and from earlier manuscript collections, however, were published in massive compilations of Latin verse.[186]

Among theorists of the *impresa*, Bocchi's *Symbolicae Quaestiones* did receive notice. The book was, not surprisingly, treated with respect by the Bolognese publication in 1575 of Giovanni Andrea Palazzi's *I Discorsi . . . Sopra L'Imprese. Recitati Nell' Academia d'Vrbino* in which Palazzi praised "il caualier Bocchio Bolognese" and recommended his "Simboli" as a useful source for devices and "inuentioni" ("sopra tutto serve à far' Imprese"; above all, it is useful in the making of devices).[187] Girolamo Ruscelli mentioned Bocchi briefly, along with Alciato and Costalius, in a short chapter on emblems in his *Le Imprese Illvstri* (1584).[188] Although Giulio Cesare Capaccio borrowed devices from Bocchi without citing his source, he discussed Bocchi only once and with contempt for Bocchi's esotericism:

> E quei che Simboli chiamò il Bocchio (dotto huomo veramente, e curioso) in molte parti dal recondito significato Simbolico si dilungano, ha uendoli egli ridotto alle Forche, a i busti tronchi, & molti Simolacri c'hanno spetie di sogni; benche non dubito che quel valent'huomo, volse dallo stile comune allontanarsi, per mostrar l'ingegno, e di nouvi segni abellir questo nome.[189]

> (And those which Bocchi, a truly learned and inquisitive man, called symbols have digressed for the most part from the hidden symbolic meaning; he has reduced them to the gallows, selling them out to truncated statues and to many images that are like dreams. However, I do not doubt that that worthy man turned away from the common style to distance himself in order to display his ingenuity and to enhance his name by new styles.)

In the seventeenth century, Père Claude-François Menestrier often cited Bocchi's "emblemes" as examples, for the most part with approval; he also placed Bocchi third (after Alciato and Schoonhovius) in a list of authors of emblem books "avec vn recueil des plus beaux sur diuers suiets" (with a collection of very beautiful ones on diverse subjects).[190]

Insofar as emblem books are concerned, the fortune of the *Symbolicae Quaestiones* took a submerged path often difficult to track, for few of its engravings were copied closely in later emblem books. Despite the obvious influence of Alciato on emblem subjects and their visual applications, most of the midsixteenth-century emblem producers seemed eager to develop original ideas or at least to vary their treatments of the more common subjects. The writer with the greatest debt to Bocchi was Johannes Sambucus (Janos Sámboky), who, like Bocchi, dedicated many of his emblems to friends and patrons. To his former teacher he dedicated "Dum potes viue. / Ad Achillem Bochium, tanquam parentem, de sepia" (Live while you can. To Achille Bocchi, who was like a parent to me, on the cuttlefish). When he adapted motifs from Bocchi, they were placed in new contexts or otherwise transformed. For example, Bocchi depicts a ferocious Chimera about to be vanquished by Bellerophon and only in his text associates the tripartite monster with the three parts

of rhetoric (CXXXVII, Figure 14). Sambucus, however, introduces into his visual allegory of history and the trivium a domesticated Chimera as an attribute of personified Rhetoric.[191] Yet Hadrianus Junius, who had studied at Bologna for a *laurea* in philosophy and medicine (1540) and who was a friend of Sambucus, shows no influence of Bocchi in his own 1565 *Emblemata*.[192]

Nevertheless, Bocchi's symbols have much in common with the *Pegme* of Petrus Costalius (Coustau, Costal). However, because Bocchi's *Symbolicae Quaestiones* appeared in the early months of 1555 and Costalius' Latin edition and its French translation came out in January 1556 (dated January 1555, Julian calendar style), there is little likelihood that the published work of Bocchi had much impact on Costalius. Costalius was a lawyer, and, therefore, he may have studied in Bologna around 1550 and may have visited Bocchi's academy at a time when many of Bocchi's symbols were already being written, illustrated, and discussed.[193] Costalius, like Bocchi, used several Pythagorean *symbola* (although different ones), referred occasionally to his emblems as "symbols" in his verses, and frequently described his images as statues or portraits. Like Bocchi, he often touched on secrecy and hidden knowledge.[194]

Some of Bocchi's symbol topics – Mercury, Minerva, Hercules, Proteus, Fortuna, the herb moly, and obelisks, for example – appeared in so many other emblem books, never being presented in just the same manner in any two of them, that borrowing and influence cannot be determined. Other topics are sufficiently specific and uncommon to make it clear that Bocchi's *Symbolicae Quaestiones* was known in Spain (especially by Juan de Horozco y Covarrubias, *Emblemas Morales,* 1589), in France (Jean Jaques Boissard, Denis Lebey de Batilly, and Georgette de Montenay), in the Low Countries (Lorentius Haectanus and Florentius Schoonhovius), in Germany (Joachim Camerarius, Nicolas Reusner, and Peter Isselburg and Georg Rem), and in England (Geoffrey Whitney, Francis Thynne, and F. Tolson).[195]

In one case, the *Emblemata Politica* of Peter Isselburg and Georg Rem (Nuremberg, 1640) contains two emblems on historical themes also found in Bocchi but almost nowhere else. In its Emblem 25, "Anima Consilii silentium," a simplified version of the episode is provided in the German epigram, whereas the four-line Latin epigram under the engraving offers a more general counsel of silence. Bocchi's Symbol CXIX informs the reader that the letter improperly read by its courier, Hephestion, contained "arcana" and calumny against Antipatros; the German version simply calls it a "heimlichn Brief" (secret letter) and counsels against prying into such secret matters (Figures 15 and 16). In the engravings of both Bocchi and Isselburg, Alexander the Great is shown in front of a tent in the act of placing a ring in the mouth of Hephestion to seal his lips; there the resemblance ends. The Isselburg/Rem Alexander, wearing a turban, is seated in oriental splendor on a thronelike chair decorated by a crouching sphinx. Bocchi's Alexander is dressed very simply as a Greek soldier with only a plume to indicate rank, and he stands. Bocchi's scene is crowded with figures, some gesturing agitatedly, whereas the German emblem has but two figures and one tent. In other emblems, Bocchi and Isselburg/Rem both illustrate the attempt to corrupt the Roman Fabritius by money and gold; again there are major differences between the two treatments. Also, Bocchi follows Symbol XXX on Fabritius by another symbol (XXXI) representing a failed attempt at corruption, this one on Marcus Curius and a Samnite delegation. Here Bocchi uses

a motto beginning PECVNIA HAVD CORRVMPITVR, which is similar to both motto ("Ne corrumpar") and Latin verse in the German emblem on Fabritius.[196] In many cases, then, authors of emblem books used other works of the genre to suggest appropriate topics, which they then reworked to fit their own desired style, level of audience, or even religious orientation.

Bocchi's title, the *Symbolicae Quaestiones,* was the first of many similar titles of emblem and other illustrated books, among them Claude Paradin's *Symbola heroica* (a 1562 *imprese* collection) and Joachim Camerarius' *Symbolorvm & Emblematvm ex re herbaria* (1590) and *Symbolarvm & Emblematvm ex animalibvs qvadrvpedibvs* (1595). Titles using "symbol" to refer to the personal mottoes of individuals also followed Bocchi in a more specific way: Nicholas Reusner's *Symbolorvm Imperatoriorvm* (first published in 1588) studied the mottoes of the emperors from antiquity to his own time, and the *Liber unus symbolorum variorum* of Jan Fongers (Fungerus) probably was similar in scope.[197] Northerners called their personal mottoes "symbols," as Bocchi's pupil Petrus Lotichius Secundus did, or wrote epigrams with that title, as Lotichius' friend Johan Lauterback did in his "Symbolvm Matthaei Lilienfein" and "Ad Symbolvm Alexandri Hohenbuch."[198] The Jesuit Jacob Bosch entitled his vast collection of illustrated symbols *Symbolographia, sive, De arte symbolica sermones septem.*[199]

The first published work called *symbola* to contain tripartite mixed-media units, however, had appeared in Nuremburg in 1547; this was a collection of motets by Caspar Othmayr, the *Symbola Illustrissimorum Principum Nobilium, Aliorumque doctrina, ac virtutum ornamentis praestantium Virorum, Musicis numeris explicata.* Each of the thirty-four *symbola* was dedicated to a German Protestant, including Martin Luther and Philip Melanchthon.[200] According to Edward Lowinsky, "the brief motto received an individual melodic setting and appears in the tenor in exact repetitions while the surrounding four parts were set to a text designed to comment and elaborate on the meaning of the motto."[201] Lowinsky compared Othmayr's emblematic *symbola* to Alciato's emblems. It is just possible that Othmayr also knew Bocchi's symbols in their earliest stages; Italy would have attracted Othmayr both as a graduate of the University of Heidelberg and as a musician, and Othmayr's location between 1536 and his appearance as rector of the Heilsbronner Klosterschule in 1545 is unknown. It is tempting to speculate that Othmayr, whose career as a court singer began as a boy in Neumarkt, traveled to Bologna, where he could easily have found employment in a choir and where around 1540 he could have met both Alciato and Bocchi.[202] Othmayr's first known work was the single *symbolum* he sent to the Herzog Heinrich of Braunschweig in 1542.[203]

Bocchi's afterlife in poetry became increasingly diffused as his ideas and symbolism joined the late Renaissance and early Baroque flow of icons and images. Already by 1547, Michel L'Hospital's epistle "Ad Achillem Bocchium, Equitem Bononiensem, et Praestantem Poetam, De Fide Christiana" alluded to themes common to a number of Bocchi's symbols: the love of God igniting the human mind, the play of light and darkness, the mirroring of divine light, and *arcana.*[204] Both picture and verse interested Bocchi's readers. Petrus Lotichius Secundus's "De Philomelo," for example, described a nightingale singing from a branch over a pool to its reflection below more according to the engraving of Symbol LXXXVIII (LVSCINIAE

HAVD DEFIT CANTIO; Song does not fail the nightingale) than to Bocchi's poem.[205] Likewise, the same association between Rome and the ills loosed by Pandora in Bocchi's engraving in Symbol CXXIIII was made when Joachim Du Bellay detailed the evils of contemporary Rome in a sonnet first published in 1558.[206] Close and illuminating resemblances have been discovered between symbols of Bocchi and Edmund Spenser's Proteus in the *Faerie Queene,* Shakespeare's Eros and Anteros in the *Sonnets,* and Goethe's *Pandorens Wiederkunft* (1807).[207]

The visual arts too benefited from the *Symbolicae Quaestiones* of Bocchi and its engraver, sometimes in very specific ways. The symbol of Pan and Pitys (CL), which Bocchi dedicated to Giovanni Battista Pigna of Ferrara, furnished the design not only for Pigna's medal but also for a faked antique mosaic of unknown origin (perhaps eighteenth century) now in the Museo Archeologico Nazionale in Naples.[208] Several symbol engravings took on concrete form in architectural structures. John Caius, who had studied medicine and Greek at Bologna from around 1539 to 1544, planned gates of Humility, Honor, and Virtue for Gonville and Caius College at Cambridge, rather more elaborate than Bocchi's simple temples of Symbol XXXIII (VIRTVS VESTIBVLVM EST HONORIS ALMA; Beloved virtue is the gateway to honor).[209] Even more striking is the materialization of the leaning tower of the Ruini family *impresa* from Bocchi's Symbol CXLVI in the allegorical garden architecture at Bomarzo by Jacopo Barozzi da Vignola for Pier Francesco (Vicino) Orsini. Both towers symbolize the good wife who gives strength to her husband in all his difficulties: Bocchi's leaning tower paid tribute to Isabella Filicina Ruini, and Orsini's commemorated his deceased wife.[210]

In late-Renaissance painting and drawing, the illustrations of Bocchi's *Symbolicae Quaestiones* contributed mythological and allegorical prototypes for works by Bolognese artists, such as Bartolommeo Cesi and Ludovico and Annibale Carracci, and by a French artist, Jean Cousin.[211] In the Palazzo Sanguinetti in Bologna, a painting by Orazio Sammachini that depicted Marcus Curius cooking turnips and rejecting corruption adapted both the engraving and the motto of Bocchi's Symbol XXX.[212] Even religious paintings utilized motifs from the symbols: The *San Raimondo di Pennafort* that Lodovico Carracci painted for the church of San Domenico encircles the saint with a sail similar to that of Bocchi's Blind Fortune (LXVI), and Cesi's painting *Divine Justice* is adapted from Symbol CXXX's personification of Faith, itself borrowed from Raphael.[213] Such adaptations were not limited to Bologna, for Irving Lavin has explored Caravaggio's debt to Bocchi's conception of Socrates (III and CXXXVIII) in the *St. Matthew Composing His Gospel* altarpiece (the first version, now destroyed): "Taken together, Bocchi's emblems provide the key to most of the Socratic content of Caravaggio's altarpiece: a picture with an underlying meaning, which consists in the divine revelation of truth to him who is aware that he does not understand."[214]

In a more general way, the *Symbolicae Quaestiones* contributed to the art of the Baroque, both in Italy and in Northern Europe.[215] Although Bocchi's conceptions of Fortuna (Symbol CXXI) and of the earth as a transient bubble or glass globe (Symbol CXXXX) may have fed into the immensely popular Northern *vanitas* tradition in art, it is the esoteric Bocchi that had the most demonstrable impact on later artistic themes. Soon after Bocchi's symbols were published, a vernacular

mythology by Vincenzo Cartari (1556) appeared in print as a guide to the pantheon of ancient gods and goddesses, the same gods derived by Bocchi from sources less accessible to most readers. Among these deities was Hermathena, who figured as the *impresa* of Bocchi's academy. Bocchi was the first to provide an illustration of this rare combination of Hermes (Mercury) and Athena in Symbols CII and CIX (Figures 17 and 18) and in the 1555 print of the Palazzo Bocchi facade (Figure 10). His Hermes and Athena each had a herm (columnlike) base and upper torso on the corner of the Palazzo Bocchi; they linked arms, and between them Eros reined the mouth of a lion's head.

Subsequent descriptions of Hermathena agreed on its usefulness as a symbol of academies. In 1556, Cartari, alluding to Cicero's statue of Hermathena, remarked that "la tennero nelle Academie per mostrare à chi quiui si esercitava, che la eloquenza, e la prudenza hanno da essere insieme giunte..." (they place them in academies to show whoever exercises there that eloquence and prudence must be joined together); this was echoed by some mythographers and also by Claude Mignault's commentary on Alciato's *Emblemata*.[216] One of the later Bolognese academies, the Accademia de Gelati, founded by Melchiorre Zoppio in 1588, met in a room called "Ermatena" in Zoppio's house.[217] Bocchi's interpretation (Symbol CIX) received its fullest development in the *Hermathena* of Jean van Gorp (Goropius Becanus), a treatise on language and the symbolism of letters first published posthumously in 1588. In Book VII, Gorp, like Bocchi, touches on the themes of wisdom, marriage, restraint of speech, and mortality: "Hinc Hermathena interpretationem sapientiae supremae copulat; quo coniugo nihil potest beatius ab iis optari, qui discendi caussa vel scholas adeunt, vel mutos magistros consulunt" (Thus Hermathena couples interpretation with supreme wisdom; those who, to educate themselves, attend school or consult mute teachers can wish for nothing more blessed than this marriage).[218]

Artists, however, apparently were uncomfortable with the herm bases depicted in Bocchi's Hermathena symbols, perhaps because of the blatantly male sexuality of many antique herms (Cartari provides some examples). Later Hermathenas are characterized by linked arms, as in Bocchi, or by embraces, but all have full-length bodies, and no Eros appears between them. The illustrated editions (from 1571 on) of Cartari placed the embracing Hermes and Athena on a square base with the same attributes found in Bocchi: a shield, helmet, and spear for Athena; and the caduceus and winged hat for Hermes (Figure 19).[219] Federico Zuccari's ceiling painting in the Sala dell'Aurora of the Palazzo Farnese at Caprarola (begun by Vignola for Bocchi's patron, Cardinal Alessandro Farnese) portrays the god and goddess seated close together, arms around each other's shoulders. The legs are ambiguous: Hermes clearly has two, but Athena's legs are either completely hidden or else shared with Hermes.[220] The more common standing Hermathenas appeared in the 1566 edition of Girolamo Ruscelli's *Le imprese illustri*, in the emblem, DISCIPLINAE ANIMVS ATTENTVS, of Otto Van Veen (Vaenius) in 1607, in an engraving by Aegidius Sadeler copied from a drawing by Joris Hoefnagel (1593), in an 1599 entry in Antwerp, and in seventeenth-century drawings by Peter Paul Rubens, who also placed statues of Athena and Hermes over an archway leading to the garden of his home.[221] By the late seventeenth century, Hermathena had come to be seen as the protector of artists, especially in the cultural circles associated with the court of

Rudolf II at Prague.[222] Only much later did another emblem book adopt the Academia Bocchiana's *impresa* as its title and leading emblem: the *Hermathenae, or Moral Emblems* by Francis Tolson, which was probably published in London around 1740 (Figure 20).[223]

Another Bocchi symbol, never as rare as Hermathena, derived from both mystical/Neoplatonic traditions and from ancient technology. Bocchi offered to then Cardinal Marcello Cervino his Symbol LX with its motto CONCIPIVNT IGNES SPECVLARIA CONCAVA SOLIS (Concave mirrors catch the sun's fire). In this symbol the ancient Greeks use a metal-burning mirror to light the fire on an altar immolating sacrificial hearts, just as God (the sun) ignites the human soul through divine love (Figure 21). The burning-glass emblem was particularly appropriate for Cervino, who was fascinated by the mechanical arts (especially architecture), who founded a printing press in the Vatican to publish Greek texts, who translated part of Hero of Alexandria's *Pneumatica,* and whose country property on Monte Amiato in Tuscany contained a furnace or forge.[224] Bocchi's own delight in the burning glass may have encouraged his pupil Ercole Bottrigari to translate Oronce Finé's *De speculo ustorio,* written by 1555, into Italian from a presently unknown manuscript.[225] Burning mirrors appeared in other emblems and *imprese,* in engraved plates illustrating concave mirrors catching and refracting burning rays from the sun in Joannes David's *Duodecim Specula* of 1610, and in scattered plates in Jacob Bosch's *Symbolographia,* among others.[226] The ultimate in symbolic refraction was probably Giambattista Vico's frontispiece for his third edition (1744) of the *Scienza Nuova* in which the "ray of the divine providence illuminating a convex jewel which adorns the breast of metaphysic [is] . . . reflected . . . onto the statue of Homer."[227] That the *Symbolicae Quaestiones* lent its designs to buildings, coins, mosaics, and paintings, circulated its images and myths among poets and playwrights, and swelled the growing repertory of visual symbolism of the late sixteenth and early seventeenth centuries is an outcome that Achille Bocchi would very much have appreciated.[228]

# The Generic Mix and Bocchi's Symbol Construction

# Poetics and the Emblem

> Bright-eyed Fancy hov'ring o'er
> Scatters from her pictur'd urn
> Thoughts, that breath, and words, that burn.
> (Thomas Gray, "The Progress of Poesy," 3.3)[1]

As an integral part of Bocchi's cultural program, the *symbola* fulfilled various functions. They disseminated ideas to both a local audience and a broader external one, they solicited patronage, they provided gifts for distant friends and graduating students, they created topics for the Academia Bocchiana's discussions, and they gave Bocchi a medium for experiments in the interactions between word and image. Because in the academy-oriented society of the midsixteenth century, poets were discovering more opportunities to circulate their works, the *Symbolicae Quaestiones* reached, as its author intended, an audience considerably larger than the one that could fully grasp its more abstruse examples. As it had early in Bocchi's poetic life, poetry still fulfilled a social function, just as did the most ancient *symbola*. The very term *symbolum,* going back to the early Greek "tokens of exchange" and "contributions to banquets," implied, for Bocchi, an audience that would be receptive to his promulgation of ancient wisdom.

The purpose of Part II is twofold: first, to explore the contribution of theories of poetry and the symbol to the development of emblematic genres, and second, to demonstrate a crucial poetic strategy – paradox – and a crucial symbolic strategy – myth. Because Bocchi was first a poet, I begin by discussing his poetics and the poetic theory and practice of his time (Chapter 4). Both the increasing sophistication of Renaissance poetics and the era's fascination with analogies between the arts, particularly between poetry and painting in the sixteenth century, created a background favorable to the development of emblem and symbol. The focus then shifts (Chapter 5) to symbol as genre, to symbols as subjects, and to Bocchi's symbolic questions. I conclude (Chapters 6 and 7) by treating the paradox, playfully emergent in Bocchi's full title, *Symbolicarvm Qvaestionvm De Vniverso Genere Qvas Serio Lvdebat,* and myth both as poetic strategies and as the sources of emblem topics.

## Bocchi and Sixteenth-century Poetics

In the sixteenth century, published debates on poetic theory appeared in increasing numbers, beginning early in the century with commentaries on Horace's *Ars Poetica*. Informal letters between friends discussing aspects of poetic theory followed, and by the 1540s, the first of many independent treatises on poetics had emerged, as well as the first commentary on Aristotle's *Poetics*.[2] This productivity mirrored the rise and spread of literary academies. Padua and, to a lesser degree, Florence were the major centers of activity from the 1540s on.[3]

There was no real discontinuity between the Renaissance theorists and those of their medieval forebears who had preceded or stood apart from Scholasticism.[4] Nevertheless, the early Renaissance poetics of writers such as Boccaccio and Coluccio Salutati did respond to a need to defend poetry against charges of lying and immorality, and, according to Concetta Carestia Greenfield, humanist poetics arose from these defenses.[5] By the sixteenth century, though, the need to defend poetry was less urgently felt. Those defenses that were published usually involved responses to Plato's attack on poets (*Republic,* Book X) and reasserted the necessity for poets to speak in veiled and symbolic language.[6] The theories of the first half of the century – the period that concerns this study – were based largely on Horace's *Ars Poetica,* with occasional references to Aristotle's *Poetics*.[7] Poetry shared its figures with rhetoric; it was seen to have similar ends – to delight, to instruct, and at times to persuade – and even similar structures.[8] What cannot be found in the theories of the earlier sixteenth century is a clear demarcation between poetry and rhetoric, although the theorists devoted considerable effort to the classification of poetry and rhetoric among the sciences and arts.[9]

Some aspects of poetics and the relationship between poetry and picture were treated by authors of emblem books in prefaces or in brief remarks in emblem verses. According to Robert Clements, these claims for poetry in emblem books tended to agree with contemporary poetic theory most in the areas of imitation, *ut pictura poesis,* and the idea of perspicuity.[10] Bocchi addressed the same issues in his third symbol, which summarized for Cardinal Alessandro Farnese a position in poetic theory typical of the period around 1540 but developed to a degree unique in early emblem books.[11] Neither an art of poetry writing nor a formally organized treatise, the text of Symbol III does not even introduce a term for poetry until nearly halfway through (*poemata,* line 18). Nevertheless, Bocchi touches on many topics common to Platonizing Horatian poetics. Because of its importance, the full text and a translation based on that by Thomas Marier are included here:

> Ivdicio Phoebi sapientum maximus ille
> Et fons, et lumen, si forte obscura prophani
> Uulgi in cognitionem olim deducere vellet,
> Quaeque sibi in primis notissima proponebat.
> Sic etenim haud ab re firmissima cuncta putabat
> Ac tutissima, non modo lucida, de quibus ipse
> Disserere aggrediebatur. Sic magnus Homerus
> Securum oratorem Ithacum laudauit Ulyssem.

Quippe animos hominum trahere his quocunque liberet,
Concilians sibi passim omnes per maxime aperta.
Propterea quicunque bonis foeliciter essent
Progressim studijs, non sunt tam arcana secuti
Omnia, vt assequerentur prorsus: at esse putabant
Quaedam pauca satis, possent si attingere parce,
Quae ipsa irritamenta forent gratissima deinceps
Veri indagandi. Vates sic condidit ille
Fabellas Phrygius bellas. sua symbola quondam
Panthoides samius. Sic dia poemata vates
Pinxere, atque homines mire allexere, libenter
Auribus ut uellent aurire, et credere honesta,
Quae fuerant oculis subiecta fidelibus ante.
Ergo mihi nemo obijciat, quod seria inani
Pictura grauium ostendendo pondera rerum,
Miscere annitar summa cura utile dulci,
Si qua forte queam laudis punctum omne tulisse,
Ne satias quenquam capiat, Naturam imitari
Constitui, et varias sensis inducere formas,
Nil vt iners, nil non aliquid sit agensue, loquensue.
Me sane impediunt nullius vincula sectae.
Sed quocunque trahit species pulcherrima Veri,
Deseror hospes, apisque Matinae morae, modoque
Lilia per multum libantis grata laborem
Fingo itidem tenui, ast operosa carmina Musa,
Aurea depascens veterum decreta Sophorum.
Tu vero interea, Farnesi Maxime, nostra
Ne rogo ne spernas haec qualiacunque: reposco
Gratiam ego inuentis, sed omissis, vt Stagyraeus
Optime Aristoteles, ueniam. mihi sat voluisse,
At facilem erratis par est te ignoscere nostris.
Nam simul inuentum, et perfectum nil fuit inquam.
Si rudia ista polire aliquis dignabitur olim
Aut defecta explere, id forsitan efficietur
Quod cum fructu aliquo multos cognosse iuuarit.

> (Abbreviations expanded by italics)

(Whenever that man [Plato], by the judgment of Phoebus the greatest of wise men, the source and light of wisdom, wished to relate obscure truths for the edification of the common people, he would put forth, above all, those images with which he was most familiar. For he thought, and not without good reason, that in this way everything he undertook to discuss would be not only lucid, but most sound and least liable to refutation. For the same reason the great Homer praised Ulysses of Ithaca as an assured speaker, because he could lead the minds of men wherever he wished, winning over everyone to his side by means of arguments most manifest. That is why whoever had made progress

in liberal studies did not pursue all branches of arcane wisdom in order to understand them thoroughly; instead, people thought that it would be enough to attain, if only they could, certain small amounts of knowledge, bits that would be, one after another, most welcome incentives for the exploration of the truth. Thus the famous Phrygius once composed his delightful fables and Panthoides of Samos his symbols.

Just so the poets embellished their divine poems and attracted men in wondrous fashion, that with their ears they might desire to hear, and to believe honorable, those things which had been set before their faithful eyes. Therefore, let no one charge that by demonstrating the grave importance of weighty matters by means of what is nothing but a picture I am striving to blend the useful with the delightful in the hope that I may be able to garner everyone's vote of praise and in order that no one may grow weary of my work. I have decided to imitate Nature, and to clothe my thoughts in various forms, in order that none of my creations may be insipid, and that none, whether in action or in speech, may be without value. I am certainly not hindered by the chains of any one school. But wherever the most beautiful vision of the Truth draws me, I am abandoned to it, a sojourner, and just like the bee of Mount Matinus that laboriously tastes of pleasant lilies, I fashion poems with a scant but painstaking Muse, feeding on the golden sayings of the ancient sages.

In the meantime, you, who are the greatest of the Farnese, do not, I beg, scorn these lines of ours, whatever worth they may have: I ask that you show me, as Aristotle of Stagira once put it so well, gratitude for my discoveries and pardon for my omissions. It is enough for me to have made the effort; it is just for you to forgive me my mistakes benevolently. For, I assert, nothing has ever been perfect at the moment of its invention. If anyone deigns one day to polish these crude verses or to fill them out where they are deficient, there will perhaps come about that which many will be glad to have understood with no small benefit.)

Bocchi's poetics begin with a traditional defense of poetic veiling and allegory. Plato, he claims, used familiar images to make difficult truths understandable; the Ulysses of Homer did the same with his remarkable persuasive skills. Aesop, the Phrygian poet/seer veiled difficult and obscure matter with beautiful fables as did Pythagoras of Samos with symbols or allegory (lines 16–18).[12] By this method, the poet leads not only the able but unaware student to a comprehension of deeper truth but also the "profane" masses to their first steps toward understanding. Up to this point, Bocchi seems to agree with Boccaccio's definition of poetry as fable written in "exquisite speech," but Bocchi does not in this symbol claim access to poetic furor as Boccaccio does for his poet – only to direction from Apollo and, later, from his Muse.[13]

Paradoxically, the very images and allegories that cover the truth make it manifest to ordinary readers. By stressing the teaching function of poetry, Bocchi seems closer to the purpose of poetic veils propounded by Lodovico Ricchieri (Caelius Rhodiginus) in his *Antiquae Lectiones,* Book IV (1516) and Pietro Pomponazzi in the *De Incantationibus* (1520).[14] Although Bocchi does not always seem consistent in his

treatment of hidden truth – in Symbol XCVIII, for instance, the motto is ARCANA QVAERENS CVRIOSVS, PERIT (The curious man perishes in seeking out hidden things) – he does not claim that his symbols offer the full truth, which devotees of "prisca theologia" warn against allowing the vulgar crowd to profane.[15] What his symbols yield are tiny fragments of truth accessible to those who understand the necessity of looking under the surface of the text. The pleasure of each successful attempt to find a piece of the truth whets the reader's appetite to exercise the mind in further exploration. Therefore, Bocchi does not cheapen the truth by popularizing it with pictures and fables; he brings people to wonder and belief.

On the topic of imitation, Bocchi takes a position close to that of his friend Bartolomeo Ricci in *De Imitatione libri tres* (1541) in advocating a form of imitation, moderated by art, which lies between a slavish imitation of nature and a strict adherence to one writer as a model.[16] Bocchi emulates Horace's morning bees, selecting the best literary models for his own poems (Horace, *Carmina,* 4.2.27–32); his is an art of borrowing[17] and of deprecating his own abilities. The "nature" Bocchi presents is that which is apprehended by the senses and is roughly equivalent to the inner self. The passions, however, are not mentioned.

It is the analogy between painting and poetry in this symbol that commands our attention. In poetic theory, such analogies were made as early as Aristotle's *Poetics,* although Aristotle distinguished between poetry and painting when comparing their modes of imitation.[18] The subject of the engraving (Figure 22) is painting, namely, Socrates limning a figure – a self-portrait – on an easel while his daimon leans over his shoulder (both figures are labeled in Greek characters). Daimons, according to Proclus, transmit to the artist the Idea, or intellectual form, that cannot itself reside in the human soul. The arts, therefore, cannot be produced without the aid of the appropriate daimon.[19] As he works, Socrates grasps his brush (or pen) in one hand and holds high a compass and right angle in the other. With these tools he faithfully imitates nature; with the prompting of his daimon he imitates his inner self. The tools permit Socrates to reproduce the exact proportions of his subject in his painting, or, in other words, to produce Plato's ikastic art. Perhaps the daimon also represents Plato's fantastic art, although this is unclear. Plato's view of fantastic art was negative – it creates, his Eleatic Stranger said, a surface appearance of accuracy by falsifying proportions according to rules of perspective and by inventing monsters that never existed.[20] Obviously, Bocchi himself had no quarrel with fantastic art, either with the rules of perspective so popular in the early sixteenth century or with fantastic creatures such as his chimera of rhetoric in Symbol CXXXVII.

Symbol III's illustration, like the poem, opens deep and serious matters that have previously been concealed from the understanding of the reader. The motto over the engraving reads: PICTVRA GRAVIVM OSTENDVNTVR PONDERA RERVM. QVAEQ. LATENT MAGIS, HAEC PER MAGE APERTA PATENT (A picture shows how great is the profundity of weighty matters; whatever lies hidden, is revealed through the picture's demonstrative openness). Bocchi cements the union of poetry and painting by associating his use of picture with the verbal embellishing of ancient poetry, and he links the effects on eyes of viewers and ears of listeners together in one sentence (lines 18–21). Both picture and poem have the same Horatian end of utility and pleasure (lines 22–4).[21] Like the oratory of Ulysses,

both persuade. But whereas the poet imitates the best styles of other poets, the painter follows visible nature and his own genius.[22] Poetry and painting are similar, but they are not identical.

Only in his "Index Personarvm et Rervm" does Bocchi cite the Horatian doctrine of "[ut] pictura poesis," referring the reader to the poem of Symbol III. Immediately following this symbol in the index is "Pictura vis" with the page number of that symbol's illustration. Sixteenth-century comparisons of the arts were dominated by the words *ut pictura poesis* read in various ways. Horace's famous formula (*Ars Poetica, Epistole,* II.3.361) was read by some, including Bocchi, in terms of its context as "poems at times resemble paintings." Often, however, the words were taken out of context without Horace's qualifying phrases as a brief dogmatic precept: "just as painting is (does), so is (does) poetry."[23] Such a precept could easily be manipulated, as Benedetto Varchi did in the first of two lectures before the Florentine Academy in 1547. Varchi claimed that poetry and painting were identical in their description of "illusory images," but at the same time he promoted sculpture as the "'essence' of a god."[24] Defenses of painting frequently added to the Horatian phrase a quotation by the Greek poet Simonides, known only from a citation by Plutarch, that called poetry a speaking painting and painting a mute poem.[25] A long line of defenders of painting from Leon Battista Alberti in the early fifteenth century to Leonardo da Vinci later in that century and on into the eighteenth century employed the Simonides and Horatian analogies to dignify the art of painting.[26]

The mutual attraction between poetry and the visual arts was more intense than defenses of poetry or of painting alone can explain. We see sixteenth-century writers turning the analogy around to examine it from both sides – poetry and art. When Pomponio Guarico adapted rhetorical and poetic terms to art in his *De Sculptura* of 1514, he had already commented on Horace's *Art Poetica* around 1510.[27] Lodovico Dolce proclaimed every learned writer a painter in his *Dialogo della pittura intitolato Aretino* (1557), but he concluded a comparison of imitation in poetry and painting in his *Osservationi nella Volgar Lingva* (1550): "Ne mancarono di quegli, che il Poeta parlante Dipintore, & all'incontro il Dipintore mutolo Poeta addimandorono" (There will not be lacking some of those who will question that the poet is a speaking painter and, on the contrary, that the painter is a mute poet).[28]

When word and picture were fused in the *imprese,* treatises on the subject (there were none on the emblem in this period) drew on the poetry/painting analogy. In 1562, Battista Pittoni cited the Simonides comparison of speaking painter and silent poet, and Scipione Ammirato derived the *impresa* from the equivalence between poetry and painting, defining the *impresa* as "'una significazione della mente . . . sotto un modo di parole e di cose'" (a signification of the mind beneath a mode of words and of things).[29] With *ut pictura poesis,* suggested François Lecercle, "la formule sert de cri de ralliement à cette poussière de petits genres qui unissent d'un lien nouveau et beaucoup plus étroit le texte et l'illustration" (the formula serves as a rallying point to that sprinkling of little genres that unite text and illustration by a new and much more narrow link).[30] Because the Renaissance poet or artist took *ut pictura poesis* so seriously, argued David Rosand, the modern critic should appreciate the stance as revealing the Renaissance creator's "cultural sense of himself": "*Ut pictura poesis* was

clearly more than academic rhetoric to the Renaissance poet; it was rather an active principle, indeed, a creative challenge."[31]

*Ut pictura poesis* generated other analogies as writers further explored relationships between words and the arts. There was, for example, Antonio Lull claiming that the analogy between painting and oratory is more precise than that between painting and poetry:

> Quid enim orationi similius, quam pictura? Equidem quod alij de poesi dixerunt, id ego aptius magis*que* proprie dixerim, orationem loquentem picturam esse: picturam vero, mutam orationem.
>
> <div align="right">(Abbreviations expanded by italics)[32]</div>

> (For what is more like a speech than a picture? The claim that others make concerning poetry, I, for my part, would restate more aptly and precisely as follows: namely, that a speech is a picture that speaks, while a picture is a speech that is mute.)

Music was compared to rhetoric,[33] to architecture,[34] and, more often, to poetry.[35] Music theorists following in the footsteps of Pietro Aaron and Giovanni Spataro (known to Bocchi, as we saw in Chapter 1) coined the terms "musico poeta" and "poetici" to distinguish practitioners of the new expressive style of composition from that of the traditional "mathematici," and, in turn, their musical styles contributed to poetics:[36] "Et di qui è che la musica Cromatica piu che la Diacronica m'aggradisce: nel modo che piu la Tragedia che la Comedia," commented G. B. Pigna (and from this it is chromatic music more than the diachronic that pleases me: in the same way, tragedy more than comedy).[37] Architecture was compared not only to language, an analogy favored by the followers of Vitruvius, but also to poetry and rhetoric.[38] Nor did similarities between history and poetics go unnoticed.[39]

The sixteenth-century theorists, then, were reading treatises, sometimes highly technical ones, on all the arts. They were expressing thought *on* images in an iconic way. It is hard to say whether the poets' language drew more upon images, as Claude-Gilbert Dubois has suggested, or whether their images are more marked by the "peculiar dependence of visual symbol on verbalization," as Walter J. Ong posits.[40] Ong found an explanation in the transition from a verbal/aural to a visual organization of culture in the Renaissance.[41] Certainly, the ability of the printing press to spread illustrated texts to an expanded audience contributed to the writer's desire to enhance verbal images with visual ones.[42] The poetic theorist's analogies may also stem from ways of thinking about the place of poetry among the other arts and sciences and from experimentation with new schemes of classification, as with Sperone Speroni's "pleasurable" arts, which are arranged according to whether they please the spirit (rhetoric and poetry) or whether they appeal to bodily senses (painting, music, perfumery, cooking, and heating).[43]

Bocchi's organization, which can be partially extrapolated from his "Syntagma" (a classified index), divides into "Theologica," "Physica," "Moralia," and "Philologia." Philology is a humanist grouping of the discursive, or "instrumental," sciences. Under the heading "In Qvarta Classe Svnt Philologica" fall Symbol III on poetics, Symbol XXXVI on art, Symbols XLIII and XCIIII on eloquence, Symbol L on disputation, Symbol LXII on dialectics, and Symbol CXXXVII on rhetoric. Bocchi's

classification is, of course, of poems rather than a schematic chart of the sciences, but it does indicate that he, like so many of his peers, was also thinking through the relationships between fields of study.

When we move to specific comparisons of their relationships to poetics, we find that the very terms *emblem* and *symbol* have certain literary contexts. Each term had a preexistent association with Roman literature. *Emblemata* as inlaid ornament figured in Lucilius' criticism of the *literary* style of Titus Albucius, and mosaics (not the type termed "emblemata") were compared to the "Asian" linguistic style by Cicero; in both cases the literary style was deemed ornate and lifeless.[44] The symbol did not occur in a parallel role in poetic style; however, according to Coluccio Salutati, it is the use of symbols that characterizes poetry, and, to Julius Caesar Scaliger, in his *Poetices libri septem* (1561), all language is symbolic, and words, like pictures, are images of things.[45] In addition, a *symbolon* in the *De Elocutione* (paragraph 243), attributed to the Greek Demetrius (or Demetrios), is a rhetorical figure similar to allegory.[46] Thus, the use of the terms *emblem* and *symbol* in literary contexts as well as visual ones may have facilitated their adaptation for a mixed genre.

In a culture that was actively transferring the literary terminology inherited from classical rhetoric to the description of art and music,[47] it is not inappropriate to suggest that certain techniques and figures contributed to the kinds of visual/verbal associations found in emblem and symbol. Chief among these rhetorical techniques in its resemblance to the *ut pictura poesis* formula is *ekphrasis,* or the verbal evocation of an object, picture, or scene – the poet's speaking pictures. The Renaissance poet, following ekphrastic practices established by Alexandrian poets, strove to render the visual impact of an object, often a work of art, by the immediacy and vividness of a description that was not necessarily "realistic."[48] This type of literary creation, which Jean H. Hagstrum termed "literary pictorialism," went back at least as far as Homer's shield of Achilles and was sometimes called "iconic," as in Lucian's dialogue *Eikones* and the Elder Philostratus' prose *Imagines.*[49]

The fact that several of Bocchi's symbols portray statues and that many of the emblems of Petrus Costalius (Coustau, or Costal) in *Pegme* are explicitly termed paintings or sculptures links them to the ekphrastic poems of the Greek Anthology and to passages in other classical works.[50] Symbols LXIII and CXXI are companion pieces – one, dated 1548, on the discovery of an ancient statuette of favorable Fortune and the other, dated 1549, a statuette of Ill Fortune.[51] In each, the first half of the poem describes the newly discovered antiquity in terms of attributes, missing limbs, and expressions on faces. The second half of each poem interprets the meaning of the image and applies this symbolism to Bocchi's own time – to a Bologna enjoying peace, prosperity, and justice in 1548 and to a Bologna suffering under a malign, prostituted Fortune in 1549. Both poems could stand alone, because the description is adequate. These symbols of Bocchi, however, differ from ancient ekphrasis in their explicit allegorizing.

Furthermore, Bocchi's descriptions in Symbols LXIII and CXXI are lacking in vividness and emotional evocativeness, qualities crucial to successful ekphrastic poetry. For this vivid quality in pictorial description, poets often borrowed the rhetorical term *enargeia* to indicate the technique for making the reader "see" the text. The term frequently appeared in discussions of ekphrasis and *ut pictura poesis,*

and Julius Caesar Scaliger included its Latin counterpart, *efficacia,* as one of four "virtutes poetae."[52] Aristotle, however, substituted the term *energeia* for oratorical vividness. According to Jean Hagstrum, this produced a quite different effect:

> *Enargeia* implies the achievement in verbal discourse of a natural quality or of a pictorial quality that is highly natural. *Energeia* refers to the actualization of potency, the realization of capacity or capability, the achievement in art and rhetoric of the dynamic and purposive life of nature. Poetry possesses *energeia* when it has achieved its final form and produces its proper pleasure, when it has achieved its own independent being quite apart from its analogies with nature or another art, and when it operates as an autonomous form with an effectual working power of its own. But Plutarch, Horace, and the later Hellenistic and Roman critics found poetry effective when it achieved verisimilitude – when it resembled nature or a pictorial representation of nature. For Plutarchian *enargeia,* the analogy with painting is important; for Aristotelian *energeia,* it is not.[53]

One problem for midsixteenth-century emblem books was how far they could develop the ekphrasis and *enargeia* their authors had been trained to admire. Too vivid a verbal description of the figure of the emblem rendered that picture redundant, but too little correspondence between poetry and picture violated entrenched expectations concerning the closeness of poetry to painting. Alciato's ties to the ekphrastic tradition ensured that his poems could be read apart from their pictures (and they were sometimes printed that way).[54] This was true of most of the early French emblem books – Corrozet, La Perrière, and Guérault – although Barthélmy Aneau in 1551 published some emblems for which the picture was essential to the understanding of the poem.[55] Bocchi's two symbols of Fortune clearly rely on ekphrasis for their self-contained poems. Symbol III on poetics, discussed earlier in this chapter, does not: Its poem can stand alone but neither describes the engraving nor completes the analogy by itself. Poets came to the emblem from the Horatian tradition of literary pictorialism; they were eventually forced to move away from *enargeia* in their emblem verse toward Aristotle's *energeia* in order to permit the total unit of picture, motto, and poem to realize its full potential.

Figurative language – called variously tropes, *colores,* figures of speech (figures of words and figures of thought) – contributed to the emblem in several ways. First, it added to the quality of vividness associated with the mix of verbal and visual. The most familiar of these figures are metaphor (Latin: *translatio*), simile, and allegory.[56] To borrow an example popular among English Renaissance writers, a simile is *like* a star, a metaphor *is* a star, and an allegory is a *constellation.*[57] Aristotle molded the *eikon,* which depended on his concept of *energeia* for vivid description, into a figure equivalent to the metaphor. Like the metaphor, this figure instructs by means of logical demonstration and delights the reader.[58] The *eikon* is similar in function to the *imago* (a type of oratorical proof) of Cicero and the *Ad Herennium.* As a broader category in Quintilian, the *imago* contains within itself both simile and metaphor, as well as the *signum* (demonstrative evidence).[59] Both *imago* and *eikon* imply a visual effect; George Puttenham termed the *eikon* a kind of similitude, a "*Resemblance* by *Pourtrait* or *Imagery,* which the Greeks call *Icon.*"[60]

Second, the structure of some figures of speech can be seen as analogous to that of the emblem. Although sixteenth-century critics lacked a highly developed theory of metaphor, there were some attempts to link emblem to metaphor and simile.[61] As early as 1539, William Hunger, in the preface to his German translation of Alciato's emblems, alluded to the yoking of poetry and painting in the emblem as yielding "the most effective metaphor."[62] The analogy functioning in the emblem and symbol may have suggested the simile to Guillaume La Perrière, whose *Morosophie* of 1553 borrows extensively from the compilation of similes in Erasmus' *Parabolae sive Similia*.[63] To Scipione Bargagli (1578), the *impresa* was a kind of similitude or metaphor in which the transference of meaning theorized by Aristotle took place.[64] Other late-sixteenth-century writers on the *impresa* also saw the Aristotelian transference (*translatio*) of meaning taking place between the two parts (now called "body" and "soul") of the *impresa,* with the metaphoric and obscure sense residing in the words (or "soul"). The actual figure of speech employed was said to be metaphor, simile, or metonymy (the figurative substitution of one word for another), and sometimes other more specialized terms were listed.[65]

Furthermore, the metaphoric qualities of emblem and *impresa* suggested to the theorists the quality of the marvelous; by the seventeenth century, the relationship between metaphor and *impresa* was being explored by Emanuele Tesauro for its *arguzia* and by Baltasar Gracián (1648), who found in both figures "startling observations in obscure language."[66] More recently, the riddle as metaphor and as emblematic method has been studied by Andrew Welsh. According to Welsh, "The full form of the riddle, we saw, is essentially a metaphor with one element concealed; similarly, it is possible to see the emblem as a metaphor existing in a dual medium."[67] There has also been some discussion of emblems as a continuation of medieval allegory.[68]

Bocchi does not tell us whether he thought of his complete symbolic units as metaphor or simile. Nevertheless, because the *symbolon* as an allegorical figure of speech would have been one of the many forms of symbol he collected, there is some basis for assuming that he thought of his own *symbola* as a type of verbal figure.

Third, the allegorical figures of speech, which include metaphor, allegory, *collatio* (comparison), *symbolon,* and irony, all conceal something, all say something different from what literally appears on the surface of the text. Recognition of this covert quality in literary figures came early. Demetrius, the only early rhetorician to treat the *symbolon* as a rhetorical figure, classed it as an abbreviated form of allegory akin to metaphor:

> For this reason symbolic expressions [*symbola*] are forcible, as resembling brief utterances. We are left to infer the chief of the meaning from a short statement, as though it were a sort of riddle. Thus the saying "your cicalas shall chirp from the ground" is more forcible in this figurative form than if the sentence had simply run "your trees shall be hewed down."[69]

The symbol, according to James Coulter, played an important role in Neoplatonic literary theory: "The symbol hints, but because it hints it also hides. And what is concealed is related to what is revealed by unseen correspondences" (that is, by

analogy).[70] This concealment was also noted by medieval writers on poetics such as Geoffrey of Vinsauf. Geoffrey's metaphoric *collatio occulta*, Peter Dronke observed, "illuminates the relation between the poet's imagery and his theme":

> It is a paradoxical relation: at first it seems that, no matter how intimately image and theme can be conjoined or unified, this can never result in a complete fusion. There is always an element of "dissembling."[71]

*Dissimulatio*, either as an ironic strategy or a synonym for the allegorical figure *ironia*,[72] was familiar to sixteenth-century authors from the lengthy and problematized treatment of irony in Book Two of Giovanni Pontano's *De Sermone* (completed in 1502) and from theories of laughter, such as Vincenzo Maggi's "De Ridiculis" (1550) and Trissino's *Poetica* (1529).[73] Perception of doubleness in rhetorical figures reached a peak with George Puttenham's *The Arte of English Poesie* (written around 1579) in which *allegoria*, named "*false semblant or dissimulation*," leads a whole crew of dissimulating figures, including enigma (riddle), irony, *sarcasmus*, hyperbole, and periphrasis (or ambage):

> To be short euery speach wrested from his owne naturall signification to another not altogether so naturall is a kinde of dissimulation, because the wordes beare contrary countenaunce to th'intent.[74]

By the seventeenth century, the transfer of meaning in a trope evoked admiration; in the words of Emanuele Tesauro, "L'Vltima Metafora è la DECETTIONE: diffi-cile e rara nelle Argutezze Verbali; ma piaceuole, & frequente nelle Simboliche."[75]

A few writers of emblems discuss dissimulation as a topic, among them Guillaume Gueroult (1550), Guillaume de La Perrière, and Petrus Costalius (1556), the latter alluding to a "faux semblant" as Puttenham would later do.[76] In a sense, every emblem, because it draws on a figurative relationship like metaphor and allegory, dissembles. In the emblem, however, the metaphorical process is often explicated and made more explicit; the illustration tends to represent the figure and the text the figural extension or interpretation. Ideally the true meaning cannot be ascertained until the riddling elements are conjoined. For Bocchi, this means that a certain level of training and intelligence will permit full understanding by some readers and restrict it among others. This is an intentional kind of deception but not necessarily indicative of a false position. Nor can we accuse Bocchi of a consistently ironic tone, for despite his devotion to serious play and to the idea of Socratic irony, there is an earnestness about his symbols that precludes a jesting doubleness.[77]

Poetic and rhetorical techniques such as ekphrasis and figures of speech contributed to the conception of the emblem. Another technique useful to emblem study, *varietas*, was of great importance to humanist poetics and represented to Marco Girolamo Vida and Julius Caesar Scaliger one of the virtues of the poet.[78] The emblem, according to Diego López in an address on Alciato (published in 1615), was the ultimate form of rhetorical *varietas* in its abundance of picture, "historia," morality.[79] Bocchi appears to have considered the need for variety quite seriously in the *Symbolicae Quaestiones;* he varies length, subject matter, tone, and degrees of difficulty

more than any other sixteenth-century emblematist. There are facetious symbols, moralizing symbols, symbols in praise of individuals, and deep allegories. In general, the emblems become progressively more symbolic and difficult, but a few lighter touches continue to liven the text even in Book V. The virtuosity of Bocchi's performance raises the question of whether such variety can exist in an emblem book without threatening the balance between text and picture.

In addition to the role of poetic techniques, the issue of genre also arises. The poetic genres of epigram and ode may also have contributed to the development of the emblem and symbol, although sixteenth-century theory does not explore this possibility in depth.[80] Several modern critics have suggested that the ekphrastic epigrams of the Greek Anthology were emblems in everything but the name.[81] Etymologically, the epigram originally meant "inscription," and as the inscription, or *titulus,* appended to a classical statue or inserted into a medieval wall painting, it can be viewed as a precursor of the Renaissance emblem.[82] Dieter Sulzer offered the possibility that the emblem may have developed from two-part epigrams like those of the *Physiologus* with the picture/verse combination of the emblem a parallel to the *ut/ita* (just as/so) structure of the epigram.[83] The quatrains themselves in the 1553 *Morosophie* of La Perrière follow this pattern very consistently, often with a parallel foreground/background structure in the engravings (which are never necessary for understanding the verses); unlike Bocchi, La Perrière pursued a goal of "uniformité."[84] Bocchi may also have found the ode generically suggestive. Pindar's odes, according to Carol Maddison, begin with a "brilliant opening, often an image, or a piece of gnomic wisdom, sometimes a prayer or an invocation," and they conclude in a reflective mood and with a moral tone.[85] Horace's odes have been studied for their "epigraphic technique" – the "practice of beginning an Ode with a motto-like citation of another poet." To Gian Biagio Conte, this "new text therefore tends to become a visible 'sign' of the old."[86] Some of Bocchi's *symbola* parallel the structure of the odes with their (detached) mottoes, visualized allusions to specific occasions or praiseworthy individuals, and reflective verse commentary.

Genres not poetic in origin – especially the paradox, question, and dialogue – demonstrate the commonality of serious play between Bocchi's symbols and the literary activities of the academies. The question (*quaestio, problemata, dubbio*) originated in collections of scientific problems from the time of Aristotle. Both the question and the paradox had rhetorical functions as well. From the Sophists' paradoxical encomia to Erasmus' *Moriae encomium* (1511), from Cicero's collected *Paradoxa Stoicorum* to the *Paradossi* of Ortensio Landi (1543), and from Cicero's discussion of the limited and unlimited question in legal oratory to Hieronimo Garimberto's *Problemi* (1549) and Ortensio Landi's *Dubbi* (1552), these professional and scholarly genres shifted to a popular, vernacular form. The question, in particular, closely tied to dialogue, also had a long tradition in amatory poetry, beginning with medieval Italian and Provençal question and answer poems (*joc-partit, partimen*) and developing into the games so popular in the sixteenth century according to Girolamo Bargagli and Innocenzio Ringhieri.[87]

Some of Bocchi's dialogic symbols adopt a question and answer technique, either beginning in a formulaic pattern ("Dic age Melpomene," CXLI, and "Dic Musa quaeso," XC) or inserting the question into the center of a miniature dialogue as in

the "Hospes" of Symbol XXXIX: "Dum mundi autorem, mundum gestares et ipsum / Quaeso vbi tum fuerat, dic mihi, Christophorus" (Tell me, please, Christopher, where you had been up to the time when you carried the creator of the world and the world itself?). Just as in ancient rhetoric the problem was to identify the *quaestio*, so in Bocchi's *Symbolicae Quaestiones* the keys to the symbols are the questions themselves.[88] Many of the poems do follow a question and answer pattern, but in keeping with Bocchi's practice of *variatio* sometimes only the question is posed within the text and the answer left for the reader to determine (XIX and LXXXI), whereas at other times the title functions as a question (XXXVI and LXXX) or the question is posed in abbreviated form in an inscription within the picture ("Qvod Sat Est," LXVIII). Responsibility for stating the question can fall on the reader (CXVI), because the question is of equal importance to the answer.

After genre, there is the issue of style and of Petrarchism, *the* literary style animating not only Italian poetry in the sixteenth century but also neo-Latin and the vernaculars of all Europe. Petrarchan conceits inspired love themes in emblem poets, especially Maurice Scève in his *Délie* woodcuts, Daniel Heinsius' *Emblemata amatoria* (ca. 1602), and Otto Van Veen's *Amorum emblemata* (1608). According to Leonard Forster, "The visual character of Petrarch's imagery made its transposition into pictorial form extremely easy; the mottoes to the emblems are often taken from Petrarch's sonnets."[89] Bocchi, as Mario Praz noted, published a few emblems that "repeat Alexandrian and Petrarchan erotic themes."[90] Several of these Bocchian treatments of amorous themes, however, involve Eros and the Platonic Anteros (Symbols XX and LXXX), and others develop myths not associated with Petrarch, such as the metamorphosis of Pitys into a Pine (CL) and Pan vanquished by Cupid (LXXV). The two symbols most "Petrarchan" in subject – "Rivalitas Cupidini durissima" (VI) on Cupid shot by his own bow and "Amor negociosus in ocio" (VII) on blind Cupid – appeared first in Bocchi's youthful manuscript collections of poems. Symbol VII ends with the oxymorons common to Petrarchan poems: "Unde est mors viuens, irrequieta quies" (whence comes living death and rest that knows no rest). Symbols devoted to the theme of erotic love occupy a very small percentage of the total – quite the inverse of Petrarch's *Canzoniere,* in which poems unrelated to love (on Italy, on the corruption of the Avignon papacy, in praise of the Colonna family, on grief over the death of friends, and, at the very end, on the Marian "Vergine bella") form the minority of poems. In Bocchi's work, the enflamed heart, and, more often, the enflamed mind are charged by divine love; desire appears only in sublimated form.

Both Bocchi and Petrarch structured their collections. Whereas Petrarch grouped his sonnets around three clusters of longer *canzoni* and devised a complex calendrical structure based on the anniversaries of the event of the *innamoramento,* Bocchi, because of his more varied topics, imposed a numerical and architectural division into five books, four of them almost equal in length (with thirty-two, thirty, thirty-one, and thirty-one symbols respectively) and the fifth somewhat shorter (twenty-seven symbols) but containing the majority of the long poems.[91] Bocchi's is an externally organized structure that mirrors the facade of the Palazzo Bocchi with its five vertical bays and five above-ground levels. Bocchi's symbols become increasingly complex and abstract as the work progresses, but there is no fundamental change, no

conversion as in Petrarch, nor would a change be possible when such emotion as does surface is more public than private.

Where the *Symbolicae Quaestiones* and the *Canzoniere* reveal their kinship is in the strong personae – Petrarch's poet as imperfect lover and Bocchi's poet as perfect academician – with which their creators endowed them. To my knowledge, no other emblem collection portrays its author to the extent that the Bolognese work does, although Bocchi's pupil Johannes Sambucus comes close. Symbol I illustrates Bocchi's personal *impresa*, Symbol II his portrait by Prospero Fontana, Symbol V the Bocchi coat of arms, Symbol XXVII his modest private life, Symbol LIX Bocchi the father chastising an errant son, Symbol LXXXII the illustration from his medal, Symbol CII the *impresa* of his academy, Symbol CIX the Palazzo Bocchi, Symbol CXVIII his presence at a banquet, Symbol CXLV his poetic laureation, and Symbol CXLVII his tribute to his son Pirro. Other emblems are dedicated to close friends such as Romolo Amaseo and Sebastiano Corrado, to patrons (especially members of the Farnese family), and to students. And yet, Bocchi's persona remains an externalized one, quite different from the lyrical, internalized voice of the Petrarchan persona. His is the academic ideal of a human presented in a way that Sambucus, who also portrays himself as a scholar, does not follow.[92]

Bocchi's persona performs a linking function as well, binding into a fictive and ideal academy all the individuals named as dedicatees. As a recurrent theme, the idealized Bocchi joins such other themes as Hercules, labor and leisure, Mercury and Athena, Fortuna, and divine wisdom both to reinforce his message and to unify the work. The loosely emplotted lyrical sequence of Petrarch had also drawn on recurrent motifs: the blond hair, the laurel, the broken column, the anniversary. Some subtle links between adjacent symbols were another unifying device employed by Bocchi, as in the interior of a lecture hall in Symbol CXLIIII and the exterior of the lecture theater as labyrinth in Symbol CXLV, both implying criticism of popular university teaching methods. Or, in Symbols LIX and LX, two mirrors contrast: the anamorphic mirror reflects a soul in need of cleansing in the burning light of divine truth, whereas the burning glass of the following symbol demonstrates a heart already immolated by a pure love of God. Where two or more symbols are closely linked by subject, usually at least one of them involves Bocchi's persona; in the afore-mentioned pairs, for example, Symbol CXLV depicts Bocchi crowned with laurel and Symbol LIX his role as a father exhorting an errant son.

In conclusion, the literariness of early emblems, and of Bocchi's in particular, compel a critical reevaluation of the role of sixteenth-century poetics in the generation of emblems. Daniel Russell, who theorized that both picture and poem are to be read as parallel texts, commented:

> By presenting the emblem as a double "text," and the emblem's audience as "readers," I have wished to stress that, contrary to the belief held by most students of the emblem (until quite recently), the emblem is primarily a literary phenomenon. This becomes clear if the emblem is considered as a double method or mode of apprehension and communication rather than as the "Doppelform" implied by certain German critical and historical studies of the emblem.[93]

In Bocchi's *Symbolicae Quaestiones*, it is particularly tempting to read the picture as a text because there so often is text within the pictures. Yet the theoretical relationship between text and picture in the formula *ut pictura poesis* requires taking seriously the picture *as* picture. Poetics may have stimulated the formation of the emblem, but the specification of the relationship between poetry and painting remained the emblem's goal.

 CHAPTER FIVE

# Bocchi and the Symbol

Qvid Symbolum sit, ne amplius
Roges, breuissime, vt potest,
Conabimur nunc edere.
(Symbol I: SYMB. SYMBOLORVM)[1]

In the *Symbolicae Quaestiones*, Bocchi probed the multivalent *symbolum*. By using an emblematic medium, he avoided the constraints of a formal, logically structured work in treating a topic of great fluidity and scope. Polysemy offered Bocchi an indication of the value of a word or symbol; it opened up what had been closed; it replaced poverty of meaning with copiousness. Always, there was a certain tension between this multiplicity (and looseness) of meaning and the singularity of the original meaning, from whose sacred and irrational sources the Greek and Latin symbols retained only traces. Always, there was a certain ambiguity. Abner Cohen defined the symbol in this way:

> Symbols are objects, acts, concepts, or linguistic formations that stand *ambiguously* for a multiplicity of disparate meanings, evoke sentiments and emotions, and impel men to action. They usually occur in stylised patterns of activities like ceremonial, ritual, gift exchange, prescribed forms of joking, taking an oath, eating and drinking together.[2]

The emblem as genre permitted a full exploration of both the visual and the verbal aspects of symbolism in a way that text alone could not accomplish. By the Renaissance, the symbol had come to signify an object (a Greek token), a verbal construct (such as motto, fable, and riddle), a visual image (the hieroglyph), or a mixed verbal/visual formula (such as emblem and *impresa*). Except for some of the most ancient of the Greek *symbola*, symbols extend their meaning beyond the surface of literality. For Bocchi, most important was the hidden meaning, pure and sacred. For this reason, the study of symbol in this chapter proceeds from the simpler, earlier symbols toward the most complex and emblematic forms of the Renaissance in order to recapture Bocchi's understanding of the symbol. Bocchi himself provided a partial guide to symbols and their interpretation in his opening emblem, his "Symbol of

Symbols" (SYMB. SYMBOLORVM, Figure 4) dedicated to the "Elegant and Studious Reader," from which I quote:

Est nanque signum συμβολον
Vt signa militaria.
Collatio etiam dicitur,
Quod multi in vnum conferunt.
Hinc symbolum Terentius
Poeta dixit nobilis.
Orator ARPINAS notam,
Sed Anulum Graij vocant
Plaerunque signatorium.
Porro omen, atque insignia.
Isto quoque ipso nomine
Quaedam notantur tesserae,
Quae a ciuitatibus dari
Solent quibusdam, publice
Vt quenque par sit accipi,
In foederatis oppidis,
Amice, & hospitaliter.
Sic possumus iam tesseras
Vocare collybisticas,
Quasi institutas omnibus
Mutandam ad externam locis
Pecuniam, quae litterae
Vulgo feruntur cambij.
Pollux nomisma paruulum,
Stagyraeus ille maximus
Vocabulorum originem:
Quam originationem ait
Fabius. fuere symbola
Priscorum in arcanis diu
Mysterijs, vt gratia
Verbi, papauer fertilem
Signabat annum. Huiusmodi
Sunt Pythagorica Symbola
Αλληγορίαι, Αινίγματα,
VT ALCIATI Emblemata
Dicuntur & συνθηματα,
Mysteriorum plena, quae
Documenta commodissima
Illa omnium, & pulcherrima
Vitae, atque morum continent,
Sanis retecta, caeterum
Incognita imprudentibus.

(I, lines 4–45, abbreviations expanded)

97

("The Greek term *symbolon* ['symbol'] means a sign – a military standard would be an example of one. One might even refer to a symbol as an "amalgam,' because many people combine such things into a whole. The great poet Terence uses *symbolus* ['symbol'] in this sense. When the orator from Arpinum [Cicero] uses the term, he means 'distinguishing mark,' whereas the Greeks, when they use it, usually mean a 'signet-ring.' It can also mean an 'omen' or 'token.' This same term 'symbol' is also used to designate those vouchers that are customarily given to certain people by states, entitling the holder, in allied towns, to a reception that is friendly and hospitable. By 'symbols,' moreover, we may refer to 'moneychanging tokens,' established, as it were, for the exchange of foreign currency in every location, equivalent to what popularly are called 'bills of exchange.' Pollux said that originally the term referred to a small coin, and that that great philosopher from Stagira [Aristotle] was of the same opinion. Fabius [Quintilian] concurs that this was its etymology. Symbols were for a long time employed in the secret rites of the ancients. The poppy, for example, signified a fertile harvest. Of this same kind were the Pythagorean symbols, the so-called *allegorai* ['allegories'], *ainigmata* ['enigmas'], as the *Emblems* of Alciato are called, and *sunthemata* ['conventional signs'], being full of secrets, and containing those fitting and magnificent examples of all things – of life and of character – revelations to men of sound mind, but unknowable to the ignorant." Adapted from Thomas Marier's translation.)

## Symbol as Thing (Res)

As nouns, the terms *symbolon, symbolos* (Greek), and *symbolum* (Latin) drew their derivation from the Greek verb *symballein*, "to join or bring together."[3] The *symbolos* was an "omen or augury, such as predictions made from entrails of birds or the positions of the stars."[4] The *symbolon* from the first had a legal and monetary function: As a tablet, or piece of bone or rod cut in half so that the two parts fit together like pieces in a jigsaw puzzle, it served to identify the two parties of a contract, whether in payment of tribute or in visits to a strange city on business or for some other purpose requiring prearranged hospitality.[5] *Symbola* also were the monetary contributions brought together to finance banquets and were the tokens given in payment on entering a Greek theater.[6] When used for identification, the symbol, and especially the Roman *symbolum*, often meant a signet ring.[7]

Because the joining of the two parts of the oldest *symbola* implied that something was added to the meaning of the whole, the term "symbolon" very early on "by metaphorical extension," according to James A. Coulter, "was applied to any object, word, or event whose significance was not readily self-evident (and therefore somehow intriguing) and which also, for that reason, required for its interpretation some special prior knowledge on the part of the interpreter."[8] Thus, the Greeks called a celestial sign believed to portend a future event a *symbolos* or *symbolon*.[9] The distinction between the two words became blurred. *Symbolon* was, in fact, for the Greeks (including Aristotle) a synonym for the word "sign" (*séma, sémeion*), which had at first indicated those marks that distinguished one person, animal, or object

from another and was later extended to include divine messages (thunder, lightning, shooting stars, eagles fighting in the sky, and similar phenomena) or a mark indicating possession (such as military insignia, a branded slave, or a tomb). Signs could be the secret messages of oracles as well.[10] Although modern theorists go to some lengths to distinguish between sign and symbol,[11] the figurative and conventional signs were by the Hellenistic and Roman period referred to as both "sign" and "symbol." That is, crowns of victory or of royalty, coins, military insignia, and signs indicative of secret communities, all of them originally called "signs" or *séma,* could also be termed *symbola.*[12]

Renaissance scholars inherited the late antique confusion between sign and symbol, and Bocchi profited from that coalescence in his *Symbolicae Quaestiones.* Besides the explicit equation of "signum symbolon" in line 4, Symbol I alludes to a number of signs and symbols that were things: military insignia, contributions (*collatio*) in the sense given by Terence (that is, for banqueting expenses), the tokens (*nota*) of Cicero, signet rings, *tesserae* (the two-part symbols of identification), *collybisticae* (currency exchange or letters of exchange), small coins, and omens. Some of these symbolic objects enrich the engraved illustrations of Bocchi's symbols. For example, the military insignia of Emperor Charles V (Symbol XXI) enabled Bocchi to interpret the double eagle as a symbol of good government, whereas a symbolic helmet fashioned as a dragon's head represents the blind pride of Alexander of Macedon (LXVI). In another *exemplum* (CXIX), this one demonstrating wisdom on the part of Alexander, the Macedonian is depicted in the act of placing a signet ring in the mouth of the courier Hephestion, who had read a letter entrusted to his services, a letter containing slander and "plurima arcana"; the ring is a sign commanding Hephestion to silence concerning those secrets (Figure 15).[13] Bocchi's Symbol CV exemplifies a Greek and Roman version of theater *symbola:* Officials on the stage of a circular theater throw coins to the crowd to buy their favor.[14] Money more than honor draws the vulgar masses to the "Spectacula," but here Bocchi is probably dealing out covert criticism of the practice of the popes and emperors of his own day throwing coins to people watching ceremonial entries. Although Bocchi did not illustrate the two-part symbols of exchange, Claude Paradin's second edition of *Devises Heroïqves* (1557, first published 1551) depicts a medieval version of the two jagged-edged halves of a coin that was said to have restored Childericus, fourth king of France, to the throne (Figure 23).[15]

Other Bocchian *symbola* refer more directly to the sixteenth century by honoring families through their coats of arms. Some of them appear to have been written to congratulate their dedicatees on their accessions to high office. The Del Monte (Julius III) and Medici (Clement VII) coats of arms are accompanied by papal tiaras (CXI and CXLVIII), and those symbols dedicated to Cardinals Alessandro Farnese (CIX), Ranuccio Farnese (XXXIII), Alessandro Campeggi (CXXIII), and Othonius, cardinal of Augusta (Cardinal Otto Waldburg of Augsburg, CXXXI), add cardinals' hats. There are only a few nonecclesiastical personages so honored. Atop the coat of arms of the Bolognese Ruini family (CXLVI) is a triple-headed portrait bust of Carlo, Antonio, and Isabella Ruini fashioned after the three-faced symbol of Prudence.[16] Bocchi's own coat of arms, crest, and insignia (V) are presented to him by a mythical ancestor, "Bocchvs Rex," probably Bocchorus, one of the last pharaohs of Egypt.

He accepts a shield with three stars on an azure field: "Avrea norma tribus stellis circundata signat / Ceruleo Bocchi stemma tuum in spatio" (A golden square surrounded by three stars in an azure field adorns your coat of arms, O Bocchi).[17]

Most of these symbols as things (res) have as their added meaning a political or historical signification not difficult to grasp. Symbolic things like omens (mentioned by Bocchi in Symbol I, but not illustrated) and hieroglyphs, however, conceal their meaning more deeply. The hieroglyphs, believed to be pure picture-writing (ideographs) and proclaimed by Bocchi as the most ancient and mysterious form of symbol, were images of things and concepts. It was Andrea Alciato's interest in the interpretation or "reading" of hieroglyphs that contributed in part to the creation of the first book of emblems. According to the Milanese lawyer in his *De Verborum Significatione* (1542): "Verba significant, res significantur. Tametsi et res quandoque etiam significant, ut hieroglyphica apud Horum et Chaeremonem, cujus argumenti et nos carmine libellum composuimus, cui titulus est Emblemata," which Bernard F. Scholz translated as "Words denote, things are denoted. However, things, too, at times denote, as for example the hieroglyphics in Horus and Chaeremon. And on the basis of this idea we, too, have written a book of poems with the title *Emblemata*."[18]

Hieroglyphs, although a partially phonetic language among the Egyptians, were believed by the Greeks to form a symbolic, allegorical language, just as Egyptian animal gods were seen by Greeks as symbols of gods rather than as the gods themselves. The Greeks did not try to save evidence of a dying language; they merely projected their own very different kind of abstract and symbolizing thought onto what little was left to learn of a late version of the Egyptian language.[19] Among the later Greeks – historians, Neoplatonists, early Christian fathers – the hieroglyphs enjoyed a resurgence of interest, which scholars have gone so far as to call "Egyptomania."[20] Examples were preserved of hieroglyphs viewed as representations of words (Ammianus Marcellinus), as moral symbols (Plutarch), as enigmas (Plutarch), and as allegorical concepts (Plotinus).[21]

By the Renaissance, however, of the many Greek works on hieroglyphs, only a fragment from Chairemon and an imperfect manuscript by the Egyptian Horapollo (or, Horus Apollinus Niliacus) survived. The latter, transcribed by a Greek named Philip, surfaced on the island of Andros and was carried back to Florence by Cristoforo Buondelmonte in 1419. The presence of this text in Italy initiated a humanist vogue for hieroglyphs and everything Egyptian.[22] A copy of Horapollo accompanied Cyriaco D'Ancona to Egypt in 1535 in a search for inscriptions that might match the hieroglyphs contained in it.[23] Another copy, translated into Latin by Giorgio Valla, remained unpublished, although Filippo Beroaldo the Elder, one of Bocchi's teachers, made an epitome of it.[24] Then came the publication of the Greek text by Aldus Manutius in 1505 and the Latin translation by Bocchi's friend and Alciato's teacher, Filippo Fasanini, in Bologna in 1517.[25]

The excitement over hieroglyphics in learned circles in Florence,[26] Venice,[27] Bologna,[28] and Germany[29] was not matched by a corresponding abundance in their applications to emblems. This was due in part to the strangeness of the symbolism, especially that of Horapollo, to the European mind.[30] In the midfifteenth century, Leon Battista Alberti had optimistically championed the use of hieroglyphs on

buildings and monuments as a "readable" and unvarying substitute for languages, which change over time.[31] By the early sixteenth century, when doubts had surfaced about the possibility of creating a permanent visual code, scholars turned to more limited and pragmatic applications of hieroglyphs. Fasanini recommended the use of hieroglyphs as a code to enable a small network of highly educated individuals to keep their correspondence private or to provide a secret language between lovers. Other practical applications for hieroglyphs suggested by Fasanini were in the decorative arts, the study of natural history, and mnemonics.[32]

Creators of emblems drew on hieroglyphs both for subject matter and for a concept of a visual symbol that could be understood in a flash as a signifying thing (Alciato's "res ... significant"). This concept of the immediacy of the image also entailed a belief that a series of images could be grouped together to permit the instantaneous comprehension of a concept or proposition without the intervention of language.[33] In fact, there seems to have been little effort put into placing the hieroglyphics of Horapollo and the Greek sources into readable clusters.[34] One Renaissance author who did try to compose readable hieroglyphic inscriptions created his own hieroglyphs, largely based on images from an antique Roman frieze. This was Francesco Colonna, author of the allegorical romance, *Hypnerotomachia Poliphili,* published in an elaborately illustrated edition in 1499.[35] Colonna devised several hieroglyphic inscriptions, translated them, and provided commentary. Although Bocchi reproduced one of Colonna's hieroglyphic inscriptions with only superficial alterations in his Symbol CXLVII, dedicated to his son Pirro, he barely alluded to Colonna's translation of the passage in his own poem (Figures 2 and 3).[36]

Bocchi seems to have been the only emblem author to have placed a hieroglyphic text in an emblem picture; whether this implies a theory of readable pictures on Bocchi's part is not clear. This hieroglyphic inscription from Colonna is a "visible text" made up of a cluster of signs, according to Daniel Russell. He ascribed the lack of such "chains" of signs in emblems to the fact that "the hieroglyphic chain *was* a text" and had to be read as a narrative rather than perceived in an instantaneous act; an emblematic image, on the other hand, was not a text "and needed a supplementary text, whether explicit or implicit, in order to make one of its virtual messages actual."[37]

The use of the single hieroglyphic sign as emblem motif also posed certain problems for emblematists, no matter how venerable and mysterious they thought them to be. It was not so much the obscurity of hieroglyphs as it was the difficulty in establishing an analogy between the hieroglyphic image and its meaning that caused problems.[38] The relationship could seem strange, but it should not appear irrational, as, for example, did Horapollo's interpretation of a baboon as the moon.[39] A few of Horapollo's hieroglyphs did become widely known in the Renaissance. A serpent biting its tail, for example, illustrates immortality in the emblem Costalius entitled "Des Hieroglyphiques des Egyptiens" and in Alciato's "Ex literarum studiis immortalitatem acquiri."[40] Another hieroglyph, a winged hand, appears in several variations, including those of Johannes Sambucus and Hadrianus Junius.[41]

Although Bocchi applied hieroglyphs more frequently than most emblem writers did, he used only a limited number of motifs. He drew on Horapollo's hieroglyph of vigilance for a pair of lions supporting columns in a church or temple in Symbol

CXXIII, whose poem begins: "Lvminibus vigilat clausis Leo. dormit apertis, / Hinc sacris custos peruigil appositus" (The lion keeps watch with his eyes closed and sleeps with his eyes open; that is why he is an ever-vigilant guardian when set near holy objects).[42] The lions, however, are not the center of the emblem: Cardinal Alessandro Campeggi's coat of arms (half eagle and half the dog god Anubis) has that honor. Bocchi's other hieroglyph, the ox skull, or *bucranium,* also functions as an attribute in two of its four appearances. It probably derived from Colonna's *Hypnerotomachia* rather than from an ancient source, although there are antiquities with the motif in Rome and elsewhere. Colonna interpreted *bucrania* in one hieroglyphic panel as LABORE, in another as PATIENTIA, in a third as part of a trophy on a staff, and in a fourth as decoration on a capital ("ossatura di boue").[43] Bocchi's borrowed hieroglyphic panel of Symbol CXLVII contains an ox skull, and two more ox skulls appear on trophies: a personification of Patience with a yoke around her neck holds one in Symbol XLIX, and a personification of Ars Docta holds another in Symbol XXXVI, the latter with awls and a band reading VSVS LABOR; both are called "bregma bouis" in their respective poems. The *bucranium* of Symbol I (Figure 4) occupies the center of its engraving as Bocchi's personal *impresa;* its two awls specify labor as its meaning, and the accompanying palm branches and laurel wreath indicate glory: VICTORIA EX LABORE / HONESTA, ET VTILIS (A victory that results from hard work is honorable and expedient). The *bucrania* and the vigilant lions – the two hieroglyphs of the *Symbolicae Quaestiones* – are also the two images that alternate in the frieze at the top of Bocchi's ideal palazzo (Figures 9 and 10). Here, these two hieroglyphs do not make up a narrative "chain" but can be "read" in a flash by the initiated viewer.

Although Bocchi's individual hieroglyphs do function as signs to be read instantaneously and do serve as recurrent motifs in a number of guises, they are not the predominant kind of image. Hieroglyphics, according to Daniel Russell and Claude Françoise Brunon, did not actually play so large a role in emblem books as their authors would have us believe.[44] Russell questioned whether the hieroglyph could function as such in the emblem and found Colonna's hieroglyphs even less successfully adapted to the emblem than Horapollo's, although Alciato, for example, produced emblems based on both authors (the serpent biting its tail after Horapollo and the anchor and dolphin motif from Colonna). The importance of hieroglyphs to the emblem would have been their ideal of an ideogrammatic language as justification for the emblem's existence, according to Russell.[45] Brunon viewed the hieroglyphs, especially those in the more elaborate editions with text and translation, mottoes and titles, image, and ornate border, as radically transformed in their new cultural context and their new structure.[46]

The fate of hieroglyphs as a pictorial language system in the sixteenth century was being sealed by Bocchi's friend and contemporary, Piero Valeriano Bolzano. After Valeriano's massive compilation *Hieroglyphica* was published in 1556, there could be no possibility of thinking of a hieroglyph as having a single, immediately knowable meaning, because it had become a symbol in the broader sense of the word. Each of Valeriano's chapters, including those dedicated to Bocchi and to Romolo Amaseo, devoted to a single hieroglyph (usually an animal) every interpretation that could possibly be culled from pagan antiquity through the Christian Middle Ages.[47]

Valeriano's work was better organized than Horapollo's collection. Unlike Horapollo, however, Valeriano deemed the moral import of the hieroglyph to be of primary concern, and like Fasanini he also promoted the work as a sourcebook for the visual arts.[48]

## Verbal Symbols

In the same fashion as their substantive counterparts, symbols as words, phrases, or other verbal formulas originated in early Greek culture. The oldest of these verbal symbols known to the Renaissance scholar were the Pythagorean *symbola* (later called *acusmata*), a collection of gnomic precepts whose origins in early cults associated with Pythagoreanism and Orphism had already become remote by the time that Aristotle and later Greeks (often the same writers who collected hieroglyphs) transmitted fragmentary collections of them.[49] The *symbola* included such sayings as "Don't sit on a peck-measure or *choenix*," "Don't take a sparrow into your house," and "Refrain from eating beans."[50]

Because the humanist position concerning these *symbola* was molded by Neo-platonists, especially Jamblichos and Porphyry, and by early Christian fathers such as Jerome and Clement, the Pythagorean sayings were considered allegories designed to be intelligible only to the initiated.[51] Not only did Pythagoras remain respected by Christians for his mathematical and musical theories, but his cult with its division of students into the *esoteric,* or those who had earned the right to take part in discussions led by Pythagoras within a veiled enclosure, and the *exoteric,* or those neophytes who kept silent and listened from without, was believed to have been a precursor of Christian monasticism.[52] It may also have been a prototype for the Academia Bocchiana where the younger boys of the school listened in silence while their elders debated literary and philosophical topics.[53] By the same token, legendary accounts (in Isocrates, Plato, Herodotus, and others) of the journeys of Pythagoras to Egypt, the Middle and Far East, and even Europe in a quest for the teachings of Egyptian and Chaldean priests, Persians, Arabs, Hebrews, Hindus, and Druids only served to increase the respect of the Renaissance syncretists for the Pythagorean *symbola.*[54]

The authors of emblem books drew on Pythagorean *symbola* conveniently collected by, and often explicated by humanists: Ficino, Pico della Mirandola, Giovanni Nesi, Filippo Beroaldo the Elder, Joannes Reuchlin, Erasmus, J. A. Brassicanus, Lilio Gregorio Giraldi, and others.[55] For the scholarly reader, Giraldi provided the most extensive collection of the first half of the century in his *Pythagorica Praecepta Mystica a Plvtarcho Interpretata* (completed in 1543); Giraldi expanded the definition of *symbola* to include the sayings of Zoroaster and Solomon.[56] Because Beroaldo's *Symbola Pythagorae Moraliter Explicata* (1500) and Erasmus' *Collectanea* (1500) and the expanded *Adagia* (1508) were widely used as school texts in the six-teenth century, some of the symbols became familiar to the more general reader as well.[57]

Nevertheless, the Pythagorean *symbola* received limited treatment in emblem books. Alciato only used one, that which forbids anyone to sit on a *choenix* or peck-measure (that is, to be lazy). Even here an early translator (the Italian adaptation

by Marquale, Lyon, 1551) dropped the symbol and any reference to Pythagoras; other vernacular translations eliminate the reference to the *choenix* (Wolfgang Hunger, Paris, 1542, called it a *Brotkorb* or "breadbasket").[58] Bocchi offered the same symbol (XXVI), which he also interpreted as idleness, the cause of time wasted, and the root of desire: "Quid mereare sedens in Choenice quaeris?" (What do you hope to accomplish by sitting on a basket?). The engraving depicts a man seated on a drum-shaped container with one foot resting on an overturned hourglass while a nude older woman (a harlot?) strides past. Bocchi's next symbol (XXVII), although it does not cite a specific Pythagorean saying, alludes to Pythagorean dietary restraints in its reference to simple foods and abstinence and in its illustration of Bocchi at his "nobile symposium" eating what appear to be bread and fruit.[59] Costalius' two Pythagorean *symbola*, "Ne communiquer auec meschants" (do not associate with evil-doers) and "Ne mange point du coeur" (do not eat any heart) survived their translation into French without dropping the first part of their two titles: "Sur le symbole de Pythagoras."[60] In early emblem literature theory, Pythagorean *symbola*, like hieroglyphs, played a token but perhaps obligatory role in establishing an antique pedigree for a Renaissance mixed genre.

With other early verbal symbols, we encounter problems when trying to draw a fixed line between proverb and adage, proverb and motto, and proverb and *chreia*, not to mention the *paroemia* (a synonym of adage), *sententia*, and parable. The *sententia* and parable are only sometimes equivalent to proverbs because they are not always sufficiently brief to be considered "moral sayings."[61] Maxims are general moral statements in brief from known authors.[62] The motto is a short saying taken on by an individual as a personal "symbol."[63] The *chreia* is a saying or action made by a named individual; *chreiai* are often brief, have a moral purpose, and were collected by early grammarians such as Hermogenes and Aphthonius as teaching tools.[64] A *chreia*, motto, or sentence in common usage could function as a proverb.[65] It is this common usage in antiquity that serves as one basic criterion for Erasmus' collection of moral sayings; another, according to Margaret Phillips, is the requirement of "some hidden kernal, either a figurative or allegorical meaning, or a problematic turn . . . or a form so compressed as to attain wit by brevity."[66] Or, as Rosalie Colie put it, the adages are "keys to culture or convenient agents of cultural transfer," each of which "bears a coded message, compresses much experience into a very small space, and by that very smallness makes its wisdom so communicable."[67]

These verbal fragments play a major role in the *impresa,* which consists of motto and picture, and in the emblem, which consists of motto (or superscript), poem (subscript), and picture. Theoretically, the saying should be a motto or proverb with hidden meaning. In the case of Alciato, a surprising number of mottoes consist of only one word (or one word introduced by "In," as "In avaros") – the names of plants, of virtues, of vices, and other personifications – although they are interpreted allegorically. He drew on a number of proverbs also found in Erasmus' *Adagia*. Alciato's proverbs, however, function not only in the motto: Some fall only in the epigram and others are alluded to in the pictures.[68] Proverbs used by Alciato as mottoes (or titles) include, for example, "Ars naturam adiuvans" (Art assisting nature), "Quae supra nos, nihil ad nos" (What is above us has nothing to do with us), "Virtuti fortuna comes" (Fortune is the companion of virtue), and "Herculei

labores" (the labors of Hercules).[69] He also created an emblem entitled "Terminus," Erasmus' own device, using Erasmus' motto, "I yield to no one," in the poem.[70] Whereas Alciato's superscripts more often resemble titles than mottoes, Costalius placed both a title and a maxim or sentence above each picture in his *Pegme,* as, for example, "*A la balance de Critolaus.* / Vertu surmonte tout" (On the scales of Critolaus. Virtue surpasses all.)[71]

Bocchi, like Costalius, tends to employ both a motto and a title (which sometimes is a second motto). His superscripts involve a turn of meaning or figurative sense more frequently than either Costalius' or Alciato's do; they include, for example, his VIRTVTIS VMBRA GLORIA (Glory is the shadow of virtue, Symbol XLII) or IN PARVVLIS VIM SAEPE INESSE MAXIMAM (The greatest power is often contained in small things, XCIII). Others sound more like maxims, as in VITA EST SINE QVERELA OPTIMA (The life without complaint is best, C). Some of Bocchi's sayings are termed *sententiae:* for example, SENTENTIA MEMORABILIS / AMORIS ANTIPHARMACVM (A memorable maxim is an antidote for love, XIII) and IVSTA SOPHOCLEO SENTENTIA / DIGNA COTHVRNO. / IBI EST SALVS TVTELAQ. / VBI REVERENTIA ET PVDOR (An apt saying, worthy of Sophoclean tragedy: Where respect and decency exist, there security and protection are found, CVI). The term "sententia" also recurs in Symbols XLVI, XXXIIII, and XXXVII. It is possible that Bocchi would have considered all his superscripts "sententiae." He does not use the term *chreia,* although sayings of notable people often form the nucleus of an emblem; for example, Marcus Curius in Symbol XXXI merits the motto PECVNIA HAVD CORRVMPITVR / VIR FORTIS ET FRVGI, NEC ACIE VINCITVR (The brave and honest man is neither corrupted by wealth nor conquered by battle). When he uses the term *symbolum* (I, II, XXVII, XXXIX, XLI, L, LXXXII), Bocchi appears to refer to the entire emblematic unit.

Some verbal symbols in antiquity derived their meaning by metaphoric extension from symbols as things (*res*). For example, the "collybisticas," mentioned in Bocchi's Symbol I, extended the sense of a monetary contribution to a banquet to a verbal contribution to dinner conversation. Such "table talk" could include the topics for discussion (also called *sympoticae*) as in the *Attic Nights* of Aulus Gellius: "Cum domum suam [that is, the philosopher Taurus] nos vocaret, ne omnino, ut dicitur, immunes et asymboli veniremus, coniectabamus ad cenulam non cuppedias ciborum, sed argutias quaestionum" (in John C. Rolfe's translation: "When he invited us to his home, in order that we might not come wholly tax-free, as the saying is, and without a contribution, we brought to the simple meal, not dainty foods, but ingenious topics for discussion"). Taurus expected his guests to contribute something light, charming, or even "ludicrae" to the conversation, but nothing "gravia nec reverenda."[72] In this spirit, Bocchi's Symbol CXVIII records one of his own witticisms made at a banquet hosted by Cardinal Giovanni Poggio; when an unfortunate guest accidentally swallowed the tines (*hamata*) that broke off a fork, Bocchi revived the old pun on the "hook" of love: "Nempe id significauit, vt voluptas / Tristi hamata dolore non amanda" (It signified, to be sure, that one should not seek pleasure that comes from the hook of sad grief). This is, of course, an example of the Renaissance *facetia,* another verbal "symbol."[73] Nevertheless, when the Aulus Gellius passage is compared to Bocchi's title, the "Symbolic Questions, Which Play

Seriously," it becomes clear that Bocchi's entire work can function as a collection of topics or questions suited for discussion, not only in the context of banqueting but also in the academy.

The metaphorical expansion of meaning also opened the way to medieval allegory. Thus, passwords, called *symbola, signa,* or *tesserae,* served as verbal tokens of identification when the correct response was joined to a special question in a ritual exchange required for military communication or for access to cults and sacred mysteries. According to a number of scholars, who were following the fourth-century Rufinus, the Apostles' (Nicene) Creed was called the *Symbolum* because it originated in the orally transmitted form of a password.[74] Rufinus and Cassian suggested an alternative origin for the Creed as *Symbolum* in the term *collatio* (Greek: *symballein*). That is, the *Symbolum* is a bringing together or summary of Christianity's basic beliefs.[75] According to H. J. Carpenter, however, Cyprian and Tertullian a century earlier had used *Symbolon* to designate the rite of baptism in legal terminology: It represents a pledge sealing the covenant of a "pact made between God and man in baptism" and is "embodied in [that rite's] interrogations, responses, and triple immersion."[76] The *Symbolum* as the Creed was the most important usage of the term during the Middle Ages and into the Renaissance. Bocchi probably was thinking of this meaning of *symbolum* in Symbol CXXXIII, dedicated to Romolo Amaseo, when he pledged to give up his striving for worldly fame and riches and to serve only the one God: "Uni igitur, veroque Deo seruire, nec vlli / Praeterea statuo. est etenim verus Deus vnus" (Therefore, I resolve to serve the one true God and no other, for indeed there is only one true God, lines 26–7).

In Greek allegorical interpretation, the terms *symbolon* and *symbolikos* (in a symbolic way) appeared in contexts explaining the meaning of myth, as in early discussions of Homer.[77] To later Greeks *symbolon* not only implied the interpretation of pagan myth and the attributes of the gods but also the way in which the biblical text would be read for hidden meaning.[78] Philo of Alexandria thought the obscurities of the biblical text required a symbolic interpretation, and Origen, according to Gerhart Ladner, said that "whatever happens in an unexpected or strange way in Holy Scripture is a 'semeion kai symbolon,' a sign or symbol, of something else, namely of something beyond the realm of sense experience."[79] Symbolic theory reached its highest point of development with the Neoplatonic thinkers Jamblichos, Porphyry, Plotinus, and Proklus.[80]

With the shift to Latin in the Middle Ages, the term *symbolum,* except as the Apostles' Creed and in philosophical writings, was not used as often. The Latin tradition accepted the term *allegoria* as an extension of metaphor and classified symbolic metaphor, parable, and the Word (*Verba*) as "allegoria in verbis" ("allegoria in factis" referred to symbolic events).[81] For symbolic terms, however, the Latinists preferred *signum, typus, figura, imago* (for pictures and icons), *umbra* (a more metaphoric term), enigma, and sometimes other terms such as *species, exemplum,* and *similitudo.*[82] *Signa* replaced many of the Greek uses of *symbolon. Figura* was both a rhetorical term and a Christian term for the foreshadowing of events. *Umbra* could mean *figura* or symbol (it also meant "enigma") or the shadows created when God withdrew his light from a place, according to a John Scot translation of the pseudo-Dionysian *Celestial Hierarchies.*[83] Most of these Latin terms do not have much

resonance for the emblem, although Sambucus did include "umbris figurarum" along with *sententiae, historiae,* and fable as the matter expressed in the emblem.[84] Bocchi produced no prefiguring *figura* or *umbra,* although he repeatedly called the strange, four-pointed object illustrated in Symbol CXXXIII a *figura,* or rather *the* figure of Giovanni Battista Camozzi. Bocchi's *figura* may be synonymous with the medieval *imago,* but given its Pythagorean interpretation, it would appear to represent a personal device, part of Camozzi's *impresa.* His only *umbra* is Symbol XLII's Glory as the shadow of Virtue (VIRTVTIS VMBRA GLORIA); there the shadow follows rather than prefigures.

Verbal symbols played a major role in emblematic literature. As emblem topics, these symbols – personification, mythology, fables, parables, and historical *exempla* – were easily explicated in the emblem verse and readily illustrated by engravings. All had their origins in classical antiquity. Bocchi made extensive use of personifications: for example, Sapientia (Symbol XI), Ars Docta (XXXVI), Justice (XLIIII), Patientia (XLIX), Fortuna (LI, CXXI), Occasio (LXXI), and Dialectica (LXII).[85] It was very unusual for him to avail himself of a medieval type; he did so only in DE AVARO, ET EIVS EXITV (Symbol XLVII), in which a miser clutching his moneybags is dragged off by a horned devil. Alciato, on the other hand, invoked many virtues and vices, some of which are illustrated by personifications ("Concordia insuperabilis," Emblem 39, and "Invidia," Emblem 71), some by *exempla* ("Concordia," Emblem 47, and "Gula," Emblem 91), and others by animal symbolism ("Pudicitia," Emblem 47, and "Ira," Emblem 63). Costalius' opening emblem is a personification of Justice; however, in his other emblems he preferred moral *exempla* and the symbolism of gods and goddesses.[86]

Bocchi also made liberal use of gods and goddesses (as in the discussion of true Voluptas in Symbol X, which illustrates Venus reconciled to Athena and Silenus, or in the rape of Ganymede in Symbols LXXVIII and LXXIX) and of godly attributes (Athena's owl, LXXXIII, or Saturn's urns, VIII). On a more humble level are the fables, at least three of them drawn from Aesop: the ant on an ox's horn (XXXVIII), the ass as judge (XL), and Hercules and the mule driver (LII).[87] Bocchi's fables from Aesop are simple enough to give to a very young pupil. His fable of how the turtle got its shell (Symbol CX), however, is a plea to Cardinal Alessandro Farnese for funds to complete his *domus* so that he, like the turtle, could stay in his own home: EST NVLLA VITA LAVTIOR DOMESTICA, NEC LAETIOR (No life is more luxurious or happy than the domestic one). Besides these fables, there are only a few representations of animals in Bocchi; of these his crocodile of Symbol XCIX is explicated after Pliny or Aelian rather than Horapollo or Aesop.[88]

Our last group of verbal symbols involves word play. One medieval synonym for etymology was *symbolum,* because the deep meaning of a word was believed to lie in its root. In order to decipher this root, especially in a proper name, word games were devised and riddling questions posed.[89] The riddle, or *gryphos,* as an enigma was posited as far back as Heraclitus, who said that "nature and life are a *griphos,* an enigma, and he himself [was] the riddle-solver."[90] Ausonius devised a poetic riddle on the number three, "Griphus Ternari Numeri."[91] As a coupling of the riddle with etymology, the logogryph took poetic form by the twelfth century in Philippe de Harveng's *Logogryphi et Aenigmata,* which presents a series of thirty couplets devoted

to logogryphs and a further incomplete series of ten enigmas.[92] I have not discovered how the logogryph was transmitted to the Renaissance, but Julius Caesar Scaliger (1484–1558) composed a group of them, including one on his own name: "Quo scandas tu, quoque uoles, gerit unus et idem" (One and the same person bears you; with him you may ascend and with him you may fly). That is, "Scaliger" yields *scala* (stairs), *ala* (wing), and *gero* (to bear or assume).[93]

Bocchi created a logogryph for his friend and colleague, Sebastiano Corrado, IN CORDE PVRO VIS SITA PRVDENTIAE (The power of prudence resides in a pure heart; Symbol CXXII), in which he played on the roots of "Corradus": *corradere* (to scrape together), *cor* (heart), *cordatus* (prudent), *corculum* (little heart, poor fellow), *corvo* (raven), and *concors* (harmonious or concordant). In the engraving (Figure 24), an ox with horns (*cornu*) lies on an altar (*ara*) while its heart is scraped out (*rado*) by ravens. Bocchi concludes the poem with a tribute to the contribution of this man of good heart and concordance of mind to the youth of their academy. Only the background scene with its depiction of the construction of Corrado's suburban house outside the walls of Bologna does not function as part of the play on words. Such verbal play on proper names is also a feature of the *impresa* (to be discussed in the next section). The name is, as François Rigolot suggests, "un auto-graphe, lisible et dechiffrable" – hence a symbol.[94]

### Verbal/Visual Symbols

The verbal symbols, as we have seen, tend to be translated easily into visual form. Some symbols, however, combined the verbal and the visual from their conception. Those verbal/visual forms, which were popular in the sixteenth century – rebus, medal, *impresa*, emblem, and symbol as understood by Bocchi – are interrelated in practice.

In the simplest form of verbal symbol, the rebus substituted an image for a word, as, for example, Cicero's coin with his initials "M. T." followed by a pea ("cicer"). The rebus was sometimes associated with the hieroglyph in the Renaissance, but the two are basically different.[95] The rebus combines single letters, images, and parts of words by their *sounds*, rather than their pictorial value as ideographs. For instance, Geofroy Tory wrote "Largesse" in rebus form as "S. large."[96] Leonardo da Vinci had drawn a sheet of rebus in 1497, and Giovanni Baptista Palatino published a sonnet in rebus form in 1540.[97] Charles de Bovelles played on *spera* (hope) and *sphera* (sphere) in his device of a celestial sphere within an O within a larger D – "in Deo spera."[98] Bocchi's "rebus" emblem (Symbol LXXI) is in the form of a cipher based on the name Occasio, or Chance (Figure 29):

> O nihil est. CC. bis centum nunciat, A nil
> S. Quintum, Primum, I. Rursus &, o. nihil est.
> Principium nihil est: bis Centum plurima, quin*que*
> Non satis est, vnus sat, venit inde nihil.

(O is naught. Two C's indicate twice a hundred, A nothing, S the fifth, I the first again, and O is nothing. The beginning is worth nothing, two hundred worth much; five is not enough, yet one is enough, after which comes nothing. Lines 5–8.)

Bocchi left it to his dedicatee, Johannes Junius of Antwerp, to work out the enigma completely. The rebus on proper names was also a common technique in the *impresa*. Just such a personal device was illustrated by Bocchi in Symbol CXLIX for Cardinal Innocentio del Monte by a personification of Innocence carrying a lamb and cross beside a rocky hill (*mons, montis*).

A verbal/visual medium revived in the fifteenth century was the medal. The same humanists who were fascinated by hieroglyphs devised, or had created for themselves, portrait medals. These often showed a device (a picture or an image with a brief motto) on the reverse side, as in Leon Battista Alberti's medal with a winged eye (from Horapollo), Sigismondo Pandolfo Malatesta's elephant motif, and the memorial medal for Malatesta's beloved Isotta degli Atti with its symbolic closed book.[99] The intimate relationship between the portrait and its reverse (usually with a motto) closely parallels the idea of an *impresa* as the personal device and motto of an individual.[100] Portrait medals were immensely popular in the sixteenth century, so much so that a game of "reverses" was frequently played.[101]

Bocchi's large portrait medal, like many designed to be worn as a medallion on a chain, lacks a reverse; one impression of it was embedded in the leather cover of his manuscript *Praelectiones In Libros De Legibvs .M.T. Ciceronis Habitae Bononiae In Academia Bocchiana* (Bologna, Bibl. Univ., Cod. Lat. 304). Similarly, Bocchi's daughter Constantia's medal had no reverse.[102] One of Bocchi's Symbols (LXXXII), though, is entitled "Hoc Bocchiani Symbolvm es Nvmismatis. / MATVRA FESTINATIO" (This symbol, make haste slowly, is on the medals of Bocchi); it depicts as a reverse a man holding a bridle and facing a seated ruler, while behind them stand an old man and a boy with a cornucopia. The poem interprets the picture's moral as an exhortation to maintain a medium between two extremes in all things. The picture is a close copy of the medal of Altobello Averaldo, former governor of Bologna (d. 1531).[103] In Symbol CVIII, Prudence, seated on a dolphin, wears a heart-shaped medallion with two eyes, which symbolizes "doctrina Cyclica."[104]

The *impresa,* which so captured the Italian imagination that at least twenty-one titles were published on the subject between 1556 (Paolo Giovio's *Ragionamenti*) and 1622 (Tesauro's *Idea delle perfette imprese*), developed out of medieval heraldry and was popular by the midfifteenth century.[105] It consisted of a picture (*pictura*) and a motto (*inscriptio*), more often referred to as the "body" and the "soul" of·the *impresa.* The rules for the *impresa* were basically established by Paolo Giovio in 1556, although they generated numerous minor disagreements and debate. The rules were as follows: (1) that the two parts of the *impresa* be in correct proportion to each other; (2) that they not be obscure to a literate sixteenth-century audience; (3) that they be attractive to the eye; (4) that they contain no (whole) human figures; and (5) that the motto should be no more than three or four words and in a language other than the owner's.[106] Girolamo Ruscelli added that the two individual parts of the *impresa* – picture and motto – should be impossible to understand apart from the whole. Academies also defined themselves by *imprese,* as, for example, the "Hermathena" of the Academia Bocchiana.[107]

Bocchi's personal *impresa* of the *bucranium* with wreath, palm branches, and awls (Figure 4) fits the requirements in that it depicts a strange, nonhuman image (like Giovio's "animali bizzarri") but is not completely obscure because of the symbolism

of tools and wreath. The main part of its motto, VICTORIA EX LABORE, is not over three words long and is in Latin. One could not honestly say that neither picture nor conceit can stand alone in this case. Nor is it possible to determine how many of Bocchi's emblems were derived from *imprese,* because he created some for his dedicatees and borrowed others from previously existing *imprese.* Some are identifiable. Symbol XLVIII is a design for a tomb for Ugo de Pepoli (1543) in the shape of an obelisk, which is set into a landscape with a woman looking on. Instead of one poem, there are two brief epigrams (two lines each) and several other inscriptions. The tomb design derived either from Ugo's device or from the Pepoli family coat of arms, because Girolamo Ruscelli gave as *impresa* for Count Fabio de Pepoli a broken pyramid (probably an obelisk).[108] That some of Bocchi's *symbola* were already *imprese* indicates that his readers would have found familiar images and mottoes. For example, the temples of Honor and Virute in the symbol dedicated to Ranuccio Farnese (XXXIII) were alluded to in a 1546 letter from Annibale Caro to Ranuccio's mother, the duchess of Castro. Caro suggested that the temples were a fine device for a boy but recommended that the *impresa* be changed to something more appropriate for a cardinal, preferably the "Ara Maxima" with attributes of Hercules as "contrassegno."[109] Or, the yoked figure of Patience dedicated to Orsina Grassi della Volta (Symbol XLIX) probably was devised in response to a request for an *impresa* design. A 1543 letter to Orsina from Perseo della Volta made a number of suggestions about subjects (although not Patience) and appropriate mottoes.[110]

The emblem unites three parts: picture, motto, and verse. Some twentieth-century critics do not distinguish emblem from *impresa,*[111] but for the elucidation of Bocchi's symbols it is helpful to keep the terminology as precise as possible. For one thing, the emblem may not simply represent an offshoot of the *impresa,* but may derive as well from French manuscript collections of illustrated proverbs.[112] Furthermore, because modern emblem theory has developed in large part from Baroque emblematics, it does not accommodate the earliest emblem books without awkwardness and even, at times, excludes much of Alciato's seminal work as not truly emblematic.[113] Peter Daly, in his *Emblem Theory,* has done much to reconcile German theories of the emblem, especially those of Albrecht Schöne, Dietrich Walter Jöns, Holgar Homann, and Dieter Sulzer, and to restate them in a way that can include Alciato.[114] Daly accounts for the differences in the ways emblems work out the "relationship between object and concept" by positing three categories of emblematic modes of thought: "topological, hieroglyphic and allegorical" (including personification).[115] Bocchi, however, has rarely been mentioned in these theoretical discussions.

There are no written theories of emblems from the period before 1555 in Italy, and even after that date Italian emblem theory remained embedded in *impresa* theory for purposes of comparison and contrast.[116] Girolamo Ruscelli was among the first to make such comparisons in Italy (in 1556); he mentioned "gli emblemi dell'Alciato e del Bocchio e del Costalio" as moderns who use the human figure in the form of gods, nymphs, satyrs, and herms, in contrast to the *impresa,* which can use the human figure only if it is strangely garbed or nude.[117] Girolamo Bargagli's comparison of emblem and *impresa* in his account of the game of *imprese* might have been based on Bocchi's practice: The *impresa* expresses the personal – "i suoi pensieri particolari" (one's own private thoughts) – whereas the emblem is a moral and spiritual precept

with an "avvertanza universale" (a universal instruction) like the reverse of a medal. The *impresa* should not use human or fabulous figures, and anything that does – including certain devices of academies – is an emblem. The *impresa* cannot omit the motto, but an emblem can remain an emblem without words.[118] Finally, Bargagli's example of a typical emblem is one of Bocchi's symbols (CXIX), although not cited as such. In it, Alexander of Macedon seals the lips of Hephestion against slander; Bocchi's motto is also quoted.[119]

As already mentioned, Bocchi sometimes added human figures to pictorial motifs that were originally *imprese* and then relied on the poem to make the symbol's meaning more "universal" in scope. After Bocchi's tribute to Alciato in Symbol I, he rarely used the term "emblem." In one case, the second of two Ganymede symbols (LXXIX), both of which were adapted from Michaelangelo's *Rape of Ganymede*, has as its motto: SCVLPTORIB. IAM NVNC GANYMEDEM CERNE / LEOCRAE / PACATI EMBLEMA HOC CORPORIS. ATQ. / ANIMI EST (Discern even now Ganymede among the sculptors of Leocrates: This is an emblem of the body and soul at peace). His symbol dedicated to Andrea Alciato (XL) does not mention the word "emblem"; its *sententia* is the negative response given by Aristotle to a query (*quaestio*) about whether the blind can fall in love, and it cites within the poem the proverb "oculi sunt in amore duces" (the eyes are the rulers in love) denying that the blind can fall in love. Perhaps the brevity of these two poems (eight and six lines respectively) and the relatively accessible content of their engravings is to Bocchi characteristic of the emblem.

To determine what Bocchi meant by a "symbol" puts the critic into a more difficult position. From a study of the manifold meanings of this word, the critic finds that it is possible to speak of the engraving and individual objects within it as symbols, or to read the maxim or motto as a symbol, or to interpret the verse as symbolic, or to refer to the complete verbal/visual unit as a symbol. When Bocchi calls his opening symbol "Symb. Symbolorvm," it is literally a "Symbol about Symbols." Even when one unit is an "emblem," it functions as part of the collection of symbols, as Bocchi makes clear in the last four lines of the "emblem" for Paolo Giovio (Symbol LXXXVI):

> Altrix multorum, et magnorum caussa malorum
>    Ambitio fuit, ac pessima semper erit.
> Conscia Paule istuc tua mens Emblema probauit,
>    Ne te illaudatum symbola praetereant.

(Ambition has been the source and cause of many great evils, and will always be ruinous. Paul, your perceptive intelligence has shown me the truth of this emblem, so that my symbols may not pass you by without praise.)

Bocchi used the term *symbolum* primarily because he considered it far more versatile and more inclusive than *emblema*. There is evidence that some writers after Bocchi also employed "symbol" in a generic sense. Emanuele Tesauro, for example, referred to "lo scopo delle Impresa, dello Emblema et di tutti gli altri Simboli figurati et metaforici" (the purpose of the device, the emblem, and all the other figurative and metaphorical symbols). Tesauro further defined "symbol":

Il Simbolo è una Metafora significante un Concetto, per mezzo di alcuna Figura apparente. Et questo è il Genere, che abbraccia tutta l'Arte Simbolica, differentiandola dall'Arte Lapidaria, che consiste in Caratteri, & in Parole.[120]

(The symbol is a metaphor signifying an idea by means of any visible figure, and this is the genus, which embraces the entire symbolic art, differentiating it from the art of inscription, which consists of characters and words.)

A second reason why Bocchi did not call his verbal/visual form an emblem book could be that he understood *Emblemata* to be Alciato's own title and respected it as such. It has recently been argued, quite convincingly, by Bernard Scholz, that *Emblema* was the title of a specific book of epigrams, because Alciato referred to it as a *tituli* in a number of letters.[121] This is also supported by Holgar Homann's observation that almost none of the other emblem books up to 1555 used the term "emblem" in their titles despite the immense success of Alciato's work.[122]

A third reason for Bocchi's use of the term *symbolum* was etymological. Alciato's *Emblemata* adopted a Greek term for either a certain kind of mosaic or for detachable silver or gold ornaments for vases.[123] The term *emblemata* had also come to mean an ornamental ring by the Renaissance, as in Caelio Calcagnino's "De Annulo expoliendo": "Haec signa, & haec emblemata / Tornabis annulo mihi" (Concerning a ring that is to be polished: You will turn, on your lathe, these figures and these emblems for me; lines 29–30).[124] Hence, emblems were valuable jewelry. Erasmus alluded to this usage figuratively in his edition of Origen: "'totus huius sermo sacrorum Voluminum sententiis ceu gemmulis emblematibus distinctus est'"[125] (Origen's entire argument is embellished with the sayings of sacred volumes, as if with jewels or pieces of mosaics). Furthermore, there was the early literary context for *emblemata*, discussed in Chapter 4 under poetics.

Bocchi, exploring a term even richer in meaning, went back to its root, *symballein*, "to join together." This act of uniting word and picture, however, suggests a bipartite arrangement rather than a tripartite one. That Bocchi was not strongly committed to a conception of emblem as a tightly structured cluster of three equal parts is evidenced by the fact that he was inconsistent about the placement of mottoes. Usually the motto is over the picture or sometimes over the verse replacing the verse title; occasionally there is no motto and sometimes there are two. Wherever it is placed, the motto usually receives some explication in the verse. The variations between individual symbols are great compared to the emblems of Alciato. In part this is because the "symbolic question" is positioned differently in each emblematic unit: in the text, outside the text, in the motto, or in the engraving. The reader must respond to each differently. Thus, the question and answer structure is a second bipartite structure overlapping that of text and picture. In other words, no two symbols' parts are joined in precisely the same manner; they are like the ancient Greek *symbola* broken or cut in puzzle fashion to facilitate the identification of a stranger or, here, to make possible the interpretation of the strange. The fusion of word and picture in Bocchi's *symbola* does not involve the setting in or insertion of a picture or a poem, but results from an analogic relationship deriving ultimately from the concept of *ut pictura poesis*.

Finally, a glance back to the innumerable ways something can be a symbol

demonstrates that there is no one origin for Bocchi's symbolic form, but a host of them. As Robert J. Clements noted, "The intrecciatura of metaphor, poetic or prosaic imagery, woodcuts and copper plates, statuary, painting, heraldic pageantry, and all the final manifestations of the emblematic mentality makes the study of imitation in this field an inexhaustible quest."[126] What happened in emblem books is that each of the early emblem authors used Alciato's *Emblemata* for a rough model and drew on vast "symbolic" resources for the kinds of mottoes, verses, pictures, and topics that he or she wished to have in his or her own collection. Then, modern critics, unable to examine all the myriad emblem books, moved in certain directions according to their own selections of models – toward theory and a notion of allegorical origins among German critics and toward a literary origin and moralized sources for critics of French emblems. Alciato fits in everywhere, whereas Bocchi's contribution to symbolic literature has been virtually ignored.

# Emblematic Paradox
# and Serious Play

> *Fool.* Now thou art an O without a
> figure, I am better than thou art, now.
> I am a fool; thou art nothing.
> (Shakespeare, *King Lear*, 1.4.192–4)

Emblems operate paradoxically. Bocchi's symbols do so as well, as his title, *Symbolicarvm Qvaestionvm De Vinverso Genere Qvas Serio Lvdebat Libri Qvinqve*, implies. Although many emblem books included paradoxical topics, not so many proclaimed their paradoxicality so self-consciously in their titles. Yet even before Bocchi published his symbols, Barthélemy Aneau had produced his *Picta Poesis* (1552) and Guillaume de La Perrière his *La Morosophie* (1553). After these three, there were few paradoxes in emblem titles until the 1669 *Theatrum stultorum joco-serium* of Jan de Leenheer, which owed its title as much to collections of paradoxes, such as the *Ampitheatrum sapientiae socraticae joco-seriae* by Caspar Dornavius (1619), as to emblem books.[1] Whereas Bocchi reveled in the serious play of opening up his symbols to discussion and debate, both Andrea Alciato and Petrus Costalius (Coustau, or Costal) chose titles implying a certain fixity: *Emblemata*, ornaments set in or embedded; and *Pegme*, meaning a "framework, shelf, or scaffold." Costalius, Hadrianus Junius (Adriaan de Jonghe), and others further stabilized the meaning in their emblems by providing prose commentaries. To name a collection "Symbolic Questions," however, rejects fixity and demands that the reader enter into a process of uncovering or establishing meaning.

Those two French emblem titles based on contraries both refer to paradoxical topics popular in the sixteenth century. One, La Perrière's *Morosophie*, adapted a topic that was already amusing readers of Erasmus for its unified collection of moral emblems devoted to the folly of the wise and the wisdom of the ordinary person. The other, Aneau's *Picta Poesis*, alludes directly to the paradoxical relationship between text and picture, the Horatian *ut pictura poesis*, explored by Bocchi in his Symbol III (see Chapter 4). No matter how many similarities can be found between poetry and painting, between word and image, the fundamental difference of

medium remains. The only way for words actually to become images or images words is in the figure (shape) poem or in hieroglyphs or rebus, where the eye is fixed upon word and image simultaneously. Even then, according to Elizabeth Cook, "Though figured poems initially present images to the corporeal eye which give us an immediate sense of reference and meaning, these poems imply an acute consciousness of what is involved in reading or hearing the words which make them up."[2] Emblems, however, exploit the *ut pictura poesis* formula. The pleasure comes from the dissimilarity between word and picture and is renewed with each foray into another tripartite or bipartite unit and each attempt to compare poem and image. Such pleasure could not arise from a comparison between a sonnet and an epigram, for example; it is the distance between the two parts of the metaphor that captures, astonishes, and ultimately enlightens the reader.[3] This is the paradox within the emblem.

Emblem collections make use of paradox in various ways. Paradoxes challenge received opinion and balance opposites. They operate in logic (the Liar paradox or the impossibility of the Chimera), in rhetoric, especially in collections of paradoxical essays and mock encomia, and in poetry, both in humorous verse praising "things without honor" and in figures such as oxymoron, synoeciosis, and antiphrasis.[4] Although studies of ancient literature would have familiarized Bocchi with examples of all of these, the sixteenth-century revival of the literary paradox, which was well underway by midcentury, offered outstanding and widely read paradoxes, from the Latin mock encomia by Erasmus (the 1511 *Stultitiae laus*) and Thomas More (the second book of *Utopia*, published in 1518) to the prose essay collection of Ortensio Lando (*Paradosi, cioè, Sententie fuori del comun parere*, published in 1543) and to the ribald verse "capitoli" of the school of Francesco Berni and Annibale Caro. In Italy, the vernacular paradoxes of Lando and Berni, along with a number of paradoxes mocking pedantry or Petrarchan ideal love, are closely associated with the activities of literary academies.[5] Therefore, it is likely that Bocchi's academy too fostered the playful creation of paradoxes, although in Latin.

But to what extent are Bocchi's *Symbolicae Quaestiones* also paradoxes? For several reasons, the mock encomium was not well suited to emblem restrictions. First, it required for its exposition a length rarely found in emblem texts, and, second, the inclusion of poems ironically praising subjects normally deemed trivial or base or untrue in among the more straightforward moralizing emblems would have undermined or problematized the entire work. Although some of Bocchi's symbols are exceptionally long, they do not adopt the rhetorical structures of the oration, and they do not praise lowly or unlikely topics such as fleas or shadows or nobody. Bocchi's paradoxical topics tend toward the serious, as in his MORS NORMA VITAE EST OPTIMA (CXLII), in which the blessed life is said to be the one most conducive to death, or in his Symbol CXLIIII, in which one good pupil is supposed to be better than many ordinary ones. Furthermore, several topics that would once have seemed counter to received opinion – the misery of the Curia (CXXIIII) and the benefit of the hidden life (CXXXIII) – had, like the Helen of Troy of the Greek sophist Gorgias, become conventional through a too successful application of paradoxical arguments over time.[6] The choice of topics in Bocchi resembles to some extent the collections of paradoxes of Cicero, Ortensio Landi, and John Donne; these collections are closely related to the *quaestio disputata* of the schools, which "perfects

the deliberately fallacious argument for the purpose of revealing truth."[7] Most frequently pictured in emblem books were images of the 'impossible – the Chimera (Bocchi), Cecrops the half-man, half-snake (Alciato), the winged hand (Alciato, Junius, and others), and the attempt to wash an Ethiopian white (Alciato).[8] In the texts of the emblems (and this is also true for Bocchi's symbols), the most common topics involve the play of opposites: greatest/smallest, one/many, wisdom/foolishness, war/peace, and the oxymorons of love.

For the emblem collections, the paradox raises the troublesome problem of control, because paradoxes generate new paradoxes, turn self-critical, and cross generic boundaries.[9] According to Rosalie Colie,

> It is obvious how much paradox "implies," folds into itself. Like a tight spring, the implications of any particular paradox impel that paradox beyond its own limitation to defy its own categories. A logical paradox, for instance, is never *merely* logical; it raises questions which force other considerations. Again and again, paradoxes evidently trivial . . . turn out to be deeply moral. . . . Because of its secret reach beyond its own boundaries, boundaries on which it overtly insists, paradox once again works paradoxically, drawing attention to the limitations it questions and denies.[10]

Most emblem authors, even when they allude to a larger paradoxical question in their titles, approach paradoxical topics with caution, trying to confine each topic to one emblematic unit. Because Bocchi's paradoxes recur as persistent thematic patterns and are couched as questions, reading his *Symbolicae Quaestiones* involves an intellectual challenge posed by no other collection of emblems.

### Paradoxes of Minimum and Maximum

What happens in an emblem or symbol is an explosion of meaning ignited by the spark from the impact of a tiny picture, motto, and poem coming together. Bocchi illustrates this concept with his symbol (CXIIII) on the invention of gunpowder by an alchemist whose pestle accidentally ignited a mixture of powdered sulphur, saltpeter, and carbon (Figure 25). In the resulting conflagration, the alchemist himself was destroyed, which the illustrator conveyed by placing the corpse in the background of the engraving. Bocchi concludes: "Inuentio Bombardici / Pulueris ista fuit. Sic ignem saepe fauilla, / Ut minima, maximum facit" (In this way gunpowder was invented. A spark, although very small, often produces a very great fire). The powerful force of fire is inherent in the spark, according to Aristotle, just as the force of growth of a tree is in a seed, or the power of the body is in the muscles and marrow. The power is hidden, its effect apparent.[11] The metaphor of the spark and fire reached the Renaissance by many routes Bocchi may have known. Besides the Aristotelian one, there were studies of military technology, especially those by Vanoccio Biringuccio and Nicolo Tartaglia. The Siennese Biringuccio was a protégé of Claudio Tolomei; his *De la Pirotechnia* was published in Venice in 1540 with an allusion to the powerful impact of the spark.[12] Tartaglia in his *Qvesiti Et Inventioni Diverse* (Venice, 1554) mentioned the common theory that a German alchemist invented gunpowder, although he himself believed that Archimedes had done so.[13]

The connection between gunpowder and the power of the spark was also made in an encyclopedia written by the brother of one of Bocchi's dedicatees (Symbols LXXXVII and XCVI), Cardinal Bernardino Maffei: "Ex nitro enim hodie puluerem praeparent, inflammandis, impellendisque instrumentis bellicis aptissimum, igni quamuis minimo adhibito, nouo sane inuento" (For nowadays they prepare from potash a powder ideally suited to propelling and discharging the tools of war, though the amount of fire used is very small – a truly new invention).[14] Another line of thinking on the spark and fire as minimum and maximum came through the mystical philosophy of Nicholas of Cusa, whose *De Ludo Globi* may have been read by Bocchi.[15]

The maximum/minimum paradoxes were a type of coincidence of opposites readily applied to verbal power, as Bocchi's teacher, Filippo Beroaldo the Elder, had done in describing the proverb's ability to impart moral philosophy so briefly and elegantly: "Scriptum angustum est, interpretatio latissima" (The text is very narrow, the interpretation very broad).[16] When to the brevity of the adage was joined one small picture and one (usually) short poem in the new miniature genre of the emblem, the potential for interpretation of meaning grew correspondingly in breadth. Colie observed of the emblem:

> It is important to note how this tiny form mixed genres and even arts – and how cryptic its parts were, implying far more than was said. With its gnomic grammatical involution of significance into one phrase, the adage offered one version of much in little; the epigram's syntactical economies challenged ingenuity precisely by its terseness. The addition of figures to such abbreviated forms might have opened up the emblem to a public potentially frustrated by its verbal tightness, as Alciato's publishers hoped; or, which in fact was what happened, the emblem might present a problem thrice made intricate and esoteric.[17]

However convoluted and esoteric his own symbols became, Bocchi never expected that the tightness of his small units would resist all attempts to release meaning. The teacher in him made sure that the obscure elements of a picture had some identification in the poem so that anyone with a knowledge of Latin would have at least a chance of cracking the nut. For example, the Symbol CXXXIIII on Athena and Wisdom that he dedicated to his colleague Giovanni Battista Camozzi (Camoteus) provides a detailed interpretation of the parts of the strange *figura* (Figure 26): The tricuspid (actually a quadricuspid) forming the base of a pyramidal shape symbolizes a trinity surmounted by the One (Monad); the pyramid shape points upward to higher things; the four perfectly equal points symbolize wisdom, as do the four serpents' heads, and so on. The only direct question Bocchi asks his readers is a rhetorical one concerning the upward thrust of the pyramid; the real question, with all the information given, is how to read the image as a totality. Bocchi's paradox is not only the derivation of the greatest possible meaning from one small image but also the potentiality of knowing the not-knowable through a form of purifying labor.

Great and small contrasts lead the reader into other kinds of relationships in the emblem books. With moral power, the small can triumph over the large, as in the fable of tiny birds defending their nest in an acanthus bush from the ravaging teeth

of several asses in Bocchi's Symbol XCIII, whose motto reads: IN PARVVLIS VIM SAEPE INESSE MAXIMAM (In tiny things is often contained very great strength). Joachim Camerarius reworked this fable in his ET PARVIS SVA VIS (And to the small its power).[18] Likewise, in Alciato's *Emblemata,* an apparently insignificant fish called the remora was said to cling to a large ship like a snail, causing it to stop its progress through the waves.[19] Finally, as a civic virtue, the unity of a population is expressed in the metaphor of Amphion raising the walls of Thebes by the harmony of his music in Costalius' "Sur Amphion. Par concorde choses petites croissent" (On Amphion. Through concord small things wax great).[20]

The sacred also has its paradoxes: La Perrière emblematizes faith as a mighty cypress that grew from a tiny seed; and Barthélemy Aneau's motto EX MAXIMO MINIMVM accompanies the "Relliquaie Sacrarij" of a skull and bones.[21] Although Reusner's emblem of MICROCOSMUS HOMO depicts God sculpting Adam in an image reminiscent of Bocchi's Ars Docta sculpting a man (Symbol XXXVI), Bochhi avoids direct reference to man as microcosm, perhaps because of the sensitivity of the church to the works of Pico della Mirandola. Reusner, however, exploits the theme of the smallness of a human being, who, although a minuscule world, yet contains everything: "Paruus quisque sibi mundus, nam continet omne / Vnus homo, magno quicquid in orbe video" (Everyone is a small world unto himself, for one man contains all that I see in the universe at large).[22]

What has struck the modern critics of Bocchi is not the absence of the microcosmic man, but the paradoxical hiding and disclosing that he described in his first emblem as the veiling of hidden knowledge to be revealed only to those of pure mind. This paradox goes back to the Plato who was said by Saint Augustine and others to have dissimulated his knowledge to expose the false learning of others.[23] Its fullest development came in the fifteenth-century treatise *Idiota de sapientia et de mente* of Nicholas of Cusa, who reiterated Proverbs 1.20 and Ecclesiastes 24.7 that Wisdom cries out in the streets and from the rooftops, but that her secrets can be revealed only in private places to minds desirous of true knowledge.[24] Bocchi's own portrait (see Frontispiece), entitled IN BOCCHIANIS SYMBOLIS INTELLEGI PLVS, QVAM EXPRIMI (Symbol II), is explained thus by Tiresio Foscarari:

> Prospervs os potuit, non mentem pingere Achillis.
> Res minimo pingi maxima in orbe nequit.
> Pura tamen Mens ipsa potest comprendere Mentem
> Qui sapit, heic [*sic*] plus intelligit, ac legitur.

> (Prospero [Fontana] was able to paint the face but not the mind of Achille. A very large thing cannot be painted in a very small circle. Yet a pure mind is itself able to comprehend the divine Mind. He who has understanding intuits more things than are read.)[25]

The same paradox of hidden matter and openness occurs in the third symbol (Figure 22): PICTVRA GRAVIVM OSTENDVNTVR PONDERA RERVM. QVAEQ. LATENT MAGIS, HAEC PER MAGE APERTA PATENT (With this image it is intended to show how serious is the weight of things. The more hidden these things are, the more evident they are shown to be). The emblem, like poems alone, reveals and conceals at the same time. Bocchi's invention, for which he

apologizes, makes possible the unveiling of ideas and symbols; if Cardinal Farnese has difficulty enjoying or understanding his invention, it is because of the author's inexperience in such work and consequent roughness: "Nam simul inuentum, et perfectum nil fuit inquam. / Si rudia ista polire aliquis dignabitur olim / Aut defecta explere, id forsitan efficietur / Quod cum fructu aliquo multos cognosse iuuarit" (For nothing was ever perfect at the moment of its invention. If someone one day thinks it worthwhile to polish these roughly made poems or to make up for their defects, that which many will have been pleased to know, and not unfruitfully, will perhaps come to pass).

Closely related to the great/small paradox is that of the one and the many. With a visual juxtaposition between Democritus speaking to a crowd in a lecture theater and the philosopher Antimichus with his one pupil, Plato, Bocchi makes the point that one good follower is worth many ordinary ones (Symbol CXLIIII). Or, he who conquers himself (one), can easily conquer all things, according to Symbol LXXVII – IPSVM QVI VINCIT FACILE OMNIA VINCIT – which plays on the theme of *Amor vincit omnia*. Similarly, in the symbol of the tribute offer refused by the Roman general Fabritius (XXX), the motto states that he who can govern himself, although he does not have many possessions, ought to be called the richest man of all (NON MVLTA POSSIDENS, SED IMPERANS SIBI DICENDVS EST DITISSIMVS). Not every one/many paradox yielded so positive an interpretation; as Johannes Sambucus lamented in his emblem of Hercules, the monstrous Hydra symbolizes not one but many ills ("Nullum malum solum; vel / Vno bono sublato, mille existunt"; Not merely one evil: in fact, for every one endured through a good deed, a thousand remain).[26] There are further relational paradoxes. Bocchi's symbols also call up paradoxes of less and more (the variant motto for Symbol LVI promises that the more one trusts in one's own worth the less envy one will draw from others), as well as great and greater paradoxes, such as Symbol XCIIII (Figure 27), which praises Claudio Tolomei's magnificent oratory as more powerful than the force of cannons bombarding a city: "Magnificentius eloquitur, sentitque mouetque / Fortius, vt valeat prorsum nil sistere contra" (He orates so magnificently, feeling emotion and stirring it in his listeners so powerfully, that nothing can resist what he says). The motto reads: VIS ELOQVENTIAE POTEST VNA OMNIA (The one force of eloquence can achieve all).

## Paradoxes of Nothing

The problem of nothing leads to deep philosophical problems of logic and ontology; it raises troublesome questions about God and the creation from nothing; and it casts doubt on the value of what we know, but it also leads to verbal play and wit. Rosalie Colie devoted three chapters of her *Paradoxia Epidemica* to just these problems and their generative force in Renaissance literature:

> The term "nothing" presents logical problems as surely as does the term "infinity" – and presents as well much the same problem. At either end of the conceptual scale, "nothing" and "infinity" both bring man to the same impassable intellectual position, where he is himself by definition no longer the

measure of all things, nor even the measure of anything at all. The problem of "nothing," beginning as a problem raised by negative affirmation, even in literature soon turned into a psychological as well as a logical and rhetorical problem. Not only is the logical problem raised, of affirming what is "not," but also, by the affirmation, "nothing" seems to be transformed exactly into "something," a positive entity.[27]

Applied to the emblem books, the paradoxes of nothing threaten the impression of moral certainty that most of the emblem collections tried to convey, although the very popularity of such paradoxes meant that some inevitably would be packaged in this genre. Bocchi, who structured his symbols around questions, was in a position to exploit such paradoxes, but even he attempted to control the way in which his "nothings" could be interpreted.[28]

On the lighter side of the problem were the "nobody" paradoxes. As a young poet, Bocchi had exercised his wit on an epitaph entitled TVMVLVS NICHILI NEBVLONIS (Tomb of Nothing, a Worthless Person), another version of which was called TVMVLVS NIHILI MORIONIS (Tomb of Nothing, the Fool):

> Hic Nihilus iaceo nihili dum uita manebat.
> Ex Nihilo moriens in Nihilum redij.[29]
> (Here I rest, Nothing, worth nothing while I lived.
> In dying, I returned from Nothing to Nothing.)

The satirical poem *Nemo* (*Nobody*) of Ulrich von Hutten, a three-part tract written for university friends in Frankfurt around 1507, was first published in 1510 (a year before the first edition of Erasmus' *Praise of Folly*) and republished in 1516 and in three editions in 1528. Not only did it circulate widely in Germany and beyond, but Hutten himself was a reluctant student of law at the Studio of Bologna between 1512 to 1513 and 1515 to 1517. While he was at the Studio, Hutten parodied Leandro Alberti's edition (1515) of prophecies of Joachim di Fiore.[30] What Hutton added to the 1518 edition of *Nemo* included political attacks on the corruption of Rome and on the disunity of Germany and also a new title page illustration of the Cyclops Polyphemus to whom Odysseus had introduced himself in the *Odyssey* of Homer as "Nobody."[31]

One wonders if the young Bocchi read and laughed at Hutten's paradoxical encomium – although, of course, Bocchi kills off his Nihil without praise, whereas Hutten's Nemo can do everything, know everything, live forever, and be entirely free and good. Hutten's *Nemo* is a humanist adaptation of a theme already appearing in German poems and in German prints, where it took on a distinctive iconographical cast with Nemo (or Niemand) sprouting owl's wings in place of ears and surrounding himself with a welter of disparate broken objects – a Northern European Fool.[32] Bocchi's *Symbolicae Quaestiones* avoids the figure of Nobody, perhaps because of Hutten's association with the early stages of Protestant reform movements. Alciato did produce an emblem on Polyphemus and Odysseus that alluded only indirectly to "Nobody."[33]

Closer to the heart of emblem books than the foolish Nobody was the Socratic

wise fool and the corresponding idea of *docta ignorantia* (learned ignorance). In Plato's *Symposium,* Alcibiades compared a mask of Silenus, a minor sylvan deity with horse's ears often portrayed in the shape of a humorous bust that could be opened up to reveal the image of a god, to a Socrates, rough and uncomely in his exterior appearance and speech but concealing within a brilliant and virtuous mind.[34] Through antique busts surviving in the Renaissance and through the patristic author Theodoretus of Cyrrhus' description of the philosopher as an almost completely illiterate stonecutter, based on a now lost life by Porphyry, a portrait of Socrates entered Western tradition.[35] The vivid description of Socrates in the Prologue of the first book of *Pantagruel* by Rabelais, for example, followed that of Erasmus' essay on the adage "Sileni Alcibiadis" from the 1515 edition of the *Adagiorum Chiliades.* Erasmus, besides the paradox of outer crudeness and inner beauty and that of hidden knowledge, quoted Socrates on his own ignorance: "Socrates alone said that he was sure of one thing only, that he knew nothing."[36] There have been other Sileni, said Erasmus, namely, Antisthenes, Diogenes, Epictetus, and especially Christ, "the most extraordinary Silenus of all," all of whom were mocked and condemned by most of their contemporaries.[37]

Another Silenus was the "Idiota" (or uneducated Layman) of Nicholas of Cusa, a humble spoon maker, who challenged the arrogance of a learned orator and succeeded in convincing him that there was another and higher kind of wisdom beyond human learning. Cusanus' Layman is a wise fool, his orator a foolish "wise" man. It was to the foolishness of those conventionally accepted as wise that Guillaume de la Perrière directed his *La Morosophie* and Erasmus his *Encomium Moria.* La Perrière, who cites the "docte Nicolas Cusan Cardinal, qui à l'un de ses liures mit le tiltre de docte ignorance," introduces his topic of foolish wisdom with a quatrain ending: "Aussi n'est il homme si sage, / Qu'il n'ait contrepois de folie" (Also, there is no man so wise that he does not have a counterweight of folly).[38] Among the moral emblems of La Perrière are Diogenes seeking truth with a lantern (31), Democritus seeking truth down a well (48), the absurdity of an ass in a prince's palace (49), and a male figure garbed as a fool (19). La Perrière's fool speaks from a podium to an assembly of men and women near a wine cellar; Erasmus made Folly a woman with an audience from every walk of life, a Folly whose virtuoso praise of herself is a true paradoxical encomium that almost (but not quite) evolves into an ultimately Christian transcendence.[39]

Bocchi limns both foolish fools and wise fools. One of the former is a young Gallic fool beaten with a club (TEREBRA GALLICA VTILIS), because he can learn only by receiving punishment (Symb. LXIX; STVLTVS MALO ACCEPTO SAPIT). Another, garbed in the traditional fool's cap and with bells around his legs, as a symbol of the "stolidum, atque ignobile vulgus" (stolid and ignoble masses), precedes Pallas Athena (Virtue), who is followed by Gloria (Symbol XLII; VIRTVTIS VMBRA GLORIA). Besides the asses who were driven from the birds' nest in the acanthus bush (XCIII) and the ass as the incompetent judge of Symbol XC (IVDEX INEPTVS PESTE PEIOR PESSIMA; The inept judge is worse than the worst plague), there is, in Symbol LII, an ass mired in mud, whose lazy driver is the greater fool for calling on Hercules to aid him, although the problem could easily be remedied by removing the heavy saddlebags from the ass. The driver, Agaso, has

tried nothing and will achieve nothing (DE AGASONE, ET DIVO HERCVLE. CVRANS NIHIL, PRORSVM EST NIHIL).

To attain true wisdom by knowing one's own ignorance is the Socratic goal. Bocchi urges his son Pirro to follow the wisdom and strength of his own Genius (like Socrates' daimon of Symbol III) as opposed to his own weakness and folly and to cultivate as Socrates once did both innocence and justice (Symbol CXLVII; IVSTE, INNOCENTERQ. GENIVM COLAS TVVM; May you cherish your Genius innocently and in due measure). A son of Bocchi (Pirro?) is further exhorted in Symbol LIX (Figure 28) to follow the Socratic maxim, "Know theyself," though in this case the knowledge is of a corrupted self reflected in the distorted mirror held up by the father in the guise of Socrates (the figure seated at Bocchi's table confronting Bocchi's son is labeled "Socrates" and has the divided beard seen on ancient portraits of the Athenian). Bocchi's two mottoes both refer to the Socratic paradox of knowledge of self as knowledge of everything: EN VIVA E SPECVLO FACIES SPLENDENTE REFERTVR, HINC SAPIES, POTERISQ. OMNIA, DVM IPSE VELIS (Behold your face reflected vividly in the shiny mirror: From here you will acquire wisdom and will be able to do anything, if only you yourself wish it so), and IPSVM TE NOSCENS DVBIO PROCVL OMNIA NOSCES (By getting to know yourself, you will doubtless learn all). Bocchi would also have known of Sabba Castiglione's praise of the mirror as necessary to show the real nature of the self; Socrates, according to Sabba, studied his face in a mirror, and Demosthenes practiced speaking before a mirror.[40]

Even if knowing oneself is everything, one still knows nothing. In Symbol LIIII, which portrays a cock sacrificed in fire to Asclepius (alluding to Socrates' request that such a sacrifice be made for him after his death), Asclepius is compared to God, the master physician of souls, and the cock represents the human mind, which is warned that true Wisdom, the one daughter (*vnigena*) of God the Father, is learning nothing beyond what it is necessary to know (". . . nil sapere vlterius, quam opus est, sapere vnum est"). One motto over the engraving is the commonplace, "Those things which are above us pertain to us in no way" (QVAE SVNT SVPRA NOS PERTINERE AD NOS NIHIL); the other is the Socratic "He is wise who knows that he knows nothing" (QVI SCIRE SCIT SE NIL, SAPIT).

The "nothing" of self-knowledge is what Bishop Johannes Hangest, dedicatee of Symbol CXXXVIII, knows. Bocchi uses an image of Atlas kneeling to bear the universe on his shoulders copied after Hangest's personal medal; in it God the Father looks down from the heavens, and in a banderole between God and Atlas is the motto AD SVMMA TENDENTI TENENDA OMNIA (He who seeks the highest must hold all). The motto for the symbol, however, is SVMMA OMNIA TENET, SCIRE QVI SCIT SE NIHIL (He who knows that he knows nothing holds the highest knowledge of all). According to Irving Lavin,

> Bocchi's emblem thus expresses the ultimate irony, that paganism's greatest claim to wisdom, to know that one knows nothing, is tantamount to grasping the highest Christian mystery. In Socrates' knowledge of his own ignorance lay his foreknowledge of the Trinity.[41]

Bocchi twice repeats the phrase "stratus humi" (prostrate on the ground) to indicate

both the weight of self-knowledge and the humility it requires: "You would foolishly attribute to yourself knowledge of all, unless you, prostrate on the ground, teach that even you know nothing" ("I modo, scire tibi attribuas stulte omnia, ni iam / Stratus humi discas te quoque scire nihil"). Like Molorchus of Nemea, who was the first human to recognize the divine nature of Hercules, and like the Attic teacher recognized as wise by the oracle of Apollo (Socrates), Hangest had attained that wisdom that is paradoxically so low and so high, the same wisdom that Bocchi was trying to impart in his *Symbolicae Quaestiones*. In fact, it was under the auspices of Socrates that wisdom descended from the heavens to us, according to Symbol CXXVII: "Ast vbi Socratico auspicio sapientia ad vsum / Communem aethereo nobis demissa ab olympo est" (but when wisdom through Socratic guidance has been sent down to us from the heavenly Olympus for public use).

A third paradox of nothing has to do with creation, with the coming into being of something, with infinity and the void. Theology placed certain limits on free speculation about such paradoxes. In negative theology, the attempts to define the incommensurable and incomprehensible nature of God through the coincidence of opposites led inevitably from God as Absolute Being and Nothing as Absolute Nothing to a realm of conjunction of Being and Nothingness where God the Not-Nothing is paradoxically Nothing.[42] Although Aristotle had posited that nothing could be created from nothing, in the Christian worldview, God overturned "natural" law to create everything from nothing. Humans, however, obey Aristotle's law, and therefore Bocchi obeys natural law in his creations:

> Nolim putes carissime
>> Lector, figurate ista, quae
>> Diuinitus sunt tradita,
>> Sic prodita esse de nihilo,
>>> (Symbol I, SYMB. SYMBOLORVM)

(I would not want you to think, dearest reader, that it was from nothing that these symbols, which have been handed down from heaven, were produced in the form of emblems.)

Bocchi assures his readers that he does not play God, that his symbols are inspired by forces outside himself (Symbol I), that the poems are created by looking at what is within himself with the aid of his Genius, or Daimon, and that the pictures are an imitation of nature (Symbol III). It is not quite clear how this inspiration accords with a theory of matter. Nicholas of Cusa and Charles de Bovelles both theorized that God first created unformed and undifferentiated matter (chaos) and from it shaped the world and everything in it. Analogously, in Bocchi's gunpowder symbol (CXIIII), the mixed elements in the *puluis* (powder, dust) await a spark to create an explosion. Dust is also enough, neither a maximum nor a minimum, as in Symbol LXVIII in which an old man and his son suspend a sign over the table where they are working: QVOD SAT EST (What is enough). The older man holds an hourglass symbolizing prudent use of time, and the younger one sprinkles dust over wet ink to fix it onto the page without smudging. The overall motto refers to considering always what is enough in everything (SEMPER VIDENDVM QVID SAT EST IN OMNIB.).

What is enough lies between the nothing and many; everything returns to nothing. The letter O is at once the first letter of *omnes* (all), the perfection and endlessness of the circle, the shape of an egg (a beginning), omega (the end), and the cipher *o*. All of this a later, anonymous English poet plays with until "the whole cosmos is a box of 'O's'" and zero "a cipher which, 'deciphered' – that is, understood and un-nothinged – makes 'all,'" according to Rosalie Colie.[43] Bocchi too created a cipher, playing with the O and with the idea of something and many in his OCCASIONEM QVI SAPIS NE AMISERIS (You who are wise: Do not let Chance slip by; Symbol LXXI). In the engraving, Occasio is stretched on her own wheel (another O), as though on an instrument of torture (Figure 29). From the letters forming her name, Bocchi produces the following cipher:

> O nihil est. CC. bis centum nunciat, A nil
> S. Quintum, Primum, I. Rursus &, o. nihil est.
> Principium nihil est: bis Centum plurima, quin*que*
> Non satis est, vnus sat, venit inde nihil.
>
> (lines 5–8)

Occasio begins with a worthless nothing, turns to many (twice one hundred), then to less (five), which is not enough, then to one, which can be enough, and back again to nothing. With the turn of the wheel, a person's fortune turns a full circle. Likewise, the paradox of coming into being (birth), moving forward, regressing, and finally going back into nothing (dying) is suggested. This same turning of the circle also ends Charles de Bovelles' closing poem to his readers in a treatise known to Bocchi, the *Artis oppositorum sive dedalogie* (1509):

> Omnis namque tibi res una hac arte patescet,
>     Tam nichil est unum sit inoppositum.
> Articula hec diversa parat bis binaque gignit:
>     Quodlibet in proprium volvit et oppositum.
> Nempe deus deus est, nichil est nichil aut deus est nil,
>     Aut nichil est deus hos implicat ista modos.
>     . . . . . . . . . . . . . . . . . . . . . . . . . . . . . . . . . . . . . .
> Volve igitur, confer, perfice, claude gyros.
>
> (lines 3–8, 12)[44]

(For everything will become manifest to you by this one method, just as it is true that the only thing that does not have an opposite is nothingness. This method sets discreet things at odds and then combines them twice in pairs: it turns anything whatsoever into itself and its opposite. God is God, nothingness is nothingness, or God is nothingness or nothingness is God. This method entangles these relations. . . . O turn, therefore, unite, complete, close the circle.)

For another treatise in the same collection, Bovelles created a frontispiece that illustrates a traditional version of Fortuna sitting on a sphere and holding a wheel of fortune in her hand (Figure 30).[45]

Less playful perhaps is Bocchi's ENTELECHIA PSYCHE (Symbol CXXXX), which, as we saw in Chapter 2, recapitulates Bocchi's position on the soul as both perfect (*entelechia*) and in perpetual motion (*endelechia*). God created not only matter

from nothing but also souls, which are a kind of "nothing," because they contain neither moisture, nor air, nor fire, nor earth. They are created perfect and last for eternity ("motu sempiterno"), unlike matter, which has a beginning and an ending, and unlike God, who has no beginning and no end.[46] Although the soul is a simple creation compared to its creator, its nature is unknowable and hidden.

Bocchi found Bovelles' *Libellus De Nichilo* doubly generative: He drew on the philosophical text, and he adapted Bovelles' frontispiece, itself probably copied from a medieval miniature, to illustrate his entelechia symbol (Figures 5 and 6). Both men portrayed God infusing the earth with his breath through a long pipe as though blowing a soap bubble or a crystal ball. Bovelles envisioned it as a circle of light containing symbols of the elements placed within a dark circle labeled NICHIL. Bocchi's globe gives a rough indication of continents and is surrounded by four *putti* with symbols of the four elements and their pagan gods. Bocchi's is a Renaissance God garbed in billowing robes with the triangle representing the Trinity behind his head, whereas Bovelles' God is a medieval one wearing a crown.

Both the bubble and the crystal ball widely used symbols of fragility and impermanence, but they evoke two different iconographic traditions. Bubbles entered the humanistic consciousness at the beginning of the sixteenth century with the widely read interpretations of the proverb "Homo bulla est" by Filippo Beroaldo the Elder and Erasmus. To Beroaldo, in his *Oratio prouerbialis,* the bubble is the type and the image of human life:

> Tu qui immortalia animo volutas: cuius cupiditati orbis ipse non sufficit. cui nihil est satis: bulla es: scito homine nihil esse fragilius: cum eodem nihil set superbius.[47]

> (You who ponder things immortal; you, for whose desire the world itself does not suffice, for whom nothing is enough: you are a bubble. Know that nothing is more fragile than man, though nothing is more arrogant than he.)

Erasmus, much indebted to Beroaldo, popularized the adage further in his *Adagia,* making it a symbol of vanity known to most of literate Europe.[48] Bocchi himself in a formal letter of consolation wrote of life that "Bullae simillima est."[49] There were few representations of bubble blowing in art before 1555, and perhaps none in Italian art, because the *putti* engaged in that play in the French edition of Francesco Colonna's *Hypnerotomachia Poliphili* had no counterparts in the earlier Italian edition. Similar childish bubble blowers did appear in some later emblem books, most notably in Hadrianus Junius' *Emblemata* of 1565 and Geoffrey Whitney's *A Choice of Emblems* of 1586,[50] Junius and Whitney both associated the bubbles with foolishness and nothing (ET TVTTO ABBRACCIO ET NVLLA STRINGO; I both embrace everything and clasp nothing). Later in the sixteenth century and on through the Baroque period, the bubble was an enormously popular addition to the "Vanitas" paintings of northern Europe, as, for example, the very emblematic *Vanitas* by Jacques de Geyn II (1603), in which a huge bubble reflecting a wheel (Fortuna) and a "flaming heart pierced by an arrow" hovers over a skull.[51] Richard Crashaw's poetic "Bvlla" (by 1634) evokes abundantly the Vanitas tradition and its associations with Venus and Fortuna; the long poem concludes: "O sum scilicet o nihil!" (Oh, I am certainly O nothing!).[52]

The earth as a sphere of crystalline glass derives from a different tradition, ultimately from the earth as a shining golden plaything of the gods in Apollonius of Rhodes.[53] The ancients prized naturally occurring crystalline globes of ice or quartz, according to a cluster of seven epigrams by Claudianus, but Claudianus also wrote an epigram on Archimedes' sphere ("In sphaeram Archimedis") as a human re-creation in glass of the heavenly sphere. Claudianus says that Jove laughed at the idea of it: "Iam meus in fragili luditur orbe labor?" ("Is my handiwork now mimicked in a fragile globe?").[54] The Creator as Glassblower metaphor was introduced in a Hellenistic work known as the *Theology of Aristotle* and developed by Nicholas of Cusa in his *Dialogus De genesi* and the *Idiota;* in the latter, Cusa placed it in the context of a discussion of the creation of the soul by God:

> For willing and performing coincide in omnipotence, as when a glass blower makes glass. He blows his breath (*spiritus*) that accomplishes his will. In his breath exists word or conception as well as power. For if power and conception did not exist in the breath of the glass blower when he blows, no glass would come into being.[55]

Bovelles' God would have been a glassblower rather than a bubble blower, because this student of Nicholas of Cusa transformed verbal metaphors within the text of others into the engraved drawings ornamenting his own text, as in the case of the frontispiece for *De Nichilo*. In Bocchi's Symbol CXXXX, given his closeness to the "bulla" tradition, the glossy globe of Earth could be either a soap bubble or a glass crystal, because the pipe used to blow it resembles neither a glassblower's straight tube nor a bubble pipe, originally made from a reed or other thin tube. Rather, it is a straight trumpet, and the only similar depiction I have found is the much later emblem of Fame blowing bubbles in the *Trajano regio Principi Paridi* of Hieronymus Sperling (1740), which obviously drew on Bocchi's symbol.[56]

The ambiguous relationship between bubble and crystal has delighted playful artists and poets. For example, the glossy transparent globe on which Fortuna crouches in a Dosso Dossi painting (around 1535) in the collection of the J. Paul Getty Museum in Malibu, California, could be either a bubble or a crystal sphere, and as recently as 1936 the surrealist artist Man Ray photographed a pipe holding a crystal ball (a Christmas ornament) rather than a soap bubble.[57] Or, there is Crashaw's bubble, which is "More clear than glass, more fragile than glass, and more glassy than glass" ("Sed uitro nitida magis, / Sed uitro fragili magis, / Et uitro uitrea magis").[58] We cannot see the souls in the Bocchi engraving, but the bubble's moisture and air and the glassy crystal's fire and earth (dust) are all acknowledged in the symbols of the elements, which are accompanied by *putti*, a familiar presence in later bubble pictures. Physical existence on such a fragile Earth is subject to finitude, to the havoc wreaked by the elements, and to the instability of Fortuna, whose wheel is one of the attributes of the *putto* symbolizing the element earth in the lower right corner of the emblem and whose rolling sphere is depicted in Bocchi's Symbols XXII, XXIII, and CXI, as well as in Bovelles' Fortuna (Figure 30).

The final "nothing" is that of darkness and of privation of light. Just as nonbeing is the paradoxical opposite of being, so the light of God/Apollo is the paradoxical opposite of the sensory realm. Bovelles, in *De Sapientia*, posited four stages: *lux,* the

divine light of God; *lumen*, the first emanation, or angelic intelligence; *ombra*, the shadows of refracted light from the moon, or rational humans; and *tenebrae*, privation of light, or the realm of the irrational and the senses.[59] Because the human mind is mixed and not pure and because it represents light refracted from the spotted face of the moon, a human face is "maculosa" as in the distorting mirror of Bocchi's Symbol LIX (Figure 28).[60] In Symbol XLII, VIRTVTIS VMBRA GLORIA (Glory is the shadow of Virtue), Glory is a human affair and therefore solid and corporeal: "Gloria Virtutis comes est, vt corporis vmbra, / Et solida" (Glory is the companion of Virtue, just as the shadow is the companion of the body, and has substance). She follows Pallas Athena in the guise of Virtue, but she also follows the dull Fool. In a related emblem (64), La Perrière depicts a view beyond a room of shadow and envy toward a sunrise seen through a doorway; we cannot see shadows when there is no light, he says, and, likewise, envy has no power where glory does not exist.[61] More often, the world of shadow is represented as one tinged with decay; even the brightest light humans do see is but reflected light, the shadow of God ("Lux est umbra Dei").[62] The light beyond the shadows is too strong for human eyes, according to Bocchi's Symbol XCVIII, ARCANA QVAERENS CVRIOSIVS, PERIT (The curious one, searching out the hidden, perishes). Just as human eyes exposed too much to the sun begin to perceive light warring with darkness and then blind darkness, so those seeking too far into divine secrets will be struck down. Only Christ was able to escape the realms of shadow and darkness into that of light, as depicted in Symbol XCVIII's engraving (after Raphael) of the Transfiguration of Christ.

## The Coincidence of Opposites

Over and over, emblem books return to some types of oxymorons and paradoxes, not just to parade their compilers' wit but to challenge their readers' intellects. Concepts difficult to grasp are condensed into mottoes and then rephrased poetically and visually. According to E. H. Gombrich, this is because "what appears to be mutually exclusive in language is not so in fact."[63] One of the most popular and widely understood Renaissance paradoxes was "Make haste slowly." Expressed visually as a dolphin (a creature capable of great speed) entwined around an anchor, it was a device associated with the Emperors Augustus and Titus. By the early sixteenth century, it had been adopted as the printer's mark of Aldus Manutius in Venice and been interpreted by Erasmus in his *Adagia*. Before long, new images were devised to express FESTINA LENTE and MATURA CELERITAS: a winged hand (Hadrianus Junius); and "a tortoise carrying a sail, a dolphin tied to a tortoise, a sail attached to a column, a butterfly on a crab, a falcon holding the weights of a clock in its beak, a remora twisting around an arrow [Alciato], an eagle and a lamb, a blindfolded lynx, – these and innumerable other emblematic combinations were adopted to signify the rule of life that ripeness is achieved by a growth of strength in which quickness and steadiness are equally developed," according to Edgar Wind.[64] Bocchi's contribution (LXXXII) takes the form of a medal he calls his "symbol": HOC BOCCHIANI SYMBOLVM ES NVMISMATIS MATVRA FESTINATIO (You are this symbol on Bocchi's medallion: Haste should be timely). This was originally the medal of a former governor of Bologna, Altobello Averoldo, which

was copied closely except for the resetting of the original motto, MATVRA CELERITAS, from the outer perimeter of the coin to a space at the bottom.[65] Seated on a dais, an orator called "Alce" (Alcaeus?) gestures with his fingers as he delivers weighty arguments on every topic, while in the background Old Age confronts a Youth clasping a cornucopia, an allusion to the *puer senex* topos of a combination of the wisdom of an old man joined to the vitality of a youth (Figure 31).[66] The fourth man, facing Alce, represents the middle-aged Bocchi. He holds a spur and bridle signifying haste and control of speed; he urges an equilibrium between doing nothing and taking on too much: NEC NIL, NEC NIMIVM (Neither nothing, nor too much).

Another type of paradox found in emblem collections is the emotional one linking pleasure and pain. Bocchi's COMES VOLVPTATIS DOLOR (Pain as the companion of pleasure; VIII) depicts two heavenly urns, one for Pleasure beside Jupiter and the other for pain beside Saturn; their contents are mixed by Ganymede, who stands between them ("laetis / Tristia miscentes"; mixing sadness with joy). Over the engraving is a second title: MEDIO DE FONTE LEPORVM SVRGIT AMARI ALIQVID (In the midst of the spring of pleasantness rises something bitter).[67] In La Perrière's *Morosophie,* it is Minerva who joins the hands of the mournful Saturn and the jovial god: "Saturne dueil, Iuppiter ioye meyne: / Pallas les deux tempere sagement" (Pallas tempers wisely Saturn's mourning and Jupiter's joy).[68] A similar theme, that of the weeping Heraclitus and laughing Democritus, was pictured in Ficino's study and inspired a popular poem, *Doi Philosophi,* by Antonio Fregoso. In an emblem, Alciato claimed to weep with Heraclitus because of the misfortunes of his times and to laugh with Democritus because life has grown more ludicrous ("In vitam humanam," Emblema CLII).[69]

To include at least a token emblem on the paradoxical emotions of love was standard practice. In Rosalie Colie's words, "Love is a wearing emotion, as Petrarca set it down, full of the psychological paradoxes of willing and unwilling, of love and distress, of self-hatred and pride."[70] Petrarchan conceits converted into pictorial wit, and Petrarchan mottoes had an enormous impact on emblem collections and, transformed by their visual applications, on the poetic imagery of the succeeding centuries.[71] Only at the conclusion of his Symbol VII, AMOR NEGOCIOSVS EST IN OCIO (Love is busy in leisure), did Bocchi indulge in the usual amorous oxymoron of a burning love affair as a living death and an unquiet repose ("Urenteis pariunt semper lenta otia amores, / Unde est mors viuens, irrequieta quies"; For those who are inflamed with desire, a love affair always brings forth long-drawn-out leisure, whence comes a living death, restless rest). In love, the arrows of Cupid are stronger than the thunderbolts of Jupiter; that is, love's fire is stronger than fire, according to Alciato's "Vis amoris" ("igne / Dum demonstrat vti est fortior ignis Amor"; Yet by fire it is demonstrated that Love is stronger than fire).[72] The theme of bittersweet love was one easily illustrated by the fable of Eros stung by bees while stealing honey, as in Alciato's "Dulcia quandoque amara fieri" (Sweetness sometimes changes to bitterness).[73] Sambucus interpreted his "Dulcia cum amaris" more broadly, however, as the pain and sweetness of life, illustrated by Pan in the center of the universe.[74] The paradox of emotional life explored by sixteenth-century

emblematists must have contributed in no small way to an increasing understanding of human psychology.

Eros wars against humankind and makes Mars put down his arms.[75] In the emblems, concord and discord, love and war, and war and peace are always in opposition, always seeking equilibrium. The authors of emblems never envision a world without strife; the most they can hope for is that war occur only as a last resort. Much better than war is the peacetime occupation of a soldier who raises bees in his army helmet so that something sweet can come out of the bitter, as in Alciato's "Ex bello pax" (From war, peace).[76] Nor is this use of military paraphernalia uncommon in emblems of peace in which olive branches rest upon shields and Amazons with olive branches represent armed peace.[77] Concord, often illustrated by the strings of a lute or viol, presupposes discord, as in the "Discors concordia" of Sambucus and the "Concordia discors" of Wilhelm Zincgreff.[78] Despite Ariosto's lamenting the inventions of gunpowder and cannon as the destroyers of chivalry, most educated persons of the Renaissance deplored war, although at the same time they openly admired the power and trappings of military technology.[79] Thus, Biringuccio said cannons should be ornamented and made beautiful; Sebastiano Serlio advocated military ornament for houses, including incendiary balls as chimney pots; and Sabba Castiglione recommended books and arms as the best decorations for homes. Bocchi, who knew only short periods of peace during his life, does not even make symbols of peace and concord. The violence of his comparison in Symbol XCIIII between Claudio Tolomei's eloquence and the bombardment of a city hardly suggests an orator famous for a speech on peace. Instead, the gunpowder fascinates the reader with its power, a power that in some way represents the explosion of understanding. Only in his last symbol (CLI) does Bocchi indicate a yearning for peace, which even then he cannot express without alluding to Janus and the open doors of the temple of war. Perhaps there were topics about which he was too disheartened to attempt the wit of paradox.

When war and peace are concerned, even the gods appear as paradoxes. Janus has his temple of war and peace and Athena her trappings of war – helmet, sword, and Medusa shield – with only an olive branch to identify her as a goddess of peace. Mars might lay down his arms for love, but sixteenth-century humans could not do so, even though war often represented to them weakness and decadence (Machiavelli), human bestiality (Erasmus), or original sin (Milton).[80] Yet the *idea* of war requires an *idea* of peace: Innocenzio Ringhieri, for example, could not devise a game of war without a corresponding game of peace.[81] Reconciliation of these opposites on the human level could, however, occur in love with all its strangeness. Thomas Greene comments on the "disturbing" nature of a *dizain* (443) from the *Delie* (1544) of Maurice Scève in which the metaphoric incineration of Semele fuses death and rebirth, war and peace.[82] Those opposites that humankind cannot resolve, however, the gods can unite. Minerva, Janus, and Mars are *dei ambigui,* to borrow a term that Edgar Wind developed from Colonna's *Hypnerotomachia Poliphili.* Within each god or goddess inheres its opposite. Each god or goddess in the Orphic pantheon transmitted to the Renaissance, especially by Pico della Mirandola, can change his or her nature to create a balance and harmony.[83] According to Wind,

In short, all the gods, without exception, appear in Orphic theology both as inciters and as moderators, they are *dei ambigui* . . . ; and because each god thus shares in the temperament of other gods, they are able to assist and also to offset each other. The wild Dionysus, on Mount Parnassus, finds himself checked by a stern Apollo, who in his turn, when he appears opposite to Minerva, softens her severity.[84]

Paradox demands from its readers a transcendent effort to move beyond the printed page, beyond the limits of the human mind, and beyond the world of nature.

# The Mythographic Union
# of Eloquence and Wisdom

Laurigeros domini, liber, intrature penates
disce verecundo sanctius ore loqui.
nuda recede Venus; non est tuus iste libellus:
tu mihi, tu Pallas Caesariana, veni.
(Martial, *Epigrams*, VIII.1)[1]

Achille Bocchi sang of the gods and the art of language. To Bocchi, the problems of knowing, speaking, and keeping silent, of disseminating or withholding knowledge, and of representing all these visually could be expressed symbolically through myths. In this, he was not alone. The sixteenth century, commented Claude-Gilbert Dubois, rarely thought of matters of language except through images and myths.[2]

It is no accident that about half of Bocchi's emblems draw in some way on the mythology of the classical world, because the Bolognese scholar and his contemporaries were poring over a vast array of newly available ancient texts with their favorite medieval encyclopedias and recent mythologies in hand. By the end of Bocchi's life, printing presses had issued the major postantique mythologies: Giovanni Boccaccio's *Genealogia Deorum Gentilium* (first published in Venice in 1472), Giglio Gregorio Giraldi's *De deis gentium* (Basel 1548), Natale Conti's *Mythologiae sive Explicationis Fabulorum* (Venice 1551), Vincenzo Cartari's *Le imagini con la spositione de i dei de gli antichi raccolte* (Venice 1556), and also Georg Pictor's 1532 *Theologica Mythica* and 1538 *Apotheseos* [sic] *Tam Exterrarvm Gentivm Qvam Romanorvm Deorvm Libri Tres*.[3] Although most teachers of rhetoric kept manuscript notes on the deities they so often explained in commenting on classroom texts, anyone could turn to the printed mythographies to supplement formal education and to satisfy curiosity.[4] The new mythographers strove for completeness; only gradually did they develop organizational methods suited to a more general audience. Modern readers, unaccustomed to what E. H. Gombrich characterized as a "bewildering farrago of pedantic erudition" and skeptical about the value of these works, have criticized the compilers for lack of selectivity.[5]

Nevertheless, both mythographers and devisers of emblems found each other's

131

work immensely useful. Whereas the emblem books had an impact on mythologies, from the partially, and crudely, illustrated *Apotheseos* of Pictor and the fully illustrated 1571 Venetian edition of Cartari's *Le Imagini de i dei de gli antichi,* printed by Bolognino Zaltieri on, the mythologies provided a tool for creators of emblem books as well.[6] What Bocchi learned from his mythographical researches were the ways in which gods were worshiped, the many local variants of the gods, the gods' attributes, and the functions of the gods. In his emblems, he depicted ancient sacrifices – of a cock to Asclepius, of an ox, of hearts – and unusual manifestations of gods – the Gallic Hercules, for example. Variants on names helped many a poet with meter and variety: Bocchi could call Hercules "heros Amphitrioniades" (Symbol XCII) or Minerva "Pallas Tritonia" (LXXXIII).

Although Bocchi drew on some stories about the gods, particularly narratives concerning Hercules and one non-Ovidian metamorphosis (Pitys into a pine tree in Symbol CL), he was far more interested in the symbolic interpretation of the gods. To him, each major god represented a dense cluster of meanings. For single meanings, Bocchi could and did employ personifications like Virtus, Felicitas, or Occasio – those entities called by Giraldi "Dei ex humanis actionibus" (gods that represent human actions).[7] Some of the density of meaning, though, came from the conflation of early cult forms of the gods, first among the Greek territories – Pallas and Athena – and then over the entire Mediterranean world – Pallas Athena and Minerva or Mercury as Hermes Trismegistus and Thoth. Either by blending other forms of themselves, as with Hercules Ogmios, or by "infolding" a different deity – Concordia into Constantia or Pan into Proteus – they become "hybrid" gods, according to Edgar Wind.[8] When these hybrid deities also paradoxically unite opposing meanings, they represent what Francesco Colonna in the *Hypnerotomachia Poliphili* termed *dei ambigui,* with the implication that divinity transcends even the most radical differences.[9] One way to represent their ambiguity is through attributes: an armed Athena holding an olive branch, for example; or a Venus disguised as one of Diana's nymphs. The other way is the depiction of gods themselves as hybrids, such as Hermaphrodite, two- or three-faced Janus, Pan the Satyr, or even as mythic monsters, such as the Chimera and the Minotaur. Furthermore, there are the changeable gods, Vertumnus and especially Proteus. The more complex the symbol, the more likely it was to involve ideas of mind and language. Although there were negative aspects of the speech of the gods (gossiping Hercules and lying Hermes), Bocchi avoided such examples of transgression, preferring instead to combine symbols of eloquence with prudent restraint; his gods offer a perfected form of language.

### Divine Hercules: Virtue, Labor, and Strength of Mind

To Bocchi, Hercules was both mortal and divine, a hero and a god. Born to a mortal mother (Alcmena) and Jove, this demigod through his labors earned full divinity after death. Bocchi, however, attempted neither to explain Hercules as an outstanding human (euhemerism) nor to identify him with Christ as some sixteenth-century writers did.[10] In only one of Bocchi's symbols does Hercules appear as a heavenly god, and that one (LII), a fable about a driver named Agaso

with an ass stuck in mire, has a conventional moral: The gods help those who help themselves (Agaso has not tried removing the heavy saddlebags weighing down his beast).

Underlying all the Hercules emblems is the theme of virtue. Although Bocchi did not illustrate the Choice of Hercules (or, Hercules at the Crossroads), a favorite of humanists,[11] he took care to portray a Hercules who has already chosen Virtue over Vice (or Pleasure). This is most explicit in Bocchi's addition of a statue of Hercules over the Roman temple of Virtue in Symbol XXXIII (Figure 32). The worshiper had to pass through the foretemple (*vestibulum*) of Virtue to reach the temple of Honor beyond.[12] In Symbol XLIII (Figure 33), by placing the unexpected cube on a square cart, Bocchi was providing Hercules with a "seat of virtue" like that described in his Symbol CXXVII with its added inscription, VIRTVTI MERITO SEDES QVADRATA DICATVR (The squared seat is justly devoted to virtue). In Symbol IX, Hercules joins Perseus and Aeneas as one of three heroes exemplifying the virtue of Constancy.

Fortitude, the traditional virtue of Hercules, signifies in part the great physical strength the hero exhibited in accomplishing his labors.[13] Artists delighted in the muscular body of Hercules pitted against the power of wild beasts. No doubt Bocchi had seen and admired a frieze of the Labors of Hercules by Baldassare Peruzzi and other wall frescoes of Herculean labors painted by Sebastian del Piombo around 1510 to 1512 for Agostino Chigi's Roman palace (later called the Farnesina by its Farnese owners).[14] He may also have taken note of the detailed series of labors framing the title page of the *De Orbe Novo* of Pietro Martire d'Anghiera (1530).[15] Further encouragement for an emblematic treatment of Hercules derived from the emblems of Andrea Alciato, especially the emblem on Herculean labors added to the 1546 edition of the *Emblemata,* in which each line of the twelve-line epigram lists a separate labor, briefly allegorized.[16] Bocchi's Hercules pits his strength against prodigious beings. He is the subduer of monsters, the "monstrorum domitor" (Symbol CXII), who defeats the Cleonean (Nemean) lion (CVII), the *draco* (dragon or serpent) guarding the golden apples of the Hesperides (LV), and the Hydra (called "draconis" and "monstrum" in Symbol XCII); he drags the monster Cerberus out of Styx (IX). Bocchi's insistence on the monstrous nature of the beasts Hercules overcomes is reminiscent of the language used by Boccaccio to describe many of the thirty-one labors that the fourteenth-century mythographer enumerated, although Bocchi's friend Lilio Gregorio Giraldi also characterized as "Hercules" those men who were strong enough to be tamers of monsters ("monstrorum domitores").[17] Such heroic fortitude requires fearless and untiring activity. Bocchi's Constantia in Symbol IX (Figure 34), for example, represents strength of purpose in dangerous undertakings: Perseus' decapitation of Medusa; Aeneas' flight from Troy to Italy "per varios casus, longos*que* labores" (through varied misfortunes and long suffering); and Hercules' labors of subduing Cerberus, the Lernaean and Nemean lions, Diomedes' wild horse, and the Minoan bull.

The power of Hercules is more than physical. Just as Hercules killed the many-headed Hydra (XCII) with fire rather than a sword, the hero, as Bocchi advised Duke Ercole Gonzaga, can conquer envy and unpopularity through benefaction rather than revenge. Envy is the interpretation given by Erasmus in his adage

"Herculei labores" to the Hydra, that most difficult of all monsters to overcome. Erasmus addresses the envy that accompanies all high and virtuous deeds and, in particular, the envy that pursues the laboring scholar. He quotes from Horace (*Epistles,* II.1.10–11) a passage that Bocchi would have known well:

> He who crushed the fearsome Hydra,
> And subjected a notorious monster by his destined labour,
> Learnt that envy remained to be vanquished at the end of all.[18]

Bocchi discusses how those in public office, like his dedicatee, can deal with dangerous envy.

This same moral fortitude permits heroic individuals to rule themselves. In Symbol CVII (Figure 35), when Hercules tears apart the jaws of the Cleonean (Nemean) lion with his bare hands and forces its tongue back into its throat, he symbolizes the control of the tongue and of wrath. With more detail, the nude statue of Hercules depicted in Symbol LV, standing in a country landscape, holds three apples, a club, and lion grasped by the tail (Figure 36). To answer the question posed about what this statue means, Bocchi provides an interpretation very close to that of Giovanni Pierio Valeriano's paragraph "Tres Hercvlis Virtutis" from the *Hiero-glyphica:* The three Hesperidean apples represent the three heroic virtues of modera-tion of wrath, control of greed, and contempt for pleasure; the lion symbolizes strength of soul and mind; and the club stands for reason and discipline (according to Valeriano), or power (Bocchi), which defeat the dragon of the libido or desire in us. This allegory apparently began with the Greek commentator Herodoros.[19] The statue itself Valeriano identified as a bronze found on the Capitoline Hill in Rome.[20]

The Hesperidean Hercules, furthermore, represents vigor of mind: reason and an outstanding intellect ("mentisque praestantiam") to Valeriano; wisdom and magna-nimity to Bocchi ("Magnanimi Alcidae vera, & sapientis imago est"; Here is the true image of wise and magnanimous Hercules); and the philosophy and prudence by which Hercules subdued the monster of the soul and empty thoughts ("quibus rebus Hercules animi monstra edomuit, & cogitationes uanas") to Giraldi.[21] Because Atlas had acquired by the sixteenth century a reputation for being an astrologer, so Hercules too, by undertaking the labor of supporting the globe, was believed to understand the secrets of the universe.[22] In Symbol CXII (Figure 37), Bocchi developed this theme. Which is better, he asked, Atlas studying a book about the stars or Hercules measuring the universe (an armillary sphere) with a compass? Both are semigods, both learned; the one sees, the other acts ("hic videt, alter agit"). Here, Bocchi answers the question decisively in favor of the active Hercules over the contemplative Atlas. If Hercules can bear the weight of the globe, he has the strength and qualities necessary to conquer himself ("Verus hic Alcides solida est qui mente, animoque / Impauido, iustus propositique tenax"; This man is a true Hercules who has a steadfast mind, a fearless soul, and is just and tenacious of purpose). Only by virtue and the active use of the mind can one gain praise (VIRTVTIS OMNIS EST IN ACTIONE LAVS; The glory of all virtue is in performance).

Another active way to gain the praise and attention of other people is through

eloquence attained by diligent study. Bocchi's Gallic Hercules (XLIII, Figure 33) represents the labor of study through which one can become not only eloquent but also wise ("Ille desertus erit non modo, sed sapiens"). Based on the Greco-Syrian Lucian's eyewitness account of the god Ogmios in procession in Gaul (2d c. A.D.), Bocchi's text describes the Gallic god, whom Lucian interpreted to be Hercules, as an old man with club, bow and arrows, and lionskin, his hair sparse and his skin as wrinkled and weathered as that of an old sailor. The most striking feature about this Hercules, according to Lucian, was his bifurcated tongue from which chains of gold and electra (an alloy of gold and silver) ran to the ears of his followers, symbolizing the force of eloquence. These two chains, according to Bocchi, signify knowledge of the divine and the human. The poem speaks of the extraordinary eloquence of the old, whose minds have become stable and serious. Only the labor of a lifetime of study could yield a Nestor in whose mouth words could be distilled into honey: "Propterea vates Smyrnaeus mel senis olim / Fluxisse e dulci Nestoris ore canit" (That is why the Smyrnaean poet sings that honey once flowed from the sweet-sounding mouth of aged Nestor).

The illustration to Bocchi's symbol adds material not in Lucian's original text or in any other Renaissance depiction of Ogmios. There had been a burst of artistic and scholarly interest in the Gallic Hercules in the early sixteenth century: Cratander of Basel pictured the god in elegant frontispieces for his editions of Lucian, of Aulus Gellius, and of a Greek-Latin dictionary (1519),[23] and Geofroy Tory printed a similar illustration of the Gallic Hercules, based, he said, on a copy he had made from a "riche peinture" seen in Rome, along with Latin and French translations of Lucian's text in his *Champ Fleury* (Paris, 1529).[24] The first illustration to Alciato's "Eloqventia fortitvdine praestantior" (Eloquence is more eminent than strength), in the 1531 Augsburg edition, depicted a chain from Hercules' back stretching to encircle the waists of the followers, but this image was corrected in every subsequent edition to show the chains running back from the mouth of the aged god to the ears of his followers.[25] Bocchi's Ogmios, however, is anything but frail and wrinkled, and no one but Bocchi staged the procession for the Gallic Hercules on a cart drawn by two bulls, which are goaded on by the two small boys (*amoretti*) riding on their backs. Bocchi, therefore, envisioned not so much a religious procession as a triumph of the god, for which a cart would have been as necessary in the sixteenth century as a float would be in a modern parade.

Through these symbols, Bocchi built up a portrait of a divine hero who was master of his passions and his tongue and, consequently, the master of all dangerous and difficult situations. Nevertheless, in his last two Hercules symbols, Bocchi turned away from the ideal of the active hero. When in Symbol CXXXIII, dedicated to Romolo Amaseo, he vowed to retire from the pursuit of worldly fame and wealth and seek only the one true God, he illustrated it with an engraving of the old gladiator Veianius seated on cubic stones in front of a rustic, straw-roofed shelter (Figure 38). Nearby, a circular temple dedicated to Hercules exhibits a statue of the robust god above its entrance and a suit of armor hung on a post by the door. Over the temple, Bocchi added an inscription from Horace's *Epistles*, I.1.4–6: "Veianivs armis Hercvlis ad postem fixis latet abditvs agro ne popvlvm extrema totie[n]s exoret harena" ("Veianius hangs up his arms at Hercules' door, then lies hidden in the country, that

he may not have to plead with the crowd again and again from the arena's edges").[26] Bocchi too wished to retreat from the world of "tantisque laboribus, atque periclis" (with all its many and formidable struggles and dangers).

Finally, in Symbol CXLII, a strong Hercules with the standard attributes of club and lionskin gazes away from the city in the background and downward towards the *dioptra* in his right hand, a right-angled surveying instrument with a plumb line hanging down from its center.[27] From both sides of the quadrant hang oil lamps, one lit, the other extinguished. This Hercules is again outstandingly virtuous, strong, and wise ("haec temperies animi est, / quam praestans virtute sua Fortis, Sapiensque, / Nil est quod timeat, quod doleat, cupiat"; This is the moderation of soul, showing how through his virtue, being strong and wise, he fears nothing, suffers nothing, desires nothing), but the quadrant with the lamps signifies an equilibrium of soul attained by weighing life against the norm of death. Death and the uncertainty of the Last Judgment are good to those who have led a happy life (BENE EST VITA BEATA MORI; It is well to die if one's life has been happy). These two symbols reflect the more contemplative nature of Book V.

What more suitable model for an ambitious scholar could there be than Hercules? The strength of body, character, and intellect together with heroic struggle promise glory, even apotheosis. And was not Labor essential to the scholar? In the *De nuptiis Philologiae et Mercurii* of Martianus Capella, Philology called on her "faithful ward," Labor, "whom she loved above all others," to support one front corner of the palanquin that was to carry her heavenward for her marriage.[28] According to the rules for a personal *impresa*, however, neither a god nor a personification was a suitable topic, so Bocchi selected a symbol of Labor instead. The bucranium (ox skull, or, in Greek, *bregma*) with which Bocchi illustrated Symbol I (Figure 4) had decorated antique temple friezes along with tassels or swag garlands.[29] To Sebastiano Serlio, the ox skull as a decorative motif on a temple frieze had no meaning other than its associations with ancient sacrifices.[30] The interpretation of the bucranium with tools (hoes or hammers) as "Labor" probably originated with Francesco Colonna in the *Hypnerotomachia Poliphili;* among the appearances of this "ossatura di boue" are one on the socle of an elephant statue and another in a "hieroglyphic" panel, clearly identified as "Labore."[31] The ox skull has been purged of its skin and flesh through hard work, according to Giovanni Pierio Valeriano and some editions of the *Hieroglyphics* of Horapollo, and thus it reveals what has been hidden.[32] In other words, Bocchi labors to unveil the deeper meanings of symbols for his readers. The *impresa* skull, however, also has palm branches, representing victory, sprouting from its eye sockets and a laurel wreath for poetic glory floating over it.

Another version of the bucranium, with only its tools and a scroll reading VSVS LABOR, tops a trophy in Symbol XXXVI, ARS DOCTA NATVRAM AEMVLATVR... (Learned Art emulates Nature). Personified as a sculptor, Art measures with a double compass labeled BONVM and VERVM a boy she is recreating in stone.[33] While one end of the compass traces a circle around the face of the boy she is copying, using the evidence of the senses, the other end of the compass simultaneously encircles her own face to demonstrate self-knowledge. Labor is essential to Art. Bocchi ends the poem with a commentary on the bucranium:

Sed quid Βρέγμα bouis, quid agrestia fixa tropaeo
 Arma volunt? labor est acer, et assiduus.
Daedala Naturam pro viribus Ars imitatur,
 Et vincit, dum vsus praeist, et ipse labor.

(But what does the skull of an ox mean, and what the rustic tools fixed on the trophy? Work is harsh and unceasing. Skillful Art imitates Nature as well as she can, and she triumphs, so long as she is accompanied by practice and hard work.)

The bucranium in the hieroglyphic inscription copied from Colonna for Bocchi's Symbol CXLVII (Figures 2 and 3) is another symbol of Labor with tools. Not all of Colonna's bucrania, however, have tools attached to signify work: Several, including one with palm branches, are identified as symbols of Patience.[34] Bocchi's yoked personification of Patience in Symbol XLIX carries a trophy decorated with an ox skull, a plume, and a helmet, which signify that his kinswoman, Ursina Grassi della Volta, should surrender herself to endure willingly all difficult things ("Omnia dura libens didici tolerare, bouisque / Βρέγμα id significat, pennicoma et galea").

Although the bucranium had no traditional symbolic connection with the Hercules myths that I have found other than its interpretation as labor, Bocchi may have made the association after seeing the various animal skulls decorating the columns that divide the individual labors of Hercules on the title page of Pietro Martire d'Anghieri's *De orbe novo* (1530).[35] In addition, one of the labors Hercules performed was the capture of the wild bull ravaging the province of Attica, to which Bocchi briefly alludes in the symbol of Constantia (IX).

## Athena, the Virtuous

The goddess Athena, half sister to Hercules, has much in common with him in the *Symbolicae Quaestiones*. Both are active gods; both represent virtue; and both aided the mortal race, Hercules by his labors and Athena by her assistance to Prometheus and her teaching the arts and industry to humans. A goddess with many names – Minerva, Athena, Pallas, and Tritonia – and many regional epithets, she was always Pallas to Bocchi, except when united with Hermes in Hermathena.

Most frequently, Bocchi figures Pallas as Virtue. The mythographers argued that she was, by reason of her motherless birth directly from the lofty top of Jove's skull, pure and uncorrupted.[36] This Pallas appears with Fortuna before Cardinal Giulio de Medici in Bocchi's Symbol CXI; Fortuna offers the papal crown to the future Clement VII, and Pallas gestures to the light radiating through the cardinal's crystal ball. The cardinal's virtue is even greater than his good fortune, and he remains uncorrupted in his splendor: ILLAESVS CANDOR SEMPER VBIQ. MANET (Brilliance always and everywhere remains uncontaminated). Bocchi seems preoccupied with the relationship between virtue and glory. Although the palm branches and laurel wreath of his *impresa* suggest his personal aspirations, he insists in his emblems, especially in those to great men, that virtue must come first. In Symbol XLII (Figure 39) with its Senecan motto, VIRTVTIS VMBRA GLORIA

(Glory is the shadow of Virtue), Glory, winged and with a trophy, is the companion of Pallas Athena as Virtue. Although she follows Virtue as a shadow follows a body, unlike Seneca's empty glory, she is real ("solida est").[37] Thus, the glory of Ottavio Farnese, Bocchi's dedicatee, follows the virtue of his grandfather, Pope Paul III. The message is much like that of the twin temples of Virtue and Honor in Symbol XXXIII (Figure 32), where to achieve Honor, one must first proceed through the temple of Virtue with its statue of Hercules. In that emblem, the message to the young dedicatee, Ranuccio Farnese, Ottavio's brother, is that his honor will derive from the virtue of the same Paul III.

In those of Bocchi's symbols on Athena without dedications, however, the message to the general reader is clear: Do not burn with the desire to seek fame, but follow virtue instead. Pallas leads a winged Fame, whose hands are bound together, in Symbol XCI. In the foreground, Socrates looks out at the reader to answer a question about whether there is any easy way to acquire great fame. "There is," replies Socrates, " if only you resolve to present yourself as you choose to be regarded in the eyes of all" ("Ipsum si modo talem te, ait, / Decreueris praestare, qualis omnibus / Optas haberi"). Here, Fame is again the companion of Virtue, just as infamy is the companion of criminality ("Virtutis est comes, vt sceleris infamia"). Not only do ambitious people seek glory for its own sake, but they seek it in the wrong ways. In Symbol LXV, INANIS EST INFRVCTVOSA GLORIA (Vain is fruitless glory), Athena's gift of an olive tree to the Athenian people in a contest among the gods to name the Attic city triumphed over Neptune's gift of a horse (Figure 40). The horse is a protector of cities in war, but Athena in her wisdom produced a gift that would bear fruit and support the city in peace:

> Vnde est pax alma, et gloria frugiferens.
> Contra equus exercens horrentia bella superbit.
> Ast omnis vana est gloria fruge carens.

(Whence comes gentle peace and fruitful glory. By contrast, a horse engaged in dreadful wars is haughty. Thus, every glory that does not bear fruit is wanting.)

Through her gift, Athena became known as the goddess of peace, a "Minerva Pacifica," and the olive tree became the symbol of peace.[38]

Athena's peaceful interventions on the part of humans – her gifts of the olive tree and the arts, her counsel (consilium) and aid (auxilium), her roles as servatrix of the people and protectrix of cities – balance and oppose the warlike nature of the militant Athena, who leaped out fully armed at birth with a fierce and masculine-looking face ("uultu in primis uirili & truculento," according to Giraldi, citing Cornutus).[39] Not unlike Hercules, she is indefatigable in work and invulnerable in war ("infatigabilis ullo labore... vel inuulnerabilis in bello").[40] Athena's virtues are active ones. In Bocchi's Symbol LI, Athena saves Fate (Sors) from the ocean, where that unwelcome goddess was cast by gods angry at their lots. Fate, with the forelock of hair characteristic of Occasio (Chance), is lifted from the waves by Athena's right arm; Athena points heavenward with her left arm to encourage the chastised victim to hope for a better reception. The motto, FORTVNA FORTI SVBLEVANDA

INDVSTRIA (Fortune supporting the strong with industry), seems to reverse the roles of the two goddesses.

What Pallas Athena also has to offer the human race is her wisdom. Because Pallas was born directly from Jove's brain, hers is a severe and abstract intellect, uncorrupted by the physical and symbolized by her attributes, a crystal-clear shield, a helmet, and a sharp spear.[41] Because her only parent was Jove, her wisdom is a unified whole; she is "Vnigena Minerua."[42] To Bocchi in Symbol LIIII, an abstract Wisdom is the only daughter born to the highest God ("Ipsa patris summi vnigena est Sapientia"), and she represents a body of knowledge of which we can know only the small portion needed for human use. There are two approaches to the little we can know: the active and the contemplative. In the symbol (LXXXI) dedicated to Mario Nizolio, a staunchly Ciceronian rhetorician, Pallas, holding a book in her outstretched hand, sits astride a stag fleeing two dogs at its flanks; a hunter blows his horn in the distance (Figure 41).[43] One of the dogs, Thaumastus, represents the admirer of Pallas; the other, Camaterus, symbolizes persistent labor. The admiration of wisdom generates an astonishing love for it, but Bocchi asks, "What can hard and persistent work not accomplish?" ("Quid non improbitas dura laboris agit?"). To follow Pallas Athena necessitates a long struggle.

Furthermore, the wisdom of Athena paradoxically requires both eloquent speech for its communication and prudent restraint of speech to show that the message has been learned. On the one hand, in Bocchi's *figura* of wisdom in Symbol CXXXIIII (Figure 26), Athena gestures at the symbolic image resting on a *murex* (or, *tribolus*), a four-pointed spike thrown at horses and wagons to disable them in wars. Four serpent heads decorate the object, their mouths open to signify wisdom, in order that wisdom may be expressed through eloquence, harm no one, and assist everyone ("inde vt sapientia sese / Efferat eloquio, noceat nulli, omnibus adsit"). The snakes or serpents are Athena's attributes insofar as they represent the head of the snake-haired Gorgon embedded in Athena's shield. According to Giraldi, the Gorgon's tongue protrudes, which signifies the use of language or discourse: "& in ipsa quidem aegide caput erat Gorgonis, linguam exerens: ideo quod linguae usus, id est sermonis, in omni re praestet..." (and on the shield itself was the head of Gorgon, sticking out her tongue, for the reason that the use of the tongue, that is, of speech, is superior, in every respect).[44]

On the other hand, Athena is frequently represented with another attribute, the night owl (*noctua*), a symbol of prudence in speech. Alciato's night owl, depicted on a shield, bears the motto "Prudens magis quam loquax" (prudent rather than loquacious), which alludes to an anecdote about Minerva replacing the chattering, tale-bearing crow with the night owl as her attribute.[45] Bocchi's Attic owl (LXXXIII) perches on Athena's hand, a banderole with a Greek inscription trailing from its beak (Figure 42). In response to a question about what the Greek means, the owl responds,

> Prudens esto, inquit, non omnibus aduolo passim,
> Passim stulta cadunt nec bene consilia.

(Be prudent, the owl says, not to everyone do I fly far and wide; far-flung counsels turn out to be foolish and ill-considered.)

The owl is also Athena's because it has grey-green eyes (*glauci oculi*) like the goddess, and its ability to see in the dark resembles the penetrating intellect of Athena.[46]

Although Wisdom is Athena's most important signification, Bocchi tended to associate her primarily with an active wisdom of teaching and of prudence. In identifying wisdom with prudence, Bocchi was drawing on Roman traditions found in early Latin poets and in Cicero.[47] Contemplative Wisdom he gave instead to the personification of Sapientia in Symbol XI (Figure 43). This nude representation of Wisdom seated on a cube inscribed SEMPER EADEM (Always the same) contemplates her beauty in a mirror framed with heavenly bodies in order to know herself. The only thing that this Sapientia has in common with Athena is the snake at her feet, so she may be closer to the Sapientia of Martianus Capella, who was the foster sister of Minerva.[48] Visually, she is a Renaissance reworking of the Sapientia illustrated by Charles de Bovelles along with Fortuna (Figure 30). Unlike traditional portrayals of Sapientia, following Boethius, which depict her with book and scepter, both Bocchi and Bovelles seat her on a cube holding similar mirrors framed with stars and moons.[49] Bocchi petitions his goddess of wisdom to turn her luminous eyes on him in order to banish the sad shadows and clouds from his soul and to wound him with her sweet flames ("dulcibus... flammis"), because his very life is a death far sweeter than all things to him: "Ista mihi longe est vita mors dulcior omni." This is the language of mysticism. The symbol (X) immediately preceding Sapientia, CVM VIRTVTE ALMA CONSENTIT VERA VOLVPTAS (True Pleasure harmonizes with genial Virtue), depicts Pallas and Venus seated together on a rocky prominence, embracing each other and crowning the drunken Silenus below them with a garland. To Edgar Wind, the reconciliation of opposites in Bocchi's symbol implies transcendence:

> The more comprehensive the virtues and the pleasures become, the more largely they are bound to overlap; and when a pleasure or virtue becomes all-embracing – that is, when they reach a perfection achieved only in states of ecstasy – then goodness becomes indistinguishable from bliss.[50]

Both knowledge of self and reconciliation of opposites lead to the same transcendent wisdom.

### Hermes, Mercury, and Thoth: Eloquence and Silence

Hermes/Mercury, a pre-Athenian god, is depicted as an unbearded youth, even a boy, in contrast to the full maturity of Hercules. His is the speed; Hercules has the strength. Like Athena, Hermes forms part of the academy's Hermathena *impresa*, but Bocchi represents him less often than either Athena or Hercules. Among the roles of this ancient Near Eastern deity as god of merchants, of travelers, of thieves, of shepherds, and of eloquence, only the last seems to have much importance for Bocchi in the *Symbolicae Quaestiones*. Mercury himself intercedes for Bocchi in a plea to Pope Julius III for patronage (Symbol LXXXV), which begins, "Aret ager meus..." (My land is dry...). Although the text does not even mention Mercury, the god stands in the foreground of an engraving of country fields near a plow and grapevines (Figure 44). Mercury, his caduceus lying on the ground, stretches his hands toward

the heavenly Jupiter in an eloquent gesture of supplication, while in the background a personification of *Benignitas Diuina* also intercedes to prevent the withering of Bocchi's resources and hopes. The Mercury of this symbol also acts as *nuncio,* or messenger, to communicate between gods and humans.

When the gods intervene in Symbol CXXIX to rescue Odysseus from the snares of Circe, Mercury again is messenger, bearing a remedy, the moly (Figure 45). While virtuous Pallas looks on, Mercury hands Odysseus the symbolic plant with the black roots and white flowers that is so difficult for mortals to dig out of the earth. Alciato was the first of many emblematists to illustrate the moly; his "Facundia difficilis" (Eloquence is difficult) follows the Homeric account of the moly as an antidote to the charmed drink ("medicata in pocula") offered by Circe; then it compares the white flower to the splendor of eloquence and readiness of expression ("Eloquij candor facundiaque"), which cannot be achieved without great labor.[51] Bocchi's long poem says little about the moly itself but draws on post-Homeric interpretations of the moly and learning. For example, to answer the question posed at the end of the poem, EXPERIENTIA MAIOR ARTE? (Is experience greater than craft?), Bocchi ponders whether learning alone can give humans dignity (*decus*) and reward (*pretivm*). Because Bocchi has dedicated this symbol to his teacher and mentor, Giovanni Battista Pio, he alludes to Mercury's role as a symbol of the disciplines of rhetoric and dialectic, interpretations Giraldi ascribed to Iamblichus and Strobaeus: "uel ut quidam dicunt, eloquens Mercurius, qui in manibus dialecticae symbolum gestat, serpentes scilicet se inuicem inspicientes" (perhaps, as some say, eloquent Mercury, who carries in his hands the symbol of dialectic, in other words, snakes gazing at one another).[52] But, according to Bocchi, the true art is to leave enough time free from the rhetorical and dialectical disciplines so that one can engage in real experiences. For that reason, an ancient as wise as Pythagoras visited Egypt and many other places, and Homer's Ulysses saw the cities, the deeds, and the varied customs of very many peoples ("Vidisset vrbes plurimorum et / Acta hominum, variosque mores," *Odyssey,* 1.4). Experience and memory, therefore, were said to be the parents of wisdom itself ("Inde optime ipsius sapientiae / Vsum parentem, et Mnemosynen ferunt").

With the moly, Bocchi places Mercury into a context of learning and virtue. But Bocchi's Hermes/Mercury never represents an unalloyed force of eloquence in the way the Gallic Hercules does. Not once but twice, Hermes cautions silence by resting a finger over his lips (Symbols LXIIII and CXLIII). In the first of these, SILENTIO DEVM COLE (Worship God in silence), Hermes, clad only in a cape and winged hat, holds a seven-branched candelabrum (Figure 46). His gesture of silence, Wind points out, "was transferred by Achille Bocchi . . . from Harpocrates to Hermes the mystagogue . . . who guides the souls from outward appearances back to the inward One."[53] Thus, he combines features from the Hermes variants of the mythographers: "the identification of the Greek Hermes with the silencing Hermes Trismegistus and the association of eloquent Hermes with Harpocrates via the rhetorical tradition of silent eloquence," according to Raymond B. Waddington.[54] The Hermes Wind describes is the same Hermes honored by a statue in an arch on the Athenian Acropolis (mentioned in Bocchi's poem), who represents the father of eloquence and liberal arts ("eloquentiae & disciplinarum parens") and the initiator and guardian of the mysteries ("mystagogus, & mysteriorum praefectus"), in Giraldi's words.[55] Wind

was also referring to the title of the second part of Bocchi's poem, REVOCANDA MENS A SENSIBVS, / DIVINA CVI MENS OBTIGIT (The mind which the divine mind has touched ought to be recalled from passion), which seems to echo and transmute Boccaccio's "officium revocandi animas ad corporis" (duty of recalling souls to the body [from the underworld]).[56] The "inward One" the mind seeks is the circle of light above Hermes/Mercury's head, which is inscribed MONAS MANET IN SE (The One remains in itself). The second part derives, as Bocchi says, from the writings ascribed to Hermes Trismegistus:

> Hermetis hanc sententiam ter maximi
> Qui cordi habebit, esse non potest miser.

(He who holds this maxim of thrice great Hermes in his heart cannot be unhappy.)

This sixty-fourth symbol has generated more commentary than any of Bocchi's other symbols. Using Wind's brief comments as a starting point, Louis Marin developed a semiotic interpretation. He noted that the figure of Mercury stands on a rectangular pedestal, with the "trivial" Greek proverb inscribed on it here rendered as "la parole est d'argent, mais le silence est d'or" (the word is of silver, but silence is of gold), and the head of Mercury reaches the heavens, almost touching the circle of light with its "proposition philosophique hermétique."[57] Marin examines the contradictory, even incompatible, elements of the engraving – the silence of the god of eloquence, the stillness of the god of travel, the light and the darkness – and ascribes these to Hermes, as god of contraries, who unifies by a "jeu circulaire" played out through the texts within the engraving.[58] Barbara Bowen takes issue with Marin's reading, preferring to interpret this engraving as a variant on the "Mercury at the Crossroads" type, essentially "an extremely banal moral commonplace."[59] The MONAS MANET IN SE inscription derives, appropriately enough, from the *De garrulitate* of Plutarch, whereas the Greek inscription is rendered by Bowen as "'He often repents of speaking, never of remaining silent,'" which is essentially the way Bocchi's Latin title translates it: SAEPE LOQVI NOCVIT, NVNQVAM NOCVIT TACVISSE (It often does harm to speak, but never to keep silent).[60] Speech and silence are merely "two sides of the same *topos*" and not contradictory.[61]

One can, however, never be overconfident in Renaissance interpretations. What Bowen calls "Marin's ignorance of the intellectual context" may in fact be a position supported by a different intellectual context, one valid for a reading of Bocchi. The mythographers help. In addition to the traditions that Bowen mentions of the seven-branched candelabrum in Christianity and Cabala, there is also a classical one for Mercury: The "Stilbon" Mercury refers to the brightness of the planet, termed "Stilba," as a type of lamp that, Giraldi reports, was customarily placed on a candelabrum ("hinc etiam Stilba lucernae species, quae supra candelabrum poni solet").[62] The clouds on the left side of the sky are associated with Mercury in motion. According to Boccaccio, Mercury, trusting in that wand, disperses the winds and sails through the stormy clouds ("Illa [virga] fretus agit ventos et turbida tranat Nubila...."; Vergil, *Aeneid* 4.245).[63] The stillness of the flames on the right clearly opposes the clouds and wind-tossed cloak on the left, alluding to an alternative

meaning for *silentium* as "inactivity": Not only do we honor God in silence, but also in stillness.

In addition, the light and darkness, immobility and speed, speech and silence, and mind and senses oppositions, which are worked out in upper versus lower and right versus left quadrants in the engraving, with Mercury/Hermes as a mediating center, recall the "quadrature oppositorum" of Charles de Bovelles in his *Ars Oppositorum*, although Bocchi does not tackle the mixed forms. Bovelles opposes not only light to shadow but also speech to silence: "Loquens vocem dicit, silentia loquitur. Silens vero silentia fatur, vocem silet" (In speaking one says a word, but speaks silence. In being silent, however, one utters silence, but does not say a word).[64] Because the use of light in the engraving is patterned after Bovelles' degrees of light in *De sapientia* – the *monas* in its circle as pure light (*lux*), the heavenly or angelic light of the candelabrum as a lesser light (*lumen*), human light as shadow (*umbra*), and the dark spaces in the heavens as undifferentiated matter (*materia*) – Bocchi does appear to be setting up oppositions for mediation by this Mercury.[65]

The second silencing Mercury (Symbol CXLIII) comes out of a different tradition, and the mythographers do not elucidate for us this image of a fully clothed Mercury standing in fire while the dove of the Holy Spirit descends to him (Figure 47). This is the only symbol entitled "Mercurius Silens" in Bocchi's index. He holds not only his caduceus for healing and calling forth souls but also palm branches for victory. The flames and the appellation "Divinus Amator," according to Edgar Wind, identify this Hermes with Eros; he is Hermeros.[66] The dove could be the Logos coming to the silent god; the poem identifies it as the wind (*zephyrus*) fanning the flames of that love that tempers whatever mortal is in us ("Euge beate ignis zephyri aura incense supremi, / Mortale in nobis excoque quicquid inest"; O blessed fire, lit by the breeze of the lofty west wind, burn away whatever is mortal in us). Such a wind in the Hebrew Genesis is the breath, the spirit, and the voice of God.[67] Mercurius Silens seems to be an exemplary rather than an intermediary figure with his motto, FERT TACITVS, VIVIT, VINCIT DIVINVS AMATOR (In silence the divine lover suffers, lives, and conquers).

### Hermathena: Wisdom and Eloquence Conjoined

Only when Hermes and Athena join together in harmonious union as Hermathena (Symbol CII) does each one represent for Bocchi most fully the most characteristic Renaissance interpretations of eloquence or wisdom. But here, Wisdom restrains Eloquence, and Eloquence tempers Wisdom. They do not stand alone together as one would expect in an *impresa* but are mediated by Eros/Amor, who holds reins attached to a ring in the mouth of the "monster" below (Figure 17). In the motto inscribed under Hermathena, SIC MONSTRA DOMANTVR (Thus the monsters are tamed), Eros, standing on the monster's head and pointing up at Hermathena, links agent and effect. A further inscription under the monster's head is repeated in the verse: "me duce perficies; tu modo progredere" (With me as guide you will perfect yourself; by yourself, you only progress). A related motto for the symbol as a whole is placed above the engraving: SAPIENTIAM MODESTIA, PROGRESSIO

ELOQVENTIAM, FELICITATEM HAEC PERFICIT (Modesty brings to comple-
tion Wisdom, progress Eloquence; this one god[dess] perfects happiness).

To interpret Bocchi's Hermathena as a marriage of Wisdom and Eloquence,
however, is to risk iconographical difficulty. Like the Roman wedding scenes on
coins, urns, and sarcophagi, there is a winged boy as intermediary, but Bocchi's
"sancte puer" has a bow to identify him as Eros, whereas the Roman Hymen
(Hymenaeus or Thalassus) often holds a torch as an attribute and a wedding symbol.
Also, the Romans usually placed beside or behind the couple a *pronuba* figure, either
a *Juno pronuba* or a female personification of Concordia.[68] Like the Roman couples,
Athena and Hermes turn toward each other, but unlike the ancient prototypes they
link arms rather than clasp right hands (the "dextrarum iunctio").[69] It is possible that
Bocchi did not know about this characteristic gesture, because even Lilio Gregorio
Giraldi, for all his Roman textual sources for Hymenaeus/Thalassus as a god of
weddings, does not mention the joining of hands.[70] Bocchi does allude in Symbol
CX to his own death as being called by Jove to the heavenly nuptials of "good"
Hermathena ("vt vocatus ab Ioue / Nostro ad cupitas nuptias queam / Bonae
Hermatenae adesse").

Nevertheless, Bocchi would have encountered the same problem Martianus
Capella did: Minerva is the chaste half-sister of Mercury. For that reason, Martianus
had Mercury, god of hermeneutics, marry Philology, daughter of Phronesus
(another form of wisdom), although medieval commentators interpreted the bride
as wisdom or as *intelligentia* (compared to Minerva's "summa sapientia").[71] For
Bocchi the separate herm bases and linked arms of Hermes and Athena demonstrate
a union only of minds, combining and transcending in the manner of a Florentine
Neoplatonic love.[72] He has fashioned not an allegory of a marriage, but a symbol of
a major topos, beginning with the *oratio/ratio* (speech and reason) of Isocrates and the
*sapientia/ eloquentia* of Cicero, Saint Augustine, and writers throughout the Middle
Ages.[73] In Bocchi's *impresa,* however, the balance has shifted from the humanist
insistence that the prudent person be eloquent.[74] With the reins and the ring, the
emphasis is more on restraining eloquence than on promoting it.

One further meaning probably underlies the *impresa*. Edgar Wind interprets
Bocchi's Hermathena "as a secret admonition in the style of *festina lente:* Combine
the swiftness of the god of eloquence (Hermes) with the steadfastness of the goddess
of wisdom (Athena)!"[75] Bocchi's numismatic Symbol LXXXII (Figure 31), with its
mottoes, MATVRA FESTINATIO (over the poem) and MATVRA CELERITAS
(under the picture), and idealized portrait holding spurs and bit, supports this reading,
as does the speed and stillness of Mercurius Silens in Symbol LXIIII (Figure 46).

The last of the figures forming part of the Hermathena *impresa* is the monster,
which appears to be the head of a lion. As such it might allude to the Lernaean lion
overcome by Hercules (Symbol IX), which then becomes a symbol of fortitude, or
the Cleonean lion, whose tongue Hercules overpowers (CVII), which then becomes
a symbol of the containment of wrath and self-rule in Symbol CXV (the *impresa* of
Bologna personified as Bononia). The ring in the mouth of the monster head signifies
a like restraint of intemperate speech, and the reins, featured in the symbol of a good
ruler (LXVII), suggest moderation. In Bocchi's poem (CII), the monster is also Orcus,
the Underworld, or death, from which Mercury's caduceus draws forth souls ("en

virga te iam Deus euocat orco"; Lo, God summons you now from death with his staff). The monster represents sin or the life of the senses, which the combined forces of persuasion and prudence can control.

Another interpretation for Bocchi's monster is the Chimera, that lion-headed, goat-bodied, serpent-tailed, and fire-breathing monster of Homer and Hesiod. Symbol CXXXVII depicts Bellerophon, a hero aided by Minerva *Frenatrix,* flying down on Pegasus to kill the monster (Figure 14).[76] The last part of the motto over the engraving echoes the Hermathena *impresa* – SIC MONSTRA VITIOR. DOMAT PRVDENTIA (Thus Prudence tames the monsters of vice) – but the first part of the motto makes an analogy to rhetoric that in this context seems forced: ARS RHETOR. TRIPLEX MOVET, IVVAT, DOCET, SED PRAEPOTENS EST VERITAS DIVINITVS (The triple art of rhetoric moves, pleases, and teaches, yet preeminently powerful is Truth from heaven). Bellerophon performs the same controlling function on speech here as Hermathena does in the *impresa.* This rhetorical reading of the Chimera was based, according to Giovanni Pierio Valeriano, on a patristical text by Gregory of Nazianzus, although it was widely available to sixteenth-century readers of the popular *Antiquae Lectiones* of Lodovico Ricchieri (Caelius Rhodiginus), first published in an incomplete Venetian edition in 1516.[77] In Annibale Caro's words (in a 1537 letter to Paolo Manuzio), "Io lo so ora che siete stato a guisa di quei grandi eroi a domare i Cerberi, le Chimere e gli altri mostri de la lingua latina per immortalarvi, non per morire" (I know now that you have acted in the manner of those great heroes in taming the Cerberuses, the Chimeras, and the other monsters of the Latin language, not in order to die, but in order to immortalize yourself).[78]

Bocchi, after modestly disclaiming any skill in opening the inner meaning (*enucleare*) for his friend Giovanni Battista Camozzi (Camoteus), makes it clear that his monster is the corruption of legal rhetoric, whether in court, in the classroom, or in the Senate ("Siue in foro . . . / Siue meditentur rostra, siue curiam").[79] The reader is also warned to avoid the crafty audacity of mortals rushing headlong into forbidden crime, spewing forth lightning and thunder from their mouths, and imitating highest Jove ("Vomentium ore fulgura, et tonitrua / Imitantium Iouis supremi"). It would be tempting to say that Bocchi's Chimera emblem also reflects the major archeological find of an Etruscan bronze Chimera in Arezzo in November 1553, a work restored by Benvenuto Cellini for the collection of Cosimo de' Medici and described in letters by humanists such as Annibale Caro, Pietro Aretino, Piero Vettori, and Giorgio Vasari, but Bocchi's symbol was probably written by 1550.[80]

For Bocchi's depiction of Hermes and Athena as linked herms no visual precedents have been located. Of the very few Hermathenas extant today, only one, now in the Capitoline Museum in Rome, is a double herm with Mercury and Athena having separate torsos and heads (they share one base), and that one was discovered in the ruins of Pompei.[81] The first and only ancient texts referring to Hermathena are in the collected letters from Cicero to his friend Atticus. Cicero had requested by late 68 B.C. that Atticus locate for him in Greece statues appropriate for his *gymnasium,* or lecture hall (1.6), and, more specifically, herms such as Hermeracles (Hermes and Hercules, 1.9 and 1.10).[82] In early 66, he was delighted to hear from Atticus of success:

Quod ad me de Hermathena scribis, per mihi gratum est. Est ornamentum Academiae proprium meae, quod et Hermes commune omnium et Minerva singulare est insigne eius gymnasii. (1.4)

("I am delighted at your news about the Hermathena. It is a most suitable ornament for my Academy, since no class-room is complete without a Hermes, and Minerva has a special appropriateness in mine.")[83]

Just over a year later (July, 65 B.C.), Cicero wrote,

Hermathena tua valde me delectat et posita ita belle est, ut totum gymnasium eius ἀνάθημα esse videatur. Multum te amamus. (1.1)

("I am highly delighted with your Hermathena, and have found such a good position for it, that the whole class-room seems but an offering at its feet. Many thanks for it.")[84]

Humanists revived the idea of Hermes and Athena as gods belonging to places of scholarship. Marsilio Ficino, for example, spoke of the academy as honoring Pallas and Mercury, and Pietro Aretino described the Paduan house of Pietro Bembo as "un publico, e mondissimo tempio consegrata a Minerva" (a public and perfect temple dedicated to Minerva).[85] Increasingly, in the sixteenth century, the gods of eloquence and learning became associated with smaller domestic rooms set aside for more specialized use, such as studies, libraries, and treasure rooms for collections (*studioli*) with appropriate decoration.[86] Thus a frieze painted around 1520 on the two long walls of the *studiolo* of the Casa Pellizzari in Castelfranco combines numerous inscriptions with symbols of virtue, of death, and of the liberal arts, including Minerva's Gorgon head.[87] Paolo Giovio dedicated a *cubiculum* to Minerva and the library next to it to Mercury in his "Museo," a home built in the late 1530s on the shore of Lake Como, and Giraldi translated Cicero's *gymnasium* as *bibliotheca* (library) in his brief account of Hermathena.[88]

Nothing remains to tell us whether Bocchi also had a study or a library dedicated to the goddess of wisdom or the god of eloquence. Because his Hermathena was attached to the exterior corner of the building, just outside the room where the academy met, it implies both the academy and the larger structure. Bocchi's is probably an indigenous version of Hermathena, rooted in local university teaching, such as Beroaldo the Elder on culture as the harmonizing of wisdom and eloquence, or classroom commenting on Cicero's letters and the *De Nuptiis* of Martianus Capella. Bocchi had written the poem to accompany his Hermathena by 1548, when he announced in a letter to Romolo Amaseo (Milan, Ambros., MS. D145 inf., fol. 16v), "Mitto tibi Symbola quattuor Academica, quorum primum est marmoreum futurij in Angulo Domus sub titulo HERMATHENAE" (I send you four academic symbols, of which the first, under the title *Hermathena,* is the marble work on the corner of my future residence). The idea for this name probably went back at least to 1514, when Giovanni Battista Pio wrote from Rome to his former pupil, praising the hospitality of Achille's mother, Constantia, and the "Domus Bochia," a home he called a "Hermathena" ("Hermathena est").[89] Furthermore, the 1522 *Hermathena Sev De Eloquentiae Victoria* of Papyrius Geminus Eleates may also have been inspired

by Bolognese teaching, because the anonymous author was a friend of Richard Pace, who studied rhetoric in Bologna with Paolo Bombace around 1501.[90]

### Janus: Vigilance, Peace, and Wisdom

Janus is the last of this group of deities with interconnecting significances. He only appears twice in the *Symbolicae Quaestiones,* once in Symbol CXLVI, near the end, and again in Symbol CLI, the concluding symbol. In Symbol CXLVI, the triple head representing Carlo Ruini and his parents, Isabella Filicina and Antonio Ruini, intentionally recalls the Tricipit or Trifrons Janus, a symbol of the three faces of Prudence – Memoria, Intelligentia, and Prudentia – and the three divisions of time – past, present, and future.[91] Just below the three heads is one winged head, which, according to Bocchi, signifies strength of mind (*Mens*) in relation to time.[92] It suggests in addition a winged sun, also associated with Janus. Below the heads, a coat of arms combines the leaning tower of the Ruini family on its "firm base" and the Felicina fern (*filix*), so fortunate (*felix*) a choice for Antonio's wife. Bocchi's last quatrain clarifies the analogy to Janus:

> Denique felicem faciat Deus ille triceps, cui
> > Quae fuerunt, quae sunt, quaeque futura patent.
> Quaere, pete, insta, spe, officio, studioque fideli,
> > Quae cupis inuenies omnia, et accipies.

(Finally, may that three-headed god to whom all the past, present and future are revealed make you fortunate. Seek, chase after, pursue, with hope, a sense of duty, and faithful zeal, and you shall find and receive all that you desire.)[93]

Sometimes the three-faced, prudent Janus, with its topos of the divisions of time going back to Plato's *Timaeus* (37D–38B), is represented by the heads of a boy, an adult male, and an old man; sometimes it is also illustrated, as in an emblem of Sambucus, as Serapis with its triple wolf, lion, and dog heads (another "monster"). Titian's strange *Allegory of Prudence* combines both sets of heads, the human heads over the animal ones.[94]

To close the *Symbolicae Quaestiones,* Bocchi shows us a Janus temple with open doors and the double (*bicipit*) head of the god sculpted on the pediment over the entrance (Figure 48). The poem itself is resolutely binary, addressing its second part directly to Janus in his role as doorkeeper (*Ianitor*) and key bearer (*Clauiger*) of the temple. He is both Patulcius and Clusius (after the *Fasti* of Ovid), the god of past and present, of the day (as the sun), and of the new year.[95] Janus, said Ovid, is the custodian of the world.[96] He closes what is open and opens the closed, according to Bocchi ("Claudis aperta / Clausa aperisque"); the motto on the temple itself is ADHVC PATET (It has been open until now). Bocchi, speaking for his dedicatee, Francesco Baiardo of Parma, prays that the great iron gates ("ferrea...Limina") be shut to return the land to happy centuries of peace ("foelicia secula pacis").

If Francesco Baiardo was the son of Andrea Baiardo (d. 1511), which seems likely, the double theme of the poem honors this patrimony; Andrea not only was outstanding as a citizen-defender of Parma against the besieging forces of the

emperor and the Spanish, but he also was said to have written a prose work entitled *Della Mente* (now lost), the subject of the first part of Bocchi's poem.[97] The Janus of the first part of the poem, then, symbolizes Wisdom, not just the wise king of the Golden Age of Saturn but also the wise man drawn by Charles de Bovelles in his *Liber de Sapiente* (Cap. XVI) as a double-headed figure.[98] Bocchi begins by positing that the two greatest instruments (*instrumenta*) given humans by *Natura creatrix* are the mind and the hand. The mind itself, Nature's greatest gift, has a double power:

> duplex vis nostrae mentis habetur.
> Hinc gnaua inferior ratio, diuinior illinc
> Mens ipsa, et longo sublimior interuallo.
> Illa humana regit, diuina haec suspicit alte
> Contemplans, coelo, et coelestibus imperat astris.

(The power of our mind is held to be twofold. On the one hand, there is an active reason, the lower of the two powers. On the other, there is mind itself, which is more divine and far more lofty. The former power governs human affairs; the latter oversees divine affairs from heaven above, and, contemplating, it rules over the heavenly bodies.)

God ignites the higher part of the mind, just as he does the light in fire ("Haud secus accendit, quam lumen in igne corusco"); fire is the element associated by Bovelles with the intellect, the natural seat of humans (Cap. 1).[99]

The motto over the temple with its Janus head and open doors is OMNIA MENS SPECVLATVR, AGIT PRVDENTIA ET ARTE (The mind watches all things; it acts with prudence and skill). Thus, the temple is also the temple of Mens, one of several temples dedicated on the Capitoline Hill after a disastrous Roman defeat at Lake Trasimene, according to Livy,[100] and it is the same temple, furthermore, sought by the Philosopher visiting Rome in the *De Sapientia* of Nicholas of Cusa. Although Cusanus' stranger learns that the structure has been destroyed along with all of its books, he finds his way to a Layman (Idiota), a shoemaker who assists him in his search for wisdom.[101] Paradoxically, the reasoning power of the mind hopes that the doors of the temple will close, whereas the contemplative power requires that they open.

### Bocchi's Symbolic Program

The *Symbolicae Quaestiones* uses myth to promulgate a double wisdom – a practical wisdom based on eloquent prudence and prudent eloquence and a transcendent wisdom spoken through silence. As a teacher and academician, Bocchi saw his role as a custodial one. Although he left no treatise to explain his educational theory and practice, he did write into the idealized facade of the Palazzo Bocchi a programmatic statement.[102] Both the 1545 engraving (Figure 9) and the modified 1555 engraving (Figure 10) speak a symbolic language explicated in the emblems. We read the palazzo and penetrate the book. As Adalgisa Lugli has perceptively pointed out,

> Più volte, nei simboli, Bocchi esprime preoccupazione per le vicende costruttive
> della sua casa, che va anch'essa riguardata come un'opera carica di segni, un

altro libro, sulla cui facciata, come in un gigantesco frontespizio, sono tuttora leggibili i versetti del salmo 119/120 in lingua ebraica e una sentenza de Orazio. Lo stesso Bocchi, in uno degli emblemi più significativi dell'intera serie, sembra identificare il libro col palazzo, entrambi trasfigurati nella forma suggestiva del labirinto dei simboli. . . .[103]

(Often, in the symbols, Bocchi expresses a preoccupation with the state of the construction of his house, which was itself regarded as a work laden with signs, another book, on whose facade, as in a gigantic frontispiece, are still legible the verses of Psalm 119/120 in Hebrew characters and a maxim from Horace. The same Bocchi, in one of the most significant emblems of the entire series [CXLV], seems to identify the book with the house, both of them transformed into the interesting guise of a labyrinth of symbols.)

The palazzo can be perused on the inside as well as the outside, according to Carlo Cesare Malvasia, who compared the book with Prospero Fontana's painted ceiling scenes of "varie figure rappresentanti Virtù e Deità, designando per l'istesso molti de'rami, che occorsero nell'erudito libro delle sue Simboliche Quistioni, intagliate da Giulio Bonasone" (varied figures representing virtues and deities, designating by the same man [Bocchi] many of the copper plates which occur in the erudite book of his Symbolic Questions, engraved by Giulio Bonasone).[104]

Indeed, "frontispiece" was an architectural term for a facade before it became a printing term.[105] But what does this unique facade tell us? According to Naomi Miller, Renaissance architecture had a rhetorical function. Bologna's public buildings, she says, display the panegyric mode of rhetoric, but Miller backs away from a rhetorical interpretation of domestic architecture, particularly Bocchi's palazzo, which she likens to an expression of grammar or legal pedagogy.[106] It is true that the mixed styles of the facade make a unified rhetorical reading difficult. Nevertheless, on the level of symbol, or what Bocchi called "symbolic philology" (Symbol CXLV), the facade becomes another emblem, made readable by the *Symbolicae Quaestiones*. In the prints of the Palazzo Bocchi, this is made explicit by the depiction of people in the street, people who not only indicate the scale of the building, but who also gaze at its exterior.

As a whole, the facade of the palazzo, in both the 1545 and 1555 versions, represents a large cube surmounted by a small cube. There are also square elements embedded in the design, especially the window above the door and the cluster of "Palladian" (Doric) windows in the center of the top story. The cubic palazzo presents itself as the seat of virtue and of wisdom like cubes in the symbols of the Gallic Hercules and Sapientia (Figures 33 and 43). Horizontally, the facade is divided into five bays, just as the *Symbolicae Quaestiones* is divided into five books, as we saw in Chapter 3. Because the number five in medieval number symbolism signified marriage, it suggests the marriage of wisdom and eloquence in Hermathena.[107] This wisdom is an essentially secular one, and Bocchi was no doubt taking care to distinguish it from the words of the book of Proverbs: "Sapientia aedificavit sibi domum, excidit columnas septem" (Wisdom has built her house, she has set up her seven pillars, Prov. 9.1).

When changes were made to the facade design for the 1555 print, nothing altered

the cubic design or the pattern of five. These changes resulted in a more cluttered and less harmonious facade, but there may have been reasons for the altered design. First, the changes reflect the site of the house. Although both prints depict it as a freestanding structure, the front facade is in reality joined on one side to an older, more traditional house with a shallow arcade. By adding a heavy balcony across the entire facade, Bocchi may have been making a propitiatory gesture toward sheltering his fellow citizens from the elements. Moving the separate statues of Hermes and Athena from the roof level and joining them as Hermathena on the ground level acknowledges the house's position on a street corner; the Hermes can now represent a Mercury of the Crossroads as well as eloquence.

Second, all the changes reinforce the centrality of the middle bay, from the more dramatic treatment of the portal's stonework and over it the new opening with a small balcony to the deeper projection of the *piano nobile* (principal floor) balcony above. The frieze of lion heads and *bucrania* on the mezzanine below the top floor has also has been altered; rather than a strictly alternating pattern running from left to right, the left side of the new version has become a mirror image of the pattern on the right, so that the 1555 print would have a matched pair of *bucrania* at each end and another pair on either side of the central window. Furthermore, on the roof, the individual statues of Hermes and Athena, competing for the viewer's attention on the left and right corners, were replaced by the simpler lines of an identical pair of obelisks, which would enable the viewer to focus more easily on the central *tempietto*. By emphasizing the five main elements of the central bay (and by playing down the less significant mezzanine levels), the architect encourages the viewer's eye to travel upward for different levels of reading.

Our reading of the facade begins at the ground level. The massive cut stones (*bugne*, or bosses) of the escarpment, the rustic portal, and the alternation of rounded and pointed pediments over ground floor (*pianterreno*) windows proclaim the Tuscan/rustic style, first identified as an ancient order in its own right by Sebastiano Serlio. Its chthonic heaviness anchors the cubic structure even more firmly to the earth, the ancient soil of what once was Etruscan Felsina. According to Serlio and Philibert Delorme, the Tuscan order was the order closest to nature, and its rough strength and variety drew praise from Giorgio Vasari and Pirro Ligorio.[108] Although Serlio in his Fourth Book recommended the Tuscan style for public buildings – especially fortresses, castles, city gates, armories, treasuries, and prisons – he also envisioned its use in a middle level of domestic structure for an urban merchant or a scholar.[109] The Palazzo Bocchi, as both the home of a literary person and the seat of a literary academy open to the public (it met in a large room on the ground floor), doubly met Serlio's qualifications for use of the Tuscan order.

One contradictory effect of Bocchi's facade, however, is its defensiveness. Despite the public nature of the ground floor rooms, the fortresslike base suggests the walling out of troubles. The Hebrew inscription from Psalm 119/120.2 reinforces this impression: "Deliver me, O Lord, from lying lips, from a deceitful tongue." Bocchi made the same plea to his patron, Cardinal Alessandro Farnese, in Symbol CIX: If the cardinal will not see the house completed, insidious tongues ("linguas male cautus") will harm Bocchi and the insolent and garrulous crow, once banished by Athena, will cry out. This house will shelter Bocchi from slander; it will be his faithful

friend ("amica fida," CIX, and "Amica semper est domus," CX) and refuge for the rest of his earthly life. Like the turtle who came late to a nuptial feast of the gods in an anecdote in Symbol CX, Bocchi acquires a shell into which he can retreat.

Nevertheless, the predominant theme of the ornament of the lower floors is virtue. Bocchi proclaims it in a quotation from Horace, which begins on the right side of the door and continues past the corner and along the side of the structure: "Rex eris, aiunt, si recte facies. hic murus aeneus esto, nil conscire sibi, nulla pallescere culpa" ("'You'll be king, if you do right.' Be this our wall of bronze, to have no guilt at heart, no wrongdoing to turn us pale").[110] The sculpture on the Tuscan levels unites both the moral and intellectual objectives. First, the lion/Chimera head on the corner in both the 1545 and 1555 prints symbolizes the containment of vice and of rhetorical excess. In the 1555 print, the one in which Mercury and Athena have been moved from their place on the roof, there is a discrepancy between print and book: The latter illustrates Hermathena on the corner above the lion's head; the former depicts a larger-than-life herm attached below the lion's head to the escarpment. This male herm could be a Hermeracles, but probably reflects a different artist's conception of what Hermathena might look like. The academy *impresa* asserts its founder's prudence, as well as the academy's role in promoting wisdom through tempered eloquence. Above the Tuscan ground-floor windows, and above the door of the 1545 print, rectangular panels hold pairs of relief portrait busts, probably representing ancient writers and philosophers such as Homer and Socrates. Such pairings are sometimes encountered on Renaissance title pages; the 1518 Froben edition of Erasmus' *Adagiorum Chiliades,* for example, surrounds the title with a series of smaller frames, each with a pair of ancients, except in the top row, where Homer, Solomon, and Hesiod each occupies his own niche.[111] In addition, the 1540 title page of Agostino Steucho's *De Perenni Philosophia* had similar rows of portrait pairs to the left and to the right of the title and larger insets across the top for Aristotle, Plato, Solomon, Socrates, and Pythagoras.[112] These exemplary models would have conveyed moral probity as well as advertising the program of study to be carried on within the walls.

The private life of the Palazzo Bocchi was to take place on the levels decorated by the more domestic Doric order. The ancients, according to Serlio, had used mixed orders, and he especially admired Florentine villas for their blend of "quella rustichezza, & delicatura."[113] With such justification, Bocchi's mezzanine frieze combines Serlian elements from a Doric frieze (the ox skulls) and from a Tuscan frieze (the lion heads).[114] The frieze can be read on more than one symbolic level. First, it is an allusion to the owner's name, an imprecise rebus playing on the wrath of Achilles (the lion as a symbol of wrath) and *bocca* (Italian), "mouth," and *bucca* (Latin), "cheeks" or "jaws," linking the name to the *bucranium,* Bocchi's personal *impresa.* But the wrath of the lion is paradoxically the opposite of the ox skull's other meaning as patience: Bocchi tempers his righteous wrath (perhaps aroused by slander) with patience. Patience, in turn, makes possible vigilance, another virtue symbolized by the lion (Symbol CXXIII). Vigilance and labor (the ox skull) together occupy the scholar/teacher. On another level, the frieze, with its alternating symbols of labor and magnanimity (the lion), suggests Hercules, the god who appears most often in the *Symbolicae Quaestiones* and the god to whom the Doric order was dedicated,

according to Serlio.[115] Hence, Bocchi associates his private role as scholar and writer with Hercules. Furthermore, like Athena, Hercules symbolizes Virtue through the domination of the senses, and like Hermes/Mercury he stands for eloquence (the Gallic Hercules), thus uniting the public and private zones of Bocchi's facade.

To the top level, the roof, belongs the Doric temple, a monument to Bocchi's own aspirations. As a Janus temple, its door closed, it symbolizes peace, the opposite of strife. Under Janus, prudence reigns. Because the Janus temple occupies in the palazzo engravings a position analogous to the Janus temple in the book – top and end respectively – the completed work is also a new beginning. What had been the most ancient wisdom has been given new form to pass on to future generations. Bocchi, in his role of *custos* (custodian), transmits knowledge; like Janus, he watches over the gateway of learning and virtue. In one sense, Bocchi's hopes are intensely personal and private, but his book of symbols and his students will go forth to present him to the world. Wisdom has a public role; as in the first book of the biblical Proverbs, "Wisdom cries aloud in the street; in the markets she raises her voice; on the top of the walls she cries out..." ("Sapientia foris praedicat; in plateis dat vocem suam; / In capite turbarum clamitat...," Prov. 1.20–1). Again, in the eighth book, "Does not wisdom call, does not understanding raise her voice? On the heights beside the way, in the paths she takes her stand..." ("Numquid non sapientia clamitat, et prudentia dat vocem suam? / In summis excelsisque verticibus supra viam, in mediis semitis stans," Prov. 8.1–2). The temple of wisdom becomes for Bocchi a temple of fame.

# *Appendix:*
## *Membership in Academies Associated with Bocchi*

*Members of the Accademia del Viridario*

Giovanni Filoteo Achillini

Romolo Amaseo (?)

Leandro Alberti (?)

Lodovico Boccadiferro (?)

Achille Bocchi

Giulio Camillo (?)

Filippo Fasanini

Giovanni Antonio Flaminio (?)

Giovanni Andrea Garisendi

Cornelio Lambertini (?)

Alessandro Manzuoli

Angelo Michele Salimbene

*Members of, and Visitors to, the Academia Bocchiana*

Antonio Agostin

Leandro Alberti

Andrea Alciato

Ulisse Aldrovandi

Pompilio Amaseo

Romolo Amaseo

Lodovico Beccadelli (?)

Antonio Bernardi

Marco Tullio Berò (?)

Pirro Bocchi

Romeo Bocchi (?)

Francesco Bolognetti (?)

Costantino Brancaleo (?)

John Caius (?)

[Tommaso?] Calcagnino

Giovanni Battista Camozzi

Bishop Giovanni Campeggi

Sebastiano Corrado

Giovanni Antonio Delfino

Nicolò Dracone (?)

Cardinal Alessandro Farnese

Vincenzo Fontana

Prospero Fontano

Tiresio Foscarari

Lilio Giraldi (?)

Francesco Guicciardini

Johannes Hangest (Genlis) (?)

Simon Lemnius

Michel de L'Hospital

Alberigo Longo

Petrus Lotichius Secundus

Luca Macchiavelli (?)

Antonio Manuzio (?)

Alessandro Manzuoli

Matteo Maria de Maresani

Panfilo Monti

Cesare Odone

Camillo Paleotti (?)

Gabriele Paleotti
Sebastiano Regolo
Innocenzo Ringhieri
Gavino Sambigucius
Johannes Sambucus
Ascanio Sforza (?)
Carlo Sigonio
Pietro Stufa

Camillo Tori
Claude d'Urfé
Antonio Vacca (?)
Benedetto Varchi
Piero Vettori (?)
Giano Vitale
Cardinal Otto Waldburg (?)

# Notes

## 1. The Early Years

1. They say that Achilles, in concealing his wrath, used to sustain himself with such diversions to the refrains of his lyre, to sweeten the sad memory of his mistress; see Joachim Du Bellay, "A Monsievr D'Avanson," in *Les Antiquitez de Rome et Les Regrets,* ed. E. Droz (Paris: Droz, 1945), 32, lines 17–20.

2. "Introduction," in *The Renaissance Image of Man and the World,* ed. Bernard O'Kelly (Columbus: Ohio State University Press, 1966), 14.

3. E. H. Gombrich, *In Search of Cultural History,* The Philip Maurice Deneke Lecture, 1967 (1969; reprint, Oxford: Clarendon, 1978), 39–40.

4. Giovanni Nicolò Pasquali Alidosi, *Dottori bolognesi di teologia, filosofia, medicina, e d'arti liberali dall'anno 1000 per tutto marzo del 1623* (1623; reprint, Bologna: Forni, 1980), 11.

5. Pompeo Scipione Dolfi, *Cronologia delle famiglie nobili di Bologna* (1670; reprint, Bologna: Forni, 1973), 175.

6. Pellegrino Antonio Orlandi, *Notizie degli Scrittori Bolognesi e dell'opere loro stampate e manoscritte* (Bologna: Per Costantino Pisari, 1714), 28, 37; Francesco Saverio Quadrio, *Della storia e della ragione d'ogni poesia,* 5 vols. in 7 (Bologna: Ferdinando Pisarri, 1739–52), 1:56; Giammaria Mazzuchelli, *Gli scrittori d'Italia, cioé notizie storiche, e critiche intorno alle vite, e agli scritti dei letterati italiani,* 2 vols. in 6 (Brescia: Giambattista Bossini, 1753–63), 2:3:1389–90; and Giovanni Fantuzzi, *Notizie degli scrittori bolognesi,* 9 vols. (Bologna: Nella stamperia di San Tommaso D'Aquino, 1781–94), 2:221–32, 9:661–3.

7. For instance, Fantuzzi, like Agostino Chiesa (*Teatro Delle Donne Letterate* [Mondovì: Giovanni Gislandi e Gio. Tomaso Rossi, 1620], 134) before him, insisted that the Constantia Bocchi said to be writing Italian poetry early in the sixteenth century had to be the same Constantia (Costanza) Bocchi, daughter of Achille, who was learned in Greek and wrote poetry in Latin (*Notizie,* 2:225). Because Achille's daughter, according to one of his letters (Bologna, Bibl. Univ., MSS. Ital. 295 [231], fol. 129r), was of marriageable age in 1556, she could not have been old enough to write poetry early in the century. Chiesa's Constantia was probably the Constantia who exchanged vernacular poetry with Bocchi's close friend Giovanni Filoteo Achillini (punningly referred to by his verse as a *bocchina,* or "little morsel"); she died before the completion of Achillini's verse sequence and therefore before 1536 (Florence, Bibl. Laurenziana, Fondo Acquisti e Doni 397, fols. 118r, 145r). Bocchi's mother was Constantia Zambeccari Bocchi (d. 1515), and he may

155

have had a sister (or even a daughter who died early) named Constantia. Fantuzzi also shows a strong class bias against artists, architects, and musicians and may have omitted information about them in connection with Achille.

8. Antonio Rotondò, "Bocchi, Achille," *Dizionario biografico degli Italiani* (hereafter cited as *DBI*), 11:67–70.

9. None of Dorotea's orations and *praelectiones* were still extant by the eighteenth century, according to Mazzuchelli in *Gli scrittori*, 2:3:1392–3, and Giuseppi Guidicini, *Cose notabili della città di Bologna, ossia Storia cronologica de' suoi stabili publici e privati*, 5 vols., ed. Ferdinando Guidicini (Bologna: Vitali, 1868–73), 1:382. Also learned in philosophy and probably a pupil of Dorotea was the Aristotelian Orsina Bocchi (fl. 1461), wife of Baldassari Grassi and mother of Cardinal Achille Grassi (Orlandi, *Notizie*, 221, and Fantuzzi, *Notizie*, 4:230). Orsina was Bocchi's great-aunt.

10. Gisela Ravera Aira, "Achille Bocchi e la sua 'Historia Bononiensis,'" *Studi e memorie per la storia dell' Università di Bologna* 15 (1942): 61–2.

11. Young noblemen, sponsored by older ones, were introduced to the *Anziani* as a kind of "coming of age." Giulio was sponsored by gonfalone Angelo Ranuzzi in 1497 and a cousin, Vincenzo Bocchi, by gonfalone Mino Rossi in 1503; see Dolfi, *Cronologia*, 175, and Rotondò, "Bocchi," 11:67.

12. Thus we have reports of the mothers of Achille and Romeo Bocchi attending a Bentivoglio wedding and of a cousin, Cesare, joining the small party of noblemen accompanying Anton Galeazzo Bentivoglio on a secret pilgrimage to the Holy Land in 1498 (Dolfi, *Cronologia*, 175).

13. This level of teaching, the lowest class in Bologna's public grammar schools, rarely gets discussed by contemporaries; its presence is suggested by such allusions as that of Battista Spagnuoli Mantuano in *Apologia contra detrahentes* (a pejorative remark) and the reference in a 1530 letter by Girolamo Aleandro to "Francisco Amaltheo Ludi magistro" as teacher of Aleandro's nephew, who is called a *puer;* see Battista Spagnuoli Mantuano, [*Opera*] (Lyons: In officina Bernardi Lescuyer, 1516), fol. ccviir, and Girolamo Aleandro, *Lettres familières de Jérome Aléandre (1510–1540)*, ed. J. Paquier (Paris: Picard et Fils, 1909), 136–8. Paul F. Grendler identifies the *ludi magistri* with grammarians on the elementary level; see his detailed study, *Schooling in Renaissance Italy: Literacy and Learning, 1300–1600*, Johns Hopkins University Studies in Historical and Political Science, 107th ser., 1 (Baltimore and London: Johns Hopkins University Press, 1989), 28. Perhaps the *ludi magistri* inherited the role often played by women in the Middle Ages as poorly paid teachers of young children of both sexes from the working classes; see Maria Ludovica Lenzi, *Donne e madonne: L'educazione femminile nel primo Rinascimento italiano* (Turin: Loescher, 1982).

14. For what is known of sixteenth-century grammar schools, see Paul F. Grendler, "The Organization of Primary and Secondary Education in the Italian Renaissance," *Catholic Historical Review* 71 (1985): 185–205, and Grendler, *Schooling in Renaissance Italy*, 137. Grendler assumes that a lay humanist would necessarily have obtained a lay education in the pre-Counter-Reformation period. The teaching that was provided choirboys associated with churches, however, could have had an equally classical basis; for example, at the choir school of the cathedral of Lucca, grammar, arithmetic, and music were taught by John Hothby, an English Carmelite composer who had studied at Oxford; see Peter Burke, *Culture and Society in Renaissance Italy, 1420–1540* (New York: Scribner, 1972), 49.

15. Beroaldo was honored during the funeral with the award of a posthumous laurel crown; see Pasquali Alidosi, *Dottori bolognesi*, 62–65, and Vincenzo Lancetti, *Memorie intorno ai poeti laureati d'ogni tempo e d'ogni nazione* (Milan: Manzoni, 1839), 663–4.

16. Angiolo Silvio Ori, *Bologna raccontata: Guida ai monumenti, alla storia, all'arte della città* (Bologna: Tamari, 1976), 358.

17. Christoph Scheurl, "Ad Sixtum Tucherum" (November 22, 1506), in *Christoph Scheurl's Briefbuch, ein Beitrag zur Geschichte der Reformation und ihrer Zeit*, ed. Franz von Soden and J. K. F. Knaake, 2 vols. in 1 (Aalen: Zeller, 1962), 1:39.

18. Umberto Dallari, ed., *I Rotuli dei lettori legisti e artisti dello Studio bolognese dal 1384 al 1799*, 4 vols. in 5 (Bologna: Fratelli Merlani, 1888–1924), 1:118, et passim (cited hereafter as *Rotuli*); for Mazzoli, see Fantuzzi, *Notizie*, 5:337.

19. *Rotuli*, 1:188, 194, and Fantuzzi, *Notizie*, 4:78–100. Garzoni was an admirer and correspondent of Poliziano; see Ida Maïer, *Les Manuscrits d'Ange Politien: Catalogue descriptif...* (Geneva: Droz, 1965), 365, 369.

20. Ezio Raimondi, "Umanesimo e università nel Quattrocento bolognese," *Studi e memorie per la storia dell'Università di Bologna*, n.s., 1 (1956): 355.

21. Dolfi, *Cronologia*, 175. Students with limited means often left without the *laurea* after their completing class work because they could not afford the expenses of graduation: a series of taxes; a procession through the city streets by examiners, parents, friends, and musicians; a banquet; and the distribution of boxes of sweets to the student's teachers; see Burke, *Culture*, 48; Ludovico Frati, *La vita privata di Bologna dal secolo XIII al XVII* (1900; reprint, Rome: Bardi, 1968), 119–20; and Guido Zaccagnini, *Storia dello Studio di Bologna durante il Rinascimento* (Geneva: Olschki, 1930), 123–4.

22. Taddea is described in some sources as a *nipote* of the cardinal (Rotondò, "Bocchi," 11:67) and in others as a *razza* (descendant, family member) of Cardinal Carlo Grassi (Fantuzzi, *Notizie*, 4:239), who was a cousin of Cardinal Achille and brother of *Bishop* Achille Grassi, so confusion is only too likely. Furthermore, Cardinal Achille Grassi kept an illegitimate family of his own, according to contemporary satires; see *Pasquinate romane del Cinquecento*, ed. Valerio Marucci, Antonio Marzo, and Angelo Romano, 2 vols. (Rome: Salerno, 1983), 1:89, 205, 206, 247; Barbara McClung Hallman, *Italian Cardinals, Reform, and the Church as Property* (Berkeley, Los Angeles, and London: University of California Press, 1985), 113, 118; and Fantuzzi, *Notizie*, 4:230.

23. *Rotuli*, 1:202 passim, 2:6 passim.

24. Vatican, Bibl. Apost. Vat. Fondo Barbariniano Lat. 2030, fols. 539v–569r; and a draft copy in Barb. Lat. 2163.

25. In Vat. Barb. 2029 are the "Argumenta," "Achilles Bocchius quaestiones," "De scribende ratione" (also in 2163), and "Rhetoricae compendiae argumenta." The Ciceronian material is cited by John O. Ward, "Renaissance Commentators on Ciceronian Rhetoric," in *Renaissance Eloquence: Studies in the Theory and Practice of Renaissance Rhetoric*, ed. James J. Murphy (Berkeley, Los Angeles, and London: University of California Press, 1983), 149, and by Paul Oskar Kristeller, *Iter Italicum: A Finding List of Uncatalogued or Incompletely Catalogued Humanistic Manuscripts of the Renaissance in Italian and Other Libraries*, 4 vols. in 5 to date (London: Warburg Institute; Leiden: Brill, 1963–), 2:102, 450.

26. Alberto Serra-Zanetti, *L'arte della stampa in Bologna nel primo ventennio del Cinquecento* (Bologna: Comune, 1959), 203–4, nos. 92–3; Rotondò, "Bocchi," 11:67; and Fantuzzi, *Notizie*, 7:37–8.

27. Paul Oskar Kristeller, *Humanismus und Renaissance*, ed. Eckhard Kessler and trans. Renate Schweyen-Ott (Munich: Fink, 1974), 1:100; August Buck, "Einführung," in *Der Kommentar in der Renaissance*, ed. August Buck and Otto Herding (Bonn-Bad Godesberg: Deutsche Forschungsgemeinschaft, 1975), 7–19; Neal W. Gilbert, *Renaissance Concepts of Method* (New York: Columbia University Press, 1960), xxii, 24–5, 120; Rudolf Pfeiffer, *History of Classical Scholarship from 1300 to 1850* (Oxford: Clarendon Press, 1976),

54; and Giovanni Pozzi, ed., *Hermolai Barbari Castigationes Plinianae et in Pomponium Melam*, 4 vols. (Padua: Antenore, 1973–9), 1:clxvi. For commentaries on individual ancient authors, the major reference tool is the *Catalogus Translationum et Commentariorum: Medieval and Renaissance Latin Translations and Commentaries, Annotated List and Guides*, ed. Paul Oskar Kristeller and F. Edward Cranz (Washington, DC: Catholic University of America Press, 1960–), of which six volumes have appeared.

28. See British Library, *General Catalogue of Printed Books*, 190:44–6, for Pio's editions of Fulgentius (1498), Sidonius Apollinaris (1498), Plautus (1500, 1508, 1511), Lucretius (1511, 1514), Nonus Marcellinus (1511, 1519), Lucan's *Pharsalia* (1514, 1519), and Columella (1520, 1529, 1543).

29. For a fuller listing of Beroaldo's commentaries, see Konrad Krautter, *Philologische Methode und humanistische Existenz: Filippo Beroaldo und sein Kommentar zum Goldenen Esel des Apuleius* (Munich: Fink, 1971), 188–94, and M. Gilmore, "Beroaldo, Filippo, senior," *DBI*, 9:382–4.

30. According to Anthony Grafton: "A commentary on almost any ancient author could thus become an introduction to ancient language, literature, and culture. In short, the commentary was a highly flexible instrument of instruction" ("On the Scholarship of Politian and Its Context," *Journal of the Warburg and Courtauld Institutes* 40 [1977]:153). On allegorical interpretation (*expositio ad litteram, ad sensum*, and *ad sententiam*), see Paul M. Clogan, "The Latin Commentaries to Statius: A Bibliographic Project," in *Acta Conventus Neo-Latini Lovaniensis: Proceedings of the First International Congress of Neo-Latin Studies, Louvain, 23–28 August 1971*, ed. J. IJsewijn and E. Kessler (Munich: Fink; Louvain: Leuven University Press, 1973), 151. On digressions in commentaries, see Pozzi, *Hermolai Barbari*, 1:xlvi–xlvii; Ezio Raimondi, "Il primo commento umanistico a Lucrezio," in *Tra Latino e Volgare per Carlo Dionisotti*, ed. Gabriella Bernardoni Trezzini et al., 2 vols. (Padua: Antenore, 1974), 1:658–9; Gabriel Harvey, *Gabriel Harvey's "Ciceronianus,"* ed. Harold S. Wilson and trans. Clarence A. Forbes (Lincoln: University of Nebraska at Lincoln, 1945), 16–17; and Maria Teresa Casella, "Il metodo dei commentatori umanistici esemplato sul Beroaldo," *Studi medievali*, 3d ser., 16 (1975): 660–7.

31. Bernard Weinberg, *A History of Literary Criticism in the Italian Renaissance*, 2 vols. (Chicago: University of Chicago Press, 1961), 1:47. As a tool for scholarship and teaching the commentary in printed form opened up a much wider readership that Beroaldo had been quick to exploit. The greater availability of printed texts, however, may have led to fewer original readings of ancient authors and fewer student *recollectae*, or classroom notes, for posterity; see Remigio Sabbadini, *Il metodo degli umanisti* (Florence: Le Monnier, 1922), 35, 37, 42–3, on *recollectae*.

32. On the formal structure of these lectures, see Sabbadini, *Metodo*, 35, 37.

33. I have not been able to locate copies of any of Pio's lectures. For a listing of these individually published lectures, see Ludwig Hain, *Repertorium Bibliographicum*, 2 vols. in 4 (Stuttgart: Cotta; Paris: Renouard, 1838), 2:2:112, nos. 13026–7. Pio's unpublished works were bequeathed to Achille Bocchi and by Bocchi's will of 1556 to his heirs with the request that Pio's work be published. No further works of Pio were ever printed, and the manuscripts, whatever they were, have since disappeared; see Ravera Aira, "Achille Bocchi," 63.

34. Filippo Beroaldo, *Orationes, Prelectiones, Praefationes . . .* (Bologna, 1504; Paris, 1508); Antonio Codro Urceo, *Orationes, seu Sermones : . .* , ed. Filippo Beroaldo the Younger (Cologne: Petrus Leichtensteyn, 1506); and Carlo Dionisotti, *Gli umanisti e il volgare fra Quattro e Cinquecento* (Florence: Le Monnier, 1968), 19–20.

35. Beroaldo spoke on music in "Oratio Habita in Enarratione Quaestionum Thusculanarum

et Oratii Flacci," on agriculture ("De Laude Agriculturae Oratio"), on love ("Oratio Habita in Principio Propertii"), on the utility of studying history ("Oratio Habita in Enarratione Titi Livi ac Silij Italici"), and on the wisdom of proverbs and symbols ("Oratio Proverbialis" and "Symbola Pythagorica"). All these are published in his *Orationes*. Politian used the prolusion to deliver "vere dissertazioni filologiche," according to Sabbadini (*Metodo*, 38). He also wrote prelections in Latin hexameters, which he called *Silvae*; see Pfeiffer, *Classical Scholarship*, 44, and Vittore Branca, *Poliziano e l'humanesimo della parola* (Turin: Einaudi, 1983), 73–90.

36. According to John F. D'Amico, the annotations gave their authors a forum for their own opinions and served "as an arena for wide-ranging discussions" (*Theory and Practice in Renaissance Textual Criticism: Beatus Rhenanus between Conjecture and History* [Berkeley, Los Angeles, and London: University of California Press, 1988], 20–1). For the annotations of Aulus Gellius, see Jens Erik Skydsgaard, *Varro the Scholar: Studies in the First Book of Varro's "De Re Rustica"* (Copenhagen: Munksgaard, 1968), 103. The first humanist to announce such a collection of annotations was Domizio Calderini in 1475, but beyond a few "observations," he published nothing of the sort; see Grafton, "On the Scholarship," 156. The Poliziano, Beroaldo, Pio, and Cruce annotations were republished in *Annotationes, castigationes, observationes, racemationes* (Brescia, 1496; Venice, 1502 and 1508) and in the *Lampas, sive Fax Artivm Liberalivm* of Janus Gruterus (Frankfurt: Jonae Rhodi Bibliopola, 1602), vol. 1, Sylloges i–iii.

37. Roberto Abbondanza, "La laurea di Andrea Alciato," *Italia medievale e umanistica* 3 (1960): 326, 328.

38. Rosalie Colie, *The Resources of Kind*, ed. Barbara K. Lewalski (Berkeley and Los Angeles: University of California Press, 1973), 33–4. Two other academic genres were the oral disputation and the *quaestio;* see for these Herbert J. Matsen, "Students' 'Arts' Disputations at Bologna around 1500, Illustrated from the Career of Alessandro Achillini (1463–1512)," *History of Education* 6 (1977): 169–81, and Brian Lawn, *The Salernitan Questions: An Introduction to the History of Medieval and Renaissance Problem Literature* (Oxford: Clarendon Press, 1963). The questions, which appeared in collective form, began to be adapted for literary titles after 1525. For Bocchi's treatment of the question, see Chapter 4.

39. Friedrich Adolf Ebert, *Allgemeines bibliographisches Lexikon*, 2 vols. (Leipzig: Brockhaus, 1821), 1:1030, 2:524. For a table of *editiones principis*, see John Edwin Sandys, *A History of Classical Scholarship*, 3 vols., 3d ed. (Cambridge, 1921; reprint, New York: Hafner, 1958), 2:102–3. In addition, Apuleius was first published in 1469, Pio was teaching it around 1495–6, and Beroaldo before 1500; see Remigio Sabbadini, "'Apuleius rudens' e il latino neo-africano," *Rivista di filologia* 32 (1904): 61, and Krautter, *Philologische Methode*, 131.

40. Rudolf Hirsch, *Printing, Selling, and Reading, 1450–1550*, 2d ed. (Wiesbaden: Harassowitz, 1974), 47, and Curt F. Bühler, *The University and the Press in Fifteenth-Century Bologna* (Notre Dame, IN: Medieval Institute, University of Notre Dame, 1958), 39.

41. E. Mioni, "Bombace (Bombasius, Paolo)," *DBI*, 11:374. Full texts were not often covered in the sixteenth-century classroom. Antonio Agustin, after reporting (in 1539) that Lazzaro Bonamico, Padua's leading rhetorician, was negligent in his teaching, praised his Bolognese professors as more learned, saying: "At meus Romulus [Amaseo] totus est in primo libro oratorio Ciceronis, et septimo virgilii interpraetandis" (But my Romolo is engrossed in the interpretation of the first book of Cicero's orations and the seventh book of Vergil's *Aeneid*); see *Epistolario de Antonio Agustin*, ed. Candido Flores Selles, Acta Salmanticensia. Filosofia y Letras 115 (Salamanca: Ediciones Universidad de Salamanca, 1980), 73.

42. For the younger Beroaldo, see E. Paratore, "Beroaldo, Filippo, iunior," *DBI*, 9:384–8;

and Dionisotti, *Gli umanisti,* 106–7. A promising pupil of Beroaldo the Elder, his cousin, Beroaldo the Younger, produced the first, albeit a mediocre, complete edition of the *Annals* of Tacitus. Dionisotti suggests that Pio, who was edged out of the competition, would have been far more competent and enthusiastic. For Fasanini (Phasianus), see Serra-Zanetti, *L'arte,* 257, 307; Fantuzzi, *Notizie,* 3:300–2; and D. L. Drysdall, "Filippo Fasanini and His 'Exploration of Sacred Writing' (Text and Translation)," *Journal of Medieval and Renaissance Studies* 13 (1983): 127–55.

43. The Latin text and an English translation of the "Declaratio" and texts of the Pio and Bocchi poems appear in Drysdall, "Fasanini," 130–1, 153n.

44. R. Avesani, "Amaseo, Romolo Quirino," *DBI,* 2:660–6.

45. Hirsch, *Printing,* 30, and Serra-Zanetti, *L'arte,* 38, 44.

46. Andrea Alciato, Letter 1 (1518), in *Le lettere di Andrea Alciato giuresconsulto,* ed. Gian Luigi Barni (Florence: Le Monnier, 1953), 2. Also, according to Eva M. Sanford, texts for less advanced students came to predominate over the more scholarly works, and the making of commentaries shifted to northern Europe; see her "Juvenalis, Decimus Junius," in *Catalogus Translationum,* 1:176.

47. Mioni, "Bombace," 11:375; and Paolo Prodi, *Il Cardinale Gabriele Paleotti (1522–1597),* 2 vols. (Rome: Edizioni di Storia e Letteratura, 1959–67), 1:31–4. Camillo Paleotti was the uncle of the future Cardinal Gabriele Paleotti, a Bocchi pupil, and a relative, probably the brother, of the wife of Filippo Beroaldo the Elder. Another brother, Alessandro, who taught canon law, also was imprisoned with Camillo in the Castel Sant'Angelo.

48. For Renaissance encyclopedism, see especially Maria Teresa Casella and Giovanni Pozzi, *Francesco Colonna, biografia e opere,* 2 vols. (Padua: Antenore, 1959), 1:312; Vittorio Cian, *Contributo alla storia dell'enciclopedismo nell'età della Rinascita: Il "Methodus Studiorum" del Card. Pietro Bembo* (Lucca: Baroni, 1915), 19, 26–7; A. H. T. Levi, "Ethics and the Encyclopedia in the Sixteenth Century," in *French Renaissance Studies, 1540–1570: Humanism and the Encyclopedia,* ed. Peter Sharratt (Edinburgh: University Press, 1976), 172–7; Franco Simone, "La notion d'Encyclopédie: Elément caractéristique de la Renaissance française," in *French Renaissance Studies,* 237, 253; and Richard McKeon, "The Transformation of the Liberal Arts in the Renaissance," in *Developments in the Early Renaissance: Papers of the Second Annual Conference of the Center for Medieval and Early Renaissance Studies, State University of New York at Binghamton, 4–5 May 1968,* ed. Bernard S. Levy (Albany: State University of New York Press, 1972), 169–80. For the use of the word "encyclopedia" in the Renaissance, see Jürgen Henningsen, "'Enzyklopädie' zur Sprach- und Bedeutungsgeschichte eines pädagogischen Begriffe," *Archiv für Begriffsgeschichte* 10 (1966): 276–88.

49. Filippo Beroaldo, "Oratio habita in enarratione rhetoricum: Continens laudationem eloquentiae atque Ciceronis," in *Orationes, Prelectiones, Praefationes & quaedam Mithicae Historiae...* (Paris: In Aedibus Ascensianis, 1511), fol. xiir. Also see Eugenio Garin, "Filippo Beroaldo il vecchio e il suo insegnamento bolognese," in Garin, *Ritratti di umanisti* (Florence: Sansoni, 1967), 43–5.

50. Cicero's *Brutus* defined the Apuleian style of oratory as ornate, copious, elevated, and most suited to a young orator, and he described Attic oratory as plain, characterized by brevity, and suited to the gravity of the mature orator; see Cicero, *Cicero's Brutus, or Remarks on Eminent Orators,* trans. T. S. Watson (Reading, PA: Handy, n.d.), lv, xcv. The young Cicero, although condemning the tendency of Asianism to become loose and overly luxuriant, claimed that brevity and eloquence could not be compatible (*Brutus,* xiii). The mature Cicero moved toward the Attic style. His earlier grand style would later be criticized by Quintilian for use of Asian techniques. On the Asian/Attic debate, see Aldo Scaglione, *The Classical Theory of Composition from Its Origins to the Present: A*

*Historical Survey,* University of North Carolina Studies in Comparative Literature 53 (Chapel Hill: University of North Carolina Press, 1972), 10–11, 65–6.

51. For Sabino, see Remigio Sabbadini, "Vita e opere di Francesco Florido Sabino," *Giornale storico della letteratura italiana* 8 (1986): 360–1, and Raimondi, "Il primo commento," 2:672, who agree that Sabino gave the Asian style its "official burial" in his *Lectionis subcisivae.* For Sabbadini's attitude toward Apuleianism, see his *Storia del Ciceronianismo e di altre questioni letterarie nell'età della rinascenza* (Turin: Loescher, 1885) and his "'Apuleius rudens,'" 60–2. Poliziano, who was also labeled "Apuleian" by Ciceronian critics, spoke out against the slavish aping of Cicero; see Pfeiffer, *Classical Scholarship,* 43; Eugenio Garin, "Note in margine all'opera di Filippo Beroaldo il Vecchio," in *Tra latino e volgare per Carlo Dionisotti,* ed. Gabriella Bernardoni Trezzini et al., 2 vols. (Padua: Antenore, 1974), 2:437–56; and Garin, "Filippo Beroaldo," 199–200.

52. Raimondi, "Umanesimo," 341–3. He cited Beroaldo for his love of *copia,* of the picturesque, and of verbal preciosity. Also, see W. Parr Greswell, *Memoirs of Angelus Politianus, Joannes Picus of Mirandula, Actius Sincerus Sannazarius, Petrus Bembus, Hieronymus Fracastorus, Marcus Antonius Flaminius, and the Amalthei,* 2d ed. (Manchester: Printed by R. & W. Dean for Cadell & Davies, London, 1805), 213.

53. Urceo, *Orationes seu sermones,* Sermo I, fol. IIr. Raimondi considered Urceo anti-Ciceronian in his search for an archetypal Greek purity of language (*Politica e commedia: Dal Beroaldo al Machiavelli* [Bologna: Il Mulino, 1972], 51).

54. On the *stile a mosaico,* see R. R. Bolgar, *The Classical Heritage and Its Beneficiaries* (Cambridge: Cambridge University Press, 1958), 271–2. This selection of the best styles antiquity had to offer was advocated by Chrysolorus, the Guarinis, and Francesco Pico della Mirandola. On this selective approach to style, one difficult for all but an educated elite to master, see Salvatore Camporeale, *Lorenzo Valla, umanesimo e teologia* (Florence: Istituto Nazionale di Studi sul Rinascimento, 1972), 40–2, 94, and John F. D'Amico, "The Progress of Renaissance Latin Prose: The Case of Apuleianism," *Renaissance Quarterly* 37 (1984): 356.

55. Serra-Zanetti, *L'arte,* 31–2; Krautter, "Imitatio," 226; Krautter, *Philologische Methode,* 40–2, 87–8; and Raimondi, "Il primo commento," 2:657–8. On the Renaissance view of the Latin language as impoverished in comparison to Greek, see Sem Dresden, "The Profile of the Reception of the Italian Renaissance in France," in *Iter Italicum,* ed. Heiko Oberman (Leiden: Brill, 1975), 131.

56. Casella and Pozzi, *Francesco Colonna,* 2:309–10; Gianfranco Folena, *La crisi linguistica del Quattrocento e l' "Arcadia" di I. Sannazaro* (Florence: Olschki, 1952), 4, 6, 15, 105; Charles Mitchell, "Archeology and Romance in Renaissance Italy," in *Italian Renaissance Studies: A Tribute to the Late Cecilia M. Ady,* ed. E. F. Jacob (London: Faber & Faber, 1960), 467; and R. Weiss, *The Spread of Italian Humanism* (London: Hutchinson, 1964), 99.

57. Raimondi, "Il primo commento," 2:644–5. The emendations were not republished with the *Annotamenta* in Gruter's *Lampas* in 1605 and probably not in the Badius Ascensius edition of 1511 on which Gruter drew; these were the texts most available to northern Europe.

58. Battista Spagnuoli Mantuano, "Apologia contra detrahentes," in his [*Opera*], fols. ccvir, ccviiir; and Benedict Zimmerman, OCD [Fr. Benoît-Marie de la Croix], "Les Carmes humanistes (environs 1465 jusque 1525)," *Etudes Carmelitaines* 20 (1935): 81.

59. Raimondi, "Il primo commento," 2:643–5. Neologisms in the early sixteenth century were not confined to Apuleians, but also occurred in otherwise "Ciceronian" poets such as Marcantonio Flaminio and Girolamo Fracastoro; see Carlo Malagola, *Della vita e delle opere di Antonio Urceo detto Codro: Studi e ricerche* (Bologna: Fava e Garignani, 1878), 391–2. Apuleians more often employed uncommon or archaic words than newly coined

ones. Neologisms, however, were accepted by followers of Quintilian as sometimes necessary for the purpose of keeping the Latin language viable; see D'Amico, "Progress," 355, 361, 389. Garzoni's reproofs were those of a concerned friend; for example, see the letters from Garzoni to Pio edited by Del Nero in "Note sulla vita," 259–63.

60. Raimondi cited Beroaldo's words from the 1502 edition of the works of Urceo; see "Il primo commento," 2:649. On Pio's tribulations, see note 86 below.

61. Dionisotti, *Gli umanisti e il volgare*, 110.

62. G. W. Pigman, III, "Imitation and the Renaissance Sense of the Past: The Reception of Erasmus' *Ciceronianus*," *Journal of Medieval and Renaissance Studies* 9 (1979): 155–77, on Erasmus' belief in the evolution of Latin and Giulio Camillo's opposing views on the death of Latin as a language. In the fifteenth century the debate had raged between the anti-Ciceronian Poliziano and the "pure" Ciceronians Bartolomeo Scala and Paolo Cortesi; see Thomas M. Greene, *The Light in Troy: Imitation and Discovery in Renaissance Poetry* (New Haven and London: Yale University Press, 1982), 147–55. Cortesi, after his early sparring with Poliziano, moved first to a position of moderate Quintilianism and finally to a language close to Apuleianism in his last work, the *De Cardinalatu* of 1510; see D'Amico, "Progress," 371–3. For a study of the humanist theory of linguistic change and evolution, see Richard Waswo, *Language and Meaning in the Renaissance* (Princeton, NJ: Princeton University Press, 1987).

63. According to John D'Amico:

> Both Erasmus and his Roman opponents posited a unity between culture [and]... religion. The Romans found in classicism and its acceptance by the important elements in the Curia justification for advocating their cultural norms in a classical Latinity that had almost hieratic qualities.... Erasmus opposed this view by denying the close relationship between culture and religion. He did not see himself as a high priest serving a religious formalism; he accused the Roman Circeronians of doing that. Neither group could separate its religious ideals from its literary and cultural ideals. (*Renaissance Humanism in Papal Rome: Humanists and Churchmen on the Eve of the Reformation*, Johns Hopkins Studies in History and Political Science, 101st ser., no. 1 [Baltimore and London: Johns Hopkins University Press, 1983], 141–2).

> For the *Latinitas* of the Roman Church, see also Denys Hay, "Italy and Barbarian Europe," in *Italian Renaissance Studies*, 61–2; and Dionisotti, *Gli umanisti*, 108–9.

64. Jean-Claude Margolin, "Alberto Pio et les Cicéroniens italiens," in *Società, Politica e cultura a Carpi ai tempi di Alberto III Pio*, 2 vols. (Padua: Antenore, 1981), 1:258. As Izora Scott notes in her *Controversies over the Imitation of Cicero as a Model for Style and Some Phases of Their Influence on the Schools of the Renaissance* (New York: Teachers College, Columbia University, 1910), 104, many writers of this period were labeled Ciceronian by one critic and anti-Ciceronian by another.

65. The "pure" Ciceronians flourished most strongly in two centers: in Padua and Venice around Pietro Bembo, Cardinal Benedetto Accolti, Francesco Maria Molza, Cristoforo Longolio (Longueil), Marcantonio Flaminio, and Lazzaro Bonamico; and in Rome within the circles of the Accademia Coriciana of Johan Goritz and the University (or "Accademia") of Rome. Some of those from the Venetian area also associated with the Coriciana in Rome, especially Bembo, Flaminio, and Longolio; see Alessandro Pastore, *Marcantonio Flaminio, fortune e sfortune di un chierico nell'Italia del Cinquecento* (Milan: Angeli, 1981), 38, and Federico Ubaldini, *Vita di Mons. Angelo Colocci: Edizione del testo originale italiano (Barb. Lat 4882)*, ed. Vittorio Fanelli (Vatican City: Biblioteca Apostolica Vaticana, 1969), 114–15. At least four former Bolognese professors of rhetoric who had moved to Rome appear as members of the Coriciana during the papacy of Leo X on a

list compiled by or for Paolo Giovio: Camillo Paleotti the Elder, Filippo Beroaldo the Younger, Paolo Bombace, and Gaspare Mazzoli Argilensis. Others on the list either taught at Bologna briefly or were students there; see Ubaldini, *Vita*, 114–15.

66. Bocchi later dedicated poems to at least five members of the Coriciana: Paolo Giovio, Gaspare Mazzoli, Cardinal Alessandro Farnesi, Guido Posthumo Silvestri, and Marcantonio Flaminio. The attacks on Pio came in verse (Filippo Beroaldo the Younger), in a play, *Olsci et Volsci dialogus ludis Romanis actus* (an anonymous play actually written by Mariangelo Accursio and performed in the Piazza del Campidoglio in 1513 for Giuliano and Lorenzo de' Medici), and in several other anonymous works in 1513. For these attacks, see Dionisotti, *Gli umanisti*, 111–13, 117–21; A. Campana, "Accursio (Accorso), Mariangelo," *DBI*, 1:126; and Geofroy Tory, *Champ Fleury, ou l'art et science de la proportion des lettres*, ed. Gustave Cohen (Paris, 1529; reprint, Paris: Bosse, 1931), 7 (also translated by George B. Ives, New York: Grolier, 1927, see 12, 198). Nor did the Romans spare even the "pure" Ciceronian Longolio, whom they accused on the nationalistic grounds of his supposed *laesa majestas* in praising Northerners such as Erasmus and Budé; he was subjected to a mock trial in a protest against his having been made Count Palatine and Cavaliere Aureato by Leo X; see Ph. Aug. Becker, *Christophle de Longueil: Sein Leben und sein Briefwechsel*, Veröffentlichungen des Romanischen Auslandsinstituts der Rheinischen Friedrich Wilhelms-Universität Bonn, Bd. 5 (Bonn and Leipzig: Schroeder, 1924), 29–35.

67. For Amaseo as a Ciceronian, see Alessandro Montevecchi, "La cultura del Cinquecento," in *Storia della Emilia Romagna*, ed. Aldo Berselli, 3 vols. (Bologna: University Press, 1977), 2:559. D'Amico explained the appeal of Ciceronianism for the Romans as a style that "provided objective criteria for evaluating eloquence" and could be learned by anyone: "This 'learnability' made Ciceronianism especially suitable and popular with those engaged in teaching and in secretarial work." The eclectic style, on the other hand, was the most difficult style to master: "Eclecticism could be successful only in the hands of the literarily talented; it was a style for an elite" ("Progress," 356, 358–9).

68. For Erasmus in Rome, see Deno John Geanakoplos, *Greek Scholars in Venice: Studies in the Dissemination of Greek Learning from Byzantium to Western Europe* (Cambridge, MA: Harvard University Press, 1962), 258–9. Geanakoplos erroneously assumed that the Bolognese contribution to Erasmus was negligible (273). Bombace, for example, wrote a defense of Erasmus's *Antibarbari*. For parallels between Erasmus and Beroaldo, see Maria Cytowska, "Erasme et Beroaldo," *Eos* 65 (1977): 265–71; Cytowska, "Erasme grammairien," *Eos* 64 (1976): 223–9; and Eugenio Garin, *Rinascite e Rivoluzioni: Movimenti culturali dal XIV al XVII secolo*, 2d ed. (Bari: Laterza, 1976), 206.

69. Pio was cited as an example of foolishly avoiding common clarity in *De pronuntiatione*, and Beroaldo received more praise than blame from Erasmus. The harshest views expressed in the correspondence were in letters to Erasmus rather than the other way around; see Desiderius Erasmus, *Opera Omnia Deisderii Erasmi Roterodami*, Ordinis Primi, vol. 4 (Amsterdam: North-Holland, 1973), 736, lines 737–42.

70. Terence Cave, *The Cornucopian Text: Problems of Writing in the French Renaissance* (Oxford: Clarendon, 1979), especially 19, 25; Judith Rice Henderson, "Erasmus on the Art of Letter-Writing," in *Renaissance Eloquence: Studies in the Theory and Practice of Renaissance Rhetoric*, ed. James J. Murphy (Berkeley and Los Angeles: University of California Press, 1983), 351, 353, 355; and Pigman, "Imitation," 158–9. Erasmus was especially concerned about the impropriety of using Latin in its most pagan form in the Roman Church. See also Sister Geraldine Thompson, *Under Pretext of Praise: Satiric Mode in Erasmus' Fiction* (Toronto: University of Toronto Press, 1973), 138–9, Cytowska, "Erasme et Beroaldo," 266; and Cytowska, "Erasme grammairien," 229.

71. Some, such as Etienne Dolet and Giulio Camillo Delminio, still defended the name of Cristoforo Longolio, the presumed model for the Ciceronian Nosoponus of Erasmus, and some still upheld the ideal of a perfect vocabulary, as in the Cicero lexicon published by Mario Nizolio in 1535. For Nizolio, see Quirinus Breen, "Marius Nizolius: Ciceronian Lexicographer and Philosopher," *Archiv für Reformationsgeschichte* 46 (1965): 72. The trend away from strict adherence to Cicero in the sixteenth century was gradual, prompting a scholar of seventeenth-century Attic prose to look back at Ciceronianism as support for "the conservative orthodoxies" based on "the love of authority and a single standard of reference which still flourished in the medieval mind of the sixteenth century" (Maurice Croll, "Muret and the History of Attic Prose," *PMLA* 39 [1924]: 267).

72. For Camillo, see Pigman, "Imitation," 169. According to Cesare Vasoli, Camillo was present at the mock trial of Longolio in Rome; see "Su uno scritto religioso di Giulio Camillo Delminio," in *I miti e gli astri* (Naples: Guida, 1977), 185. For Amaseo, see Montevecchi, *Storia,* 2:559; and Luigi Sbaragli, *Claudio Tolomei umanista senese del Cinquecento: La vita e le opere* (Siena: Accademia per le Arti e per Lettere, 1939), 36–7. Sbaragli cited Varchi's opinion that Amaseo did not really believe what he was promoting in this prolusion; see also Benedetto Varchi, *L'Ercolano,* ed. Maurizio Vitale, 2 vols. (1804; reprint, Milan: Cisalpino-Goliardica, 1979), 2:242. Mirko Tavoni discussed the question of the historical basis for Latin and pointed out that Carlo Sigonio in 1566 delivered an oration with the same title as Amaseo's; see "Sulla difesa del Latino nel Cinquecento," in *Renaissance Studies in Honor of Craig Hugh Smith,* ed. Andrew Morrogh et al., 2 vols., Villa I Tatti, The Harvard University Center for Italian Renaissance Studies 7 (Florence: Giunti Barbèra, 1985), 1:495.

73. Raimondi, "Il primo commento," 2:651, 658; and Del Nero, "Note sulla vita," 252.

74. Del Nero, "Note salla vita," 252, and Malagola, *Della vita,* 94–5. The Boccardo attack was so harsh, even by sixteenth-century standards, that the Brescian was later chastised by Cardinal Quirini; see Fantuzzi, *Notizie,* 7:36. I was unable to examine a copy of Bocchi's *Apologia.*

75. Erasmus, *Ciceronianus, or A Dialogue on the Best Style of Speaking,* trans. Izora Scott (Albany, NY: Brandow, 1908), 95. Another translation of Plutarch's life of Cicero, attributed to Bocchi but actually made by the early-fifteenth-century Jacopo Angeli, appeared in editions of Plutarch from 1514 on; on this confusion, see Vito R. Giustiniani, "Sulle traduzioni latine delle "Vite' di Plutarco nel Quattrocento," *Rinascimento,* n.s. 2, 1 (1961): 38–9.

76. Sabbadini, "Vita," 360.

77. Ghiselli, *Memorie,* 26:644, quoted in Zaccagnini, *Storia,* 276; Ovidio Montalbani, *Minervalia Bonon. Ciuium Anademata, Sev Bibliotheca Bononiensis, Cvi Accressit antiquorum Pictorum, & Sculptorum Bonon. Breuis Catalogus, Collectore, Io. Antonio Bvmaldo . . .* (Bologna: Typis Haeredis Pictorij Benatij, 1641), 5; Leandro Alberti, *Historie di Bologna,* Historiae urbium et regionum Italiae rariores 44 (1541–91; reprint, Bologna: Forni, 1970), sig. Aiiv; and for the Flaminio poem, Bocchi's *Libellus Leon X,* fol. 18r; and *Carmina Illustrium Poetarum Italorum,* ed. Joannes Bottari 11 vols. (Florence: Typis Regiae Celsitudinis, apud Joannem Cajetanum Tartinum et Sanctem Franchium, 1719–26), 4:417.

78. "Cum . . . / Dulcis fluentem lacteo eloquentiae / Torrente saepius citeret Tullium," in *Lusuum,* fol. 4r; and *Libellus,* fol. 3v–4v. The younger Beroaldo was a Medici protégé.

79. Tolomei's *Il Cesano* was first published in Venice in 1555 by Giolito without the author's permission and from an incomplete copy. For reconstruction of its composition and circulation in manuscript, see Sbaragli, *Tolomei,* 27–9, and two modern editions of *Il Cesano de la Lingua Toscana,* one edited by Ornella Castellani Pollidori (Florence: Olschki,

1974) and the other by Maria Rosa Franco Subri (Rome: Bulzoni, 1975). See also Waswo, *Language and Meaning*, 181–4. Tolomei studied law in Bologna around 1513 to 1516 and there published his early *Laude delle donne bolognese* (1514; reprint, Bologna: Forni, n.d.), which was praised by Ariosto in *Orlando Furioso*, canto 45; see Sbaragli, *Tolomei*, 369. Giovanni Filoteo Achillini's *Annotationi Della Volgar Lingua*...(Bologna: Vicenzo Bonardo da Parma, & Marcantonio da Carpo, 1536) would have been intended as well to counter Amaseo's pro-Latin oration of 1330, which Tolomei may also have heard, according to Subri (*Il Cesano*, vii, xlii).

80. The Achillini *Annotationi* has not been republished and the only modern attention to it appears in Claudio Scarpati's comparison of it to Sabba Castiglione's *Epistola delle lingue d'Italia al venerabile Padre* (Bologna, 1549). Scarpati suggested that the dedicatee was Leandro Alberti and that the *Epistola* served as a defense of Castiglione's *Ricordi* in the same manner that Achillini's *Annotationi* defended his *Fedele* against a Tuscan "monismo." Thus, according to Scarpati, "la tesi di Achille Bocchi...difende una posizione di 'liberalismo' linguistico analoga a quella di Sabba"; see his *Studi sul Cinquecento italiano* (Milan: Vita e Pensiero, Pubbl. della Università Cattolica, 1982), 114–15.

81. The two empty places at the luncheon table were a result of a disputation that Boccadiferro had to attend and of Achillini's own business, which had taken him to his beloved country property in the Val del Reno (*Annotationi*, fol. 6v–7r). Achillini also makes a pointed reference to the events of 1529/30 by having Bocchi relate a brief discussion between himself and "Compare M. Petro Bembo" (fol. 37).

82. Pigman, "Imitation," 164; Charles B. Schmitt, *Gianfrancesco Pico della Mirandola (1469–1533) and his Critique of Aristotle* (The Hague: Nijhoff, 1967), 199; and Greene, *The Light*, 172, 177.

83. Raimondi, "Umanesimo," 332–3, 334–47, 349–50, 354; and for Urceo, see Ezio Raimondi, *Codro e l'Umanesimo a Bologna* (Bologna: Zuffi, 1950).

84. Raimondi viewed Beroaldo's teacher Puteolano as the first of the "courtier" academics in his role as Bentivoglio tutor ("Umanesimo," 335), and Del Nero described the political factors delaying Pio's attainment of a position in Rome as "nel modello del'umanista cortegiano" ("Note sulla vita," 253).

85. This claim is made in Beroaldo's dedication to Ficino's commentary on Propertius; see Raimondi, "Umanesimo," 344. The Ficinian shift of the creative human from the astrological sign of Mercury to that of Saturn (most fully developed in his *De vita triplici*, 1482–9), according to Rudolf and Margot Wittkower, changed artists' views of themselves and began a trend toward melancholic eccentricity in artists; see Wittkower and Wittkower, *Born under Saturn: The Character and Conduct of Artists; a Documented History to the French Revolution* (New York: Random House, 1963; reprint, New York and London: Norton, 1969), especially 102–5; "In the late sixteenth century a veritable wave of 'melancholic behavior' swept across Europe" (104). Also see Maniates, *Mannerism*, 86–7, 527n, on the association of eccentric personalities in the arts and sciences with Mannerism.

86. Greene, *The Light*, 176.

87. *Bartholomaei Riccii Lvgiensis Epistolarvm Familiarvm Libri VIII* (Bologna, 1560), and Walter Moretti and Renato Barilli, "La letteratura e la lingua, le poetiche e la critica d'arte," in *Cultura e vita civile tra Riforma e Controriforma*, ed. Nicola Badaloni et al. (Rome and Bari: Laterza, 1973), 115–201; also published in *Il Cinquecento dal Rinascimento alla Controriforma*, ed. Nicola Badaloni et al., IV, vol. 2, of *La letteratura italiana, storia e testi* (Rome and Bari: Laterza, 1973), 513.

88. Greene, *The Light*, 177; Carlo Dionisotti, "Chierici e laici," in *Geografia e storia della letteratura italiana* (Turin: Einaudi, 1967), especially 64–5, 71; and D'Amico, *Renaissance*

*Humanism*, 33. In the sixteenth century the Curia itself had become increasingly closed to the lay humanists who had formed part of the secretariat in the fifteenth century. Not only had Bologna been removed from the host of courts by its return to the Papal States in 1506, but also some of the small principates, such as Carpi and Mirandula, had been swallowed up by larger ones; see Giorgio Chittolini, "Il particolarismo signorile e feudale in Emilia fra Quattro e Cinquecento," in *Il Rinascimento nelle corte padane: Società e cultura* (Bari: De Donato, 1977), 35–46.

89. Ezio Raimondi, "Dalla natura alla regola," in *Rinascimento inquieto* (Palermo: Manfredi, 1965), 7–21.

90. Both collections were presentation copies prepared by scribes. The dates cannot be fixed with more precision at this time but were probably toward the end of each range of years.

91. For Spagnuoli, see Zimmerman, "Les carmes," 72–85; Joachim Smet and Ulrich Dobhan, *Die Karmeliten: Eine Geschichte der Brüder U. L. Frau vom Berge Karmel, von den Anfängen (ca. 1200) bis zum Konzil von Trient*, trans. Ulrich Dobhan (Freiburg, Basel, and Vienna: Herder, 1981), 168, 206, 208; and Wilfred P. Mustard, "On the Eclogues of Baptista Mantuanus," *Transactions and Proceedings of the American Philological Association* 40 (1909): 151–83. In Italy, the vogue for the prolific Carmelite waned quickly after his death, but elsewhere in Europe the "beloved Mantuan" remained influential.

92. Burke, *Culture*, 295–302. On the *viator* poems, see Elvira Favretti, "Una raccolta di Rime del Cinquecento," *Giornale storico della letteratura italiana* 158 (1981): 566–7; and for neo-Latin genres in general, see Paul van Tieghem, "La Littérature latine de la Renaissance: Etude d'histoire littéraire européene," *Bibliothèque d'Humanisme et Renaissance* 4 (1944): 177–418 (republished separately, Paris: Droz, 1944); and Pierre Laurens and Claudie Balavoine, eds. and trans., *Mvsae redvces: Anthologie de la poésie latine dans l'Europe de la Renaissance*, 2 vols. (Leiden: Brill, 1975), 1:16–26.

93. Renaissance humanists replaced the Latin term "Carmen" with the Greek verb meaning "to sing" to describe their trim, learned, and public poems, according to Carol Maddison in *Apollo and the Nine: A History of the Ode* (Baltimore: Johns Hopkins Press, 1960). Their ode was "a lyric poem written in the newly found classical tradition, under the influence of Horace, later of Pindar, and finally of Anacreon. Thus the Humanists invented a new poetic genre, a poem celebrating contemporary experience in the ancient taste" (2).

94. For d'Arco (1492 or 1493–1546 or 1547), see G. Rill, "Arco, Nicolò d'," *DBI*, 3:793–4, and *Nicolaus Archius comes carmina* (Florence. Laur., Ashb. 266 [198], fol. 10v), a collection dated 1542. Credit for the invention of the *lusus pastoralis* has been given variously to M. A. Flaminio (W. Leonard Grant, "The Neo-Latin *Lusus pastoralis* in Italy," *Medievalia et Humanistica* 11 [1957]: 94–5), Sannazaro (Maddison, *Apollo*, 99), and Andrea Navagero (Fred J. Nichols, ed. and trans., *An Anthology of Neo-Latin Poetry* [New Haven and London: Yale University Press, 1979], 688). Others who contributed collections of *lusus pastoralis* were Girolamo Amalteo (Grant, "The Neo-Latin *Lusus*," 98) and Francesco Vinta, both members of the circle around Flaminio, and, in the North, Joachim Du Bellay, *Divers Jeux Rustiques*, and Barnabe Barnes, *Odes Pastoral* (Maddison, *Apollo*, 222, 289, and Sukanta Chaudhuri, *Renaissance Pastoral and Its English Development* [Oxford: Clarendon, 1989], 98, 103–5). The only modern edition of any of these collections of "diversions" is the bilingual edition of Navagero's *Lusus* by Alice E. Wilson (Nieuwkoop: De Graaf, 1973). For selections from all the Italian "lusus" poets, see *Carmina illustrium Poetarum Italorum*. The *lusus*, according to Benedetto Croce, was very stylized and "letterato" but capable of great elegance, abundance, and sensual attraction; see "La poesia latina," in *Poesia popolare e poesia d'arte: Studi sulla poesia italiana dal tre al cinquecento* (Bari: Laterza, 1933), 255–6. Bocchi strove for these qualities in his two collections of *lusus*, although he used fewer pastoral and amorous poems than his fellow poets.

95. Ercole Cuccoli, *M. Antonio Flaminio, studio* (Bologna: Zanichelli, 1897), 174, and Chaudhuri, *Renaissance Pastoral*, 79 (on Varchi).

96. Bocchi's manuscript included both these poems together; in later collections they were printed apart by author, as in the *Carmina illustrium Poetarum Italorum*, 2:354 (Bocchi) and 4:417 (Flaminio). For the Western tradition of eye imagery, see Lance K. Donaldson-Evans, *Love's Fatal Glance: A Study of Eye Imagery in the Poets of the Ecole Lyonnaise* (University, MI: Romance Monographs, 1980).

97. Giovanni Antonio Flaminio, ... *Epistolae Familiares*, ed. Fr. Dominico Josepho Capponi (Bologna: Ex Typographia Sancti Thomae Aquinatis, 1744), Liber V, Epist. II, p. 196; Lib. X, Epist. X, XI, XIV, pp. 393–5, 398–9. In his letter to Marcantonio (p. 196), Giovanni Antonio went on to suggest that his son be "hilariorem ... atque jocosam, sed prudentiorem ... ac minus lascivientem" (merrier and light-hearted, but more prudent and not so lewd) and mentioned that Achille Bocchi had just visited him in Imola.

98. See *Nicolaus Archius comes carmina*, fol. 163v, revised from a draft version on fol. 181r.

99. Translated by Carol Maddison, *Apollo*, 117–18. Maddison, although noting the skill with which Marcantonio structured his poem in the manner of an inscription and his mastery of Latin poetic style, at the same time criticized the poem as too perfect an imitation of Horace and Catullus.

100. For the tongue in emblems, see Barbara C. Bowen, "*Lingua quo tendis?* Speech and Silence in French Renaissance Emblems," *French Forum* 4 (1979): 255–6, and also Bowen, "The Emblematic Tongue, 'That unruly Member,'" in *Words and the Man in French Renaissance Literature* (Lexington, KY: French Forum, 1983), 93–109. The theme of errancy in Marcantonio's poem also plays on the name of Bocchi's country property, the "Vado de Bucchi," where, presumably, the tree dedication took place.

101. Bocchi did not dedicate any of his symbols to Valeriano, suggesting that he may have wished to distance himself from his early persona, though Valeriano did also present the stag as a biblical symbol of the perfect man; see Giovanni Piero Valeriano Bolzano, *Hieroglyphica, Lyon, 1602* (reprint, New York and London: Garland, 1976), 64–72.

102. Pastore, *Flaminio*, 17–18; Marcantonio Flaminio, *Lettere*, ed. Alessandro Pastore, Università degli Studi di Trieste, Facoltà di Lettere e Filosofia, Istituto di Storia Medievale [e] Moderna 1 (Rome: Ateneo & Bizzarri, 1978), 1; and Francesco Maria Mancurti, ed., in M. A. Flaminio, *Alcune lettere e biografia di Marcantonio Flaminio* (Turin, 1855), 20–2.

103. Domenico Gnoli, *La Roma di Leon X: Quadri e studi originali*, ed. Aldo Gnoli (Milan: Hoepli, 1938), 109, 115, 121, 128, and J. B. Trapp, "The Poet Laureate: Rome, *Renovatio* and *Translatio Imperii*," in *Rome in the Renaissance: The City and the Myth. Papers of the 13th Annual Conference of the Center for Medieval & Early Renaissance Studies*, ed. P. A. Ramsey (Binghamton, NY: Center for Medieval & Early Renaissance Studies, 1982), 117–19. Bologna had its own prolific vernacular poet laureate, also a Medici protégé (and Medici jeweler), in Girolamo da Casio; after Casio's death, Governor Francesco Guicciardini agreed with the Senate of Bologna that the post of laureate and its annual pension of 200 lire should be abolished because "in verità mi pare che habbino ragione: pur con difficultà si potrebbe concedere a un poeta sì buono" (in truth, it seems to me they are right, because it would be difficult to concede to a poet so good); see *Carteggi di Francesco Guicciardini*, ed. Roberto Palmarocchi and Pier Giorgio Ricci, 17 vols. (Bologna: Zanichelli; Rome: Istituto Storico Italiano per l'Età Moderna e Contemporanea, 1938–72), 16:56.

104. Gnoli, *La Roma*, 266–99. Bernardo (l'Unico) Accolti of Arezzo improvised in both Latin and Italian but may have sung only in Italian (Gnoli, 143). Mariangelo Accursio was another Roman improviser in Latin and Italian (Gnoli, 128), as was Bocchi's friend, Panfilo Sasso of Modena (d. 1527); see Antonio Rossi, *Serafino Aquilano e la poesia*

*cortegiana* (Brescia: Morcelliana, 1980), 218–21. A continuous tradition of singing classic Latin verse existed in Europe, with at least fifteen manuscripts of the poetry of Horace, Vergil, Boethius, and others containing musical notations in the margins known to exist from the ninth century through the Renaissance; see Giuseppe Vecchi, "Catullo e l'umanesimo musicale," *Convivium*, no. 2 (1949): 277, 280, 287. Vecchi concluded that these musical settings served a purpose merely "pedagogico-didattica." Petrarchism will be discussed in Chapter 4.

105. Fantuzzi, *Notizie*, 4:232, and Rossi, *Serafino*, 142–4.
106. Rossi lists the more than 150 contributing poets (*Serafino*, 138–42), and Alessandro D'Ancona's essay, "Del secentismo nella poesia cortegiana del secolo XV," in his *Studj sulla letteratura italiana de' primi secoli* (Ancona: Morelli, 1884), 154–60, also lists many of them with some titles and brief descriptions of the poems. Achille Bocchi, then age sixteen, is not among the names, but an Antonio Bocchi is. Antonio Bocchi, along with some of the other eulogizers of Serafino, also had written verse for an earlier manuscript collection on the death of Fra Mariano da Genazzano in Bologna (Bologna, Bib. Univ., Cod. 2628, ca. 1498), probably the first of the memorial compilations.
107. Fantuzzi, *Notizie*, 4:72–73, and Matsen, "Students' 'Arts' Disputations," 169 passim.
108. The text has been edited by Lodovico Frati in his *Rimatori bolognesi del Quattrocento* (Bologna: Romagnoli dall'Acqua, 1908), 283–327. Printed editions without the dedication appeared in Venice in 1518 and 1522, attributing the work to Giovanni Filoteo Achillini, but the existence of two earlier manuscripts seems to make Garisendi's authorship more secure; see Lodovico Frati, "Gio. Andrea Garisendi e il suo Contrasto d'Amore," *Giornale storico della letteratura italiana* 49 (1907): 73–82, and Teresa Basini, "Spigolature e dipanature intorno alle opere di Gio. Filoteo Achillini," *Paideia* 11 (1956): 256–8. Fantuzzi attributes the work to both poets (*Notizie*, 1:64, 4:73).
109. Foscarari's improvisation followed a dinner at the end of a hunt celebrated in a long narrative poem by Guido Postumo Silvestri (with whom Bocchi also exchanged verse); see Gnoli, *La Roma*, 265, and Fantuzzi, *Notizie*, 3:356. Foscarari wrote the epigram for Symbol II on Bocchi's portrait in the *Symbolicae Quaestiones*. Another singing poet and teacher of rhetoric in this Bolognese circle (around 1503 to 1513) was Camillo Paleotti, who was praised by Ariosto for his "soave e chiara voce" in *Orlando Furioso*, canto 42, 88, ed. Cesare Segre, 2 vols. (Milan: Mondadori, 1982), 2:1095.
110. Frati, *Rimatori*, 299–300.
111. Frati, *Rimatori*, 319, and Dora Panofsky and Erwin Panofsky, *Pandora's Box: The Changing Aspects of a Mythical Symbol*, 2d ed. rev. (New York: Pantheon, 1962), 62, on Bocchi's symbol of Pandora.
112. Garisendi has Phylero follow Antiphylo's "prerogative" of Amor with a parallel structure of praise for Amor. Vernacular poetic debates for and against Love were not uncommon in the fifteenth century (Frati, *Rimatori*, 280, 300). Musical debates, however, traditionally were supposed to have begun in 1514, but they probably had been performed for several decades previously; see Fausto Torrefranca, *Il segreto del Quattrocento: Musiche ariose e poesia popolaresca* (Milan: Hoepli, 1939), 156–79.
113. Panofsky and Panofsky, *Pandora's Box*, 67. The Panofskys also discussed two unfinished Goethe plays, *Prometheus* (1773) and *Pandorens Wiederkunft* (1807), in which Prometheus has a jealous and short-tempered son named Phileros (22–3, 125–7). Nevertheless, it seems unlikely that Goethe, for all his travels through Italy, would have based his Phyleros/Pandora association on Garisendi. Goethe was familiar with emblem books, however; he knew those of Alciato and Sambucus, so it is possible that he may have seen Bocchi's emblem of Pandora, but this would not have given him the Phyleros connection; see William S. Heckscher, "Goethe im Banne der Sinnbilder: Ein Beitrag zur Emblematik,"

in *Emblem und Emblematikrezeption: Vergleichende Studien zur Wirkungsgeschichte vom 16. bis 20. Jahrhundert,* ed. Sibylle Penkert (Darmstadt: Wissenschaftliche Buchgesellschaft, 1978), 356, 368, 370.

114. Frati, *Rimatori,* 325–7. The Platonic conception of a divine furor seizing the mind (*ingenium*) of the poet and inspiring through cosmic revelation the greatest poetry was developed fully in the second half of the fifteenth century with Niccolò Perotti, Cristoforo Landino, and Marsilio Ficino; see Raimondi, "Dalla natura," 8; Francesco D'Episcopo, *Civiltà della parole,* vol. 1, *Il Rinascimento: La rivolta della poesia* (Naples: Edizioni Scientifiche Italiane, 1984), 83–4 (an earlier version appeared in *Res Publica Litterarum* 4 [1981]: 43–66); and William O. Scott, "Perotti, Ficino and Furor Poeticus," *Res Publica Litterarum* 4 (1981): 273–84. The inspired poet was called *vate,* a term now purged of earlier medieval associations with lying and black magic; see Tibor Kardos, "Il concetto di 'vate' e la coscienza della vocazione poetica agli inizi del Rinascimento," *Atti del R. Istituto Veneto di Scienze, Lettere ed Arti, Venezia. Classe di scienze morale e lettere* 123 (1964–5): 1–26. In Ficino there was a clear relationship between improvised song and notions of *prisca theologia;* see D. P. Walker, "Le Chant orphique de Marsile Ficin," in *Musique et poèsie au XVIe siècle: Colloques Internationnaux du Centre National de la Recherche Scientifique, Sciences humaines V, Paris, 30 Juin–4 Juillet 1953* (Paris: Editions du Centre National de la Recherche Scientifique, 1954), 22, 26.

115. Frati noted some of the Dante allusions; see *Rimatori,* 281.

116. The influence of Neoplatonism was felt more strongly in the arts of poetry, music, and painting than was the Aristotelianism predominating in other sectors of culture. According to Jerrold E. Seigel: "Thus humanism and scholasticism coexisted in the universities uneasily at times, but more harmoniously than humanist polemics suggest." He points out that the humanist challenge to Scholasticism occurred only in ethics and logic and not in natural philosophy, metaphysics, and theology; see *Rhetoric and Philosophy in Renaissance Humanism: The Union of Eloquence and Wisdom* (Princeton, NJ: Princeton University Press, 1968), 226–7.

117. Fantuzzi, *Notizie,* 2:219. Bocchi alluded to a major financial setback in a poem dedicated to his father and probably written around this year (*Lusuum,* fols. 3v–4v). Fantuzzi does not tell us how much the position of organist paid Bocchi. An organist a generation earlier at the larger church of San Petronio, Roger Saignand, had received three gold ducats a month and a furnished house to live in; see Nanie Bridgman, *La Vie musicale au Quattrocento et jusqu'à la naissance du madrigale (1400–1530)* (Mayenne: Gallimard, 1964), 42. Bocchi lived within a short distance of San Pietro, but the combination of daily lecturing and daily organ playing must soon have proved a heavy burden.

118. Frank Tirro, "Lorenzo di Giacomo da Prato's Organ at San Petronio and Its Use During the Fifteenth and Sixteenth Centuries," in *Essays Presented to Myron P. Gilmore,* ed. Sergio Bertelli and Gloria Ramakus, 2 vols., Villa I Tatti, The Harvard University Center for Italian Renaissance Studies 2 (Florence: La Nuova Italia, 1978), 2:489; also see Fantuzzi, *Notizie,* 8:29–30, and Nan Cooke Carpenter, *Music in the Medieval and Renaissance Universities* (Norman: University of Oklahoma Press, 1958), 132. Organ music, like vocal music, was often improvised; see Warren Kirkendale, "Ciceronians versus Aristotelians on the Ricercar as Exordium, from Bembo to Bach," *Journal of the American Musicological Society* 32 (1979): 2.

119. Filippo Beroaldo the Elder praised Piero Bono, a noted lutenist, in an epigram (Burke, *Culture,* 66). He discussed *vox asse* (voice alone) as the earliest form of music in his commentary on Apuleius, which John Dowland would later cite in a translation of *Andreas Ornithoparcus His Micrologus* (London: Printed for Thomas Adams, 1609), 77, and he composed a 1491 oration in praise of the poet-musician as a prelection for a course

on Cicero's *Tusculan Disputations*; see James Hutton, "Some English Poems in Praise of Music," in *Essays on Renaissance Poetry*, ed. Rita Guerlac (Ithaca, NY, and London: Cornell University Press, 1980), 33.

120. Pietro Aaron, *Libri tres de institutione harmonica*, Bibliotheca musica bononiensis, sezione 2, n. 8 (1516; reprint, Bologna: Forni, 1970). For a biography of Aaron, see A. Bonaccorsi, "Aaron (Aron), Pietro," *DBI*, 1:1–2.

121. "Phileros me'... iuvenis candidissimus & grece latineque doctissimus utriusque nostrorum familiaris"; see Aaron, *Libri tres*, fol. 5v.

122. Aaron, *Libri tres*, fol. 5v. The Beroaldo oration was read closely and copied, sometimes almost verbatim, by Richard Pace (a Beroaldo student), Lilio Gregorio Giraldi, John Case, and Ben Jonson; see Hutton, "Some English Poems," 33, 37, 41; and Richard Pace in his 1517 *De Fructu qui ex Doctrina Percipitur* (The benefit of a liberal education), ed. and trans. Frank Manley and Richard S. Sylvester (New York: Publ. for The Renaissance Society of America by Frederick Ungar, 1967), 38–47, 153.

123. Bocchi's ode to Aaron was also published in the *Carmina Illustrium Poetarum Italorum*, 2:348–9, but not in his *Symbolicae Quaestiones*.

124. Ramos left Bologna because the chair of music he had been promised never materialized, but the controversy over his *Musica practica* (Bologna, 1482) went on for half a century. Giovanni Spataro, the music director of San Petronio, was the most fully involved in Ramos' defense in a long series of polemical exchanges; see Gustave Reese, *Music in the Renaissance*, rev. ed. (New York: Norton, 1959), 181–3, 586–7; Carpenter, *Music*, 128–32; and Fantuzzi, *Notizie*, 12:29–30.

125. Reese, *Music*, 181–3, and Maniates, *Mannerism*, 131. There are at least twenty-nine extant letters from Spataro to Aaron (Bonaccorsi, "Aaron," 1:1).

126. Garin, "Filippo Beroaldo," 197–218 (also published in *Tra latino e volgare*, 2:440–1); Michael Baxandall and E. H. Gombrich, "Beroaldo on Francia," *Journal of the Warburg and Courtauld Institutes* 25 (1962): 113–15; and Giuseppe Piazzi, *Le opere di Francesco Raibolini detto il Francia, orefice e pittore* (Bologna: Azzoguidi, 1925), 4, 72, 74–5.

127. Giovanni Filoteo Achillini, *Viridario de Gioanne Philotheo Achillino Bolognese* Bologna: Hieronymo di Plato Bolognese, 1513), fols. clxxxvii$^v$–clxxxviii$^v$. For Marcantonio Raimondi's portraits of Achillini, see Marzia Faietti, "Stampe e disegni di Marcantonio (1–58)," in *Bologna e l'Umanesimo, 1490–1510*, ed. Marzia Faietti and Konrad Oberhuber, Bologna, Pinacoteca Nazionale, 6 marzo–24 aprile 1988 (Bologna: Nuova Alfa, 1988), 123–5.

128. The destruction of the Bentivoglio palace extended to the loss of frescoes by Francia, Perugino, and Lorenzo Costa; some objects of art were looted and sold to collectors elsewhere, and many others disappeared from Bologna in the nearly twenty carriages of possessions that Ginevra Bentivoglio (whose greed helped precipitate the family's fall) took with her during her flight by night from Bologna; see Andrea Emiliani and Konrad Oberhuber, "Bologna 1490: Dall'Umanesimo severo alla suavitas rinascimentale," in *Bologna e l'Umanesimo*, xxvi; and Sandro de Maria, "Artisti 'antiquari' e collezionisti di antichità à Bologna fra XV e XVI secolo," in *Bologna e l'Umanesimo*, 30. For works of art in Bologna, see Giordani, *Della venuta*, N321, N331; Pietro Lamo, *Graticola di Bologna: Gli edifici e le opere d' arte della città nel 1560*, ed. Giancarlo Roversi (Bologna: Atesa, 1977), 32–3; and Charles Dempsey, "Malvasia and the Problem of the Early Raphael and Bologna," in *Raphael before Rome*, ed. James Beck, Studies in the History of Art, vol. 17 (1986), 57–70.

129. Jacopo Rainieri, *Diario bolognese*, ed. G. Guerrini and C. Ricci (Bologna: Regia tipografia, 1887), 39, and de Maria, "Artisti 'antiquari' e collezionisti," 17–42. Achillini

was one of seven antiquaries listed for Bologna by Leandro Alberti (*Historie di Bologna*, fol. Giir).

130. Emiliani and Oberhuber, "Bologna 1490," xv.

131. Serra-Zanetti, *L'arte*, 45, 50.

132. Enid T. Falaschi, "Valvassori's 1553 Illustrations of *Orlando furioso*: The Development of Multi-narrative Technique in Venice and Its Links with Cartography," *Bibliofilia* 77 (1975): 227–51.

133. Francesco Colonna, *Hypnerotomachia Poliphili, Venice, 1499* (reprint; New York and London: Garland, 1976).

134. Achillini, *Viridario*, fols. xlviiiiv, and *Annotamenta*, fol. 42r, and Tolomei, *Laude*, sig. Eiir–Eiiir.

135. Karl Giehlow, "Die Hieroglyphenkunde des Humanismus in der Allegorie der Renaissance, besonders der Ehrenpforte Kaisers Maximilian I," *Jahrbuch der Kunsthistorischen Sammlungen des Allerhöchsten Kaiserhauses (Wien)* 32 (1915): 147, and Roberto Weiss, *The Renaissance Discovery of Classical Antiquity* (Oxford: Blackwell, 1969), 124.

136. For Bocchi's role, see G. A. Flaminio, *Epistolae familiares*, 407 passim. Alberti praises Bocchi and Fasanini as "iuuenes litteratissimi, necnon uirtutibus ornatissimi" (most literate youths and, moreover, adorned with virtues) in Liber Quartus; see Leandro Alberti, *De Viris Illvstribvs Ordinis Praedicatorvm Libri Sex In Vnvm Congesti* (Bologna: In aedibus Hieronymi Platonis, 1517), fol. 151v.

137. Alberti, *De Viris*, fol. 151v.

138. Fantuzzi, *Notizie*, 9:219.

139. Paul Grendler, *Critics of the Italian World (1530–1560): Anton Francesco Doni, Nicolò Franco & Ortensio Lando* (Madison, Milwaukee, and London: University of Wisconsin Press, 1969), 89.

140. Grendler, *Critics*, 15, 83; Lord Montagu of Beaulieu, *More Equal Than Others: The Changing Fortunes of the British and European Aristocracies* (London: Joseph, 1970), 109; Benedetto Croce, *La Spagna nella vita italiana durante la Rinascenza* (Bari: Laterza, 1917), 197, 241–7; and, on *onore*, Francesco Erspamer, *La Biblioteca di Don Ferrante: Duello e onore nella cultura del Cinquecento* (Rome: Bulzoni, 1982), 44–6, and Frederick Robertson Bryson, *The Point of Honor in Sixteenth-Century Italy: An Aspect of the Life of the Gentleman* (New York: Institute of French Studies, Columbia University, 1935), 1–2. Some sixteenth-century authors, most of them lawyers, who wrote on *onore* and the duel and also taught in Bologna, included Andrea Alciato, Antonio Bernardi, Mariano Socino, Claudio Betti, and Achille Marozzo; see Bryson, *The Point*, 2; and Erspamer, *La Biblioteca*, 21, 86–8, 127, 215.

141. Carlo Dionisotti, "Chierici e laici," in *Geografia e storia della letteratura italiana* (Turin: Einaudi, 1967), 65–6 (essay first published in *Problemi di vita religiosa in Italia nel Cinquecento* [Padua: Antenore, 1960], 167–85); D'Amico, *Renaissance Humanism*, 5; Burke, *Culture*, 238; and Giancarlo Angelozzi, "La trattistica su nobiltà ed onore a Bologna nei secoli XVI e XVII," *Atti e memorie [della] Deputazione di Storia Patria per le Province di Romagna*, n.s. 25–6 (1974–5): 231.

142. Charles Dempsey, "Some Observations on the Education of Artists in Florence and Bologna during the Later Sixteenth Century," *Art Bulletin* 62 (1980): 552–69; Burke, *Culture*, 51, 65, 70, 281; Wittkower and Wittkower, *Born under Saturn*, 16, 33, 62, 93, 158, 216. The musician, Gian Maria, was awarded the right to use the Medici name and crest as well, but he lost all his privileges on the death of Leo X; see Gnoli, *La Roma*, 135. The emperors Frederic III and Charles V each named a Jewish personal physician to the Order of the Golden Spur as "eques auratus"; see Louis Kukenheim, *Contributions*

*à l'histoire de la grammaire grecque, latine et hébraïque à l'époque de la Renaissance* (Leiden: Brill, 1951), 96, and Cecil Roth, *The History of the Jews in Italy* (Philadelphia: Jewish Publication Society of America, 1946), 202.

143. Giovanni Della Casa, *Il Galateo,* ed. Giorgio Manganelli and Claudio Milanini, rev. ed. (Milan: Rizzoli, 1980), 86. The title of Count Palatine was suppressed in 1875 after much abuse. In the Renaissance this title was usually awarded in conjunction with that of *eques aureato*; see Hyginus Eugene Cardinale, *Orders of Knighthood, Awards and the Holy See* (Gerrards Cross, Buckinghamshire, England: Van Duren, 1983), 22, 37.

144. Serra-Zanetti, *L'arte,* 292–3.

145. "Informatione," in Bologna. Archiginnasio, MS B470, no. 9, 368; Mazzuchelli, *Gli scrittori,* 2:3:1389; and Del Nero, "Note sulla vita," 252. For Alberto Pio, see Cesare Vasoli, "Un principe diplomatico e umanista: Alberto III Pio da Carpi," in *La cultura delle corti,* ed. Cesare Vasoli (Bologna: Capelli, 1980), 106, and Myron P. Gilmore, "Italian Reactions to Erasmian Humanism," in *Itinerarium Italicum: The Profile of the Italian Renaissance in the Mirror of Its European Transformations, Dedicated to Paul Oskar Kristeller,* ed. Heiko A. Oberman and Thomas A. Brady, Jr. (Leiden: Brill, 1975), 71.

146. G. Mazzatinti, *Inventari dei manoscritti delle biblioteche d'Italia,* vol. 65 (Forli: Bordandini, 1937), 33, concerning Bologna. Biblioteca Gozzadini. MS. Cartone I. 13 (a copy). I have seen another copy of this privilege, signed by Cesare de Riario, Patriarch of Alexandria; the date was illegible, however (Bologna, Archiginnasio, MS. B. 1283).

147. Vatican, Lat. 2163, fols. 109r–110r: "Achilles Ph. Bochius Bartholomeo Raimundo & Mario Siderotomo, S. I."

148. Ravera Aira, "Achille Bocchi," 65.

149. Flaminio, *Alcune lettere,* 20, 24. The years 1512 to 1513 were the same years in which Bocchi's mentor G. B. Pio was being mocked in Rome for his style, cruelty that may have disgusted and disillusioned the young Bocchi.

150. Mazzuchelli, *Gli scrittori,* 2:3:1389, and Fantuzzi, *Notizie,* 9:61–2; 2:223.

151. Mazzuchelli, *Gli scrittori,* 2:3:1389–90.

152. Prodi, *Il Cardinale Gabriele Paleotti,* 2:75. Paleotti had several illegitimate daughters, who received excellent educations. Prodi quotes Bocchi's epigram and says that Bocchi also wrote a brief presentation letter for a manuscript copy, now in Bologna's Archivio Isolani. By 1550 opinion may have become more conservative on the issue of legitimizing bastards, because not even Paleotti claimed that the bastards should be equal to legitimate children or should bear the same name; see Roberto Zapperi, "I ritratti di Antonio Carracci," *Paragone: Arte,* 38, n.s. 4, no. 449 (1987): 8.

153. Pompeo Vizani, . . . *Dieci Libri Delle Historie Della Sva Patria* (Bologna: Presso gli Heredi di Gio. Rossi, 1602), 547; and Serafino Mazzetti, comp., *Memorie storiche sopra l'Università e l'Istituto delle Scienze di Bologna* (Bologna: Tipi di S. Tommaso d'Aquino, 1840), 49–50, 57. The never-legitimized Gerolamo Cardano, for example, was allowed to teach in Milan in 1529 only after the intervention of Archbishop Archinto and was supported against rumor and hostility in his chair of theoretical medicine at Bologna (1562–70) by Cardinals Carlo Borromeo, Francesco Alciato, and Giovanni Morone; see J.-Roger Charbonnel, *La Pensée italienne au XVIe siècle et la courant libertin* (1919; reprint, Geneva: Slatkine, 1969), 274, and Emilio Costa, "Gerolamo Cardano allo Studio di Bologna," *Archivio storico italiano,* 5th ser., 35 (1905): 425–6. Although not all of Cardano's problems can be blamed on his illegitimacy, the instability of his birth and uncertainty of his family must have contributed to his visions, familiar spirits, and superstitions; see his autobiography, *The Book of My Life (De Vita Propria Liber) by Jerome Cardan,* trans. Jean Stoner (London and Toronto: Dent, 1931), and also, Markus Fierz, *Girolamo Cardano, 1501–1576, Physician, Natural Philosopher, Mathematician, Astrologer,*

*and Interpreter of Dreams,* trans. Helga Niman (Boston, Basel, and Stuttgart: Birkhäuser, 1983).

154. Bocchi had dedicated three odes to Amaseo in his *Lusuum,* fols. 13r–15r, and in his *Libellus,* fols. 11r–v, 14v–15v, 16r–17v.

155. Avesani, "Amaseo," 2:660–1.

156. Fantuzzi, *Notizie,* 4:141. The godfathers included Giovanni Bonasoni, a teacher of law, who may have been a brother of Bocchi's illustrator, Giulio Bonasoni.

157. Avesani, "Amaseo," 2:661; and Adriano Prosperi, *Tra Evangelismo e Controriforma: G. M. Giberti (1495–1543)* (Rome: Edizioni di Storia e Letteratura, 1969), 104, 234. Cardinal Giberti sent young clerics to Bologna to study with Amaseo.

158. In a letter to his father on March 8, 1525, Romolo bragged about having approximately ninety good pupils in his school and complained of the envy of others, especially Pio and Bocchi, who, he said, were hoping to ruin him; see Fantuzzi, *Notizie,* 2:219, and Vittorio Cian, "Per la storia dello Studio bolognese nel Rinascimento: Pro e contro l'Amaseo," in *Miscellanea di studi critici in onore di Arturo Graf* (Bergamo: Istituto Italiano d'Arti Grafiche, 1903), 209–13. Cian took Amaseo's claims of hostility from Bocchi and Pio seriously without considering the provocation from Amaseo – having one's former pupil come back at a higher salary and compete for private paying students as well must have been painful to finances as well as to egos.

159. Milan, Ambrosiana, D. 145 inf. For a description of the Cremona, Fondo Civico manuscripts, see Kristeller, *Iter Italicum,* 1:50. I did not see the Cremonese manuscripts, and they were not known to Fantuzzi and Cian. Fantuzzi knew of the Ambrosiana letters, but because he had not seen them, he assumed they could not have been by Achille Bocchi because of the quarrel (*Notizie,* 2:232–3).

160. Avesani, "Amaseo," 2:662; and Gregorio Amaseo, Leonardo Amaseo, and Giovanni Antonio Azio, *Diarii udinesi dall'anno 1508 all'anno 1541,* Monumenti storici pubblicati dalla R. Deputazione Veneta di Storia Patria, vol. 11, ser. 3, Cronache e Diarii, vol. 2 [i.e., 1] (Venice: Visentini, 1884), 339. The letter of March 28, 1533, provides detailes about the balloting, registration, and public decree required in the process of "restitution" of citizenship.

### 2. The Quiet Years: Bocchi's Religion and Philosophy

1. Silence is the companion to great counsels and the faithful minister of security; therefore, be silent, or only speak as much as necessary to dissimulate that which is hidden within your heart; see Federico Della Valle, *Tutte le opere,* ed. Pietro Cazzani (Verona: Mondadore, 1955), 325.

2. Delio Cantimori, "Note su alcuni aspetti della propaganda religiosa nell'Europa del Cinquecento," in *Aspects de la propagande religieuse nell'Europa del Cinquecento: Etudes publiées par G. Berthaud [et al.]* ed. Henri Meylan (Geneva: Droz, 1957), 346–8. The question of libertinism will be discussed later in this chapter.

3. *Rinascimento,* 2d ser., 2 (1962): 126–7.

4. Antonio Rotondò, "Bocchi, Achille," *Dizionario biografico degli Italiani* (hereafter cited as *DBI*), 11:67–70.

5. Rotondò, "Atteggiamenti della vita morale italiana del Cinquecento: La pratica nicodemitica," *Rivista storica italiana* 79 (1967): 1016.

6. Rotondò, "Atteggiamenti," 1016.

7. Camillo Renato, *Opere: Documenti e testimonianze,* ed. Antonio Rotondò (Florence: Sansoni; Chicago: Newberry Library, 1968), 85.

8. Hubert Jedin, *Geschichte des Konzils von Trient,* 4 vols. (Freiburg: Herder, 1950–75), 3:8.

9. George Huntston Williams, "Camillo Renato (c. 1500–?1575)," in *Italian Reformation Studies in Honor of Laelius Socinus*, ed. John A. Tedeschi (Florence: Le Monnier, 1965), 117.

10. Aldo Stella, *Anabattismo e Antitrinitarismo in Italia nel XVI secolo: Nuove ricerche storiche* (Padua: Liviana, 1969), 60.

11. Carlo Ginzburg, *Il Nicodemismo: Simulazione e dissimulazione religiosa nell'Europa del '500* (Turin: Einaudi, 1970), 179–80.

12. Salvatore Caponetto, *Aonio Paleario (1503–1570) e la Riforma protestante in Toscana* (Turin: Claudiana, 1979), 119. There was indeed an Angelo Bocchi (son of Romeo), who entered law school in Bologna around 1540 and later taught law there. Nothing is known of his associates, but a group of legal lectures by the two A. Bocchis are confused in a manuscript in Bologna. Bib. Univ., Cod. Lat. 350 (595K)-10.

13. Romeo De Maio, *Michelangelo e la Controriforma* (Rome and Bari: Laterza, 1978), 406n.

14. Cesare Vasoli, "Considerazioni su alcuni temi retorici di Giulio Camillo Delminio," in *Retorica e poetica. Atti del III Convegno Italo-Tedesco (Bressanone, 1975)*, ed. D. Goldin, Quaderni del Circolo filologico linguistico padovano 10 (Padua: Liviana, 1979), 257.

15. Gennaro Savarese, "Introduzione," in *La letteratura delle immagini nel Cinquecento*, ed. Gennaro Savarese and Andrea Gareffi (Rome: Bulzoni, 1980), 23–5.

16. Manfredo Tafuri, *Venezia e il Rinascimento: Religione, scienza e architettura* (Turin: Einaudi, 1985), 97–101.

17. Adalgisa Lugli, "Le 'Symbolicae Quaestiones' di Achille Bocchi e la cultura dell'emblema in Emilia," in *Le arti a Bologna e in Emilia dal XVI al XVII secolo*, ed. Andrea Emiliani, vol. 4 of *Atti del XXIV Congresso Internazionale di Storia dell'Arte*, 10 vols. (Bologna: CLUEB, 1982–3), 87–96, pl. 96–117. For a discussion of Bocchi that is even more concerned with hermetic secrecy and initiation, see Samuele Giombi, "Umanesimo e mistero simbolico: La prospettiva di Achille Bocchi," *Schede umanistiche* 1(1988): 169–216.

18. Lugli, "Le 'Symbolicae Quaestiones,'" 89, 93n.

19. Vera Fortunati Pietrantonio, "L'immaginario degli artisti bolognesi tra maniera e controriforma: Prospero Fontana (1512–1597)," in *Le arti*, 97–111.

20. Anna Maria Orazi, *Jacopo Barozzi da Vignola, 1528–1550, apprendistato di un architetto bolognese* (Rome: Bulzoni, 1982).

21. Orazi, *Jacopo Barozzi*, 257–8, 262–4.

22. *Giulio Bonasone*, Catalogo di Stefania Massari, 2 vols. (Rome: Edizioni Quasar, 1983), 1:9–29.

23. *Giulio Bonasone*, 1:18–19.

24. Frederick G. Schab, in a review of Massari's catalogue, was particularly critical of this attribution to Bonasone of "the entire iconographic elaboration of this work"; see "Bonasone," *Print Quarterly* 2 (1985): 59.

25. Mutini was reacting specifically to Massari's catalogue, *Giulio Bonasone*; see his review, "Bonasone e i 'Symbola' di Bocchi nella versione di M. Bianchelli Illuminati [the translator of Bocchi's text in Massari, 2:187–235]," *Galleria* 35 (1985): 243–7.

26. *Giulio Bonasone*, 1:19. Mutini also made this point ("Bonasone," 244).

27. See the "Pasquino alli signori dottori legisti bolognese: Epitteti di natura," in *Pasquinate romane del Cinquecento*, ed. Valerio Marucci, Antonio Marzo, and Angelo Romano, 2 vols. (Rome: Salerno, 1983), 1:496. The description of Bocchi reads: "Il cavalier di Bocchi / Non cognosce alcun pazzo il suo difetto, / che la miseria acceca l'intelletto" (the knight Bocchi: no madman is aware of his own defect, as misery blinds his intellect). Other professors were accused of ugliness (Andrea Alciato), ignorance (Achille's cousin Romeo Bocchi), attraction to loose women or little boys, deceit, and other, mostly negative, attributes.

28. De Maio, *Michelangelo,* 406, and *Giulio Bonasone,* 1:27.

29. Peter Burke, *Culture and Society in Renaissance Italy, 1420–1540* (New York: Scribner, 1972), 238. A "Messer Achille," a physician later suspected of heresy who read philosophy and logic to a group of young intellectuals in Siena a decade after this dialogue, was Achille Benvoglienti; see Valerio Marchetti, "La formazione dei gruppi ereticali senesi del Cinquecento," in *Essays Presented to Myron P. Gilmore,* ed. Sergio Bertelli and Gloria Ramakus, 2 vols., Villa I Tatti. The Harvard University Center for Italian Renaissance Studies 2 (Florence: La Nuova Italia, 1978),1:115–43.

30. Giovanni Di Napoli, *L'immortalità dell'anima nel Rinascimento* (Turin: Società Editrice Internazionale, 1963), 234, 310, 347.

31. Reginald Pole, *Epistolarum Reginaldi Poli S. R. E. Cardinalis et aliorum ad ipsum,* ed. Angelus Maria Card. Quirinus, 5 vols. (1744–57; reprint, Farnborough, England: Gregg, 1967). Nor does Bocchi appear in Lodovico Beccadelli's biography of Pole, in *Monumenti di varia letteratura tratti dai manoscritti di Beccadelli,* 2 vols. (1797; reprint, Farnborough, England: Gregg, 1967). However, Fantuzzi said that Bocchi's son Pirro was sent from Paris on a diplomatic mission to Cardinal Pole in England (around 1554?); see Giovanni Fantuzzi, *Notizie degli scrittori bolognesi,* 9 vols. (Bologna: Nella stamperia di San Tommaso D'Aquino, 1781–94), 2:234.

32. For an example of a firmly Roman Catholic teacher whose heretical pupil maintained friendly ties with him despite their separate religious identities, see Walter L. Moore, Jr., "Catholic Teacher and Anabaptist Pupil: The Relationship between John Eck and Balthasar Hubmaier," *Archiv für Reformationsgeschichte* 72 (1981): 68–97.

33. Giulio Camillo was also there, but so was the entire faculty of rhetoric, including "il Bocchio, con le Muse a Colli e Monti"; see Girolamo Casio de Medici, *Libro intitulato Bellona nel quale si tratta di Arme, di Letere, e di Amore* (Bologna, 1525), sig. b iv$^v$.

34. Carlo Ginzburg, ed., *I costituti di don Pietro Manelfi* (Florence: Sansoni; DeKalb: Northern Illinois University Press; and Chicago: Newberry Library, 1970), 48.

35. Vasoli, "Considerazioni," 256; Alessandro Pastore, *Marcantonio Flaminio, fortune e sfortune di un chierico nell'Italia del Cinquecento* (Milan: Angeli, 1981), 45, 73; François Secret, "Les cheminements de la Kabbale à la Renaissance: Le *Théâtre du monde* de Giulio Camillo Delminio et son influence," *Rivista critica di storia della filosofia* 14 (1959): 424–6; and Cesare Vasoli, "Il 'luterano' Giovanni Battista Pallavicini e due orazioni di Giulio Camillo Delminio," *Nuova rivista storica* 58 (1973): 64–70, 448–58.

36. Gustav C. Knod, *Deutsche Studenten in Bologna (1289–1562): Biographischer Index zu den Acta Nationis Germanicae Biblioteca Universitatis Bononiensis* (1889; reprint, Darmstadt: Scientia Verlag Aalen, 1970), 298.

37. Symbol XVII was originally dedicated to Bovio; see British Library, MS. Sloane 3185, fol. 14r. For Bovio, see Jacopo Rainieri, *Diario bolognese,* ed. G. Guerrini and C. Ricci (Bologna: Regia tipografia, 1887), 103, 163; and Filippo Valenti, ed., "Il carteggio di padre Girolamo Papino informatore estense dal Concilio di Trento durante il periodo bolognese," *Archivio storico italiano,* 124, no. 451 (1966): 413–14.

38. Renato, *Opere,* 85, 59.

39. Paolo Giovio, *Lettere,* ed. Giuseppe Guido Ferrero, vols. 1–2 of *Pauli Iovii Opera,* ed. Societatis Historicae Novocomensis (Rome: Istituto Poligrafico dello Stato, 1956), 1:310, and Giovanni Filoteo Achillini, *Annotationi della volgar lingva di Gio. Filotheo Achillino* (Bologna: Vicenzo Bonardo da Parma e Marcantonio da Carpo, 1536), fol. 5v. For Lambertini and Manzuoli, see Pompeo Scipione Dolfi, *Cronologia delle famiglie nobili di Bologna* (1670; reprint, Bologna: Forni, 1973), 445–6, 515.

40. Antonio Battistella, *Il S. Officio e la riforma religiosa in Bologna* (Bologna: Zanichelli, 1905), 83, 199.

41. So far I have found only scattered, often oblique, references to prosecution of cases of homosexuality before 1555, such as the banishment of Aldo Manuzio's second son, Antonio; see Guillaume Pellicier, *Correspondance politique de Guillaume Pellicier, 1540–42*, ed. Alexandre Tausserat-Radel (Paris: Alcan, 1899), 269. The climate quickly changed, however, when Carafa became Paul IV – he celebrated his first Christmas in office (December 25, 1555) by having five men and two women burned for sodomy, considered a form of heresy; see Paolo Simoncelli, *Il caso Reginald Pole: Eresia e santità nelle polemiche religiose del Cinquecento* (Rome: Edizioni di Storia e Letteratura, 1977), 151. One wonders whether the *spirituali*, as well as a Camillo Renato, gave him cause to associate sexual crimes with heresy.

42. The preceding Symbol LVIII employs the term *sordidus* to refer to avarice and corruption. Renato's poems to four young Danese brothers tutored by him harp on this word in the sense of "illiberality," but Renato also uses *sordidus* in reference to sodomy, as in "De quodam puer [sic] sordidulo"; Renato, *Opere*, 15–16, 284).

43. Williams, "Camillo Renato," 129.

44. Williams, "Camillo Renato," 122.

45. Carlo Ginzburg, *Il formaggio e i vermi: Il cosmo di un mugnaio del '500* (Turin: Einaudi, 1976), 186. For Bonasone, see Serafino Mazzetti, comp., *Repertorio di tutti i Professori antichi, e moderni della famosa Università, e del celebre Istituto delle scienze di Bologna* (Bologna: Tipografia di S. Tommaso d'Aquino, 1848), 63.

46. Ginzburg, *Il formaggio*, 140; and Renato, *Opere*, 53. For Francesco Bolognetti, see his *Lettera inedita del Senatore Francesco Bolognetti di Bologna*, ed. Conte Tommaso Piccolomini Adami (Orvieto: Marsili, 1886), 405, and Giammaria Mazzuchelli, *Gli scrittori d'Italia, cioé notizie storiche, e critiche intorno alle vite, e agli scritti dei letterati italiani*, 2 vols. in 6 (Brescia: Giambattista Bossini, 1753–63), 2:3:1483–4.

47. Dale Kent has adapted the concept of instrumental friendship, first proposed by Boissevain in 1966, to the Florentine Renaissance; see Kent, *The Rise of the Medici: Faction in Florence, 1426–1434* (Oxford: Oxford University Press, 1978), 83n, 185.

48. For Tolomei's position as "rigido ortodosso," see Paolo Simoncelli, *Evangelismo italiano del Cinquecento: Questione religiosa e nicodemismo politico* (Rome: Istituto Storico Italiano per l'Età Moderna e Contemporanea, 1979), 288, and for his "fidelità assoluta," see Paola Fabi, "La poesia religiosa di Claudio Tolomei," *Studium* 69 (1973): 950.

49. Simoncelli, *Evangelismo*, 82, 85, 167.

50. For this survey, I used Pole, *Epistolarum*; Beccadelli, *Monumenti*; and Gasparo Contarini, *Regesten und Briefe des Cardinals Gasparo Contarini, 1483–1542*, ed. Fr. Dittrich (Braunsberg: Huye, 1881).

51. Fantuzzi, *Notizie*, 2:231, 234.

52. Gaetano Giordani, *Della venuta e dimora in Bologna del sommo Pontifice Clemente VII. per la coronazione di Carlo V. Imperatore celebrata l'anno MDXXX: Cronaca* (Bologna: Alla Volpe, 1842), N223, Doc. XLII, R.57–58; Giulio Camillo Delminio, *Opere...* (Venice: Appresso Gabriel Giolito De' Ferrari, 1560); Marcello Fagiolo, "Il giardino come teatro del mondo e della memoria," in *La città effimera e l'universo artificiale del giardino: La Firenze dei Medici e l'Italia del '500*, ed. Marcello Fagiolo (Rome: Officina, 1980), 126; Albert R. Cirillo, "Giulio Camillo's *Idea of the Theater*: The Enigma of the Renaissance," *Comparative Drama* 1 (1967): 26; and Vasoli, "Considerazioni," 256–7.

53. Paola Zambelli, "Bernardi, Antonio," *DBI*, 9:148–51; Di Napoli, *L'immortalità*, 262–3; and Marcantonio Flaminio, *Lettere*, ed. Alessandro Pastore, Università degli Studi di Trieste. Facoltà di Lettere e Filosofia. Istituto di Storia Medievale [e] Moderna 1 (Rome: Ateneo & Bizzarri, 1978), 111n.

54. M. Flaminio, *Lettere*, 24–5, 36.

55. Milan, Bibl. Ambros., MS. D.145 inf., fols. 8v, 22r, 29v, and Pastore, *Flaminio*, 24–5. Also see Vasoli, "Considerazioni," 256–7.

56. Beccadelli, *Monumenti*, 1:9, 26; G. Alberigo, "Beccadelli, Ludovico," *DBI*, 7:409; Eugénie Droz, *Chemins de l'hérésie: Textes et documents*, 4 vols. (Geneva: Slatkine, 1970–6), 3:203; and Gigliola Fragnito, "Per lo studio dell'epistolografia volgare del Cinquecento: Le lettere di Ludovico Beccadelli," *Bibliothèque d'Humanisme et Renaissance* 43 (1981): 61–87. The latter article mentions the existence of many yet unpublished letters of Beccadelli.

57. Beccadelli monitored writings that mentioned their names, using Scipione Bianchini of Bologna to infiltrate a conventicle of " 'questi novi nostri cristiani' " in order to ascertain whether a copy of Ochino's *Prediche*, published in Geneva after Ochino's apostasy, was damaging to Contarini. By January 16, 1542, Bianchini was able to reassure Beccadelli that the " 'Prediche ginevrine ... poco tocco l'honor del car[dinal]le ...' "; see Simoncelli, *Evangelismo*, 201–2n. Beccadelli was later named by the Tridentine Council to a commission to reform the *Indici* and worked to bring back, at least in emended form, works of Flaminio, Savonarola, and a few others; see Antonio Rotondò, "La censura ecclesiastica e la culture," in *Storia d'Italia*, 6 vols. in 10 (Turin: Einaudi, 1972–6), 5:2:1429, 1431.

58. Simoncelli, *Evangelismo*, 69, 192–3, 205, and his *Il caso*. Beccadelli's biographies were all published in his *Monumenti*, and the life of Pole was also translated into Italian by Andre Dudith Sbardellati, who accompanied Pole to England in 1553–4; see Pierre Costil, *André Dudith, humanist hungrois, 1533–1589: Sa vie, son oeuvre et ses manuscrits grecs* (Paris: Société d'Edition "Les Belles Lettres," 1935), 42–72. According to Domenico Caccamo, *Eretici italiani in Moravia, Polonia, Transylvania (1558–1611): Studi e documenti* (DeKalb: Northern Illinois University Press; Chicago: Newberry Library, 1970), 109, 112, Dudith's translation shows clear reform tendencies and anti-papal polemics not found in the original.

59. The letter about Corrado was addressed to Francesco Bolognetti, a friend of Bocchi in Bologna; both letters appeared in *Bartolomaei Riccii Lvgiensis Epistolarvm Familiarvm Libri VIII* (Bologna, 1560), Lib. IIII, fols. 11r–12r; and S. W[eiss], "Corrado (Sébastien)," *Biographie Universelle (Michaud) ancienne et moderne*, 45 vols. (Paris: Desplaces; Leipzig: Brockhaus, 1854–n.d.), 6:254.

60. Francesco Saverio Quadrio, *Della storia e della ragione d'ogni poesia*, 5 vols. in 7 (Bologna: Ferdinando Pisarri, 1739–52), 1:1:94.

61. A study that begins to grapple with the question of male bonding in friendship in the Renaissance is Eve Kosofsky Sedgwick's *Between Men: English Literature and Male Homosocial Desire* (New York: Columbia University Press, 1985). Sedgwick's study does not, of course, take into account Italian social structures, but her paradigm of the triangle in which two males use a female to their advantage in fostering a male homosocial relationship opens up the whole question of male social structures. We do not have enough information about the social structure in Padua circles to explain its impact, although the bonds were founded in part on homosexual relationships.

62. Bartolommeo Fontana, *Renata di Francia, duchessa di Ferrara*, 3 vols. (Rome: Forzani, 1899), 3:xxi, xxxvii, xxxviii, xlii; Thomas Frederick Crane, *Italian Social Customs of the Sixteenth Century and Their Influence on the Literatures of Europe*, Cornell Studies in English 5 (1920; reprint, New York: Russell & Russell, 1971), 285; and Pellegrino Antonio Orlandi, *Notizie degli Scrittori Bolognesi e dell'opere loro stampate e manoscritte* (Bologna: Costantino Pisarri, 1714), 186.

63. Fantuzzi, *Notizie*, 7:195.

64. Symbol LXI seems to praise Renée's position of the moment. That it was written not

long before the 1555 publication is suggested by the fact that the manuscript version of the *Symbolicae Quaestiones* (British Library, MS, Sloane 3185, fols. 62v–63r) displays revisions, whereas none of the symbols known to have been written before 1550 show any sign of change.

65. The sonnet attributed to Gambara begins: "Scelse da tutta la futura gente / Gli eletti suoi l'alta bontà infinita, / Predestinati a la futura vita / Sol per voler de la divina mente" (The sublime infinite good selects from all future people his elect, predestined for future life only by the will of the divine mind). See Veronica Gambara, *Rime e lettere di Veronica Gambara,* comp. Felice Rizzardi (Brescia: Giammaria Rizzardi, 1759), 44. Because of its confused manuscript history and its topic, however, the poem's author was probably Vittoria Colonna. See Alan Bullock, "Veronica o Vittoria? Problemi di attribuzione per alcuni sonetti del Cinquecento," *Studi e problemi di critica testuale* 6(1973): 115–31.

66. For such cases, see Battistella, *Il S. Officio;* Rotondò, *Atteggiamenti,* 210; Rotondò, "La storia"; Adriano Prosperi, "Un gruppo ereticale italo-spagnolo: La setta di Giorgio Siculo (secondo nuovi documenti)," *Critica storica* 19 (1982–3): 335–51; Silvana Seidel Menchi, "Sulla fortuna di Erasmo in Italia: Ortensio Lando e altri eterodossi della prima metà del Cinquecento," *Schweizerische Zeitschrift für Geschichte* 24 (1974): 537–634; Myron P. Gilmore, "Anti-Erasmianism in Italy: The Dialogue of Ortensio Lando on Erasmus' Funeral," *Journal of Medieval and Renaissance Studies* 4 (1974): 1–14; Ginzburg, *Il formaggio,* 186; Simoncelli, *Evangelismo,* 160, 164, 201–7; and L. Carceri, "Cristoforo Dossena, Francesco Linguardo e un Giordano, librai processati per eresia a Bologna (1548)," *L'Archiginnasio* 5 (1910): 180. Carceri reported that Linguardo was supported by Claude d'Urfé, delegate to the Council of Trent, and by many "gentlemen" of Bologna (their names are not recorded here); see Carceri, 183–4.

67. Massimo Firpo and Dario Mercatto, "Il primo processo inquisitoriale contro il Cardinal Morone (1552–53)," *Rivista storica italiana* 93 (1981): 71–3; Aldo Adversi, "Ulisse Aldrovandi bibliofilo, bibliografo e bibliologo del Cinquecento," *Annali della Scuola Speciale per Archivisti e Bibliotecari dell'Università di Roma* 8 (1968): 108; Rainieri, *Diario bolognese,* 163; and Massimo Roatti, "La cultura scientifica tra conservazione e innovazione," in *Storia della Emilia Romagna,* ed. Aldo Berselli, 3 vols. (Bologna: University Press; Imola: Santerno, 1976–80), 2:401.

68. British Library, MS. Sloane 3185, fol. 14; Fantuzzi, *Notizie,* 1:167, 2:342–4; and Rainieri, *Diario bolognese,* 163.

69. Gilmore, "Anti-Erasmianism," commented: "The fact that Lando, presumably writing in 1538 or 1539, could include him [Agostino Mainardi] among the orthodox shows how complicated and confused was the situation in these decisive years" (11). See also Caponetto, *Aonio Paleario,* 21, 67, 185n.

70. Christopher F. Black, *Italian Confraternities in the Sixteenth Century* (Cambridge: Cambridge University Press, 1989), 89.

71. Carlo Cesare Malvasia, *Felsina pittrice: Vita de' pittori bolognese,* ed. Giampietro Zanotti, 2 vols. (1841; reprint, Bologna: Forni, 1967), 1:64. Present scholarship does not help us much with cultural networks. The best study of the complex relationships – personal friendships, family, *parentado,* neighbors, and instrumental friendships – that make up the power structure of a city is Kent's *Rise of the Medici,* especially pages 15–17, 50–3, 61–4, 82, 185. Ronald F. E. Weissman, without citing Kent, comes to similar conclusions about the complexity of an individual's relationships with others and comments: "If anything, the Renaissance town suffered from too much community, rather than from individualism or anomie." He argues for applying the concept of "interactionism" developed by the Chicago School of sociology to the social and economic history of the Renaissance; see "Reconstructing Renaissance Sociology: The 'Chicago School' and the Study of

Renaissance Society," in *Persons in Groups: Social Behavior as Identity Formation in Medieval and Renaissance Europe: Papers of the Sixteenth Annual Conference of the Center for Medieval and Early Renaissance Studies,* ed. Richard C. Trexler (Binghamton NY: Medieval & Renaissance Texts & Studies, 1985), 239. These models do not take into account the frequent correspondence between humanists and their movements from place to place in the sixteenth century. For the importance of letters in promoting a "continuity and a consensus of interests" that ignored geographic boundaries, see Leatrice Mendelsohn, *Paragoni: Benedetto Varchi's Due Lezzioni and Cinquecento Art Theory* (Ann Arbor, MI: UMI Research Press, 1982), 5. Sedgwick's *Between Men* (see n. 61) opens the subject of male bonding from the other end of the spectrum with the smallest grouping, pairs, of friends. I think Burke's observations about the manner in which the notable artistic and literary achievements of the Renaissance always occurred in clusters give us the *results* of male bonding in a culture (*Culture,* 3, 284).

72. Cantimori, "Note," 346–8, and Eva-Maria Jung, "On the Nature of Evangelism in Sixteenth-Century Italy," *Journal of the History of Ideas* 14 (1953): 511–27. For various positions regarding Evangelism, see Elizabeth G. Gleason, "On the Nature of Sixteenth-Century Italian Evangelism: Scholarship, 1953–1978," *Sixteenth Century Journal,* 9, no. 3 (1978): 3–25; Simoncelli, *Evangelismo,* 2–3, 84; and Delio Cantimori, *Prospettive di storia ereticale italiana del Cinquecento* (Bari: Laterza, 1960), 28–30.

73. Philip McNair, *Peter Martyr in Italy: An Anatomy of Apostasy* (Oxford: Clarendon, 1967), 3–16. It is probable that Bocchi while still a student met Erasmus in 1506, because Erasmus spent most of that year in the home of Paolo Bombace, teacher of rhetoric at the Studio from 1505 to 1510; see E. Mioni, "Bombace (Bombasius), Paolo," *DBI,* 11:373–4.

74. Rotondò, "La storia," 127n.

75. Hubert Jedin, "Il significato del periodo bolognese per le decisioni dogmatiche e l'opera di riforma del Concilio di Trento," in *Problemi di vita religiosa in Italia nel Cinquecento: Atti del Convegno di Storia della Chiesa in Italia (Bologna, 2–6 sett. 1958)* (Padua: Antenore, 1960), 3, and Luigi Carceri, *Il Concilio di Trento dalla traslazione a Bologna alla sospensione, marzo–settembre 1547* (Bologna: Zanichelli, 1910), 158, 183.

76. For example, Vasari's 1547 painted vault of Santa Maria di Scolca in Rimini syncretized prophets, sibyls, Orpheus, Homer, and Vergil as prefigurations of Christian truths, but after 1550 Vasari used only biblical prefigurations of New Testament events; see Jean Rouchette, "La domestication de l'ésotérisme dans l'oeuvre de Vasari," in *Umanesimo e esoterismo* [V⁰ Convegno Internazionale di Studi Umanistici], 2 vols., in *Archivio di filosofia* (1960), nos. 2–3, 363. Even closer to the Bologna session was François I's ambassador to the council, Claude d'Urfé, who arrived in Bologna in 1547 and remained until at least 1548 (he was in Rome early in 1549). Among the many art works d'Urfé bought and commissioned in Italy were a set of marquetry panels executed by Fra Damiano of Bergamo in San Domenico in Bologna after drawings attributed to Vignola and similar to the earlier panels commissioned by Leandro Alberti for San Domenico itself (1528–51) and two panels made for Francesco Guicciardini when he was governor of Bologna. Alberti, who gave the date of the commission as 1548, thought d'Urfé had ordered the panels for the king; instead, they went to d'Urfé's private chapel in his chateau, La Bastie. Within the panels' framework of architectural fantasy appear New Testament scenes of sacramental importance: the Marriage of the Virgin, the Circumcision, and the Last Supper with texts relating to transubstantiation. It was, therefore, one of the first works of art directly inspired by the council. It also suggests contact with Bocchi's academy in that spaces between columns of the *Cena* reveal a Vignolesque palace very close in design to that begun by Bocchi in 1545; see Olga Raggio, "Vignole, Fra Damiano et Gerolamo Sicolante à la Chapelle de La Bastie d'Urfé," *Revue de l'Art* 15 (1972): 29–52. Achille's

cousin, Romeo Bocchi (1493–1577), made an Italian translation from the "Epistole morale di Monsu Dufre [D'Urfé]"; see Orlandi, *Notizie*, 242. I found no trace of Romeo's translation but did locate a reference to d'Urfé in a letter by Achille Bocchi dated February 14, 1548 [1549]; see Milan, Ambros., D.145 inf., fol. 51r.

77. Cantimori, "Note," 348. Bocchi's religious views may represent an early example of "nonconfessional" Christianity, opposed to any institutionalized church, a form of religious consciousness studied by Leszek Kolakowski in *Chrétiens sans Eglise: La Conscience religieuse et le lien confessionnel au XVIIe siècle*, trans. Anna Posner (Paris: Gallimard, 1969). However, it does not seem likely that Bocchi consciously rejected the Roman Church, and Kolakowski dismissed the pursuit of ancient religion and of syncretism – both concerns of Bocchi to be discussed – from his model (13).

78. In the words of Jerome Friedman:

> The period of the first half of the sixteenth century . . . witnessed the greatest growth in Hebraica and the best work by the best scholars in that area. Additionally, this half century witnessed the most significant conflicts among Hebraists themselves and sits at the junction of the Renaissance and the Reformation. It was also the five-decade period in which the different varieties of Christian-Hebraica first and most clearly manifested themselves.

> See *The Most Ancient Testimony: Sixteenth-Century Christian Hebraica in the Age of Renaissance Nostalgia* (Athens, OH: Ohio University Press, 1983), 5.

79. For Manetti, see John F. D'Amico, *Renaissance Humanism in Papal Rome: Humanists and Churchmen on the Eve of the Reformation*, Johns Hopkins University Studies in History and Political Science, 101st ser., no. 1 (Baltimore and London: Johns Hopkins University Press, 1983), 120–1. Dominicans already were actively trying to convert the Jews in the thirteenth century; see Kenneth R. Stow, *Catholic Thought and Papal Jewry Policy, 1555–1593* (New York: Jewish Theological Seminary of America, 1977), 20.

80. Claude-Gilbert Dubois, *Mythe et langage au seizième siècle* (Bordeaux: Ducros, 1970), 67, 69.

81. See *Joannes Reuchlin, 1455–1522: Festgabe seiner Vaterstadt Pforzheim zur 500: Wiederkehr seines Geburtstages*, ed. Manfred Krebs (Pforzheim: Stark, 1955), 198, and Franco Giacone and Guy Bedouelle, "Une lettre de Gilles de Viterbe (1469–1532) à Jacques Lefèvre d'Etaples (c. 1460–1536) au sujet de l'affaire Reuchlin," *Bibliothèque d'Humanisme et Renaissance* 36 (1974): 335–45. According to Heiko A. Oberman in *The Roots of Anti-Semitism in the Age of Renaissance and Reformation*, trans, James I. Porter (Philadelphia: Fortress, 1984), Reuchlin's defense of the Jews was limited to their civil rights and stopped short of considering them free from mass guilt (139).

82. The letter to Grassi concerned legal studies rather than Hebrew; see Johannes Reuchlin, *Johann Reuchlins Briefwechsel*, ed. Ludwig Geiger (1875; reprint, Hildesheim: Olms, 1962), 276, 280, 305–6.

83. Cesare Vasoli, *Profezia e ragione: Studi sulla cultura del Cinquecento e del Seicento* (Naples: Morano, 1974), 177; Pontien Polman, *L'Elément historique dans la controverse religieuse du XVIe siècle*, Universitas Catholica Lovaniensis, Dissertationes ad gradum magistri in Facultate Theologica consequendum conscriptae, Ser. II, Tom. 23 (Genbloux: Duculot, 1932), 7; M. A. Screech, "Two Attitudes to Hebrew Studies: Erasmus and Rabelais," in *Rebirth, Reform, and Resilience: Universities in Transition, 1300–1700*, ed. James M. Kittelson and Pamela Transue (Columbus: Ohio State University Press, 1984), 297; Charles Zika, "Reuchlin and Erasmus: Humanism and Occult Philosophy," *Journal of Religious History* 9 (1977): 223–46; and Werner L. Gundesheimer, "Erasmus, Humanism, and the Christian Cabala," *Journal of the Warburg and Courtauld Institutes* 26 (1963): 51.

84. Friedman, *Most Ancient Testimony*, 6–7, 174.

85. William Popper, *The Censorship of Hebrew Books* (diss., Columbia University, 1899; New York: Knickerbocker, 1899), 42, 51, 55; Fr. Heinrich Reusch, *Der Index der Verbotenen Bücher: Ein Beitrag zur Kirchen- und Literaturgeschichte*, 2 vols. (Bonn: Cohen & Sohn, 1883), 1:49; Fr. Heinrich Reusch, *Die Indices librorum prohibitorum des sechzehnten Jahrhunderts* (Tübingen: Laupp, 1886), 203, 464; Vittore Rava, *Gli Ebrei in Bologna: Cenni storici* (Vercelli: Guglielmoni, 1872), 11–15; and Vasoli, *Profezia e ragione*, 177. These measures were taken by the Roman Church to convert Jews through intense pressure and only secondarily to punish them for failure to convert, according to Stow, *Catholic Thought*, 4–5, 13, 35.

86. Friedman, *Most Ancient Testimony*, 22.

87. Jacobus Quétif and Jacobus Echard, *Scriptores Ordinis Praedicatorum*, 2 vols. in 4 (1719–23; reprint, New York: Franklin, 1959), 2:2:96. Giustiniani died in 1536.

88. There are a number of conflicting accounts of the teaching of Hebrew at the Studio. Cecil Roth, *The Jews in the Renaissance* (Philadelphia: Jewish Publication Society of America, 1959), 144, claimed that Vincentius did not hold a chair until 1488 although he had taught for the preceding twenty-five years; Umberto Dallari, ed., *I Rotuli dei lettori legisti e artisti dello Studio bolognese dal 1384 al 1799*, 4 vols. in 5 (Bologna: Fratelli Merlani, 1888–1924), 1:67–141 passim (Roth also made G. A. Flaminio the son of M. A. Flaminio instead of the father). Ercole Cuccoli thought that the "D. Ioannes Flaminius" of the *Rotuli* was actually a converted Jew according to a document he had examined; see *M. Antonio Flaminio, studio* (Bologna: Zanichelli, 1897), 23, 25. More recent studies have neither proved nor disproved this attribution, and I am assuming that it was G. A. Flaminio, who arrived in Bologna to teach at the Studio the same year that "Flaminius" was first entered on the *Rotuli*.

89. Cuccoli, *M. Flaminio*, 23.

90. For Sforno, see Israel Zinberg, *A History of Jewish Literature*, trans. Bernard Martin, 12 vols. (Cincinnati: Hebrew Union College Press; New York: KTAV, 1972–8), 4:94, and Rava, *Gli Ebrei*, 10–11. Hebrew texts were published as early as 1477 (Psalms) and 1480 (David Kimchi's lexicon); see Louis Kukenheim, *Contributions à l'histoire de la grammaire grecque, latine et hébraïque à l'époque de la Renaissance* (Leiden: Brill, 1951), 96; Albano Sorbelli, *Storia della stampa in Bologna* (Bologna: Zanichelli, 1929), 70–1, 122–3; and Rava, *Gli Ebrei*, 9.

91. Charles B. Schmitt, "Perrenial [*sic*] Philosophy: From Agostino Steuco to Leibnitz," *Journal of the History of Ideas* 27 (1966): 575, and McNair, *Peter Martyr*, xvii, 125.

92. François Secret, "Les Dominicains et la Kabbale chrétienne à la Renaissance," *Archivum Fratrum Praedicatorum* 27 (1957): 326–7.

93. Remigio Sabbadini, "Vita e opere di Francesco Florido Sabino," *Giornale storico della letteratura italiana* 8 (1886): 335, 339; Adversi, "Aldrovandi," 101, 108; Fantuzzi, *Notizie*, 2:320; and Charles J. Lees, ed., *The Poetry of Walter Haddon* (The Hague: Mouton, 1967), 53.

94. Io. Maria Brasichell, comp., *An Exact Reprint of the Roman Index Expurgatorius*, ed. Richard Gibbings (1608; reprint, Dublin: Milliken & Son; London: Rivington, 1837), 507–8, 572–3.

95. Popper, *Censorship*, 42, 51, 55, and *Giulio Bonasone*, 1:pl. 41c. Nevertheless, the full inscription remains on the facade to this day.

96. Paolo Rossi, "Le origini della Pansofia e il Lullismo del Secolo XVII," in *Umanesimo e esoterismo* [V^e Convegno Internazionale di Studi Umanistici], 2 vols., in *Archivio di filosofia* (1960), nos. 2–3, 205.

97. Schmitt, "Perrenial [*sic*] Philosophy"; Charles B. Schmitt, "Prisca Theologia e Philosophia

Perennis: Due temi del Rinascimento italiano e la loro fortuna," in *Il pensiero italiano del Rinascimento e il tempo nostro: Atti del V. Convegno internazionale del Centro di Studi Umanistici, Montepulciano, Palazzo Tarugi, 8–13 agosto 1968*, ed. Giovannangiola Tarugi (Florence: Olschki, 1970), 211–36; D. P. Walker, "Orpheus the Theologian and Renaissance Platonists," *Journal of the Warburg and Courtauld Institutes* 16 (1953): 100–20; Eugenio Garin, *Il ritorno dei filosofi antichi*, Istituto Italiano per gli Studi Filosofici. Lezioni della Scuola di Studi Superiori in Napoli 1 (Naples: Bibliopolis, 1983), 68–9; Cesare Vasoli, "Profezia e astrologia in uno scritto di Annio da Viterbo," in *I miti e gli astri* (Naples: Guida, 1977), 68; and Sem Dresden, " The Profile of the Reception of the Italian Renaissance in France," in *Itinerarium Italicum: The Profile of the Italian Renaissance in the Mirror of Its European Transformations, Dedicated to Paul Oskar Kristeller on the Occasion of His 70th Birthday*, ed. Heiko A. Oberman and Thomas A. Brady, Jr. (Leiden: Brill, 1975), 171–3. Other terms sometimes used were *docta pietas* and *prisca filotea;* see Lorenzo Giusso, *La tradizione ermetica nella filosofia italiana* (Rome: Fratelli Bocca, n.d.), 38–9.

98. Walker, "Orpheus," 104–6; Schmitt, "Perrenial [*sic*] Philosophy," 508, 513, 521; Vasoli, "Profezia e astrologia," 19–20; Jerome Friedman, "Sixteenth-Century Christian-Hebraica: Scripture and the Renaissance Myth of the Past," *Sixteenth Century Journal* 11 (1980): 85; and Friedman, *Most Ancient Testimony*, 54, 72, 258–63.

99. Arnaud Tripet, "Aspects de l'analogie à la Renaissance," *Bibliothèque d'Humanisme et Renaissance* 39 (1977): 7–21; Cesare Vasoli, "La metafora nel linguaggio magico rinascimentale," *Lingua nostra* 38 (1977): 8–14; and Erich Auerbach, "Figura," in *Scenes from the Drama of European Literature*, 2d ed. (Minneapolis: University of Minnesota Press, 1984), 11–76.

100. Cristoforo Landino, *Scritti critici e teorici*, ed. Roberto Cardini, 2 vols. (Rome: Bulzoni, 1974), 1:63–6, 231; Vittorio Cian, *Contributo alla storia dell'enciclopedismo nell'età della Rinascita: Il "Methodus studiorum" del Card. Pietro Bembo* (Lucca: Baroni, 1915), 26–7; A. H. T. Levi, "Ethics and the Encyclopedia in the Sixteenth Century," in *French Renaissance Studies, 1540–1570: Humanism and the Encyclopedia*, ed. Peter Sharratt (Edinburgh: University Press, 1976), 174–5; James A. Coulter, *The Literary Microcosm: Theories of Interpretation of the Later Neoplatonists* (Leiden: Brill, 1976), 27–9; and Concetta Carestia Greenfield, *Humanist and Scholastic Poetics, 1250–1500* (Lewisburg, PA: Bucknell University Press; London and Toronto: Associated University Presses, 1981), 143, 232.

101. Hebrew was prized as the language in which the signifier came closest to identity with the signified; see Dubois, *Mythe*, 69, 122, and François Rigolot, *Poétique et onomastique: L'Exemple de la Renaissance* (Geneva: Droz, 1977). The Cabala contributed to the mystical overtones of syncretism; see Leonard Barkan, *Nature's Work of Art: The Human Body as Image of the World* (New Haven and London: Yale University Press, 1975), 26–7; Dubois, *Mythe*, 73–7, 81; and Polman, *L'Elément*, 7.

102. Vasoli, "La metafora," 8, 12, 14; Coulter, *Literary Microcosm*, 27; and Françoise Joukovsky, *Le Regard intérieur: Thèmes platoniens chez quelques écrivains de la Renaissance française* (Paris: Nizet, 1982), 241, and Dresden, "Profile," 188–9.

103. See Ludwig Volkmann, *Bilder Schriften der Renaissance: Hieroglyphik und Emblematik in ihren Beziehungen und Fortwirkungen* (1923; reprint, Nieuwkoop: De Graaf, 1962), 36, and Peter Dronke, *Fabula: Explorations into the Uses of Myth in Medieval Platonism* (Leiden and Cologne: Brill, 1974), 44–5.

104. Auerbach, "Figura," 27, and Marcus Fabius Quintilianus, *Institution oratoire*, ed. and trans. Jean Cousin, 7 vols. (Paris: Société d'édition "Les Belles Lettres," 1975–80), 5:156–201, Lib. IX. 1–3.

105. Dubois, *Mythe*, 13; also see Paolo Rossi, *Clavis universalis: Arti mnemoniche e logica combinatoria da Lullo a Leibniz* (Milan: Ricciardi, 1960), 36–7.

106. Schmitt, "Prisca," 211. Dresden criticized the use of the term *syncretism* for the Renaissance: "This concept is, in my opinion, a modern anachronism, which stems from and accentuates the indisputable need for certain historical and religious distinctions. But it is just these distinctions which are absent from the *docta religio*" ("Reception," 172). The term was in use by the eighteenth century, however, and does not necessarily imply distinctions or systems.

107. Johann Jacob Brucker, *Historia Critica Philosophiae A Mvndi Incvnabvlis Ad Nostram Vsqve Aetatem Dedvcta*, 6 vols., 2d ed. (Leipzig: Impensis Haered. Weidemanni et Reichii, 1766–7), 5:1:750–75. Brucker raised eight philosophical and theological objections to syncretism.

108. On the double truth see, for example, Paul O. Kristeller, "Le mythe de l'athéisme de la Renaissance et la tradition française de la libre pensée," *Bibliothèque d'Humanisme et Renaissance* 37 (1975): 341, and on antirationalism, see D'Amico, *Renaissance Humanism*, 169–73. Some antirationalists and skeptics, of course, rejected syncretism as well (183, 185).

109. Ernst Cassirer, "Giovanni Pico della Mirandola: A Study in the History of Ideas," *Journal of the History of Ideas* 3 (1942): 345.

110. Schmitt, "Perrenial [*sic*] Philosophy," 516; Mendelsohn, *Paragoni*, 5; William J. Bouwsma, "Postel and the Significance of Renaissance Cabalism," *Journal of the History of Ideas* 15 (1954): 232; and Joseph Leon Blau, *The Christian Interpretation of the Cabala in the Renaissance* (Port Washington, NY: Kennikat, 1944), 112.

111. Marjorie O'Rourke Boyle, in *Christening Pagan Mysteries: Erasmus in Pursuit of Wisdom* (Toronto, Buffalo, and London: University of Toronto Press, 1981), explores the way in which Erasmus converted to Christian ends classical pagan literature, philosophy, and mystery religions. Also see Blau, *Christian*, 77, and Vasoli, *Profezia e ragione*, 177.

112. Schmitt, "Prisca," 236; Garin, *Il ritorno*, 71; and John G. Burke, "Hermetism as a Renaissance World View," in *The Darker Vision of the Renaissance: Beyond the Fields of Reason*, ed. Robert S. Kinsman, UCLA Center for Medieval and Renaissance Studies, Contributions 6 (Berkeley, Los Angeles, and London: University of California Press, 1974), 104–6.

113. Schmitt, "Prisca," 213–14. For Steuco, see Th. Freudenberger, *Augustinus Steuchus aus Gubbio, Augustinerchorherr und päpstlicher Bibliothekar (1497–1548)* (Münster: Aschendorff, 1935), and Charles B. Schmitt's introduction to Agostino Steuco, *De Perenni Philosophia*, ed. Charles B. Schmitt (1540; reprint, New York and London: Johnson Reprint, 1972).

114. See Vasoli, *Profezia e ragione*, 313, and his comparison of the motifs of heretics and syncretists, 291n, 294n, passim; see also Walker, "Orpheus," 117.

115. Dino John Geanakoplos, *Greek Scholars in Venice: Studies in the Dissemination of Greek Learning from Byzantium to Western Europe* (Cambridge, MA: Harvard University Press, 1962), 258; Vincenzo Busacchi, "Le relazioni nel campo della medicina fra la Nazione Germanica e l'Università di Bologna," *Strenna storica bolognese* 21 (1971): 72; Schmitt, "Perrenial [*sic*] Philosophy," 515; Camillo, *Opere*, 295, 297; Giordani, *Della venuta*, Doc. XLIV, pp. 58–9, N452; and Giovanni Piero Valeriano Bolzano, *Hieroglyphica, Lyons, 1602* (reprint, New York: Garland, 1976), 64.

116. William Harris Stahl, *The Quadrivium of Martianus Capella . . .*, vol. 1 of Stahl, *Martianus Capella and the Seven Liberal Arts*, 2 vols. (New York: Columbia University Press, 1971–7), 85–90. Martianus' philology as the science of interpretation that unites all the *artes* is the subject of Pietro Ferrarino's "La prima, e l'unica, 'Reductio omnium artium ad philologiam': Il *De Nuptiis Philologiae et Mercurii* di Marziano Capella e l'apoteosi della filologia," *Italia medioevale e humanistica* 12 (1969): 1–7. Bocchi alluded to the wedding

of Mercury and Philology in a letter to Romolo Amaseo dated 1548 (Milan, Bibl. Ambros., MS. D.145 inf., fol. 2v); he probably taught courses on Martianus.

117. Ezio Raimondi, *Politica e commedia: Dal Beroaldo al Machiavelli* (Bologna: Il Mulino, 1972), 25; J.-Roger Charbonnel, *La Pensée italienne au XVIe siècle et le courant libertin* (1919; reprint, Geneva: Slatkine, 1969), 203n; and Cesare Vasoli, "Note su Galeotto Marzio," in Vasoli, *La cultura delle corti* (Florence and Bologna: Cappelli, 1980), 38–63.

118. Bocchi rarely mentioned Beroaldo, with whom Pio quarreled; see Carlo Dionisotti, *Gli umanisti e il volgare fra Quattro e Cinquecento* (Florence: Le Monnier, 1968), 80–1. Yet Bocchi lived in the "casa Bocchi" almost next door to the "casa Beroaldi" (at 20 and 22 Via Oberdan respectively); see Umberto Beseghi, *I palazzi di Bologna* (Bologna: Tamari, Ente provinciale per il turismo, 1957), 358, and the anonymous "Informat[ion]e della familg[i]a et propria linea di Fran[cesc]o Bocchj, . . . ," dated 1587 (Bologna, Archiginnasio, MS. B.470), [368]. Both Bocchi and Beroaldo were buried in the nearby church of San Martino. For hieroglyphic and Pythagorean studies at the Studio, see Konrad Krautter, *Philologische Methode und humanistische Existenz: Filippo Beroaldo und sein Kommentar zum Goldenen Esel des Apuleius* (Munich: Fink, 1971); Andrea Gareffi, "Egizerie umanistiche: La mantica geroglifica tra Quattro e Cinquecento," *FM: Annali dell'Istituto di Filologia Moderna dell'Università di Roma* (1977): 14–15; and Valerio Del Nero, "Note sulla vita di Giovan Battista Pio (con alcune lettere inedite)," *Rinascimento,* 2d ser., 21 (1981): 247–63.

119. D. L. Drysdall, "Filippo Fasanini and His 'Exploration of Sacred Writing' (Text and Translation)," *Journal of Medieval and Renaissance Studies* 13 (1983): 135–6.

120. Leandro Alberti, using Fasanini as a mouthpiece in the dialogue comprising "Liber Quartus" of his *De Viris Illvstribvs Ordinis Praedicatorvm Libri Sex, In Vnvm Congesti* (Bologna: In aedibus Hieronymi Platonis, 1517), compared the Dominican poet Francesco Colonna to Dante "tam in concinnitate carminum, dulcedine ac elegantia, quam in sententiarum grauitate . . ." (as much in harmony of song, charm, and elegance as in seriousness of meaning; fol. 151v). Furthermore, each of the six books has a frontispiece depicting the triumph of the Dominican featured in that book on a *carro* with symbolic attributes in a sacred and chaste parody of Colonna's illustrations (and, of course, of Petrarch's *Trionfi*). Although Alberti's attribution of the *Hypnerotomachia* to the Venetian Dominican has been challenged by Maurizio Calvesi in *Il sogno di Polifilo prenestino* (Rome: Officina, 1980), this does not fully explain the attribution by Alberti, who took orders in Friuli in 1479 (A. L. Redigonda, "Alberti, Leandro," *DBI,* 1:699) and may have met the Venetian Frate Francesco Colonna. On the evidence for the priest Francesco Colonna as author, see Maria Teresa Casella, *Biografia,* vol. 1 of Maria Teresa Casella and Giovanni Pozzi, *Francesco Colonna, biografia e opere,* 2 vols. (Padua: Antenore, 1959), and Peter Dronke, "An Introduction," in Francesco Colonna, *Hypnerotomachia Poliphili (Venetiis, Aldo Manuzio, 1499)* (reprint; Zaragoza: Las Ediciones del Pórtico, 1981), 12–16.

121. Massari, in *Giulio Bonasone,* 1:17–19, discussed Neoplatonic influences in some detail.

122. There are scattered references to the Cabala in descriptions of apparel and attributes of divinities in Giovanni Filoteo Achillini's *Viridario De Gioanne Philotheo Achillino Bolognese* (Bologna: Per Hieronymo di Plato Bolognese, 1513), fols. XLVIIIv–Lr passim. On the Cabala, see Vasoli, *Profezia e ragione,* 176, and André Stegmann, "L'Europe intellectuelle de J. A. de Thou," in *La Conscience européene au XVe et au XVIe siècle. Actes du Colloque Internationale organisé à l'Ecole Normale Supérieure de Jeunes Filles (30 septembre–3 octobre 1980)* (Paris: L'Ecole Normale Supérieure de Jeunes Filles, 1982), 404, both with lists of sixteenth-century Hebraizing works, and Popper, *Censorship,* 44.

123. Rotondò found the letter to Giovanni Battista Pigna in the Archivio di Stato

of Modena, see *DBI*, 11:69. Bocchi's will was partially transcribed by Gisela Ravera Aira in her "Achille Bocchi e la sua 'Historia Bononiensis,'" *Studi e memorie per la storia dell'Università di Bologna* 15 (1942): 110–11.

124. Despite antirationalist trends roughly parallel to Christian anti-Aristotelianism, Jews showed limited interest in the Cabala and mysticism until the banning of the Talmud and the increased repression after 1554; see Isaac E. Barzilay, *Between Reason and Faith: Anti-Rationalism in Italian Jewish Thought, 1250–1650* (The Hague: Mouton, 1967), 63–5.

125. See, for example, an expurgator's note concerning Cardano's *De Subtilitate*, 7:439, of the 1560 Basel edition: "Verum fortasse dicit, sed non bene dicit quia videtur Christum cum Socrate, & Scipione coniungere..." (Perhaps he says the truth, but he does not say it well, because he apparently links Christ with Socrates and Scipio; see Brasichell, *An Exact Reprint*, 468. The records show that the Commission on the Index performed erratically, subjecting some authors to lengthy delays, some to re-correction of previously approved texts, and some at times to minute and harassing charges, such as those brought against Carlo Sigonio's edition of Sulpitius Severus, which had been commissioned by Bologna's Cardinal Paleotti. Sigonio was accused, among other charges, of using insufficiently "Christian" language and of "republicanism"; see Charles Dejob, *De l'Influence du Concile de Trente sur la littérature et les beaux-arts chez les peuples catholiques* (1884; reprint, Geneva: Slatkine, 1969), 8, 22–80, and Paolo Prodi, "Storia sacra e controriforma: Nota sulle censure al commento di Carlo Sigonio a Sulpicio Severo," *Annali dell'Istituto Storico Italo Germanico in Trento* 3 (1977): 98–9. Yet a 1543 treatise on the art of preaching, which was based on a Lutheran work and never on the Index, was highly recommended by Roberto Bellarmine; see John W. O'Malley, "Lutheranism in Rome, 1540–43: The Treatise by Alfonso Zorilla," in O'Malley, *Rome and the Renaissance: Studies in Culture and Religion* (London: Variorum Reprints, 1981), pt. 10, 263–8.

126. Charles B. Schmitt, "Philosophy and Science in Sixteenth-Century Universities: Some Preliminary Comments," in *The Cultural Context of Medieval Learning: Proceedings of the First International Colloquium on Philosophy, Science, and Theology in the Middle Ages, September 1973*, ed. John Emory Murdoch and Edith Dudley Sylla (Dordrecht and Boston: Reidel, 1975), 489, 492. Eckhard Kessler spoke of the Platonic and Aristotelian traditions of philosophy in the Renaissance as being "in continuous dialogue"; see "The Transformation of Aristotelianism during the Renaissance," in *New Perspectives on Renaissance Thought: Essays in the History of Science, Education and Philosophy in Memory of Charles B. Schmitt*, ed. John Henry and Sarah Hutton (London: Duckworth; Istituto Italiano per gli Studi Filosofici, 1990), 144.

127. Pomponazzi gradually distanced himself from some Averroistic teachings and displayed an increasingly Stoic and deterministic point of view; see Franco Graiff, "I prodigi e l'astrologia nei commenti di Pietro Pomponazzi al *De Caelo*, alla *Meteora* e al *De Generazione*," *Medioevo* 2 (1976): 331; Graiff, "Aspetti del pensiero di Pietro Pomponazzi nelle opere e nei corsi del periodo bolognese," *Annali dell'Istituto di Filosofia dell'Università di Firenze* (1979): 91; Martin Pine, "Pietro Pomponazzi and the Scholastic Doctrine of Free Will," *Rivista critica di storia della filosofia*, 28 (1973): 26; and Charbonnel, *La Pensée*, 252–3. Pomponazzi's pupils included Alberto Pio, the prince of Carpi, Cardinals Ercole Gonzaga and Gaspare Contarini, Juan Ginès de Sepúlveda, Paolo Giovio, Julius Caesar Scaliger, and many others; see Schmitt, "Alberto Pio," 48–50, and Brucker, *Historia Critica*, 4:182–97. For Achillini, see Herbert Stanley Matsen, *Alessandro Achillini (1463–1512) and his Doctrine of "Universals" and "Transcendentals": A Study in Renaissance Ockhamism* (Lewisburg, PA: Bucknell University Press; London: Associated University Presses, 1974), 21–3.

128. Boccadiferro studied with Pomponazzi and Achillini; he taught, among others, Julius Caesar Scaliger, Francesco Piccolomini, and Benedetto Varchi; see Brucker, *Historia Critica,* 4:765–6n; Di Napoli, *L'immortalità,* 350; and Bruno Nardi, *Studi su Pietro Pomponazzi* (Florence: Le Monnier, 1965), 320–2. Bernardi, who studied with Pomponazzi and Boccadiferro, taught at the Studio from 1533 to 1539. He entered the service of Cardinal Alessandro Farnese and later became a bishop and a delegate to the Council of Trent; see Di Napoli, *L'immortalità,* 362–5, and M. Flaminio, *Lettere,* 111n.

129. Raimondi, "Umanesimo e università," 352–3.

130. Pio's work, the first Renaissance commentary on Lucretius, was more systematic than the commentaries of Beroaldo. Pio commanded an enormous range of sources, although, according to Fusil and others, his was an erudition often pedantic and *mal digerée;* see C.-A. Fusil, "La Renaissance de Lucrèce au XVIe siècle en France," *Revue du Seizième Siècle* 15 (1928): 137; Henri Busson, *Le Rationalisme dans la littérature française de la Renaissance,* 2d ed. rev. (Paris: Vrin, 1971), 30–2, 41; Raimondi, "Il primo commento," 2:661–2; Eugenio Garin, "Commenti Lucreziani," *Rivista critica di storia della filosofia italiana* 28 (1973): 83–4; F. Joukovsky, "Quelques Sources epicuriennes au XVIe siècle," *Bibliothèque d'Humanisme et Renaissance* 31 (1969): 13–15; and Maria Carmela Tagliente, "G. B. Pio e il testo di Lucrezio," *Res Publica Letterarium* 6 (1983): 337–45.

131. Casella, "Metodo," 654; Raimondi, "Umanesimo e università," 345, 353; and Garin, "Commenti Lucreziani," 84.

132. Further comments on the Pythagorean contribution appear in Chapters 3 and 5. Studies on the impact of Pythagoreanism in the Renaissance include Bronisław Bilinski, *Il Pitagorismo di Niccolo Copernico* (Wroclaw, Kraków, and Gdansk: Ossolineum, 1977); S. K. Heninger, *Touches of Sweet Harmony: Pythagorean Cosmology and Renaissance Poetics* (San Marino, CA: Huntington Library, 1974); Lino Sighinolfi, "Domenico Maria Novara e Nicolò Copernico allo Studio di Bologna," *Studie e memorie per la storia dell'Università di Bologna* 5 (1920): 205–36; and G. L. Hersey, *Pythagorean Palaces: Magic and Architecture in the Italian Renaissance* (Ithaca, NY, and London: Cornell University Press, 1976).

133. Reusch, *Die Indices,* 462, 469; Vasoli, *Profezia e ragione,* 463; and Battistella, *Il S. Officio,* 156–7.

134. Kristeller, "Le Mythe," 342, 348; Charles B. Schmitt, "The Recovery and Assimilation of Ancient Scepticism in the Renaissance," *Rivista critica di storia della filosofia* 27 (1972): 383; and Jean Wirth, "'Libertins' et 'Epicuriens': Aspects de l'irréligion au XVIe siècle," *Bibliothèque d'Humanisme et Renaissance* 39 (1977): 626–7.

135. Charbonnel, *La Pensée,* and Don Cameron Allen, *Doubt's Boundless Sea: Skepticism and Faith in the Renaissance* (Baltimore: Johns Hopkins University Press, 1964).

136. Schmitt, "Recovery," 379–80; D'Amico, *Renaissance Humanism,* 183; and Richard H. Popkin, *The History of Scepticism from Erasmus to Descartes* (Assen: Van Gorcum, 1960), 19–20. Pico was an antirationalist who believed in, but disapproved of, the existence of witchcraft; his *Strix siue de ludificatione daemonum* (1523) was translated by Bocchi's friend Leandro Alberti in 1524; see Charles B. Schmitt, *Gianfrancesco Pico della Mirandola (1469–1533) and His Critique of Aristotle* (The Hague: Nijhoff, 1967), 3–5, 28, 200.

137. For Nizolio, see Quirinus Breen, "Marius Nizolius: Ciceronian Lexicographer and Philosopher," *Archiv für Reformationsgeschichte* 46 (1955): 76. Bocchi's Symbol LXXXI is dedicated to him.

138. Di Napoli, *L'immortalità,* 223–4; Felix Gilbert, "Cristianesimo, umanesimo e la bolla 'Apostolici regiminis' del 1513," *Rivista storica italiana* 79 (1967): 976, 980, 986; Delio Cantimori, *Eretici italiani del Cinquecento: Ricerche storiche,* 3d ed. (Florence: Sansoni, 1977), 10–12; and John W. O'Malley, *Giles of Viterbo on Church and Reform* (Leiden: Brill,

1968), 41–2. According to O'Malley, Giles (Egidio) probably was "instrumental in procuring the Fifth Lateran Council's condemnation of the thesis" (42), but Di Napoli claimed that Cajetan and Egidio da Viterbo objected to the restriction on teaching (223).

139. The manuscript letter (Florence, Bibl. Naz., Cod. Magliab. XII, 16) is cited by Di Napoli in *L'immortalità*, 234.

140. Di Napoli, *L'immortalità*, 350, and Nardi, *Studi su Pomponazzi*, 322, 361.

141. Bernardi (1502–65) tutored Alessandro Farnese and had friends among the *spirituali*. He was attacked several times (1542 and 1546) as a Lutheran by the very conservative Jacopo Giacomelli; see Giuseppe Alberigo, *I vescovi italiani al Concilio di Trento (1545–1547)* (Florence: Sansoni, 1959), 206, and Zambelli, "Bernardi," 9:149–50. Bernardi had been a delegate to the Council of Trent and was named the bishop of Caserta in 1553.

142. Pio provided his readers with a background history of the philosophy of the soul in antiquity; see Del Nero, "L'anima," 31, 36–9, 47. On the Lucretian distinction between *animus* and *anima*, see Ubaldo Pizzani, "La psicologia Lucreziana di G. B. Pio," *Res Publica Litterarum* 6 (1983): 291–302.

143. Schmitt, *Pico*, 28, 193. The dedicatory letter to Pico's *De animae* was written by Bocchi's friend Leandro Alberti; see Fantuzzi, *Notizie*, 1:153. Fantuzzi taught theoretical medicine at the Studio of Bologna; see A. Mondolfo, "Achillini, Cinzio," *DBI*, 1:145, and Sorbelli, *Storia della stampa*, 95.

144. Cesare Cataneo is an unknown figure, perhaps the son of Andrea Cattaneo, who taught philosophy and medicine at Bologna between 1507 and 1527 and was the author of a commentary on Aristotle's *De anima* entitled *Opus De intellectu et de causis* (Florence, ca. 1507); see C. Colombero, "Cattaneo (Cattani), Andrea (Andrea da Imola)," *DBI*, 22:413–14.

145. Charles de Bovelles (Carolus Bovillus), *De Nichilo*, in *Que hoc volumine contine[n]tur. Liber de intellectu. Liber de sensu. Liber de nichilo. Ars Oppositorum. Liber de sapiente. Liber de duodecim numberis. Epistole complures* (Paris: Ex officina Henrici Stephani, 1510), fol. 63r, and Bovelles, *Le Livre du néant*, ed. and trans. Pierre Magnard (Paris: Vrin, 1983), 37.

146. Jill Kraye, "Cicero, Stoicism and Textual Criticism: Poliziano on ΚΑΤΟΡΘΩΜΑ," *Rinascimento* 23 (1983): 83–4, and Angelo Poliziano, *Miscellaneorum Centuriae Primae*, in *Omnium Angeli Politiani operum* (Paris: Ascensius, 1519), fols. cxxvii^v–cxxxr (also discussed in a letter to Pico della Mirandola, Lib. XII, Epist. 1, fol. xcviii^v). Other humanists who joined the debate were Cosmo Ruggeri, Hermolao Barbaro, Guillaume Budé, Coelius Rhodiginus, Lodovico Boccadiferro, Boniface Amerbach, and Charles de Bovelles; see Charbonnel, *La Pensée*, 102; Hans Burchard, *Der Entelechiebegriff bei Aristoteles und Driesch* (Quakenbrück: Kleinert, 1928), 13; and Busson, *Le Rationalisme*, 140, 150, 156, 196, 222–5, 250.

147. Mendelsohn, *Paragoni*, 5–6. According to Mendelsohn, the "*trattati d'amore* issuing from the Paduan milieu humanized and concretized the more abstract Florentine Platonism, and the proliferation of these tracts in both cities [Padua and Florence] contributed to a blurring of regional distinctions in the 1540's" (6).

148. K. T. Butler, comp., *"The Gentlest Art" in Renaissance Italy: An Anthology of Italian Letters, 1549–1600* (Cambridge: Cambridge University Press, 1954), 75, and Sabba Castiglione, *Ricordi Overo Ammaestramenti ... Ne Qvali Con Prvdenti, E Christiani discorsi si ragiona di tutte le materie honorate, che si ricercano a vn vero gentil'huomo* (Venice: Per Pavlo Gherardo, 1554), fol. 2v. The Milanese Sabba (ca. 1480–1554) studied law and letters at Pavia and entered the Order of Saint John of Jerusalem on Rhodes in 1514. He entertained the friendship of Guicciardini and Macchiavelli. As "commendadore" of Faenza he undertook local parish reforms along the lines advocated by the *spirituali*. He resigned his post at the *comenda* in 1544 to devote his time to his *Ricordi*, of which the first two redactions

were published in Bologna in 1546 and 1549 and the third posthumously in Venice in 1554; see Claudio Scarpati, *Studi sul Cinquecento italiano* (Milan: Vita e Pensiero, Pubbl. della Università Cattolica, 1982), 38, 46–7, 49, 53, 71, 77. Scarpati portrayed a Sabba Castiglione as developing increasing ties with Dominicans, especially Leandro Alberti, and as carrying on a subterranean dialogue with his distant cousin's *Cortegiano* on the formation of a "caualier cristiano, religioso, & virtuoso" (*Ricordi,* fol. 4v), and, at the same time, as maintaining an ambivalent reformism marked by an increase in eschatological themes by the 1554 edition (*Studi,* 71–2, 77). Scarpati's comparison of the three stages of the *Ricordi* is helpful but leaves a stronger impression of "Evangelism" than seems justified by the 1554 edition with its heavy appeals to obedience, submission, and authority and its request for correction by the "santa sede catolica" of its "obedientissimo figliuolo" (fol. 4v). Also, the eschatology probably derived from the Dominican Alberti, who published a pseudo-Joachimite *Profetia circa li pontefici et R. E.* (Bologna, 1515; Venice, 1527); see Anne Jacobson Schutte, *Printed Italian Vernacular Religious Books, 1465–1550: A Finding List* (Geneva: Droz, 1983), 190.

149. Baldassare Castiglione, *Il libro del cortegiano,* ed. Michele Scherillo (Milan: Hoepli, 1928), 268 (III, 8). Castiglione used the term frequently (see also pages 126, 133, 142, 173, 217, 308, 325, 337). A lighter, never censured, use of the term was in games of love, such as Innocenzio Ringhieri's "Givoco d'Amore" in which one of the questions posed was "Qual sia maggior difficulta non amando disimular d'amare? o uero amando simular di non amare" (*Cento Givochi Liberali, Et D'Ingegno* [Bologna: Ansel. Giacarelli, 1551], Liber Primo).

150. "... tum illa quae maxime quasi irrepit in hominum mentes, alia dicentis ac significantis dissimulatio, quae est periucunda cum orationis non contentione sed sermone tractatur" (... then irony, or saying one thing and meaning another, which has a very great influence on the minds of the audience, and which is extremely entertaining if carried on in a conversational and not a declamatory tone); see Cicero, *De Oratore,* ed. and trans. E. W. Sutton and H. Rackham, vols. 3–4 in *Cicero in Twenty-eight Volumes,* Loeb Classical Library (Cambridge, MA: Harvard University Press; London: Heinemann, 1977–9), 4:162–3.

151. Bocchi, *Lusuum Libri II,* fol. 35r, line 6.

152. Milan, Bibl. Ambros., MS. D.145 inf., fol. 14r, line 14.

153. Francesco Guicciardini, *Ricordi,* ed. Raffaele Spongano (Florence: Sansoni, 1951), 144. In a popular collection of quotations from ancient writers, the *Poetarum Illvstrivm Flores,* compiled by Octaviano Mirandula and edited by the younger Filippo Beroaldo (Venice, 1507), a Virgilian quote under "De Simvlatione" links simulation to prudence, and there are related entries under "De Dissimvlatione" and "De Tacitvrnitate" (706, 243–4, 719–22, cited from the 1611 London edition printed by Arthur Johnson).

154. Giovanni Gioviani Pontano, *De Sermone Libre Sex,* ed. S. Lupi and A. Risicato (Lucani: Thesaurus Mundi, 1954); Sergio Lupi, "Il 'de sermone' di Giovanni Pontano," *Filologia romanza* 2 (1955): 416; and Mario Santoro, *Fortuna, ragione e prudenza nella civiltà letteraria del Cinquecento* (Naples: Liguori, 1967), 23–66. See also Rita Belladonna, "Aristotle, Machiavelli, and Religious Dissimulation: Bartolomeo Carli Piccolomini's *Trattati nove della prudenza,*" in *Peter Martyr Vermigli and Italian Reform,* ed. Joseph C. McLelland (Waterloo, Canada: Wilfrid Laurier University Press, 1980), 29–41.

155. In *La Giapigia e varii opusculi,* trans. S. Grande, 3 vols. (Lecce: Garibaldi, 1867–8), 1:227–47.

156. *Ragionamenti di mons. Galeazzo Florimonte, vescovo di Sessa, sopra l'Ethica di Aristotele* (Venice: Appresso Domenico Nicolini, 1567), fols. 63v–64r. However, Gerolamo Cardano, never too careful, included a chapter entitled "De Simulatione" in his *De*

*Prudentia Ciuili;* see Cardano, *Opera Omnia,* ed. August Buck, 10 vols. (1663; reprint, Stuttgart-Bad Cannstatt: Frommann, 1966), 1:394–5.

157. B. Castiglione, *Cortegiano,* 86, 128, 140, 151; and S. Castiglione, *Ricordi,* fol. 31r.

158. Ginzburg, *Nicodemismo,* 11.

159. Albano Biondi, "La giustificazione della simulazione nel Cinquecento," in *Eresia e riforma nell'Italia del Cinquecento. Miscellanea I* (DeKalb: Northern Illinois University Press; Chicago: Newberry Library; Florence: Sansoni 1974), 10, 17; Carlos M. N. Eire, "Calvin and Nicodemism: A Reappraisal," *Sixteenth Century Journal* 10, no. 1 (1979): 62.

160. Ginzburg, *Nicodemismo,* 39, 48, 85–124; Biondi, "La giustificazione," 11, 31–2, 44; and Cantimori, *Prospettive,* 246.

161. Rotondò, *Atteggiamenti,* 1012.

162. Biondi, "La giustificazione," 61. Cloaked by the pseudonym "Eusebio Renato," an unknown Bolognese noble, a lawyer probably in the circle around Ortensio Lando, wrote letters to Martin Bucer about Northern religious currents; see Seidel Menchi, "Sulla fortuna," 543, 554. The first letter was carried from Bologna to Bucer by the Dutch Erasmian Arnaldo Arlenio, who was a member of a sodality that met in Lando's house in Bologna; see Gilmore, "Anti-Erasmianism," 9.

163. Rotondò, "La storia," 111–12, and Renato, *Opere,* 196–7. Fra Giulio had first been arrested after preaching in Bologna in 1538; he eventually changed his views on Nicodemism and after fleeing to Switzerland in 1542 wrote an exhortation to martyrdom; see Giuseppe De Leva, "Giulio da Milano, appendice alla storia del movimento religioso in Italia nel secolo XVI," *Archivio veneto* 7 (1874): 236, 249, and Ginzburg, *Nicodemismo,* 160.

164. Pole, *Epistolarum,* 3:40–1.

165. Ginzburg, *Nicodemismo,* 172–3; Rotondò, *Atteggiamenti,* 1014, and Cantimori, *Eretici,* 57–70.

166. Ginzburg, *Nicodemismo,* 171.

167. Ginzburg, *Nicodemismo,* 172. Five years after the Council, nine members of the College of Spain, including doctors of law and theology, were examined and forced to abjure. Although some of them may have had direct contact with Siculo, their "heretical" formation was with the Spanish "Illuminati" movement; see Prosperi, "Un gruppo," 341–54, and Antonio Battistella, *Processi d'eresia nel Collegio di Spagna, 1553–1554: Episodio della storia della riforma in Bologna* (Bologna: Zanichelli, 1901), 2–5.

168. Simoncelli, *Il caso,* 43.

169. Dermot Fenlon, *Heresy and Obedience in Tridentine Italy: Cardinal Pole and the Counter Reformation* (Cambridge: Cambridge University Press, 1972), 224.

170. Carlos M. N. Eire, "Prelude to Sedition? Calvin's Attack on Nicodemism and Religious Compromise," *Archiv für Reformationsgeschichte* 76 (1985): 126; Eire, "Calvin and Nicodemism," 45–70; and Antonio Rotondò, "I movimenti ereticali nell'Europa del Cinquecento," *Rivista storica italiana* 78 (1966): 134–5.

171. Biondi, "La giustificazione," 9, Eire, "Calvin and Nicodemism," 69.

172. Eire, "Calvin and Nicodemism," 69.

173. Eire, "Calvin and Nicodemism" 69n, and Biondi, "La giustificazione," 8.

174. Biondi, "La giustificazione," 27–8.

175. Ginzburg, *Nicodemismo,* 181.

176. Caponetto, *Aonio Paleario,* 50, and Antonio Santosuosso, "The Italian Crisis at Mid-Sixteenth Century: A Matter of Shift and Decadence," *Canadian Journal of History* 10 (1975): 147–64.

177. Peter Zagorin, *Ways of Lying: Dissimulation, Persecution, and Conformity in Early Modern Europe* (Cambridge, MA, and London: Harvard University Press, 1990), 330.

178. Gregorio Amaseo, Leonardo Amaseo, and Giovanni Antonio Azio, *Diarii udinesi dall'anno 1508 all'anno 1541*, in *Monumenti storici publicati dalla R. Deputazione Veneta di Storia Patria*, vol. 11, ser. 3. Chronache e diarii, vol. 2 [i.e., 1] (Venice: Visentini, 1884), 287.

179. Biondi, "La giustificazione," 8. Guicciardini, governor of Bologna from 1530 to 1532, received a letter in 1537 from Bocchi, who referred to "our Academy" (Bologna, Archiginnasio, MS. B.3146, fol. 2v). The Guicciardini text (*Ricordi*, 114–15) reads:

> E lodato assai negli uomini, e è grato a ognuno, lo essere di natura liberi e reali e, come si dice in Firenze, schietti. E biasmata da altro canto, e è odiosa, la simulazione, ma è molto più utile a se medesimo; e quella realità giova più presto a altri che a sè. Ma . . . io loderei chi ordinariamente avessi el traino suo del vivere libero e schietto, usando la simulazione solamente in qualche cosa molto importante, le quali accaggiono rare volte. Così acquisteresti nome di essere libero e reale . . . e nondimeno, nelle cose che importassino più, caveresti utilità della simulazione, e tanto maggiore quanto, avendo fama di non essere simulatore, sarebbe più facilmente creduto alle arti tue.

> (Much praised in men, and pleasing to everyone, is being of a frank and genuine nature and, as they say in Florence, blunt. On the other hand, simulation is blamed, but it is much more useful in itself; and that reality more readily helps others than oneself. But . . . I would praise that person who ordinarily would have as his burden to live openly and plainly using simulation only in a few very important cases, which are rarely blamed. Thus, you would acquire for yourself the name of an open and genuine person . . . and, notwithstanding, in things which matter most, you would obtain for yourself the utility of simulation, and, so much more so for having the reputation of not being a simulator, it would be more easily believed by your skills.)

180. Translated by Guido Waldman; see Ludovico Ariosto, *Orlando Furioso* (London, Oxford, and New York: Oxford University Press, 1974), 30, and *Orlando Furioso di Lvdovico Ariosto secondo le stampe del 1516 e del 1521*, 3 vols. (Rome: Presso la Società, 1909–13), 2:68–9. These lines appeared first in the original edition of 1516, as well as in subsequent editions. Cantimori, *Eretici*, 288, also cited this passage.

181. Marcello Palingenio Stellato, *Marcelli Palingenii Stellati Zodiacus Vitae sive De Hominis Vita Libri XII*, ed. Car. Herrm. Weise (Leipzig: Tauchnitus, 1832), 77, lines 682–4. Biondi, "La giustificazione," 62, also quoted this passage. Palingenio in the same book ("Lib. IV. Cancer") added: "Verbaque foemineae vires sunt, facta virorum. / Dissimulat prudens, fortis tacet" (Words are a feminine strength, deeds masculine. The prudent man dissimulates, the strong one is silent; see 81, lines 804–5).

182. George Puttenham, *The Arte of English Poesie [June?] 1589*, ed. Edward Arber (1869; reprint, New York: AMS, 1966), 196–9, and *The Oxford Dictionary of English Proverbs*, 3d ed., rev., ed. F. P. Wilson (Oxford: Clarendon Press, 1970), 437. Also, for Puttenham, see Heinrich F. Plett, *Rhetorik der Affekte: Englische Wirkungsästhetik im Zeitalter der Renaissance* (Tübingen: Niemeyer, 1975), 82–3; and Jonathan Crewe, *Hidden Designs: The Critical Profession and Renaissance Literature* (New York and London: Methuen, 1986), 119–29. If Crewe is correct, Puttenham as the front for Edmund Spenser was the greatest dissembler of them all.

183. Eugenio Garin found in the *Zodiacus vitae* the Lucretian themes of Filippo Beroaldo the Elder and Giovanni Battista Pio; see Garin, "Commenti Lucreziani," 85–6. Perhaps this suggests a Bolognese education for the obscure Palingenio. Benedetto Croce deemed Palingenio a "nuovo Cecco d'Ascoli" who wrote "un latino così facile e limpido che è quasi un volgare"; see Croce, "Poesia latina del Rinascimento," *La critica* 30 (1932): 326.

184. Abraham Ortelius, *Album Amicorum Abraham Ortelius,* facsim. ed., annotated and trans. Jean Puraye (Amsterdam: Van Gendt, 1969), fol. 50v. Puraye translated as follows: "Vis caché. / Qui a bien caché sa vie a bien véçu, et celui qui é trop connu de tous meurt sans se connaître lui-même" (43).

185. Bocchi's Latin motto is quoted from Horace, Epist. I, 17, 10; see Georg Luck's notes in Ovid, *Tristia,* ed. Georg Luck, 2 vols. (Heidelberg: Winter, 1967), 2:187n.

186. Luigi Frati, "Delle monete gettate al popolo nel solenne ingresso in Bologna di Giulio II per la cacciata di Gio. II Bentivoglio," *Atti e memorie della R. Deputazione di Storia Patria per le Provincie di Romagna,* 3d ser. 1 (1882–3): 477, 479.

187. Marcello Fagiolo, "L'effimero di stato: Strutture e archetipi di una città d'illusione," in *La città effimera e l'universo artificiale del giardino: La Firenze dei Medici e l'Italia del '500,* ed. Marcello Fagiolo (Rome: Officina, 1980), 9–11.

188. Frederick Hartt, "Power and the Individual in Mannerist Art," in *The Renaissance and Mannerism,* vol. 2 of *Studies in Western Art: Acts of the Twentieth International Congress of the History of Art* (Princeton, NJ: Princeton University Press, 1963), 237.

189. Giordano Conti, "L'incoronazione di Carlo V a Bologna," in *La città effimera,* 46, and Fagiolo, "L'effimero," 17. See also Bonner Mitchell, "The S.P.Q.R. in Two Roman Festivals of the Early and Mid-Cinquecento," *Sixteenth Century Journal* 9, no. 4 (1968): 94–7, and Mitchell, *Italian Civic Pageantry in the High Renaissance: A Descriptive Bibliography of Triumphal Entries and Selected Other Festivals for State Occasions* (Florence: Olschki, 1979).

190. Maria Luisa Madonna, "L'ingresso di Carlo V a Roma," in *La città effimera,* 63.

191. Cesare Vasoli, "Prefazione," in his *La cultura delle corti* (Bologna: Cappelli, 1980), 7–8, and Giulio Ferroni, "'Sprezzatura' e 'simulazione,'" in *La corte e il "Cortegiano,"* ed. Carlo Ossola, 2 vols., Centro Studi "Europa della Corti," Biblioteca del Cinquecento 8–9 (Rome: Bulzoni, 1980), 1:142. This veil of wisdom, as Orest Ranum has suggested to me, did leave the prince exposed to the manipulations of the scholars who understood it.

192. Nancy S. Struever, "Proverbial Signs: Formal Strategies in Guicciardini's *Ricordi,*" Annali d'Italianistica 2 (1984): 102.

193. Santoro, *Fortuna, ragione e prudenza,* 466–8, 474.

194. Orazi, *Jacopo Barozzi,* 236, and Lugli, "Le 'Symbolicae Quaestiones,'" 89–90.

195. Giovanni Battista Pigna, *I Romanzi Di M. Giouan Battista Pigna* ... (Venice: Appresso Vincenzo Valgrisi, 1554), 100, and Lilio Gregorio Giraldi, ... *Opera Omnia* ..., 2 vols. (Louvain: Apud Hackium, Boutesteyn, Vivie, Vander AA, & Luchtmans, 1696), 2:565.

196. Eugenio Garin, "Note su alcuni aspetti delle retoriche rinascimentali e sulla *Retorica del Patrizi,*" in *Testi umanistici su la retorica,* ed. Eugenio Garin, Paolo Rossi, and Cesare Vasoli, no. 3 in *Archivio di filosofia* (1953): 32–5.

197. Venice had laws against its citizens associating with foreign nationals, so some of the accusations most important in the Badoer case were only applicable to Venice. See Lina Bolzoni, "L'Accademia Veneziana: Splendore e decadenza di una utopia enciclopedica," in *Università, accademie e società scientifiche in Italia e in Germania dal Cinquecento al Settecento,* ed. Laetitia Boehm and Ezio Raimondi, Annali dell'Istituto storico italo-germanico, quaderno 9 (Bologna: Il Mulino, 1981), 117, 146–9, 159, 163.

198. Lugli, "Le 'Symbolicae Quaestiones,'" 89.

199. Cantimori, "Note," 347. Anne Jacobson Schutte, *Pier Paolo Vergerio: The Making of an Italian Reformer* (Geneva: Droz, 1977), suggested that the *spirituali* adopted a veiled and oblique manner of writing more as a come-on to lure readers into a promised world of insiders' privilege than as a necessary precaution for security (13).

200. *Ionnis Antonij Delfini e Casali Maiori, Conventualivm Franciscanor[um] Generalis meritissimi. In Symbolvm Decimvm Achillis Bocchij. Commentariolvs* (Bologna, Archiginnasio, MS.

B.1513). Delfino was the author of a treatise on dialectics published in Bologna in 1555 and, more importantly, a Council of Trent delegate with a Scotist philosophical position; see Valens Heynck, "A Controversy at the Council of Trent Concerning the Doctrine of Duns Scotus," *Franciscan Studies* 9 (1949): 214, 218–21, 257.

201. Rotondò, "I movimenti," 134–5.

202. Francis Bacon, *Essayes or Counsels Civill & Morall of Francis Bacon Lord Verulam* (1906; reprint, New York: Dutton, 1928), 17–19.

203. Bacon, *Essayes,* 17–18.

## 3. The Scholar's Utopia: Bocchi's Projected Vision

1. I am that one who, treating through good direction and infallible ways both the line and the square, and teaching the world to design with good proportion and symmetry a lovely edifice, established a stable column to my name and raised an immortal temple to my glory; and I built more strongly than any marble an obelisk to Death out of fragile paper; see Giovanni Battista Marino, *La Galleria,* ed. Marzio Pieri, 2 vols. (Padua: Liviana, 1979), 1:56.

2. Giovanni Fantuzzi, *Notizie degli scrittori bolognesi,* 9 vols. (Bologna: Nella stamperia di San Tommaso D'Aquino, 1781–94), 2:227–31. For a summary of the contents of each volume, see Gisela Ravera Aira, "Achille Bocchi e la sua 'Historia Bononiensis,'" *Studi e memorie per la storia dell' Università di Bologna* 15 (1942): 77–82.

3. Fantuzzi, *Notizie,* 2:222–3. The March 3, 1533, *breve* of Clement VII was signed by Pietro Bembo and Blosio Palladio; see Fantuzzi, *Notizie* 2:221, and Ludwig von Pastor, *A History of the Popes, from the Close of the Middle Ages,* vols. 7–14, ed. Ralph Francis Kerr, 3rd ed., 40 vols. (London: Kegan Paul, French, Trubner, & Co., 1923–53), 10:343. Eric Cochrane, in his *Historians and Historiography in the Italian Renaissance* (Chicago and London: University of Chicago Press, 1981), assumed that Bocchi had "plenty of time" because of his freedom from teaching and "plenty of money" (251); but in the dedication to vol. 16, Bocchi begged for a vacation from public teaching in order to schedule more time for writing history; see Fantuzzi, *Notizie,* 2:232.

4. Cochrane, *Historians,* 107; and Paul Oskar Kristeller, "Niccolò Perotti ed i suoi contributi alla storia dell'Umanesimo," *Res Publica Litterarum* 4 (1981): 18. Bologna also had a rich tradition of chronicles, many of which are no longer extant; see Cochrane, *Historians,* 104, and Gina Fasoli, "La storia delle storie di Bologna," *Atti e memorie [della] Deputazione di Storia Patria per le Province di Romagna* 17–19 (1965–8): 69–70.

5. Cochrane, *Historians,* 252. As Arnaldo Momigliano pointed out, however, literary evidence was the basis for sixteenth-century historiography; even when later in the century historians such as Carlo Sigonio and Fulvio Orsini began to combine archeological and epigraphical evidence with literary sources, they looked on these as supplements to history and never as corrections to received texts; see "Ancient History and the Antiquarian," *Journal of the Warburg and Courtauld Institutes* 13 (1950): 290–2, 313.

6. Ravera Aira, "Achille Bocchi," 83.

7. Garzoni also began his history with the Flood; see Fasoli, "La storia," 71–3. Cochrane showed how by the early sixteenth century antiquarian items such as coins and inscriptions were being collected but were not adapted to the use of historians until around the middle of the century (*Historians,* 224–6). Humanists looked at literary applications of antiquities before they thought of historical uses; that is, they studied inscriptions for elegance and correct spelling and coins in the light of ancient literature; see Roberto Weiss, *The Renaissance Discovery of Classical Antiquity* (Oxford: Blackwell, 1969), 145–50, 211. Bocchi received some praise but also criticism from a seventeenth-

century historiographer, Giovambattista Capponi, for the insufficiently antiquarian approach of his history. As Capponi pointed out, Bocchi was well aware of the antiquities discovered in his time, "come da' di lui Simboli può vedersi"; cited in Carlo Cesare Malvasia, *Marmora Felsinea Innumeris Non Solum Inscriptionibus Exteris Hucusque Ineditis . . .* (Bologna: Ex Typographia Pisariana, 1690), 109–10.

8. Cochrane, *Historians*, 252.

9. Ravera Aira also credited Bocchi with introducing archival sources, with admitting his disbelief in the so-called Privilege of Theodosius, and with asserting people's responsibility for their own actions rather than calling on Providence or Fortune; see Ravera Aira, "Achille Bocchi," 92, 99, 105.

10. Leandro Alberti, *Historie di Bologna, Opera di Leandro Alberti* (reprint; Bologna: Forni, 1970), sig. Aii^v. There are also passing references in the *Historie* to Bocchi, but his name did not appear in Alberti's *Descrittione di tvtta l'Italia*, published in 1550.

11. Pietro Aretino, *Lettere: Il primo e il secondo libro*, ed. Francesco Flora and Alessandro del Vita, vol. 1 of *Tutte le opere di Pietro Aretino* (Verona: Mondadori, 1960), 156, Letter no. 127. Aretino's degree of acquaintance with Bocchi is unknown. One mutual friend was Sebastiano Serlio, said to be running a school of architecture in Venice between 1537 and 1540; see Fantuzzi, *Notizie*, 7:396, 402.

12. Romeo Bocchi, *Della Giusta Vniversal Misvra Et Svo Typo . . .*, 2 vols. in 1 (Venice: Appresso Antonio Pinelli, 1621), 2:59. This guide to the history and use of money also praised Bocchi's emblems (1:36).

13. Sigonio's history actually encountered more problems with the pope than with the Senate of Bologna; see Fasoli, "La storia," 77–8, 83, and Cesarina Casanova, "La storiografia a Bologna e in Romagna," in *Storia della Emilia Romagna*, ed. Aldo Berselli, 3 vols. (Bologna: University Press, 1976–80), 2:613–24. Alberti's *Historie di Bologna* appeared in fascicles in 1514, 1547, 1588, and 1590, with a complete edition not published until the reprint of 1970. Also see Fantuzzi, *Notizie*, 1:152, for Alberti's history.

14. Fantuzzi, *Notizie*, 9:63. This agreement guaranteed an annual stipend of 300 lire on condition that Pirro produce two volumes a year.

15. A September 1556 letter from Bocchi as "cliens" to Tamas Nadasdy, a powerful Hungarian count and a former student of Bocchi's, explained the situation, protested Pirro's innocence, and requested aid from Nadasdy for Pirro in Paris (Bologna, Archiginnasio, B.470). A further letter from another former Hungarian student, Bishop Paulus Abstemius (Pál Bornemisza), written from Alba Iulia, Transylvania, in January 1557, reported that Nadasdy had seen him and that Abstemius too wanted to aid Pirro, who was invited to come to Alba Iulia when the current "troubles" had ceased (Bologna, Bibl. Univ., Mss. Ital. 295 [231]). See also Fantuzzi, *Notizie*, 2:233–4, 9:63, 94, and Endre Veress, *Matricula et Acta Hungarorum in Universitatibus Italiae-Studentium, 1221–1864: Olasz Egyetemeken járt Magyarországi Tanulók Anyakönyve és iratai, 1221–1864*, 2 vols. (1915–17; reprint, Budapest: Academia Scientiarum Hungarica, 1941), 1: 83–4.

16. Fantuzzi, *Notizie*, 2:234, 9:94. Sigonio, with the backing of Cardinal Gabriele Paleotti, produced the *De Rebus Bononiensibus*, beginning like Bocchi with pre-Roman Felsina and continuing to 1057. According to Cochrane (*Historians*, 252–3, 484), Sigonio managed to reduce excessive detail to some extent and had a thesis to shape his work, a conviction that Bologna owed its greatness to its liberty rather than to its antiquity. Antonio Rotondò discovered an early seventeenth-century proposal to continue Bocchi's history made by Thomas Dempster, a Scottish poineer of Etruscan studies teaching in Bologna from about 1616 to 1621; see "Bocchi, Achille," *Dizionario biografico degli Italiani* (hereafter cited as *DBI*), 11:68; however, Dempster's friends dissuaded him from the undertaking.

17. Funambulism was a popular sixteenth-century entertainment, but the Turkish cap of Symbol LVII permits the dating of this event; see Lodovico Fratti, *La vita privata di Bologna dal secolo XIII al XVII* (1900; reprint, Rome: Bardi, 1968), 139–40. For the inventive and talented Scappi, who escaped his humble Bolognese beginnings and eventually rose to the position of papal cook, see L. R., "Il maestro cuoco di un Cardinale e le sue liste," *Bologna: Rivista mensile de Comune*, 22, no. 4 (April 1935): 93–100. Scappi's *Libro di cucina*, published also in his *Opera di M. Bartolomeo Scappi, cuoco secreto di Papa Pio Quinto* (Venice: Appresso Michele Tremezzino, 1570), illustrated the use of the fork in a banquet scene very similar to the engraving for Bocchi's Symbol CXVIII.

18. Pompeo Vizani, . . . , *Diece Libri Delle Historie Della Sva Patria* (Bologna: Pressi gli Heredi di Gio. Rossi, 1602), 118–9, 21. The organizer of the apparatus for this entry was a former Bocchi pupil, Scipione Bianchini.

19. The fresco (now known only from contemporary descriptions and a drawing) of the Del Monte motto's arms, keys, triple mountain, tiara, and other symbolism came to be called a "Geroglifico" (hieroglyph) locally. Its program was devised by Giovanandrea Bianchi, called Albio, after the *Hypnerotomachia Poliphili* of Francesco Colonna, the *Emblemata* of Alciato, and other sources; see Silvie M. Béguin, ed., *Mostra di Nicolò dell'Abate: Catalogo critico*, Bologna, Palazzo dell'Archiginnasio, 1 settembre–20 ottobre 1969, Associazione per le arti "Francesco Francia" (Bologna: Alfa, 1969), 99–100, and Béguin, "A Lost Fresco of Niccolò dell'Abate at Bologna in Honor of Julius III," *Journal of the Warburg and Courtauld Institutes* 18 (1955): 121–2, and 19 (1965): 302.

20. Bonner Mitchell, *Italian Civic Pageantry in the High Renaissance: A Descriptive Bibliography of Triumphal Entries and Selected Other Festivals for State Occasions* (Florence: Olschki, 1979), 15, and Luigi Frati, "Delle monete gettate al popolo nel solenne ingresso in Bologna di Giulio II per la cacciata di Gio. II Bentivoglio," *Atti e memorie della R. Deputazione di Storia Patria per le Provincie di Romagna*, 3d ser., 1 (1882–3): 474–87. According to Justinian law, only emperors could throw gold coins to people, and therefore, it was not surprising when Charles V did so during his entry in 1529; see Giacinto Romano, ed., *Cronaca del soggiorno di Carlo V in Italia (dal 26 luglio 1529 al 25 aprile 1530)* (Milan: Hoepli, 1892), 121–2.

21. Fantuzzi, *Notizie*, 2:219. Bocchi may have assisted his mentor Pio for a time after 1508 before establishing a school of his own or inheriting Pio's school.

22. This small work was the discovery of Gedeon Borsa; see "Bornemisza Pál megemlékezése Várdai Ferencröl és a többi, Mohács elötti bolognai, magyar vonatkozású nyomtatvány," *Irodalomtörténeti Közlemények* 87 (1983): 48. The only known copy is in Naples; see *Primo catologo collettivo delle biblioteche italiane*, 9 vols. to date (Rome, 1962–), 1:150, no. 3625. I was not able to read Borsa's article, but he does include in his description of the contents of the book three poems by Bocchi (48).

23. Giovanni Antonio Flaminio, . . . *Epistolae Familiares*, ed, Fr. Dominico Josepho Capponi (Bologna: Ex Typographia Sancti Thomae Aquinatis, 1744), 445.

24. Girolamo Tiraboschi, *Biblioteca modenese, o, Notizie della vita e delle opere degli scrittori natii degli stati del . . . duca di Modena*, 6 vols. (Modena: Società tipografica, 1781–6), 1:34–8; the dedication to Gambara was published in Camillo's *De subiecto totius Logicae quaestio* in Bologna in 1520.

25. Christoph Scheurl, *Christoph Scheurl's Briefbuch, ein Beitrag zur Geschichte der Reformation und ihrer Zeit*, ed. Franz von Soden and J. K. F. Knaake, 2 vols. in 1 (Aalen: Zeller, 1962), 1:140. Scheurl also refered to Bologna's Studio as a "gymnasium litterarum" and to his own university as "Wittenburgensis academiae" in the same letter (Nr. 92, 23 April 1515, 1:140–1). For Brenner, see Veress, *Matricula*, 1:478–9. The term "academy" was first used for learned societies in the Renaissance by Donato Acciaioli in 1455, according to

Peter-Eckhard Knabe, "Die Wortgeschichte von *Akademie*," *Archiv für das Studium der neueren Sprachen und Literaturen* 214 (1977): 249, but Knabe had nothing to say about the use of the term for private schools.

26. Colocci's school was variously called "Neacademia," "Collegio Greco," "Academia Graeca," and other names. It had short-lived offshoots in Florence and Padua; see Vittorio Fanelli, "Il Ginnasio greco di Leone X a Roma," in *Ricerche su Angelo Colocci e sulla Roma cinquecentesca,* ed. José Ruysschaert and Gianni Ballistreri (Vatican City: Biblioteca Apostolica Vaticana, 1979), 91–110.

27. Giulio Cattin, "La musica nella vita e nelle opere di Giangiorgio Trissino," in *Convegno di studi su Giangiorgio Trissino,* ed. Neri Pozza [Vicenza, 31 March–1 April 1979, Odeo del Teatro Olimpico] (Vicenza: Accademia Olimpica, 1980), 160.

28. Palladio and Trissino had formed a long friendship before 1538; see Lionello Puppi, *Andrea Palladio,* trans. Pearl Sanders (Boston: New York Graphic Society, 1975), 8–10. Bocchi may have known Trissino's school directly or at least through his close friend, Alessandro Manzuoli, who visited Trissino in Vicenza in 1543 for a consultation about Ranuccio Farnese's education; see *Lettere d'uomini illustri conservati in Parma nel R. Archivio dello Stato,* ed. Amadio Ronchini (Parma: Reale Tipografia, 1853), 569–70.

29. Fantuzzi, *Notizie,* 3:190; Paolo Prodi, *Il Cardinale Gabriele Paleotti (1522–1597),* 2 vols. (Rome: Edizioni di Storia e letteratura, 1959–67), 1:48; and Gian Paolo Brizzi, *La formazione della classe dirigente nel Sei-Settecento: I seminaria noblilium nell'Italia centro-settentrionale* (Bologna: Il Mulino, 1976), 79–82, 116–18n. An eighteenth-century life of G. A. Flaminio by Francesco Maria Mancurtius (in Marcantonio, Giovanni Antonio, and Gabriele Flaminio's *Carmina* [Padua: Josephus Cominus, 1743], 427) called G. A. Flaminio's school in Bologna (1520–6) an academy. I have not been able to locate copies of two Bolognese treatises on education that mention Bocchi, the *Dialogus de educatione liberorum ac institutione* (1524) of G. A. Flaminio and the *De liberali educatione* (1560) of Luca Macchiavelli; see Fantuzzi, *Notizie,* 5:107, and F. Buisson, comp., *Répertoire des ouvrages pédagogiques du XVIe siècle* (Paris: Imprimerie Nationale, 1886), 289. Nicolaus Pevsner, on the use of the term *academy* in Italy, says: "The use of 'academy' for a *grammar-school* is rare in Italy. The only case which I have come across is the Accademia degli Ardenti at Bologna (1565), a school founded by the Confraternity of the Somasca"; see Pevsner, *Academies of Art, Past and Present* (Cambridge: University Press, 1940), 11n. My sources do not say anything about the role of a confraternity in any of the academies named, but this association may have accompanied the increasing church involvement in schools after 1560.

30. Fantuzzi, *Notizie,* 3:189.

31. Marozzo trained young nobles to become soldiers; Count Guido Rangone of Modena studied with him according to *Opere nova di Achille Marozzo Bolognese, Mastro Generale di larte de larmi* (Mutine, 1536); see Fantuzzi, *Notizie,* 5:275–6.

32. Giovanni Battista Pigna, *I Romanzi Di M. Giouan Battista Pigna, Al S. Donno Lvigi Da Este Vescovo Di Ferrara, Divisi In Tre Libri* (Venice: Appresso Vincenzo Valgrisi, 1554), 100.

33. Brizzi, *La formazione,* 7, 79.

34. Prodi, *Il Cardinale Gabriele Paleotti,* 1:43–4.

35. Fantuzzi, *Notizie,* 3:190.

36. Cattin, "La musica," 160.

37. O. Mischiati and A. Cioni, "Bottrigari, Ercole," *DBI,* 13:491–2. Bottrigari's later work shows the impact of this course of studies: he wrote treatises on music, translated into Italian scientific works by Ptolemy and the French mathematician Oronce Finé, edited collections of vernacular poetry, printed on his own press as a teenager some comedies

and a prognostication, and, in addition, amassed a collection of rare scientific and poetic texts and maintained a private musical group (*musica riservata*) in his home; see Mischiati and Cioni, "Bottrigari," 13:492–5. For Simo, see Fantuzzi, *Notizie,* 8:8–9, and Lodovico Ferrari and Niccolò Tartaglia, *Cartelli di sfida matematica: Riproduzione in facsimile delle edizioni originali, 1547–1548,* ed. Arnaldo Masotti (reprint; Brescia: Ateneo, 1974), lxxix. Simo also taught Bocchi's pupil Ulisse Aldrovandi and may, therefore, have tutored in Bocchi's school.

38. Girolamo Muzio, *Lettere inedite di Girolamo Muzio Giustinopolitano pubblicate nel IV Centenario della sua nascita,* ed. Albino Zenatti (Capodistria: A spese del Comune, 1896), 45. The academies as schools were well established by the late sixteenth century, as a memorandum concerning dioscesan government in Bologna directed to Cardinal Paleotti in 1584 attests: " '*Dell'Academia.* Questa institutione riesce assai utile per il bisogno d'allevare figliuoli de Gentil'huomini, della quale n'hanno cura i deputati mantenendovi Precettori et altri officiali, et hanno uno capelletta, quale alle volte si fa' visitare' "; see Paolo Prodi, "Lineamenti dell'organizzazione dioscesana in Bologna durante l'episcopato del card. G. Paleotti (1566–1597)," in *Problemi di vita religiosa in Italia nel Cinquecento: Atti del Convegno di storia della Chiesa in Italia (Bologna, 2–6 sett. 1958)* (Padua: Antenore, 1960), 358.

39. The reasons for his teaching law are obscure: He may have wished to augment his income – law teachers were paid more – or he may have filled a vacancy left by a teacher of law, perhaps his increasingly busy cousin, Romeo Bocchi, who was prior of the law faculty from 1542 and active in city government (Bologna, Archiginnasio, MS. B.470, p. 362, and MS. B1292, fol. 4r). Or, perhaps Bocchi, inspired by Andrea Alciato's philological studies of legal texts, was eager for the opportunity to teach some texts usually reserved for teachers of law.

40. Bologna, Bibl. Univ., Cod. Lat. 304. This folio manuscript has gold lettering on the titles in the text and a portrait medal of Bocchi (ACHILLES BOCCIVS BONON. AN. AET. LXVII) embedded in its front cover. Contuberio (perhaps Thomas of Canterbury) was vice-legate from 1557 to 1558 and served as governor in 1559; see Paolo Prodi, "Crotonotassi critica dei legati, vicelegati e governatori di Bologna dal Sec. XVI al XVII," *Atti e memorie, Deputazione di Storia Patria per le Province di Romagna,* n.s. 23 (1972): 204, 234.

41. Jacopo Rainieri, *Diario bolognese,* ed. G. Guerrini and C. Ricci (Bologna: Regia tipografia, 1887), 136. There were also several Antonio Bocchis and an Angelo Michele (son of Romeo and also a lawyer), whose dates make them less likely candidates; see Pompeo Scipione Dolfi, *Cronologia delle famiglie nobili di Bologna* (1670; reprint, Bologna: Forni, 1973), 176–7.

42. Bologna, Bibl. Univ., Mss. Ital. 199 (90). The collection also includes a letter to Achille Bocchi and an exchange of letters between Gaspare Bocchi and Cardinal Cesi.

43. Rotondò, "Bocchi," 11:68–9.

44. The fifteenth-century humanists modeled their villa retreats on those in classical Roman literature; see David R. Coffin, *The Villa in the Life of Renaissance Rome,* Princeton Monographs in Art and Archeology 34 (Princeton, NJ: Princeton University Press, 1979), 11–12. The shift from loosely structured groups meeting in the *locus amoenus* of Ficino and Landino to academies as "organisierte Gesellschaften" is discussed in Werner M. Bauer, "Die 'Akademienlandschaft' in der neulateinischen Dichtung," *Euphorion* 63 (1969): 40–53. Gino Benzoni spoke of the proliferation of academies in towns all over Italy in the second half of the sixteenth century; he called them "minuscole corporazioni" (also "anticorte"); see Benzoni, *Gli affanni della cultura: Intellettuali e potere nell'Italia della*

*Controriforma e Barocca* (Milan: Feltrinelli, 1978), 172, 198. Eric Cochrane, discussing Florentine academies, attributed the formal organizing of academies to Cosimo I Medici's promotion of culture as a mode of power; see Cochrane, "Le accademie," in *Firenze e la Toscana dei Medici nell'Europa del '500,* 3 vols. (Florence: Olschki, 1983), 1:4–6. This may not have been the reason for the organizing of academies in other cities, although formal rules for academies were established in cities other than Florence around the same time, that is, in the early 1540s.

45. For Scornetta as *locus amoenus,* see Herman Knuyt von Slyterhoven's comedy, *Scornetta* (Bologna, 1498), republished in Johannes Bolte, "Zwei Humanistenkomödien aus Italien, II," *Zeitschrift für Vergleichende Literaturgeschichte und Renaissance-Literatur,* n.s., 1 (1887–8): 231–44.

46. Michele Maylender, *Storia delle Accademie d'Italia,* 5 vols. (Bologna, Rocca S. Casciano, and Trieste: 1926–30), 5:477–9, and Giampiero Cuppini and Anna Maria Matteucci, *Ville del Bolognese,* 2d ed. rev. (Bologna: Zanichelli, 1969), 367. The Palazzina della Viola was built in the late fifteenth century by Annibale Bentivoglio.

47. Francesco Saverio Quadrio, *Della storia e della ragione d'ogni poesia,* 5 vols. in 7 (Bologna: Ferdinando Pisarri, 1739–52), 1:55, and Antonio di Paolo Masini, *Bologna perlvstrata,* 3 vols., 3d ed. (Bologna: Per l'Erede di Vittorio Benacci, 1666), 1:1555. This motto had been painted on a wall in Ficino's Villa Careggi. According to Quadrio, as early as 1320 in Bologna certain "Accademie o compagnie" had arms that reflected their names (1:55). Maylender has said that the only known member of the Viridario besides Achillini was the Bolognese poet Michele Salimbene, il "Calvitio," but Achillini's close and often documented association with Bocchi, G. A. Flaminio, Leandro Alberti, Alessandro Manzuoli, and others makes them probable members as well (*Storia delle Accademie,* 5:479). Achillini's long didactic poem *Viridario* (Bologna, 1513) does not mention any academy but is known for its lists of and tributes to all the important poets, scholars, artists, musicians, and other luminaries of Bolognese culture of the poet's time. The bulk of the work is an allegorical hodgepodge of the information deemed useful to boys and girls, from medieval philosophy to artificial memory techniques and from descriptions of the costumes of gods and goddesses to beauty techniques ("esperimenti").

48. For Colocci's press, see Fanelli, "Il Ginnasio," 98. For Cinzio Achillini, see A. Mondolfo, "Achillini, Cinzio," *DBI,* 1:145, and Albano Sorbelli, *Storia della stampa in Bologna* (Bologna: Zanichelli, 1929), 95–6. Cinzio's editions included a *Sphaera* of Proclus Diadochus (1526), the *Supplementum in Sphaerum Procli Diadochii* by Lodovico Vitale (1526), a volume of poetry by Vincenzo Bursio, a work on the essence of the soul by Giovambattista Fantuzzi, and a treatise on heretics and "sortilegi" by Paolo Griffo, described by Sorbelli as "una magnifica edizione con superbo frontispizio figurata" (*Storia della stampa,* 95–6). His printer's mark was an elaborate altar over which appeared the word MATVRA and, at the top, a winged turtle, soon to be a popular emblem illustration.

49. Borsa, "Bornemisza Pál," 48.

50. Veronica Gambara, who had founded the Accademia Correggio in Correggio around 1520 (Maylender, *Storia della Accademie,* 5:218), was a temporary resident in Bologna while her brother, Umberto Gambara, served as vice-legate and governor in Bologna from early 1528 to fall 1530; see Prodi, "Crotonotassi," 201, 231.

51. Besides the Bolognese, members were said to include Pietro Bembo, G. C. Trissino, Claudio Tolomeo, M. A. and G. A. Flaminio, Girolamo Vida, Giulio Camillo, Francesco Molza, and Francesco Berni; see Gaetano Giordani, *Della venuta e dimora in Bologna del sommo Pontifice Clemente VII. per la coronazione di Carlo V. Imperatore celebrata l'anno*

*MDXXX: Cronaca* (Bologna: Alla Volpe, 1842), 77–8, N61–2. For Gandolfi, whose works remain mostly in manuscript and whose wife, Anastasia, was also a poet, see Fantuzzi, *Notizie,* 4:58–9.

52. Lodovico Domenici, "Ragionamento," in Paolo Giovio, *Dialogo Dell'Imprese Militari et Amorose*...(Lyon: Appresso Gvglielmo Roviglio, 1559), 164–5, and Maylender, *Storia della Accademie,* 5:218. Prodi followed Maylender in linking the Sonnacchiosa to Veronica Gambara and in Domenici's founding date of 1543; he noted that it was headed by Paolo Verallo, a friend of Paleotti (*Il Cardinale Gabriele Paleotti,* 59n).

53. Fantuzzi, citing sources no longer known for Veronica Gambara, said: "questa illustre donna fù aggregata all'Accademia de Sonacchiosi di Bologna il 5, Aprile 1543, e riferisce la letera, che questa Signora scrisse in quella congiuntura al Magn. Sig. Paolo Emilio Verallo Principe dell'Accademia in ringraziamento di tale aggregazione. Di questa Accademia si conservano gl'atti autentici presso il Sig. Dott. Gabriello Brunelli Prefetto dell'Orto Bottanico di Bologna" (*Notizie,* 3:366).

54. Prodi, "Crotonotassi," 201, 232, and Francesco Guicciardini, *Carteggi,* ed. Roberto Palmarocchi and Pier Giorgio Ricci, 17 vols., Fonti per la storia d'Italia (Bologna: Zanichelli; Rome: Istituto Storico Italiano per l'Età Moderna e Contemporanea, 1938–72), 16:75, 172.

55. Fantuzzi quoted the incipit and explicit of this letter (*Notizie,* 9:63). The original letter, in a poor state of preservation in Bologna (Archiginnasio, MS. B146, fol. 2), was written as a recommendation for a youth to the praetorian guards.

56. Giordani, *Della venuta,* N16, 63, 246; he did not divulge his source.

57. Tolomei, in a letter to Conte Agostino de Landi dated November 14, 1542, spelled out the project, which he estimated would take three years to complete; see Claudio Tolomei, *Delle lettere di M. Claudio Tolomei libri sette,* ed. Vincenzo Cioffi, 2 vols. (Naples: Tipi del R. Albergo de' Poveri, 1829), 1:247–62. By June 8, 1543, Tolomei had written to Alessandro Manzuoli that work was completed on the middle books of Vitruvius and that the group was planning to start on the last three books when its members returned from their vacations in early October of that year (*Delle lettere,* 2:193–4). No mention is made of the original plans to provide *figure* (drawings, plans, maps, and so on) to accompany the text. The Accademia della Virtù existed prior to 1542; probably it began around 1539 under Farnese patronage, meeting twice a week for both scholarly and playful activities; see Claudio Tolomei, *Il Cesano de la Lingua Toscana,* ed. Maria Rosa Franco Subri (Rome: Bulzoni, 1975), xv, and Luigi Sbaragli, *Claudio Tolomei umanista senese del Cinquecento: La vita e le opere* (Siena: Accademia per le Arti e per Lettere, 1939), 51–2, 75.

58. Tolomei, *Il Cesano,* xv. There must have been some continuity between them with a break occurring in 1538 to 1539, when Tolomei's first patron, Cardinal Ippolito dei Medici, died; see Sbaragli, *Tolomei,* 52, and Maylender, *Storia della Accademie,* 5:480. The issue is complicated by Tolomei's "Accademia della Nuova Poesia," which published its experiments in quantitative Italian verse, the *Versi et regole de la Nvova Poesia Toscana,* in 1539 (Rome: Antonio Blado d'Asola, 1539).

59. This may represent a deduction made because Marcello Cervino, supposedly the head of the earlier Vitruvian academy, commissioned the teenaged Philibert Delorme to sketch the ruins and to establish correct Roman measurements from the feet of antique statues; see Anthony Blunt, *Philibert De L'Orme* (London: Zwemmer, 1958), 5–7. Delorme was to become the leading French architect of the Renaissance.

60. The architects Guillaume Philandrier and Jacopo Barozzi da Vignola were associated with the Accademia della Virtù's project to record the remains of antiquity in Rome; see Gabriele Morolli, *"Vetus Etruria," il mito degli Etruschi nella letteratura architettonica nell'arte e nella cultura da Vitruvio a Winckelmann* (Florence: Alinea, 1985), 148.

61. Maria Calì, "Francesco da Urbino, Romolo Cincinnati e l'ambiente romano di Claudio Tolomei nei rapporti fra Italia e Spagna," *Prospettiva* 48 (1987): 17, 19.

62. Marcantonio Flaminio, *Lettere,* ed. Alessandro Pastore, Università degli Studi di Trieste. Facoltà di Lettere e Filosofia. Istituto di Storia Medievale [e] Moderna 1 (Rome: Ateneo & Bizzarri, 1978), 217n, and Tolomei, *Delle lettere,* 1:172, 230, 2:196. In the letters to Gianfrancesco Lione (Leone), Tolomei lamented Manzuoli's absence; in the letter to Manzuoli, he urged him to return to Rome for study of the final books of Vitruvius (2:197). In none of these letters did he actually refer to "nostra compagnia" as the Accademia della Virtù. By 1547 Tolomei had given up his academy to move to Parma in the service of Pier Luigi Farnese, leaving his Vitruvian project incomplete; see Sbaragli, *Tolomei,* 75, 81. Yet another architectural project proposed by Tolomei, in 1544, was a new fortified city to be built beside the Mediterranean in Sienese territory; see Claudio Tolomei, *Della edificazione d'una città sul Monte Argentario: Ragionamenti di Claudio Tolomei e Pietro Cataneo (1544–1547)* (Florence: Tipografia dell'Arte della Stampa, 1885).

63. Pier Nicola Pagliara, "Vitruvio da testo a canone," in *Memoria dell'antico nell'arte italiana,* ed. Salvatore Settis, 3 vols. (Turin: Einaudi, 1986), 3:72. Ignazio Danti reported that Vignola left Rome in 1537. Vignola's biographer Anna Maria Orazi proved that he did not go to Rome until 1539–40 and argued that the drawings he did there were part of his own architectural projects and not connected with any academy. The Tolomei academy, she believed, was devoted exclusively to problems of language; see Anna Maria Orazi, *Jacopo Barozzi da Vignola, 1528–1550, apprendistato di un architetto bolognese* (Rome: Bulzoni, 1982), 95–8. It was Manzuoli who later recommended Vignola as an architect to Pier Luigi Farnese, however.

64. Fantuzzi, *Notizie,* 7:402, and Francesco Milizia, *Memorie degli architetti antichi e moderni,* 2 vols., 4th ed. rev. (Bassano: A spese Remondini di Venezia, 1785), 1:260.

65. Philandrier went to Venice as a courtier in the train of the French ambassador and bishop of Rodez, Georges d'Armagnac; see Loredana Olivato, "Dal Teatro della memoria al grande teatro dell'architettura: Giulio Camillo Delminio e Sebastiano Serlio," *Bollettino del Centro internazionale di studi di architettura Andrea Palladio* 21 (1979): 245–6, and Milizia, *Memorie,* 2:22. After he returned to France, Philandrier became archdeacon of Rodez, a commentator on Quintilian, and a friend of Rabelais and of the Pléiade poets; see Pierre de Nolhac, *Ronsard et l'Humanisme,* Bibliothèque de l'Ecole des Hautes Etudes 227 (Paris: Champion, 1921), 281–2, 287, 292. The Franciscan Francesco Giorgio worked out his *De harmonia mundi totius* (1525) from Neoplatonic theories of harmony and geometry and musical proportions; he served as consultant after 1534 for the program of Jacopo Sansovino's design for San Francesco della Vigna in Venice; see Rudolf Wittkower, *Architectural Principles in the Age of Humanism,* 3d ed. rev. (New York and London: Norton, 1971), 102–7.

66. Serlio's will was witnessed by Alessandro Citolini and the painter Lorenzo Lotto; see Loredana Olivato, "Per il Serlio a Venezia: Documenti nuovi e documenti rivisitati," *Arte Veneta* 25 (1971): 285. Presumably Serlio had not yet married.

67. J.-C. Margolin, "Erasme et Mnemosyne," in Margolin, *Recherches Erasmiennes* (Geneva: Droz, 1969), 80–1.

68. Sebastiano Serlio, "A li Lettori," in *Il Terzo Libro nel qval si figvrano e descrivono le antiqvità di Roma e le altre che sono in Italia e fvori d'Italia . . .* (Venice: Impresso per F. Marcolino, 1540), fol. clv.

69. Quadrio, *Della storia,* 1:62, 68, 85, 94, and the "Chronology of Dated Events Mentioned in Papers," in *The Fairest Flower: The Emergence of Linguistic National Consciousness in Renaissance Europe: International Conference of The Center for Medieval and Renaissance*

*Studies, University of California, Los Angeles, 12–13 December 1983,* and *[ Atti del Congresso Internazionale per il ] IV Centenario dell'Accademia della Crusca* (Florence: Presso l'Accademia, 1985), 203.

70. Eric Cochrane, "The Renaissance Academies in Their Italian and European Setting," in *The Fairest Flower,* 23–5; Armand L. De Gaetano, "The Florentine Academy and the Advancement of Learning through the Vernacular: The *Orti Oricellari* and the *Sacra Accademia," Bibliothèque d'Humanisme et Renaissance* 30 (1968): 29–31, 35; and Emilio Sanesi, "Dell'Accademia fiorentina nel'500," *Atti e memorie dell'Accademia Toscana di Scienze e Lettere la Colombaria* (1936): 226.

71. Prodi, *Il Cardinale Gabriele Paleotti,* 1:58–62.

72. Maylender, *Storia delle Accademie,* 1:187–8, 5:193.

73. Prodi, *Il Cardinale Gabriele Paleotti,* 1:49.

74. Fantuzzi, *Notizie,* 2:163–5. Several works by the Modenese Claudio Betti, who taught philosophy and medicine from 1545 to 1581 in Bologna, were associated with his activities in the Gelati; see G. Stabile, "Betti, Claudio, detto Betto giovane," *DBI,* 9:713–14. Others said that it was founded by Melchiorre Zoppio in his own home in 1588 (Quadrio, *Della storia,* 1:56), so there may have been a break in its activities.

75. Francesco Bolognetti, *Lettera inedita del Senatore Francesco Bolognetti di Bologna,* ed. Conte Tommaso Piccolomini Adami (Orvieto: Marsili, 1886), 5; Quadrio, *Della storia,* 1:55–6; and Mazzuchelli, *Gli scrittori,* 2:3:1483. Bolognetti probably belonged to Bocchi's academy in 1556, but he was a cousin of the Paleotti brothers as well.

76. The Peregrini was founded by Cirillo Franco to promote letters and erudition; see Fantuzzi, *Notizie,* 3:360–1. For lists of Bolognese academies also see Girolamo Tiraboschi, *Storia della letteratura italiana,* 9 vols. in 15 (Venice: Molinari, 1823–5), 7:1:200–2; Alessandro Montevecchi, "La cultura del Cinquecento," in *Storia della Emilia Romagna,* ed. Aldo Berselli, 3 vols. (Bologna: University Press, 1976–80), 2:559; and Amadeo Quondam, "La scienza e l'Accademia," in *Università, accademie e società scientifiche in Italia e in Germania dal Cinquecento al Settecento,* ed. Laetitia Boehm and Ezio Raimondi, Annali dell'Istituto storico italo-germanico, Quaderno 9 (Bologna: Il Mulino, 1981), 32, 39. Thomas Frederick Crane thought that there was also an academy called the "Ritruovati" flourishing in 1551 (*Italian Social Customs of the Sixteenth Century and Their Influence on the Literatures of Europe,* Cornell Studies in English 5 [1920; reprint, New York: Russell & Russell, 1971], 285). James Haar, however, has shown this to be a misreading of the title page of Innocenzio Ringhieri's *Cento Givochi Liberali* (Bologna, 1551); see "On Musical Games in the Sixteenth Century," *Journal of the American Musicological Society* 15 (1962): 26.

77. Mario Fanti, ed., *Notizie e insegne delle accademie di Bologna da un manoscritto del secolo XVIII* (Bologna: Rotary Club del Bologna Est, 1983). Bocchi's academy was included in this manuscript (44–5).

78. Gustav C. Knod, *Deutsche Studenten in Bologna (1289–1562): Biographischer Index zu den Acta Nationis Germanicae Universitatis Bononiensis* (1889; reprint, Darmstadt: Scientia Verlag Aalen, 1970), 298. Lemnius died of plague in Chur in 1550; see Vincenzo Lancetti, *Memorie intorno ai poeti laureati d'ogni tempo e d'ogni nazione* (Milan: Pietro Manzoni, 1839), 423–4. One source gave the founding date of the Bocchiana as 1522, but without supporting evidence and in a section on academies that was riddled with errors; see Giuseppi Guidicini, *Cose notabili della città di Bologna, ossia Storia cronologica de' suoi stabili publici e privati,* ed. Ferdinando Guidicini, 5 vols. (Bologna: Vitali, 1868–73), 1:382.

79. Quoted in Paul Merker, *Simon Lemnius: Ein Humanistleben* (Strassburg: Trübner, 1908), 91–2.

80. Umberto Pirotti, *Benedetto Varchi e la cultura del suo tempo* (Florence: Olschki, 1971), 18–20; Leatrice Mendelsohn, *Paragoni: Benedetto Varchi's Due Lezzioni and Cinquecento Art Theory* (Ann Arbor, MI: UMI Research, 1982), 23; and Cochrane, "Le accademie," 185–7.

81. Benedetto Varchi, "Ad Eundem" [Cesare Ercolani], in *Carmina Qvinqve Hetrvscorvm Poetarvm* (Florence: In Apud Ivntas, 1562), 154. Other Bolognese scholars praised in this poem – and identifiable as Bocchi's *sodales* – included Leandro Alberti, Pompilio Amaseo (Romolo's son, also a teacher of rhetoric at the Studio), Sebastiano Regulo, Ulisse Aldrovandi, and the poet Marco Tullio Berò, followed by a list of Varchi's own *sodales;* see Pirotti, *Benedetto Varchi,* 52n.

82. Florindo V. Cerreta, "An Account of the Early Life of the Accademia degli Infiammati in the Letters of Alessandro Piccolomini to Benedetto Varchi," *Romanic Review* 48 (1957): 249–50.

83. Sorbelli, *Storia della stampa,* 99.

84. Bologna. Bibl. Univ. Cod. Lat. 304, fol. 18v, p. 1.

85. Anton Francesco Doni, *La Libraria,* ed. Vanni Bramanti (Milan: Longanesi, 1972), 410. However, then followed "L'Academia Bocchiale, detto Hermateno" (Masini, *Bologna perlvstrata,* 1666, 1:155), "Accademia Bocchi detta Ermatena" (Orlandi, *Notizie degli Scrittori Bolognese,* 1714, 28), "Accademia bocchi o Bocchia detta anche *Ermaténa*" (Mazzuchelli, *Gli scrittori,* 1753, 2:3:1389), "Accademia Bocchiana" (Tiraboschi, *Storia,* 7:1:200), and, in Maylender (*Storia delle Accademie,* 1:452), "Accademia Bocchiana" and variants "Ermatena," "Hermathena," and "Bocchiale."

86. For example, was the "academia di Bologna" that attacked Ortensio Landi with "dui sonettuzzi e quattro ballattette" Bocchi's, or was it Gabriele Paleotti's Affumati or the Sonnachiosa? See Ortensio Landi, *Paradossi Cioe Sententie Fvori Del Comvn Parere . . .* (Venice, 1545), fol. 71v. The Affumati may not have been in existence after 1543, but either of the latter was more likely to have been involved in vernacular quarrels. Was the academy described by Bartolommeo Ricci in an undated letter (probably from the late 1550s) as "in Bononiae celeberrima Academia" and in a 1556 letter to Bocchi's friend Francesco Bolognetti (whose Accademia Conviviale may or may not have been meeting this early) as "vestra Bononiensis academia" also Bocchi's academy? See Bartolommeo Ricci, *Epistolarvm Familiarvm Lib. IIII* (Venice, 1562), 1:11r, 14v. Bolognetti, a cousin of Camillo and Gabriele Paleotti, may also have been a member of the Affumati; see R. Cesarini, "Bolognetti, Francesco," *DBI,* 11:320. Because as an interlocutor Ricci had praised Bocchi's academy in Lilio Gregorio Giraldi's *De Poetis svorvm temporvm,* Dialogvs II (in *Opera Omnia* [Louvain: Apud Hackium, Boutesteyn, Vivie, Vander AA & Luchtmans, 1696], col. 505), Ricci's comments may well refer to the Academia Bocchiana.

87. Bocchi also shared the responsibilities of the academy with Romolo Amaseo and, after Amaseo left for Rome, with Sebastiano Corrado (Amaseo's successor in the chair of rhetoric until 1555) and Pompilio Amaseo. Caelio Calcagnino died in 1541; his letters to Tommaso show a strong interest in hieroglyphs, emblems, and other topics popular in Bologna; see Caelio Calcagnino, "De rebvs aegyptiacis commentarivs," in *Opera aliqvot* (Basel: Froben, 1544), 1–46, 228–52. Alberico Longo, who spent many years studying and collecting in Greece, was in Bologna from July 1549 until his murder there in 1555; see Giuseppe Coluccia, "Un inedito petrarchista salentino del '500: A. Longo," *Critica letteraria* 3 (1975): 104–6. Rotondò ("Bocchi," 11:69) listed Odone as a *principe,* but I could find no biographical data for him. Some academies also had a *censore* to ensure conformity to the academy's standards of language (Italian) and style; Benedetto Varchi held such a post in the Infiammati, according to Cochrane ("Le accademie," 10).

Cochrane (7) and De Gaetano ("The Florentine Academy," 28) suggested that the structure of sixteenth-century academies may have been patterned after the lay confraternities; also see Martin Lowry, "The Proving Ground: Venetian Academies of the Fifteenth and Sixteenth Centuries," in *The Fairest Flower*, 42–4.

88. Michel de L'Hospital composed a verse epistle, "Ad Achillem Bocchium, Equitem Bononiensem, et Praestantem Poetam, De Fide Cristiana." For L'Hospital, see Michel de L'Hospital, *Oeuvres complètes*, ed. P. S. S. Duféy, 3 vols. (Paris: Boulland, 1824–5), 1:64–5, 3:67–70; *Poésies complètes du Chancelier Michel de L'Hospital*, trans. Louis Bandy de Nalèche (Paris: Hachette, 1857), 32–5; and Marcel Jardonnet, "Michel de l'Hospital, poète néo-latin et humaniste," *L'Auvergne littéraire, artistique et historique* 35 (1958): 13, 49, 107. For d'Urfé, see Olga Raggio, "Vignole, Fra Damiano et Gerolamo Siciolante à la Chapelle de La Bastie d'Urfé," *Revue de l'art* 15 (1972): 29–52, and Jean Canard, *Urfé; hier et aujourd'hui: Histoire et histoires* (n.p.: Imprimé par l'auteur, 1973), 48. Both d'Urfé and L'Hospital were honored in odes by Pierre Ronsard; see Carol Maddison, *Apollo and the Nine: A History of the Ode* (Baltimore: Johns Hopkins University Press, 1960), 233, 238–48, and Isidore Silver, *Ronsard and the Greek Epic*, vol. 1 of *Ronsard and the Hellenic Renaissance in France* (St. Louis: Washington University, 1961), 210.

89. Members of the academy, according to Maylender, were A. Longo, Camillo Pori, M. Vincenzo Fontana, Costantino Brancaleo, Mons. Gio. Battista Campeggi, and Pietro Stufa (*Storia delle Accademie*, 1:452–3). L. E. Dupré believed that L'Hospital met Piero Vettori, Lilio Giraldi, Marcantonio Flaminio, and Antonio Agustin at Bocchi's academy (*Michel de l'Hospital*, 1:124–5, 2:183), but L'Hospital probably met Flaminio in Rome rather than Bologna. He may already have known many Italians from his student days in Padua (1526–32) and in Rome and Bologna in 1533 (Maddison, *Apollo*, 228n, and L'Hospital, *Oeuvres*, 2:504).

90. Doni, *Libreria*, 410.

91. Orlandi, *Notizie*, 28–9. Also see Mazzuchelli, *Gli scrittori*, 2:3:1389; Tiraboschi, *Storia*, 7:1:200–2; and Maylender, *Storia delle Accademie*, 1:452. Rotondò, however, is careful not to make this claim ("Bocchi," 9:69).

92. Sorbelli, *Storia della stampa*, 105–6, 119. Maylender claims Sambiguccio published a "Discorso" at the academy in 1556; I can find no confirming bibliographical sources and must assume that Maylender was referring to the Manuzio edition.

93. According to Cochrane, the early academies comprised a diverse body of merchants, priests, teachers, and administrators ("Le accademie," 7).

94. Rotondò, "Bocchi," 11:69.

95. For Alciato, see Roberto Abbondanza, "Alciato, Andrea," *DBI*, 2:69–77, and Abbondanza's "Una inedita prolusione bolognese di Andrea Alciato," *Annali di storia del diritto* 3–4 (1959–60): 399–400.

96. Carlo Dionisotti viewed this "attività collettiva" of the ideal academy of around 1540 as corresponding in some real way to the function of the Council of Trent; see "La letteratura italiana nell'età del Concilio di Trento," in Dionisotti, *Geografia e storia della letteratura italiana* (Turin: Einaudi, 1967), 190.

97. Milan, Ambros., Cod. Lat. D145 inf., fol. 7v. Each of these men contributed poems to the *Symbolicae Quaestiones*: Symbols II (Foscarari) and CXLV (Longo), and there are dedicatory poems to the 1555 edition by each of the three (*Symbolicae Quaestiones*, 1555, fols. 23r–26r). For Foscarari (1485–1552), the intended recipient of Symbol LIIII, see Fantuzzi, *Notizie*, 3:355–6, and for Longo, see Coluccia, "Un inedito petrarchista salentino," 102–8. Camozzi (Camoteus; 1515–81) was Bocchi's colleague in rhetoric for the year 1549/50 and then held the chair of philosophy in the Spanish College of Bologna from 1550 to 1555. His lengthy dedicatory poem in Greek and the two emblems Bocchi

dedicated to him (Symbols CXXXIIII and CXXXVII) show the two scholars to be very close in their mystical philosophy. For Camozzi, see P. Schreiner, "Camozzi (Camosio), Giovanni Battista," *DBI*, 17:297–8.

98. After proclaiming that Bocchi's fame has reached across the Alps, L'Hospital's verse epistle proceeds to topics from symbols Bocchi was working on by early 1548 (especially Symbols CIII and CXXXII): "Quas animi tenebras, tanquam sol lucidus, olim / Discutit alma fides, vel, si quis dicere malit, / Mens accensa fide!" (see *Oeuvres complètes*, 3:67, lines 17–19). Petrus Lotichius Secundus and Johannes Sambucus were in Bologna as students from 1555 to 1556, according to Stephen Zon, *Petrus Lotichius Secundus, Neo-Latin Poet*, American University Studies, ser. 1, Germanic Languages and Literatures 13 (New York, Frankfort, and Berne: Lang, 1983), 294–5, 306, 311. The poem by Lotichius which begins "Musis amica, dedicata Gratiis / Flos vrbium, Bononia," was published in Book II of his *Poemata Qvae Exstant Omnia*, ed. Petrus Burmannus Secundus and Christianus Fridericus Quellius (Dresden: Gerlach Vidvam et Fil., 1773), 435. Sambucus (Janos Sámboky, or Zsámboky), who said Bocchi was like a second father to him, dedicated "Deum potes viue" to Bocchi in his *Emblemata, Cvm Aliqvot Nvmmis Antiqvi Operis* (Antwerp: Ex Officina Christophori Plantini, 1564), 76–7.

99. Mendelsohn discusses the academies' tendency to employ "collectively certain techniques commonly found in lectures" to harmonize them with "an essentially neo-Platonic ideology": "Like sonnets based on a single formula, the lectures often sound nearly indistinguishable from one another, even though their titles promise different subjects" (*Paragoni*, 17). Because lectures in Bocchi's academy were delivered in Latin rather than in the Italian many then were seeking to perfect, there may have been less pressure to produce lectures in complete conformity to a set of rules.

100. Benzoni, *Gli affani*, 187–8. Selections from this text are provided in Italian in Maylender, *Storia delle Accademie*, 1:453. Also see Mario Praz, *Studies in Seventeenth-Century Imagery*, vol. 1, 2d ed. enl. (1964; reprint, Rome: Edizioni di Storia e Letteratura, 1975), 486.

101. Bologna, Archiginnasio, Ms. B.1513. The Venetian Delfino (later bishop of Torcello) may have shared Bocchi's interest in architecture: A 1569 Latin edition of Sebastiano Serlio's *De Architectvra Libri Quinque* was dedicated to him by its translator, Giovanni Carlo Saraceno. His *Dialectica* was published in Bologna in 1555; see Buisson, *Répertoire*, 198.

102. Milan, Ambros., D145 inf., fols. 3r–4r. Although Bocchi did not employ a line-by-line commentary in this letter, he may have done so when delivering a public self-commentary.

103. Maylender, *Storia delle Accademie*, 1:452; and Walter Moretti and Renato Barilli, "La letteratura e la lingua, le poetiche e la critica d'arte," in *Il Cinquecento dal Rinascimento alla Controriforma*, ed. Nicola Badaloni et al., vol. 4:2 of *La letteratura italiana, storia e testi* (Rome and Bari: Laterza, 1973), 532. Among Caro's letters fulminating against Castelvetro, a few mentioned the academy of Alberico Longo and others in Bologna, although Bocchi was never named; see Annibale Caro, *Lettere familiari*, ed. Aulo Greco, 3 vols. (Florence: Le Monnier, 1957–9), 2:183, 186–91, 195–7 (Letters 431, 434, 440). Benedetto Varchi in his *L'Ercolano* ... (ed. Maurizio Vitale, 2 vols. [Milan: Cisalpino-Goliardica, 1979], 1:12–13) mentioned the rumor as not believed by anyone, and he warned readers to be cautious in the presence of rumor.

104. The other three for Bologna (there were separate lists for other Italian cities) were Ludovico Vitale, Niccolò Simo, and Hannibale dalla Nave, all teachers of mathematics and astronomy at the Studio of Bologna; see Ferrari and Tartaglia, *Cartelli di sfida matematica*, lxv, lxxxii, 11. Jean-Claude Margolin pointed out that the renewal of the study of mathematics came about as a response to philological humanism and was,

therefore, a cultural movement rather than a scientific one; see Margolin, "L'Enseignement des mathematiques en France (1540–70): Charles de Bovelles, Fine, Peletier, Ramus," in *French Renaissance Studies, 1540–70: Humanism and the Encyclopedia,* ed. Peter Sharratt (Edinburgh: University Press, 1976), 140–2.

105. Although there was a clear tendency for academies to become more specialized and narrow in scope (see, for example, Paul F. Grendler, *Critics of the Italian World (1530–1560): Anton Francesco Doni, Nicolò Franco & Ortensio Lando* (Madison, Milwaukee, and London: University of Wisconsin Press, 1969), 140), even those with a specialized mission allowed themselves considerable flexibility and breadth (Cochrane, "Renaissance Academies," 32). According to Cesare Vasoli, the academies developed "new forms of elaboration and transmission of knowledge" but were confused and uncertain about the scope of their activities. Especially influential was Giulio Camillo who helped spread Northern ideas of dialectic and rhetoric in Italy and whose Memory Theater encouraged academies to develop encyclopedic and systematic cultural programs; see Vasoli, "Le accademie fra Cinquecento e Seicento e loro ruolo nella storia della tradizione enciclopedica," in *Università, accademie e società scientifiche in Italia e in Germania del Cinquecento al Settecento,* ed. Laetitia Boehm and Ezio Raimondi, Annali dell'Istituto Storico Italo-germanico, quaderno 9 (Bologna: Il Mulino, 1981), 83, 104–5, 107.

106. According to Thomas F. Crane, "The social and convivial element played a large part in the meetings of the bodies, in many of which women assisted both by their presence and active participation" (*Italian Social Customs,* 143, 145).

107. A document of January 5, 1543, recorded an agreement between the painter Prospero Fontana (who later decorated the meeting room of Bocchi's academy) and Gabriele Paleotti and Armodio de Santi for Fontana to provide set and costumes for the Affumati's comedy; see Prodi, *Il Cardinale Gabriele Paleotti,* 1:60.

108. Innocenzio Ringhieri, *Cento Givochi Liberali, Et D'Ingegno* (Bologna: Ansel. Giacarelli, 1551), fol. 137r. Ringhieri, whose adult career spanned roughly the period between 1543 and 1558, provides us with a collection of games republished twice and translated in part into French in 1555 (Fantuzzi, *Notizie,* 7:194–6). Games had long been a part of the villa retreat, and their absence in fifteenth-century meetings of Florentine scholars at the villa of Franco Sachetti was unusual enough to be noted by Vespasiano da Bisticci; see Coffin, *The Villa,* 11.

109. Ringhieri, *Cento,* fols. 46v–57r, 58r.

110. Romeo De Maio, in *Michelangelo e la Controriforma* (Rome and Bari: Laterza, 1978), credited Ringhieri with being among the first to place Michelangelo among the top-ranking Italian painters (173). Bocchi also praised Michelangelo in his Symbol CXXXII, a poem dedicated to Amaseo and written by 1547 (Milan, Ambros., Lat. D145 inf., fol. 6r). On Ringhieri's game, see also Cecil L. Striker, "Innocenzio Ringhieri's *Giuoco della pittura,*" in *Essays in Honor of Walter Friedlaender,* Marsyas Supplement 2 (New York: Institute of Fine Arts, New York University, 1965), 165–76.

111. Ringhieri, *Cento,* fols. 149v–151v, 159r–160v. Ringhieri, however, did not stress *imprese*-related games as much as Girolamo Bargagli did in his better-known collection, *Dialogo De' Givochi Che Nelle Vegghie Sanesi Si Vsano Di Fare.* Del Materiale Intronato (Siena: Per Luca Bonetti, 1572). This work of Bargagli (1537–86) was written earlier, as a youthful response to his participation in the Accademia Intronata of Siena; see N. Borsellini, "Bargagli, Girolamo," *DBI,* 6:342–3. Bargagli reported that the game of *imprese* and that of proverbs were the most frequently played in Siena (Dialogo, 140).

112. Ringhieri, *Cento,* fols. 55r–56r; Vasoli, "Le accademie," 96, and "Contributo alla bibliografia delle opere di Ulisse Aldrovandi," in *Intorno alla vita e alle opere di Ulisse Aldrovandi* (Bologna: Libreria Treves di L. Beltrami, 1907), 69–139. Pythagorean games

go back at least a century: The Florentine academician Cosimo Bartoli translated Leon Battista Alberti's *Ludi matematici* into Italian, and LeFèvre d'Etaples published a "Rithmomachia" game in his *Arithmetica* in 1496; see Vasoli, "Le accademie," 98–9, and S. K. Heninger, *Touches of Sweet Harmony: Pythagorean Cosmology and Renaissance Poetics* (San Marino, CA: Huntington Library, 1974), 58, 67. Some of these games may have been devised as teaching aids for younger students in the academies, as was Thomas Murner's *Chartiludium Logicae,* a card game to teach logic published first in 1507; see W[eis]s, "Murner (Thomas)," in *Biographie Universelle (Michaud) ancienne et moderne,* 29:614–15.

113. Coffin, *The Villa,* 10.

114. Alberti, *Historie di Bologna,* sig. Eiiir. A tiny sketch of the Vado de Bocchi made in the year 1578 appears in the anonymous MS "Gozzadino 171" in the Biblioteca Communale dell'Archiginnasio of Bologna, published in Mario Fanti, ed., *Ville, castelli e chiese bolognesi da un libro di disegni del Cinquecento* (Bologna: Forni, 1967), 51, and fig. 88. The "Vado" was a ford in the stream that ran along the property. The villa and its dovecote no longer exist, and their exact position is unknown; they probably sat on the edge of what is now the fairgrounds of Bologna. Bocchi wrote an early poem (ca. 1520) "In Vado Bocchiano," which begins "Dulcis frondosi dum carpimus ocia ruris" (*Lvsvvm Libri Dvo*), fols. 56r–57r.

115. Guido Zucchini, "Una palazzina bentivolesca colpita e ricostruita," in *Atti del V Convegno Nazionale di Storia dell'Architettura, Perugia, 23 Settembre 1948* (Florence: Noccioli, 1957), 650. Zucchini theorized that a document and three faïence plates with the Bocchi coat of arms (made between 1520 and 1530) that were found during a restoration project in 1916 link the Bocchi family to the Palazzina, but there is no way to determine which branch of the family used the property. The Palazzina was purchased in 1540 by Cardinal Legate Bonifacio Ferrario for five thousand scudi to house the Collegio della Viola for Piedmontese students and is now owned by the University of Bologna (Zucchini, "Una palazzina," 649–50, and Fantuzzi, *Notizie,* 3:189).

116. The "domus academica" may have been suggested in part by a description of an ideal (though nonurban) school, a "domus scholastice discipline," in the *Rhetorica novissima* of Boncompagno da Segni; see Eugenio Garin, "Introduzione," in *Il pensiero pedagogico dello Umanesimo,* ed. Eugenio Garin (Florence: Giuntino & Sansoni, 1958), xxii. Also, Bocchi may have heard through Leandro Alberti of Giovanni Caroli of Santa Maria Novella in Florence calling the Dominican community there a "templum-domus"; see Salvatore I. Camporeale, O.P., "Giovanni Caroli e le 'Vitae Fratrum S. M. Novellae': Umanesimo e crisi religiosa (1460–1480)," *Memorie domenicane,* n.s., 12 (1981): 183, 185.

117. Guido Zucchini, "Il Vignola a Bologna," in *Memorie e studi intorno a Jacopo Barozzi pubblicati nel IV centenario dalla nascita,* Per cura del Comitato preposto alle onoranze (Vignola: Monti, 1908), 240–2.

118. The Vitruvian term *orthographia* refers to a frontal view of the facade of a building. The 1545 engraving exists in three copies, each representing a different state of the engraving process and each dedicated to Paul III (pope, 1534–49). The second of the series identifies a publisher, Gian Francesco Camocis. Stefania Massari attributed the 1545 engraving to Jacopo Barozzi da Vignola and an altered 1555 engraving (dedicated to Pius IV) to Giulio Bonasone; see *Giulio Bonasone,* Catalogo di Stefania Massari, Ministero per i beni culturali e ambientali, Istituto nazionale per la grafica-calcografia, 2 vols. (Rome: Edizioni Quasar, 1980), 1:52–3, pl. 41–2.

119. Zucchini, "Il Vignola," 211, 239–41.

120. Orazi, *Jacopo Barozzi,* 184–5, 242–4. Besides Orazi, see the following studies of the Palazzo Bocchi: Francesco Malaguzzi Valeri, *L'architettura a Bologna nel Rinascimento*

(Rocca S. Casciano: Cappelli, 1899), 193; Umberto Beseghi, *I palazzi di Bologna* (Bologna: Tamari 1957), 207–12; Maria Walcher Casotti, *Il Vignola,* 2 vols., Università degli Studi di Trieste. Facoltà di Lettere e Filosofia, Pubblicazioni 11 (Trieste: Istituto di Storia dell'Arte Antica e Moderna, 1960), 1:60–3, 143–6; Johann Karl Schmidt, "Zu Vignolas Palazzo Bocchi in Bologna," *Mitteilungen der Kunsthistorisches Institut in Florenz* 13 (1967): 83–94; Giampiero Cuppini, *I palazzi senatorii a Bologna: Architettura come immagine del potere* (Bologna: Zanichelli, 1974), 27; Naomi Miller, "La 'retorica' come chiave di interpretazione dell'architettura bolognese (1380–1565)," *Il Carrobbio* 5 (1979): 319–46; Daniela Monari, "Palazzo Bocchi e l'opera rustica secondo il Vignola," in *Natura e artificio: L'ordine rustico, le fontane, gli automi nella cultura del Manierismo europeo,* ed. Marcello Fagiolo (Rome: Officina, 1979), 113–28; Monari, "Palazzo Bocchi: Il quadro storico e l'intervento del Vignola," *Il Carrobbio* 6 (1980): 263–71; and Giancarlo Roversi, *Palazzi e case nobili del '500 a Bologna: La storia, le famiglie, le opere d'arte* (Bologna: Grafis, 1986), 46–59.

121. Egnazio Danti, "Vita di M. Iacomo Barrozzi da Vignola..." in Jacopo Barozzo da Vignola, *Le due regole della prospettiva pratica* (1633; reprint, Bologna: Arte Grafiche Tamari for Cassa di Risparmio di Vignola, 1974), fol. 3v. For a summary of scholarly comments on the architect of the Palazzo Bocchi, see Roversi, *Palazzi,* 54–6.

122. Malaguzzi Valeri, *L'architettura a Bologna,* 193; I. B. Supino, *L'arte nelle chiese di Bologna,* 2 vols. (Bologna: Zanichelli, 1932–8), 2:32; and Walcher Casotti, *Il Vignola,* 1, 143.

123. Roversi, *Palazzi,* 54.

124. On Vignola's style in relation to the Palazzo Bocchi, see especially Orazi, *Jacopo Barozzi,* 226–37, and Monari, "Palazzo Bocchi e l'opera rustica," 115–20.

125. Serlio began publishing his work in parts in 1537, but Bocchi may have had access to prints or drawings by Serlio before 1540 through Serlio's school in Venice. Serlio and the engraver Agostino Veneziano had also turned out a series of engraved plates of architectonic orders as early as 1528 (now in the Albertina Museum in Vienna); see Loredana Olivato, "La scena dell'architettura: I fondamenti teorici della prassi," in *Architettura e utopia nella Venezia del Cinquecento, Venezia, Palazzo Ducale, Luglio-Ottobre 1980,* ed. Lionello Puppi (Milan: Electa, 1980), 172.

126. Lib. IV, Cap. VII, cited in Gabriele Morolli, "'A quegli idei selvestri': Interpretazione naturalistica, primato e dissoluzione dell'ordine architettonico nella teoria cinquecentesca sull'Opera Rustica," in *Natura e artificio,* 66. Serlio was the first writer to identify Tuscan as a separate order from the Doric (60).

127. Not only the antiquity of the style but also the overtones of the sacred attributed to Etruscan buildings and the supposed ties between Etruscans and the ancient Jews would have appealed to a student of "prisca theologia"; see Morolli, "*Vetus Etruria,*" 97. Vignola was to use Tuscan elements for the Farnese family, first in the Villa Giulia of Julius III in Rome and later for Cardinal Alessandro Farnese's villa at Caprarola – both of these churchmen were patrons of Bocchi's academy. Also, and even more striking, is the resemblance between the *piano nobile* of Bocchi's palazzo and that of the Cardinal Del Monte palazzo by Sansovino in Monte San Savino. Monte San Savino is itself near Arezzo, the provenance of an Etruscan burial urn (now in the Museo Archeologico in Florence) that has the same architectural motif of alternating round and angled window cornices as the two palaces of Bocchi and Del Monte. Morolli described the Palazzo del Monte as "severo e ortodosso tuscanico" in style, but he did not mention the Etruscan urn ("*Vetus Etruria,*" 140). The architectural burial urn as a source of Renaissance architecture has scarcely been noticed. Several other Etruscan urns evoke Florentine buildings, most notably Leon Battista Alberti's Palazzo Rucellai; see C. C. Van Essen,

"Elementi etruschi nel Rinascimento toscano," *Studi etruschi* 13 (1939): 497–9, pl. XLIII–XLV.

128. Sebastiano Serlio, *Tvtte L'Opere D'Architettvra, Et Prospetiva, Di Sebastiano Serlio Bolognese,* ed. Gio. Domenico Scamozzi Vicentino (1619; reprint, Ridgewood, NJ: Gregg, 1964), fols. 143r, 153r–155r. Other decorative details link Serlio and Bocchi's ideal palace, especially the ornamental frieze containing *bucrania* (ox skulls), fol. 117r.

129. Serlio, *Tvtte,* fol. 126v.

130. It is not clear where the criticism originated. Vignola was always more cautious than Serlio in combining styles. Conservative Bolognese taste, however, would not have appreciated the revised version either, because it omitted the traditional ground-level arcade for pedestrians and evoked a style favored in the rival province of Tuscany.

131. James S. Ackerman, "Sources of the Renaissance Villa," in *The Renaissance and Mannerism,* vol. 2 in *Studies in Western Art: Acts of the Twentieth International Congress of the History of Art* (Princeton, NJ: Princeton University Press, 1963), 11, and also the general treatment of cubic structures in G. L. Hersey, *Pythagorean Palaces: Magic and Architecture in the Italian Renaissance* (Ithaca, NY, and London: Cornell University Press, 1976).

132. A sketch of the ground-floor plan can be found in *La vita e le opere di Jacopo Vignola,* 51.

133. Johann Kepler's *Harmonices mundi,* Book 5, for example, compared five regular geometric solids to elements, with the cube as earth; see Heninger, *Touches of Sweet Harmony,* 108. On cubic stability and architecture, see Vitruvius Pollio, *Vitruvius on Architecture,* ed. and trans. Frank Granger, 2 vols., Loeb Classical Library (Cambridge, MA: Harvard University Press; London: Heinemann, 1970), 1:253; and Lise Bek, *Towards Paradise on Earth: Modern Space Conception in Architecture, a Creation of Renaissance Humanism,* Analecta Romana Instituti Danici 9 (Odense: Odense University Press, 1980), 242.

134. The concept of the quadrate man as a good man derived from Simonides of Cos as cited in Plato, Aristotle, and other ancients and was linked to four-sided herms that were seen as stable and firm in their early signpost function; see Arnold Ehrhardt, "Vir Bonus Quadrato Lapidi Comparatur," *Harvard Theological Review* 38 (1945): 177–93. Erasmus chose as his personal *impresa* the quadrate god Terminus and included the proverb "Quadratus homo" in his *Adagia;* see William S. Heckscher, "Goethe im Banne der Sinnbilder: Ein Beitrag zur Emblematik," in *Emblem und Emblematikrezeption: Vergleichende Studien zur Wirkungsgeschichte vom 16. bis 20. Jahrhundert,* ed. Sibylle Penkert (Darmstadt: Wissenschaftliche Buchgesellschaft, 1978), 362–3 (Heckscher cites Bocchi's Symbol XLVIII on the association between the square and good men, 366–7).

135. Francesco Colonna, *Hypnerotomachia Poliphili, Venice, 1499* (reprint; New York and London: Garland, 1976), sigs. Ciiir, Giiii$^v$; Maurizio Calvesi, *Il sogno di Polifilo prenestino* (Rome: Officina, 1980), 102; and Bek, *Towards Paradise,* 28, 242.

136. This raises questions about the creator of the engraving, who probably was not Vignola. Serlio had himself inherited the collection of drawings made by his late teacher, Baldassare Peruzzi, who had worked in Bologna and whose palaces, especially the Albergati and Lambertini, may have influenced Bocchi.

137. Gian Giorgio Trissino, *Tutte le opere di Giovan Giorgio Trissino . . .* (Verona: Vallarsi, 1729), 1:xi, and Wittkower, *Architectural Principles,* 59. John F. D'Amico (*Renaissance Humanism in Papal Rome: Humanists and Churchmen on the Eve of the Reformation* [Baltimore: Johns Hopkins University Press, 1983], 86–7) reported that M. Maffei had also been called on to supervise the rebuilding of St. Peter's and the completion of the Villa Madama in Rome after the death of Raphael.

138. Calvesi, *Il sogno,* 57–60; Ackerman, "Sources," 11; and David R. Coffin, "Pope

Marcellus II and Architecture," *Architectura, Zeitschrift für Geschichte der Baukunst* 9 (1979): 11–29. Aleandro, in a 1540 letter, specified that his stairway ("una bella scala di pietra viva") must run from the bottom to the top of the house and that the kitchen must be moved to enlarge the portico; see Girolamo Aleander, *Lettres familières de Jérome Aléandre (1510–1540)*, ed. J. Paquier (Paris: Picard, 1909), 176–7. Bocchi may have acquired a fund of practical knowledge of building in addition to his theoretical knowledge from Vitruvius when the extensive renovations to his "Vado di Bucchi" were made; it is possible that a remodeling project was his link to Serlio, who discussed remodeling and renovation of buildings in his *Libro Settimo*. It is probably no coincidence that Serlio praised as outstanding in their grasp of architecture the two Bolognese – Achille Bocchi and Alessandro Manzuoli – that Leandro Alberti reported as having made extensive renovations to their country properties; see Alberti, *Historie di Bologna*, sigs. Eiiiᵛ–Eivᵛ.

139. For a brief survey of ancient analogies between architecture and verbal structures, see Ellen Frank, *Literary Architecture. Essays toward a Tradition: Walter Pater, Gerard Manley Hopkins, Marcel Proust, Henry James* (Berkeley and Los Angeles: University of California Press, 1980), 149–53. The analogies were especially strong in Claudio Tolomei (*Il Cesano*, 56–7, and *Delle lettere*, 1:106) and in Giulio Camillo Delminio's "Della imitazione [ca. 1530]" (in Bernard Weinberg, ed., *Trattati di poetica e retorica del Cinquecento*, 4 vols., Scrittori d'Italia, no. 247 [Rome and Bari: Laterza, 1970–4], 1:169–70, 178, 184), and they occur both in rhetorical treatises, such as Antonio Lull's *De oratione Libri septem* (Basel: Ioannis Oporinus, 1558), 370–1, and in architectural studies, such as Philibert Delorme's *Architectvre* (1548; reprint, Ridgewood, NJ: Gregg, 1964), fols. 9r, 51r, 110r, in which Vitruvius is praised as a great rhetorician.

140. For d'Urfé, see Chapter 2, note 76, and for Michel de L'Hospital, above note 87. Johannes Hangest, bishop of Noyon and a patron of Charles de Bovelles, was the recipient of Symbol CXXXVIII from Bocchi; for Hangest, see Stefano Caroti, "Nicole Oresme, Claudio Celestino, Oronce Fine e i 'Mirabilia Naturae,'" *Memorie Domenicane*, 94–5, n.s., 8–9 (1977–8): 361. Filippo Archinto (1500–8) studied law in Bologna before 1519, was in Bologna with Charles V in 1529 and 1530, held a benefice in a Bolognese priory, and participated in the Council of Trent in Bologna until February 1548, when he returned to Rome. Archinto entered the Jesuit order in 1547; see G. Alberigo, "Archinto, Filippo," *DBI*, 3:761–4, and Richard J. Betts, "Titian's Portrait of Filippo Archinto in the Johnson Collection," *Art Bulletin* 49 (1967): 59. Most of his writings have been lost. Others approached for aid in 1548 were Sebastiano Pighino, Giovanni Michele Sarraceno, Luigi Lippomano, and "Jacobellum philosophum" (Milan, Ambros., MS. D145 inf., fol. 25v).

141. Daniele Benati, "Le decorazioni," in Roversi, *Palazzi*, 57.

142. Fantuzzi, *Notizie*, 2:231.

143. "E no molto lonta di quj [San Martino] è il palacio del Caualiero bochio di bona architatura toscanica molto laudabille quantuchel' no sia finito"; see Pietro Lamo, *Graticola di Bologna: Gli edifici e le opere d'arte della città nel 1560*, ed. Giancarlo Roversi (Bologna: Atesa, 1977), 33.

144. "IVLIVS PAPA," in *Symbolicae Quaestiones* (Bologna, 1555, Vatican copy), fol. [4]. The incipit of Bocchi's dedicatory poem to Julius III is "Beatvs est, nullo addito malo in bonis" (fol. 1).

145. Variant 1555 copies that I have found are the following: Vatican (additions to the poems in Symbols III, XLIII, and CXXIII and duplication of engravings for XCIX and CII); Kunsthistorisches Institut Firenze (duplication of engravings in XLI and XLII); Folger Shakespeare Library (duplication of engravings in LXXXIII and LXXXV); Princeton University Library (duplication of engravings in CXXIX and CXXXVI in copy 1); and

British Library (two of three copies in the *General Catalogue of Printed Books*, London, 1965, have differing variations).

146. Rhodes compared two British library copies of the *Symbolicae Quaestiones* with at least six other works printed by Giaccarelli between 1551 and 1556; a third copy, however, lacks the decorated initials and may represent an entirely different printing. See Dennis E. Rhodes, "Due questioni di bibliografia bolognese del Cinquecento," *Archiginnasio* 81 (1986): 321–4.

147. Another Paul IV version is in the New York Public Library's collection. A "perfect" copy (that is, a 1555 copy whose pagination corresponds exactly to the 1572 edition) is in the collection of the Biblioteca Riccardiana in Florence; some of its engravings appear to have been retouched. The collation of early printed texts has rarely been done, except for the most prominent works; as M. A. Screech observed concerning Rabelais, "no two copies of a Renaissance printed book ever appear to be completely identical"; see Screech, "Printers' Helps – and Fruitful Errors," *Etudes de Lettres*, no. 2 (Avril–Juin 1984): 115.

148. The Folger Shakespeare Library and the New York Public Library have copies with a letter from Henri II dated January 29, 1555, which would be 1556 by the reformed Gregorian calendar adopted in 1582. Adalgisa Lugli ("Le 'Symbolicae Quaestiones'"), who reported the François I version, said that four engravings were completely redone for the 1572 edition (87, 93), although, given the variants in the 1555 edition, it is possible that the new engravings were made for a late printing of the 1555 edition.

149. The one real change made by the printers and not indicated by the manuscript, however, was the deletion of the name of the dedicatee of Symbol XVII, Vincentio Bovio (fol. 14r).

150. Carlo Cesare Malvasia, *Felsina pittrice: Vita de' pittori bolognese,* ed. Giampietro Zanotti, 2 vols. (1841; reprint, Bologna: Forni, 1967), 1:68.

151. *Giulio Bonasone,* 1:26; Lugli, "Le 'Symbolicae Quaestiones,'" 4:88, 93–4n; Diane DeGrazia, *Correggio and His Legacy: Sixteenth Century Emilian Drawings* (Washington, DC: National Gallery of Art, 1984), 265; and Frederick G. Schab, "Bonasone," *Print Quarterly* 2 (1985): 58 (a review of Massari).

152. DeGrazia, *Correggio,* 265, and Schab, "Bonasone," 59.

153. Lugli, "Le 'Symbolicae Quaestiones,'" 4:88, 93n.

154. Lugli, "Le 'Symbolicae Quaestiones,'" 4:93n.

155. Malvasia, *Felsina,* 1:64.

156. Serlio and Vignola both began their careers as perspective painters. For Bologna as a center of perspective studies, see Walcher Casotti, *Il Vignola,* 1:12–16.

157. Bonasone, named as a member of an artist's company in a list published in 1576, was said to be the son of an Antonio Bonasone. Sources give his birth date as either 1498 or around 1510 and his date of death as either 1564 or 1576 or after; see Malvasia, *Felsina,* 1:64; *Giulio Bonasone,* 1:9, 26n; and Alfredo Petrucci, "Bonasone, Giulio," *DBI,* 11:591–4. The death date of 1564 cannot be that of the artist, and the 1498 birth date also seems unlikely as it would make Giulio over thirty years old at the outset of his career. These two dates probably belong to the noble Giulio Bonasone, brother of law professor Antonio Bonasone and son of Giovanni d'Antonio Bonasone (d. 1529), also a law professor and the "richissimo" godfather of Pompilio Amaseo (Giovanni married the daughter of a money changer called "Turdino di Domenico de' Conti cambiatore"; see Guidicini, *Cose notabili,* 3:29–30). According to Dolfi's *Cronologia,* Giulio and his brothers were made "Caualieri, e Conti Palatini dell Imperatore Carlo V con la facoltà solite" (334). Never is there a hint of nobility concerning Giulio Bonasone the artist, who must have lived from around 1510 to around 1576. This must be another case of pairs of Bolognese cousins with the same name, usually their paternal grandfather's. Our Giulio worked in Mantua, Parma, Rome (until 1547), Bologna, and later the Veneto; see Petrucci, "Bonasone,"

11:591, *Giulio Bonasone*, 1:26n, and Maria Catelli Isola, "Giulio Bonasone e un disegno di Michelangelo in una stampa sconosciuta," in *Studi di storia dell'arte, bibliografia, ed erudizione in onore di Alfredo Petrucci* (Milan and Rome: Bestetti, 1969), 19.

158. Pigna, *I Romanzi*, 100.

159. Vittorio Rossi, "Per la cronologia e il testo dei dialoghi 'De Poetis Nostrorum Temporum' di Lilio Gregorio Giraldi," *Giornale storico della letteratura italiana* 37 (1901): 247, 251, 276.

160. Giraldi, *Opera Omnia*, 2:565.

161. Amaseo had been summoned to Rome by Julius III by 1535 but did not want to leave Bologna. In March 1545, he was still requesting permission through Cardinal Legate Morone to stay in Bologna; however, it must have been soon thereafter that he succeeded Blosio Palladio as papal secretary; see Ornella Moroni, *Carlo Gualteruzzi (1500–1577) e i corrispondenti* (Vatican City: Biblioteca Apostolica Vaticana, 1984), 64, 274–5, and De Maio, *Michelangelo*, 375.

162. On Alciato in Bologna, see Abbondanza, "Una inedita prolusione bolognese," 399–400, and E. Costa, "Andrea Alciato allo Studio di Bologna," *Atti e memorie della R. Deputazione di Storia Patria per le Provincie di Romagna*, 3d ser., 21 (1903): 318–42. For editions of Alciato, see the bibliographies of John Landwehr, *Emblem Books in the Low Countries, 1554–1949: A Bibliography*, nos. 8–25 [unpaged]; *German Emblem Books, 1531–1888: A Bibliography*, 23–5; and *French, Italian, Spanish, and Portuguese Books of Devices and Emblems, 1534–1827: A Bibliography*, 25–40, published in 1970, 1972, and 1976, respectively, by Haentjens Dekker & Gumbert in Utrecht.

163. Maria Antonietta De Angelis, *Gli emblemi di Andrea Alciato nella edizione Steyner del 1531: Fonti e simbologia* (Salerno: Lito Dottrinari, 1984), nos. 6, 94, and Andrea Alciato, *Andreas Alciatus*, ed. Peter M. Daly, Virginia W. Callahan, and Simon Cuttler (Toronto, Buffalo, and London: University of Toronto Press, 1985), nos. 9, 38.

164. A. Bocchi .Bon. Praelectiones In Libros De Legibvs .M.T. Ciceronis Habitae Bononiae In Academia Bocchiana (Bologna, Bibl. Univ., Cod. Lat. 304), fol. 1v.

165. Rotondò, "Bocchi," 11:69, and Ravera Aira, "Achille Bocchi," 111.

166. Ricci, *Epistolarvm familiarvm*, fol. 16v. Ricci commented that Bocchi always used the fuller form "Didone" instead of "Dido."

167. Bologna, Bibl. Univ., Aldrovandi, 38², vol. IV, fol. 313r.

168. Ravera Aira, "Achille Bocchi," 61.

169. Ravera Aira, "Achille Bocchi," 60–1.

170. Ravera Aira, "Achille Bocchi," 111.

171. Ravera Aira, "Achille Bocchi," 61, 111.

172. Francesco was matriculated in the law school of Bologna in 1542 and went on to hold a number of positions in the city's government; see Bologna, Archiginnasio, MS. B.470, pp. 367, 369, and MS. B1292, fol. 4v.

173. Constantia's medal (a portrait only) has been published in G. F. Hill's *Renaissance Medals from the Samuel H. Kress Collection at the National Gallery of Art*, rev. ed. by Graham Pollard (London: Phaidon Press for the Samuel H. Kress Foundation, 1967), 86.

174. A. Bocchi, *Praelectiones*, in Bologna, Bibl. Univ., MS. Ital. 231, fol. 128, and Bocchi's letter to Abstemius, Bibl. Univ., MS. Ital. 295 (231).

175. Fantuzzi, *Notizie*, 2:225. Giuseppe Guidicini said that Camilla Bocchi, wife of Francesco Maria Riccardi of Ortona, was the last of Achille's line (*Cose notabili*, 1:382); however, she was not mentioned in the will and may represent another of the Bocchi lines.

176. The society functioned from 1572 to 1582; see Albano Sorbelli, "Carlo Sigonio e la Società tipografica bolognese," *Bibliofilia* 23 (1922): 95–9, and Sorbelli, *Storia della stampa*, 14–15.

177. Johannes Sambucus, *Sámboky János Könyvtára: Bibliotheca Joannis Sambuci, scripsit et catalogum anni 1587*, ed. Pál Gulyás (Budapest: Privately printed, 1941), 323, and Leandro Perini, "Libri e lettori nella Toscana del Cinquecento," in *Firenze e la Toscana dei Medici nell' Europa del' 500*, 3 vols. (Florence: Olschki, 1983), 1:131.

178. *Dictionnaire bibliographique, historique et critique des livres rares, précieux, singuliers, curieux, estimés et recherchés*, ed. Duclos, 4 vols. (Paris: Cailleau et Fils, 1790), 1:153. Autograph books, popular primarily with northern students, began appearing in the 1540s and frequently used emblem books bound with interleaved blank pages; see Max Rosenheim, "The Album Amicorum," *Archaeologia* 62 (1910): 251–308; M. A. E. Nickson, *Early Autograph Albums in the British Museum* (London: Trustees of the British Museum, 1970); and Jörg-Ulrich Fechner, "Stammbücher als kulturhistorische Quellen: Einführung und Umriss der Aufgaben," in *Stambücher als kulturhistorische Quellen*, ed. J.-U. Fechner, Wolfenbütteler Forschungen 11 (Munich: Kraus, 1981), 7–21. Ramus was constantly being asked for autographs by Germans in Paris; he would use only his own motto: "Labor improbus omnia vincit" (almost identical with Bocchi's); see Walter J. Ong, "Ramus éducateur: Les procédés scolaires et la nature de la réalité," in *Pédagogues et juristes: Congrès du Centre d'Etudes Supérieures de la Renaissance de Tours: Eté 1960* (Paris: Vrin, 1963), 217.

179. *British Library Catalogue*, 9:266; *Catalogue général des livres imprimés de la Bibliotheque National* (Paris, 1903), 19:645; Landwehr, *French, Italian, Spanish, and Portuguese Books*, 55; and Arthur Henkel and Albrecht Schöne, eds., *Emblemata: Handbuch zur Sinnbildkunst des XVI. und XVII. Jahrhunderts* (Stuttgart: Metzler, 1967), xlvii. The copies are in the British Library (three), Bibliothèque Nationale (two), Herzog August Bibliothek Wolfenbüttel, Kunsthistorisch Instituut Utrecht, Glasgow, Newcastle on Tyne, the Vatican Library, Archiginnasio of Bologna, the Riccardiana, Marucelliana, and Kunsthistorisches Institut libraries of Florence, the Newberry Library (Chicago), the libraries of Princeton University (two), the University of Iowa, the University of California at Berkeley, and the University of Kentucky, and the Folger Shakespeare Library, New York Public Library, and Dallas Public Library.

180. *Symbolicarum Quaestionum de Universo Genere, Bologna, 1574* (1574; reprint, New York and London: Garland, 1979).

181. There are several reports of other editions: The 1624 edition cited by Robert J. Clements in his *Picta Poesis: Literary and Humanist Theory in Renaissance Emblem Books* ([Rome: Edizioni di Storia e Letteratura, 1960], 10, 44, 156n, 173) comes from a typographical error in the *Dictionary Catalogue of the History of Printing from the John M. Wing Foundation in the Newberry Library* (Boston: Hall, 1961), under "Bocchi." A *Symbolographia* (Augsburg and Dillengen, 1702) attributed to Bocchi by Monika Hueck is actually by Jacobus Boschius (Bosch); see Hueck, *Textstruktur und Gattungssystem: Studien zum Verhältnis von Emblem und Fabel im 16. und 17. Jahrhundert* (Kronberg/TS, Scriptor, 1975), 180.

182. John Caius, *The Works of John Caius, M. D., Second Founder of Gonville and Caius College and Master of the College, 1559–1573*, With a Memoir of his Life by John Venn, ed. E. S. Roberts (Cambridge: Cambridge University Press, 1912), 74, 102. Caius, who spent many years in Italy and probably entered the priesthood there, defended the "old" pronunciation of Greek as opposed to the newer style promulgated by English universities; see John Caius, *De Pronunciatione Graecae et Latinae Linguae cum Scriptione Nova Libellus (1574)*, facsimile, ed. and trans. by John Butler Gabel (Leeds: University of Leeds School of English, 1968).

183. "Hoc optime nouit & in suis symbolis significauit Achilles Bocchius praeceptor meus vir doctissimus & optimus..." (Bologna: Ex Typographia Ioannis Rubai, 1563), 76, and Don Cameron Allen, *Mysteriously Meant: The Rediscovery of Pagan Symbolism and*

*Allegorical Interpretation in the Renaissance* (Baltimore and London: Johns Hopkins University Press, 1970), 158.

184. Paulus Bolduan listed Bocchi under general works on philosophy rather than under the heading "Emblemata" with Alciato and other emblematists; see Bolduan, *Bibliotheca philosophica, sive: Elenchus Scriptorum Philosophicorum atqve Philologicorum Illustrium* (Jena: Apud Joannem Weidnerum, 1616), 1.

185. In the sixteenth century, for example, Bocchi's name was cited in prefatory matter by Joachim Camerarius and Geoffrey Whitney and in some editions of Alciato; see Camerarius, *Symbolorvm Emblematvm Ex Animalibvs Qvadrvpedibvs Desvmtorvm Centvria Altera* (Nuremberg, 1595); Whitney, *A Choice of Emblemes and Other Devises* (1586; reprint, Amsterdam: Theatrvm Orbis Terrarvm; New York: Da Capo, 1969), sig. ★★4r; and F. W. G. Leeman, *Alciatus' Emblemata: Denkbeelden en voorbeelden* (Groningen: Bouma, 1984), 94. Camerarius also quoted Bocchi's Symbol I in full in his *Symbolorvm & Emblematvm Ex Re Herbaria*... (Nuremberg, 1590), fol. 5.

186. Janus Gruter, ed., *Delitiae C. C. Italorvm Poetarvm, Hvivs Svperiorisqve Aevi illustrium*, Collectore Ranvtio Ghero, 2 vols. (Frankfurt: In officina Ionae Rosae, 1608), 1:443–52, and *Carmina illustrium Poetarum Italorum*, ed. Joannes Bottari, 11 vols. (Florence: Typis Regiae Celsitudinis, apud Joannem Cajetanum Tartinium et Sanctem Franchium, 1719–26), 2:333–60.

187. (Bologna: Per Alessandro Benacci, 1575), 68–9. The exact dates of the lectures in Urbino are unknown.

188. *Le Imprese Illvstri Ded S.ᵒʳ Ieronimo Rvscelli. Aggivntovi Nvovam Il Qvarto Libro Da Vincenzo Rvscelli Da Viterbo*... (Venice: Appresso Francesco de francesci Senesi, 1584), 14.

189. *Delle Imprese Trattato Di Givlio Cesare Capaccio. In tre Libri diuiso*... (Naples: Appresso Gio. Giacomo Carlino, & Antonio Pace, 1592), I:9v.

190. *L'Art Des Emblèmes, Lyons, 1662*, Introduction by Stephen Orgel (New York and London: Garland, 1979), 117–18. Menestrier classified some of Bocchi's emblems (III, VI, and XLIII) as "Emblemes Academiques," meaning they were merely exhortations to study (42), but discussed others as examples of "Emblemes Doctrinaux" (41), of various types of mottoes (73–5), and of allegory (89).

191. Sambucus, *Emblemata*, 80–1, 182–3, and Bocchi's Symbol CXXXVII. Sambucus studied in Bologna from around 1555 to 1557 after taking a medical degree from Padua. As court historian in Vienna and a book collector, he made further trips to Italy; see Hans Gerstinger, ed., *Die Briefe des Johannes Sambucus (Zsámboky), 1554–1584; mit einem Anhang die Sambucusbriefe in Kreisarchiv von Trnava von Anton Vantuch*, Oesterreische Akademie der Wissenschaften, Phil.-Hist. Kl., Sitzungsberichte 255 (Vienna, Graz, and Cologne: Bölau, 1968); Gerstinger, "Johannes Sambucus als Handschriftensammler," in *Festschrift der Nationalbibliothek in Wien* (Vienna: Oesterreichischen Staatsdruckerei, 1926), 251–402; and Veress, *Matricula*, 1:53–67.

192. Junius, who was in Bologna during the early part of Alciato's stay there, studied with Alciato and may have been present for discussions on emblems in which Bocchi and Alciato participated. By 1543 Junius was in England; he became Holland's official poet in 1565 but lost his extensive library during the Spanish sack of Haarlem. He died in Middelburg in 1575; see Hadrianus Junius, *Epistolae, Quibus accedit Ejusdem Vita & Oratio De Artium liberalium dignitate*... (Dordrecht: Apud Vincentium Caimax, 1652), 26, 99; Junius, *Emblemata, 1565*, introductory note by Hester M. Black (reprint, Menston: Scolar Press, 1972); and K. Bostoen, *Dichterschap en koopmanschap in de zestiende eeuw: Omtrent de dichters Guillaume de Poetou en Jan vander Noot* (Deventer: Sub Rosa, 1987), 200–1.

193. Nothing is known of Costalius, or Coustau, except that he also published a legal text in

Lyons in 1554 ("authore Petro Costalio") and a poem, *Petri Costalii De pace carmen*, in Paris in 1559; see *Catalogue général des livres imprimés de la Bibliotheque Nationale*, 33:652–3. He came from Vienne, however, probably from the Costal family; see M. Mermet, Aîné, *Histoire de la Ville de Vienne*, vol. 3, ed. Mlles. Mermet (Vienne: Timon Frères, 1854), 297. The French translation of the *Pegma* was made by Lantome de Romieu, who may have guessed at a French equivalent of Costalius.

194. *Petri Costalii Pegma, cum narrationibus philosophicis* (Lyons: Matthias Bonhomme, 1555), and Petrus Costalius, *Le Pegme de Pierre Coustau, Lyons, 1555*, introduction by Stephen Orgel (reprint, New York and London: Garland, 1979), 81, 144–6, 167, 307, 310, 319.

195. On Bocchi as a source for Horozco y Covarrubias and Valentinus Thilo, see Landwehr, *French, Italian, Spanish, and Portuguese Books*, 110, 183. For a thematic index to continental emblem books (though not complete), see the monumental Henkel and Schöne, *Emblemata*, and for a detailed thematic index to English emblem books, see Huston Diehl, *An Index of Icons in English Emblem Books, 1500–1700* (Norman: Oklahoma University Press, 1986).

196. Peter Isselburg and Georg Rem, *Emblemata Politica In aula magna Curiae Noribergensis depicta Quae sacra Virtvtvm suggerunt Monita Prvdenter administrandi Fortiterqve defendendi Rempublicam*, ed. Wolfgang Harms (1640; reprint, Bern and Frankfurt am Main: Lang, 1982), nos. 25–6.

197. Landwehr, *Emblem Books in the Low Countries*. Reusner's symbols of emperors were extremely popular, especially in grammar schools; see T. W. Baldwin, *William Shakspere's Small Latine & Lesse Greeke*, 2 vols. (Urbana: University of Illinois Press, 1944), 2:300.

198. Lotichius Secundus, *Poemata*, 152, and Johann Lauterbach, … *Epigrammatum Libri VI* (Frankfurt: Ex Officina Ludovici Lucij, 1562), 159, 256.

199. Augsburg and Dillengen: Joannes Caspar Bencard, 1702.

200. Kaspar Othmayr, *Symbola*, vol. 1 of *Ausgewählte Werke*, ed. Hans Albrecht, 2d ed. (Leipzig: Peters, 1962).

201. Edward Lowinsky, "Matthaeus Greiter's Fortuna," *Musical Quarterly* 42 (1956): 511.

202. Hans Albrecht, *Caspar Othmayr, Leben und Werk* (Kassel and Basel: Bärenreiter, 1950), 8–11.

203. Albrecht, *Caspar Othmayr*, 126.

204. L'Hospital, *Epistolarum Liber I*, in *Oeuvres complètes*, 3:67–70, and in French translation in L'Hospital, *Poésies complètes*, 52–4. L'Hospital begins with praise for Bocchi's widening fame: "Bocchi, percelebri jamdudum cognite fama / Trans Alpes Rhodanumque mihi versibus illis / Queis hominum mentes divino incendis amore / Ad verum fidei cultum, cultumque Deorum / Noscere te cupio, numerumque augere tuorum" (Bocchi, known to me because your fame has traveled across the Alps and the Rhône, I wish to know you better and to increase the number of your followers, for with your poetry you inflame the minds of men with divine love, leading them to the true cultivation of faith and of the gods [lines 1–5, "Epistolarum," 3:67]).

205. The nightingale, not realizing that its reflection was not a real bird, sang to compete and finally dived at its mirror image; in Bocchi's version, naiads by the pool laugh at the bird; see Bernhard Coppel, "Philomela in Bologna und Wittenberg: Die Nachtigall als Topos, Epigrammstoff und Vogelmaske in der propagandistischen Reformationsdichtung," in *Acta Conventus Neo-Latini Bononiensis: Proceedings of the Fourth International Congress of New-Latin Studies, Bologna, 26 August to 1 September 1979*, ed. R. J. Schoeck (Binghamton, NY: Medieval & Renaissance Texts & Studies, 1985), 420–9. Lotichius wrote the poem between his arrival in Bologna in the summer of 1555 and his death in Heidelberg on November 7, 1560; see Zon, *Petrus Lotichius Secundus*, 389–91.

206. Dora Panofsky and Erwin Panofsky, *Pandora's Box: The Changing Aspects of a Mythical*

*Symbol,* 2d ed. rev. (New York: Pantheon, 1962), 58, 67 (also see the discussion of Bocchi and Pandora in Chapter 1). To Du Bellay both the good and the bad of the past were interred in the ruins of Rome:

> Tout le parfait dont le ciel nous honnore,
>    Tout l'imparfait qui naist dessous les cieux,
>    Tout ce qui paist noz espritz & noz yeux,
>    Et tout cela qui noz plaisirs devore,
> Tout le malheur qui nostre aage dedore,
>    Tout le bonheur des siecles les plus vieux,
>    Rome du temps de ses premiers ayeux
>    Le tenoit clos, ainsi qu'une Pandore.

(lines 1–8 of Sonnet XIX, *Les Antiquitez de Rome,* in Joachim Du Bellay, *Les Antiquitez de Rome et Les Regrets,* ed. E. Droz [Paris: Droz, 1945], 12).

207. James Nohrnberg, *The Analogy of "The Faerie Queene"* (Princeton, NJ: Princeton University Press, 1976), 112–13; Peggy Muñoz Simonds, "Eros and Anteros in Shakespeare's Sonnets 153 and 154: An Iconographical Study," *Spenser Studies* 7 (1986): 275–7 (and also a talk by Simonds, "Alciati's Eros and Anteros in Shakespeare's *Cymbeline,*" on December 29, 1988, at the MLA Convention in New Orleans); and Panofsky and Panofsky, *Pandora's Box,* 125–7.

208. G. Pollard, "Cambio (Cambi)," *DBI,* 17:141, and Mariette De Vos, "La recezione della pittura antica fino alla scoperta di Ercolano e Pompei," in *I generi e i temi ritrovati,* vol. 2 of *Memoria dell'antico nell'arte italiana,* ed. Salvatore Settis, 3 vols. (Turin: Einaudi, 1984–6), 376, figs. 306–7.

209. John Summerson, *Architecture in Britain, 1530 to 1830,* 5th ed. (Harmondsworth: Penguin Books, 1969), 101, pl. 68A–B, and Frederick J. Stopp, *The Emblems of the Altdorf Academy: Medals and Medal Orations, 1577–1626* (London: Modern Humanities Research Association, 1974), 30. There are various written accounts, including that of Vitruvius, of the ancient temples of Honor and Virtue, and they were depicted on a Roman coin. Bocchi's version, which Caius probably knew, discussed the necessity of attaining Virtue before Glory. Sambucus, Bocchi's pupil a decade after Caius was in Bologna, also made an emblem of the two temples, as did Sebastián de Covarrubias; see Ferdinando Moreno Cuadro, "La visión emblematica del gobernante virtuoso," *Goya,* no. 187–8 (1985): 26. Caius, using a Flemish architect, planned to have his collegians enter through a Gate (actually a door) of Humility, proceed "through a more elaborate Gale of Virtue ... incorporated in one of his new wings, and finally ... through a Gate of Honour ..., an impressive little building in three richly carved storeys terminating in a domed hexagon and leading towards the Schools" (Summerson, *Architecture,* 101–2). The Gate of Honor exists only in a drawing left at Caius's death in 1573.

210. For a careful and convincing study of the allegorical program of Bomarzo, see Margaretta J. Darnall and Mark S. Weil, "Il Sacro Bosco di Bomarzo: Its Sixteenth-Century Literary and Antiquarian Context," *Journal of Garden History* 4 (1984), 1–94. They provide a translation of Bocchi's Symbol CXLVI (79n).

211. Lugli, "Le 'Symbolicae Quaestiones,'" 4:91, 95n, and Heinz Ladendorf, "Kairos," in *Festschrift Johannes Jahn zum XXII. November MCMLVII* (Leipzig: Seemann, for Kunsthistorischen Institut der Karl-Marx-Universität, 1957), 228. Bocchi's local influence lasted into the eighteenth century; see Adalgisa Lugli, "Giovanni Antonio Burrini," in *Torquato Tasso tra letteratura, musica, teatro e arti figurative,* ed. Andrea Buzzoni (Bologna: Nuova Alfa, 1985), 327–9.

212. Lugli, "Le 'Symbolicae Quaestiones,'" 4:91, figs. 108–9.

213. Lugli, "Le 'Symbolicae Quaestiones,'" 91–2, figs. 114–17.

214. Irving Lavin, "Divine Inspiration in Caravaggio's Two *St. Matthews*," *Art Bulletin* 56 (1974): 60, 71, 73–4.

215. According to William S. Heckscher, "In view of the fact that Bocchi's emblem-book made High Renaissance compositions easily accessible to the members of the *Accademia degli Incamminati* (1582 ff) [the Bolognese academy of artists] its importance as a transmitter ... of the very substance that went into the making of the Bolognese baroque, will be appreciated"; see "Renaissance Emblems: Observations Suggested by Some Emblem-Books in the Princeton University Library," *The Princeton University Library Chronicle* 15 (1953–4): 60. Gottfried Kirchner saw in Bocchi's statuette of Fortuna (Symbol CXXI) an interpretation of a "Vanitasstimmung," baroque in its nature; see *Fortuna in Dichtung und Emblematik des Barock: Tradition und Bedeutungswandel eines Motivs* (Stuttgart: Metzler, 1970), 17.

216. Cartari, Vincenzo, *Le imagini ... degli dei, Venice, 1571* (reprint, New York and London: Garland, 1976), 356, 369, and Andrea Alciato, *Emblemata cum Commentariis, Padua, 1621*, ed. Claude Mignault (1621; reprint, New York and London: Garland, 1976), 53. In the words of mythographer Alexander Ross, "Of old, in Academies and Colledges, they used to paint *Mercury* and *Minerva* close together, which picture they called *Hermathena*, from *Hermes* and *Athene*; to signifie that Wisdom and Eloquence must not be separated, but that Scholars should strive as well to have wise heads, as eloquent tongues"; see *Mystagogus Poeticus; or, The Muses Interpreter, London, 1648* (1648; reprint, New York and London: Garland, 1976), 285.

217. Fantuzzi, *Notizie*, 7:303. Also, Cardinal Federico Borromeo (d. 1584) called a group formed from his more able students at the Seminario di Milano an "Accademia degli Ermatenaici;" see Maylender, *Storia delle Accademie*, 1:464; 2:300–3.

218. Jean van Gorp, "Hermathena," in *Opera Ioan. Goropii Becani ...* (Antwerp: Excudebat Christophorus Plantinus, 1580), 171. In Book 4, Goropius (1518–72) said: "Hinc nostra Hermathana [*sic*], vetere loquendi consuetudine, vocum est interpretatio, de sapientiae fontibus deriuate" (Thus our Hermathena, the ancient practice of speaking, is called interpretation, derived from the fount of wisdom; 62).

219. Cartari, *Le Imagini*, 459 (Hermathena), and 314, 326 (herms). On the illustrations for the 1571 edition, see Madeline Lennon, "Cartari's *Imagini*: Emblematic References in the Relationship of Text and Image," *Emblematica* 3 (1988): 263–82.

220. The Hermathena chamber at Caprarola (painted by 1565) was on the side of the palazzo devoted to the "vita contemplativa et solitaria"; see Wolfgang Liebenwein, *Studiolo: Die Entstehung eines Raumtyps und seine Entwicklung bis um 1600*, Frankfurter Forschungen zur Kunst 6 (Berlin: Mann, 1977), 137, 139, fig. 86.

221. Theodora A. G. Wilberg Vignau-Schuurman, *Die emblematischen Elemente im Werke Joris Hoefnagels*, 2 vols. (Leiden: Universitaire Pers, 1969), 2:78n; D. J. Gordon, "Rubens and the Whitehall Ceiling," in *The Renaissance Imagination: Essays and Lectures by D. J. Gordon*, ed. Stephen Orgel (Berkeley, Los Angeles, and London: University of California Press, 1975), 48–9; Thomas DaCosta Kaufmann, "The Eloquent Artist: Towards an Understanding of the Stylistics of Painting at the Court of Rudolf II," *Leids Kunsthistorisch Jaarboek* 1 (1982): 142–3n; and Otto Van Veen, *Quinti Horati Flacci Emblemata: Imaginibus in aes incisis, Notisque illustrata*, foreword by Dmitrij Tschižewskij (1607; reprint, Hildesheim and New York: Olms, 1972), fols. Gi$^v$–Gijr. I was not able to locate Hermathena in the 1572 Venetian edition of Ruscelli. Rubens had visited the Farnese palace at Caprarola and the house of the artist Giulio Romano in Mantua, where painted statues of Hermes and Athena flank a doorway; his own drawings include the heads of the god and goddess back to back, a "Musathena," and other juxtapositions of Hermes

and Athena for printers' marks and ornamental title pages. See Jeffrey M. Muller, *Rubens: The Artist as Collector* (Princeton, NJ: Princeton University Press, 1989), 26–9, figs. 4, 8, 10, and J. Richard Judson and Carl van de Velde, *Book Illustrations and Title Pages*, 2 vols., pt. 21 of *Corpus Rubenianum Ludwig Burchard* (London and Philadelphia: Miller-Heyden & Son, 1978), plates 55–6, 60, 204–7, 214–5, 246–9, 275–8. The term *Hermathena* has also been applied loosely to any appearance of Athena and Hermes together whether actually contiguous or not; see Robert Griffin, "La Concorde des deux langages: Discordia concors," in *Literature and the Arts in the Reign of François I: Essays Presented to C. A. Mayer,* ed. Pauline M. Smith and I. D. McFarlane (Lexington, KY: French Forum, 1985), 73, 80n.

222. Wilberg Vignau-Schuurman, *Die emblematischen Elemente,* 2:78, and Kaufmann, "The Eloquent Artist," 119–48.

223. Francis Tolson, *Hermathenae, Or Moral Emblems, And Ethnick Tales, with Explanatory Notes,* vol. 1 (n.p., n.d.), 1. No other volumes came out, although a *Proposals for printing Hermathenae* (London, 1739) has been reported to exist; see Peter M. Daly and Mary V. Silcox, "A Short Title Listing of English Emblem Books and Emblematic Works Printed to 1900," *Emblematica* 4 (1989): 372.

224. Cervino, who was named cardinal of Santa Croce in 1539 and Pope Marcellus II on April 10, 1555 (he died three weeks later), attended the Council of Trent in Bologna in 1547; see Filippo Maria Renazzi, *Storia dell'Università di Roma,* 4 vols. in 2 (1803; reprint, Bologna: Forni, 1971), 1:126, 204–5, and Coffin, "Pope Marcellus II," 11–13.

225. Ercole Bottrigari, trans., *De speculo ustorio,* in Oronce Finé, *Opere di Orontio Fineo del Delfinato: Diuise in cinque Parti . . . Et gli Specchi, Tradotti dal Caualier Ercole Bottrigaro . . .* (Venice: Presso Francesco Frenceschi Senese, 1587). Perhaps the manuscript of Finé had first belonged to Bocchi or one of his close friends.

226. Henkel and Schöne, *Emblemata,* cols. 1352–3; Jurgis Baltrušaitis, *Le Miroir: Révélations, science-fiction et fallacies* (Paris: Du Seuil, 1979), 97; Herbert Grabes, *Speculum, Mirror und Looking-Glass* (Tübingen: Niemeyer, 1973), Abb. 9; and Bosch, *Symbolographia,* passim.

227. Giambattista Vico, *The New Science of Giambattista Vico,* 3d ed., trans. Thomas Goddard Bergin and Max Harold Tisch (Ithaca, NY, and London: Cornell University Press, 1984), 5.

228. In addition, Bocchi's taste in building, despite local criticism of it, was adapted for use on other Bolognese palaces, especially the Palazzo Fantuzzi with its *impresa* of elephants (the family's name was originally spelled "Elefantuzzi"); see Beseghi, *I palazzi,* 209. Bocchi's impact on architects such as Vignola and possibly Giulio Romano cannot be determined from presently available evidence; the exchange of ideas probably flowed both ways.

### 4. Poetics and the Emblem

1. Thomas Gray, *The Works of Thomas Gray in Prose and Verse,* ed. Edmund Gosse, 4 vols. (Providence, RI: Gregory, n.d.), 1:37.

2. Bernard Weinberg, *A History of Literary Criticism in the Italian Renaissance,* 2 vols. (Chicago: University of Chicago Press, 1961), 1:45, 94, 97, 100–1; O. B. Hardison, *The Enduring Monument: A Study of the Idea of Praise in Renaissance Literary Theory and Practice* (Chapel Hill: University of North Carolina Press, 1962), 15; and J. E. Spingarn, *A History of Literary Criticism in the Renaissance,* 2d ed. (1924; reprint, Westport, CT: Greenwood Press, 1976).

3. Baxter Hathaway, *The Age of Criticism: The Late Renaissance in Italy* (Ithaca, NY: Cornell University Press, 1962), 306.

4. Concetta Carestia Greenfield, *Humanist and Scholastic Poetics, 1250–1500* (Lewisburg PA: Bucknell University Press; London and Toronto: Associated University Presses, 1981), 308, 311, 314, and Francesco Tateo, *Retorica e poetica fra Medioevo e Rinascimento* (Bari: Adriatica, 1960), 13. For medieval poetics, see Peter Dronke, *The Medieval Poet and His World* (Rome: Edizioni di Storia e Letteratura, 1984).

5. Greenfield, *Humanist*, 311. See also Spingarn, *A History*, 3–23, 315, on humanist defenses of poetry; and, for Salutati, see Jan Lindhardt, *Rhetor, Poeta, Historicus: Studien über rhetorische Erkenntniss und Lebensanschauung im italienischen Renaissancehumanismus* (Leiden: Brill, 1979).

6. Weinberg, *History*, 1:105, 278–80; Tateo, *Retorica*; and Hathaway, *The Age*, 70. On Plato's criticism of poetry, see Elizabeth Belfiore, "Plato's Greatest Accusation against Poetry," in *New Essays on Plato*, ed. Francis Jeffrey Pelletier and John King-Farlow, Suppl. vol. 9 of *Canadian Journal of Philosophy* 9 (1983): 39–62; R. A. Goodrich, "Plato on Poetry and Painting," *British Journal of Aesthetics* 22 (1982): 126–37; and H. S. Thayer, "Plato's Quarrel with Poetry: Simonides," *Journal of the History of Ideas* 36 (1975): 3–26. On Saint Augustine's theory that poets intend pleasure and not deceit by their fables, see Kathy Eden, *Poetic and Legal Fiction in the Aristotelian Tradition* (Princeton, NJ: Princeton University Press, 1986), 120–1. Savonarola accepted poetry's role to instruct and delight but condemned pagan poetry and any attempt to read poetry as theology; see Greenfield, *Humanist*, 252–4; and Spingarn, *History*, 14.

7. Weinberg, *History*, 1:108, and Marvin T. Herrick, *The Fusion of Horatian and Aristotelian Literary Criticism, 1537–1555*, Illinois Studies in Language and Literature 32 (Urbana: University of Illinois Press, 1946), 106.

8. Tateo, *Retorica*, 96–8; Weinberg, *History*, 1:89, 108, 147, 196; Hardison, *Enduring Monument*, 21, 26; and Francesco D'Episcopo, *Civiltà della parola*, 2 vols. (Naples: Edizioni Scientifiche Italiane, 1984), 1:67.

9. This was also true in late antiquity, when the epideictic oration and the poem of praise were seen to differ only in meter; see Hardison, *Enduring Monument*, 32. The sixteenth-century classifications included, for example, the grouping under the oratorical arts of *oratio*, *historica*, and *poetica* by Julius Caesar Scaliger; see Pierre Lardet, "Jules-César Scaliger et ses maîtres: La Rhétorique dans le champ du savoir," *Rhetorica* 4 (1986): 392. Similar groupings appear in other treatises on poetics; see Weinberg, *History*, 1:316.

10. Robert Clements, "Ars Emblematica," *Romanistisches Jahrbuch* 8 (1957): 93–9. Clements also discusses ways in which emblem writers diverged from contemporary theory, but emblem writers were hardly alone in didactic approaches or critical remarks about theorists (101).

11. Alciato did not emblematize his views on poetry; however, the Mignault (Minos) commentary of 1621 used his "In Deo Laetandum" as a springboard for an extensive treatment of poetic allegory; see Hardison, *Enduring Monument*, 61. Petrus Costalius (Coustau, Costal) in his *Pegme* of 1555 referred to criticisms of poets by ancient writers but offered no real defense of poetry; see Costalius, *Le Pegme de Pierre Coustau, Lyons, 1555* (reprint; New York and London: Garland, 1979), 257–60. Bocchi's friend and pupil Johannes Sambucus later entitled one of his own emblems "Poetica ad Dionysium Lambinum"; this, however, is a brief treatment of poetry as serious play; see Sambucus, *Emblemata, Cvm Aliqvot Nvmmis Antiqvi Operis* (Antwerp: Ex Officina Christophori Plantini, 1564), 50.

12. Robert J. Clements interpreted this passage quite differently: "Like Ripa, Bocchi abets the fusion of prophetic and poetic furors, writing that 'the prophets [like Cybele] fashioned divine poems that men might be drawn to hear freely with their ears and believe as openly true what had formerly been divulged to the eyes of the faithful'; see

Clements, *Picta Poesis: Literary and Humanistic Theory in Renaissance Emblem Books* (Rome: Edizioni di Storia e Letteratura, 1960), 55. The Greeks said that the fable was invented in Phrygia in Asia Minor; see Morten Nøjgaard, *La Fable antique*, 2 vols. (Copenhagen: Busck, 1964), 1:432. Cybele was a Phrygian goddess; however, I think that the Phrygian origin of the fable was intended here. There was an obscure Greek dialectician named Panthoides, but "Panthoides samius" was Pythagoras, a Samian native known for a series of gnomic *symbola*.

13. Tateo, *Retorica*, 96–8, 112, 118, and Charles G. Osgood, trans., *Boccaccio on Poetry, Being the Preface and the Fourteenth and Fifteenth Books of Boccaccio's "Geneologia Deorum Gentilium" in an English Version with Introductory Essay and Commentary* (Princeton, NJ: Princeton University Press, 1930), 44.

14. Weinberg, *History*, 1:258, 260.

15. D. P. Walker, "Esoteric Symbolism," in *Poetry and Poetics from Ancient Greece to the Renaissance: Studies in Honor of James Hutton*, ed. G. M. Kirkwood, Cornell Studies in Classical Philology 38 (Ithaca, NY, and London: Cornell University Press, 1975), 225, and Hardison, *Enduring Monument*, 6.

16. Weinberg, *History*, 1:102. On the theory of imitation in the Renaissance, see Hathaway, "Part One. Poetry as Imitation." in *The Age*, 3–125; Thomas M. Greene, *The Light in Troy: Imitation and Discovery in Renaissance Poetry*, The Elizabethan Club Series 7 (New Haven and London: Yale University Press, 1982), especially 171–96; Eugenio Battisti, "Il concetto d'imitazione nel Cinquecento italiano," in his *Rinascimento e Barocco* (n.p.: Einaudi, 1960), 175–216; and Herrick, *The Fusion*, 107–8.

17. Clements, "Ars Emblematica," 99.

18. Jean H. Hagstrum, *The Sister Arts: The Tradition of Literary Pictorialism and English Poetry from Dryden to Gray* (Chicago and London: University of Chicago Press, 1974), 5–7.

19. Proclus, *Proclus' Commentary on Plato's "Parmenides,"* trans. Glenn R. Morrow and John M. Dillon (Princeton NJ: Princeton University Press, 1987), 189. As Irving Lavin has noted, at the feet of Socrates' daimon are the terms "daimon" and "eudaimon," which allude both to a negative (cautionary) and a positive ("good") spirit; see "Divine Inspiration in Caravaggio's Two *St. Matthews*," *Art Bulletin* 56 (1974): 71, 74.

20. On ikastic art, see Plato, *Sophist*, 235D–E, 236C, in *Theaetetus; Sophist*, trans. Harold North Fowler, in *Plato*, 12 vols., Loeb Classical Library (Cambridge, MA: Harvard University Press; London: Heinemann, 1967), 7:232–7; Arthur F. Kinney, *Humanist Poetics: Thought, Rhetoric, and Fiction in Sixteenth-Century England* (Amherst: University of Massachusetts Press, 1986), 28; and Eden, *Poetic and Legal Fiction*, 65–7.

21. On the effect and ends of poetry, see Heinrich F. Plett, *Rhetorik der Affekte: Englische Wirkungsästhetik im Zeitalter der Renaissance* (Tübingen: Niemeyer, 1975), 109–17, and Spingarn, *History*, 47–52. According to Giancarlo Innocenti, the emblem's only effect is to delight; see Innocenti, *L'immagine significante: Studio sull'emblematica cinquecentesca* (Padua: Liviana, 1981), 16. Bocchi, however, gives equal weight to teaching and delighting.

22. Lodovico Dolce said the painter should copy nature almost perfectly and when painting the human figure surpass it. Perhaps the daimon enabled Socrates in Bocchi's symbol to achieve this result with the figure he is drawing; see Rensselaer W. Lee, "*Ut pictura poesis*: The Humanist Theory of Painting," *Art Bulletin* (1940): 197–269; republished as *Ut Pictura Poesis: The Humanistic Theory of Painting* (New York and London: Norton, 1967), 10.

23. Hagstrum, *Sister Arts*, 9, 58, 60. Horace made further comparisons between poetry and art in the *Ars* and in other poems. See also Wesley Trimpi, "Horace's 'Ut Pictura Poesis': The Argument for Stylistic Decorum," *Traditio* 34 (1978): 29–73, which corrected his

earlier article, "The Meaning of Horace's *ut pictura poesis*," *Journal of the Warburg and Courtauld Institutes* 36 (1973): 1–34, and Giorgio Padoan, "'Ut pictura poesis': Le 'pitture' di Ariosto, le 'poesie' di Tiziano," in his *Momenti del Rinascimento veneto* (Padua: Antenore, 1978), 347–70. Weinberg noted how the early-sixteenth-century commentaries of Horace's *Ars Poetica* mined it for a series of quickly imparted precepts; see *History*, 1:89. For a more complete bibliography of *ut pictura poesis*, see John Graham, "'Ut Pictura Poesis': A Bibliography," *Bulletin of Bibliography and Magazine Notes* 29 (1972): 13–15, 18.

24. Leatrice Mendelsohn, *Paragoni: Benedetto Varchi's Due Lezzioni and Cinquecento Art Theory* (Ann Arbor MT: UMI Research Press, 1982), 77, 102. Varchi's *Due Lezzioni* was published in 1551.

25. The source of the fragment is Plutarch's *De Gloria Atheniensium*, III, 346F–347C. On Simonides, see Thayer, "Plato's Quarrel," 13–14, and Hagstrum, *Sister Arts*, 10–11. Plutarch's writings support a very close analogy between poetry and painting. On the use of Horace's *ut pictura poesis* as a defense of painting, see the seminal study by Lee, *Ut pictura poesis*.

26. François Lecercle, *La Chimère de Zeuxis: Portrait poétique et portrait peint en France et en Italie à la Renaissance* (Tübingen: Narr, 1986), 10–50; Vladimír Juřen, "Politien et la théorie des arts figuratifs," *Bibliothèque d'Humanisme et Renaissance* 37 (1975): 133; Demenico De Robertis, "*Ut pictura poesis* (uno spiraglio sul mondo figurativo albertiano," *Interpres* 1 (1978): 27–42; Gerard G. LeCoat, *The Rhetoric of the Arts, 1550–1650* (Berne and Frankfurt am Main: Lang, 1975), 14; Hagstrum, *Sister Arts*, 66–8; and Peter Burke, *Culture and Society in Renaissance Italy, 1420–1540* (New York: Scribner, 1972), 134. On the continuing interest in this analogy, see Carlo Ossola, *Autunno del Rinascimento: "Idea del tempio" dell'arte nell'ultimo Cinquecento* (Florence: Olschki, 1971), 33–111; H. James Jensen, *The Muses' Concord: Literature, Music and the Visual Arts in the Baroque Age* (Bloomington and London: Indiana University Press, 1976); and Niklaus Rudolf Schweizer, *The Ut Pictura Poesis Controversy in Eighteenth-Century England and Germany* (Berne: Herbert Lang; Frankfurt am Main: Peter Lang, 1972). Since the publication of Gotthold Lessing's *Laocoön* in 1766 few claims for a close relationship between poetry and painting have been made, but the subject is still discussed; see for instance, the special issue *Literary and Art History* in *New Literary History* 3 (1972), with articles by Svetlana Alpers, Paul Alpers, Alastair Fowler, and others.

27. Weinberg, *History*, 1:88–90; Lecercle, *La Chimère*, 15–17; and Robert Klein, "Pomponius Guaricus on Perspective," *Art Bulletin* 43 (1961): 215–16.

28. Lee, *Ut Pictura Poesis*, 3, and Lodovico Dolce, *Osservationi nella volgar lingva* (Venice: Appresso Gabriel Giolito de Ferrari e Fratelli, 1550), fol. 87v.

29. Maria Luisa Doglio, ed., in Emanuele Tesauro, *Idea delle perfette imprese*, Università di Torino, Centro di Studi di Letteratura Italiana in Piemonte "Guido Gozzano," Testi 1 (Florence: Olschki, 1975), 13–15, and Innocenti, *L'immagine*, 84–5.

30. Lecercle, *La Chimère*, 22.

31. David Rosand, "*Ut Pictor Poeta*: Meaning in Titian's *Poesie*," *New Literary History* 3 (1972): 532.

32. *Antonii Lvlli Balearis de Oratione Libri septem* (Basel: Ioannis Oporinus, 1558), 495–6; also quoted in Romeo De Maio, *Michelangelo e la Controriforma* (Rome and Bari: Laterza, 1978), 183.

33. LeCoat, *The Rhetoric of the Arts*, and Claude V. Palisca, "*Ut Oratoria Musica*: The Rhetorical Basis of Musical Mannerism," in *The Meaning of Mannerism*, ed. Franklin W. Robinson and Stephen G. Nichols, Jr. (Hanover, NH: University Press of New England, 1972), 37–65.

34. Burke, *Culture*, 50, 132.

35. Weinberg, *History*, 1:455–7; Marc Bensimon, "Modes of Perception of Reality in the Renaissance," in *The Darker Vision of the Renaissance: Beyond the Fields of Reason*, ed. Robert S. Kinsman, UCLA Center for Medieval and Renaissance Studies, Contributions 6 (Berkeley, Los Angeles, and London: University of California Press, 1974), 237; Martha King, "*Ut Musica Poesis:* The Effect of Music on Italian Poetics in the Cinquecento," *Italian Quarterly*, 18, no. 70 (Fall 1974): 49–62; Isidore Silver, "The Marriage of Poetry and Music in France: Ronsard's Predecessors and Contemporaries," in *Poetry and Poetics*, 152–84; and LeCoat, *The Rhetoric of the Arts*, passim.

36. Maria Rika Maniates, *Mannerism in Italian Music and Culture, 1530–1630* (Chapel Hill: University of North Carolina Press, 1979), 209–10.

37. Giovanni Battista Pigna, *I Romanzi Di M. Giouan Battista Pigna, Al S. Donno Lvigi Da Este Vescovo Di Ferrara, Divisi In Tre Libri* (Venice: Appresso Vincenzo Valgrisi, 1554), 28.

38. Per Palme, "Ut Architectura Poesis," in *Idea and Form*, ed. Nils Gösta Sandblad, Acta Universitatis Upsaliensis, Figura, NS 1 (Stockholm: Almqvist & Wiksell, 1959), and Ellen Frank, *Literary Architecture. Essays toward a Tradition: Walter Pater, Gerard Manley Hopkins, Marcel Proust, Henry James* (Berkeley and Los Angeles: University of California Press, 1980).

39. Weinberg, *Histroy*, 1:14, 40.

40. Walter J. Ong, "From Allegory to Diagram in the Renaissance Mind: A Study in the Significance of Allegorical Tableau," *Journal of Aesthetics and Art Criticism* 17 (1959): 439. According to Dubois: "Le XVIe siècle n'a guère pensé les faits de langue que par images"; see Dubois, *Mythe et langage au seizième siècle* (Bordeaux: Ducros, 1970), 13.

41. Ong, "From Allegory," 439, also see Innocenti, *L'immagine*, 54.

42. Lecercle, *La Chimère*, 22.

43. Weinberg, *History*, 1:2, 5, 13, 37.

44. This early literary context for emblems was pointed out by Trimpi in "Horace's 'Ut Pictura Poesis,'" 41–2.

45. Richard Waswo, *Language and Meaning in the Renaissance* (Princeton, NJ: Princeton University Press, 1987), 187; Heinrich J. Plett, "The Place and Function of Style in Renaissance Poetics," in *Renaissance Eloquence: Studies in the Theory and Practice of Renaissance Rhetoric*, ed. James J. Murphy (Berkeley, Los Angeles, and London: University of California Press, 1983), 360; and Hagstrum, *Sister Arts*, 65.

46. Demetrius, *Demetrius on Style*, trans. W. Rhys Roberts, in Aristotle, *The Poetics; "Longinus" on The Sublime; Demetrius on Style*, rev. ed., in *Aristotle in Twenty-Three Volumes*, Loeb Classical Library (1932; reprint, London: Heinemann; Cambridge, MA: Harvard University Press, 1973), 23:450–1, and Henri Louis Fernand Drijepondt, *Die antike Theorie der "varietas": Dynamik und Wechsel im Auf und Ab als Charakteristikum von Stil und Struktur*, Spudasmata 37 (Hildesheim and New York: Olms, 1979), 179. This Demetrius was probably the same author as the "Demetrius" in Bocchi's list of authorities (sig. a3r) and was first published by Aldus Manutius in 1508.

47. Palisca, "Ut oratoria musica," 37–65, and Klein, "Pomponius Guaricus," 216.

48. Hardison, *Enduring Monument*, 32; Lucia Faedo, "L'impronta delle parole: Due momenti della pittura di ricostruzione," in *I generi e i temi ritrovati*, vol. 2 of *Memoria dell'antico nell'arte italiana*, ed. Salvatore Settis, 3 vols. (Turin: Einaudi, 1984–6), 5–7; and Svetlana Leontief Alpers, "*Ekphrasis* and Aesthetic Attitudes in Vasari's Lives," *Journal of the Warburg and Courtauld Institutes* 23 (1960): 191–2, 194.

49. Hagstrum, *Sister Arts*, xvii, 15, 30.

50. Bocchi, *Symbolicae Quaestiones*, Symbols LV, LXIII, CII, CXXI, and Costalius *Pegme*, 7, 29, 54, 59 passim.

51. Bocchi's two symbols were reproduced in Carlo Cesare Malvasia's study of antiquities in

Bologna in the seventeenth century; see Malvasia, *Marmora Felsinea Innumeris Non Solum Inscriptionibus Exteris Hucusque Ineditis*...(Bologna: Ex Typographia Pisariana, 1690), 47–51.

52. Plett, "The Place," 362.

53. Hagstrum, *Sister Arts*, 12. On Renaissance commentaries on Aristotle's *Energeia*, see Plett, *Rhetorik*, 184–93. Bocchi would also have encountered a discussion of the Ciceronian use of *enargeia* as "evidence" in the *Orationes* of the Bolognese rhetorician Filippo Beroaldo the Elder (Hathaway, *The Age*, 122). The concept of *enargeia* was further developed in the seventeenth century; see John D. Lyons, "Speaking in Pictures, Speaking of Pictures: Problems of Representation in the Seventeenth Century," in *Mimesis: From Mirror to Method, Augustine to Descartes*, ed. John D. Lyons and Stephen G. Nichols, Jr. (Hanover and London: Publ. for Dartmouth College by the University Press of New England, 1982), 168–69.

54. The young Alciato in 1521 alluded to "pictas fabellas" in a dedicatory poem praising Stephanus Niger's translation of Philostratus's *Icones;* see John Manning, "Alciati and Philostratus's *Icones,*" *Emblematica* 1 (1986): 207–8.

55. Alison Saunders, "Picta poesis: The Relationship between Figure and Text in the Sixteenth-Century French Emblem Book," *Bibliothèque d'Humanisme et Renaissance* 48 (1986): 626, 631, 646.

56. The categories that these figures are placed in vary from treatise to treatise.

57. Rosemond Tuve, *Elizabethan and Metaphysical Imagery: Renaissance Poetic and Twentieth-Century Critics* (Chicago and London: University of Chicago Press, 1947), 108; Heinrich F. Plett, "Konzepte des Allegorischen in der englischen Renaissance," in *Formen und Funktionen der Allegorie: Symposion Wolfenbüttel 1978*, ed. Walter Haug, Germanistische Symposien Berichtsbände 3 (Stuttgart: Metzler, 1979), 313; and E. H. Gombrich, *Symbolic Images*, 3d ed., vol. 2 of *Studies in the Art of the Renaissance* (Chicago: University of Chicago Press, 1985), 165–8. Metaphor also has a naming function, as, for example, calling a defective car a "lemon." Allegory is usually considered an expanded metaphor, and simile can be expanded into what is termed the "epic simile."

58. Eden, *Poetic and Legal Fiction*, 70–1.

59. Eden, *Poetic and Legal Fiction*, 86–7. The *imago* is difficult to pin down. Erasmus said that it was neither a similitude nor a proof, but a means of vivid presentation or emphasis; see Lee A. Sonnino, *A Handbook to Sixteenth-Century Rhetoric* (London: Routledge & Kegan Paul, 1968), 107–8.

60. George Puttenham, *The Arte of English Poesie*, ed. Gladys Doidge Willcock and Alice Walker (Cambridge: Cambridge University Press, 1936), 241. Puttenham's first draft was probably written around 1579. Also see Tuve, *Elizabethan and Metaphysical Imagery*, 54–5, 73–4, 109.

61. For the development of Baroque theories of metaphor, see Gerd Breitenbürger, *Metaphora: Die Rezeption des Aristotelischens Begriffs in den Poetiken des Cinquecento* (Krönberg: Scriptor, 1975).

62. Maniates, *Mannerism*, 30.

63. Irene M. Bergal, "Word and Picture: Erasmus' *Parabolae* in La Perrière's *Morosophie*," *Bibliothèque d'Humanisme et Renaissance* 47 (1985): 113–14.

64. Doglio, in Tesauro, *Idea*, 19–20, and Innocenti, *L'immagine*, 180–2.

65. Innocenti, *L'immagine*, 58–9, 83, 135, 180–99. These treatises of late-sixteenth-century Italy are chiefly concerned with the *impresa*, which consists of picture and motto, rather than picture, motto, and verse as in the emblem. Innocenti himself saw little difference between emblem and *impresa:* "L'impresa-emblema dunque si istituisce all'incrocio e nella combinazione della metafora e della metonomia" (9). As "macrosegno complesso,"

the emblem is a metaphor of a metaphor, whereas the *impresa* is a metaphor of the subject (195). Innocenti, unlike most critics of emblems, draws extensively on theories by Derrida, Kristeva, and others in discussions of emblem and *impresa*. See also F. W. G. Leeman, *Alciatus' Emblemata: Denkbeelden en voorbeelden* (Groningen: Bouma, 1984), 83–8.

66. Maniates, *Mannerism*, 29; Innocenti, *L'immagine*, 58, 83, 196; and Breitenbürger, *Metaphora*, 45.

67. Andrew Welsh, *Roots of Lyric: Primitive Poetry and Modern Poetics* (Princeton, NJ: Princeton University Press, 1978), 47.

68. See Alexander von Bormann, "Emblem und Allegorie: Vorschlag zu ihrer historisch-semantischen Differenzierung (im Beispiel des Reyens im humanistischen und baroken Drama)," 535–50, and Konrad Hoffmann, "Alciati und die geschichtliche Stellung der Emblematik," 514–34, both in *Formen und Funktionen der Allegorie*, and Gerhard Kurz, *Metaphor, Allegorie, Symbol* (Göttingen: Vandenhoeck & Ruprecht, 1982), 51.

69. Demetrius, *Demetrius on Style*, paragraph 243, p. 451.

70. James A. Coulter, *The Literary Microcosm: Theories of Interpretation of the Later Neoplatonists* (Leiden: Brill, 1976), 43.

71. Dronke, *Medieval Poet*, 25. Geoffrey's *Poetria nova*, dedicated to Pope Innocent III at the beginning of the thirteenth century, exists in at least eighty manuscript copies and was probably still being read in the Renaissance (21). *Collatio*, or "comparison," was a another term still in use in the Renaissance; see Sonnino, *A Handbook*, 39.

72. Heinrich F. Plett, *Einführung in die rhetorische Textanalyse*, 5th ed. (Hamburg: Buske, 1983), 96–7.

73. On Pontanus, see especially II, vii, "De ironicis," and II, xv, "De dissimulatoribus," in *De Sermone Libri Sex*, ed. S. Lupi and A. Risicato (Lucani: Thesauri Mundi, 1954), 64, 74–5. On laughter and dissimulation, see Breitenbürger, *Metaphora*, 51–2, 58; Vincenzo Maggi and Bartolomeo Lombardi, *In Aristotelis Librum De Poetica Communes Explanationes (1550)* (1550; reprint, Munich: Fink, 1969), 114, 317–18; and Mary A. Grant, *The Ancient Rhetorical Theories of the Laughable: The Greek Rhetoricians and Cicero*, University of Wisconsin Studies in Language and Literature 21 (Madison: University of Wisconsin, 1924), 120, 125, 127.

74. Puttenham, *The Arte*, 186.

75. Emanuele Tesauro, *Il Cannocchiale Aristotelico*, ed. August Buck (1670; reprint, Bad Homburg, Berlin, and Zurich: Gehlen, 1968), 261.

76. Costalius *Pegme*, 154–5; Guillaume de la Perrière, *La Morosophie de Guillaume de la Perriere Tolosain, Contenant Cent Emblemes moraux, illustrez de Cent Tetrastiches Latins; rediutz en autant de Quatrains François* (Lyon: Macé Bonhomme, 1553), nos. 66, 95; and Guillaume Gueroult, *Le Premier Livre des emblemes composé par Guillaume Gueroult à Lyon, chez Balthazar Arnoullet M. D. XXXXX*, ed. DeVaux de Lancy (Rouen: Lainé, 1937), 30–2.

77. That Bocchi was concerned with Socratic irony and paradox is clear; Irving Lavin said of Bocchi's Socrates with his daimon and Socratic "wise profession of ignorance" (Symbols III and CXXXVIII) that "he follows the heuristic tradition formulated in antiquity of conveying profound ideas through irony" ("Divine Inspiration," 74).

78. Plett, "The Place," 362; Tateo, *Retorica*, 231, 237, 257; and Burke, *Culture*, 137, 139. For classical views on *varietas*, see Drijepondt, *Die antike Theorie der "varietas."*

12. Jürgen Nowicki, *Die Epigrammtheorie in Spanien vom 16. bis zum 18. Jahrhundert: Eine Vorarbeit zur Geschichte der Epigrammatik* (Wiesbaden: Steiner, 1974), 82, 131.

80. For Renaissance theory on the epigram, see Nowicki, *Die Epigrammtheorie*, 38–74, and Marion Lausberg, *Das Einzeldistichon: Studien zum antiken Epigramm* (Munich: Fink, 1982), 78–81.

81. Nowicki, *Die Epigrammtheorie*, 6, in a discussion of Mario Praz's *Studi sul concettismo*, 2d ed. (Florence: Sansoni, 1946), 164. The Praz work is also available as *Studies in Seventeenth-Century Imagery*, vol. 1, 2d ed. enl. (1964; reprint, Rome: Edizioni di Storia e Letteratura, 1975); vol. 2 (Rome: Edizioni di Storia e Letteratura, 1974).

82. Faedo, "L'impronta," 6, and Alpers, "*Ekphrasis*," 197. Svetlana Alpers noted: "In mediaeval *ekphrasis*, art, rather than being judged as a human artifact, had what might be called a mystical function in which the *tituli* played an integral role" (197). Similar combinations of picture and epigram have been found in Pompei; see Peter M. Daly, *Literature in the Light of the Emblem: Structural Parallels between the Emblem and Literature in the Sixteenth and Seventeenth Centuries* (Toronto, Buffalo, and London: University of Toronto Press, 1979), 9. Whether any Roman examples were known in the Renaissance is uncertain.

83. Dieter Sulzer, "Zu einer Geschichte der Emblemtheorien," *Euphorion* 64 (1970): 41. Jürgen Nowicki discussed the relationship between epigram and emblem (and *impresa*) only in terms of late-sixteenth-century theories of body/soul and *inscription/pictura/subscriptio;* see *Die Epigrammtheorie*, 72–82.

84. La Perrière, *Morosophie*, sig. B1r. He often used the terms "[sic]ut" and "sic" in the Latin quatrains; in Number 74 the first line begins with "Vt" and the third with "Sic" in a tidy balancing of the two parts of the quatrain. Nevertheless, the author achieves a touch of variety by saying that although coal creates heat in a fireplace, a much greater heat is produced by rancor in the heart.

85. Carol Maddison, *Apollo and the Nine: A History of the Ode* (Baltimore: Johns Hopkins University Press, 1960), 8, 9–11.

86. Gian Biagio Conte, *The Rhetoric of Imitation: Genre and Poetic Memory in Virgil and Other Latin Poets*, ed. Charles Segal, trans. Susan George, Anthony L. Johnson, and Sylvia Notini, Cornell Studies in Classical Philology 44 (Ithaca, NY, and London: Cornell University Press, 1986), 25.

87. On the paradox (which will be discussed further in Chapter 6), see Cicero, *Paradoxa Stoicorum*, in vol. 2 of *De Oratore*, trans. E. W. Sutton, 2 vols., vols. 3–4 of *Cicero in Twenty-Eight Volumes*, Loeb Classical Library (Cambridge, MA: Harvard University Press; London: Heinemann, 1977–9), 2:356–7; Helen Peters, "General Introduction," in John Donne, *Paradoxes and Problems* (Oxford: Clarendon Press, 1980), xvi–xxvii, and A. E. Malloch, "The Techniques and Function of the Renaissance Paradox," *Studies in Philology* 53 (1956): 191–6. For the question, see Cicero, *De Partitione Oratoria*, xviii. 61, in *Cicero*, 2:356–7; Peters, "General Introduction," xxvii–xlv; Malloch, "The Techniques," 196–200; and Thomas Frederick Crane, *Italian Social Customs of the Sixteenth Century and Their Influence on the Literatures of Europe*, Cornell Studies in English 5 (1920; reprint, New York: Russell & Russell, 1971), especially Chapters 1–3 and 6.

88. On the role of the identification of the question in rhetorical theory, see William Harris Stahl and Richard Johnson with E. L. Burge, trans., *The Marriage of Philology and Mercury*, vol. 2 of Stahl, *Martianus Capella and the Seven Liberal Arts*, 2 vols. (New York: Columbia University Press, 1971–7), 161n.

89. Leonard Forster, *The Icy Fire: Five Studies in European Petrarchism* (Cambridge: Cambridge University Press, 1969), 52–3. Forster's is still the best general study on Petrarchism and the reasons for its long popularity. For sixteenth-century Italian Petrarchism, see also Amadeo Quondam, *Petrarchism mediato: Per una critica della forma "antologia"* (Rome: Bulzoni, 1974).

90. Praz, *Studies*, 39–40. Praz lists Symbols VI, VII, XII, XIII, XX, and LXXV as amatory emblems.

91. Petrarch's calendrical structure was studied by Thomas P. Roche, Jr., in "The Calendrical

Structure of Petrarch's *Canzoniere*," *Studies in Philology* 71 (1974): 152–72, and the use of clusters of *Canzoni* as "structural pillars" was discussed by Robert M. Durling, trans., *Petrarch's Lyric Poems: The Rime Sparse and Other Lyrics* (Cambridge, MA: Harvard University Press, 1976), 23–5. The emblem, of course, fed back into the Petrarchist poem its own conceits; see Mario Praz, "Petrarca e gli emblematisti," in *Ricerche anglo-italiane* (Rome: Edizioni di Storia e Letteratura, 1964), 303–19, and Giancarlo Innocenti, "La struttura emblematica nel sonetto 'Alla notte' di Giulio Camillo," *Forum Italicum* 12 (1978): 391–407.

92. Sambucus, *Emblemata*, 165, 175, 200, includes his own coat of arms and that of his birthplace, Trnava. He also adds more intimate touches like a tribute to his father, a description of his trip to Italy on horseback accompanied by his faithful dogs, Bombo and Madel, and his debt to Bocchi, who was like a father to him.

93. Daniel Russell, "Du Bellay's Emblematic Vision of Rome," *Yale French Studies*, no. 47 (1972): 100.

## 5. Bocchi and the Symbol

1. "Do not inquire any further what a symbol is; we will attempt to explain what it is as briefly as possible," I, lines 1–3 (translated by Thomas Marier).

2. Abner Cohen, *Two-Dimensional Man: An Essay on the Anthropology of Power and Symbolism in Complex Societies* (1974; reprint, Berkeley and Los Angeles: University of California Press, 1976), ix.

3. James A. Coulter, *The Literary Microcosm: Theories of Interpretation of the Later Neoplatonists* (Leiden: Brill, 1976), 43; R. Falus, "La Formation de la notion 'symbole,'" *Acta Antiqua Academiae Scientiarum Hungaricae* 29 (1981): 117–18; and Gerhart B. Ladner, "Medieval and Modern Understanding of Symbolism: A Comparison," *Speculum* 54 (1979): 223. For early uses of "symballein" and "symbolon," see Peter Crome, *Symbol und Unzulänglichkeit der Sprache – Jamblichos, Plotin, Porphyrios, Proklos* (Munich: Fink, 1970), 205–8.

4. Northrop Frye, "The Symbol as a Medium of Exchange," in *Symbols in Life and Art: The Royal Society of Canada Symposium in Memory of George Whalley*, ed. James A. Leith (Kingston, Ont.: McGill-Queen's University Press, 1987), 3.

5. Falus, "La Formation," 119–21; Ladner, "Medieval and Modern Understanding," 223; and Philippe Gauthier, *Symbola: Les Etrangers et la justice dans les cités grecques*, Annales de l'Est, 2, Mémoire, no. 42 (Nancy: Université de Nancy, 1972).

6. Gauthier, *Symbola*, 74; Falus, "La Formation," 128; and Caelestis Eichenseer, "De Vocabulo Symbolae," *Latinitas* 13 (1965): 123, 126.

7. H. J. Carpenter, "Symbolum as a Title of the Creed," *Journal of Theological Studies* 43 (1942): 2; Falus, "La Formation," 128, and Ladner, "Medieval and Modern Understanding," 223–4.

8. Coulter, *Literary Microcosm*, 43, and also see Ladner, "Medieval and Modern Understanding," 223. According to Frye, it was the *symbolon* that was incomplete and the *symbolos* that "links us to something too complex or mysterious to grasp all at once" ("The Symbol as a Medium," 4).

9. Coulter, *Literary Microcosm*, 62, and Falus, "La Formation," 118. "Symbolice" in Martianus Capella is the personification of one of the seven prophetic arts; she "compares future events with prognostications, and reconciles the conclusion of omens with happenings" (her name literally means "symbolic or riddling"); see William Harris Stahl and Richard Johnson with E. L. Burge, trans., *The Marriage of Philology and Mercury,*

vol. 2 of Stahl, *Martianus Capella and the Seven Liberal Arts,* 2 vols. (New York: Columbia University Press, 1971–7), 347.

10. Falus, "La Formation," 115–17, 119, 127.

11. Ladner, "Medieval and Modern Understanding," 228–56, and Tzvetan Todorov, "Introduction à la symbolique," *Poétique* 11 (1972): 275–81.

12. Falus, "La Formation," 128, and Carpenter, "Symbolum," 5.

13. The source is Plutarch's Life of Alexander, 39; see Arthur Henkel and Albrecht Schöne, eds., *Emblemata: Handbuch zur Sinnibildkunst des XVI. und XVII. Jahrhunderts* (Stuttgart: Metzler, 1967), cols. 1151–2.

14. Falus says that this was the custom of Roman emperors and aristocrats ("La Formation," 128), although Bocchi ascribed it to the Athenians.

15. Claude Paradin, *Devises Heroïqves* (Lyon: Ian de Tovrnes, et Gvil. Gazeav, 1557), 15, and *The Heroicall Devises of M. Claudius Paradin (1591),* introduction by John Doebler (reprint, Delmar, NY: Scholars' Facsimiles & Reprints, 1984), 15.

16. Edgar Wind, *Pagan Mysteries in the Renaissance,* rev. ed. (New York and London: Norton, 1968), 23, 260–1.

17. For heraldry and emblematic literature, see Michel Pastoureau, "Aux Origines de l'emblème: La Crise de l'hèraldique européenne aux XVe et XVIe siècles," in *Emblemes et devises au temps de la Renaissance,* ed. M. T. Jones-Davies (Paris: Touzot, 1981), 129–36.

18. Bernard F. Scholz, "'Libellum composui epigrammaton, cui titulum fece Emblemata': Alciatus's Use of the Expression *Emblema* Once Again," *Emblematica* 1 (1986): 219; also cited in Gennaro Savarese and Andrea Gareffi, eds., *La letteratura delle immagini nel Cinquecento* (Rome: Bulzoni, 1980), 115, and Holgar Homann, *Studien zur Emblematik des 16. Jahrhunderts...* (Utrecht: Haentjens Dekker & Gumbert, 1971), 125.

19. Christian Froidefond, *Le Mirage égyptien dans la littérature grecque, d'Homère à Aristote,* Publications Universitaires des lettres et sciences humaines d'Aix-en-Provence (Aix-en-Provence: Ophrys, 1971), 202–5; and Erik Iverson, *The Myth of Egypt and Its Hieroglyphs in European Tradition* (Copenhagen: Gec Gad, 1961), 12, 19, 25.

20. Maurice Pope, *The Story of Archeological Decipherment from Egyptian Hieroglyphs to Linear B* (New York: Scribners, 1975), 17; Mariette de Vos, *L'Egittomania in pitture e mosaici romano-campani della prima età imperiale,* trans. Arnold de Vos (Leiden: Brill, 1980), and Karl H. Dannenfeld, "Egypt and Egyptian Antiquities in the Renaissance," *Studies in the Renaissance* 6 (1959): 7–27.

21. For a list of many of these sources, see Pope, *The Story,* 20. Also see Iverson, *Myth,* 40, 44–7; Patrizia Castelli, *I geroglifici dell'Egitto nel Rinascimento* (Florence: Edam, 1979), 11–14; and Daniel Russell, "Emblems and Hieroglyphics: Some Observations on the Beginnings and the Nature of Emblematic Forms," *Emblematica* 1 (1986): 228–9.

22. Karl Giehlow, "Die Hieroglyphenkunde des Humanismus in der Allegorie der Renaissance, besonders der Ehrenpforte Kaisers Maximilian I," *Jahrbuch der Kunsthistorischen Sammlungen des Allerhöchsten Kaiserhauses (Wien)* 32 (1915): 12, 16; Roberto Weiss, *The Renaissance Discovery of Classical Antiquity* (Oxford: Blackwell, 1969), 155; Iverson, *Myth,* 46; and Pope, *The Story,* 19. For the Greek text, see Horapollo, *Hieroglyphica,* ed. Francesco Sbordone (Naples: Loffredo, 1940); and for an English translation, see *The Hieroglyphics of Horapollo,* trans. George Boas (New York: Pantheon, 1950).

23. Weiss, *Renaissance Discovery,* 155; Castelli, *I geroglifici,* 23; and Giehlow, "Hieroglyphenkunde," 20.

24. Weiss, *Renaissance Discovery,* 155n; Andrea Gareffi, "Egizierie umanistiche: La mantica geroglifica tra Quattro e Cinquecento," *FM: Annali dell'Istituto di Filologia Moderna dell'Università di Roma* (1977): 14–15; and Robert Aulotte, "D'Egypte en France per l'Italie: Horapollon au XVIe siècle," in *Mélanges à la mémoire de Franco Simone: France et*

*Italie dans la culture européenne,* 4 vols., Centre d'Etudes Franco-Italien, Universités de Turin et de Savoie, Bibliothèque Franco Simone 4, 6, 8–9 (Geneva: Slatkine, 1980–4), 1:556, 570.

25. D. L. Drysdall, "Filippo Fasanini and His 'Exploration of Sacred Writing' (Text and Translation)," *Journal of Medieval and Renaissance Studies* 13 (1983): 127–9, and Cesare Vasoli, "per la fortuna degli 'Hieroglyphica' di Orapollo: La versione italiana in 1547," in *Esistenza, mito, ermeneutica, scritti per Enrico Castelli,* 2 vols., *Archivio di filosofia* (1980), 1:191–207. For a study of editions and commentaries, see Sandra Sider, "Horapollo," in *Catalogus Translationum et Commentariorum: Medieval and Renaissance Latin Translations and Commentaries,* ed. F. Edward Cranz, Virginia Brown, and Paul Oskar Kristeller, 6 vols. to date (Washington, DC: Catholic University of America Press, 1960–) 6:15–29.

26. Giehlow, "Hieroglyphenkunde," 79–86.

27. Giehlow, "Hieroglyphenkunde," 97, 114.

28. Giehlow, "Hieroglyphenkunde," 27, 38; Drysdall, "Filippo Fasanini," 127–8; and Vasoli, "Per la fortuna," 195.

29. Giehlow, "Hieroglyphenkunde," 6–7, 216–18; and Claude-Françoise Brunon, "Signe, Figure, Langage: Les *Hieroglyphica* d'Horapollon," in *L'Emblème à la Renaissance: Actes de la Tournée d'Etudes du Mai 1980,* ed. Yves Giraud, Société Française des Seiziémistes, (Paris: SEDES, 1982), 34, 37–8.

30. Russell, "Emblems and Hieroglyphics," 235–6.

31. Giehlow, "Hieroglyphenkunde," 30–2; Erik Iverson, "Hieroglyphic Studies of the Renaissance," *Burlington Magazine* 100 (1958): 19; and Liselotte Dieckmann, *Hieroglyphics: The History of a Literary Symbol* (St. Louis: Washington University Press, 1970), 32–3.

32. Drysdall, "Filippo Fasanini," 134–5. Writers on natural history did use plant and animal lore from hieroglyphics; see Karl-Adolf Knappe and Ursula Knappe, "Zur Tierdarstellung in der Kunst des 15. und 16. Jahrhunderts," *Studium Generale* 20 (1967): 286–7, and Ludwig Volkmann, *Bilder Schriften der Renaissance: Hieroglyphik und Emblematik in ihren Beziehungen und Fortwirkungen* (1923; reprint. Nieuwkoop: De Graaf, 1962), 31. Hieroglyphs were readily adapted for use in Renaissance art; see Giehlow, "Hieroglyphenkunde," 6, 70, 88; Knappe and Knappe, "Zur Tierdarstellung," 285–90; Gareffi, "Egizierie," 20; Dieckmann, *Hieroglyphics;* and Raphaelle Costa de Beauregard, "La Hieroglyphe et le mythe des origines de la culture au XVIe siècle," in *Emblèmes et devises au temps de la Renaissance,* 96–7. On mnemonics and hieroglyphics, see Volkman, *Bilder,* 80–1, 85, and Claudie Balavoine, "Hiéroglyphes de la mémoire: Emergence et métamorphose d'une écriture hiéroglyphique dans les arts de mémoire du XVIe et du XVIIe siècle," *XVIIe Siècle* 40 (1988): 51–87, figs. 1–8.

33. Hieroglyphs were seen to reveal the hidden essences of things by Plotinus and by Ficino and his admirers; see Iverson, "Hieroglyphic Studies," 16; Iverson, *Myth,* 46, 64; and Russell, "Emblems and Hieroglyphics," 228, 235.

34. In art there are a few examples, according to Charles Dempsey; see Dempsey "Renaissance Hieroglyphic Studies and Gentile Bellini's *Saint Mark Preaching in Alexandria,*" in *Hermeticism and the Renaissance: Intellectual History and the Occult in Early Modern Europe,* ed. Ingrid Merkel and Allen G. Debus, Folger Institute Symposia (Washington, DC: Folger Shakespeare Library; London and Toronto: Associated University Presses, 1988), 342–65; and Diana Galis, "Concealed Wisdom: Renaissance Hieroglyphic and Lorenzo Lotto's Bergamo *Intarsie,*" *Art Bulletin* 62 (1980): 363–75; and Giehlow, "Hieroglyphenkunde," 1–6.

35. Francesco Colonna, *Hypnerotomachia Poliphili, Venice, 1499* (reprint, New York and London: Garland, 1976); Francesco Colonna, *Hypnerotomachia Polifili,* ed. Giovanni Pozzi and Lucia A. Ciapponi, 2 vols. (1974; reprint, Padua: Antenore, 1980); Maria Teresa

Casella and Giovanni Pozzi, eds., *Francesco Colonna, biografia e opere*, 2 vols., rev. ed. (Padua: Antenore, 1980); and Francesco Colonna, *Hypnerotomachia Poliphili (Venetiis, Aldo Manuzio, 1499)*, introduction by Peter Dronke (reprint, Zaragoza: Las Ediciones del Pórtico, 1981). The authorship of the work has been questioned: see Maurizio Calvesi, *Il sogno di Polifilo prenestino* (Rome: Officina, 1980) (Francesco Colonna of Palestrina); Emilio Menegazzo, "Per la biografia di Francesco Colonna," *Italia medioevale e umanistica* 5 (1962): 231 (Francesco Colonna, the Dominican monk of Venice); and Dorotea Schmidt, *Untersuchungen zu der Architekturekphrasen in der Hypnerotomachia Poliphili: Die Beschreibung des Venus-Tempels* (Frankfurt am Main: Fischer, 1978), on Leon Battista Alberti as author of the first version of the work. For a bibliography of works on Colonna, see Dronke's 1981 reprint of the *Hypnerotomachia*, 71–5; Giovanni Pozzi, "Les Hiero-glyphes de l'*Hypnerotomachia Poliphili*," in *L'Emblème à la Renaissance*, 15–27; and essays by Michelangelo Muraro, Giovanni Morelli, and Maurizio Calvesi in *La letteratura, la rappresentazione, la musica al tempo e nei luoghi di Giorgione*, ed. Michelangelo Muraro (Rome: Jouvence, 1987), 119–31, 163–83.

36. The engraving of Symbol CXLVII places the hieroglyphs on a giant scroll unfurled by Pirro's Genius, a winged being copied from Raphael's *Divine Inspiration* in the Vatican Stanza della Segnatura. Bocchi alludes to "Custos fideles" in line 5, but devotes most of the emblem verse to the subjects of innocence and justice. Colonna's reading of the group is as follows: "EX LABORE DEO NATVRAE SACRIFICA LIBERALITER, PAVLATIM REDVCES ANIMVM DEO SVBIECTVM. FIRMAM CVSTODIVM VITAE TVAE MISERICORDITER GVBERNANDO TENEBIT, INCOLVMEM QVE SERVABIT" (fol. Cr).

37. Russell, "Emblems and Hieroglyphics," 235.

38. Russell, "Emblems and Hieroglyphics," 235.

39. Horapollo, *Hieroglyphics*, 66–7.

40. Petrus Costalius, *Le Pegme de Pierre Coustau, Lyons, 1555* (reprint, New York and London: Garland, 1979), 319–23; Horapollo, *Hieroglyphics*, 57–8; and Andrea Alciato, *The Latin Emblems, Indexes and Lists*, vol. 1 of *Andreas Alciatus*, ed. Peter M. Daly, Virginia W. Callahan, and Simon Cuttler (Toronto, Buffalo, and London: University of Toronto Press, 1985), Emblem 133.

41. Volkman, *Bilder*, 46–7.

42. The lion was believed to sleep with its eyes open; see Horapollo, *Hieroglyphics*, 71: "To indicate that one is wide awake and on guard, they draw the head of a lion. For the lion while on guard closes his eyes, but when sleeping keeps them open . . . Wherefore they place lions as guards in the courtyards of the temples, as symbols" (70). Alciato also illustrated a pair of lions supporting columns, this time flanking the door of a church facade, in his "Vigilantia & Custodia"; see Alciato, *The Latin Emblems*, vol. 1, Emblem 15.

43. Colonna, *Hypnerotomachia Poliphili*, sigs. cr, dviir, uviii$^v$, uiiir. See also Volkman, *Bilder*, 15–17.

44. Russell, "Emblems and Hieroglyphics," 236, and Brunon, "Signe," 40–5.

45. Russell, "Emblems and Hieroglyphics," 236, and also Brunon, "Signe," 47.

46. Claude Françoise Brunon, "Lecture, rupture ou les vertus du discontinu: La communica-tion emblèmatique," in *Lectures, systèmes de lecture*, ed. Jean Bessière (Paris: PU de France, 1984), 123–35.

47. Giovanni Piero Valeriano Bolzano, *Hieroglyphica, Lyon, 1602* (reprint, New York and London: Garland, 1976). On Valeriano, see especially Giehlow, "Hieroglyphenkunde," 125–6; Iverson, *Myth*, 71–2; and Rudolf Wittkower, "Hieroglyphics in the Early Renaissance," in *Developments in the Early Renaissance: Papers of the Second Annual Conference of the Center for Medieval and Early Renaissance Studies, State University of New*

*York at Binghamton, 4–5 May 1968,* ed. Bernard S. Levy (Albany: State University of New York Press, 1972), 91–2.

48. Giehlow, "Hieroglyphenkunde," 125–6.

49. S. K. Heninger, *Touches of Sweet Harmony: Pythagorean Cosmology and Renaissance Poetics* (San Marino, CA: Huntington Library, 1974), 57–9, 271, and J. A. Philip, *Pythagoras and Early Pythagoreanism,* Phoenix: Journal of the Classical Association of Canada, Supplementary vol. 7 (Toronto: University of Toronto , 1966), 135–7.

50. See especially Plutarch, *Table-Talk,* trans. Edwin L. Minar, Jr., in *Plutarch's Moralia,* 15 vols., Loeb Classical Library (London: Heinemann; New York: Putnam, 1927–61), 9:39, 165–73, and Athenaeus, *The Deipnosophists,* trans. Charles Burton Gulick, 7 vols., Loeb Classical Library (Cambridge, MA: Harvard University Press; London: Heinemann, 1961), 1:3, 287, 2:65, 3:385, 387. Athenaeus frequently made reference to the Pythagoreans and their practices. For lists of *symbola,* see Heninger, *Touches,* 273–4, and Cesare Vasoli, "Pitagora in monastero," *Interpres* 1 (1978): 263–4n.

51. Heninger, *Touches,* 272; Philip, *Pythagoras,* 135–7; and Crome, *Symbol und Unzulänglichkeit,* 62–3.

52. John F. Mahoney, "Philippe de Harveng's *Logogrypha et Aenigmata:* An Unfinished Decipherment," *Medievalia et Humanistica* 12 (1958): 20, and Vasoli, "Pitagora," 265. Pythagoras was also believed to be the author of the *Carmina Aurea,* or "Golden Verses," which in the hands of Renaissance commentators was made to sound almost Christian; see Heninger, *Touches,* 56.

53. A sculpted memorial to Piero Canonici (d. 1502) and formerly in Bocchi's neighborhood church of San Martino suggests such a prototype: In a classroom setting, a teacher and six pupils, four of them young men and two others bearded and older men, discuss something with animated gestures, while above the wooden paneling the heads of four very young boys look down; see I. B. Supino, *L'arte nelle chiese di Bologna,* 2 vols. (Bologna: Zanichelli, 1932–8), 2:392–3. Supino thought that the heads of the little boys were "bizzarro," but the scene can be read as a Pythagorean division between neophytes and an inner circle in a Renaissance setting.

54. Heninger, *Touches,* 22, 47; Philip, *Pythagoras,* 190; and Karl H. Dannenfeld, "The Renaissance and Pre-Classical Civilizations," *Journal of the History of Ideas* 13 (1952): 435, 438, 440. Even such an accomplished scholar as Cardinal Bessarion referred to the supposed meeting between Pythagoras and the Druids; see Heninger, *Touches,* 37n.

55. Heninger, *Touches,* 66–7n, 274–5; Vasoli, "Pitagora," 256, 258, 265; Giehlow, "Hieroglyphenkunde," 133; and also Emil Major, "Das 'Symbolum pythagoricum' des Conrad Lycosthenes," *Basler Zeitschrift* 42 (1943): 103–12.

56. Lilio Gregorio Giraldi, ... *Opera Omnia Dvobvs Tomis Distincta* ... , 2 vols. in 1 (Louvain: Apud Hackium, Boutesteyn, Vivie, Vander AA, & Luchtmans, 1696), 2:cols. 640–1. Caelio Calcagnini thought that the *symbola* originated in Egypt and that Pythagoras was only one of a number of wise Greeks who went to Egypt to study; see Calcagnini, *De Rebvs AEgyptiacis Commentarivs,* in *Opera Aliqvot* ... (Basel: Per Hier. Frobenivm, 1544), 229, 231.

57. Heninger, *Touches,* 66–7n, 274, and S. K. Heninger, Jr., "Pythagorean Symbola in Erasmus' *Adagia,*" *Renaissance Quarterly* 21 (1968): 163–5.

58. Andrea Alciato, *The Latin Emblems,* vol. 1, Emblem 82. The scholarly edition of Alciato by Claude Mignault (Minos) does discuss the Pythagorean *symbola* and their sources; Mignault also lists them in his "Syntagma de Symbolis," and in some editions (e.g., Paris 1601, 1602) he published a list of Pythagorean *symbola* as well; see Alciato, *Emblemata cum Commentariis, Padua, 1621,* ed. Claude Mignault (reprint, New York and London: Garland, 1976), 360–2, and Heninger, *Touches,* 67n, 275.

59. The dietary prohibitions of the Pythagoreans were many: They were not supposed to eat fish, brains, the heart, beans, mallows, and, according to some, any meat; see Heninger, *Touches*, 273–4, and Vasoli, "Pitagora," 263n.

60. Costalius, *Pegme*, 81, 167.

61. Margaret Mann Phillips, *Erasmus on His Times: A Shortened Version of the "Adages" of Erasmus* (1967; reprint, Cambridge: Cambridge University Press, 1980), x–xi.

62. Ronald F. Hock and Edward N. O'Neil, *The Chreia in Ancient Rhetoric*, vol. 1–, Society of Biblical Literature, Texts & Translations 27, Graeco-Roman Religion 9 (Atlanta, GA: Scholars Press, 1986–), 263.

63. I do not know when "symbolum" began to be used as a synonym for "motto." Bocchi's student, the poet Petrus Lotichius Secundus, took as his personal *symbolum* the motto "Simpliciter sine strepetu"; see Secundus, *Poemata Qvae Exstant Omnia*, ed. Petrus Burmannus Secundus Hoogstratanus and Christianus Friderich Quellius (Dresden: Apud Io. Nic. Gerlachi Vidvam et Fil., 1724), 152. The mottoes of emperors from Roman times to the Renaissance, collected by Nicholas Reusner in his *Symbolorvm Imperatoriorvm*, aided schoolmasters; it was published first in 1588 (I consulted the 4th edition, London: Billivs, 1619).

64. Hock and O'Neil, *Chreia*. Hock and O'Neil note the difficulty of giving any adequate translation of the word *chreia* (51n).

65. Alain Michel, "Rhetorique et philosophie de l'emblème: Allegorie, realisme, fable," in *Emblèmes et devises au temps de la Renaissance*, 23.

66. Phillips, *Erasmus*, xi. Proverbs formed a part of Bologna's educational system long before Erasmus arrived. Boncampagno and Bene da Firenze of the Bologna school of *dettatoria* collected proverbs for use in teaching epistolography and other *artes*, although medieval teachers often preferred *sententiae* to proverbs because of the hidden meanings and obscurity of the proverbs; see Giuseppe Vecchi, "Il 'proverbio' nella practica letteraria dei dettatori della scuola di Bologna," *Studi mediolatini e volgari* 2 (1954): 285, 302. Bocchi's own teachers, Giovanni Battista Pio and Filippo Beroaldo the Elder, adapted proverbs to humanistic teaching. Pio in his 1505 *Annotamenta* (Bologna: Platonicus de Benedictis) devoted scattered chapters to the explication of individual proverbs, which he admired for their antiquity, moral utility, and eloquence. Beroaldo, who had explicated many proverbs in his commentaries, led the way to a new "accommodation" of the proverb into Renaissance literature in his *Oratio proverbialis*, first published in Bologna in 1499 (see his *Orationes, Prelectiones, Praefationes & quaedam Mithicae Historiae*, Paris, 1508, fols. xlix, lx). To Beroaldo, proverbs, although brief, permit the broadest possible interpretation. After Erasmus had encountered the work of Beroaldo in Bologna in 1506, he revised his *Collectanea* into the essay form of the *Adagia;* see Maria Cytowska, "Erasme et Beroaldo," *Eos* 65 (1977): 267–9; and Eugenio Garin, "Note in margine all'opera di Filippo Beroaldo il Vecchio," in *Tra Latino e Volgare per Carlo Dionisotti*, ed. Gabriella Bernardoni Trezzini et al., 2 vols. (Padua: Antenore, 1974), 2:444.

67. Rosalie L. Colie, *The Resources of Kind*, ed. Barbara K. Lewalski (Berkeley and Los Angeles: University of California Press, 1973), 33–4.

68. Virginia Callahan,"The Mirror of Princes: Erasmian Echoes in Alciati's Emblematum liber," in *Acta Conventus Neo-Latini Amstelodamensis: Proceedings of the Second International Congress of Neo-Latin Studies, Amsterdam, 12–24 August 1973*, ed. P. Tuynman, G. C. Kuiper, and E. Kessler (Munich: Fink, 1979), 183.

69. For "Herculei labores," see Virginia Callahan, "The Erasmus–Alciati Friendship," in *Acta Conventus Neo-Latini Lovaniensis: Proceedings of the First International Congress of Neo-Latin Studies, Louvain, 23–28 August 1971*, ed. J. I. IJsewijn and E. Kessler (Louvain: Leuven University Press; Munich: Fink, 1971), 136–8, and Phillips, *Erasmus*, 13–31.

70. Callahan, "The Mirror of Princes," 183–96; Erwin Panofsky, "Erasmus and the Visual Arts," *Journal of the Warburg and Courtauld Institutes* 32 (1969): 212–15; and Jean Guillaume, "*Hic Terminus Haeret:* Du Terme d'Erasme à la devise de Claude Gouffier, la fortune d'un emblème à la Renaissance," *Journal of the Warburg and Courtauld Institutes* 44 (1981): 187–90.

71. Costalius *Pegme,* 121. Costalius referred to at least one emblematic superscript as a "sentence" (414).

72. Aulus Gellius, *The Attic Nights of Aulus Gellius,* trans. John C. Rolfe, 3 vols., Loeb Classical Library (London: Heinemann; New York: Putnam, 1927–8), 2:124–5 (Book VII, xiii, 2).

73. Barbara Bowen compared the Renaissance joke collections to the emblem book in her "Two Literary Genres: The Emblem and the Joke," *Journal of Medieval and Renaissance Studies* 15 (1985): 33.

74. Carpenter, "Symbolum," 1–2, 4.

75. Carpenter, "Symbolum," 2, and Ladner, "Medieval and Modern Understanding," 224.

76. Carpenter, "Symbolum," 9–11. For legal aspects of the Greek term, see Silvio Cataldi, *Symbolai e relazioni tra le città greche nel V secolo A.C.* (Pisa: Scuola Normale Superiore, 1983).

77. Coulter, *Literary Microcosm,* 64, 66–7.

78. Crome, *Symbol und Unzulanglichkeit,* 52–6, 60, 98, 138–42, and Falus, "La Formation," 130.

79. Coulter, *Literary Microcosm,* 66, and Ladner, "Medieval and Modern Understanding," 224.

80. Coulter, *Literary Microcosm,* 67, and Crome, *Symbol und Unzulänglichkeit,* 197–200.

81. Ladner, "Medieval and Modern Understanding," 225, and Francesco Zambon, "*Allegoria in verbis:* Per una distinzione tra simbolo e allegoria nell'ermeneutica medioevale," in *Symbolo, metafora, allegoria: Atti del IV Convegno italo-tedesco (Bressanone, 1976),* ed. D. Goldin (Padua: Liviana, 1980), 73–106.

82. Erich Auerbach, "Figura," trans. Ralph Manheim, in *Scenes from the Drama of European Literature,* 2d ed. (Minneapolis: University of Minnesota Press, 1984), 19–20, 49–50.

83. Ladner, "Medieval and Modern Understanding," 225–6; Auerbach, "Figura," 20, 25, 47; and Peter Dronke, *The Medieval Poet and His World* (Rome: Edizioni di Storia e Letteratura, 1984), 52–3.

84. Cornelia Kemp, *Angewandte Emblematik in süddeutschen Barockkirchen* (Munich and Berlin: Deutscher Kunstverlag, 1981), 9.

85. Emilio Pianezzola located the source of personification in rhetorical *controversiae,* where conflicts were seen as occurring between types of people; see Pianezzola, "Personificazione e allegoria: Il *topos* della contesa," in *Symbolo, metafora, allegoria,* 71.

86. Costalius, *Pegme,* 7. The emblem numbers for Alciato refer to those of the Padua 1621 edition as reprinted in *Andreas Alciatus,* vol. 1.

87. Carlo Filosa, *La favola e la letteratura esopiana in Italia dal Medio Evo ai nostri giorni* (Milan: Vallardi, 1952), 99. Alciato drew on Aesop and Babrius and their Renaissance collectors; see Filosa, *La favola,* 99, and P. Thoen, "Les grands recueils ésopiques latins des XVe et XVIe siècles et leur importance pour les littératures des temps modernes," in *Acta Conventus Neo-Latini Lovaniensis,* 659–66. Also see Eugenio Battisti, "Il mondo visuale delle fiabe," in *Umanesimo e esoterismo,* ed. Enrico Castelli, *Archivio di filosofia* (1960), nos. 2–3:291–320.

88. Henkel and Schöne, *Emblemata,* col. 667.

89. François Rigolot, *Poétique et onomastique: L'Exemple· de la Renaissance* (Geneva: Droz,

1977), 12, 15, 17, and Claude-Gilbert Dubois, *Mythe et langage au seizième siècle* (Bordeaux: Ducros, 1970), 122.

90. Johan Huizinga, *Homo Ludens: A Study of the Play Element in Culture* (Boston: Beacon, 1955), 116.

91. See Liber XVI in *Ausonius*, trans. Hugh G. Evelyn White, 2 vols., Loeb Classical Library (Cambridge, MA: Harvard University Press; London: Heinemann, 1961), 1:352–69.

92. Mahoney, "Philippe de Harveng," 18–22.

93. Pierre Laurens and Claudie Balavoine, eds. and trans., *Mvsae Redvces: Anthologie de la poésie latine dans l'Europe de la Renaissance*, 2 vols. (Leiden: Brill, 1975), 2:276–7.

94. Rigolot, *Poétique*, 230. Emanuele Tesauro referred briefly to a kind of verse involving word play and letter substitution, which he called "grifi" or "grifi verbali"; see Tesauro, *Il cannocchiale Aristotelico*, ed. August Buck (1670; reprint, Bad Homburg, Berlin, and Zurich: Gehlen, 1968), 376. On word games in general, including shaped verse, anagrams, and the rebus, see Giovanni Pozzi, *La parola dipinta* (Milan: Adelphi, 1981); Jean-Claude Margolin, "Devises, armes parlantes et rébus au temps des grands Rhétoriqueurs," in *Emblèmes et devises au temps de la Renaissance*, 65–80; and François Rigolot, "La figure de la lettre: Graphisme et paradigmatisme à l'aube de la Renaissance," *Revue des sciences humaines* 51 (1980): 47–59, 113–14.

95. Eva-Maria Schenck, *Das Bilderrätsel* (Hildesheim and New York: Olms, 1973), 14, 19.

96. Geofroy Tory, *Champ Fleury, ou l'art et science de la proportion des lettres*, ed. Gustave Cohen (Paris, 1529; reprint, Paris: Bosse, 1931), fol. LVII$^v$.

97. Schenck, *Das Bilderrätsel*, 34–5, pl. 76–80, and Praz, *Studies*, 72.

98. The full rebus appears at the end of the 1515 *Theologicarum conclusionum libri decem* of Bovelles; see Stanislas Musial, "Dates de naissance et de morte de Charles de Bovelles," in *Charles de Bovelles en son cinquième centenaire, 1479–1979: Actes du Colloque International tenu à Noyon les 14–15–16 septembre 1979* (Paris: Trédaniel, 1982), 52–3.

99. G. F. Hill, *Renaissance Medals from the Samuel H. Kress Collection at the National Gallery of Art, Based on the Catalogue of Renaissance Medals in the Gustave Dreyfus Collections*, ed. Graham Pollard, rev. and enl. ed. (London: Phaidon Press for the Samuel H. Kress Foundation, 1967), 16–17, and Giehlow, "Hieroglyphenkunde," 35–7.

100. Josephe Jacquiot, "Les Devises dans la medaille de 1438 à 1599 en France et en Italie," in *Emblèmes et devises au temps de la Renaissance*, 81, and Daly, *Literature*, 25–7.

101. Girolamo Bargagli, *Dialogo De' Givochi Che Nelle Vegghie Sanesi Si Vsano Di Fare*, Del Materiale Intronato (Siena: Per Luca Bonetti, 1572), 159–61 ("De' Rouesci," Giu. 118). On some early books of medals, see Johannes Sambucus, *Emblemata, Cvm Aliqvot Nvmmis Antiqvi Operis* (Antwerp: Ex Officina Christophori Plantini, 1564); Sebastiano Erizzo, *Discorso . . . Sopra la Medaglie de gli Antichi* (Venice: Gio. Varisco, & Paganino Paganini, 1559); and Costa de Beauregard, "Le Hieroglyphe et le mythe," 95.

102. Constantia's medal was struck in 1560 in Reggio, possibly as a wedding present; see Hill, *Renaissance Medals*, 86, fig. 451. The medal seems to be one art form in which tribute was paid to women; Constantia Bocchi and several other women whose medals are illustrated in Hill (86–91) were poets, and Lavinia Fontana, also of Bologna, was a painter.

103. Hill, *Renaissance Medals*, 89–90, fig. 470.

104. See also Henkel and Schöne, *Emblemata*, col. 1556.

105. Paolo Giovio thought that the *impresa* was introduced into Italy by the late-fifteenth-century French invasions, but this does not seem to have been the case; see Pastoureau, "Aux Origines," 129–33; Antonio Rossi, *Serafino Aquilano e la poesia cortegiana* (Brescia: Morcelliana, 1980), 69–70; Francesco Malaguzzi-Valeri, *La corte di Lodovico il Moro: La vita privata e l'arte a Milano nella seconda metà del Quattrocento*, 4 vols. (Milan: Hoepli,

1913–23), 1:323; and Robert Klein, "La Théorie de l'expression figurée dans les traités sur les *Imprese, 1555–1612,*" in his *La Forme et l'intelligible: Ecrits sur la Renaissance et l'art moderne,* ed. André Chastel (Paris: Gallimard, 1970), 126. For lists of titles, see especially Maria Luisa Doglio's introduction to Tesauro, *Idea,* 12–23, and Praz, *Studies,* 2:74–5.

106. Daly, *Literature,* 21; Klein, "La Théorie," 128; Dieter Sulzer, "Zu einer Geschichte der Emblemtheorien," *Euphorion* 64 (1970): 32; André Stegmann, "Les Théories de l'emblème et de la devise en France et en Italia (1520–1620)," in *L'Emblème à la Renaissance,* 66; and Paolo Giovio, *Dialogo dell'imprese militari e amorose,* ed. Maria Luisa Doglio (Rome: Bulzoni, 1978), 37. For texts on *impresa* theory, see also Tesauro, *Idea;* Savarese and Gareffi, *La letterature italiana, storia e testi,* 127–62; and vol. 3 of *Scritti d'arte del Cinquecento,* ed. Paola Barocchi, in *La letteratura italiana, storia e testi,* 32 (Milan and Naples: Ricciardi, 1977), 2772, 2802, 2828.

107. A 1601 definition of an academic *impresa* was "[an] instrument of our intellect, composed of figures and words which represent metaphorically the interior concept of the academician"; see Klein, "La Théorie," 127, 129.

108. Girolamo Ruscelli, *Le Imprese Illvstri ... Aggivntovi Nvovam Il Qvarto Libro Da Vincenzo Rvscelli ...* (Venice: Appresso Francesco de Francesci Senesi, 1584), 236–7.

109. Annibale Caro, *Lettere familiari,* ed. Aulo Greco, 3 vols. (Florence: Le Monnier, 1957–9), 2:7–8.

110. Gian Lodovico Masetti Zannini, *Motivi storici della educazione femminile, scienza, lavoro, giuochi* (Naples: D'Auria, 1982), 303–4.

111. See Battisti, *L'Antirinascimento,* 120; Peter Daly, *Emblem Theory: Recent German Contributions to the Characterization of the Emblem Genre* (Nendeln: KTO, 1979), 94; and Giancarlo Innocenti, *L'immagine significante: Studio sull'emblematica cinquecentesca* (Padua: Liviana, 1981), 9. This confusion was also common in the Baroque period; see Robert J. Clements, *Picta Poesis: Literary and Humanist Theory in Renaissance Emblem Books* (Rome: Edizioni di Storia e Letteratura, 1960), 20.

112. For an example of such a manuscript, probably from the end of the fifteenth century, see Gustav Cohen, ed., "Emblèmes moraux inedits du XVe siècle d'après un manuscrit des Archives départmentales de Gap (Hautes-Alpes)," in *Mélanges de littérature, d'histoire et de philologie offerts a Paul Laumonier par ses élèves et ses amis* (Paris, 1935; reprint, Geneva: Slatkine, 1972), 89–96. Alciato, who taught in France for scattered periods of his life, may have seen something similar to this one with its sixteen proverbs, each accompanied by a drawing and a verse in French.

113. Daly, *Emblem Theory,* 73–4.

114. Some of the texts discussed at length by Daly are Schöne, *Emblematik und Drama im Zeitalter des Barock,* 2d ed. (Munich: Beck, 1968); Jöns, *Das "Sinnen-Bild": Studien zur Emblematik bei Andreas Gryphius* (Stuttgart: Metzler, 1966); and Sulzer, "Poetik synthetisierender Künste und Interpretation der Emblematik," in *Geist und Zeichen: Festschrift für Arthur Henkel zu seinem sechzigsten Geburtstag,* ed. Herbert Anton, Bernhard Gajek, and Peter Pfaff (Heidelberg: Winter, 1977), 401–26.

115. Daly, *Emblem Theory,* 80.

116. There were also few emblem books in Italy. Besides those of Alciato and Bocchi, two emblem books were printed in Bologna according to Giovanni Fantuzzi: Ippolito Megliorini's *Emblemi con le loro dichiarazioni in diverse Rime* (1564), and Paolo Mazzi's *Emblemata Epigrammatis illustrata cum figuris* (1628); see Giovanni Fantuzzi, *Notizie degli scrittori bolognesi,* 9 vols. (Bologna: Nella stamperia di San Tommaso D'Aquino, 1781–94), 4:3, 5:375–7. I have been able to find nothing about Megliorini, but Mazzi's *Emblemata,* printed by Clemens Ferronius, appeared under the Latinized name, Paulus Maccius. Although it shows no specific borrowings, Mazzi's emblem book resembles

Bocchi's in its dedications to fellow academicians (Gelati and Ardenti) and its strongly architectural settings.

117. Girolamo Ruscelli, *Le imprese*, in *Scritti d'arte del Cinquecento*, 3:2827–8.

118. Bargagli, *Dialogo*, 152, 157–9.

119. Bargagli, *Dialogo*, 157. See also Daniel S. Russell, *The Emblem and Device in France* (Lexington, KY: French Forum, 1985), 142–4.

120. Tesauro, *Il Cannocchiali*, 604, 623, 627, 731, and Innocenti, *L'immagine*, 83.

121. Scholz, "'Libellum composui,'" especially 222. Scholz thinks it originally referred to a particular kind of ekphrastic epigram practiced within a small circle of *letterati* in Milan in the 1520s. This argument builds on those of Hessel Miedema and Daniel Stearns Russell on the epigrammatic origin of Alciato's emblems; see Miedema, "The Term *Emblema* in Alciati," *Journal of the Warburg and Courtauld Institutes* 31 (1968): 324–50, and Russell, "The Term 'Emblème' in Sixteenth-Century France," *Neophilologus* 59 (1975): 337–51.

122. Homann, *Studien*, 39–40. In fact, the emblem authors went out of their way to individualize their titles: for example, Aneau's *Picta Poesis* (1552), Perrière's *Morosophia, contenant Cent Emblèmes moreaux* (1553), and Costalius' *Pegme* (1555).

123. Miedema, "The Term *Emblema*," 234–5, and Frank B. Sear, *Roman Wall and Vault Mosaics*, Mitteilungen des Deutschen Archaeologischen Instituts, Roemische Abteilung, Hft. 320, in *Bulletin dell'Istituto Archaeologico Germanico: Sezione romanica*, suppl. 23 (Heidelberg: Karle, 1977). Both of these meanings were discussed by Poliziano in a 1490 letter to Hieronymus Donatus; see Angelo Poliziano, *Omnium angeli Politiani Operu[m]* (Paris: Ascensianus, 1519), fols. xvii$^v$–xixr.

124. *Carmina illustrium Poetarum Italorum*, ed. Joannes Bottari, 11 vols. (Florence: Typis Regiae Celsitudinis, apud Joannem Cajetanum Tartinium et Sanctem Franchium, 1719–26), 3:106.

125. Quoted in Sem Dresden, "The Profile of the Reception of the Italian Renaissance in France," in *Itinerarium Italicum: The Profile of the Italian Renaissance in the Mirror of Its European Transformations, Dedicated to Paul Oskar Kristeller on the Occasion of His 70th Birthday*, ed. Heiko A. Oberman and Thomas H. Brady, Jr. (Leiden: Brill, 1975), 145.

126. Clements, *Picta Poesis*, 184.

## 6. Emblematic Paradox and Serious Play

1. For titles of emblem books and other emblematic works, see Hilary M. J. Sayles, "Chronological List of Emblem Books," in Mario Praz, *Studies in Seventeenth-Century Imagery*, vol. 2 (Rome: Edizioni di Storia e Letteratura, 1974), 53, 82. For Dornavius, see Rosalie L. Colie, *Paradoxia Epidemica: The Renaissance Tradition of Paradox* (Princeton, NJ: Princeton University Press, 1966), 5.

2. Elizabeth Cook, *Seeing through Words: The Scope of Late Renaissance Poetry* (New Haven and London: Yale University Press, 1986), 45, 47.

3. Rosalie Colie referred to such metaphors as "metaphors of extreme contrast" in her *Paradoxia Epidemica*, 26.

4. For the Liar paradox, see Colie, *Paradoxia*, 6–7, 10, and for Zeno's Arrow, 9–11; for chimeras and incompatibility in logic, see E. J. Ashworth, "Chimeras and Imaginary Objects: A Study in the Post-Medieval Theory of Signification," *Vivarium* 15 (1977): 57–79.

5. For example, Francesco Molza, one of the Roman Vignaiuoli, wrote a "Capitolo in lode de' Fichi" (alluding to the slang term for a woman's pudenda), for which Annibale Caro, a member of Tolomei's Accademia della Virtù, wrote a mock commentary published in Rome in 1538 or 1539; see David O. Frantz, *"Festum Voluptatis": A Study of Renaissance*

*Erotica* (Columbus: Ohio State University Press, 1989), 26–38. Half of the *Dieci Paradosse Degli Academici Intronati Da Siena* (Milan: Appresso Gio. Antonio degli Antonij, 1564) argue that a woman should love an ugly man and other such topics.

6. Colie discussed the failure of paradoxes such as Helen to remain paradoxical after a brilliant exposition changed received opinion about the nature of the topic or after overuse rendered them trivial (*Paradoxia,* 8–9, 508–9).

7. The *quaestio disputata* took the form of dialogue and differed "from the paradox in containing a written refutation"; see A. E. Malloch, "The Technique and Function of the Renaissance Paradox," *Studies in Philology* 53 (1956): 191, 196. On Cicero, Landi, and Donne, see Colie, *Paradoxia,* 5, 14; Helen Peters, "General Introduction," in John Donne, *Paradoxes and Problems* (Oxford: Clarendon Press, 1980), xvi–xxvii; and Don Cameron Allen, "Introduction," in John Hall, *Paradoxes (1650)* (reprint, Gainesville: Scholars' Facsimiles & Reprints, 1956), xvii–xxii.

8. Rabelais' *Pantagruel* lists the impossible tasks accomplished by the servants of Queen Whim, including the washing of the Ethiopian; see Colie, *Paradoxia,* 46.

9. Colie, *Paradoxia,* 21, 508.

10. Colie, *Paradoxia,* 11–12.

11. Edgar Wind, *Pagan Mysteries in the Renaissance,* rev. ed. (New York and London: Norton, 1968), 221–2. Wind discusses Bocchi's gunpowder symbol on page 109; and J. R. Hale briefly notes "the device of a large explosion issuing from a tiny space, a symbol of man's intelligence and its effects, already familiar from emblem books" in his "Military Title Pages of the Renaissance," in *Renaissance War Studies* (London: Hambledon, 1983), 212.

12. Biringuccio did not know who had invented gunpowder but gave several theories, including a demonic one; see the tenth book of Biringccio, *De La Pirotechnia. Libri .X.* ... (Venice: Per Venturino Rossinello, 1540), fols. 149r–152r. Much of Biringuccio's career was spent making artillery pieces in Florence, and he died shortly after moving to Rome under the patronage of Tolomei in 1537; see U. Tucci, "Biringucci (Bernigucio), Vannoccio," *Dizionario biographico degli Italiani* (here after cited as *DBI*), 10:625–31.

13. Nicolo Tartaglia, *Quesiti Et Inventioni Diverse De Nicolo Tartaglia, Di Novo Restampati* ... (Venice: Per Nicolo Bascarini, 1554), fol. 38v. Gunpowder was invented by the Chinese, but the first military use was in early-fourteenth-century Europe; see *A History of Technology,* ed. Charles Singer, E. J. Holmyard, A. R. Hall, and Trevor I. Williams, 7 vols. (Oxford: Clarendon Press, 1954–6), 2:377, 726–7. Another widely circulated reference to a German origin for gunpowder was in Ludovico Ariosto's *Orlando Furioso,* ed. Cesare Segre, 2 vols. (Milan: Mondadori, 1982), 1:312 (canto 11, 21–2).

14. Raffaele Maffei, *Commentariorvm Vrbanorvm Raphaelis Volaterrani, Octo Et Triginta Libri* ... (Basel: Froben, 1559), 647.51.

15. Wind, *Pagan Mysteries,* 109. Cusanus' works were better known in France in the early sixteenth century; however, Pico della Mirandola knew them well (Wind, 239).

16. Filippo Beroaldo, *Oratio prouerbialis,* in *Orationes, Prelectiones, Praefationes & quaedam Mithicae Historiae* (Paris: In Aedibus Badius Ascensianis, 1511), fol. xlviii$^v$.

17. Rosalie L. Colie, *The Resources of Kind,* ed. Barbara K. Lewalski (Berkeley, Los Angeles, and London: University of California Press, 1973), 37.

18. Arthur Henkel and Albrecht Schöne, eds., *Emblemata: Handbuch zur Sinnbildkunst des XVI. und XVII. Jahrhunderts,* 2d ed. (Stuttgart: Metzler, 1976), col. 868.

19. Andrea Alciato, "In facile a virtute desciscentes," in *Andreas Alciatus,* ed. Peter M. Daly, Virginia W. Callahan, and Simon Cuttler, 2 vols. (Toronto, Buffalo, and London: University of Toronto Press, 1985), vol. 1, Emblem 83.

20. Petrus Costalius, *Le Pegme de Pierre Coustau, Lyons, 1555,* introduction by Stephen Orgel (reprint, New York and London: Garland, 1979), 85.

21. Guillaume de la Perrière, *La Morosophie de Guillaume de la Perriere Tolosain, Contenant Cent Emblemes Moraux, illustrez de Cent Tetrastiques Latins, reduitz en autant de Quatrains Françoys* (Lyons: Macé de Bonhomme, 1553), 81, and Henkel and Schöne, *Emblemata*, col. 997. The great tree from the tiny seed was a paradox also developed in the "Sileni Alcibiadis" adage of the *Adagia* of Erasmus; see Wind, *Pagan Mysteries*, 222.

22. Henkel and Schöne, *Emblemata*, col. 1842.

23. The Augustine text from *De civitate Dei*, VIII.3, is translated in Herbert Spiegelberg and Bayard Quincy Morgan, eds. and trans., *The Socratic Enigma: A Collection of Testimonies Through Twenty-Four Centuries* (Indianapolis: Bobbs-Merrill, 1964), 49.

24. Nicholas of Cusa, *The Layman on Wisdom and the Mind*, ed. and trans. M. L. Führer, Centre for Reformation and Renaissance Studies, University of Toronto, Translation Series 4 (Ottawa: Dovehouse, 1989), 22–4, 34.

25. The motto of Symbol II was not original with Bocchi; he must have seen a 1526 engraving by Dürer of the German teacher and scholar, Phillip Melanchthon, inscribed: VIVENTIS POTVIT DVRERIVS ORA PHILIPPI MENTEM NON POTVIT PINGERE DOCTA MANVS (Dürer, with his skilled hands, could depict the visage of the living Philip, but not the mind). Melanchthon's portrait was not enclosed in an oval frame as Bocchi's was. For the Dürer portrait and some critical comments made on it, see *The Intaglio Prints of Albrecht Dürer: Engravings, Etchings and Dry-Points*, ed. Walter L. Strauss (New York: Kennedy Galleries and Abario Books, 1976), 288–9.

26. Johannes Sambucus, *Emblemata, Cvm Aliqvot Nvmmis Antiqvi Operis, Ioannis Sambvci Tirnaviensis Pannonii* (Antwerp: Ex Officina Christophori Plantini, 1564), 138.

27. Colie, *Paradoxia*, 119.

28. There was always a worry among moralists that the paradox could lead to skepticism or religious doubt; for a recent comment along that line, see Jean-Claude Margolin, "Le Paradoxe, pierre de touche des 'jocoseria' humanistes," in *Le Paradoxe au temps de la Renaissance*, ed. M. T. Jones-Davies (Paris: Touzot, 1982), 79.

29. These appear in Bocchi's manuscripts *Lvsvvm Libellvs Ad Divvm Leonem .X. Pont.* (Florence, Bibl. Laurenziana, Plut. 33, Cat. 42, fol. 26r) and *Lvsvvm Libri Dvo* (Vatican, Bibl. Apostolica, Vat. Lat. 5793, fol. 17v), respectively.

30. Waltraut Schwarz, *Deutsche Dichter in Bologna, Bologna in der deutschen Dichtung*, Quaderni dall'Istituto di Filologia Germanica IIIA (Bologna: Tecnofoto, 1972), 13, 24.

31. Gerta Calman, "The Picture of Nobody," *Journal of the Warburg and Courtauld Institutes* 23 (1960): 80–1.

32. Calman, "The Picture," 60–84. A partial text of Hutten, with French translation, appears in Pierre Laurens and Claudie Balavoine, eds. and trans., *Mvsae Redvces: Anthologie de la poésie latine dans l'Europe de la Renaissance*, 2 vols. (Leiden: Brill, 1975), 1:348–51.

33. Alciato, "Iusta vindicta," in *Andreas Alciatus*, vol. 1, Emblem 172.

34. Spiegelberg and Morgan, *Socratic Enigma*, 22–4. The riddles and paradoxes of Plato's *Parmenides* began the tradition of *docta ignorantia*; see Colie, *Paradoxia*, 22.

35. Irving Lavin, "Divine Inspiration in Caravaggio's Two *St. Matthews*," *Art Bulletin* 56 (1974): 64, 67–9, which reproduces some early portrayals of the distinctive and ugly face of Socrates. Ingeborg Scheibler, in a study of the persistent facial characteristics of ancient busts of Socrates, theorizes that the lost originals were patterned after statues of Silenus and satyrs; see Scheibler, "Zum ältesten Bildnis des Socrates," *Münchner Jahrbuch der bildenden Kunst*, 3d ser., 40 (1989): 7–33.

36. Desiderius Erasmus, *Erasmus on His Times: A Shortened Version of the "Adages" of Erasmus*, ed. and trans. Margaret Mann Phillips (Cambridge: Cambridge University Press, 1967), 78. On Rabelais, see Colie, *Paradoxia*, 47–8.

37. Erasmus, *Erasmus on His Times*, 79.

38. La Perrière, *Morosophie*, sigs. A3r, A7r.

39. See especially Clarence H. Miller, trans., "Introduction," in Desiderius Erasmus, *The Praise of Folly* (New Haven and London: Yale University Press, 1979), xvii, xxv.

40. Sabba Castiglione, *Ricordi Overo Ammaestramenti Di Monsignor Saba Da Castiglione Cavalier Gierosolimitano, Ne Qvali Con Prvdenti, E Christiani discorsi si ragiona di tutte le materie, che si ricercano a vn vero gentil'huomo* (Venice: Per Paulo Gherardo, 1554), fols. 53v–54r.

41. Lavin, "Divine Inspiration," 74.

42. Joseph M. Victor, *Charles de Bovelles, 1479–1553: An Intellectual Biography* (Geneva: Droz, 1978), 176, and Colie, *Paradoxia*, 221.

43. Colie, *Paradoxia*, 225–6. The poem, "On the Letter O," was published in London in 1817 in a collection entitled *Facetiae*.

44. Charles de Bovelles, *Ars Oppositorum*, in *Que hoc volumine contine[n]tur. Liber de intellectu…* (Paris: Ex officina Henrici Stephani, 1510), fol. 96, and Bovelles, *L'Art des opposés*, ed. and trans. Pierre Magnard (Paris: Vrin, 1984), 176–7. The canon of Noyon (1480–1533) was possibly known to Bocchi either through his brief visits to Italy in 1507–8 and perhaps in 1509 or 1510 or through Alberto Pio of Carpi, Bocchi's early patron, who met Bovelles in Paris in July 1510 and discussed the immortality of the soul with him; see Victor, *Charles de Bovelles*, 13, 17, 85. There is no evidence that Bocchi was especially interested in philosophical problems that early, so a more likely source was Bovelles' patron, Bishop Johannes Hangest (Genlis), who attended the Bologna session of the Council of Trent in 1547 and to whom Bocchi dedicated Symbol CXXXVIII.

45. Bovelles, *Liber de Sapiente*, in *In hoc volumine*, fol. 116v.

46. Bovelles, *Libellus De Nichilo*, in *In hoc volumine*, fol. 65v; and Jean-Claude Margolin, "Bovelles et sa correspondance," in *Charles de Bovelles en son cinquième cententaire, 1479–1979: Actes du Colloque International tenu à Noyon les 14–15–16 Septembre 1979* (Paris: Trédaniel, Publ. avec le concours du Centre National des Lettres, 1982), 74. Bovelles also wrote a group of dialogues that was not published until 1551 and that dealt extensively with the theme of endelechy (I do not know if Bocchi had access to them) and another treatise on entelechy, now lost; see Margolin, "Bovelles," 25; Victor, *Charles de Bovelles*, 80; and Peter Sharratt, "Le *De Immortalitate* de Bovelles, manifeste et testament," in *Charles de Bovelles en son cinquième centenaire*, 130–2.

47. Beroaldo, *Orationes*, fol. xlixr.

48. The first written account of "Homo bulla" as a proverb was in the *De re rustica* of Varro (ca. 36 B.C.); see Wolfgang Stechow, "'Homo Bulla,'" *Art Bulletin* 20 (1938): 227, and Eugene R. Cunnar, "Crashaw's *Bulla*: A Baroque and Paradoxical Mirror Image of Religious Poetics," *Journal of Medieval and Renaissance Studies* 15, no. 2 (Fall 1985): 186–7.

49. Life is similar to a bubble. The incomplete manuscript letter (Vatican, Fondo Barb., Lat. 2163, fol. 108r) was written before 1526.

50. Horst W. Janson, "The Putto with the Death's Head," *Art Bulletin* 19 (1937): 447n; Hadrianus Junius, *Emblemata, 1565*, introductory note by Hester M. Black (1565; reprint, Menston: Scolar Press, 1972), 22; and Stechow, "'Homo Bulla,'" 227. The art of making soap bubbles seems to have been known by some in the late Middle Ages, but regarded as a magic trick whose recipe was kept secret; see Lynn Thorndike, *A History of Magic and Experimental Science*, 8 vols. (New York: Columbia University Press, 1923–58), 2:787, 790.

51. The *Vanitas* is now in the Metropolitan Museum of Art; see I. Q. van Regteren Altena, *Jacques de Geyn, Three Generations*, 3 vols. (The Hague, Boston, and London: Nijhoff,

1983), 2:15, 3:15, and Alberto Vaca, *Vanitas: Il simbolismo del tempo* (Bergamo: Galleria Lorenzelli, 1981), 64, 67.

52. Laurens and Balavoine, *Mvsae Redvces*, 2:506–13, and Pierre Laurens, "Un Grand Poème latin baroque: *La Bulle* de Richard Crashaw," *Vita Latina*, no. 57 (March 1963): 22–33.

53. Hugo Rahner, *Man at Play* (New York: Herder & Herder, 1967), 17.

54. Translated by Maurice Platnauer; see Claudius Claudianus, *Claudian*, 2 vols., Loeb Classical Library (1922; Cambridge, MA: Harvard University Press; London: Heinemann, 1963), 2:262–7, 278–81 (Epigrams XXXIII–XXXIX and LI). The crystal ball pierced by sunlight was the *impresa* of Pope Clement VII, according to Bocchi's Symbol CXI, ILLAESVS CANDOR SEMPER VBIQ. MANET (Inner radiance always and everywhere remains uncontaminated).

55. Translated by M. L. Führer; see Nicholas of Cusa, *The Layman*, 99, and Cusa, *Dialogus de genesi*, in *Opuscula*, 1, ed. Paulus Wilpert, in *Opera Omnia* (Hamburg: Meiner, 1959–    ), 4:117.

56. Henkel and Schöne, *Emblemata*, col. 1317.

57. Man Ray, "Ce qui manque à nous tous," in *Perpetual Motif: The Art of Man Ray*, ed. Merry Foresta et al. (Washington, DC: National Museum of Art, Smithsonian Institution; New York: Abbeville Press, 1988), 255–6.

58. Laurens and Balavoine, *Mvsae Redvces*, 2:510, lines 114–16.

59. Bovelles, *De Sapientia*, in *In hoc volumine*, fols. 140r, 142v, and Cesare Vasoli, "Note sur les thèmes 'solaires' dans le *De Sapiente*," in *Charles de Bovelles en son cinquième centenaire*, 117.

60. Bovelles, *Liber De intellectv*, in *In hoc volumine*, fols. 2v, 8r.

61. La Perrière, *Morosophie*, Emblem 64.

62. Colie, *Paradoxia*, 230–2.

63. E. H. Gombrich, *Symbolic Images*, 3d ed., vol. 2 of *Studies in the Art of the Renaissance* (Chicago: University of Chicago Press, 1985), 168.

64. Wind, *Pagan Mysteries*, 98–9; and also see Gombrich, *Symbolic Images*, 168.

65. Wind, *Pagan Mysteries*, 99, pl. 57–8. Wind treats the seated figure in Bocchi's version as though he were the governor and suggests that Bocchi invented the device for the governor. What Bocchi may have been implying is that he took the device for his own after the death of the governor. For illustrations of the original medal, Bonasone's engraving of the medal for Bocchi, and a maiolica plate on the same model, see *Piccoli bronzi e placchette del Museo Nazionale di Ravenna*, by Luciana Martini and Maria Grazia Ciardi Dupré Dal Poggetto, Ministero per i Beni Culturali e Ambientali, Soprintendenza per i Beni Ambientali e Architettonici Ravenna (Bologna: University Press, n.d.), 63.

66. Wind, *Pagan Mysteries*, 99. The allusion is also to the Ciceronian dictum that abundant speech is the province of the youthful orator, whereas brevity is that of the old.

67. The latter comes from a passage condemning the pleasures of Venus in Lucretius' *De Rerum Natura*, IV, 1133–4: "nequiquam, quoniam medio de fonte leporum surgit amari aliquit quod in ipsis floribus angat" ("but all is vanity, since from the very fountain of enchantment rises a drop of bitterness to torment amongst all the flowers"), translated by W. H. D. Rouse, 2d ed., Loeb Classical Library (London: Heinemann; New York: Putnam, 1928), 328–9. The urns, according to Achilles in the twenty-fourth book of the *Iliad*, are placed at the threshold of Zeus; from them mortals receive portions of good and evil; see Katherine Callen King and Deborah Nourse Lattimore, *Achilles: Paradigms of the War Hero from Homer to the Middle Ages* (Berkeley and Los Angeles: University of California Press, 1987), 45.

68. La Perrière, *Morosophie*, Emblem 50. This is the most paradoxical of La Perrière's

emblems and with its theme of joining hands makes a fitting center for the one hundred emblems in the collection.

69. Alciato, *Andreas Alciatus,* vol. 1, no. 152. Fregoso's work was made up of two shorter poems, "Riso di Democrito" and "Pianto di Eraclito," both written before 1532; see Mario Santoro, "Il Dialogo di Fortuna di Antonio Fileremo Fregoso," in his *Fortuna, ragione e prudenza nella civiltà letteraria del Cinquecento* (Naples: Liguori, 1967), 313–58, and Wind, *Pagan Mysteries,* 49n.

70. Colie, *Paradoxia,* 81.

71. Leonard Forster, *The Icy Fire: Five Studies in European Petrarchism* (Cambridge: Cambridge University Press, 1969), 52–4.

72. Alciato, *Andreas Alciatus,* vol. 1, Emblem 108.

73. Alciato, *Andreas Alciatus,* vol. 1, Emblem 112.

74. Sambucus, *Emblemata,* 174–5.

75. Wind, *Pagan Mysteries,* 90–2.

76. Alciato, *Andreas Alciatus,* vol. 1, Emblem 178.

77. Henkel and Schöne, *Emblemata,* col. 1560 (Corrozet), col. 1561 (Aneau).

78. Sambucus, *Emblemata,* 188, and Henkel and Schöne, *Emblemata,* col. 1299.

79. Wind, *Pagan Mysteries,* 108–9, and Thomas M. Greene, "Renaissance Warfare: A Metaphor in Conflict," in *The Holy War,* ed. Thomas Patrick Murphy (Columbus: Ohio State University Press, 1976), 160. The latter points out Erasmus' opposition to war and the play on *bellum/belua* (war/beast).

80. Greene, "Renaissance Warfare," 162–3.

81. *Cento Givochi Liberali, Et D'Ingegno* (Bologna: Ansel. Giacarelli, 1551), fols. 65r–66v, 67r–69r ("Givoco della Gverra," XXXXIIII, and "Givoco della Pace," XXXXV).

82. Greene, "Emblem and Paradox in Scève's 'Delie,'" *Oeuvres & critiques* 11 (1986), 56–7.

83. Wind, *Pagan Mysteries,* 161–4, and Francesco Colonna, *Hypnerotomachia Poliphili, Venice, 1499* (reprint, New York and London: Garland, 1976), sig. b vr.

84. Wind, *Pagan Mysteries,* 196.

### 7. The Mythographic Union of Eloquence and Wisdom

1. In the translation by Walter C. A. Ker: "Thou, my book, who art purposed to enter my Master's laurel-wreathed abode, learn to speak more reverently in modest speech. Undraped Venus, stand back: this little book is not thine; do thou come to me, thou, Pallas, patron of Caesar"; see Marcus Valerius Martialis, *Epigrams,* trans. Walter C. A. Ker, 2 vols., Loeb Classical Library (London: Heinemann; New York: Putnam's Sons, 1919–20), 2:4–5.

2. "Le XVIe siècle n'a guère pensé les faits de langue que par images"; see Claude-Gilbert Dubois, *Mythe et langage au seizième siècle* (Bordeaux: Ducros, 1970), 12–13.

3. Except for the works of Georg Pictor, there are modern editions or reprints for these mythographers: See Giovanni Boccaccio, *Genealogie Deorum Gentilium Libri,* ed. Vincenzo Romano, 2 vols., in Boccaccio, *Opere,* 10–11, *Scrittori d'Italia,* nos. 200–1 (Bari: Laterza, 1951); Lilio Gregorio Giraldi, *Di Deis Gentivm, Basel, 1548* (reprint, New York and London: Garland, 1976); Natale Conti (Natalis Comes), *Mythologiae, Venice, 1567* (reprint, New York and London: Garland, 1976); and Vincenzo Cartari, *Le Imagini . . . degli dei, Venice, 1571* (reprint, New York: Garland, 1976). Cartari's first edition (1556) is not illustrated, but the 1571 edition is, whereas Pictor's *Apotheseos* was already partially illustrated in 1558.

4. M. Palma, for example, lists some of the works of art and literature inspired by Cartari;

see "Cartari, Vincenzo," *Dizionario biographico degli Italiani* (hereafter cited as *DBI*), 20:975–6.

5. E. H. Gombrich, *Symbolic Images*, 3d ed., vol. 2 of *Studies in the Art of the Renaissance* (Chicago: University of Chicago Press, 1985), 120. For a similar view, see Jean Seznec, *The Survival of the Pagan Gods: The Mythological Tradition and Its Place in Renaissance Humanism and Art*, trans. Barbara F. Sessions (New York: Pantheon, 1953), 241–2. For a useful survey and bibliography of mythographers through the Renaissance, see John R. Glenn, ed., "Introduction," in Alexander Ross, *A Critical Edition of Alexander Ross's 1647 "Mystagogus Poeticus, or The Muses Interpreter"* (New York: Garland, 1987), 60–110.

6. Madeline Lennon, in "Cartari's *Imagini*: Emblematic References in the Relationship of Text and Image," *Emblematica* 3 (1988): 263–82, suggests that the Cartari illustrations may "reflect the mode of the emblem in their function and design" and possibly were also intended to be published in a separate series with inscriptions (264, 273).

7. Giraldi, *De Deis Gentivm*, 35–64. For myth as factual remnants of the most ancient lore and as symbolic fragments of a "stato puro," see Samuele Giombo, "Umanesimo e mistero simbolico: La prospettiva di Achille Bocchi," *Schede umanistiche* 1 (1988): 181–2.

8. "Infolding," a term Wind borrowed from Nicholas of Cusa, means the concealment of one deity within another, as in the medal of Constancy and Concord designed for Maria Poliziana; see Edgar Wind, *Pagan Mysteries in the Renaissance*, rev. ed. (New York and London: Norton, 1968), 76–7, 196, on infolding, and 25, 75, on hybrid gods.

9. Wind, *Pagan Mysteries*, 196.

10. For example, Bocchi may have known the "Aglaia" of Jacobius Bonus (Jacov Bunic), described as "sub figura Herculis Christi praeludum" and published in his . . . *De vitae & gestis Christi* . . . (Rome, 1526) with a dedicatory poem by Filippo Beroaldo the Younger. Much better known, but along the same lines, is Ronsard's *Hercule Chretien;* see Marcel Simon, *Hercule et le Christianisme*, Pvblications de la Facvlté des Lettres de l'Vniversité de Strasbovrg (Paris: La Société d'Editions "Les Belles Lettres," 1955), 180–4.

11. The classic study of the theme is Erwin Panofsky's *Hercules am Scheidewege und andere antike Bildstoffe in der neueren Kunst*, Studien der Bibliothek Warburg 18 (Leipzig and Berlin: Teubner, 1930). Also see Wolfgang Harms, *Homo viator in bivio: Studien zur Bildlichkeit des Weges* (Munich: Fink, 1970). A number of emblem books, such as those by Costalius, Boissard, and Paradin, do illustrate the choice or the "Y" symbol.

12. The original temples of Virtue and Honor, according to Cicero, were remodeled by a man named Marcellus, so it is most appropriate that the temple to Honor have a statue of Cardinal Marcello Cervino over it (Cervino had also been responsible for the upbringing of Ranuccio Farnese to whom the symbol was dedicated); see Cicero, *De Natura Deorum*, ed. and trans. M. van den Bruwaene (Brussels: Latomus, 1978), 86–7. For further discussion of this symbol, see Chapter 4.

13. Ancient and Renaissance mythographers counted anywhere up to forty-four labors, the most accumulated by Varro, according to Giraldi, *De Deis Gentivm*, 450.

14. David R. Coffin, *The Villa in the Life of Renaissance Rome*, Princeton Monographs in Art and Archaeology 34 (Princeton, NJ: Princeton University Press, 1979), 98–9; and Christoph Luitpold Frommel, *Baldassare Peruzzi als Maler and Zeichner*, Veröffentlichungen der Bibliotheca Hertziana (Max-Plank-Institut) in Rom. Beiheft zum Römischen Jahrbuch für Kunstgeschichte 11 (Vienna and Munich: Schroll, 1968), pl. 15c–d.

15. Reprinted in Anghiera's *Opera: Legatio Babylonica, De Orbe Novo Decades Octo, Opus Epistolarum*, ed. Erich Woldan (1516; reprint, Graz: Akademische Druck- u. Verlagsanstalt 1966).

16. Virginia Woods Callahan, "The Erasmus–Alciati Friendship," in *Acta Conventus*

*Neo-Latini Lovaniensis: Proceedings of the First International Congress of Neo-Latin Studies, Louvain, 23–28 August 1971,* ed. J. I. IJsewijn and E. Kessler (Louvain: Leuven University Press; Munich: Fink, 1973), 136–8, and Andrea Alciato, *The Latin Emblems, Indexes and Lists,* vol. 1 of *Andreas Alciatus.* ed. Peter M. Daly, Virginia W. Callahan, and Simon Cuttler (Toronto, Buffalo, and London: University of Toronto Press, 1985), Emblem 138.

17. Boccaccio, *Genealogie,* 1:633, and Giraldi, *De Deis Gentivm,* 450.

18. Margaret Mann Phillips, ed. and trans., *Erasmus on His Times: A Shortened Version of the "Adages" of Erasmus* (1967; Cambridge: Cambridge University Press, 1980), 18. The Latin text reads: "diram qui contudit hydram / notaque fatali portenta labore subegit, / comperit invidiam supremo fine domari." See Horace, *Satires, Epistles and Ars Poetica,* trans. H. Rushton Fairclough, Loeb Classical Library (London: Heinemann; and New York: Putnam, 1926), 396.

19. Jeff Shulman, "At the Crossroads of Myth: The Hermeneutics of Hercules from Ovid to Shakespeare," in *ELH* 50, no. 1 (1983): 90.

20. *Hieroglyphica, Lyons, 1602* (1602; reprint, New York and London: Garland, 1976), 576. Also, see John M. Steadman, *Nature into Myth: Medieval and Renaissance Moral Symbols,* Duquesne Studies, Language and Literature Series 1 (Pittsburgh: Duquesne University Press, 1979), 31. Perhaps a more immediate source was the marble statue of Hercules by Alfonso da Ferrara presented to the city of Bologna in 1520 by Senator Cornelio Lambertini, Bocchi's friend; see Giuseppe Guidicini, *Cose notabili della città di Bologna, ossia Storia cronologica de' suoi stabili publici e privati,* ed. Ferdinando Guidicini, 5 vols. (Bologna: Vitali, 1868–73), 1:82.

21. Valeriano, *Hieroglyphica,* 576, and Giraldi, *De Deis Gentivm,* 450.

22. D. P. Snoep, "Van Atlas tot last: Aspecten van de Betekenis van het Atlasmotief," *Simiolus* 2 (1967–8): 8–10, and Stephen Orgel, "The Example of Hercules," in *Mythographie der frühen Neuzeit: Ihre Anwendung in den Künsten,* ed. Walther Killy, Wolfenbüttler Forschungen 27 (Wiesbaden: Harrassowitz, 1984), 32.

23. Marc-René Jung, *Hercule dans la littérature française du XVIe siècle: De l'Hercule courtois à l'Hercule baroque* (Geneva: Droz, 1966), 83, and Heinz Ladendorf, "Kairos," in *Festschrift Johannes Jahn zum XXII. November MCMLVII* (Leipzig: Seemann for the Kunsthistorischen Institut der Karl-Marx-Universität, 1957), pl. 118.

24. Geofroy Tory, *Champ Fleury, ou l'art et science de la proportion des lettres,* ed. Gustave Cohen (Paris, 1529; reprint, Paris: Bosse, 1931), fols. ii^v–iii^v, and Auguste Bernard, *Geofroy Tory, peintre et graveur, premier imprimeur royal, réformateur de l'orthographe et de la typographie,* 2d ed. rev. (1865; reprint, Nieuwkoop: De Graaf, 1963), 188.

25. Jung, *Hercules,* 85–6.

26. Translated by H. Rushton Fairclough in Horace, *Satires, Epistles and Ars Poetica,* 250–1.

27. Giulio Cesare Capaccio said in 1592 that the *impresa* of "la Trutina di Hercole" (which he claimed to have invented) symbolized the honorable death of a member of the nobility. He used the same square and lamps as Bocchi but provided a different motto; see *Delle Imprese Trattato Di Givlio Cesare Capaccio . . .* (Naples: Appresso Gio. Giacomo Carlino, & Antonio Pace, 1592), I, fol. 47v.

28. William Harris Stahl, Richard Johnson, and E. L. Burge, trans., *The Marriage of Philology and Mercury,* vol. 2 of William Harris Stahl, *Martianus Capella and the Seven Liberal Arts,* (New York: Columbia University Press, 1971–7), 49.

29. Phyllis Williams Lehmann and Karl Lehmann, *Samothracian Reflections: Aspects of the Revival of the Antique,* Bollingen series 92 (Princeton, NJ: Princeton University Press, 1973), 11, 26, and Ludwig Volkmann, *Bilder Schriften der Renaissance: Hieroglyphik und*

*Emblematik in ihren Beziehungen und Fortwirkungen* (1923; reprint, Nieuwkoop: De Graaf, 1962), Abb. 5, 16.

30. Sebastiano Serlio, *Tvtte L'Opere D'Architettvra, Et Prospetiva, Di Sebastiano Serlio Bolognese ...*, ed. Gio. Domenico Scamozzi Vicentino (Venice, 1619; reprint, Ridgewood, NJ: Gregg, 1964), 140, with illustrations of the bucranium, 4, 117, 140, 142.

31. Francesco Colonna, *Hypnerotomachia Poliphili (Venetiis, Aldo Manuzio, 1499)*, introduction by Peter Dronke (reprint, Zaragoza: Las Ediciones del Pórtico, 1981), sig. cr, and Volkmann, *Bilder Schriften*, Abb. 4, 15.

32. Valeriano, *Hieroglyphica*, 30, 34 (Lib. VI), and Theodora A. G. Wilberg Vignau-Schuurman, *Die emblematischen Elemente im Werke Joris Hoefnagels*, 2 vols., Leidse Kunsthistorische Reeks 2 (Leiden: Universitaire Pers, 1969), 1:82n, 2:37n. On variations in the print of the bucranium *impresa* between the 1555 and 1572 editions, see Diane DeGrazia Bohlin, *Prints and Related Drawings by the Carracci Family: A Catalogue Raisonné* (Washington, DC: National Gallery of Art, 1979), 74–5.

33. This image is adapted, though rather clumsily, from Jacopo della Quercia's *Creation of Adam*, a marble relief panel on the doorway of Bologna's San Petronio.

34. Colonna, *Hypnerotomachia*, sig. d viir; Volkmann, *Bilder Schriften*, 17; and Wind, *Pagan Mysteries*, 93.

35. Reprinted in Anghiera's *Opera*.

36. Giraldi, *De Deis Gentivm*, 466.

37. Seneca, *Epistle* 79, 13, in *Seneca ad Lucilium Epistulae Morales*, trans. Richard M. Gummere, Loeb Classical Library, 3 vols. (London: Heinemann; New York: Putnam, 1917–25), 206. For Seneca's interpretation of glory as nothing without virtue, see Robert J. Newman, "In umbra virtutis: Gloria in the Thought of Seneca the Philosopher," *Eranos* 86 (1988): 157–9.

38. Giraldi, *De Deis Gentivm*, 468. On Minerva Pacifica, see Rudolf Wittkower, "Transformations of Minerva in Renaissance Imagery," *Journal of the Warburg and Courtauld Institutes* 2 (1938–9): 194–5.

39. Giraldi, *De Deis Gentivm*, 465–7, 486, 489. Phornutius is probably the Cornutus to whom mythological writings were ascribed.

40. Giraldi, *De Deis Gentivm*, 484.

41. Giraldi, *De Deis Gentivm*, 466; Boccaccio, *Genealogie*, 72–3; and Don Cameron Allen, *Mysteriously Meant: The Rediscovery of Pagan Symbolism and Allegorical Interpretation in the Renaissance* (Baltimore and London: Johns Hopkins University Press, 1970), 205.

42. Giraldi, *De Deis Gentivm*, 488.

43. For Nizolio, see Ruggero Battistella, *Mario Nizolio umanista e filosofo (1488–1566)* (Treviso: Zoppelli, 1904), and Cesare Vasoli, *Profezia e ragione: Studi sulla cultura del Cinquecento e del Seicento* (Naples: Morano, 1974), 445. I have not been able to locate the source for Bocchi's allegory of Pallas on the stag.

44. Giraldi, *De Deis Gentivm*, 467.

45. Alciato, *Andreas Alciatus*, vol. 1, Emblem 19. The offending crows make a brief appearance in Bocchi's Symbol CIX to represent the insolent and careless tongues of Bocchi's enemies.

46. Giraldi, *De Deis Gentivm*, 470–1, and Boccaccio, *Genealogie*, 73.

47. Ursula Klima, *Untersuchungen zu dem Begriff Sapientia von der republikansichen Zeit bis Tacitus* (Bonn: Habelt, 1971), 28.

48. Stahl, *Martianus Capella*, 2:6.

49. For the traditional inconography of Wisdom, see Marie Thérèse d'Alverny, "Quelques Aspects du symbolisme de la 'Sapientia' chez les humanistes," *Umanesimo e esoterismo*, in

*Archivio di filosofia* (1960), nos. 2–3, 323. Although the Boethian Philosophy wears tattered robes, D'Alverny notes that Ripa portrayed her as young and nude after Petrarch's verse, "Povera e nuda vai, Filosofia" (330).

50. Wind, *Pagan Mysteries*, 71.

51. Alciato, *Andreas Alciatus*, vol. 1, Emblem 182. For the moly, see especially Hugo Rahner, "Moly and Mandragora in Pagan and Christian Symbolism," in *Greek Myths and Christian Mystery*, trans. Brian Battershaw (London: Burns & Oates, 1963), 179–280, and G. F. Hartlaub, "Ein unbekanntes Lebenssymbol," *Zeitschrift für Kunst* 2 (1948): 64–5. Besides Alciato and Bocchi, a number of emblematists illustrated the moly; some of these are collected in Arthur Henkel and Albrecht Schöne, eds., *Emblemata: Handbuch zur Sinnbildkunst der XVI. und XVII. Jahrhunderts*, 2d ed. (Stuttgart: Metzler, 1976), cols. 316–18.

52. Giraldi, *De Deis Gentivm*, 414.

53. Wind, *Pagan Mysteries*, 12n.

54. Raymond B. Waddington, "The Iconography of Silence and Chapman's Hercules," *Journal of the Warburg and Courtauld Institutes* 33 (1970): 258–60.

55. Giraldi, *De Deis Gentivm*, 417.

56. Boccaccio, *Genealogie*, 79.

57. Louis Marin, "Notes sur une médaille et une gravure: Eléments d'une étude sémiotique," *Revue d'esthétique* 22, no. 2 (1969): 133.

58. Marin, "Notes sur une médaille," 134–5.

59. Barbara C. Bowen, "Mercury at the Crossroads in Renaissance Emblems," *Journal of the Warburg and Courtauld Institutes* 48 (1985): 222–9.

60. Bowen, "Mercury at the Crossroads," 228.

61. Bowen, "Mercury at the Crossroads," 228.

62. Giraldi, *De Deis Gentivm*, 416.

63. Boccaccio, *Genealogie*, 77.

64. Charles de Bovelles, *Que hoc volumine contine[n]tur* (Paris: Ex officina Henrici Stephani, 1510), fols. 77v–78v, and Bovelles, *L'Art des opposés*, ed. and trans. Pierre Magnard (Paris: Vrin, 1984), 172–5.

65. Bovelles, *In hoc volumine*, fols. 139v–40r. Bocchi omits the *tenebrae* of the animal levels. The dark matter is discussed in *De nihilo*, in *In hoc volumine*, fol. 63v, also see Figure 6.

66. Wind, *Pagan Mysteries*, 124n.

67. Jacques Bonnet, *Les Symboles traditionnels de la sagesse* (Roanne: Horvath, 1971), 15.

68. Louis Reekmans, "La 'dextrarum iunctio' dans l'iconographie romaine et paléochrétienne," *Bulletin de l'Institut Historique Belge de Rome*, fasc. 31 (1958): 28, 31, 33, 46.

69. Reekmans, "La 'dextrarum iunctio,'" 25.

70. Giraldi, *De Deis Gentivm*, 176–7.

71. Gabriel Nuchelmans, "Philologia et son mariage avec Mercure jusqu'à la fin du XIIe siècle," *Latomus* 16 (1957): 92–4.

72. Wind, *Pagan Mysteries*, 38, 43, 46. Some Florentine humanist portrait medals include Amor as one of a trinity of figures; for example, Pico's medal places Amor in the center (Wind, Figure 10).

73. Nuchelmans, "Philologia et son mariage," 84–6, and John Block Friedman, *Orpheus in the Middle Ages* (Cambridge, MA: Harvard University Press, 1970), 101–2.

74. For a careful study of the balance between prudence and eloquence in ancient and humanist writers, see Victoria Kahn, *Rhetoric, Prudence, and Skepticism in the Renaissance* (Ithaca, NY, and London: Cornell University Press, 1985), 29–40.

75. Wind, *Pagan Mysteries*, 203.

76. For Minerva Frenatrix (or the Minerva of the bridle), see Giraldi, *De Deis Gentivm*, 477.

77. John Steadman gives selections from Ricchieri, Bocchi, Valeriano, and the Sanchez commentary on Alciato on the Chimera; see *Nature into Myth*, 160–2. Also see Valeriano, *Hieroglyphica*, 14, and Ricchieri, *Antiquarum Lectionum. Commentarios sicuti concinnarat olim Vindex Ceselius, ita nunc eosdem per incuriam interceptos reparaiut Lodouicus Caelius Rhodiginus . . .* (Paris: Iodocus Badius Ascensius & Ioannus Paruus, 1517), 311. Bocchi had written a brief epigram, "Ad Lodovicvm Coelivm Rhodiginvm," for his second manuscript verse collection (*Lvsvvm Libri Dvo*, Vatican, Bibl. Apost. Vat., MS. Lat. 5793, fol. 30r).

78. Annibale Caro, *Lettere familiari*, ed. Aulo Greco, 3 vols. (Florence: Le Monnier, 1957–9), 1:49.

79. On Camozzi (1515–89), who was teaching rhetoric and philosophy in Bologna from 1549 to 1555 and had been a student there, see P. Schreiner, "Camozzi (Camosio), Giovanni Battista," *DBI*, 17:297–8.

80. In a letter to Romolo Amaseo in fall 1548 (Milan, Ambros., D145 inf., no. 11, fols. 22r–v), Bocchi mentioned his Symbols CXXXII and CXXIIII, so CXXXVII probably was written not long after these. On the Chimera of Arezzo, see Corrado Ricci, "La Chimera nel Medio Evo" in *Atti del I Congresso Internazionale Etrusco, Firenze–Bologna, 27 aprile–5 Maggio 1928* (Florence: Rinascimento del Libro, 1929), 29–30; Massimo Pallottino, "Vasari e la Chimera," *Prospettiva*, no. 8 (Jan. 1977): 4, 6n; and Piero Vettori, *Lettere di Piero Vettori per la prima volta pubblicate da Giovanni Ghinassi*, ed. Francesco Zambrini (Bologna: Gaetano Romagnoli, 1870), 36–9.

81. Henning Wrede, *Die Antike Herme*, Trierer Beiträge zur Altertumskunde, Bd. 1, 1985 (Mainz am Rhein: Zabern, 1986), 20–1.

82. Marcus Tullius Cicero, *Letters to Atticus*, trans. E. O. Winstedt, 3 vols., Loeb Classical Library (London: Heinemann; New York: Macmillan, 1912), 1:18–19, 22–5. At Tusculanum, Cicero had both an upper (*Lyceum*) and a lower gymnasium (Academia); see Wrede, *Die Antike Herme*, 34–5; and D. R. Shackleton Bailey's notes to Cicero, *Cicero's Letters to Atticus*, 7 vols. (Cambridge: Cambridge University Press, 1965), 1:282n.

83. Translation by E. O. Winstedt; Cicero, *Letters to Atticus*, 1:12–13.

84. Translation by E. O. Winstedt; Cicero, *Letters to Atticus*, 1:8–9.

85. For Bembo's house, see Wolfgang Liebenwein, *Studiolo: Die Entstehung eines Raumtyps und seine Entwicklung bis um 1600*, Frankfurter Forschungen zur Kunst 6 (Berlin: Mann, 1977), 144, 298n. For Marsilio Ficino, see his *Epistolarvm*, in *Opera Omnia*, 2 vols. in 4 (1576; reprint, Turin: Bottega d'Erasmo, 1959), 1:2:855.

86. On the development of the studio, see Liebenwein, *Studiolo*. The house anatomized in Gilles Corrozet's *Les Blasons Domestiques* (1539; reprint, Paris: Société des Bibliophiles françois, 1865) illustrates both a "cabinet" (treasure room) and a scholar's study (30, 33), though neither is dedicated to a god.

87. P. H. Hefting, "Het Enigma van de Casa Pellizzari," *Nederlands Kunsthistorisch Jaarboek* 15 (1964): 77, 91–2, pl. 8. There is also a bucranium.

88. The two rooms of the Museo held part of Giovio's portrait collection; see Paul Ortwin Rave, "Das Museo Giovio zu Como," in *Miscellanea Bibliotecae Hertzianae zu Ehren von Leo Bruhns, Franz Graf Wolff Metternich, Ludwig Schudt*, Römische Forschungen der Bibliotheca Hertziana 16 (Munich: Schroll, 1961), 275–84. For Giraldi, see *De Deis Gentivm*, 417.

89. Vatican, Fondo Barbariniano, Lat, 2163, fol. 111r.

90. Richard Pace also wrote an allegory modeled loosely after Martianus Capella but on the seven liberal arts; see Richard Pace, *De Fructu qui ex Doctrina Percipitur (The Benefit of a Liberal Education)*, ed. and trans. Frank Manley and Richard S. Sylvester (New York: Publ. for The Renaissance Society of America by Frederick Ungar, 1967), ix, xiii. On a

possible identification of Papyrus Geminus Eleatus with Thomas Elyot and of the location of the "Comi" of the dedicatory letter with Elyot's village of Combe (now Coombe), see Constance W. Bouck, "On the Identity of Papyrius Geminus Eleates," *Transactions of the Cambridge Bibliographical Society* 2 (1958): 352–8. Elyot, who was born around 1490, did know Pace, though there is no record of the former as a student in Bologna.

91. Wind, *Pagan Mysteries*, 45n, and Jurgis Baltrušaitis, *Le Moyen Age fantastique: antiquités et exotismes dans l'art gothique*, rev. ed. (Paris: Flammarion, 1981), 36–7. For the Ruini family, see Giovanni Fantuzzi, *Notizie degli scrittori bolognesi*, 9 vols. (Bologna: Nella stamperia di San Tommaso D'Aquino, 1781–4), 3:235, 237.

92. "Vis caput alatum est Mentis quae tempora quaeque / Vel puncto absoluit temporis exiguo" (The winged head symbolizes the power of the mind, which relates all epochs even in a brief moment in time). See Margaretta J. Darnall and Mark S. Weil, "Il Sacro Bosco di Bomarzo: Its Sixteenth-Century Literary and Antiquarian Context," *Journal of Garden History* 4 (1984): 79n.

93. A variant translation by Kevin Herbert appears in Darnall and Weill, "Il Sacro Bosco," 79n. My translation is based on that of Thomas Marier.

94. Wind, *Pagan Mysteries*, 259–62. The Sambucus emblem and a similar one by Covarrubias are illustrated in Henkel and Schöne, *Emblemata*, 1820–1.

95. Ovidius Naso, Publius, *Fastorum Liber Primus: Les Fastes, Livre I*, ed. Henri Le Bonniec (Paris: Presses Universitaires de France, 1961), 34–5, 44–6 (Lib. 1, lines 63–5, 129–30, 137–8); Giraldi, *De Deis Gentivm*, 208–13; and Achsah Guibbory, "Sir Thomas Browne's Allusions to Janus," *English Language Notes* 12 (1975): 269–73.

96. Ovid, *Fastorum libri*, 42 (1.42).

97. R. Ceserani, "Baiardi, Andrea," *DBI*, 5:281–3.

98. Bovelles, *Liber de Sapiente*, in *Que hoc Volumine*, especially fol. 128v.

99. Bovelles, *Liber De Sapiente*, in *Que hoc Volumine*, fol. 120r.

100. Titus Livius, *Books XXI–XXII*, trans. B. O. Foster, vol. 5 of *Livy*, Loeb Classical Library (Cambridge, MA: Harvard University Press; London: Heinemann, 1963), 230–1, and *Books XXIII–XXV*, trans. Frank Gardner Moore, vol. 6 of *Livy* (1966), 106–7. It was also mentioned briefly by Cicero, *De Natura Deorum*, 86–8.

101. Nicholas of Cusa, *The Layman on Wisdom and the Mind*, ed. and trans. M. L. Führer, Centre for Reformation and Renaissance Studies, University of Toronto, Translations Series 4 (Ottawa: Dovehouse, 1989), 56.

102. In other words, we are moving from the specific interpretive problems of iconography to the iconology of the facade, understood in E. H. Gombrich's definition of iconology as the "reconstruction of a programme" based on intersecting lines of multiple meanings and genre; see Gombrich, *Symbolic Images*, 6–8.

103. Adalgisa Lugli, "Le 'Symbolicae Quaestiones' di Achille Bocchi e la cultura dell'emblema in Emilia," in *Le arti a Bologna e in Emilia dal XVI al XVII secolo*, ed. Andrea Emiliani, vol. 4 of *Atti del XXIV Congresso Internazionale di Storia dell'Arte*, 10 vols. (Bologna: CLUEB, 1982–3), 89–90.

104. Carlo Cesare Malvasia, *Felsina pittrice: Vite de' pittori bolognese*, ed. Giampietro Zanotti, 2 vols., rev. ed. (1841; reprint, Bologna: Forni, 1967), 1:176.

105. It could also mean an ornamental pediment or an architectural framework to display a statue; the latter use appears in a number of descriptions of antiquities in Roman collections made by Ulisse Aldrovandi, Bocchi's pupil and later a noted naturalist; see Aldrovandi, *Delle statue antiche, che per tutta Roma, in diversi luoghi, e case si veggono* (1562; reprint, Hildesheim and New York: Olms, 1975), 120, 127, 129, 180, 191, and so on (Aldrovandi's text was originally published as pages 115–315 of Lucio Mauro's *Le*

*antichità della città di Roma).* According to the *Oxford English Dictionary,* the word's origin was medieval rather than ancient Latin.

106. Naomi Miller, "La 'retorica' come chiave di interpretazione dell'architettura bolognese (1380–1565)," *Il Carrobbio* 5 (1979): 337.

107. The number five also symbolized justice and the "created world"; see Russell Peck, "Number as Cosmic Language," in *Essays in the Numerical Criticism of Medieval Literature,* ed. Caroline D. Eckhardt (Lewisburg, PA: Bucknell University Press; London: Associated University Presses, 1980), 25, 60–1.

108. Gabriele Morolli, *"Vetus Etruria," il mito degli Etruschi nella letteratura architettonica nell'arte e nella cultura da Vitruvio a Winckelmann,* preface by Franco Borsi and appendixes ed. Mimmarosa Barresi (Florence: Alinea, 1985), 87–8, and Morolli, "'A quegli idei selvestri': Interpretazione naturalistica, primato e dissoluzione dell'ordine architettonico nella teoria cinquecentesca sull'Opera Rustica," in *Natura e artificio: L'ordine rustico, le fontane, gli automi nella cultura del Manierismo europeo,* ed. Marcello Fagiolo (Rome: Officina, 1979), 64. Vignola, however, accepted only four antique orders and treated Tuscan as a modern style (Morolli, *"Vetus Etruria,"* 87).

109. Serlio, *Tvtte L'Opere,* 126v, and Morolli, "'A quegli idei selvestri,'" 66, 75–8.

110. Translated by H. Rushton Fairclough in Horace, *Satires, Epistles and Ars Poetica,* 254–5.

111. Reproduced in John C. Olin, *The Catholic Reformation: Savonarola to Ignatius Loyola* (New York: Harper & Row, 1969), 70.

112. Reproduced in Agostino Steucho, *De Perenni Philosophia,* introduced by Charles B. Schmitt (Lyons, 1540; reprint, New York and London: Johnson Reprint, 1972).

113. Serlio, *Tvtte L'Opere,* 126v.

114. Serlio, *Tvtte L'Opere,* 142v (4th book), 93v (7th book).

115. Serlio, *Tvtte L'Opere,* 126r.

# Bibliography

The bibliography contains the following categories of cited works: (1) printed works by Achille Bocchi; (2) manuscript works by Bocchi and others; and (3) books and journal articles on Bocchi, selected background books and articles used in more than one chapter, and most titles of festschriften, congresses, symposia, and the like, from which essays have been cited.

### Printed Works of Achille Bocchi

Bocchi, Achille. *Apologia in Plautum. Vita Ciceronis, auctore Plutarcho Nuper Inuenta Ac Diu Desiderata.* Bologna: Ioannes Anto. Pla[tonides], 1508.

*Carmine in laudem Io. Baptistae Pii.* Bologna: Io. Antonius de Benedictis, 1509.

*Symbolicarvm Qvaestionvm De Vniverso Genere Qvas Serio Lvdebat Libri Qvinqve. . . .* Bologna: In Aedib. Novae Academiae Bocchianae, 1555.

*Symbolicarvm Qvaestionvm, De vniuerso genere, quas serio ludebat, Libri Qvinqve.* Bologna: Apud Societatem Typographiae Bononiensis, 1574.

*Symbolicarum Quaestionum de Universo Genere, Bologna, 1574.* Reprint, with introductory notes by Stephan Orgel. New York and London: Garland, 1979.

*Symbolicarvm Qvaestionvm, De vniuerso genere, quas serio ludebat, Libri Qvinqve.* Trans. Maria Bianchelli Illuminati. Vol. 2 of *Giulio Bonasone.* Catalogo di Stefania Massari. Ministero per i Beni Culturali e Ambientali, Istituto Nazionale per la Grafica-Calcografia. Rome: Edizioni Quasar, 1983.

### Manuscript Sources

Abstemius, Paulus. Letter to Achille Bocchi. Bologna. Bibl. Univ. MSS. Ital 295 (231), fols. 128r–129r.

Achillini, Giovanni Filoteo. *Canzoniere volgare.* Florence. Bibl. Laurenziana. Fondo Acquisti e Doni, 397.

Bocchi, Achille. *De Bononiensivm Rebvs Ab Vrbe Condita* (Historia Bononiensis, vol. 1). Bologna. Bibl. Univ. Cod. Lat. 205 (305).

Letter to Bartolomeo Raimundo and Mario Siderotomo. Vatican. Fondo Barbariniano. Lat. 2163, fols. 109r–110r.

Letter to Filippo Pepoli. Bologna. Archiginnasio. MS. B.3146, fol. 11r.

Letter to Francesco Guicciardini. Bologna. Archiginnasio. MS. B.3146, fol. 2v.

Letter to Tamas Nadasdy. Bologna. Archiginnasio. B.470, fol. 2v.

Letters to Romolo Amaseo. Milan. Ambros. D145 inf.

Letter to unknown. Bologna. Bibl. Univ. MSS. Ital. 199 (90), fol. 14v.

*Lvsvvm Libellvs Ad Divvm Leonem .X. Pont.* Florence. Laurenziana. Plut. 33, Cod. 42.

*Lvsvvm Libri Dvo.* Vatican. Bibl. Apost. Vat. MS. Lat. 5793.

Orations. In *Codex orationum variarium ineditarum.* Bologna. Bibl. Univ. Cod. Lat. 350 (595K)-10, fols. 22r–23v, 31r–v.

*Praelectiones In Libros De Legibvs .M.T. Ciceronis Habitae Bononiae. In Academia Bocchiana.* Bologna. Bibl. Univ. Cod. Lat. 304.

*Ptolemaevs, Sive De Officio Principis In Obtrectatores.* Vatican. Bibl. Apost. Vat. Fondo Barbariniano Lat. 2030. Also a draft copy in Barb. Lat. 2163.

*Sermo cui titulus, Democritus, Id est Vanitas.* Vatican. Bibl. Apost. Vat. Fondo Barbariniano Lat. 2030. Also a draft copy in Barb. 2163.

[*Symbolicae quaestiones*]. London. British Library. MS. Sloane 3185 (incomplete copy, begins with Symbol IV).

Delfino, Giovanni Antonio. *In Symbolvm Decimvm Achillis Bocchij Commentariolvs.* Bologna. Archiginnasio. MS. B.1513.

"Informat[ion]e della familg[i]a et propria linea di Fran[cesc]o Bocchj et di alcunij suoi antessori." 1587. Bologna. Archiginnasio. B.470, item 9.

*Lettere al Card. Farnese.* Florence. Bibl. Naz. Magliabechiana, II, IV, 489.

Pio, Giovanni Battista. Letter to Achille Bocchi. Vatican. Bibl. Apost. Vat. Fondo Barbariniano Lat. 2163, fol. 111r.

Privilege of nobility granted to Achille Bocchi by Cesare de Riario. Bologna. Archiginnasio. B.1283, item 51.

Romangilio, Giovanni. Letter to Paulo Magnolo. Bologna. Bibl. Univ. MSS. Ital. 1621, fol. 2v.

## Selected Secondary Works

Aaron, Pietro. *Libri tres de institutione harmonica.* Bibliotheca musica bononiensis, sezione 2, n. 8. Bologna, 1516. Reprint. Bologna: Forni, 1970.

Achillini, Giovanni Filoteo. *Annotationi Della Volgar Lingva Di Gio. Filotheo Achillino.* Bologna: Per Vicenzo Bonardo da Parma, & Marcantonio da Carpo, 1536.

    *Viridario De Gioanne Philotheo Achillino Bolognese.* Bologna: Per Hieronymo di Plato Bolognese, 1513.

*Acta Conventus Neo-Latini Amstelodamensis: Proceedings of the Second International Congress of Neo-Latin Studies, Amsterdam, 19–24 August 1973.* Ed. P. Tuynman, G. C. Kuiper, and E. Kessler. Munich: Fink, 1979.

*Acta Conventus Neo-Latini Bononiensis: Proceedings of the Fourth International Congress of Neo-Latin Studies, Bologna, 26 August to 1 September 1979.* Ed. R. J. Schoeck. Binghamton, NY: Medieval & Renaissance Texts & Studies, 1985.

*Acta Conventus Neo-Latini Lovaniensis: Proceedings of the First International Congress of Neo-Latin Studies, Louvain, 23–28 August 1971.* Ed. J. IJsewijn and E. Kessler. Munich: Fink; Louvain: Leuven University Press, 1973.

Alberti, Leandro, *De Viris Illvstribvs Ordinis Praedicatorvm Libri Sex In Vnvm Congesti.* Bologna: In aedibus Hieronymi Platonis, 1517.

    *Historie di Bologna. Opera di Leandro Alberti.* Reprint. Bologna: Forni, 1970.

Alciato, Andrea. *Andreas Alciatus.* Ed. Peter M. Daly, Virginia W. Callahan, and Simon

Cuttler. 2 vols. Toronto, Buffalo, and London: University of Toronto Press, 1985.
*Emblemata cum Commentariis, Padua, 1621.* Ed. Claude Mignault. Reprint. New York and London: Garland, 1976.

*Le lettere di Andrea Alciato giuresconsulto.* Ed. Gian Luigi Barni. Università degli Studi di Milano. Florence: Le Monnier, 1953.

Allen, Don Cameron. *Mysteriously Meant: The Rediscovery of Pagan Symbolism and Allegorical Interpretation in the Renaissance.* Baltimore and London: Johns Hopkins University Press, 1970.

Amaseo, Gregorio, Leonardo Amaseo, and Giovanni Antonio Azio. *Diarii udinesi dall'anno 1508 all'anno 1541.* Monumenti storici pubblicati dalla R. Deputazione Veneta di Storia Patria. Vol. 11, ser. 3. Cronache e Diarii. Vol. 2 [i.e., 1]. Venice: Fratelli Visentini, 1884.

Anghiera, Pietro Martire d'. *Opera.* Alcala, 1516. Reprint. Ed. Erich Woldan. Graz: Akademische Druck- u. Verlagsanstalt, 1966.

Ariosto, Ludovico. *Orlando Furioso.* Ed. Cesare Segre. 2 vols. Milan: Mondadori, 1982.

*Le arti a Bologna e in Emilia dal XVI al XVII secolo.* Ed. Andrea Emiliani. Comité International d'Histoire del'Art, 4. *Atti del XXIV Congresso Internazionale di Storia dell'Arte.* 10 vols. Bologna: CLUEB, 1982–3.

*Aspects de la propagande religieuse nell'Europa del Cinquecento: Etudees publiées par G. Berthaud [et al.].* Ed. Henri Meylan. Geneva: Droz, 1957.

*Atti del I Congresso Internazionale Etrusco, Firenze-Bologna, 17 aprile–5 maggio 1928.* Florence: Rinascimento del Libro, 1929.

*Atti del V Convegno Nazionale di Storia dell'Architettura, Perugia, 23 Settembre 1948.* Florence: Noccioli, 1957.

Auerbach, Erich. *Scenes from the Drama of European Literature.* Foreword by Paolo Valesio. 2d ed. Minneapolis: University of Minnesota Press, 1984.

Bacon, Francis. *The Essayes or Counsels Civill & Morall of Francis Bacon Lord Verulam.* 1906. Reprint. London and Toronto: Dent; New York: Dutton, 1928.

Bargagli, Girolamo. *Dialogo De' Givochi Che Nelle Vegghie Sanesi Si Vsano Di Fare.* Del Materiale Intronato. Siena: Per Luca Bonetti, 1572.

Barozzi da Vignola, Jacopo. *Le due regole della prospettiva pratica.* Rome, 1633. Reprint. Bologna: Arte Grafiche Tamari for Cassa di Risparmio di Vignola, 1974.

Benzoni, Gino. *Gli affanni della cultura: Intelletuali e potere nell'Italia della Controriforma e Barocca.* Milan: Feltrinelli, 1978.

Beroaldo, Filippo. *Orationes, Prelectiones, Praefationes & quaedam Mithicae Historiae Philippi Beroaldi. ...* Paris: In Aedibus Badius Ascensianis, 1511.

Beseghi, Umberto. *I palazzi di Bologna.* Bologna: Tamari, Ente provinciale per il turismo, 1957.

*Biographie Universelle (Michaud) ancienne et moderne.* 45 vols. Paris: Desplaces; Leipzig: Brockhaus, 1854–n.d.

Boccaccio, Giovanni, *Genealogie Deorum Gentilium Libri.* Ed. Vincenzo Romano. Vols. 10–11 of Boccaccio, *Opere.* In *Scrittori d'Italia,* nos. 200–1. Bari: Laterza, 1951.

Bocchi, Romeo. *Della Giusta Vniversal Misvra Et Svo Typo. ...* 2 vols. in 1. Venice: Appresso Antonio Pinelli, 1621.

Bohlin, Diane DeGrazia. *Prints and Related Drawings by the Carracci Family: A Catalogue Raisonné.* Washington, DC National Gallery of Art, 1979.

Bolgar, R. R. *The Classical Heritage and Its Beneficiaries.* Cambridge: Cambridge University Press, 1958.

*Bologna e l'Umanesimo, 1490–1510.* Ed. Marzia Faietti and Konrad Oberhuber. [Exhibition,] Bologna, Pinacoteca Nazionale, 6 March–24 April 1988. Bologna: Nuova Alfa, 1988.

Borsa, Gédeon. "Bornemisza Pál megemlékzése Várdai Ferencröl és a többi, Mohács

elötti bolognai, magyar vonatkozású nyomtatvány." *Irodalomtörténeti Közlemények* 87 (1983): 48–58.

Bovelles, Charles de. *Liber de intellectu. Liber de sensibus. Libellus de nihilo. Ars Oppositorum. Liber de generatione. Liber de sapiente.* ... Paris, 1510. Reprint. Stuttgart-Bad Cannstatt: Frommann, 1970 [1973].

Bowen, Barbara C. "Mercury at the Crossroads in Renaissance Emblems." *Journal of the Warburg and Courtauld Institutes* 48 (1985): 222–9.

　　*Words and the Man in French Renaissance Literature.* Lexington, KY: French Forum, 1983.

Bumaldo, Io. Antonio. *See* Montalbani, Ovidio.

Burke, Peter. *Culture and Society in Renaissance Italy, 1420–1540.* New York: Scribner, 1972.

Calcagnino, Caelio. ... *Opera Aliqvot. Ad illustrissimum & excellentiss. principem D. Herculem secundum, ducem Ferrariae quartum.* ... Basel: Per Hier Frobenivm, 1544.

Calcaterra, Carlo. *Alma Mater Studiorum: L'Università di Bologna nella storia della cultura della civiltà.* Bologna: Zanichelli, 1948.

Calvesi, Maurizio. *Il sogno di Polifilo prenestino.* Rome: Officina, 1980.

Cantimori, Delio. *Eretici italiani del Cinquecento: Ricerche storiche.* 3d ed. Florence: Sansoni, 1977.

　　"Note su alcuni aspetti della propaganda religiosa nell'Europa del Cinquecento." In *Aspects de la propagande religieuse,* 340–51.

Capaccio, Giulio Cesare. *Delle Imprese Trattato Di Givlio Cesare Capaccaccio, In tre Libri diuiso.* ... Naples: Appresso Gio. Giacomo Carlino, & Antonio Pace, 1952.

*Carmina Illustrium Poetarum Italorum.* Ed. Joannes Bottari. 11 vols. Florence: Typis Regiae Celsitudinis, apud Joannem Cajetanum Tartinium et Sanctem Franchium, 1719–26.

*Carmina Qvinqve Hetrvscorvm Poetarvm Nvnc Primvm in Lvcem Edita.* Florence: In Apud Ivntas, 1562.

Caro, Annibale. *Lettere familiari.* Ed. Aulo Greco. 3 vols. Istituto Nazionale di Studi sul Rinascimento. Florence: Le Monnier, 1957–9.

Cartari, Vincenzo. *Le Imagini ... degli dei, Venice, 1571.* Reprint. New York: Garland, 1976.

Casella, Maria Teresa, and Giovanni Pozzi. *Francesco Colonna, biografia e opere.* 2 vols. Padua: Antenore, 1959.

Casio de Medici, Girolamo. *Libro intitulato Bellona nel quale si tratta di Arme, di Letere, e di Amore.* Bologna, 1525.

*Catalogus Translationum et Commentariorum: Medieval and Renaissance Latin Translations and Commentaries, Annotated List and Guides.* Ed. Paul Oskar Kristeller and F. Edward Cranz. 6 vols. to date. Washington, DC: Catholic University of America Press, 1960–.

*Charles de Bovelles en son cinquième centenaire, 1479–1979: Actes du Colloque International tenu à Noyon les 14–15–16 septembre 1979.* Publ. avec le concours du Centre National des Lettres. Paris: Trédaniel, 1982.

*La città effimera e l'universo artificiàle del giardino: La Firenze dei Medici e l'Italia del '500.* Ed. Marcello Fagiolo. Rome: Officina, 1980.

Clements, Robert J. *Picta Poesis: Literary and Humanistic Theory in Renaissance Emblem Books.* Rome: Edizioni di Storia e Letteratura, 1960.

Cochrane, Eric. *Historians and Historiography in the Italian Renaissance.* Chicago and London: University of Chicago Press, 1981.

Coffin, David R. *The Villa in the Life of Renaissance Rome.* Princeton Monographs in Art and Archaeology 34. Princeton, NJ: Princeton University Press, 1979.

Colie, Rosalie L. *Paradoxia Epidemica: The Renaissance Tradition of Paradox.* Princeton, NJ: Princeton University Press, 1966.

　　*The Resources of Kind.* Ed. Barbara K. Lewalski. Berkeley, Los Angeles, and London: University of California Press, 1973.

Colonna, Francesco. *Hypnerotomachia Poliphili, Venice, 1499*. Reprint. New York and London: Garland, 1976.

*Hypnerotomachia Poliphili (Venetiis, Aldo Manuzio, 1499)*. Reprint. Introduction by Peter Dronke. Zaragoza: Las Ediciones del Pórtico, 1981.

*La Conscience européenne au XVe et au XVIe siècle. Actes du Colloque internationale organisé à l'Ecole normale supérieure de jeune filles (30 septembre–3 octobre 1980)*. Paris: Ecole normale supérieure de jeunes filles, 1982.

*Convegno di studi su Giangiorgio Trissino*. Ed. Neri Pozza. Vicenza: Accademia Olimpica, 1980.

*La corte e il "Cortegiano."* Ed. Carlo Ossola. 2 vols. Centro Studi "Europa delle Corti," Biblioteca del Cinquecento 8–9. Rome: Bulzoni, 1980.

Costalius, Petrus. *Le Pegme de Pierre Coustau, Lyons, 1555*. Reprint. Introduction by Stephen Orgel. New York and London: Garland, 1979.

Crane, Thomas Frederick. *Italian Social Customs of the Sixteenth Century and Their Influence on the Literatures of Europe*. Cornell Studies in English 5. 1920. Reprint. New York: Russell & Russell, 1971.

*Cultura e vita civile tra Riforma e Controriforma*. Ed. Nicola Badaloni et al. Roma and Bari: Laterza, 1973.

*The Cultural Context of Medieval Learning: Proceedings of the First International Colloquium on Philosophy, Science, and Theology in the Middle Ages, September 1973*. Ed. John Emery Murdoch and Edith Dudley Sylla. Dordrecht and Boston: Reidel, 1975.

Cuppini, Giampiero. *I palazzi senatorii a Bologna: Architettura come immagine del potere*. Bologna: Zanichelli, 1974.

Cuppini, Giampiero, and Anna Maria Matteucci. *Ville del Bolognese*. 2d ed. rev. Bologna: Zanichelli, 1969.

Cytowska, Maria. "Erasme et Beroaldo." *Eos* 65 (1977): 265–71.

Dallari, Umberto, ed. *I Rotuli dei lettori legisti e artisti dello Studio bolognese dal 1384 al 1799*. 4 vols. in 5. Bologna: Fratelli Merlani, 1888–1924.

Daly, Peter. *Emblem Theory: Recent German Contributions to the Characterization of the Emblem Genre*. Wolfenbüttler Forschungen 9. Nendeln: KTO, 1979.

*Literature in the Light of the Emblem: Structural Parallels between the Emblem and Literature in the Sixteenth and Seventeenth Centuries*. Toronto, Buffalo, and London: University of Toronto Press, 1979.

D'Amico, John F. *Renaissance Humanism in Papal Rome: Humanists and Churchmen on the Eve of the Reformation*. Johns Hopkins University Studies in History and Political Science, 101st ser., no. 1. Baltimore and London: Johns Hopkins University Press, 1983.

*The Darker Vision of the Renaissance: Beyond the Fields of Reason*. Ed. Robert S. Kinsman. UCLA Center for Medieval and Renaissance Studies, Contributions 6. Berkeley, Los Angeles, and London: University of California Press, 1974.

Darnall, Margaretta J., and Mark S. Weil. "Il Sacro Bosco di Bomarzo: Its Sixteenth-Century Literary and Antiquarian Context." *Journal of Garden History* 4 (1984): 1–94.

De Angelis, Maria Antonietta. *Gli emblemi di Andrea Alciato nella edizione Steyner del 1531: Fonti e simbologia*. Salerno: Lito Dottrinari, 1984.

DeGrazia, Diane. *Correggio and His Legacy: Sixteenth Century Emilian Drawings*. Washington DC: National Gallery of Art, 1984.

De Maio, Romeo. *Michelangelo e la Controriforma*. Rome and Bari: Laterza, 1978.

D'Episcopo, Francesco. *Civiltà della parola*. 2 vols. Naples: Edizioni Scientifiche Italiane, 1984.

*Developments in the Early Renaissance: Papers of the Second Annual Conference of the Center for Medieval and Early Renaissance Studies, State University of New York at Binghamton, 4–5 May 1968*. Ed. Bernard S. Levy. Albany: State University of New York Press, 1972.

Dieckmann, Liselotte. *Hieroglyphics: The History of a Literary Symbol.* St. Louis: Washington University Press, 1970.

Dionisotti, Carlo. *Geografia e storia della letteratura italiana.* Turin: Einaudi, 1967.

*Gli umanisti e il volgare fra Quattro e Cinquecento.* Florence: Le Monnier, 1968.

*Dizionario biografico degli Italiani.* 39 vols. to date. Rome: Istituto della Enciclopedia Italiana, 1960–.

Dolfi, Pompeo Scipione. *Cronologia delle famiglie nobili di Bologna.* 1670. Reprint. Bologna: Forni, 1973.

Doni, Anton Francesco. *La Libraria.* Ed. Vanni Bramanti. Milan: Longanesi, 1972.

Drysdall, D. L. "Filippo Fasanini and His 'Exploration of Sacred Writing' (Text and Translation)." *Journal of Medieval and Renaissance Studies* 13 (1983): 127–55.

Dubois, Claude-Gilbert. *Mythe et langage au seizième siècle.* Bordeaux: Ducros, 1970.

*Emblem und Emblematikrezeption: Vergleichende Studien zur Wirkungsgeschichte vom 16. bis 20. Jahrhundert.* Ed. Sibylle Penkert. Darmstadt: Wissenschaftliche Buchgesellschaft, 1978.

*L'Emblème à la Renaissance: Actes de la Journée d'Etudes du Mai 1980.* Ed. Yves Giraud. Paris: Société d'Edition d'Enseignement Supérieur, for Société Française des Seiziémistes, 1982.

*Emblèmes et devises au temps de la Renaissance.* Ed. M. T. Jones-Davies. Université de Paris-Sorbonne, Institut de Recherches sur les Civilisations de l'Occident Moderne, Centre de Recherches sur la Renaissance. Paris: Touzot, 1981.

Erasmus, Desiderius. *Erasmus on His Times: A Shortened Version of the "Adages" of Erasmus.* Ed. and trans. Margaret Mann Phillips. Cambridge: Cambridge University Press, 1967.

*Eresia e riforma nell'Italia del Cinquecento.* Miscellanea I. DeKalb: Northern Illinois University Press; Chicago: Newberry Library; Florence: Sansoni, 1974.

*Esistenza, mito ermeneutica: Scritti per Enrico Castelli.* 2 vols. In *Archivio di filosofia* (1980), nos. 1–2.

*Essays Presented to Myron P. Gilmore.* Ed. Sergio Bertelli and Gloria Ramakus. 2 vols. Villa I Tatti, The Harvard University Center for Italian Renaissance Studies 2. Florence: La Nuova Italia, 1978.

*The Fairest Flower: The Emergence of Linguistic National Consciousness in Renaissance Europe. IV Centenario dell' Accademia della Crusca. International Conference of The Center for Medieval and Renaissance Studies, University of California, Los Angeles, 12–13 December 1983.* Florence: Presso l'Accademia, 1985.

Fanti, Mario, ed. *Ville, castelli e chiese bolognesi da un libro di disegni del Cinquecento.* Bologna: Forni, 1967.

Fantuzzi, Giovanni. *Notizie degli scrittori bolognesi.* 9 vols. Bologna: Nella stamperia di San Tommaso D'Aquino, 1781–94.

Fasoli, Gina. "La storia delle storie di Bologna." *Atti e memorie [della] Deputazione di Storia Patria per le Province di Romagna* 17–19 (1965–8): 61–91.

Ferrari, Lodovico, and Niccolò Tartaglia. *Cartelli di sfida matematica: Riproduzione in facsimile delle edizioni originali, 1547–1548.* Ed. Arnaldo Masotti. Reprint. Brescia: Ateneo di Brescia, 1974.

*Festschrift Johannes Jahn zum XXII. November MCMLVII.* Kunsthistorischen Institut der Karl-Marx-Universität, Leipzig. Leipzig: Seemann, 1957.

*Firenze e la Toscana dei Medici nell'Europa del '500.* 3 vols. Florence: Olschki, 1983.

Flaminio, Giovanni Antonio. *Joannis Antonii Flaminii Forocorneliensis Epistolae Familiares . . .* Ed. Fr. Dominico Josepho Capponi. Bologna: Ex Typographia Sancti Thomae Aquinatis, 1744.

Flaminio, Marcantonio. *Lettere.* Ed. Alessandro Pastore. Università degli Studi di Trieste. Facoltà di Lettere e Filosofia. Istituto di Storia Medievale [e] Moderna 1. Rome: Ateneo & Bizzarri, 1978.

Flaminio, Marcantonio, Giovanni Antonio Flaminio, and Gabriele Flaminio. *Carmina*. Padua: Josephus Cominus, 1743.

*Formen und Funktionen der Allegorie: Symposion Wolfenbüttel 1978*. Ed. Walter Haug. Germanistische Symposien Berichtsbände 3. Stuttgart: Metzler, 1979.

Frati, Lodovico. "Gio. Andrea Garisendi e il suo Contrasto d'Amore." *Giornale storico della letteratura italiana* 49 (1907): 73–82.

    *La vita privata di Bologna dal secolo XIII al XVII*. 1900. Reprint. Rome: Bardi, 1968.

    ed. *Rimatori bolognesi del Quattrocento*. Collezione di opere inedite o rare dei prime tre secoli della lingua. Bologna: Romagnoli dall'Acqua, 1908.

Freeman, Rosemary. *English Emblem Books*. London, 1948. Reprint. New York: Octagon, 1978.

*French Renaissance Studies, 1540–1570: Humanism and the Encyclopedia*. Ed. Peter Sharratt. Edinburgh: University Press, 1976.

Garin, Eugenio. "Commenti Lucreziani." *Rivista critica di storia della filosofia italiana* 28 (1973): 83–6.

    *Rittratti di umanisti*. Florence: Sansoni, 1967.

    *Geist und Zeichen: Festschrift für Arthur Henkel zu seinem sechzigsten Geburtstag*. Ed. Herbert Anton, Bernhard Gajek, and Peter Pfaff. Heidelberg: Winter, 1977.

Geminus Eleates, Papyrius [Thomas Elyot?]. *Papyrii Gemini Eleatis Hermathena, sev De Eloquentiae Victoriae . . .* Facsimile ed. 1522. Cambridge: Clay, Clay, & Clay for University of Cambridge, 1886.

Giehlow, Karl. "Die Hieroglyphenkunde des Humanismus in der Allegorie der Renaissance, besonders der Ehrenpforte Kaisers Maximilian I." *Jahrbuch der Kunsthistorischen Sammlungen des Allerhöchsten Kaiserhauses (Wien)* 32 (1915): 1–232.

Ginzburg, Carlo. *Il Nicodemismo: Simulazione e dissimulazione religiosa nell'Europa del '500*. Turin: Einaudi, 1970.

Giombi, Samuele. "Umanesimo e mistero simbolico: La prospettiva di Achille Bocchi." *Schede umanistiche* 1 (1988): 167–216.

Giordani, Gaetano. *Della venuta e dimora in Bologna del sommo Pontifice Clemente VII. per la coronazione di Carlo V. Imperatore celebrata l'anno M.DXXX: Cronaca. . . .* Bologna: Alla Volpe, 1842.

Giovio, Paolo. *Dialogo dell'imprese militari e amorose*. Ed. Maria Luisa Doglio. Centro Studi "Europa delle Corti." Biblioteca del Cinquecento 4. Rome: Bulzoni, 1978.

    *Pauli Iovii Opera*. Ed. Societatis Historicae Novocomensis. 9 vols. to date. Rome: Istituto Poligrafico dello Stato Libreria, 1956–.

Giraldi, Lilio Gregorio. *De Deis Gentivm, Basel 1548*. Reprint. New York and London: Garland, 1976.

*Giulio Bonasone*. Catalogo di Stefania Massari. Ministero per i beni culturali e ambientali, Istituto nazionale per la grafica-calcografia. 2 vols. Rome: Edizioni Quasar, 1983.

Giustiniani, Vito R. "Sulle traduzioni latine delle 'Vite' di Plutarco nel Quattrocento." *Rinascimento*, n.s. 2, 1 (1961): 3–62.

Gombrich. E. H. *Symbolic Images*. 3d ed. Vol. 2 of *Studies in the Art of the Renaissance*. Chicago: University of Chicago Press, 1985.

Greene, Thomas M. *The Light in Troy: Imitation and Discovery in Renaissance Poetry*. The Elizabethan Club Series 7. New Haven and London: Yale University Press, 1982.

Greenfield, Concetta Carestia. *Humanist and Scholastic Poetics, 1250–1500*. Lewisburg, PA: Bucknell University Press; London and Toronto: Associated University Presses, 1981.

Grendler, Paul F. *Critics of the Italian World (1530–1560): Anton Francesco Doni, Nicolò Franco & Ortensio Lando*. Madison, Milwaukee, and London: University of Wisconsin Press, 1969.

Gruter, Jan, ed. *Delitiae C.C. Italorvm Poetarvm, Hvivs Svperiorisqve Aevi illustrium.* Collectore Ranvtio Ghero. 2 vols. Frankfurt: In officina Ionae Rosae, 1608.

Guicciardini, Francesco. *Ricordi.* Ed. Raffaele Spongano. Florence: Sansoni, 1951.

Guidicini, Giuseppe. *Cose notabili della città di Bologna, ossia Storia cronologica de' suoi stabili publici e privati.* Ed. Ferdinando Guidicini. 5 vols. Bologna: Vitali, 1868–73.

Heckscher, William S. "Goethe im Banne der Sinnbilder: Ein Beitrag zur Emblematik." In *Emblem und Emblematikrezeption,* 355–85. Republished from *Jahrbuch der Hamburger Kunstsammlungen* 7 (1962): 35–54.

Heninger, S. K. *Touches of Sweet Harmony: Pythagorean Cosmology and Renaissance Poetics.* San Marino, CA: Huntington Library, 1974.

Henkel, Arthur, and Albrecht Schöne, eds. *Emblemata: Handbuch zur Sinnbildkunst des XVI. und XVII. Jahrhunderts.* 2d ed. Stuttgart: Metzler, 1976.

Horapollo. *The Hieroglyphics of Horapollo.* Trans. George Boas. New York: Pantheon, 1950.

Huizinga, Johan. *Homo Ludens: A Study of the Play Element in Culture.* Author's trans. 1950. Boston: Beacon, 1955.

Innocenti, Giancarlo. *L'immagine significante: Studio sull'emblematica cinquecentesca.* Padua: Liviana, 1981.

Isselburg, Peter, and George Rem. *Emblemata Politica In aula magna Curiae Noribergensis depicta Quae sacra Virtvtvm suggerunt Monita Prvdenter administrandi Fortiterqve defendendi Rempublicam.* Nuremberg, 1640. Reprint. Ed. Wolfgang Harms. Bern and Frankfurt am Main: Lang, 1982.

*Italian Reformation Studies in Honor of Laelius Socinus.* Ed. John A. Tedeschi. Università di Siena. Facoltà di Giurisprudenza. Collana di Studi "Pietro Rossi," n.s. 4. Florence: Le Monnier, 1965.

*Italian Renaissance Studies: A Tribute to the Late Cecilia M. Ady.* Ed. E. F. Jacob. London: Faber & Faber, 1960.

*Itinerarium Italicum: The Profile of the Italian Renaissance in the Mirror of its European Transformations, Dedicated to Paul Oskar Kristeller on the Occasion of His 70th Birthday.* Ed. Heiko A. Oberman and Thomas A. Brady, Jr. Leiden: Brill, 1975.

Junius, Hadrianus. *Emblemata, 1565.* Reprint. Introductory note by Hester M. Black. Menston: Scholar Press, 1972.

Kaufmann, Thomas DaCosta. "The Eloquent Artist: Towards an Understanding of the Stylistics of Painting at the Court of Rudolf II," *Leids Kunsthistorisch Jaarboek* 1 (1982): 119–48.

Kirchner, Gottfried. *Fortuna in Dichtung und Emblematik des Barock: Tradition und Bedeutungswandel eines Motivs.* Stuttgart: Metzler, 1970.

Knod, Gustav C. *Deutsche Studenten in Bologna (1289–1562): Biographischer Index zu den Acta Nationis Germanicae Biblioteca Universitatis Bononiensis.* Berlin, 1889. Reprint. Darmstadt: Scientia Verlag Aalen, 1970.

Krautter, Konrad. *Philologische Methode und humanistische Existenz: Filippo Beroaldo und sein Kommentar zum Goldenen Esel des Apuleius.* Munich: Fink, 1971.

Kristeller, Paul Oskar. *Iter Italicum: A Finding List of Uncatalogued or Incompletely Catalogued Humanistic Manuscripts of the Renaissance in Italian and Other Libraries.* 4 vols. in 5 to date. London: Warburg Institute; Leiden: Brill, 1963–.

Kruszynski, Anette. *Der Ganymed-Mythos in Emblematik und mythographischer Literatur des 16. Jahrhunderts.* Worms: Werner, 1985.

Lamo, Pietro. *Graticola di Bologna: Gli edifici e le opere d'arte della città nel 1560.* Ed. Giancarlo Roversi. Bologna: Atesa, 1977.

Landwehr, John. *Emblem Books in the Low Countries, 1554–1949: A Bibliography.* Utrecht: Haentjens, Dekker & Gumbert, 1970.

*French, Italian, Spanish, and Portuguese Books of Devices and Emblems, 1534–1827: A Bibliography.* Utrecht: Haentjens, Dekker & Gumbert, 1976.

*German Emblem Books, 1531–1888: A Bibliography.* Utrecht: Haentjens, Dekker & Gumbert; Leiden: Sijthoff, 1972.

La Perrière, Guillaume de. *La Morosophie de Guillaume de la Perriere Tolosain* . . . Lyon: Macé Bonhomme, 1553.

Laurens, Pierre, and Claudie Balavoine, eds. and trans. *Mvsae Redvces: Anthologie de la poésie latine dans l'Europe de la Renaissance.* 2 vols. Leiden: Brill, 1975.

Lavin, Irving. "Divine Inspiration in Caravaggio's Two *St. Matthews.*" *Art Bulletin* 56 (1974): 59–81.

Lee, Rensselaer W. "*Ut pictura poesis:* The Humanist Theory of Painting." *Art Bulletin* (1940): 197–269. Republished as *Ut Pictura Poesis: The Humanistic Theory of Painting.* New York and London: Norton, 1967.

Leeman, F. W. G. *Alciatus' Emblemata: Denkbeelden en voorbeelden.* Groningen: Bouma, 1984.

Lennon, Madeline. "Cartari's *Imagini:* Emblematic References in the Relationship of Text and Image." *Emblematica* 3 (1988): 263–82.

*La letteratura, la rappresentazione, la musica al tempo e nei luoghi di Giorgione.* Ed. Michelangelo Muraro. Rome: Jouvence, 1987.

L'Hospital, Michel de. *Michaelis Hospitalii Galliarvm Cancellarii, Epistolarium seu Sermonum Libri Sex.* Altero ed. Lyon: Per Hugonem Gazeium, 1572.

*Oeuvres complètes de Michel L'Hospital, Chancelier de France.* Ed. P. S. S. Duféy. 3 vols. Paris: Boulland, 1824–5.

*Poésies Complètes du Chancelier Michel de L'Hospital.* Trans. Louis Bandy de Nalèche. Paris: Hachette, 1857.

Liebenwein, Wolfgang. *Studiolo: Die Entstehung eines Raumtyps und seine Entwicklung bis um 1600.* Frankfurter Forschungen zur Kunst 6. Berlin: Mann, 1977.

*Literary and Art History.* Special issue of *New Literary History* 3 (1971–2).

Lotichius, Petrus. *Petri Lotichii Secvndi Solitariensis Poemata Qvae Exstant Omnia Selectis Petri Bvrmanni Secvndi Hoogstratani Et Christiani Friderici Qvellii* . . . Ed. Carolus Traugott Kretzschmar. Dresden: Apvd Io. Nic. Gerlachi Vidvam et Fil., 1773.

Maddison, Carol. *Apollo and the Nine: A History of the Ode.* Baltimore: Johns Hopkins Press, 1960.

Malagola, Carlo. *Della vita e delle opere di Antonio Urceo detto Codro: Studi e ricerche.* Bologna: Fava e Garignani, 1878.

Malloch, A. E. "The Technique and Function of the Renaissance Paradox." *Studies in Philology* 53 (1956): 191–203.

Malvasia, Carlo Cesare. *Felsina pittrice: Vite de' pittori bolognese.* Ed. Giampietro Zanotti. 2 vols. Rev. ed. Bologna, 1841. Reprint. Bologna: Forni, 1967.

*Marmora Felsinea Innumeris Non Solum Inscriptionibus Exteris Hucusque Ineditis Sed etiam quamplurimis Doctissimorum Virorum expositionibus roborata & aucta.* Bologna: Ex Typographia Pisariana, 1690.

Marin, Louis, "Notes sur une médaille et une gravure: Eléments d'une étude sémiotique." *Revue d'esthétique 22,* no. 2 (1969): 121–38.

Masini, Antonio di Paolo. *Bologna Perlvstrata.* 3d ed. 3 vols. Bologna: Per l'Erede di Vittorio Benacci, 1666.

Maylender, Michele. *Storia delle Accademie d'Italia.* 5 vols. Bologna, Rocca S. Casciano, and Trieste: Cappelli, 1926–30.

Mazzetti, Serafino, comp. *Repertorio di tutti i professori antichi, e moderni della famosa Università, e del celebre Istituto delle scienze di Bologna.* . . . Bologna: Tipografia di S. Tommaso d'Aquino, 1848.

Mazzuchelli, Giammaria, *Gli scrittori d'Italia, cioé notizie storiche, e critiche intorno alle vite, e agli scritti dei letterati italiani.* 2 vols. in 6. Brescia: Giambattista Bossini, 1753–63.

*Mélanges à la mémoire de Franco Simone: France et Italie dans la culture européenne.* 4 vols. Centre d'Etudes Franco-Italien, Universités de Turin et de Savoie, Bibliothèque Franco Simone, 4, 6, 8–9. Geneva: Slatkine, 1980–4.

*Memoria dell'antico nel'arte italiana.* Ed. Salvatore Settis. 3 vols. Turin: Einaudi, 1984–6.

*Memorie e studi intorno a Jacopo Barozzi pubblicati nel IV centenario dalla nascita.* Per Cura del Comitato preposto alle onoranze. Vignola: Monti, 1908.

Mendelsohn, Leatrice. *Paragoni: Benedetto Varchi's Due Lezzioni and Cinquecento Art Theory.* Ann Arbor, MI: UMI Research Press, 1982.

Miedema, Hessel. "The Term *Emblema* in Alciati." *Journal of the Warburg and Courtauld Institutes* 31 (1968): 234–50.

Milizia, Francesco. *Memorie degli architetti antichi e moderni.* 2 vols. 4th ed. rev. Bassano: A spese Remondini di Venezia, 1785.

Miller, Naomi. *Renaissance Bologna: A Study in Architectural Form and Content.* University of Kansas, Humanistic Studies 56. New York: Lang, 1989.

"La 'retorica' come chiave di interpretazione dell'architettura bolognese (1380–1565)." *Il Carrobbio* 5 (1979): 319–46.

*Miscellanea Bibliotecae Hertzianae zu Ehren von Leo Bruhns, Franz Graf Wolff Metternich, Ludwig Schudt.* Römische Forschungen der Bibliotheca Hertziana 16. Munich: Schroll, 1961.

*Miscellanea di Studi critici in onore di Arturo Graf.* Bergamo: Istituto Italiano d'Arti Grafiche, 1903.

Mitchell, Bonner: *Italian Civic Pageantry in the High Renaissance: A Descriptive Bibliography of Triumphal Entries and Selected Other Festivals for State Occasions.* Florence: Olschki, 1979.

Monari, Daniela. "Palazzo Bocchi e l'opera rustica secondo il Vignola." In *Natura e artificio,* 113–28.

"Palazzo Bocchi: Il quadro storico e l'intervento del Vignola." *Il Carrobbio* 6 (1980): 263–71.

Montalbani, Ovidio [Io. Antonio Bumaldo, pseud.]. *Minervalia Bonon. Ciuium Anademata, Sev Bibliotheca Bononiensis, Cvi Accressit antiquorum Pictorum, & Sculptorum Bonon. Breuis Catalogus, Collectore, Io. Antonio Bvmaldo. . . .* Bologna: Typis Haeredis Pictorij Benatij, 1641.

Montevecchi, Alessandro. "La cultura del Cinquecento." In *Storia della Emilia Romagna,* 2:551–70. Bologna: University Press, 1977.

Morolli, Gabriele. *"Vetus Etruria," Il mito degli Etruschi nella letteratura architettonica nell'arte e nella cultura da Vitruvio a Winckelmann.* Florence: Alinea, 1985.

Mutini, Claudio. "Bonasone e i 'Symbola' di Bocchi nella versione di M. Bianchelli Illuminati." *Galleria* 35 (1985): 243–7.

*Mythographie der frühen Neuzeit: Ihre Anwendung in den Künsten.* Ed. Walther Killy. Wolfenbütteler Forschungen 27. Wiesbaden: Harrassowitz, 1984.

Napoli, Giovanni di. *L'immortalità dell'anima nel Rinascimento.* Turin: Società Editrice Internazionale, 1963.

*Natura e artificio: L'ordine rustico, le fontane, gli automi nella cultura del Manierismo europeo.* Ed. Marcello Fagiolo. Rome: Officina, 1979.

*New Perspectives on Renaissance Thought: Essays in the History of Science, Education and Philosophy in Memory of Charles B. Schmitt.* Ed. John Henry and Sarah Hutton. London: Duckworth; Istituto Italiano per gli Studi Filosofici, 1990.

Nicholas of Cusa. *The Layman on Wisdom and the Mind.* Ed. and trans. M. L. Führer. Centre for Reformation and Renaissance Studies, University of Toronto, Translation Series 4. Ottawa: Dovehouse, 1989.

Nohrnberg, James. *The Analogy of "The Faerie Queene."* Rev. ed. Princeton, NJ: Princeton University Press, 1980.

Orazi, Anna Maria. *Jacopo Barozzi da Vignola, 1528–1550, apprendistato di un architetto bolognese.* Rome: Bulzoni, 1982.

Ori, Angiolo Silvio. *Bologna raccontata: Guida ai monumenti, alla storia, all'arte della città.* Bologna: Tamari, 1976.

Orlandi, Pellegrino Antonio. *Notizie degli Scrittori Bolognesi e dell'opere loro stampate e manoscritte.* Bologna: Per Costantino Pissari, 1714.

Pace, Richard. *De Fructu qui ex Doctrina Percipitur (The Benefit of a Liberal Education).* Ed. and trans. Frank Manley and Richard S. Sylvester. New York: Publ. for The Renaissance Society of America by Frederick Ungar, 1967.

Panofsky, Dora, and Erwin Panofsky. *Pandora's Box: The Changing Aspects of a Mythical Symbol.* 2d ed rev. New York: Pantheon, 1962.

Paradin, Claude. *Devises Heroïqves.* Lyon: Ian de Tovrnes, et Gvil, Gazeav, 1557.

*Le Paradoxe au temps de la Renaissance.* Ed. M. T. Jones-Davies. Paris: Touzot for Université de Paris-Sorbonne, Institut de Recherches sur les Civilisations de l'Occident moderne, Centre de Recherches sur la Renaissance, 1982.

Pasquali Alidosi, Giovanni Nicolò. *Dottori bolognesi di teologia, filosofia, medicina, e d'arti liberali dall'anno 1000 per tutto marzo del 1623.* Bologna: Nicolo Tebaldini, 1623.

*Pasquinate romane del Cinquecento.* Ed. Valerio Marucci. Antonio Marzo, and Angelo Romano. 2 vols. Rome: Salerno, 1983.

Pastore, Alessandro. *Marcantonio Flaminio, fortune e sfortune di un chierico nell'Italia del Cinquecento.* Milan: Angeli, 1981.

*Il pensiero italiano del Rinascimento e il tempo nostro: Atti del V. Convegno internazionale del Centro di Studi Umanistici, Montepulciano, Palazzo Tarugi, 8–13 agosto 1968.* Ed. Giovannangiola Tarugi. Florence: Olschki, 1970.

Pigna, Giovanni Battista. *I Romanzi Di M. Giouan Battista Pigna, Al S. Donno Lvigi Da Este Vescovo Di Ferrara, Divisi In Tre Libri . . .* Venice: Appresso Vincenzo Valgrisi, 1554.

Plett, Heinrich F. *Rhetorik der Affekte: Englische Wirkungsästhetik im Zeitalter der Renaissance.* Tübingen: Niemeyer, 1975.

*Poetry and Poetics from Ancient Greece to the Renaissance: Studies in Honor of James Hutton.* Ed. G. M. Kirkwood. Cornell Studies in Classical Philology 38. Ithaca, NY, and London: Cornell University Press, 1975.

Poliziano, Angelo. *Omnia opera Angeli Politiani . . .* Venice, 1498. Reprint. Rome: Vivarelli & Gullà, n.d.

Pontano, Giovanni Gioviani. *De Sermone Libri Sex.* Ed. S. Lupi and A. Risicato. Lucani: Thesauri Mundi, 1954.

Praz, Mario. *Studies in Seventeenth-Century Imagery.* Vol. 1. 2d ed. enl. 1964. Reprint. Rome: Edizioni di Storia e Letteratura, 1975. Vol. 2. Rome: Edizioni di Storia e Letteratura, 1974.

Prodi, Paolo, *Il Cardinale Gabriele Paleotti (1522–1597).* 2 vols. Rome: Edizioni di Storia e Letteratura, 1959–67.

"Crotonotassi critica dei legati, vicelegati e governatori di Bologna dal Sec. XVI al XVII." *Atti e memorie, Deputazione di Storia Patria per le Province di Romagna,* n.s. 23 (1972): 117–301.

*Problemi di vita religiosa in Italia nel Cinquecento: Atti del Convegno di storia della Chiesa in Italia (Bologna, 2–6 sett. 1958).* Padua: Antenore, 1960.

Puttenham, George. *The Arte of English Poesie.* Ed. Gladys Doidge Willcock and Alice Walker. Cambridge: Cambridge University Press, 1936.

Quadrio, Francesco Saverio. *Della storia e della ragione d'ogni poesia.* 5 vols. in 7. Bologna: Ferdinando Pisarri, 1739–52.

Raggio, Olga. "Vignole, Fra Daminio et Gerolamo Siciolante à la Chapelle de La Bastie d'Urfé." *Revue de l'art* 15 (1972): 29–52.

Raimondi, Ezio. *Codro e l'Umanesimo a Bologna*. Bologna: Zuffi 1950.

    *Politica e commedia: Dal Beroaldo al Machiavelli*. Bologna: Il Mulino, 1972.

    "Umanesimo e università nel Quattrocento bolognese." *Studi e memorie per la storia dell'Università di Bologna*, n.s. 1 (1956): 324–56.

Rainieri, Jacopo. *Diario bolognese*. Ed. G. Guerrini and C. Ricci. Dei monumenti istorici pertinenti alle Provincie delle Romagne. Bologna: Regia tipografia, 1887.

Ravera Aira, Gisela. "Achille Bocchi e la sua 'Historia Bononiensis.'" *Studi e memorie per la storia dell'Università di Bologna* 15 (1942): 57–112.

*The Renaissance and Mannerism*. Vol. 2 of *Studies in Western Art: Acts of the Twentieth International Congress of the History of Art*. Princeton, NJ: Princeton University Press, 1963.

*Renaissance Eloquence: Studies in the Theory and Practice of Renaissance Rhetoric*. Ed. James J. Murphy. Berkeley, Los Angeles, and London: University of California Press, 1983.

*The Renaissance Image of Man and the World*. Ed. Bernard O'Kelly. Columbus: Ohio State University Press, 1966.

*The Renaissance Imagination: Essays and Lectures by D. J. Gordon*. Ed. Stephan Orgel. Berkeley, Los Angeles, and London: University of California Press, 1975.

*Renaissance Studies in Honor of Craig Hugh Smyth*. Ed. Andrew Morrogh, Fiorella Superbi Gioffredi, Piero Morselli, and Eve Borsook. 2 vols. Villa I Tatti, The Harvard University Center for Italian Renaissance Studies 7. Florence: Giunti Barbèra, 1985.

Renato, Camillo. *Opere: Documenti e testimonianze*. Ed. Antonio Rotondò. Corpus Reformatorum Italicorum. Florence: Sansoni; Chicago: Newberry Library, 1968.

Rhodes, Dennis E. "Due questioni di bibliografia bolognese del Cinquecento." *Archiginnasio* 81 (1986): 321–4.

Ricci, Bartolomeo. *Bartholomaei Riccii Lvgiensis Epistolarvm Familiarivm Libri VIII*. Bologna, 1560.

Rice, Eugene F. *The Renaissance Idea of Wisdom*. Cambridge, MA: Harvard University Press, 1958.

Rigolot, François. *Poétique et onomastique: L'Exemple de la Renaissance*. Geneva: Droz, 1977.

Ringhieri, Innocentio. *Cento Givochi Liberali, Et D'Ingegno*. Bologna: Ansel. Giacarelli, 1551.

*Rome in the Renaissance: The City and the Myth. Papers of the 13th Annual Conference of the Center for Medieval & Early Renaissance Studies*. Ed. P. A. Ramsey. Binghamton, NY: Center for Medieval & Early Renaissance Studies, 1982.

Rossi, Antonio. *Serafino Aquilano e la poesia cortegiana*. Brescia: Morcelliana, 1980.

Rotondò, Antonio. "Per la storia dell'eresia a Bologna nel secolo XVI." *Rinascimento*, 2d ser., 2 (1962): 107–54.

Roversi, Giancarlo. *Palazzi e case nobili del '500 a Bologna: La storia, le famiglie, le opere d'arte*. Presentazione di Gina Fasoli. Bologna: Grafis, 1986.

Ruscelli, Girolamo. *Le Imprese Illvstri Del S.^or Ieronimo Rvscelli. Aggivtovi Nvovam Il Qvarto Libro Da Vincenzo Rvscelli Da Viterbo*... Venice: Appresso Francesco de Francesci Senesi, 1584.

Russell, Daniel. *The Emblem and Device in France*. Lexington, KY: French Forum, 1985.

    "Emblems and Hieroglyphics: Some Observations on the Beginnings and the Nature of Emblematic Forms." *Emblematica* 1 (1986): 227–43.

    "The Term 'Emblème' in Sixteenth-Century France." *Neophilologus* 59 (1975): 337–51.

Sabbadini, Remigio. *Il metodo degli umanisti*. Florence: Le Monnier, 1922.

    "Vita e opere di Francesco Florido Sabino." *Giornale storico della letteratura italiana* 8 (1886): 333–63.

Sambucus, Johannes. *Emblemata, Cvm Aliqvot Nvmmis Antiqvi Operis.* Antwerp: Ex Officina Christophori Plantini, 1564.

Santoro, Mario. *Fortuna, ragione e prudenza nella civiltà letteraria del Cinquecento.* Naples: Liguori, 1967.

Saunders, Alison. "Picta poesis: The Relationship between Figure and Text in the Sixteenth-Century French Emblem Book." *Bibliothèque d'Humanisme et Renaissance* 48 (1986): 621–52.

Savarese, Gennaro, and Andrea Gareffi, eds. *La letteratura delle immagini nel Cinquecento.* Rome: Bulzoni, 1980.

Sbaragli, Luigi. *Claudio Tolomei umanista senese del Cinquecento: La vita e le opere.* Siena: Accademia per le Arti e per Lettere, 1939.

Scarpati, Claudio. *Studi sul Cinquecento italiano.* Milan: Vita e Pensiero, Pubbl. della Università Cattolica, 1982.

Schab, Frederick G. "Bonasone." *Print Quarterly* 2 (1985): 58–62.

Schenck, Eva-Maria. *Das Bilderrätsel.* Hildesheim and New York: Olms, 1973.

Scheurl, Christoph. *Christoph Scheurl's Briefbuch, ein Beitrag zur Geschichte der Reformation und ihrer Zeit.* Ed. Franz von Soden and J. K. F. Knaake, 2 vols. in 1. Aalen: Zeller, 1962.

Schmidt, Johann Karl. "Zu Vignolas Palazzo Bocchi in Bologna." *Mitteilungen der Kunsthistorisches Institut in Florenz* 13 (1967): 83–94.

Schmitt, Charles B. *Gianfrancesco Pico della Mirandola (1469–1533) and His Critique of Aristotle.* The Hague: Nijhoff, 1967.

*Scritti d'arte del Cinquecento.* Ed. Paola Barocchi. 3 vols. La letteratura italiana, storia e testi 32. Milan and Naples: Ricciardi, 1971–7.

*Sebastiano Serlio: Sesto Seminario Internazionale di Storia dell'Architettura, Vicenza, 31 agosto–settembre 1987.* Ed. Christof Thoenes. Milan: Electa, for Centro Internazionale di Studi di Architettura "Andrea Palladio" di Vicenza, 1989.

Seigel, Jerrold E. *Rhetoric and Philosophy in Renaissance Humanism: The Union of Eloquence and Wisdom.* Princeton, NJ: Princeton University Press, 1968.

Serlio, Sebastiano. *Tvtte L'Opere D'Architettvra, Et Prospetiva, Di Sebastiano Serlio Bolognese.* Ed. Gio. Domenico Scamozzi Vicentino. Venice, 1619. Reprint. Ridgewood, NJ: Gregg, 1964.

Serra-Zanetti, Alberto. *L'arte della stampa in Bologna nel primo ventennio del Cinquecento.* Biblioteca de "L'Archiginnasio," n.s. 1. Bologna: A spese del Comune, 1959.

Seznec, Jean. *The Survival of the Pagan Gods: The Mythological Tradition and Its Place in Renaissance Humanism and Art.* London, 1940. Trans. Barbara F. Sessions. New York: Pantheon, 1953.

*Società, politica e cultura a Capri ai tempi di Alberto III Pio.* 2 vols. Padua: Antenore, 1981.

Sorbelli, Albano. "Carlo Sigonio e la Società tipografica bolognese." *Bibliofilia* 23 (1922): 95–105.

*Storia della stampa in Bologna.* Bologna: Zanichelli, 1929.

Stahl, William Harris. *Martianus Capella and the Seven Liberal Arts.* Vol 1. *The Quadrivium of Martianus Capella.* Vol. 2. *The Marriage of Philology and Mercury.* Trans. William Harris Stahl and Richard Johnson with E. L. Burge. New York: Columbia University Press, 1971–7.

*Storia della Emilia Romagna.* Ed. Aldo Berselli. 3 vols. Bologna: University Press, 1976–80.

*Studi di storia dell'arte, bibliografia ed erudizione in onore di Alfredo Petrucci.* Milan and Rome: Bestetti, 1969.

Sulzer, Dieter. "Zu einer Geschichte der Emblemtheorien." *Euphorion* 64 (1970): 23–50.

Supino, I. B. *L'arte nelle chiese di Bologna.* 2 vols. Bologna: Zanichelli, 1932–8.

*Symbolo, metafora, allegoria: Atti del IV Convegno italo-tedesco (Bressanone, 1976)*. Ed. D. Goldin. Quaderni del Circolo Filologico Linguistico Padovano 11. Padua: Liviana, 1980.

*Symbols in Life and Art. The Royal Society of Canada Symposium in Memory of George Whalley*. Ed. James A Leith. Kingston, Ontario: McGill–Queen's University Press, 1987.

Tafuri, Manfredo. *Venezia e il Rinascimento: Religione, scienza e architettura*. Turin: Einaudi, 1985.

Tesauro, Emanuele. *Il Cannocchiale Aristotelico*. Ed. August Buck. 1670. Reprint. Bad Homburg, Berlin, and Zurich: Gehlen, 1968.

    *Idea delle perfette imprese*. Ed. Maria Luisa Doglio. Università di Torino. Centro di Studi di Letteratura Italiana in Piemonte "Guido Gozzano," Testi 1. Florence: Olschki, 1975.

Tiraboschi, Girolamo. *Storia della letteratura italiana*. 9 vols. in 15. Venice: Molinari, 1823–5.

Tolomei, Claudio. *Il Cesano de la Lingua Toscana*. Ed. Maria Rosa Franco Subri. Rome: Bulzoni, 1975.

    *Delle lettere di M. Claudio Tolomei libri sette*. Ed. Vincenzo Cioffi. 2 vols. Naples: R. Albergo de' Poveri, 1829.

    *Laude delle donne bolognese*. Bologna, 1514. Reprint. Bologna: Forni, n.d.

Tolson, Francis. *Hermathenae, Or Moral Emblems, And Ethnick Tales with Explanatory Notes*. Vol. 1. [London?, 1740?].

Tory, Geofroy. *Champ Fleury, ou l'art et science de la proportion des lettres*. Paris, 1529. Reprint. Ed. Gustave Cohen. Paris: Bosse, 1931.

*Tra Latino e Volgare per Carlo Dionisotti*. Ed. Gabriella Bernardoni Trezzini et al. 2 vols. Padua: Antenore, 1974.

*Umanesimo e simbolismo*. [IV° Convegno Internazionale di Studi Umanistici]. 2 vols. In *Archivio di filosofia* (1958), nos. 2–3.

*Umanesimo e esoterismo*. [Vᵉ Convegno Internazionale di Studi Umanistici]. Ed. Enrico Castelli. 2 vols. In *Archivio di filosofia* (1960), nos. 2–3.

*Università, accademie e società scientifiche in Italia e in Germania del Cinquecento al Settecento*. Ed. Laetitia Boehm and Ezio Raimondi. Annali dell'Istituto Storico Italo-germanico, quaderno 9. Bologna: Il Mulino, 1981.

Valeriano Bolzano, Giovanni Piero. *Hieroglyphica, Lyon, 1602*. Reprint. New York and London: Garland, 1976.

Varchi, Benedetto. *L'Ercolano*. Ed. Maurizio Vitale. 2 vols. Milan, 1804. Reprint. Milan: Cisalpino-Goliardica, 1979.

Vasoli, Cesare. *I miti e gli astri*. Naples: Guida, 1977.

    *Profezia e ragione: Studi sulla cultura del Cinquecento e del Seicento*. Naples: Morano, 1974.

Veress, Endre. *Matricula et Acta Hungarorum in Universitatibus Italiae Studentium, 1221–1864: Olasz Egyetemeken járt Magyarországi Tanulók Anyakönyve és iratai, 1221–1864*. 2 vols. Budapest, 1915–17. Reprint. Monumenta Hungariae Italica 3. Budapest: Academia Scientiarum Hungarica (Magyar Tudományos Akadémia), 1941.

Vignola, Jacopo. *See* Barozzi da Vignola, Jacopo.

Vizani, Pompeo. *Di Pompeo Vizani Gentil'hvomo Bolognese Dieci Libri Delle Historie Della Sva Patria*. Bologna: Presso gli Heredi di Gio. Rossi, 1602.

Volkmann, Ludwig. *Bilder Schriften der Renaissance: Hieroglyphik und Emblematik in ihren Beziehungen und Fortwirkungen*. Leipzig, 1923. Reprint. Nieuwkoop: De Graaf, 1962.

Waddington, Raymond B. "The Iconography of Silence and Chapman's Hercules." *Journal of the Warburg and Courtauld Institutes* 33 (1970): 248–63.

Walcher Casotti, Maria. *Il Vignola*. 2 vols. Università degli Studi di Trieste. Facoltà di Lettere e Filosofia, Pubblicazioni 11. Trieste: Istituto di Storia dell'Arte Antica e Moderna, 1960.

Waswo, Richard. *Language and Meaning in the Renaissance*. Princeton, NJ: Princeton University Press, 1987.

Weinberg, Bernard. *A History of Literary Criticism in the Italian Renaissance*. 2 vols. Chicago: University of Chicago Press, 1961.

—— ed. *Trattati di poetica e retorica del Cinquecento*. 4 vols. Scrittori d'Italia, nos. 247, 248, 253, 258. Rome and Bari: Laterza, 1970–4.

Weiss, Roberto. *The Renaissance Discovery of Classical Antiquity*. Oxford: Blackwell, 1969.

Wilberg Vignau-Schuurman, Theodora A. G. *Die emblematischen Elemente im Werke Joris Hoefnagels*. 2 vols. Leidse Kunsthistorische Reeks 2. Leiden: Universitaire Pers, 1969.

Wind, Edgar. *Pagan Mysteries in the Renaissance*. New Haven, 1958. Rev. ed. New York and London: Norton, 1968.

Zaccagnini, Guido. *Storia dello Studio di Bologna durante il Rinascimento*. Geneva: Olschki, 1930.

*Illustrations*

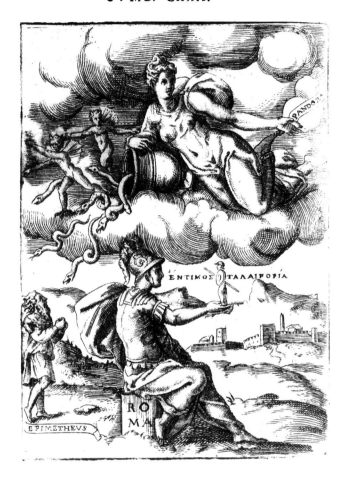

1. Pandora and Rome. Bocchi. *Symb. Qvaest.*, Symb. CXXIIII
(CXII).

2. Hieroglyphs. Francesco Colonna. *Hypnerotomachia Poliphili*, Venice 1499, sig. C.
By courtesy of the Princeton University Libraries.

PYRRHO BOCCHIO FILIO
Ex MYSTICIS AEGYPTIOVRM LITTERIS.

SYMB. CXLV.

3. Hieroglyphs for Pirro Bocchi. Bocchi,
*Symb. Qvaest.*, Symb. CXLVII (CXLV).
By permission of the Folger Shakespeare Library.

VICTORIA EX LABORE
HONESTA ET VTILIS.

4. Bucranium *impresa*. Bocchi, *Symb.
Qvaest.*, Symb. I.
By permission of the Folger Shakespeare Library.

וְרוּחַ אֱלֹהִים מְרַחֶפֶת עַל פְּנֵי הַמָּיִם :

5. Entelechy of the soul. Bocchi, *Symb. Qvaest.*, Symb. CXXXX (CXXXVIII).
By courtesy of the Princeton University Libraries.

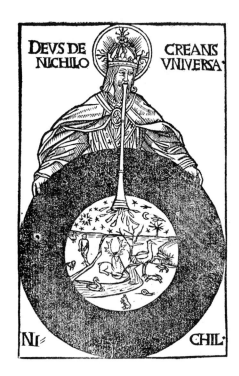

6. God creating the universe. Charles de Bovelles, *Liber De Nihilo*, Paris, 1510, fol. 63r.
By permission of the Folger Shakespeare Library.

SAT EXTAT IPSA VERITAS
VANA ABSIT OSTENTATIO

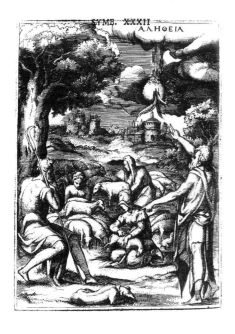

7. Truth revealed to shepherds. Bocchi,
*Symb. Qvaest.*, Symb. XXXII.
By courtesy of the Princeton University Libraries.

PHILOLOGIA SYMBOLICA.
MAGNAM HISCE HABENDAM GRATIAM
LABORIBVS.
SYMB. CXLIII.

8. Bocchi's laurel crown. Bocchi, *Symb.
Qvaest.*, Symb. CXLV (CXLIII).
By permission of the Folger Shakespeare Library.

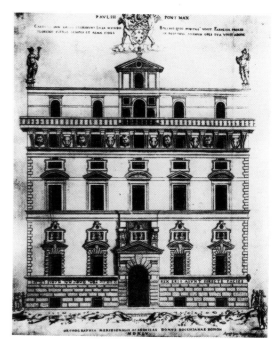

9. Facade design for Palazzo Bocchi, 1545.
Rome, Istituto Nazionale per la Grafica, F. N. 6226.

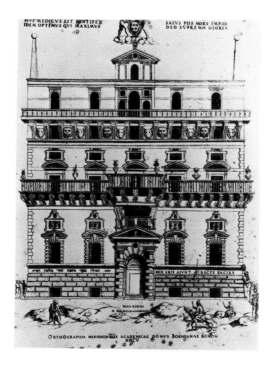

10. Facade design for Palazzo Bocchi, 1555.
Rome, Istituto Nazionale per la Grafica, F. C. 71270.

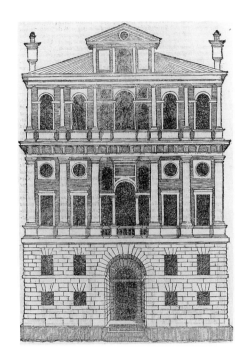

11. Doric Venetian palazzo. Sebastiano Serlio, *Tutte le opere*, Venice, 1560, *Libro Quarto*, fol. 155.
The John Work Garrett Library, Special Collections Department, The Johns Hopkins University.

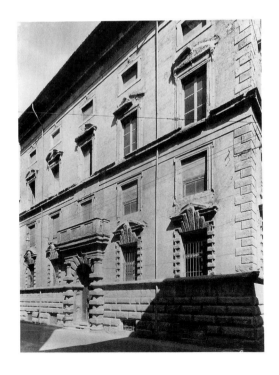

12. Jacopo Barozzi da Vignola, Palazzo Bocchi, Bologna.
Alinari/Art Resource.

13. Blindness, dedicated to Alciato. Bocchi,
*Symb. Qvaest.*, Symb. XL.
By courtesy of the Princeton University Libraries.

ARS RHETOR. TRIPLEX MOVET, IVVAT, DOCET,
SED PRAEPOTENS EST VERITAS DIVINITVS.
SIC MONSTRA VITIOR . DOMAT PRVDENTIA.
SYMB. CXXXV.

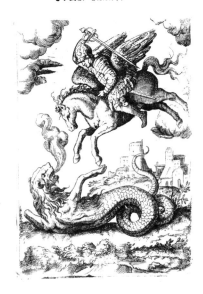

14. Chimera slain by Bellerophon. Bocchi,
*Symb. Qvaest.*, Symb. CXXXVI (CXXXV).
By courtesy of the Princeton University Libraries.

ARCANA CONTINEBIS ET CALVMNIAS·

SYMB. CXVII.

15. Hephestion and Alexander. Bocchi,
*Symb. Qvaest.*, Symb. CXIX (CXVII).
By permission of the Folger Shakespeare Library.

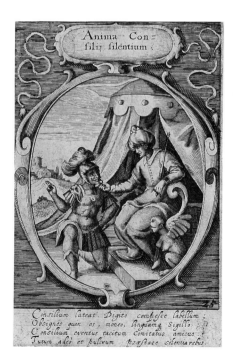

16. Hephestion and Alexander. Peter
Isselburg and Georg Rem, *Emblemata*
*Politica*, Nuremberg, 1617, no. 25.
By permission of the Folger Shakespeare Library

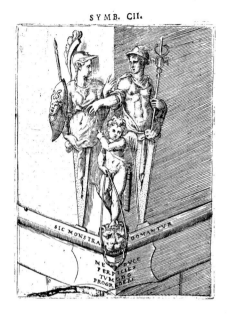

SAPIENTIAM MODESTIA,
PROGRESSIO ELOQVENTIAM,
FELICITATEM HAEC PERFICIT.

SYMB. CII.

17. Hermathena *impresa*. Bocchi, *Symb. Qvaest.*, Symb. CII.
By permission of the Folger Shakespeare Library.

ΜΗΔΕ ΔΟΜΟΝ ΓΟΙΩΝ ΑΝΕΠΙΞΕΣΤΟΝ
ΚΑΤΑΛΕΙΠΕΙΝ.
SYMB. CVII.

18. Corner of Bocchi's Palazzo with Hermathena. Bocchi, *Symb. Qvaest.*, Symb. CIX (CVII).
By permission of the Folger Shakespeare Library.

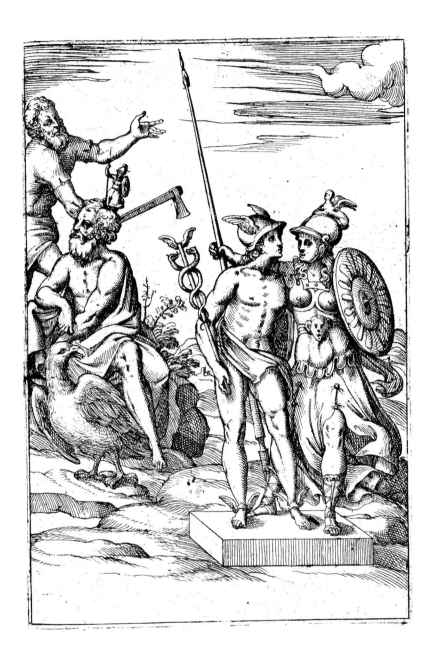

19. Hermathena. Vincenzo Cartari, *Le Imagini de i Dei de gli Antichi*, Venice, 1571, opposite p. 458.

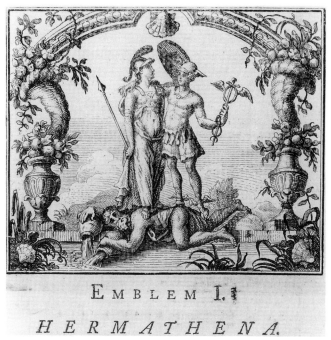

EMBLEM I.

*HERMATHENA.*

20. Hermathena. Francis Tolson, *Hermathenae*, London?, 1740?, no. 1.
The John Work Garrett Library, Special Collections Department, The Johns Hopkins
University.

21. Concave mirror. Bocchi, *Symb. Qvaest.*,
Symb. LX.
By permission of the Folger Shakespeare Library.

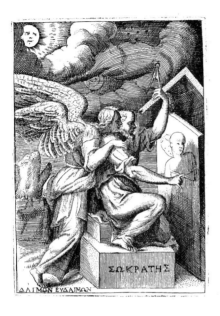

PICTVRA GRAVIVM OSTENDVN
TVR PONDERA RERVM.
QVAEQ. LATENT MAGIS, HAEC PER
MAGE APERTA PATENT.

22. Socrates and daimon. Bocchi, *Symb.*
*Qvaest.*, Symb. III.
By permission of the Folger Shakespeare Library.

Fortuna fidem mutata nouauit.

23. Symbola. Claude Paradin, *Devises*
*Heroïqves*, Lyon, 1557, p. 15.
By permission of the Folger Shakespeare Library.

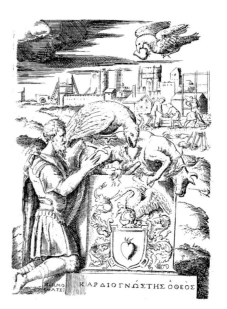

24. Sacrifice of a heart. Bocchi, *Symb. Qvaest.*, Symb. CXXII (CXX).
By permission of the Folger Shakespeare Library.

MAGNAM PARVA FACIT FAVILLA FLAMMAM.

HAEC PVLVERIS INVENTIO BOMBARDICI.
SYMB. CXII.

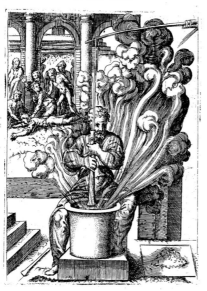

25. Invention of gunpowder. Bocchi, *Symb. Qvaest.*, Symb. CXIIII (CXII).
By permission of the Folger Shakespeare Library.

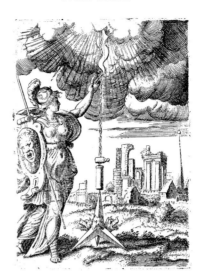

QVAM SE SE CVNQ. IN PARTEM SAPIENS
DEDERIT, STAT.

SYMB. CXXXII.

26. Pallas Athena and *figura*. Bocchi, *Symb.
Qvaest.*, Symb. CXXXIIII (CXXXII).
By permission of the Folger Shakespeare Library.

VIS ELOQVENTIAE POTEST VNA OMNIA.

SYMB. XCII.

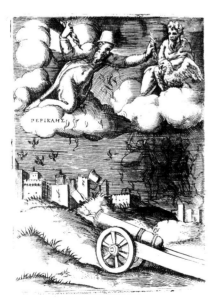

27. Power of eloquence. Bocchi, *Symb.
Qvaest.*, Symb. XCIIII (CXII).
By courtesy of the Princeton University Libraries.

EN VIVA E SPECVLO FACIES
SPLENDENTE REFERTVR,
HINC SAPIES, POTERISQ. OMNIA,
DVM IPSE VELIS.
SYMB. LIX.

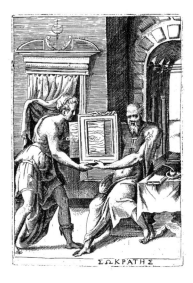

28. Bocchi and his son with a mirror.
Bocchi, *Symb. Qvaest.*, Symb. LIX.
By permission of the Folger Shakespeare Library.

OCCASIONEM QVI SAPIS NE AMISERIS·

SYMB. LXIX.

29. Occasio. Bocchi, *Symb. Qvaest.*, Symb.
LXXI (LXIX).
By courtesy of the Princeton University Libraries.

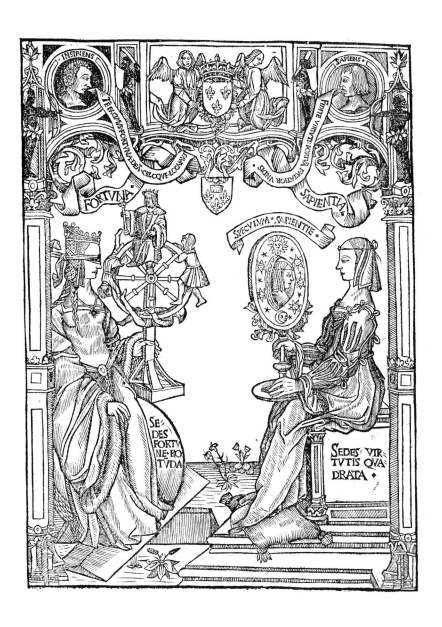

30. Fortuna and Sapientia. Bovelles, *Liber De Sapiente*, Paris, 1510, fol. 118v.
By permission of the Folger Shakespeare Library.

NEC NIL, NEC NIMIVM.
ΠΑΝΤΑ ΑΝΑΒΑΛΛΌΜΕΝΟΣ.
SYMB. LXXX.

MATVRA
CELERITAS

31. Bocchi's medal. Bocchi, *Symb. Qvaest.*,
Symb. LXXXII (LXXX).
By courtesy of the Princeton University Libraries.

VIRTVS VESTIBVLVM EST HONORIS ALMA.

SYMB. XXXIII

32. Temples of Virtue and Honor. Bocchi,
*Symb. Qvaest.*, Symb. XXXIII.
By permission of the Folger Shakespeare Library.

33. Gallic Hercules. Bocchi, *Symb. Qvaest.*,
Symb. XLIII.
By courtesy of the Princeton University Libraries.

CONSTANTIA HEIC EFFINGITVR.

SYMB. IX.

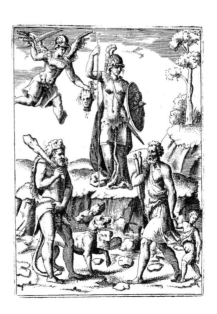

34. Constantia. Bocchi, *Symb. Qvaest.*,
Symb. IX.
By permission of the Folger Shakespeare Library.

ET LINGVAM ET IRAM CONTINE.

SYMB. CV.

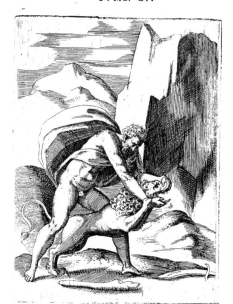

35. Hercules and the Cleonean (Nemean) lion. Bocchi, *Symb. Qvaest.*, Symb. CVII (CV).
By permission of the Folger Shakespeare Library.

FORTIS, MODESTVS, ET POTENS.

SYMB. LV.

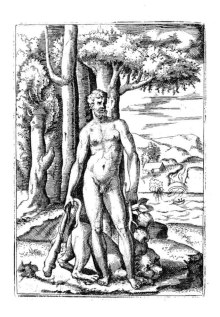

36. Victorious Hercules. Bocchi, *Symb. Qvaest.*, Symb. LV.
By permission of the Folger Shakespeare Library.

37. Hercules and Atlas. Bocchi, *Symb. Qvaest.*, Symb. CXII (CX).
By permission of the Folger Shakespeare Library.

NEC VIXIT MALE QVI NATVS,
MORIENSQ. FEFELLIT.

SYMB. CXXXI.

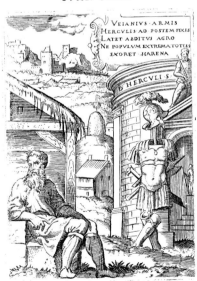

38. Veianius, the gladiator. Bocchi, *Symb. Qvaest.*, Symb. CXXXIII (CXXXI).
By permission of the Folger Shakespeare Library.

# VIRTVTIS VMBRA GLORIA.

39. Glory as the shadow of Virtue. Bocchi, *Symb. Qvaest.*, Symb. XLII.
By courtesy of the Princeton University Libraries.

# INANIS EST INFRVCTVOSA GLORIA.

SYMB. LXIII.

40. Gifts of Athena and Neptune to Athens. Bocchi, *Symb. Qvaest.*, Symb. LXV (LXIII).
By courtesy of the Princeton University Libraries.

SYMB. LXXIX.

41. Athena on stag. Bocchi, *Symb. Qvaest.*, Symb. LXXXI (LXXIX).
By permission of the Folger Shakespeare Library.

GASPARI ARGILENSI.

SYMB. LXXXI.

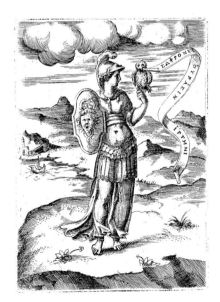

42. Athena and her owl. Bocchi, *Symb. Qvaest.*, Symb. LXXXIII (LXXXI).
By permission of the Folger Shakespeare Library.

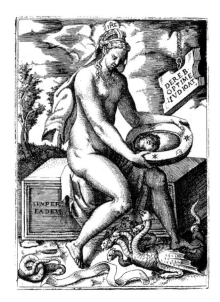

43. Sapientia. Bocchi, *Symb. Qvaest.*, Symb.
XI.
By permission of the Folger Shakespeare Library.

SPERANDA SVMMI EST PRINCIPIS BENIGNITAS,
MALIGNA VBI VRGET TEMPORVM NECESSITAS.

SYMB. LXXXIII.

44. Hermes interceding with Heaven.
Bocchi, *Symb. Qvaest.*, Symb. LXXXV
(LXXXIII).
By courtesy of the Princeton University Libraries.

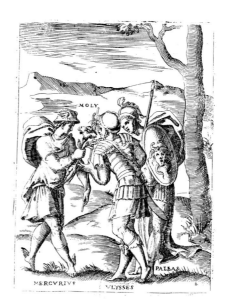

VSVM MAGISTRVM VNVM OPTIMVM.

SYMB. CXXVII.

45. Hermes giving Ulysses the moly plant.
Bocchi, *Symb. Qvaest.*, Symb. CXXIX
(CXXVII).
By permission of the Folger Shakespeare Library.

SILENTIO DEVM COLE.

SYMB. LXII.

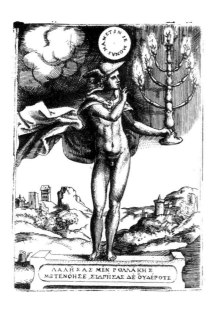

46. Hermes and silence. Bocchi, *Symb.
Qvaest.*, Symb. LXIIII (LXII).
By courtesy of the Princeton University Libraries.

FERT TACITVS, VIVIT, VINCIT
DIVINVS AMATOR.

SYMB. CXLI.

47. Hermes and silence. Bocchi, *Symb. Qvaest.*, Symb. CXLIII (CXLI).
By permission of the Folger Shakespeare Library.

OMNIA MENS SPECVLATVR, AGIT
PRVDENTIA ET ARTE.

SYMB. CLI.

ADHVC PATET

48. Janus temple. Bocchi, *Symb. Qvaest.*, Symb. CLI.
By permission of the Folger Shakespeare Library.

# Index